A Modern
Photo
Guide

Glamour Photography

Minolta Corporation
Ramsey, New Jersey

Doubleday & Company
Garden City, New York

Photo Credits: The cover
photograph and all the
photographs in this book
were taken by J. Alexander
unless otherwise credited.
p. 3: R. Farber; p. 4: R.
Farber

Minolta Corporation
Marketers to the Photographic Trade

Doubleday & Company, Inc.
Distributors to the Book Trade

This book and the other books in the
Modern Photo Guide Series were created
and produced by Avalon Communications,
Inc. and The Photographic Book Co., Inc.

Library of Congress Catalog Card Number 81-71222
ISBN: 0-385-18162-0

Cover and Book Design: Richard Liu
Typesetting: Com Com (Haddon Craftsmen, Inc.)
Printing and Binding: W. A. Krueger Company
Paper: Warren Webflo
Separations: Spectragraphic, Inc.

Manufactured in the United States of America
10 9 8 7 6 5 4 3 2 1

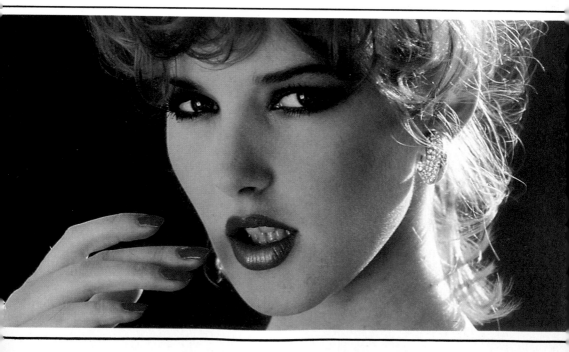

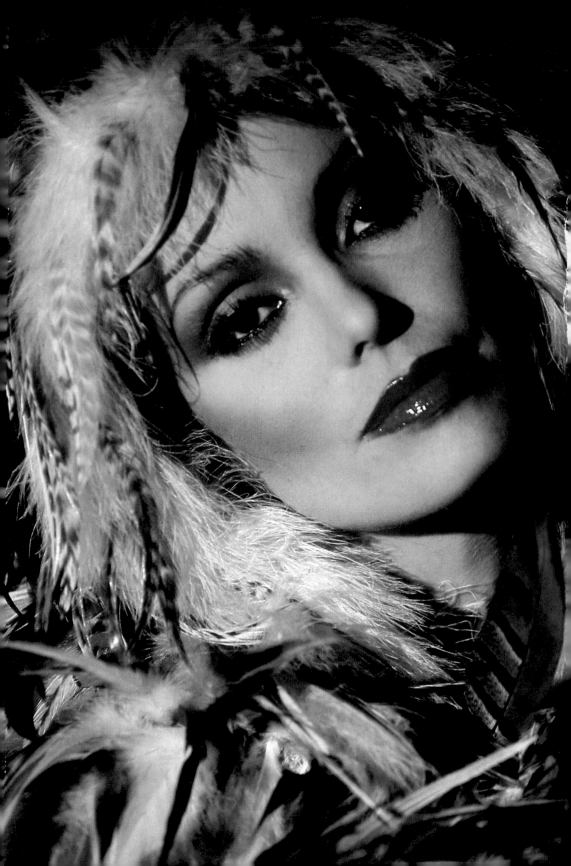

Contents

Introduction

1 Basic Equipment **12**
Choosing Lenses 14 ☐ Indoor Lighting Equipment 18 ☐ Electronic
Flash 24 ☐ Reflectors 26 ☐ Special Accessories 28

2 Backgrounds, Clothing, and Props **30**
Seamless Paper 32 ☐ Controlling Backgrounds 34 ☐ Clothing 36 ☐
Props 38

3 Basic Studio Lighting **40**
Basic Lighting Arrangements 42 ☐ Modifying Lighting 48 ☐ Bounce
Light 50 ☐ Bounce With a Flash Unit 51

4 Using Natural Light **54**
Color 56 ☐ Fill Flash 60

5 Creating a Mood **62**
Mood on Location 64 ☐ Natural Light for Mood 66 ☐ High Key and
Low Key for Mood 68

6 Working on Location **70**
Points to Consider 72 ☐ On Location in Public Places 75 ☐ On Location
in Malls or Restaurants 78 ☐ On Location at Night 80 ☐ Flash at
Night 82

7 Working With the Model **84**
Posing Shoulders, Hands and Legs 86 ☐ Corrective Posing 91 ☐ Clock
Technique for Posing 92 ☐ Portrait Posing 94 ☐ Establishing
Rapport 96

8 Makeup for Models **98**
Applying Makeup 100 ☐ Corrective Makeup and Hairstyles 102 ☐
Clothing for Women 104 ☐ Makeup for Men 108

9 Turning Pro **110**
The Model's Portfolio 112 ☐ The Composite 114 ☐ Preparing Photos
for Publication 116 ☐ Submitting Photos for Publication 118

Index **120**

Technique Tips

Throughout the book this symbol indicates material that
supplements the text and which has been set off for your
special attention. You can apply the data and information in
these Technique Tips immediately to get better results in
your photography.

Introduction

Glamour photography is usually considered a world of handsome men and beautiful women, a world of actors and actresses, models, singers, dancers, and celebrities. With your camera to record this exciting world, your work can appear in advertisements, posters, record covers, magazines and more. Or, you can avoid the commercial world entirely, and apply glamour photography techniques to photographs of family and friends. Whether you live in a small town or a major city, a knowledge of glamour photography can improve your portraits, and you can use it to provide part-time income or as a freelance business.

Glamour photography involves "selling" people as idealized images. The purpose of a commercial glamour photograph is to persuade someone to "buy" the person he or she is viewing. Often the person glamourized is part of a picture with a broader illustrative or commercial purpose. Suppose you take a picture of a model wearing a new designer dress during a fashion show and the picture appears in your local newspaper to advertise both the dress and the store in which it can be purchased. A woman seeing the advertisement might say to herself, "If I buy this dress, I will look just like the beautiful model wearing it." If this happens, your picture has "sold" the model and thus, the dress.

A glamour photograph does not have to be a stylized image of beauty. Adding a casual touch can give a picture the feeling that the subject is a flesh-and-blood human being, not just an idealized mannikin. Photo: R. Farber

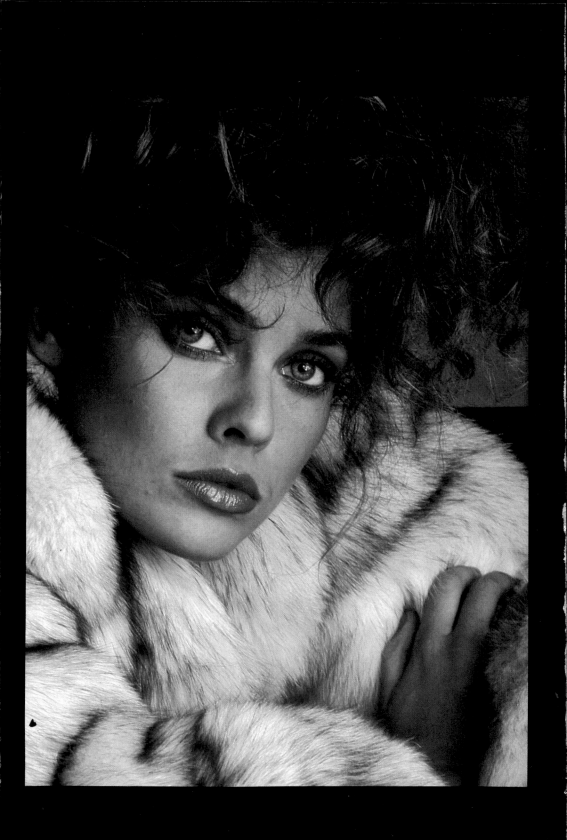

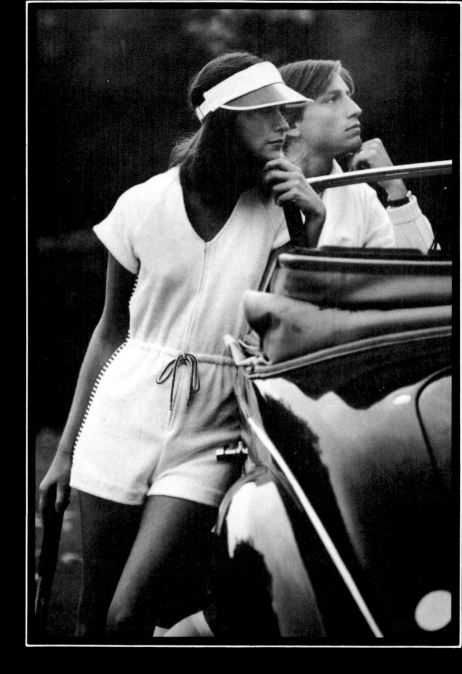

Enhance the romantic quality of a picture by posing your models next to objects that recall bygone and perhaps more genteel eras.

Or, visualize an advertising campaign for a soft drink. When you see a photograph in which a beverage is being consumed by a group of happy youths frolicking on the beach, you are being sold the image of the group. The purpose of the photography is to have you think, "If I buy this soft drink, I will feel like the happy, carefree crowd in this picture."

Or, suppose in a photograph there are actors and actresses performing in a play. Your camera recreates one of the visually dramatic scenes and the picture is used on advertising posters. Someone viewing such a poster is supposed to think, "These people certainly look interesting. I wonder what they are doing? If I go to the play, I bet I will enjoy myself."

Each picture in glamour photography is meant to "sell" people, whether you are taking photographs for a nightclub entertainer, photographing nudes for a magazine, calendar, or similar use, or taking fashion photographs for advertising. And because the viewer must be excited about the way in which a product is displayed, the people you photograph must be handsome or beautiful as well. For that reason, glamour photography is extremely important to the way businesses sell their goods and services.

The fact that you may have no interest in trying the business aspects of glamour photography does not mean you should ignore the techniques developed by professionals. No matter which area of glamour photography you select, the techniques are the same. If you engage in glamour photography as a hobby, what you will in fact be doing is "selling" the best possible images of family and friends. You will, therefore, use professional techniques in learning to see them differently so you can capture their most flattering facial expressions and poses on film. Whether you do it for fun or money, you will be photographing people in a manner that enhances their appearances.

One of the professional applications of glamour photography is to photograph a model demonstrating a particular product. The model might be showing a lawnmower for a local hardware store advertisement, or two models might be sitting in a restaurant enjoying a meal, as an advertisement for that business. Many products are sold this way, among them, towels, appliances, stereos, even nightclubs. The models are vehicles to get the user's attention and to promote the subconscious idea that you can share the model's beauty, happiness, and more, by buying the product or visiting the entertainment spot that is being advertised.

The techniques needed to create such commercial photographs can also be applied when you do glamour photography as a hobby. Understanding how to photograph someone in an unusual setting, or working with various props when creating a glamour photograph of a friend, improves your photography. The fact that all the techniques needed to provide you with more interesting hobby photos will also give you the training you need to sell your work, is an added bonus.

"Cheesecake" photographs refer to slightly sexy images which were once popular with tabloid newspapers. A pretty girl might be posed on a beach or near a lake, her low-cut dress hiked high, with plenty of leg showing, or an attractive girl might be pictured in a tight, slight bikini. These "pin-ups" are sometimes still used in magazines and newspapers to promote places with warm climates.

The nude body has been a popular subject for artists for centuries, and nude photography is considered the artful photography of the naked body. Sexual titillation, as such, is not the primary visual interest. Such photographs show the human figure as an object of art, and images are esthetic exercises in light and form. Almost all processing labs accept nude photographs and will print them.

Glamour photography, cheesecake pictures, and nude studies are not pornographic. Pornography is a degrading aberration of photography. In every case, the person recorded is debased, and in no way should such a photograph be considered related to legitimate glamour photography.

But enough of what glamour photography is or is not all about. Let's explore how you can begin making handsome photographs of men and beautiful photographs of women.

A partially clothed figure is often more enticing than a completely nude one. An appropriate setting and pose makes this costume technique more than just a pin-up trick.

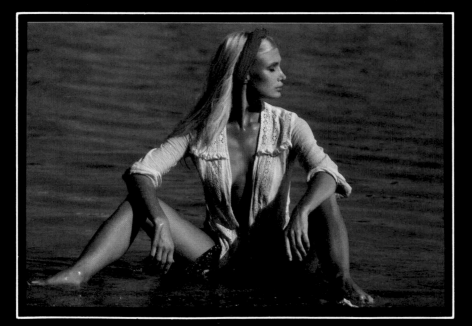

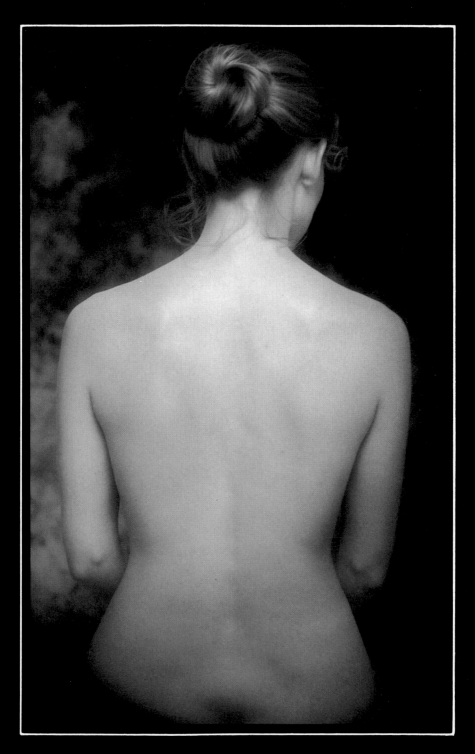

A background that complements the subject gives a unity of mood to a picture. The muted color and indistinct details in the background here provide a painterly effect that reinforces the classical feeling of this figure study.

1

Basic Equipment

The 35mm system dominates American glamour photography. The sharpness and variety of the lenses, coupled with the wide variety of color and black-and-white films, makes 35mm cameras popular for magazine illustrations, posters, and hobby use. You can work rapidly with these cameras, and optional power winders, zoom lenses, and many other accessories further increase its versatility.

A great advantage of the 35mm system is its portability. While larger-format cameras are popular with professionals because the results are easy to see, to reproduce, and to retouch when necessary; the equipment may also be heavy, noisy, and prohibitively expensive.

One of the exceptions, increasingly purchased by hobbyists, is the 4.5 × 6cm design, which takes 16 photographs on a roll of 120 film. Some of these offer interchangeable lenses and finders, motor drives, and all the other accessories of 35mm equipment at the same price as a medium priced 35mm single-lens reflex (SLR). The one advantage is a negative that is larger than 35mm so less magnification is required to achieve an enlarged print. The resulting print is less grainy and perhaps sharper than the same picture printed the same size from a 35mm negative.

Twin-lens reflex (TLR) cameras using roll film are almost silent. Currently, only the Mamiya line offers interchangeable lenses and a reasonable price compared with 35mm equipment. Unfortunately, the bulky shape, the lack of motor drive and similar accessories, and the weight make this type of camera less desirable.

Large-format cameras are popular primarily with those hobbyists who like to take scenic photographs that will require little or no enlarging of the final image.

Although this professional photographer has several assistants and uses a large amount of equipment, he still checks his lighting with an instant-picture camera. This step saves time and money, especially in color photography with a new or unusual set-up. Photo: R. Farber.

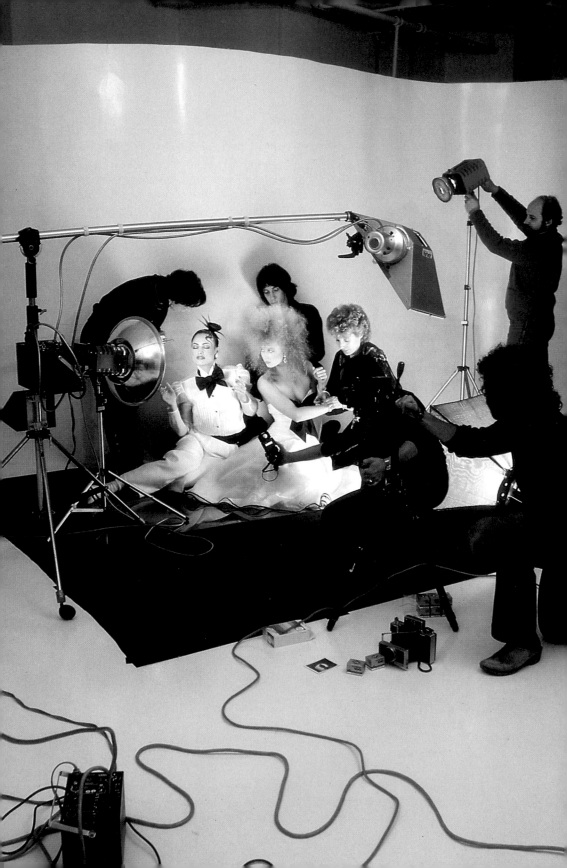

Choosing Lenses

When you look at someone you always maintain a certain distance. Your perspective changes when you move in closer. If you stand a few inches from your model, with one eye closed and the other staring directly into the model's face, the latter's head will appear distorted; it will seem much rounder. The nose will be bulbous if your angle is such that the nose is close to your eye. Move in very close to your model's face with a normal or wide-angle lens and the distortion becomes quite obvious. The closer the lens is physically positioned in relation to your subject, the more likely the resulting picture will be similar to what your eye sees when you are close to the model's face.

Normal Lenses. You can take glamour photographs with your normal 50mm lens as long as you do not try for extreme closeups of the entire head. The best distance for a normal lens is one that allows you to record your model's full head and shoulders. The normal lens is excellent for full-figure work as well.

The normal lens can be used for fashion, advertising, portraits, entertainers, and some stage work. Your normal lens probably has a maximum aperture of from $f/1.4$ or $f/2$. The smaller the number, the larger the opening and the more light it will pass. This often means you can use your normal lens inside a dark nightclub and still obtain an effective image.

Macro Lenses. If you own a close-focusing 50 mm macro lens, you will be able to photograph one facial feature, such as your model's lips. Macro lenses are often used for cosmetics advertising where the eyes or mouth fill the frame.

Wide-Angle Lenses. Wide-angle lenses should be used for full-figure work only, because of the distortion problems that occur when you move close to your subject. Wide-angle lenses are excellent when working in compact areas. Generally, you will need a working distance of 6 meters (30 ft.) with a 50mm lens on a 35mm camera. However, if you have a 35mm lens on your camera, you can move from 3 meters (10 ft.) closer and still take a full-figure photograph.

Use your 35mm lens, or the equivalent wide-angle lens for medium and larger format camera systems with caution. If you pose your model so that an arm or leg extends close to the camera, that portion of the model's body will seem distorted on film. To avoid this, keep the model's body somewhat parallel to the camera film plane.

A through the lens meter makes finding the proper close-up exposure an easy task. Here, reading from the skin tone, not the hair, is essential. Photo: R. Farber.

Telephoto Lenses. Telephoto lenses narrow the angle of your vision. While a 50mm lens will let you record almost a full-figure photograph of a model, an 85mm lens from the same distance will record considerably less of your subject. Moderate telephoto lenses are excellent tools for glamour photography. A lens in the 85–105mm

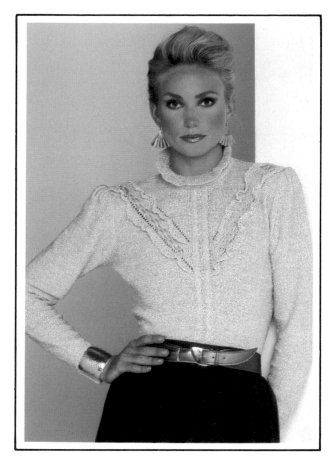

The advantage of using a zoom lens in the limited shooting space of some studios is that it allows you to select various framings without changing the camera to subject distance.

range will record a tightly framed head-and-shoulders image with a more pleasing perspective than a close-focusing normal lens. Lenses as long as 135mm are good for glamour photography, but may be difficult to hand-hold under low-light conditions.

Zoom Lenses. Zoom lenses that cover side-angle to moderate telephoto range (e.g. 35–70mm) or a short telephoto range (70–150mm) can replace a number of fixed-length lenses. But, they are usually slow ($f/3.5$ is often the maximum aperture.)

For many years, zoom lenses were optically inferior to fixed lenses in each of the specific lengths covered by the zooms. Even today, some extremely cheap private label brand zooms render a poor result. However, the majority of zoom lenses produce portrait photographs that are indistinguishable from pictures taken with fixed-length lenses. The most expensive fixed-length lenses may be superior in optical tests, but the human eye is unable to tell the difference between portraits taken with them and with most zoom lenses. The convenience of using a zoom lens far outweighs its disadvantages.

Indoor Lighting Equipment

Unless you work only with natural or available lights, you have to consider the use of a light source that you can control for glamour pictures indoors. There are several different systems you can use. The least expensive system uses photoflood bulbs powered by household current. For a relatively small amount of money, you can purchase a clamp holder and reflector capable of holding a 500-watt photoflood bulb. These holders are sold in hardware stores, and in the hardware or lighting departments of large discount stores. You will need at least two.

Multiple Lighting. The reason you cannot use one light effectively under most circumstances is because single light usually leaves areas of shadows that exaggerate facial flaws and hide attractive features. A second light can fill in the shadows and seemingly smooth the model's complexion. Other lights, aimed at the background and hair, create a separation that makes your subject seem to leap from the photograph.

A single light may also cast shadows on the background. This is the effect you get when you take a flash-on-camera photograph in which everyone is smiling and the wall behind them is a mass of unsightly shadows from the harsh light. Extra lights enable you to position your lighting to flatter your subject and also eliminate the shadows. A well-positioned light can brighten an entire area where a shadow would have otherwise appeared.

Another problem with a single light is the way it strikes your subject's face. If the light goes across the texture of the skin, every facial flaw appears magnified. Light striking your subject from the front seems to flatten the face and creates a one-dimensional image. Accurate sculpting of a face requires more than one direct light.

For a group subject like this one, multiple lighting is essential. Besides eliminating background shadows, this type of lighting arrangement adds illumination in areas that would otherwise be dark. Here, lights aimed at the background have also been used to add greater definition to the subjects.

Matching Light and Film. Lights for photography are discussed in terms of the color of their output, or more specifically, their color temperature which is expressed in degrees Kelvin (K). Daylight is considered to be approximately 5500K, while a common light bulb is rated at approximately 2900K. The lower the Kelvin number, the more red there is as a component of the light. Daylight, with the much higher Kelvin number, contains more blue. Your eye will compensate for these

(Left) A photograph taken on daylight film under the tungsten light produced by the modeling light of the photographer's flash unit demonstrates a warm, yellowish coloration caused by the film-light source imbalance. (Below) Flash units, which produce essentially the same color light as daylight, give a cooler, more normal coloration when used with daylight film.

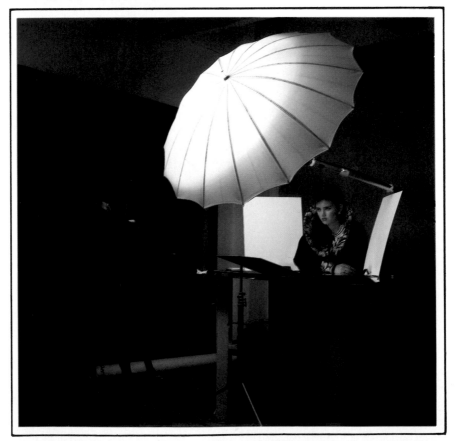

A proper matching of film and light source is as important for accurate rendition of costume color as for subject skin tone. Both of these photographs were taken by tungsten light; the one at the right was taken on daylight film, that at the left on tungsten film.

differences but your film will not. When you photograph a model in daylight using a film made for use with 3200K indoor bulbs, your model's face will take on a blue cast. This is because films are balanced for different Kelvin temperatures of light. It is, therefore, important to know the type of lighting being used and match the film to it. See the accompanying table.

Small tungsten bulbs for photography usually put out 250 watts of light. You can also buy 500-watt bulbs, (the most practical) and 1000-watt bulbs, which generate too much heat for clamp-holders, (65° watts maximum is the rating for most such holders). The 500-watt bulbs can also be used in most household light sockets, if you want to create properly balanced light in a room setting.

Matching Film and Light Source		
Light source	**Color temperature (approx.)**	**Type color films**
Daylight	5500K	Daylight
Photoflood	3200K	Tungsten (sometimes called Type B)
Floodlamp	3400K	Type A (Tungsten)
Quartz-halogen	3400K	Tungsten
Fluorescent	Varies widely	Tungsten Daylight or Tungsten with appropriate filter

Extension Cords. Make certain you have a few heavy-duty extension cords for your lights. If you use three or four 500-watt lights, they will overload an average home circuit. The extension cords will enable you to plug them into sockets connected to different circuits and avoid overloading.

Holders. Clamp holders give you tremendous flexibility at little cost. The lights can be clamped to stands, the backs of chairs, bookshelves, or practically anywhere. You can also buy Gaffer's Tape, a heavy-duty tape used in the motion-picture industry to hold lights. The tape strips hold great weights and will stick to any surface without pulling off paint or plaster.

More expensive floodlight holders are available from camera stores. These have portable stands which can be raised and lowered to any height you wish. They offer excellent control at a higher cost, and are practical for hobbyists who want to create an instant indoor studio. While you are still experimenting with bringing glamour techniques to your portraits of family and friends, however, you may find the clamp-type ones to be more practical.

For Beginners. If you are just getting started in glamour photography, continuous burning lights offer the greatest amount of light at the least cost. Tungsten bulbs in reflectors offer the beginner plenty of opportunities to learn about controlling light.

A usable and relatively inexpensive substitute for gaffer's tape is ordinary silver backed cloth tape, called duct tape. It is available in most large hardware stores.

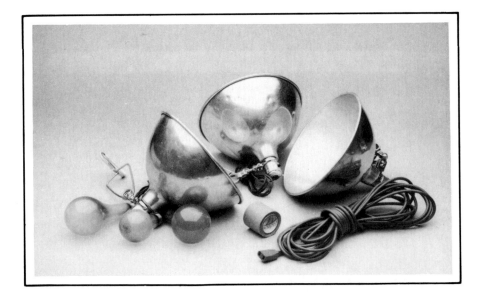

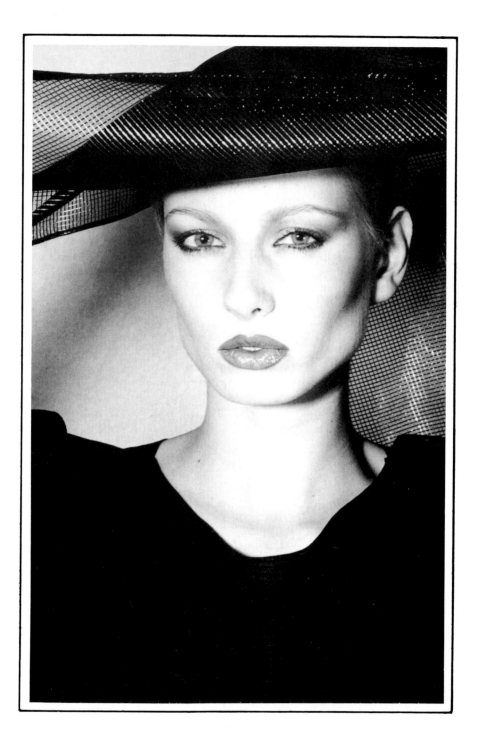

Floodlights are ideal for producing well-defined, sparkling images without the deep shadows often seen in direct-flash photographs. The relatively large light source produces a somewhat more diffuse light that eliminates the more distracting shadow areas while retaining a strong modelling effect. Photo: G. Chinsse.

*To hide the shadow from direct
flash, put the subject very close to
the background and diffuse the light.*

Electronic Flash

You probably own a portable electronic flash unit of one type or an-
other. These units may be used indoors—or outdoors, and they are
excellent for glamour photography, provided you understand what
they can and cannot do.

Direct Flash. Direct flash is one of the least preferred type of
lighting but it is sometimes useful. For example, when you take pic-
tures of a fashion show, you are essentially recording the event. The
clothing is more important than the model under such circumstances.
Direct flash is harsh, not flattering, but you are trying to photograph
the outfit being worn. The fact that the model does not look her best
is of relatively little concern.

Bounce Flash. A softer, more flattering light comes from bounc-
ing a single flash unit against a white wall or ceiling. The flash is aimed
at such an angle that its light will reflect from the ceiling, then down
around the model. The harsh flash becomes a diffused, flattering light.
Unfortunately, there are problems using bounce light. A model with
deep-set eyes and/or a hairstyle that hangs over the forehead may have
harsh shadows on his or her face when bounce light is used. The latest
model flash units have two flash heads to overcome this problem: a
large one to aim at the ceiling and a smaller one to light the face
directly.

Studio Flash. Electronic flash can be used in the same manner as continuous lighting. You need at least three units mounted on stands, the main light, the fill, and the hair or background light. One flash unit is generally wired to your camera. The others can be connected directly, but they are usually triggered by what are known as slave lights. These are inexpensive sensors that plug into the flash units. When the first unit is triggered by your camera, the flash of light strikes the sensors of the other units as well as your subject. The sensors then trigger the remaining flash units. The speed of light is so great that all three are synchronized perfectly with your shutter.

One problem with electronic flash which you do not encounter with a continuous light source is that you cannot readily see where the light will strike your model in order to position the flash for the most flattering effect. Modeling lights can help. They are low-wattage, continuous light sources that either attach to an electronic flash unit or are an integral part of it. Some studio flash units have an accessory shoe so that a portable, low-wattage light bulb in a holder can be attached to it. The light covers approximately the same area as the flash and serves as a modeling light.

More expensive professional flash units are equipped with a built-in modeling light in the center of the flash tube. You can position the flash easily, based on the continuous illumination of the modeling light.

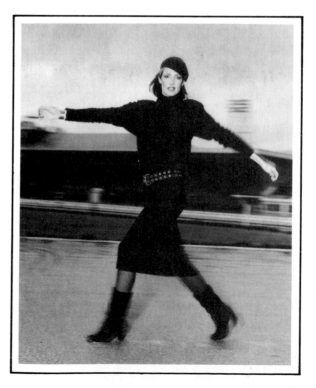

A combination of slow shutter speed and a single burst of direct flash produced this image of frozen movement. Existing light created the blurred "ghost" images of the moving arms and legs after the flash had captured the model's face with clarity.

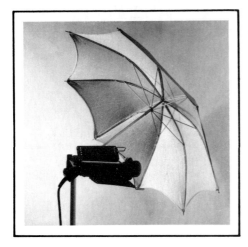

Position the reflector far enough away from the lamp so that the light given off covers the entire umbrella surface.

Reflectors

Direct light is always harsh. It brings out all the details in your model's face, and if the person has skin blemishes, the harsh direct light will exaggerate the problem. One way to reduce the harsh effect is to diffuse the light. Sometimes this is done by placing a special filter over the light source to effectively scatter the light and soften it. Such filters for floodlights are expensive because they must withstand extremely high heat for prolonged periods. Another source of diffused light is bounce light. When you aim your flash or floodlight at the ceiling, letting the light reflect down at an angle toward your subject, the light is softened. However, light bounced from a high ceiling may provide insufficient illumination and a colored ceiling can tint your pictures.

The best way to diffuse and soften light is to use a reflector.

Umbrella Reflectors. Umbrella reflectors are reflectors that fold like umbrellas for transportation and storage, yet pop instantly into shape when needed. These reflectors are generally made of metallic cloth and usually colored blue, gold or silver.

The blue reflectors are for use with daylight film and a tungsten, photoflood or quartz-halogen bulb since the reflected light from the blue surface will be close to daylight.

The silver umbrella diffuses any type of light without changing it.

The gold umbrella warms the light source. It is useful for special effects.

Pure white and pure black photo umbrellas are also available. A white umbrella reflects the same color as the light, much like a silver surface. They are less efficient than silver, so they give a softer effect. Pure black umbrellas are not reflectors. They are meant to absorb harsh light which might strike your model.

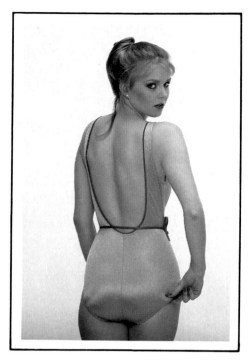

Umbrella reflectors provide a soft, wraparound lighting effect that is ideal for pastel subjects. Here, a silver-fabric umbrella was used to produce the highlights needed to bring out the shiny texture of the bathing suit.

Since photo umbrellas are somewhat expensive, some photographers make their own using inexpensive rain umbrellas. The interior surfaces are covered with either aluminum foil or white cloth and reinforced with Gaffer's Tape.

Other Reflectors. Flat reflectors sometimes known as "flats" can be easily made of a lightweight, thick board or a piece of corrugated cardboard covered with white cloth or aluminum foil. These homemade devices can be effective. When white cloth is attached, it should be wrinkle-free. Aluminum foil, however, should be wrinkled to better diffuse the light. By taking a sheet of foil, crushing it into a ball, then carefully smoothing it onto the board, the desired effect is achieved.

If the indoor light level is too dim for shake-free handheld exposures, use photographic bulbs in place of household lightbulbs for increased illumination.

27

Special Accessories

Motor Drives and Power Winders. These two devices are often discussed in relation to glamour photography. They allow you to keep the camera to your eye, press the shutter release, and have the camera take a series of photographs at rates varying from one to five frames per second, depending upon the unit.

A power winder allows you to constantly watch a model's expression rather than having to take the camera from your eye each time you need to advance the film. This gives you the opportunity to record a variety of expressions and poses that might otherwise be lost while the camera is away from your eye.

The winder is also helpful with a model who is in constant motion. It is easier to record his or her best moves if you can eliminate the delay necessary for repeated manual advancing of the film.

Star Filters. A popular optical accessory is the star filter. This is a piece of glass in which a thin wire screen has been embedded. You take your photograph through the screen, but the screen is never visible in the final picture. The screen diffuses the light slightly and softens the image imperceptibly. However, the screen's real purpose becomes apparent when you photograph a bright light source, such as a model

Sequence photographs shot with a power film advance at a rate of one or more per second require a high shutter speed. That means using a relatively large lens aperture as well for proper exposure—a good combination for throwing backgrounds out of focus.

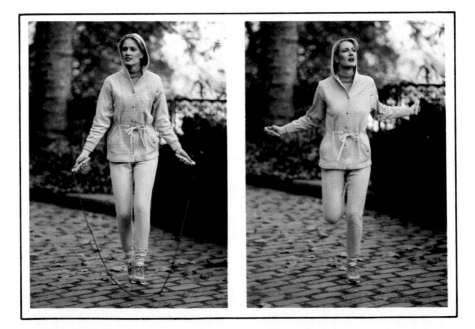

holding a candle. The screen catches the light and creates a star image. The number of points in the star is determined by the grid pattern of the screen.

Examples of star filters in use can be seen on many television specials featuring a singer in a sequined dress. As she moves, light bounces from her dress, microphone, and jewelry, and you see flashes of stars coming from those shiny surfaces.

Multi-Image Filters. Another popular optical accessory is the multi-image filter. There are numerous types, but most provide from three to five identical pictures of the same scene. Usually, the central image is sharp and the others are rather soft.

Many glamour photographers like multi-image filters. However, the problem with them is that while the filters create an interesting effect, they do not show the model at his or her best. The total picture has impact, but the model is lost to the special effect. Limit the use of such devices.

Spot Meters. A spot meter is a light meter that is designed to take light readings from subjects you cannot approach easily. For example, if you want to photograph an actor during a play but you have to work from the balcony, the spot meter can help. A spot meter reads the same area you would see if you could use your camera's through-the-lens meter with a 1200mm lens. If you cannot get close to your subject, a spot meter is useful.

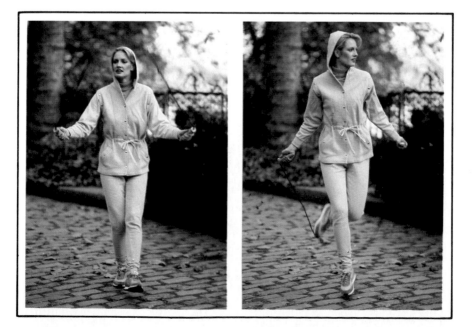

2

Backgrounds, Clothing, and Props

The creative use of backgrounds, clothing, and props is often the way to distinguish the really good glamour photographers from the mediocre ones. The creation of a scene with accessories and props is limited only by the photographer's taste, daring, and imagination. There is no formula for creating exciting glamour photographs. Sometimes the obvious works. For example, an elegantly gowned model seated in a fine restaurant drinking champagne from a crystal wineglass makes a perfectly respectable photograph for a champagne advertisement. The same model in a dressing gown against a white seamless paper background, with a white table on which is a champagne bottle and a perfect peach, creates an entirely different mood and message. You might want to do a series of experiments working with the same model and the same central theme (a champagne advertisement, for example) and see how many different ways you can present it, simply by changing accessories.

You will certainly have to spend a considerable amount of time seeking out props and clothing. The idea, however, is to spend as little money as possible on all this, a limitation that will certainly tax your ingenuity and imagination to the fullest. This chapter will give you some ideas about how to go about acquiring what you need, but what you use and how you use it is entirely up to you.

Color coordination is a must in glamour and fashion photography. In this picture, the photographer made sure that colors of the setting harmonized with the model's costume and accessories.

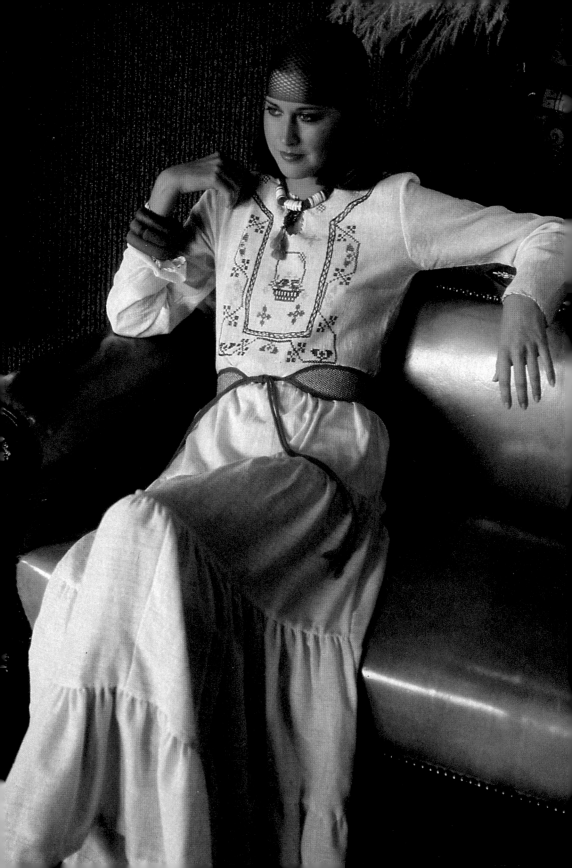

One of the advantages of seamless paper is that it creates a non-specific background. A wide variety of advertising copy may be used without the limitation of a particular environment.

Seamless Paper

One of the secrets to successful glamour photography is to be able to control backgrounds. Many hobbyists regularly appropriate a room in their homes for glamour photography. They move furniture from a family room, living room, or basement, then set up extra lights and either use a plain white wall as a background or, create a less obvious background using seamless paper. With the wall as background, however, the line where the wall meets the floor is always seen in a full-length pose.

Seamless background paper is a roll of paper approximately 3 meters wide and 11 meters long (10 ft. × 36 ft.). The exact dimensions vary with the manufacturer, but it is wide enough and long enough to cover most photographic situations. Your local photography store may have a selection on hand or be able to order it for you from one of several different manufacturers.

Seamless paper is valuable because its effect on film is one of endless color or tone behind the model. Moreover, the paper is available in a broad range of colors so you can contrast the paper with the model's clothing.

Professionals suspend seamless paper from long poles supported by floor stands or ceiling holders. Some holders are free standing; oth-

ers rely upon springs to brace them between ceiling and floor. An alternative do-it-yourself method calls for suspending the seamless paper roll from the ceiling with a length of line through the center of the roll.

Take Care. Seamless paper should be used carefully. Sections that become dirty will be recorded by your camera so they must either be cut from the roll or hidden from view.

Care should be taken to avoid damaging the paper. The simplest way to protect against damage is to have the models use masking tape on the bottoms of their shoes. Many photographers remove their shoes when working on seamless paper.

Seamless paper should be used on hard floors. If you have carpeting in the area where you will be working, the "give" of the fibers results in the paper being torn as the model moves about. However, if you place a sheet of purchase (½ inch plywood) under the paper, it will support the model without allowing the paper to tear.

Notice that the photographer's assistant has removed her shoes in order to step into the set. The photographer stays outside the picture area as he coaches the models.

A professional's studio relies on make-up artists and other specialists to insure that every detail receives proper attention.

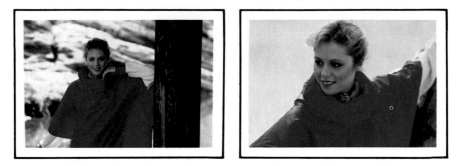

(Left) The blurred background and scarred post detract attention from the subject. (Right) A simple change of camera angle achieves a complementary background and reduces the post to an unobtrusive prop.

Controlling Backgrounds

Color. Select seamless paper colors that are not distracting. Red and orange background paper might dominate the picture, drawing attention away from your model. "Cold" colors, such as blue and green, or even black or white paper will be the best.

Always be aware of your background when on location where you cannot use seamless paper. The last thing you want is the viewer's eye drawn to an object in a corner of the picture when that object does not relate to your subject. For example, the human eye is always drawn to the color red. Imagine a color photograph of a model dressed in blue or green clothing (colors which tend to recede into the background) on a playground. If you happen to include a red ball in the corner of the photograph, the attention of the viewer's eye will be drawn to the corner where the ball is located, and taken away from the central subject.

Point of View. Sometimes a high angle will solve the background problem. At home, this can mean standing while your subject is sitting on the floor. You might also use a small stepladder for added height. With your model in the center of the room and you at a high angle, the entire floor becomes your background and the wall is not visible. This is helpful when you have no seamless background paper and there is an obvious break between the wall and the floor.

Outdoors, you can achieve this high angle by standing on a rock, a stepladder, or even your car. Some photographers have taken glamour pictures by climbing to the top of a jungle gym at playgrounds and then shooting from that position down at the "endless" blacktop on which their subject is posed. A lower angle would reveal the swings, baseball diamond, or other surrounding distractions; the high angle allows the photographer to isolate the main subject.

You can also use interesting building facades as the background for glamour photography. This might mean using a building designed

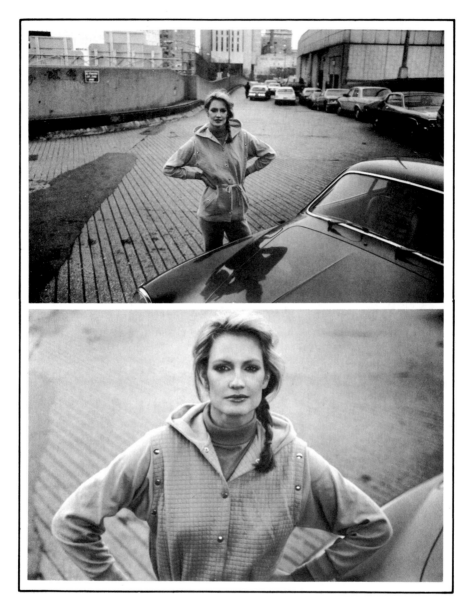

One way to "move closer" to your subject, especially when there is an object between you, is to change to a lens of longer focal length.

in the style of an ancient Greek or Roman structure, or using the weathered bricks of a building's wall as background.

Building a Set. You can turn one corner of any unused room or an unfinished basement into a permanent background. One way is to paint the wall and floor with flat black paint so that there is no obvious point where the floor and the wall meet. Another approach is to buy black fabric and make a long drape by sewing several pieces together.

It isn't necessary for each picture to be a riot of color to be effective. This subject is clothed in mostly neutral tones with color accents coming from her scarf and lipstick.

Clothing

Your models should always have a wide variety of garments for glamour photographs. Their wardrobes should include formal wear, casual wear, bathing suits, work clothes, or whatever is needed. Unfortunately, the reality is that even a professional model will not always have such a full range of outfits. Most professional models arrive at a shooting session simply dressed because the clients provide everything they need. Many amateur models will have a similar wardrobe.

There are several ways to obtain clothing and costumes. If you are working with a model who is trying to put together a first portfolio, he or she will be relying on personal clothing and outfits borrowed from friends. Borrowing clothing from stores may be difficult. No store will provide you with clothing inasmuch as a store risks having its merchandise damaged when it supplies clothing. In addition, you will probably want to use the outfits for photographs that will be of no value to the particular store.

Used and Rented Clothing. One way to get a wide variety of outfits at a reasonable cost is to go to a used clothing store. Such stores are found in cities throughout the country. In localities where such stores do not exist, chances are that public services such as the Salvation Army or Goodwill Industries operate facilities near you. Normally,

these organizations have used clothing for sale. Explain to the manager why you need the clothing. Find the items that are appropriate and in the approximate size of your model. (Slight alterations can be made with pins, clothes clips, or masking tape.)

Men's wear may have to be rented from a formal-wear location if you need a tuxedo or similar formal clothing. Since these stores are already in the business of renting, there is a good chance that you will receive a good deal when the manager knows you will be using the clothing for pictures.

Improvise. Makeshift garments can be created for women with scarves and long lengths of material. A model can "design" a sexy bikini from a large, colorful scarf. Interesting pictures result if you simply take a large quantity of whatever material seems unusual and let your model experiment in wrapping her body.

If you are trying to build your own portfolio of pictures, then the cost of outfits should be yours. The models should provide their own clothing if you are making a portfolio for them. In either case, keep in mind the potential benefits when deciding how much money should be spent on creating the right "look." Working to keep expenses to a minimum should be your goal.

A model's clothing should, in most situations, fit in with the surroundings. The simple leotard, denim skirt, and sweater worn by the model might well be part of her own wardrobe. Note how the simple, basic colors add to the impression of youth implied by the school bus used as a setting.

Props

Props are all around you. They can be anything that helps create the scene and enhance the mood you are trying to establish. Many of the first props you will use will probably be the things in your own home —your furniture, the decorative items you own, and your personal objects related to sports or hobbies. Once you begin to look at your home as a source of props, you will be amazed at what you will find. Don't stop in the house, though, check your garage, attic, and workshop.

A prop should be a natural element in a picture. It shouldn't distract or draw attention to itself. It should "work" with the context of the whole image that is being created. For example, if you are photographing a woman in an elegant evening gown, any element that does not add to the image of elegance will not support the mood you are trying to establish.

The "look" of a prop is very important. If every part of your picture conveys the image of "bright, clean, new" and one element is broken

Even when you are working with a single model in a single outfit and setting, you can increase the variety of the images you produce by providing a number of different props. This is an area for improvising poses and picture situations. The props may be appropriate to the situation, but they don't always have to be.

or chipped, the whole picture will be weakened—perhaps destroyed. It doesn't matter if only that portion of the prop that faces the camera is "bright, clean, and new," that is the portion that will be recorded. Any prop that you find will probably have to be "reconditioned" for photographic purposes—even if this means only wiping it free of dust. Professional photographers always have a wide variety of spray paints on hand so that the color of props can be changed quickly to contrast or match a set.

Props do not have to be "real." What is most important is how they will look in the finished photo. Jewelry can be made of plastic or glass, plants and flowers can be plastic, and fabulous looking fur can be fake fur. It is the illusion that counts most.

Professional Props. In many large metropolitan areas you can find companies that specialize in supplying props to photographers and filmmakers. The companies can usually provide *anything* and they can usually do so on very short notice. Of course, if a photographer must have an exotic prop, then he will have to be prepared to pay for it.

3

Basic Studio Lighting

This chapter describes standard light arrangements that are used by professionals. Study them, try them with your models, then experiment with each face you encounter. Take a floodlamp and walk around your model, studying its effect on the subject. Start with the light aimed at the model's eye level and walk completely around the person. Then raise the light so it is angled slightly downward and repeat this action. Finally, lower the light and angle it upward, going through the same movements. Each time you will see your model differently, with both good and bad points accented. When you have completely studied your model's face, place the light in the position you feel is the most flattering. This will become your main, or key, light. The main light is the strongest light that strikes your model.

Now bring in a second light of equal power, but position it at a slightly greater distance from your model than the main light. Or, as an alternative, you can use a lower powered light and position it at the same distance as the main light. In either case, you want this fill light to be less powerful than the main light when it strikes your model. The purpose of the fill light is to eliminate heavy shadows without dominating or equaling the illumination of the main light.

You will use a third light, the hair light, in a position above or behind the model to illuminate the head. This light helps to sculpt the head and gives a three-dimensional effect to the photograph. This makes the model stand out from the background.

A fourth light illuminates the area behind the model's head. You can shine it directly on the background for even greater separation.

Strong backlight needs frontlighting that looks as if the model is lighted by the reflected glow. Notice that even small picture elements like the subject's nail polish and lipstick can provide vividness in an otherwise monochromatic picture. Photo: R. Farber.

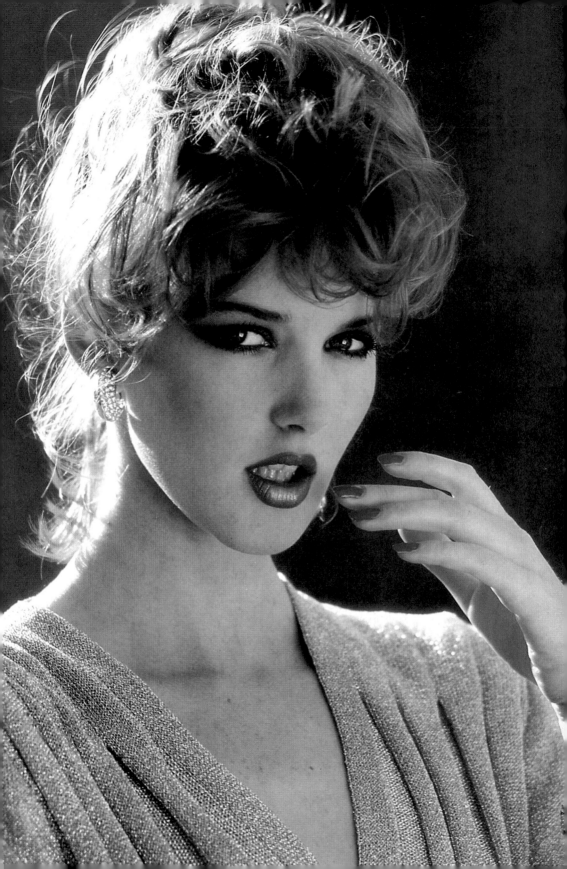

To avoid tripping over the light source when using butterfly lighting, place it behind your camera position. An added advantage is that the light won't come between camera and subject, even if you move around.

Basic Lighting Arrangements

The following basic lighting arrangements are meant to serve as guides, not hard and fast rules that must be obeyed. You can use them as the starting point for studying your model's face, then check to see if a different angle would be more appropriate. Your final photograph is always what matters, not the way in which you achieve it.

(Left)It is a common practice to light the background separately from the subject. Make sure, however, that the background light doesn't fall onto the center of interest. If necessary, place an improvised shade between light source and subject. (Right) How much light to place on the background is a matter of taste. Remember, your exposure setting will probably be made for the subject; it won't change for differences in background lighting. So, the more light on the background, the whiter it will appear.

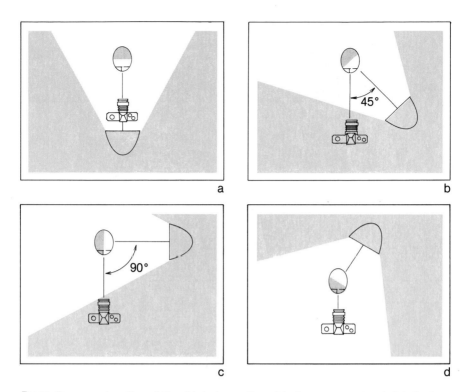

These diagrams show the relationship between the subject, camera, and main light for four basic lighting arrangements. Fill lights and others would normally be added to soften the effect of the main light. (a) butterfly or glamour lighting; (b) 45° or Rembrandt lighting; (c) hatchet or side lighting;(d) rim or back lighting.

Butterfly or Glamour Lighting. When a main light is placed at the camera position it will strike the model full in the face. This blast of light is extremely flat because there are no shadows on the model's face. It is not particularly flattering and is generally avoided by most photographers. However, when you take a front light and raise it so that the light comes downward, you now have butterfly or "glamour lighting".

What is the difference? When the light is raised so that it is higher than the model's head, small shadows are created beneath the nose and eye sockets. The shadow below the nose looks like a tiny butterfly because of the shape of the nostrils, hence the term "butterfly" lighting.

The point here is that you should be aware that true glamour lighting is any light arrangement that flatters your model's face. Try butterfly lighting and all other techniques that have been mentioned to arrive at the one that best suits your subject.

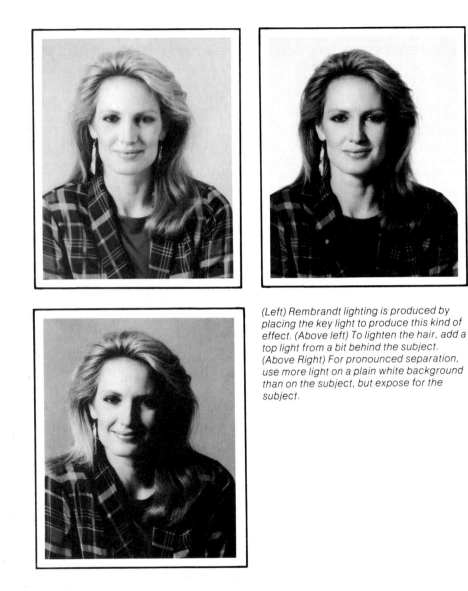

(Left) Rembrandt lighting is produced by placing the key light to produce this kind of effect. (Above left) To lighten the hair, add a top light from a bit behind the subject. (Above Right) For pronounced separation, use more light on a plain white background than on the subject, but expose for the subject.

45-Degree Lighting (Rembrandt Variation). The Dutch artist Rembrandt enjoyed using a dramatic lighting style when he painted during the seventeenth century. He would use the sun to spotlight the significant part of the subject and leave the remainder in heavy shadow.

A technique known as 45-degree lighting, or three-quarter lighting, follows the general concepts of Rembrandt. The more modern name comes from the angle created by an imaginary line drawn from the camera position in relation to the subject, and a second such line drawn from the subject to the light source. The angle formed when these two imaginary lines meet is 45°.

Many portraits are taken with the main light at a 45° angle. However, the height of the light in relation to your subject is extremely important. One side of the subject's face will have strong highlighting, the other side will show a play of light and shadows. If the height of the light in relation to your subject is too great, his or her sockets will be in dark shadows.

The 45° lighting arrangement creates skin texturing. At the points where shadows begin to form, details in the flesh seem to leap out at the viewer. If your model has any blemishes that cannot be eliminated by makeup, use fill lights to alter the effect.

Watch shadows carefully when you use 45-degree lighting. Start with the light at face height, then raise the light studying the changes in shadows and contours. You can also lower it slightly, though usually you will find that raising the light is much more flattering.

Good composition balances the dark area of the man with the light background area on the other side, and gives the central subject plenty of space to "look into."

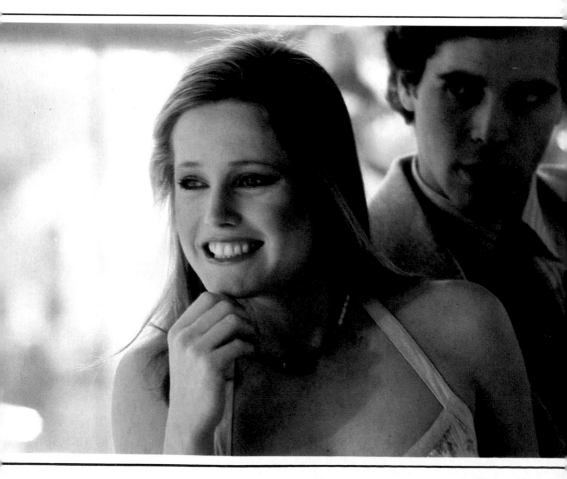

Hatchet Lighting. Hatchet lighting gets its name from the fact that it seems to cut a model's head in half. Once again determine your imaginary lines from camera-to-subject and from subject to light. With hatchet lighting, the imaginary lines form an angle of 90°.

Hatchet lighting results in the strong illumination of half the model's face and complete blackening of the other half. The light source is usually placed at face height and the model looks directly into the camera. Ask your model to turn his or her face to the right, then to the left to enable you to study the effects of this lighting technique.

Rim Lighting and Backlighting. With this type of lighting, the main light is almost entirely behind your subject. If your model is in a profile position, this lighting seems to spill over onto his or her nose, mouth, forehead, and hair, leaving the rest of the face in shadow. This is usually referred to as rim lighting. Backlighting is the term usually used when the model faces the camera.

These lighting concepts can be applied to full-figure work with glamour photography. Dancers, nudes, and others can be lighted in this manner, creating a silhouette.

If the light is moved directly behind your model, it spills around the head and through the hair. The model's face will be dark, but a halo is created. This light is always in conjunction with a second type of lighting to illuminate the subject's face.

(Left) Overall exposure readings in hatchet lighting are frequently inaccurate. Instead, take a reading close to the subject, from the lighted side of the face only. (Right) By altering the elevation of the light source, you can vary the effect of rim light. Be careful not to let any of the light shine directly into the camera lens.

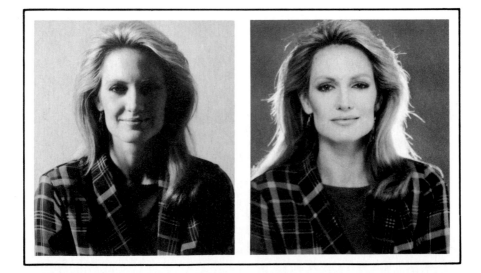

When the frontal light source is placed close to the camera, virtually no shadows will be visible on the subject regardless of how direct or diffuse the light is. Photo: R. Farber.

A texture screen effect can be produced by shooting through any thin, patterned material. When you want the screen to be slightly out of focus, place it a bit closer to the lens than the near limit of the depth of field.

Modifying Lighting

Earlier you learned that approaches to lighting are only guides, not fast rules, and that you need to constantly explore different angles to find the ones that will be the most effective and attractive for your model's face. The position of both your lights and your camera can affect the effectiveness of a photograph.

For example, you probably feel that the camera should be positioned at the same height as the model's face. However, if your model is overweight or has a double chin, or if your model's face is extremely round, positioning the camera so that it is slightly higher than eyelevel will help make the model appear more slender. The lighting will probably be the same in either situation, only the camera angle needs to be changed to correct the problem.

Sometimes, problems can be solved by having your model change position in relation to the camera. Do your model's eyes appear half closed when the camera is at eye level? Then have your model lower his or her head slightly while the camera position remains unchanged. The model, looking directly into the lens, though with head lowered, will have eyes that appear fully open and natural.

Does your model have a long nose? Then place the camera below eye level so you are shooting slightly upward.

Technique Tip: Corrective Lighting

Sometimes you will need to correct facial defects with lighting, not just with posing. The following are a few common flaws and the simple light tricks you can do to try and correct them. When combined with careful posing, they can help you bring out the best in your models.

- Bad Complexion. Frontlighting will minimize a blemished complexion, sidelighting emphasizes it. When you must use sidelighting on location, diffuse it by placing a translucent white umbrella or a piece of white cloth so that the sunlight passes through it before striking your model's face. *Any diffusion of light reduces the harshness of side lighting.*
- Too-Thin Face. Low-angle lighting, barely below eye level will make a thin face seem more round. Full front views with highlights on cheeks will increase the sense of roundness.
- Too-Round Face. A round face can be made to look thinner by keeping one side in shadow. A slightly high, side (45°) light is good, Outdoors, with the higher angle mid-morning or mid-afternoon sun, try a three-quarter view of the face.
- Large Nose. A large or long nose is made longer by shadows. Always position any model with this feature so that shadows are soft or eliminated. Low camera angles can also help. High camera angles correct what might otherwise seem like a bulbous nose.
- Deep-Set Eyes. Lights that are positioned close to eye level will illuminate eye sockets. Outdoors, work in bright shade or have the model facing the sun during its low angles, morning and evening.
- Flat Chest. Sidelighting or crosslighting will emphasize the bust line. A model with small cleavage wearing a bikini at the beach should be positioned so she catches the low angle sunlight across her body.
- Double Chin. A double chin can be corrected by having the light high and at an angle where the chin is thrown into shadow. This may require you to work toward the later morning or early afternoon when using available sunlight.

Is your model beginning to grow bald? Again a camera angle below eye level is best. The model should not raise his or her head in this circumstance, because the eyes may appear closed as he or she looks toward the lens. With the camera lowered, your model can look straight ahead and the eyes will remain perfect.

Bounce Light

Bounce light is any light that is *reflected* onto a subject. You can bounce light from natural and artificial sources to provide a softer form of illumination than that given by direct light. Ceilings, walls, and reflectors are most often used to bounce light onto a subject.

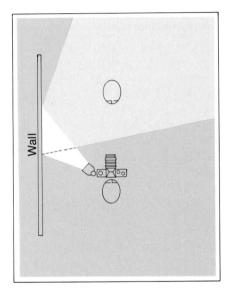

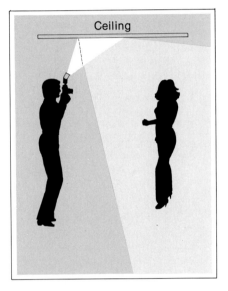

With a handheld electronic flash unit, you can bounce light off any handy surface to create a softer light than that given by direct flash. Keep in mind that the color of the ceiling, wall, or reflector will create a similar color cast in your final picture.

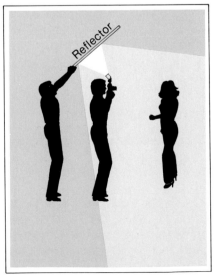

A simple arrangement to provide full frontal lighting is frequently the best way to complement a straightforward, eye-level portrait.

Bounce With a Flash Unit

Bounce lighting is one of the easiest ways to create lighting that will flatter a model on location when you have only a single electronic flash unit. It avoids the harsh lighting of direct flash as well as the problem of shadows on the wall behind the model. Bounce lighting is a well-established tool of photojournalism but is important to know for glamour work. It is especially helpful when you are on vacation or just out for a day of enjoyable photography and discover a setting that is perfect for a glamour pose.

In order to bounce the light, you aim your flash unit at the ceiling, wall, or reflector and mentally judge what will happen to the light when the unit is fired. If you aim the flash at the ceiling at a 45° angle it will be reflected downward on your model's face at the same angle. If you can bounce the light from a wall behind you it will be reflected back to strike the subject full face. The point to keep in mind is that the light will bounce off the reflecting surface at the same angle at which it struck. The light is softened by the greater than normal distance it must travel, and the fact that it is spread over a larger area.

All bounce lighting should be done off white surfaces. A dark surface will absorb most of the light and a colored surface will reflect its color onto the model. Flesh tones will be affected either positively or negatively depending on the color of the reflecting surface.

Technique Tip:
Bounce Exposure With a Manual Flash Unit

Non-auto flash units or auto units with sensors that always point in the direction of the flash head, cannot detect the flash after it strikes the subject, so bounce exposure must be determined manually.

To use bounce light with a manual unit or an auto unit in manual mode find the guide number of the flash. This is the number you will use to set the f/stop. Now estimate the distance from the ceiling to your subject. Divide the total estimated number of feet for the flash-to-ceiling and ceiling-to-subject distance into your flash unit's guide number. This will give you a number which would normally be your f/number, but you now open the lens one additional f/stop to compensate for the loss of light due to diffusion.

Exposure For Bounce Flash. With automatic flash units designed for bounce work, the unit itself determines proper exposure. The sensor, which limits the light output of the flash unit, must always remain pointed at the subject no matter where the flash head itself is pointed. In most cases the sensor is in the handle of the unit separate from the moveable flash head. With "dedicated" flash units (units matched to the electronics of the camera being used) the light falling on the subject is measured within the camera itself. With either type unit, perfect exposures are made almost all of the time.

Umbrella Reflectors. Umbrella reflectors are used by professional photographers who work both in studios and on location. The softened light from an umbrella reflector (or from any reflective surface) is almost always more flattering than direct lighting. Unfortunately, you must make a trade for this softness. The intensity of reflected light is only one-half to one-third that of direct light. This means that you must move the light closer, perhaps use a faster film, and/or a tripod to allow for a slower shutter speed.

However, this trade-off has its positive values. For example, skin texture is not accented as it would be with direct lighting. If a model has skin blemishes or signs of aging, which cannot be hidden with makeup, the softer lighting will hide them.

A single large umbrella can often take the place of two direct lights. There is such a gradual falling off of light that shadow areas are no longer harsh. The model seems to be sculpted by such light, and many professionals use only a single light bounced from a large (1.2 meters (4 ft.) at the minimum) umbrella.

Umbrella reflectors mount directly onto light stands. They can be used with every type of light source, including photofloods and electronic flash. You should be certain to have heavy-duty stands so that the equipment remains upright. There is a problem of balance with such umbrellas because lightweight stands have a tendency to be top-heavy when these reflectors are used. Weights should be used to hold them firmly to the ground. Outdoors, be aware of the direction of the wind, because a large umbrella reflector can act like a sail when a gust of wind catches it.

The larger the reflector, the broader the effective light source and therefore the softer the shadows created by its illumination.

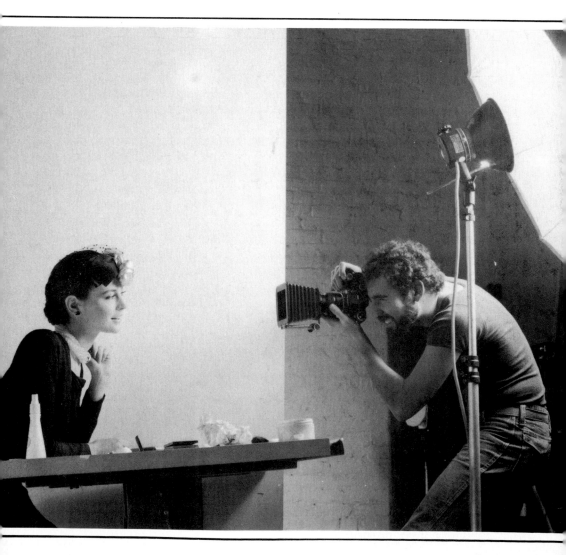

4

Using Natural Light

Since much glamour photography is done on location, often in an outdoor setting, you must learn how to work without the total control over lighting that is possible in the studio. To work successfully outside of the studio, you must learn how to take advantage of certain situations and how to avoid others. For example, how to change your angle or your model's position to take advantage of natural reflectors, or to avoid the dappling effect of overhead sun falling through the leaves. You must understand how shadows fall at different times of the day, and if you are working in color, how the color of sunlight at different hours can enhance or detract from a photograph. Also, you must learn how to use reflectors and supplemental and artificial sources of lighting, to improve your results.

During the course of a day, the relative position of the sun changes in the sky. It is low in the east in the morning, rising to directly overhead at noon, then lowering in the west in the afternoon. The angle of the sun will affect the shadows falling on your model. The position of the sun will also affect the color of your subject's flesh tones, as will different weather conditions.

To make your subject stand out clearly from the background outdoors, use contrasts of color, light intensity and focus. All these qualities in the subject are very different from those in the background.

Color

The early morning sunlight generally filters through haze, fog, mist, and other atmospheric variables, which are different depending on the location. These conditions may create a blue cast, but on clear days, early morning and late afternoon sunlight is extremely warm, heavy with yellows, oranges, and reds. By midmorning, the sun lights your subject so that your pictures record flesh tones accurately.

Ultraviolet Light. On days when the sky is overcast, more ultraviolet light reaches your subject than when the sun is brilliantly lighting the sky. Ultraviolet radiation is always present in sunlight. The human eye is not sensitive to it, but this means that your subject's flesh tones will appear slightly abnormal unless you correct for this problem. The simplest way to do this is to use an ultraviolet or skylight filter over your lens. The filter reduces the blue without affecting your photograph and the person posing for you will record almost naturally as when photographed in daylight. A warm toned filter may help even more.

Window light falls off rapidly in a dark-colored room. Group your subjects as close to the window as possible for maximum illumination. Photo: R. Farber

The warm colors of midafternoon are very flattering, particularly when the sun's light is slightly diffused by haze and no harsh shadows are evident. Photo: S. Jacobs.

Good Conditions. A good time to photograph outdoors is midmorning or midafternoon on a day when slight haze is present. Shadows are barely visible and the even lighting is flattering. The light fills even deep-set eyes and does not draw undue attention to acne or other skin blemishes.

When the sunlight is approximately 30° above the horizon, you can create some interesting backlighting effects. Pose your subject so that he or she is standing with the sun coming from behind. Move in close with your camera so that your meter reads only the face. Then step back and take your picture based on the reading for the subject's face. The result will be a halo effect on the subject's hair caused by the bright light behind the head, and which will be slightly washed out from your exposure for the face.

You can use daylight indoors as well. Have a friend stand by an open window as daylight streams through. The light striking the face will be strongest, while the rest of the person's body will get proportionately less. This lighting can be used to create soft, sensual, and moody effects. If the model is wearing a filmy gown, the light penetrating through the fabric will outline her figure.

How dark a shadow appears can be controlled by using a reflector on the side opposite from the light source. In the picture above the subject is lighted only by window light. Below, a reflector has been used to lighten the shadow side.

Look for natural reflectors when you are making your photographs. Here, the wall behind the subject "opens up" the partially shadowed side of his face. Because the wall is a light color and reflects the same color light as in the rest of the picture, there is no problem with undesirable colors ruining the image. Photo: R. Farber

Reflectors for Available Light. There are several ways of modifying available light, either to increase the amount falling on the subject, to fill in shadows, or to alter color rendition.

Light-colored clothing, indoors or out, helps fill shadows on your subject's face when the angle of the sun is not right for a particular photograph. The clothing reflects light back into the person's face, a definite help with high-angle sunlight. A light-colored wall will have the same effect. In both these instances, remember that the color of the reflector will affect the other tones in the picture; a green wall, for example, will give your subject's face a greenish cast. Your eye may compensate for this discrepancy, but your film will not, so use colored reflectors with great caution.

Sand or snow will serve as a natural light reflector to fill in shadows without adding much in the way of undesirable color (although snow sometimes, gives a bluish cast.)

Fill Flash

Besides using a reflector, you can add light to a scene in which sunlight provides the main illumination by using electronic flash. When flash is providing the only fill light, or light to fill in the shadows, you must be careful that it does not match or overpower the intensity of the sunlight. Because the "proper" flash setting would give you lighting that would equal sunlight, it is necessary to either fool the flash sensor (if you are using an automatic flash unit) or lessen some of the light output (if a manual unit is being used.)

If you are using an automatic unit, set it as though you have a film with a higher ISO/ASA number in your camera. For example, if the film you are using is rated at ISO/ASA 64, set your flash as though the film were rated at ISO/ASA 125. The flash will "think" you are working with a film twice as sensitive and so it will give you half the light.

With a manual flash attachment, set the exposure normally, then place one thickness of a clean, white cotton handkerchief over the flash head. This will reduce the light that will fall on the subject.

With only existing light, a large portion of the subject's face is in shadow.

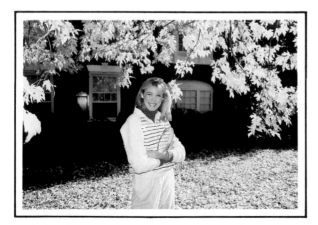

By adding a fill light, the photographer has eliminated the shadows and opened the subject to view.

(Right) Too much fill light, too small an f-stop for the background exposure.

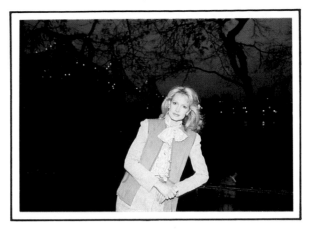

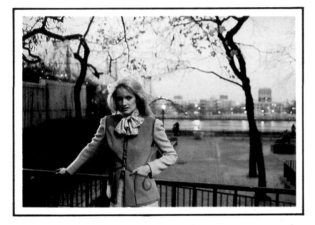

(Left) Proper exposure for too-weak fill light washes out the background. (Below) Good balance of fill to natural light illuminates the subject fully and retains the twilight appearance of the background. Green tinge on models' hair was produced by a nearby streetlight.

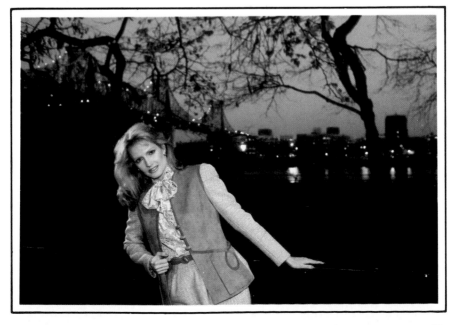

5

Creating a Mood

Mood is one of the most important aspects to glamour photography. The mood of a particular photograph is suggested by a number of separate elements which combine together to give the desired illusion. Color, lighting, props, clothing, choice of model, and background all contribute to the mood of a photograph.

Lighting is an obvious key to the mood of a photograph. Bright, high-key lighting tends to suggest happiness, innocence, and softness while somber, low-key lighting suggests mystery, sadness, or violence. Color is another indicator: in general bright colors suggest one mood while dark tones, suggest another, and pastels still another. In using color to suggest mood, you might want to experiment with color filters and different films, which will add their own distinctive colorations to your photographs. Soft-focus filters will, of course, suggest one type of mood, while a star filter strategically used can give a brilliant diamond hardness to a photograph.

Your choice of model is also an important component in the successful representation of a mood. No matter how much you like a particular model, a California blonde will not look right in an opulent Oriental setting, and a sultry, exotic brunette may look silly on a surfboard. Remember, you are not dealing with reality but illusion and fantasy. Illusion and fantasy are largely composed of stereotypes.

A very weak diffusion filter can be used to create a soft and airy effect without entirely eliminating the sense of textural qualities in a photograph. Photo: S. Sullivan.

You can find opportunities for many kinds of mood in almost any location. Here there is a sense of a pleasant, carefree day.

Mood on Location

When you wish to do photography on location, you can select places that provide the sense of happiness, danger, glamour, tranquility, or anything else you want your pictures to convey to the viewer. If you want to create an air of mystery about your model, wait for nightfall and work under a streetlamp. The harsh light contrasting with the black night will provide the right mood.

A model looking into a fancy restaurant will be illuminated by the interior lighting spilling through the window. The fact that the model is outside looking in may make the mood of the picture rather sad and lonely. If the model is on the inside looking out, then the image may be one of glamour, suggesting an expensive night out on the town.

In planning a shooting location, ask yourself what feeling a particular location evokes. If a park fills you with happiness and thoughts of a good time, try to create the same feelings in your pictures. Have your model swing on the swings, play on the slide, and wade in the pond. In parks too, you can have a couple walking arm in arm along a wooded path or playing in the grass. A model can be sitting by a lake or leaning against a tree. You can also have your model feed the ducks, pigeons, or the animals at the park. You can also photograph your model as she sits up in a tree, framed by the branches.

At night, this same park can be used to create a sense of forboding, especially in the shadow areas just beyond the well-lighted places. Use your imagination to create the mood you wish your viewers to see.

Night photography needs to be planned for both mood and light-

A different pose and expression just a few feet away produce a quiet, sensuous portrait.

ing. Because exposure times lengthen with reduced light, the model may have to hold a pose for a long time, while you can use a tripod-mounted camera and expose for five or more seconds. Models positioned outside illuminated store windows may have to be placed extremely close to the windows in order to insure there will be enough light striking their faces. Fill flash is useful in these situations.

A simple change in pose and camera angle can alter the emotional feeling of a picture. A seated subject seems small in relation to her surroundings.

Natural Light for Mood

Natural light is favored for creating mood on location. The problem is that natural light controls you to a degree, so before going outside, you must think creatively in order to be certain you know what mood you can create.

Mornings and Evenings. The softest light comes from the sun during the early morning, preferably on a slightly overcast or hazy day. You also get soft light in sheltered areas where the sun is indirect. Low-angle sunlight, occurring approximately two hours after sunrise and two hours before sunset, can attractively light your model's face. At sunset, you can also silhouette your model against the setting sun and have the beautiful colors of evening as the background. You can also do this at sunrise, but it may be harder if only because you have

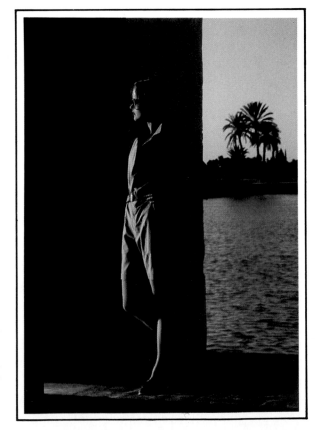

Two sources of daylight illuminate this subject. Skylight in the background is soft and diffuse, while the low angle of the setting sun dramatically "sculpts" the model's face and clothes and its color adds warmth to the scene. Photo: R. Farber.

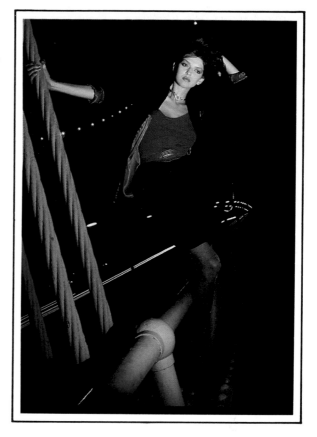

To create the romantic image shown here, the photographer combined an unusual location, a cocked camera angle and the harsh light of direct electronic flash. Photo: V. Podesser.

to convince yourself and the person posing before dawn that it is the rational thing to do for a picture.

Daytime. During the day fill lighting can be added when on location. Use the techniques described in the Fill Flash section. Reflectors can also be used to help control daylight while on location. See the section on Reflectors.

At Night. Your car's headlights can become effective tools at night, in that you can illuminate a subject that might otherwise be too dark. You can also use a small spotlight—the kind that plugs into your car's cigarette lighter socket. Such lights should be treated like tungsten lighting when you use color film.

Moonlight is the only natural source of light at night, but it is difficult to use. Existing light from streetlamps, window displays, and similar sources can be better used. Stay alert for areas where such lights can be used to create interesting images.

For a high key effect, keep the light source close to the camera and make sure the scene is fully exposed.

High Key and Low Key for Mood

In normal photographs, you can see a full range of tones. In color you see the full spectrum, in black and white the tones range from brilliant whites to middle grays to rich blacks. High key and low key images are different.

High Key. When you leave out the dark tones in your pictures, you only have the extremely light tones left, and perhaps some middle tones. This elimination of the darker tones gives the color prints a pastel quality. With black-and-white film, the result would be pure white, gray, and perhaps a touch of black.

To get this effect most photographers work outdoors at times when, or in locations where, they can avoid harsh direct sun. They do not want to record shadows since black areas need to be eliminated. Often they will photograph in early morning, especially when there is fog or mist. Very effective nudes and portraits can be taken at these times. An outdoor portrait might show a model with blonde hair, fair skin, lightly painted lips, if any makeup is used, and light clothing.

Indoors, the use of indirect lighting, a white background (some photographers have their models lay on a smooth white sheet and shoot down to isolate them), and careful attention to avoid shadows are all important. In a good high key photograph, your model might be wrapped in a white garment with a white background. The only dark areas would be her eyebrows, lips, and the pupils of her eyes.

Low Key. The opposite of a high-key photograph is a low-key photograph. This time the dark tones in a photograph dominate. There will be a richness of shadow detail instead of an attempt to eliminate it. Color pictures can reflect rich earth tones and other dark shades. A dark model dressed in dark clothes with dark hair might be posed in heavy shadow. Some lightness or middle tones will be visible to add a hint of contrast.

Your exposure for both high-key and low-key requires some careful experimentation. Move in close to the bright (high key) or dark (low key) area you want to record. Then take your reading, keeping in mind that the camera's meter will be fooled. Remember most built-in meters try to average an exposure and render a scene in middle tones. In this case you want what your meter will indicate as a "wrong" exposure. A high-key subject might indicate to your camera's meter that you need less exposure than you actually do. To ensure correct exposure, start with the one indicated by the meter, then bracket by increasing the exposure for the next three frames.

A low-key subject might fool the meter in the opposite way, indicating a reading that would overexpose the picture. To compensate, start with your camera's meter reading, then decrease the exposure for the next three frames you take. This bracketing should give you a negative that reproduces effectively as low-key.

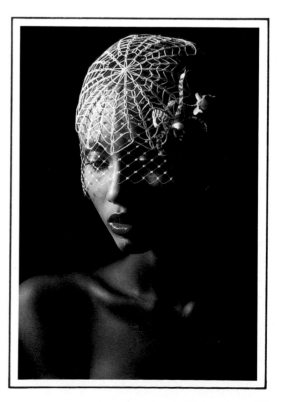

Often you can accentuate the rich, saturated tones seen in low key lighting by exposing the film a half stop less than normal. Photo: R. Farber.

6

Working on Location

There are always challenges to face when working on location. Lighting is in the hands of nature. You can modify it to a degree, but the total control found in the studio is gone. Weather is a major consideration, but even when it is adverse it can be turned to an advantage. Exciting glamour photos have been made of models soaked to the skin in rainstorms and in snow. These adverse conditions can add beautiful new elements to your pictures.

Initially you may want to use your backyard or a local park. Later, you will want to find other locations. To do this, carry a camera and small notepad with you wherever you go. Each time you spot an interesting location—an alley behind an old building, an abandoned barn in the countryside—take a picture and make note of the location. Include the direction of light at various times of day and any other points of interest. Also note the time it will take to drive to the location. Then make a file of these pictures and transfer your notes to the backs of the prints. You can periodically thumb through this location file to decide which spot might be appropriate for what you are trying to photograph.

Try to find locations that will enhance the appearance of your subject. Here, the sharp cragginess of the rocks contrasts dramatically with the smooth curves of the model's body.

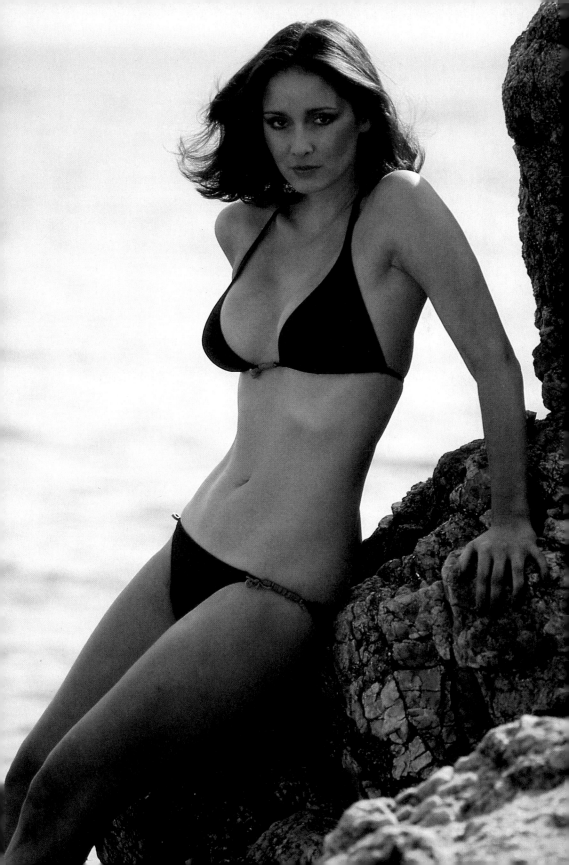

One location can be used to create more than one mood. Here, the subject's relaxed pose is in contrast to the water rushing by her.

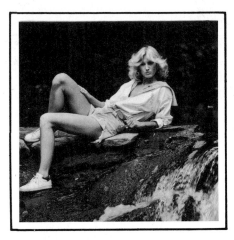

Rather than think of the location only as a backdrop, have your subject explore the surrounding area too.

Points to Consider

As an amateur you have points to consider just as a professional when doing outdoor location photography. You should ask these questions if they apply:

- Does the location provide a variety of backgrounds?
- Are there high and low vantage points to photograph from?
- Will doing nude photography create any problems?
- Will assistants be needed to hold reflectors or help with auxiliary lighting?
- Will a source of electrical power be needed?
- Is everything needed on hand? (On location there are not many opportunities to buy more film or locate a forgotten accessory.)

Framing the Subject. Each time you reach a new location, always explore the area through your lens to see what can make interesting compositional frames. Trees, plants, doorways, and arches can be used both to frame and to call attention to your model.

Experiment. Try to spot natural framing devices and pose your subject in the midst of tree branches or natural rock formations. In farm country, abandoned wheels, farm machinery, and even ladders propped against peeling barns make excellent framing devices. Take the most obvious pictures first; then move about to find new elements that will make your pictures more effective. This is especially true when your models are dancing, leaping, or running. By changing your position or by releasing the shutter when the model is at a different distance than you first thought would be effective, you may create a more visually interesting photograph. Remember that film is the least expensive part of learning glamour work. The more you experiment and study the resulting pictures, the more you will learn.

Remember when you are photographing a backlighted subject to take your exposure reading from her face and not from the light behind her. A small, portable reflector will also open up shadowed areas. Photo: D. Ramage.

On Location in Public Places

For amateur photography you are generally not required to obtain permission to photograph in public areas. However, if lights, tripods, and other free-standing equipment is needed, a permit may be necessary. Local police departments can give you details.

In Parks. Public parks provide a wide variety of settings for glamour work. Playgrounds, picnic areas, streams, lakes, rocky areas, and open fields can all be used as backgrounds for glamour photography.

One technical problem that sometimes occurs when working in parks or under trees in any wooded area is the uneven lighting falling on a subject when sunlight is filtered through foliage. The blotching effect this light creates on a subject's face can be quite unattractive. Fill-in flash can be used to create even illumination; a better solution is to diffuse the light through gauze or light cloth. This method may require the help of someone to hold the cloth in the proper position.

One common problem with photographing people outdoors is the blotchy effect created by sunlight filtering through foliage.

A simple way to solve the problem seen in the photo above is to use fill flash for even illumination.

Beaches. Beaches near oceans or lakes are good location choices because the setting is appropriate for models in bathing suits. The photographer has innumerable picture possibilities on the beach itself or in the shallow water near the sand. Picking the best time to work at a beach is critical. If you work around noon, the position of the sun will create unattractive shadows on the model's face. A better time is early morning or late afternoon when the sun strikes the model at a lower angle.

If for some reason you must work near the middle of the day, reflectors, diffusers, or fill-in flash may have to be used to provide even, flattering illumination.

Sometimes a prop can serve a practical as well as a pictorial purpose. Here the translucent parasol shades the subject from harsh light and provides a background as well.

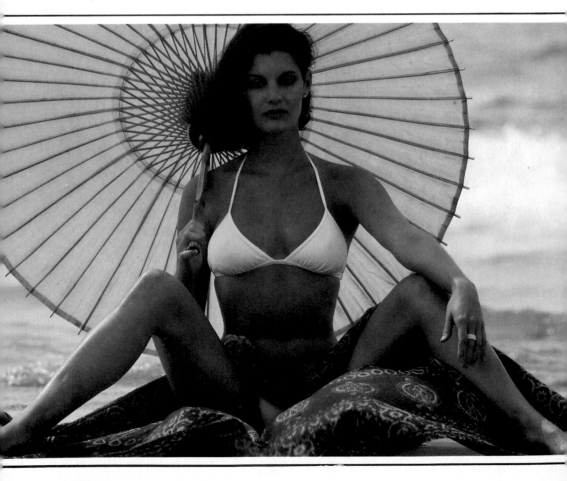

Possible locations for glamour photography are endless and certainly extend beyond the studio. Think about the buildings, parks and areas of special interest near you. Then, discuss your ideas with the person you're photographing to get his or her own suggestions.

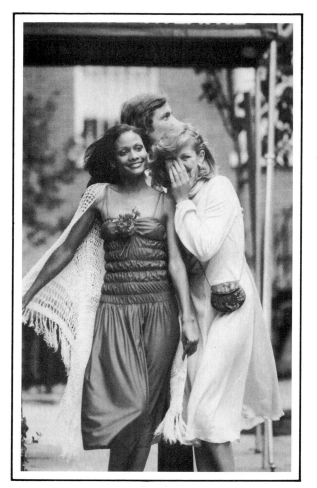

In Cities. The streets and buildings in downtown areas of most cities can provide interesting backgrounds for glamour photography. Posing your subject at the intersection of streets or in front of modern buildings can give an air of sophistication to a picture.

Depending on the mood you are trying to create, you may want to do your work at different times during the day. Working at the height of a business day will probably mean working without auxiliary equipment because your prime concern will be keeping your subject in your viewfinder on crowded streets. A moderate telephoto lens will be needed because it makes it easier to selectively keep passersby out of your pictures.

If you do your photography during non-business hours (weekend mornings are usually best), you will find that wide-angle lenses are more useful. They will give you a chance to capture the mood of an empty city with only your subject as the main point of interest.

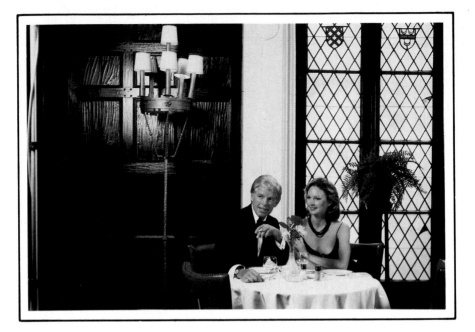

You can take photographs in restaurants during off hours, when your equipment will not disturb the regular clientele. If the manangement needs pictures of the establishment, you may be able to trade off your pictures for their cooperation.

On Location in Malls or Restaurants

When photographing on private property, it is necessary to obtain the permission of the owner or management before you begin to work. Further, if the photographs are to be published, it is also necessary to have a written release from the management stating that the publication of photos taken within the establishment is granted.

Shopping Malls. You can usually use shopping malls for your glamour photography and usually without giving advance notice to the management if you take your model there at a time when you will not disrupt business.

Most malls have interesting architectural aspects. Some have real or artificial foliage and this often gives the shopping area a park-like ambiance. Others may have winding staircases, modern sculptures, and other visually exciting backgrounds.

A poorly lighted mall means you must bring extra lights, and this requires special permission from the mall manager.

The only safe supplemental lighting for use in a shopping mall is electronic flash. You can use cordless slave triggers for lights on stands, if they are needed. This eliminates the dangers of extension cords stretched across the floor and the hazards of hot bulbs. Remember that when the stores are operating, shoppers will be curious about what you

are doing. They will be watching you, not the cords, and may be injured. You will need assistants to watch where passersby are walking to protect them from falling.

Restaurants and Clubs. Restaurants, nightclubs, and similar establishments are a bit easier to work in than shopping malls, though you will need permission to take pictures inside of them. These business establishments have slack periods—usually early in the morning —when they are cleaned and prepared for the customers. At such times, the owners will usually allow you to come in, set up lights, and use sections of the facility for photography.

Once you find a location you wish to use, talk with the manager and explain that you want to use the facility for a glamour photography background. Show the owner the area you have in mind and explain what will be involved. If you adjust your work schedule to that of the business, it is unlikely your request will be rejected.

Since you are taking pictures for experience or as part of a portfolio, you have little to offer the business owner. When you are actually on assignment, the business should receive a credit line if possible. If this is not possible, offer the owner some prints from the photography session as a token of your gratitude. If the owner has a need for pictures of the establishment, you may be able to arrive at a mutually beneficial arrangement.

A wide-angle lens is useful for photographing indoor locations restaurants and shops. It lets you work in close quarters while still showing enough of the surroundings to make the setting identifiable.

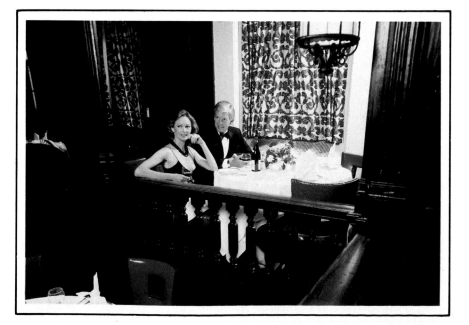

On Location At Night

Night often provides visual excitement for glamour photography. The harsh contrast of shadow and artificial lights gives an air of mystery, adventure, and exoticism. In daylight, the same models and clothing may be ordinary, but at night a dramatic element is added. Consider night lighting as a combination of available light and fill light. Here "available light" refers to whatever you find. This includes streetlighting, window displays, auto lights, or lights from signs.

The "found" lighting at night is invariably low and it is best to supplement it. Some photographers may have a model light a cigarette, then use the light given off by the match or lighter to illuminate the face. Another trick is to bring reflectors to the scene. When the model is illuminated by a fairly strong overhead light, a reflector, placed so that it is low and bouncing light upwards, is useful. Positioned just below the model, out of camera view, the reflector will add bounce light into the model's face.

The light given off by a match or cigarette lighter may be used as a light source when photographing at night. Of course, the flame will illuminate only a small area of the subject, and can be used only when the situation warrants. When used correctly, however, the effect can be quite dramatic.

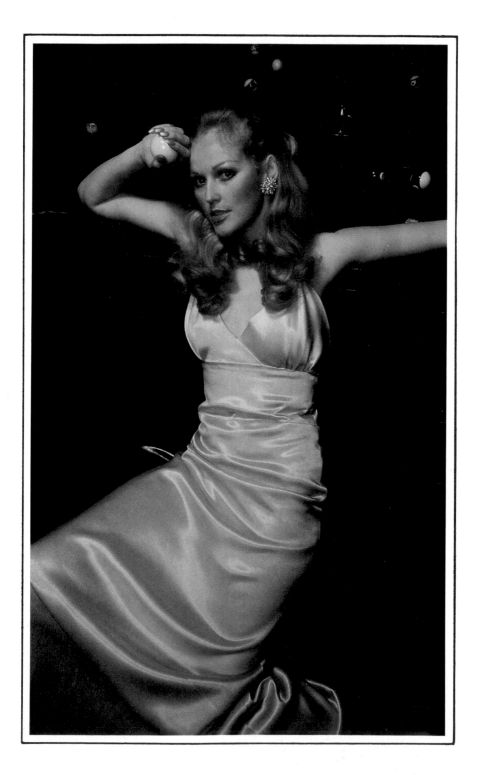

When photographing in an unusual location, turn your imagination loose to help your subject find new and different poses.

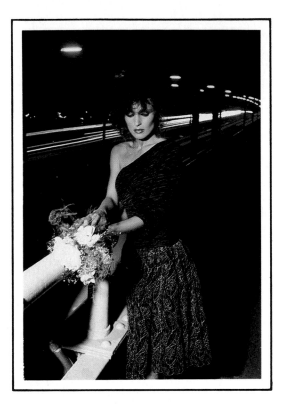

The bright lights from moving traffic provide a brightly colored background for this night shot. The effect was created by combining a slow shutter speed to capture the streaks of light with a burst of electronic flash for the model. Photo: V. Podesser.

Flash at Night

There are two approaches to using flash illumination at night:

> 1. Aim the flash directly at the subject and create a harsh effect that is somewhat theatrical. This style has been made popular by the *paparazzi* who use this method.
> 2. Use the flash discreetly so that the added light does what it should do without dominating the picture.

Each approach is valid and can produce exciting, effective pictures. The choice of style is up to the individual photographer and depends upon the desired result.

Using direct flash requires some experimentation to discover the best position for the flash unit in relation to the camera and to determine exposure (if an auto unit is not being used).

Using flash in an unobtrusive way requires careful planning for every picture and often calls for using bounce techniques (usually off reflectors) or diffusion techniques. The ability to add just the right amount of light to open shadows and highlights to a model's eyes, without over-illuminating the scene, requires the continuous refinement of techniques, as available light varies from picture to picture.

Background. The background you select should match the clothing the model is wearing. Formal clothing can be modeled at night near an expensive restaurant or luxury hotel. The establishment's uniformed doorman can add a touch of both "class" and authenticity to such photographs. As an additional touch, they can help you add light to the scene by opening the doors to allow interior light to spill onto the model.

Fill light can be used effectively in front of theaters and other structures that have illuminated overhangs. The more lights surrounding the model, the more supplemental lighting you can add without it being obvious.

One way to create a kind of glowing tinsel effect is to have a helper wave a sparkler during the exposure.

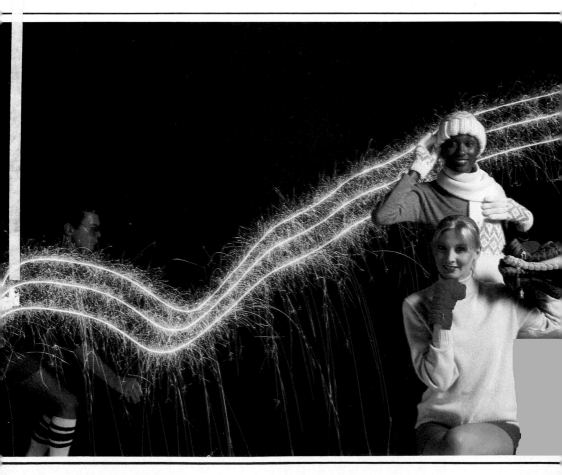

7

Working with the Model

The ideal professional model will know how to pose, having learned this art from a competent modeling school or experience. You will probably not be working with such a trained individual, because chances are that you are applying glamour photography techniques to friends and relatives, and posing will be a learning experience for both of you.

Every model looks to the photographer for guidance on posing. A professional will only need to know the type of pictures you have in mind, the mood you wish to achieve, and similar information. Amateurs, on the other hand, may require step-by-step guidance. This means you must understand the different approaches that will change the body's appearance, reduce problem areas, and keep your model moving effectively.

In addition to reading the information provided in this chapter, start studying advertisements that attract your attention in magazines and other media. Each time you see an effective pose, clip the picture and save it. Eventually, you will compile what amounts to a posing file you can show your models. Your models can try some of the poses or use them as a guide when attempting something on their own. Either way, the beginner is helped to think creatively at a time when he or she is under stress and may have no other idea of what to do.

When you're thinking about photographing a subject nude, always discuss it with him or her in advance. Approach the conversation with a straight forward attitude, explaining what you intend to do and where the pictures might be used. When publication is a possibility, be sure to get a signed model release.

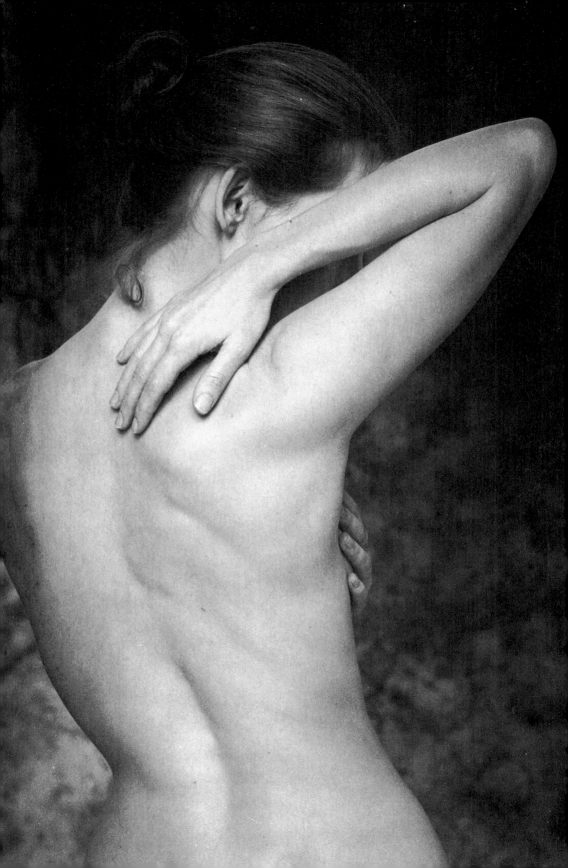

Posing Shoulders, Hands, and Legs

The following information is generally known by professional models, but since you will probably be working with friends, family members, or beginning professionals, you may have to give them posing instructions. You can deviate from these seemingly rigid rules, but always observe the results in the viewfinder.

Shoulders. A professional model is taught that his or her shoulders should be parallel to the floor at all times. Modeling schools often teach models to think of themselves as a hanger: The model's head is the loop at the top of the hanger, and the wires running on each side to the base are the model's neck and shoulders. When you place clothing on a hanger and walk with it, the hanger remains upright; the side wires supporting the garment remain parallel to the ground.

The same can be true for your model. As the model walks, his or her shoulders should remain parallel to the floor. The clothing may move freely in the breeze, but your model will seem most professional if he or she avoids tilting shoulders. Even when bending, the shoulders should remain parallel to the ground. The model must move his or her hips and torso to create the impression of leaning. This may look slightly awkward to the eye but it photographs well.

Hands. Many models do not have hands that photograph well. This is not because the hands are ugly, but rather because of the way veins tend to stand out, especially when the hands have been held down at the sides. This is most often a problem with older models, and less so with teenagers and young adults.

If the scene calls for the model's hands to be positioned on the hips, have your model angle the wrist so that it breaks at a position which shows only the fingers, with the back of the hand hidden from view. On those occasions when the backs of the hands must be shown, especially when photographing jewelry, select a model with attractive hands. Then have the model hold his or her hands at shoulder height. This brings down the blood out of the veins and smooths the hands. The model should hold the hands up until you are ready to take the picture. Then the posing is done, a few frames are exposed, and the model holds the hands up again.

Any time a model's hands will be featured in your picture, check them carefully. Female models should have soft hands, the nails properly manicured. Male models need properly manicured fingernails as well. A clear nail polish adds to their attractiveness when a colored polish is not required. Do not automatically allow your model to wear polish, since the color may not coordinate with the clothing being used. For example, if your female model is wearing bright red nail polish and clothing that is a subdued blue, her hands will draw the viewer's eye because of the red fingernails.

Macro lenses are specially designed to give excellent results at very close subject distances. Photo: R. Farber.

Legs. Leg positions have to be carefully considered when your model is seated. When the model sits with one leg crossed over the other at the knee, be certain the crossed leg rests gently. Too much pressure pushes the calf out of shape, making even a slender, attractive leg look fat and flabby.

It is best to position the legs in such a way that they are not angled closer to the camera then the plane of the model's body. If you are using a wide-angle lens, you may find that the leg closest to the camera appears unusually long. This exaggeration can make an otherwise attractive model appear a caricature.

Don't let your subjects repeat the same poses time and again. Encourage them to try the uncommon; their spontaneity will come through in the picture.

By separating the feet and keeping one at a slight angle to the other, a subject can achieve a variety of attractive and interesting poses in a single position. Here, the model has placed her weight on one leg to accentuate the slit in her skirt. Photo: G. Chinsee.

Never allow your model to stand with his or her feet together, looking stiffly into the camera. Separating the feet, with one leg at a slight angle, makes for a better weight distribution and a more attractive body position.

One approach to posing is similar to a modified "second position" in ballet. The legs are approximately shoulder width apart. The feet are positioned so that if they were brought together heel to heel, they would form an "L."

A book on ballet that features dancers in various positions will be an invaluable posing guide for your model. Ballet involves every body position that a person can assume gracefully and naturally. Your models should be able to assume many of these positions with relative ease.

Action photos require many exposures to be sure you have capured a visually balanced pose. Still subjects can be more carefully positioned to hide certain physical flaws.

Corrective Posing

The perfect photographic model does not exist. As individuals, people have different tastes, and therefore perceive beauty differently. For that reason, professional photographers frequently will argue over which reigning glamour model is actually worthy of the acclaim. It is doubtful that you will ever work with someone whose appearance pleases you 100 percent. For the less-than-perfect model, some corrective posing techniques can help.

Body Angle. A female model angled so that she is facing the camera or only slightly turned away from it can look overweight when photographed. If you turn her so she is in full body profile with her head angled back toward your camera, her hips and waist will look thinner and her bustline will be more attractive.

Your model should never be posed facing full front, feet together, her arms pressed at her sides. Instead, let her bring one foot toward the camera and turn the other foot slightly to the right. She should then turn her shoulders and body a quarter turn to the right (or reverse it and have her turn left for both, if this looks better). A three-quarter turn can be even more flattering.

Seated Models. Never let your model sit all the way back on a chair the way she might under normal circumstances. If she does, her thighs will rest in a way that causes the fatty part of the body just above the thighs to bulge. Moving forward, closer to the edge, will prevent this from occurring.

A seated model should sit up straight. If the model's spine curves, the shoulders will sag, the stomach will bulge, and in the case of a woman, the breasts may droop.

Hands. Hands should show graceful, curving lines achieved by pushing the wrist down and arching the fingers. This is more attractive when the little finger rather than the thumb is close to the camera.

Collarbones. Never let your models rest on their hands; the weight this position puts on the arms makes the collarbones protrude. This frequently happens when a model is reclining.

Some models have naturally protruding collarbones. If you encounter such a model, try poses in which the arms are behind the model's back. Scarves can also be used to cover the collarbone.

Camera Angles. A high-angle photograph of a model with large bust and bone structure will often make the legs look distorted. A low camera angle with the legs at approximately 30 degrees diagonally from the camera is more flattering. The low camera angle helps most legs, even heavy ones, look attractive.

Clock Technique for Posing

"What should I do next?" is a common question asked by amateur models seeking different poses. The picture file suggested earlier helps. Another technique, which can be quickly taught to your model, involves using a clock method for posing.

The clock method should never be considered the only way for a model to pose. Truly creative professional models rarely use it. For them, it is a last resort after an endless posing session with other ideas exhausted. However, for the beginner, it can turn a failed session into a success.

Standing Poses. Start by having your model face the camera. Tell her that she is in the middle of a clock face. Have her place her weight on one leg, with the foot at an angle of approximately 45 degrees away from the camera. Have her place the other foot so the heel is approximately 5–7.5cm (2"–3") from the instep of the weight-bearing foot. The toe of this foot should point toward the camera. (This will be the twelve o'clock position; six o'clock will be the farthest from the camera). Now have her move her foot to one o'clock, two o'clock, and so forth, with the weight-bearing foot following naturally.

As your model moves her foot around the clock face, her shoulders should be squared and remain parallel to the floor. Her hips will be twisted away from the camera as she moves.

When she has made a half circle, she returns to the center of the clock and points her toe to the other positions on the clock. Each change brings a slightly different body angle, which gives excellent posing variety when other approaches are unknown or exhausted.

Models who are seated can follow similar posing patterns. The legs can be together, with the feet parallel.

Kneeling Poses. Kneeling poses should be handled at right angles to the camera for most models. However, the angles can be changed, much like the clock position. Generally, the model's face will be toward the camera, her stomach held in, her arms forward but loose. The hands can rest on her knees, but she should hold her shoulders back, with no pressure to make them bulge. Just remember that kneeling can be uncomfortable, and your model should be given regular rest periods.

Ideally, the model should be able to find graceful poses under almost any circumstances. While the sweeping staircase in this photograph suggests any number of possibilities, this simple, unforced pose is highly effective and would work well in a variety of situations. Photo: R. Farber.

When you're making a series of pictures in which the basic framing won't change, it's convenient to mount the camera on a tripod.

Portrait Posing

The first consideration when planning a portrait is to determine what impression you want to create. A portrait can show a model looking sexy, innocent, sophisticated, childlike, and more, depending upon how you plan your photograph. Sometimes, a different blouse or hairstyle, a new facial angle, a change in expression, or some other minor alteration can be a major factor for the impression being left.

Head and Shoulders. A model who wants an attractive head-and-shoulders portrait can dress almost any way she wishes. If her blouse will be seen in the photograph, a solid color with little texture is preferable to patterned or textured fabrics. For head and shoulders pictures, turn the model away from the camera, angle her head so it looks into the lens, and crop the image tightly in the viewfinder. Keep more empty space between the model's eyes and the edge of the frame than between the back of the head and the other side of the frame.

Next have your model slowly turn her head from full profile left to full profile right. Adjust the lighting as necessary. Stop the model each time an alteration is needed. This will help you see the best angles and the different aspects of your model's face.

Most people have more than one "face." A full left profile does not look like the full right profile, and a head-on photograph matches neither of the profiles. One angle may be more flattering than another.

Next have your model tilt her head to the left and right. Again the

Sometimes, rather small changes in a subject's pose will result in quite different pictures. As a rule of thumb, when you're not sure make the photograph anyway. You can make a final choice after the pictures are processed.

appearance changes. You may also have to raise or lower your main light, depending upon the shadows created by the light as the head is shifted.

Finally, have your model raise and lower her head. You may also need to elevate your camera so that you are looking slightly downward. Sometimes the best facial appearance is achieved with a lowered head (the resultant double chin will disappear when a higher camera angle is used).

Hair. A female model with long hair will be able to make extra adjustments. Have her bring her hair over one shoulder or along one side of her face for a sexy look. Have her tilt her head to the side, then shift her hair from shoulder to shoulder. Each time she moves, she will be altering her appearance. Record a variety of poses and select the best after the film is processed.

Watch the Background. Many photographers, working with models for the first time, mentally focus on the model's expression. They are so taken by the model's mouth and smile that they forget to glance around the frame before taking the picture. They miss the pole in one corner or the tree branch that seems to be growing out of the model's ear. It is essential to consider all areas of the picture the instant before you release the shutter. If there is something distracting in the background remove the object, position the model to hide it, or choose another location.

Establishing Rapport

No matter how beautiful or handsome a person may be, almost everyone feels insecure and self-conscious when posing, even for a friend. Nothing is worse for your photographic session than not recognizing this fact. You must supply constant support and reassurance that all is going well. You do not have to record every pose that is struck. However, each time you ask your model to assume a new pose without recording the previous position, stress the fact that the new angle is better than the previous one. This constant support is essential; it helps the model to relax and gain confidence.

Most models learn to listen for your shutter. They will take a pose and listen for the click before taking another pose. If you tell a model to assume a new pose before releasing the shutter, the person will likely assume that he or she does not look attractive. A pattern of insecurity can begin to build, which can ruin your session. Some of the comments you can make if you don't like what you see can include:

"That's lovely, but my lights are wrong. Try another pose and we'll use that one later, after I've adjusted the lighting."

"Excellent, but I think we can make it even better if you tilt your head slightly."

"I'm getting shadows from my angle. Let's try some other poses and then I'll change my position because what you're doing looks good."

Every statement is positive. The only time you should mention a problem is when a strand of hair has fallen or the makeup needs retouching. In these cases, you should explain what you want done and let the model do it. If the model is a female, do not attempt to reach up and move her hair of otherwise touch her during the session, as this can be upsetting. Just explain what is needed, and when necessary, give her a break to look in a mirror.

Putting the Model at Ease. Do whatever is necessary to make your model comfortable. Provide a private area, if changing is necessary; this area should be well lighted, with a place to hang clothing and to sit down.

Music is helpful for relaxing your models. Some photographers search for old records and tapes in order to offer as broad a range of music styles as possible. Others turn on the radio to whatever station seems appropriate for the mood being created. A portable tape cassette is good for location work, as it is easily kept out of camera range and it can be used near the model as she poses.

Let your model choose the music unless you want to establish a particular mood. Some models tend to become totally absorbed in the music, forgetting why they are in the studio. When this occurs, you will need to match the music to the mood you are trying to create. A model who reacts strongly to music should not have hard-driving rock when the mood is supposed to be soft and sensuous. Other models pose effec-

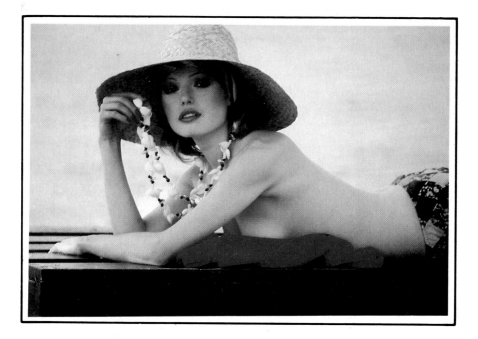

Be considerate when photographing a nude or semi-nude person. Your subject is in an unusually vulnerable circumstance; always ask permission before touching your companion to alter a pose slightly.

tively no matter what the background music. As long as you remain aware of what is happening, you should have no difficulty.

Communication. Verbal communication is an important aspect of setting the mood. Talk with your model before the session and show that you appreciate the effort being made for you. Discuss what you are trying to achieve, and listen to suggestions your model might offer. Be willing to try them.

When you start taking pictures, it is easy to get lost in thought. You become so involved with looking through the lens, watching the different positions your model is taking, and thinking about the lighting, that you become totally absorbed with the intense mental process that precedes taking the picture. Nevertheless, it is important that you converse with your model. Tell your model how good he or she looks, how great his or her poses are. Always be positive. If a position looks wrong or inappropriate, suggest one that will be better. Most models, whether friends or professionals, feel insecure about posing, and negative comments can often ruin a shooting, as stated previously.

Talking with your model, positive reinforcement, and regular breaks all help establish rapport. When you enjoy what you are doing and show it, your positive attitude helps put your model at ease and therefore willing to put forth more effort.

8

Makeup for Models

Glamour photography traditionally has meant the photography of women. However, this has changed in recent years. Many sections of this book have dealt with the use of male models or male and female models working together. At the same time, each sex has unique needs in terms of makeup and clothing, about which you should be aware. This chapter will cover tips on makeup and clothing for both men and women.

Painted Lady. Models fall into two categories: those who understand makeup and those who do not. Many times a beginning model will show up with so much "paint" that she looks like a clown. Your job is to be able to guide her so that her makeup is effective for the results you wish to achieve. When a model looks as though she is wearing makeup, she is probably using too much or using it in the wrong way.

Makeup is most often put on before the model arrives at the studio. However, touch-up work will be necessary, and she will need a place to do this. She must have a mirror, good lighting, and privacy. Incidentally, she should have access to sweat shields for her clothing, to protect it while she is posing. She should also have a large chiffon scarf she can drape over her head when dressing. This protects the clothing from being stained by her makeup, and it also keeps her makeup from smearing.

While professional photographers frequently use makeup stylists for their fashion and glamour work, an amateur model or photographer can achieve similar effects with some practice. Study photographs like this one for ideas and pointers. Photo: R. Farber

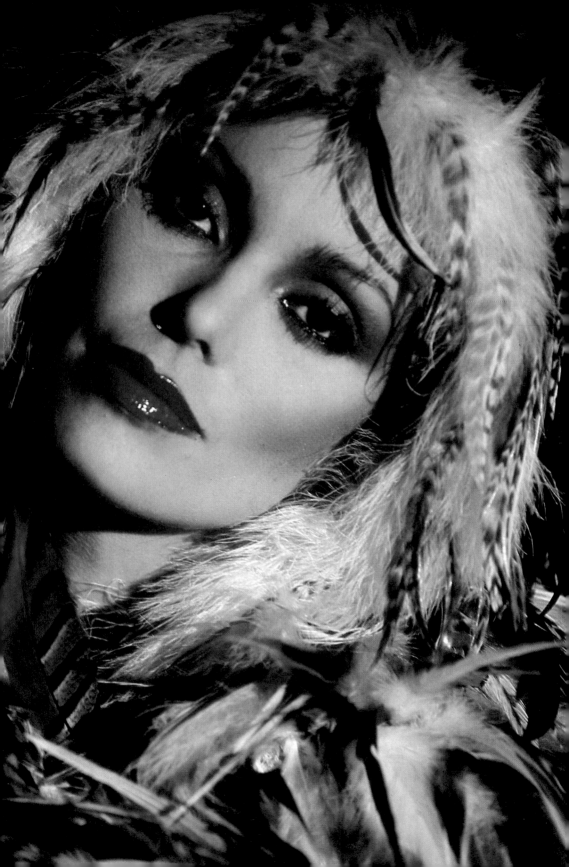

Applying Makeup

A model who turns to you for help with makeup should be taught certain basics. First, some makeup will often cause allergic reactions. For this reason, she should use hypo-allergenic, water base and/or water soluble makeup. Oil base makeup can cause acne and other skin irritations.

Makeup Kit. The foundation is applied first, either with a sponge or the fingertips. The foundation should be a color that matches the model's own complexion, and should be applied in such a way that there is no obvious dividing line between where the foundation ends and the skin begins.

The foundation should not be such a perfect match that it exaggerates your model's coloring. Pink foundation on a bright pink skin can look clown-like. Your model should experiment at home to avoid this problem. A good model will need to spend as much time in front of a mirror, experimenting with her makeup, as she might spend in learning to pose for the camera.

A basic makeup kit consists of:

cleansing lotion	lipstick
cream moisturizer	lip liner
foundation	lip gloss
transparent (colorless) powder	rouge
powder brush	eye shadows
cotton balls	mascara
rouge brush	eyeliners
contour brush	eyelash tweezers
eye-shadow brushes	eyebrow brush
highlighter	curlers

With these materials and applicators, your model can create any "look" you need.

Caution your model not to use an astringent to clean her face, unless her skin is very oily. The high alcohol content will dry her face and can cause burning and flaking.

Different cosmetics serve different purposes. A highlighter is a light-colored cream that is used to eliminate tiny lines and to alter the appearance of a recessed chin. Be careful about the amount of highlighter you use because the white will be exaggerated when foundation is placed over it.

Transparent powder is used to reduce the shine of your model's face. This helps with direct lighting which can exaggerate the shine and make otherwise hidden makeup seem to jump out when you turn on the lights.

Application. Contouring is a method of using makeup to darken a portion of a model's face to create a shadow area. A section below the

cheekbone might be darkened slightly, for example, so that when the light strikes the face, the dark makeup looks like the natural shadow a prominent cheekbone would create. The high, prominent cheekbone is considered a desirable attribute of the fashion model. With contouring, a professional model with less-than-perfect features can create the "high fashion" face.

The contouring technique is also used to reduce the apparent width of the nose. It is important to remember, however, that makeup does not alter bone structure. Even though you reduce the width of a model's nose with contouring, if you continue to use a high front (glamour) light, the actual shadow cast by the nose will not change. Makeup can never compensate for bad lighting.

The Mouth. The ideal model has rather full lips. Those with less generous mouths must compensate with makeup. However, this effect cannot be created with lipstick alone. Instead, lip pencils are used to outline a proper lip, then lipstick and lip gloss are carefully applied to fill in and shine the lips.

Your model's smile is important. Her teeth should be clean and white. If the mouth will be the focus point for your camera, the model can smear a thin film of petroleum jelly on her teeth to get them to sparkle.

Makeup extends to other parts of your model's body as well. Are her hands well-groomed and the nails attractively trimmed? What about her toes and toenails? If she will be barefoot or wearing open shoes, toenails are important and must be manicured accordingly.

Your model will be able to apply her makeup best if you supply her with a well lighted area to work in.

Corrective Makeup and Hairstyles

The model with the perfect face for photography is indeed rare, and you have already seen some of the ways to use lighting to correct facial flaws. The following are some of the common problems models experience—problems which can be corrected with a combination of makeup and good lighting.

- Nose changes are fairly simple to create. A slight darkening of the tips and sides of a long nose will seem to reduce its length. The use of dark shadowing on each side of a wide nose, coupled with a thin line of highlighter down the center, will narrow it. Shading without highlighting is used to reduce an arch or bump on the nose.
- Does your model have puffiness below her eyes? Lighten the shadow area created by the puffiness under her eyes. The puffy part itself should be shaded. This reverses the real effects and seems to smooth her skin.
- Does your model have a double chin? The entire chin area, from chinbone to neck, should be shaded. Just above the shading use a narrow line of lightener from the jawbone to the chinbone.

Hairstyles. Wigs, falls, and hairpieces can be used to complement your model's natural hair. The hair should *look* natural and the coloring must match. Have your model examine it in the daylight to make certain off-color highlights are not visible. A quality hairpiece will look and move naturally on your model's head.

The same model.
Keep in mind that the simplest
makeup to achieve a particular
look is the best.

Hairpieces should not be sprayed or dyed. When your model changes her natural hair color, she will have to go to the expense of new hairpieces to match; otherwise she will have problems with less-than-perfect color matches.

Keep in mind that your lens and film are often more sensitive and/or objective than your naked eye. Flaws will be recorded and exaggerated in the photographs. Something which seems right to the naked eye may be very wrong to the camera.

Hair can be a problem if your model's hairstyle does not suit the shape of her face. An oval face is nearly perfect for photography; even an extreme close-up, when the lens will exaggerate the shape, the oval face will not appear to be fat. Any hairstyle looks good on a model with an oval face except those styles which are so high on the top or so wide on the sides that they seem to alter the natural face line.

A model with a round face should have a hairstyle that is fairly flat on the sides and full at the top. This can be achieved by styling the hair to reduce the fullness, as well as by using wigs and hairpieces to increase the length of the model's face. A model with a round face should avoid center parts in her hair. Long hair is fine, but there should be some fullness at the top of the head.

To make a square face appear narrower, add fullness at the top to increase the length of the face. A slight dip on one side of the forehead or a "wing" of hair on one cheek will break the square lines of the face.

A somewhat triangular face needs hair that is full and wide on top to hide the real shape and give more of an oval appearance. Fortunately, these corrections can be made by most good hairdressers. A hairdresser who understands how to shape and style hair for your model's face is much easier to find than a skilled makeup artist.

Clothing for Women

Clothing with busy designs are always a problem, whether you are photographing in black-and-white or color. This means that checks, plaids, stripes, and extremely bold designs are best avoided. (Obviously, if you are doing fashion photography that features such articles of clothing, this rule cannot apply). Remember that you are usually concerned with making the model attractive, and clothing that calls attention to itself also draws attention away from the model. Relatively conservative clothing can be effective with almost any type of modeling work in the glamour field.

Clothing should not compete with your model's skin tone. A model with light skin, wearing pink, red, yellow, or orange will have the colors of her clothing competing with some of the hues of her own complexion. Cool colors usually work more effectively. These include grays, blues, greens, soft beiges, blacks, dark browns, and similar colors. Black models, on the other hand, may look stunning in brighter colors, while more subdued shades may not flatter their skin tones.

Horizontal/Vertical Lines. Clothing can alter the lines of a model's figure. Different combinations of design and color can create illusions of either horizontality or verticality with the same model. For example, a model wearing contrasting colors, a full skirt and a wide belt, will be accenting the horizontal lines. If she is slightly overweight, such an outfit will exaggerate this flaw. The same model wearing a

A waist-level approach with the camera tilted sightly upward will give a short model the appearance of being a bit taller.

Take into account your subject's personality when thinking about a picture idea. Some people look natural in certain poses but not in others; use the complimentary poses.

straight skirt, solid colors (or thin, vertical stripes), and a narrow belt the same color as the skirt, will appear taller and slimmer. These combinations create a vertical image.

Wide-brimmed hats add to the horizontal image, while small caps, color-coordinated to the rest of the model's outfit, result in a vertical line. A vertical image is always identified with matching tonal values (shoes, stockings, belts, and so on), and a horizontal image with contrasting tonal values. Heavy garments, such as bulky sweaters, full-sleeved blouses, and similar accessories, all add to the horizontal image.

There are several ways to take advantage of this knowledge of how to use clothing to alter the figure of your model. A model who is rather underweight and angular should wear clothing and contrasting colors that accent the horizontal. A model who is either overweight or who has the type of short, large-boned figure some people consider "cute," can gain sophistication by wearing clothing that accents the vertical. You can also use clothing to affect the relative heights of two models who are actually the same size. The model you want to appear taller should wear vertically patterned clothing, and the one you want to appear shorter should wear a horizontally patterned outfit. Both models may be the same height, yet the clothing creates the illusion of different heights.

Subjects frequently feel and look more relaxed when they have something to lean on.

Neatness Counts. Clothing should always be cleaned and pressed, no matter who provides it. Try not to photograph your model in the clothing he or she wears to the shooting session, as these are usually wrinkled from the trip. Carry the pressed clothing separately and let your model change into it. This also means that your model must take care during rest breaks, so as not to damage or soil the clothing.

Your subject should not wear the clothing in which she will pose while her makeup is being applied. During any touch-up work, your model's clothing should be protected with large towels, a large sheet, or something similar. To put on or remove clothing after applying makeup, your model should take a large chiffon scarf, place one end between her teeth, and drape the other end over her face, head, and hair. The clothing is then pulled over her head. The scarf absorbs any smears or stains, leaving the model's clothing clean.

Alterations. There are times when you must alter an off-the-rack outfit for your model. Perhaps a dress is too loose or a blouse hangs so as to accent the wrong parts of her body. Make temporary alterations by using clothespins to clip the fabric together behind the model where it is out of camera range. With the clips, you can tuck in a waist, emphasize the bustline, and generally alter the way the garment hangs.

Accents. Earrings and necklaces can be quite attractive. With highly reflective jewelry, you can place a star filter on the lens and position a light so that the reflection creates a star image on the film. This technique works with gemstones (real or fake) as well as with polished metals.

Jewelry appears most brilliant when lighted by a compact, direct source such as electronic flash.

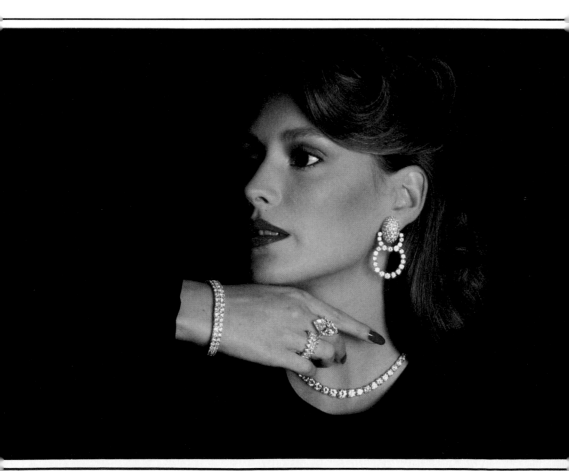

Makeup for Men

Until recently, the male model was used less frequently in glamour photography than the female model. This is because most of the advertising done with models was for products that were sold mostly to women (jewelry, cosmetics, fragrances, for example). Men, when shown at all, were usually secondary figures, generally in the background.

Today, all this is changing, and the male model is in great demand. Sometimes this is as a sex symbol; at other times as an image-maker for after-shaves, colognes, clothing, or similar items geared to the men's market. In these images, it is the male model who is featured and the female who plays the secondary role.

Although most of you will be photographing men who are not professionals, the techniques used with professional male models can make any man look more glamorous. There is no reason why women should get all the special attention in glamour photography. You can make male friends look as handsome as movie stars and top fashion models when you follow the suggestions given here.

Basic Male Makeup. A male model wears makeup for the same reasons that a woman wears it: to improve his appearance and correct facial flaws. He will use less of it than a woman and probably will not need it in many situations.

The care with which makeup is applied by a man must be greater than that exercised by a woman, because the idea of male makeup is not totally accepted in our society except for entertainment purposes. It is all right for the male model to use makeup to achieve a pleasing or dramatic visual effect, but the viewer of the photograph must not be aware of this fact.

- Dark circles under the eyes and facial blemishes usually are common areas for correction. Use a cover cream (the advice to use hypo-allergenic products applies here, just as it does for women) to eliminate such problem areas.
- Scars should be eliminated from a man's face unless a rugged look is desired. Use a liquid makeup matching the flesh tone of your model to cover the scar. A white erase stick will work as well when your model has a light flesh tone.
- The afternoon beard ("five o'clock shadow") problem often cannot be eliminated merely by shaving shortly before the photo session. A face powder in a slightly darker shade than the natural flesh tone will smooth out the appearance of the male model's face.
- Hair spray is often used by men when their hair has been styled. Have your model spray the liquid into the air above his head, letting it settle slightly on his hair. Such an approach eliminates the shiny, glue-like appearance common to hair that has been sprayed directly. There may still be a

Most male models today use some makeup, although considerably less than women, and never as noticeably. While a woman's makeup may be quite obvious, a man's is used generally for corrective purposes only—to hide scars and other blemishes, to "remodel" facial structure, and to change skin coloration.

slight reflection problem, but it will be easy to handle with a minimum shift of your lighting.

Keep in mind that it is not essential to use makeup with male friends you photograph. You can glamourize men without embarrassing them by asking them to wear makeup. The techniques mentioned in these pages will enable you to show a man to artificial perfection—the way a professional model is shown. They are discussed here to make you aware of them for possible use with any professional work you might attempt.

Remember that when you glamourize someone, you are enhancing that person's appearance. You are not denigrating his natural appearance, but only showing him as even more attractive than had ever been perceived. The tricks you will be applying are meant to bring out the best.

The corrective posing and makeup methods mentioned for women will also work with men. Review those sections with the male model in mind.

9

Turning Pro

The nice part about glamour photography is that it can be enjoyed by the professional and amateur alike. If you are an amateur trying to broaden your photographic skills, glamour photography is an exciting way to grow in ability.

This final chapter is meant to supplement the confidence you have gained from trying the techniques discussed. The fact is that if you have mastered the basics of glamour photography, you can earn money from your work. This can be accomplished by doing work for models in your community. Or you can make money selling your photographs to various markets around the world.

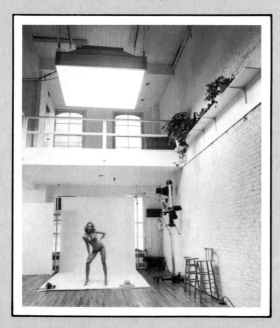

An important consideration in picking a studio is to find a place with high ceilings. This allows you ample room to set up tall equipment and backgrounds.

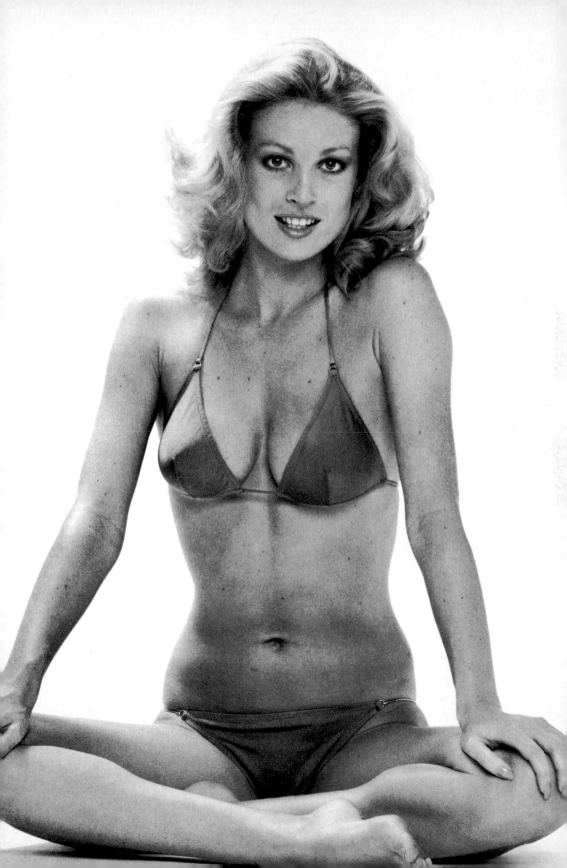

The Model's Portfolio

All men and women interested in working as models need two "tools": a composite and a portfolio. The composite is a single sheet (usually 8″ × 10″) containing two or more pictures of the model in different poses. Also on the composite are the model's name, telephone number or agency phone, and other pertinent information. This is left with potential clients as a visual reminder of the model. The portfolio is a series of photographs, usually carried in a case much like a looseleaf notebook, each photograph covered by a plastic page protector. The portfolio is shown to a potential client during a face-to-face interview to provide an in-depth impression of the model's ability and potential.

All photographs in a model's portfolio should be professional in appearance, including the printing. They must be either 8″ × 10″ or 11″ × 14″, but not both. The 8″ × 10″ is considered the smallest professional size, and nothing smaller than that should be included in the presentation. The 11″ × 14″ print is the largest the average person can comfortably examine in an office. Art directors and account executives, even those with major advertising agencies, may not have the necessary room to study larger images.

Advertising models in many major cities use color for the majority of their photographs. A new model or one in a smaller community may not have the money for many color prints, but it is still a wise idea to include at least some color along with black-and-white photographs.

Color photographs "grab" the viewer's eye. An adequate color image often has stronger visual impact than a superior black-and-white print. For this reason, the images should not be mixed in a portfolio. The black-and-white images should be presented first, followed by the color prints. This is a "saving the best for last" concept. If there are 20 prints in the portfolio, 12 of which are black-and-white, then the portfolio should show these 12 first, followed by the 8 color photographs. In this way, the full impact of each print can be fully appreciated.

What to Include in a Portfolio. There are no hard-and-fast rules for what should be included in a model's portfolio, though certain types of photographs will always be needed. Among these will be at least one head-and-shoulders portrait. A client will also want to know how the model appears in a more extreme close-up. If the model looks radically different from two or more angles and/or with varying hairstyles, then several head shots should be included. A portfolio shows the model's versatility; clients prefer not to decide whether or not to hire based only on how the model appears during the interview.

The model will also need several full-length photographs taken in formal and casual clothing. These should include images taken on location so that a variety of settings and poses can be included. All the techniques discussed in the previous chapters should be employed as you work to attain the best possible effects.

Finally, you and the model should let your imaginations run free. Try many different images, including character photos that may look like movie stills. This latter approach is important if the model is also a performer attempting to gain commercial assignments and/or other acting jobs. Thus, a male might be shown as a man about town, a priest, or a cowboy.

When you have completed the photography, go over the contact with the model, and select at least 20 different images for portfolio enlargements. A portfolio can be as thick or as thin as the model desires, though the minimum should be 12 to 15 images. With fewer than a dozen prints, the model may seem too limited. Twenty or more prints indicate greater versatility, provided they all show your model's ability and appearance effectively.

Eventually your model should use more than one photographer in assembling a portfolio. Each photographer has a distinctive style, and the fact that only one person took the pictures might imply that the model may not be able to work effectively with anyone else. Some models have difficulty relaxing, and when they find one photographer with whom they are comfortable, they try to use that photographer for all their picture-taking. Sometimes their fears are so strong that they freeze with anyone else, and the pictures resulting from such sessions are disastrous.

Advertising agencies and other companies hire models and the photographer separately. If you are a professional photographer, have talked with the company, and are actively seeking work, perhaps you will be hired to work with a model whose portfolio you prepared. However, chances are that the photographer used at any given time will *not* be the same one who made the portfolio. Thus, if there is any question about a model's ability to work with more than one photographer, he or she will not be hired. For this reason, it is very important for every model to have a portfolio reflecting more than one photographer's work. This may be overlooked for a first portfolio, but as the portfolio is updated, this fact is critical.

As added proof of professionalism, your model should also include at the back of the portfolio clippings from advertisements in which he or she has appeared.

Updating the Portfolio. The portfolio will need to be updated annually, in part because of changes in the individual's appearance, and also because of changing styles in makeup, hairstyle, and clothing. The need to keep absolutely current in terms of the season's fashion "look" cannot be stressed strongly enough. This means keeping well ahead of what is currently shown in the stores—usually by constant referral to "trade" publications. Changing pictures regularly is also a good idea if the model returns to the same businesses where he or she has applied for work in the past. Even if your model has not worked in six months, the fact that different photographs appear in the portfolio implies that he or she has been working.

The Composite

The composite is a printed sheet of paper with two or more of a model's best pictures. It is left with potential clients after a model has shown his or her portfolio. The composite has the model's name, telephone number or agency phone, and perhaps general clothing size or related information.

A composite is prepared so that it is either two pages (actually one 8" × 10" sheet of paper with both sides used) or four pages (a 16" × 10" sheet of paper folded in half to give four sides of 8" × 10" each). (The 8" × 10" size is important because it fits in the standard file folder.) The first page will have a single photograph of the model, either a head shot or a full-figure shot. This will be the lead photograph and should have strong visual impact. It is the first picture a potential client will see when thumbing through the various composites left by different models. It is the picture that may favorably remind the potential client of your model's skill, and result in an assignment.

That first-page picture should be laid out so that the model's name, perhaps the agency, if any, and a telephone number will be included. The model's age is never given, though other pertinent information, such as height, clothing size, and affiliation in unions can be included. Never include the model's address, as a means of protection. Usually, all this data is included in small but visible print at the lower right or lower left of the photograph. The model's name might appear at the top in larger type or in some other prominent position.

Each additional page, or side, will have no less than one and no more than four different images of the model. These can be some of the same shots included in the portfolio, or they can be different, equally effective pictures taken during those same sessions. A single 8" × 10" composite will have from two to five images. A 16" × 10" sheet folded to give a four-sided 8" × 10" will have from 4 to 13 photographs.

The composite should be reproduced by a printer, not a photography custom lab, unless the volume is so low that the lab is cheaper. A good printer should be able to show you samples of different quality paper, photo reproduction, and, in larger cities, examples of portfolios completed for other models. The quality of a printed sheet will not be as good as a composite, but it will cost less in large quantities.

Some models pay to have color composites. The cost factor is exceedingly high and such an approach is usually not practical. A color composite is normally used by working professionals who are earning enough money so the cost is not prohibitive and the expense is tax-deductible.

Photographers traditionally advertise on models' composites. The photographer's name, in small type, is placed either in a margin or in a bottom corner of each photograph. Again, having more than one photographer's work is important here, though not critical for the first-time model.

A model's portfolio should show him or her in a wide variety of situations as well as different poses.

The charges for a composite are usually separate from those for a portfolio when you are hired by the model for this work. Most models will hire you to do the portfolio, then select from among those photographs the images for a composite. They can build the portfolio slowly, buying prints as their budgets allow, then using the best for the composite when they have what they feel is a good selection. They either buy the photographs from the photographer at the agreed-upon rate and arrange for the printing themselves, or they have the photographer prepare the composite.

Preparing Photos for Publication

When you decide you want to sell your glamour photographs, you will have to be aware of several facts of publishing. First, do not be concerned with the fact that you are an amateur. The nice part about freelancing photographs to magazines, book publishers, and others is that all that matters is the quality of the work. If your pictures are good and they fit the publisher's needs, they will be used. Thus, you should never say that you are a beginner, nor should you ask for criticism if your work is rejected.

Most publications buy either a single print, illustrations accompanying an article, or a photo series with all pictures related. A single print will either be purchased because of its content or it will not. However, a series of photos, including photographs illustrating a story, may present potential problems.

The purpose of a magazine is to sell advertising. Without advertising, there is no money for publication. Advertising is sold, then laid out in the publication, and whatever space remains is meant for editorial use. If the editorial space is inadequate, the editorial matter is cut or altered. No publication will drop its advertising or decrease ad space to make room for an exciting article or photo series. This means that you should be aware of how your pictures fit the space; the space will not be altered to fit your pictures.

Every time you submit a series of glamour photos, one picture in the series should be able to stand alone. That single image should reflect the theme of what you are trying to record. If you are photographing a dancer, one picture might show the dancer performing on stage in the midst of others. Additional photos might show her alone under different conditions, not necessarily as a dancer. However, that single picture of her performing, taken with a wide enough angle so that it is clear what she is doing, should be able to stand alone if necessary.

Picture Formats. Taking a single, all-encompassing photograph is not enough. You actually need two such images, one horizontal and the other vertical. The reason is that, depending upon the advertising layout, the available "hole" for your picture in a publication might be horizontal or it might be vertical. If one of your photos does not match the available space, chances are you will miss an opportunity to have your photo used in a particular publication.

Support images—pictures completing the story—should also be a mix of vertical and horizontal photographs. The support pictures can all be different from each other, each representing a different aspect of the story you are telling. It is only the single, all-encompassing photo,

which might be run alone, that should be usable both vertically and horizontally.

Whether you send black-and-white prints or color slides (transparencies) will depend upon the publication. Color is expensive to reproduce, so some magazines use it only for covers. Others use a limited amount of inside color, and then only when the images are strong enough so that the color is important. If a picture can be just as effective in black-and-white, you should send the black-and-white. Never send color to a magazine that prints only black-and-white on the theory that your pictures are so strong in color, the editor will wish to make an exception. A magazine that does not use color has made that decision based on economics. Your images may very well be beautiful, but if the cost makes color printing prohibitive, the beauty of the transparencies will not change the publication's decision to stay with black-and-white.

Mailing Slides and Prints. Slides and prints should be protected when mailed. Many photographers like to send slides in plastic or cardboard boxes used by processing labs. Do not do it. This is highly unprofessional.

Slides should be placed in plastic notebook pages designed to hold 20 slides in individual pockets. These are punched for a loose-leaf binder, but can easily be mailed as individual sheets.

Black-and-white prints should be sent loose. Both the prints and the plastic slide pages should have two pieces of corrugated cardboard for protection. The cardboard makes a "sandwich" with the photographs between the two pieces of cardboard. This is adequate protection when you mail your photos to various publishers.

Always send a self-addressed, stamped envelope that can hold your prints, slide pages, and cardboard for their safe return. Affix sufficient postage for the contents you are enclosing. Because of the large number of submissions and great cost factors, a publication will not return photographs if you do not include a self-addressed, stamped return envelope. Either a somewhat larger envelope is used for the mailing, or the return envelope is folded in half when sending the original submission. You can either buy special photomailers, which come with the corrugated cardboard, or you can cut a cardboard carton to size.

Make certain each slide and print is marked with your name and address. Use a black ink stamp and lightly stamp the back of each print and each slide mount. You can also use a fine-point, indelible marking pen to place your name and address on the plastic edge used by some slide processors. A stamp only works on cardboard mounts.

Be careful how you stamp the prints. Place each one face down on a smooth, hard surface. Then stamp the back, preferably over a dark section of the picture or the border, as lightly as possible. If the stamp is pressed too hard, it will bleed through to the surface. Set each print aside as it is stamped. Do not try to stamp prints one on top of the other, or the stamping will mar the image.

Submitting Photos for Publication

A photographer who is unknown to a newspaper or magazine will have to submit photographs and illustrated articles "on speculation." This means that there is no guarantee that your work will be bought. The publication is also not legally responsible for the safety or return of the pictures. It is advisable to contact the editor in advance, explaining what you have and asking if there is an interest in seeing it. The editor may agree, but will still expect the work on speculation. If the pictures do not seem right for the publication when they arrive, they will be rejected. You have no recourse other than to try again. There is no payment for rejected work sent on speculation. When you first try to sell your pictures in this way, you will probably be forced to work on speculation, as you are an unknown to the editor. He or she will not want to contract for work and have to pay you when there is a chance you cannot deliver the pictures you are proposing.

Work requested on assignment is different. The publication is paying you to take the pictures and the price is agreed upon in advance. A decision might still be made not to use them, but the pay is certain.

The best way to learn which magazines accept freelance photography is to check both the magazines themselves and the various market guides. Many of the major users of glamour photographs have them taken on assignment only, a fact you can determine by reading captions.

The market guides are numerous. The best are generally those which are annually updated and provide in-depth information on needs. Check your library or bookstore for the latest marketing guides available. An excellent source for international marketing information is provided by the Bureau of Freelance Photographers (BFP) in England. The address is: Focus House, 497 Green Lanes, London N13 4BP, England.

A covering letter must be sent with each submission. This should be short, saying something to the effect of: "The enclosed photographs are being submitted on speculation. I think they will be of interest to your readers.

Thank you for your consideration. I look forward to hearing from you at your earliest convenience."

The letter is not the place for personal background. You are a professional photographer, if only because you are trying to sell your work. All other information is irrelevant, especially any request for criticism or improvement. You will succeed or be rejected based on the quality of your work plus the current needs of the publication and/or stock already on hand.

Glamour photography is a fascinating, exciting, and profitable field. By following the information in this book, you will be able to take professional looking pictures. There are *no* limits as to what you can do with those pictures.

It's difficult to avoid awkward shadows with directional lighting when your subject's upper body is rotated. An easy solution is to use highly diffuse bounce light.

Index

Available light, reflectors for, 59

Backgrounds, clothing, and props, 30-39
Backgrounds, controlling, 34-35
 color, 34
 photo set, 35
 point of view, 34-35
Basic equipment, 12-29
Bounce light, 24, 50-53

Clock technique, 92
Clothing, 36-37, 104-107
 accents, 107
 alterations, 107
 horizontal/vertical lines, 104-105
 improvise, 37
 neatness, 106
 used and rented, 36-37
Color, 56-59
Composite, 114-115

Electronic flash, 24-25
 bounce flash, 24
 direct flash, 24
 studio flash, 25

Fill flash, 60-61
Filters, 28-29
Flash at night, 82-83
 background, 83
Framing the subject, 73

Good conditions, 57

Hairstyles, 102-103

Lenses, 14-17
Lighting, modifying, 48-49
Lighting arrangements, 42-47
 backlighting, 46
 butterfly or glamour lighting, 43
 45-degree lighting (Rembrandt
 variation), 44-45
 hatchet lighting, 46
 rim lighting, 46
Lighting equipment
 beginners, 22
 extension cords, 22
 holders, 22
 indoor, 18-23
 matching light and film, 20-21
 multiple lighting, 18-19
Location, 70-83

Makeup, 98-109
Makeup for men, 108-109
Meters, spot, 29

Model, 84-97
Model's portfolio, 112-113
 updating, 113
 what to include, 112-113
Mood, 62-69
 daytime, 67
 high-key, 68
 on location, 64-65
 low key, 69
 mornings and evenings, 66-67
 natural light for, 66
 at night, 67
Motor drives and power winders, 28

Natural light, 54-61
Night, 80-81

Points to consider, 72-74
Portrait posing, 94-95
Posing, 86-90
 hands, 86
 legs, 88-89
 shoulders, 86
Posing, corrective, 91
 body angle, 91
 camera angles, 91
 collarbones, 91
 hands, 91
 seated models, 91
Props, 38-39
 professional, 39
Publication, preparing photos for, 116-117
 mailing slides and prints, 117
 picture formats, 116-117
Publications, submitting photos for, 118
Public places, 75-77
 beaches, 76
 cities, 77
 parks, 75

Rapport, 96-97
 communication, 97
 putting model at ease, 96-97
Reflectors, 26-27
Reflectors for available light, 59
Restaurants and clubs, 79

Seamless paper, 32-33
Shopping malls, 78-79
Single-lens reflex (SLR), 12
Special accessories, 28-29
Studio lighting, 40-53

Turning pro, 110-119
Twin-lens reflex (TLR), 12

Ultraviolet light, 56

DATE DUE

			PRINTED IN U.S.A.

The Land Shall Be Deluged
in Blood

Men, like other things, have "two sides," and often a top and a bottom in addition.
—LUNSFORD LANE, 1842

The Land Shall Be Deluged in Blood

A New History of the Nat Turner Revolt

PATRICK H. BREEN

OXFORD
UNIVERSITY PRESS

OXFORD
UNIVERSITY PRESS

Oxford University Press is a department of the
University of Oxford. It furthers the University's objective
of excellence in research, scholarship, and education
by publishing worldwide.

Oxford New York

Auckland Cape Town Dar es Salaam Hong Kong Karachi
Kuala Lumpur Madrid Melbourne Mexico City Nairobi
New Delhi Shanghai Taipei Toronto

With offices in

Argentina Austria Brazil Chile Czech Republic France Greece
Guatemala Hungary Italy Japan Poland Portugal Singapore
South Korea Switzerland Thailand Turkey Ukraine Vietnam

Oxford is a registered trade mark of Oxford University Press
in the UK and certain other countries.

Published in the United States of America by
Oxford University Press
198 Madison Avenue, New York, NY 10016

Library of Congress Cataloging-in-Publication Data
Names: Breen, Patrick H., author.
Title: The land shall be deluged in blood : a new history of the
Nat Turner Revolt / Patrick H. Breen.
Description: New York, NY : Oxford University Press, 2016. | Includes
bibliographical references and index.
Identifiers: LCCN 2015042315 | ISBN 9780199828005 (hardcover : alk. paper)
Subjects: LCSH: Turner, Nat, 1800?–1831. | Southampton Insurrection, 1831.
Classification: LCC F232.S7 B74 2016 | DDC 975.5/55203092—dc23
LC record available at http://lccn.loc.gov/2015042315

1 3 5 7 9 8 6 4 2

Printed in the United States of America
on acid-free paper

For Katie

Contents

Acknowledgments		ix
Chronology of the Revolt		xiii
Maps		xvii
	Introduction	1
1.	Signs	17
2.	The First Blood	37
3.	To Jerusalem	57
4.	Where Are the Facts?	73
5.	The Coolest and Most Judicious Among Us	89
6.	Long and Elaborate Arguments	107
7.	Willing to Suffer the Fate That Awaits Me	139
8.	Communion	155
	Conclusion	165
Afterword: From His Own Words		169
Appendix: Slave Population of Southampton County, 1824–1839		181
Notes		183
Bibliography		263
Index		277

Acknowledgments

ONE OF THE graces that comes with finishing the book is an opportunity to thank the people who have helped me along the way. This was a project that began in graduate school. As a result, my research trips were especially low-budget affairs. The kind hospitality of Paul Vandegrift in Richmond, Mark Smith and Daniel Nonte in Charlottesville, my parents in Washington, D.C., and Emory Thomas, who went above and beyond his role as advisor when he gave me the keys to the farm, allowed me to visit the research libraries where I found the materials that I have used in this study. The visits were great trips, in part because I got to talk with my hosts about the wonderful things that I had found in the region's great libraries. The staffs at the Library of Congress, the Library of Virginia, the Virginia Historical Society, the Virginia Baptist Historical Society, the Alderman Library at the University of Virginia, the Earl Gregg Swem Library at the College of William and Mary, the North Carolina Department of Archives and History, the Perkins Library at Duke University, and the Southern Historical Collection at the University of North Carolina were unfailingly helpful as they helped me search their collections for even the smallest piece of evidence about what was happening in 1831. At the Virginia Baptist Historical Society, Darlene Slater Herod was especially accommodating when she sent me copies of church records that Randolph Scully told me I had missed on an earlier visit. The late Winthrop Jordan kindly responded to a query of mine about sources; the carefully considered letter was much more than I ever expected to receive from a man I had never met. Because I have moved twice since starting my research, I have used as my home base libraries at three different schools: the University of Georgia, the University of North Carolina, Chapel Hill, and Providence College. The help I was able to get at the University of North Carolina, Chapel Hill was made possible by Peter Colclanis, who made sure that I would be able to get access to the material that I needed. At Providence

College, the interlibrary loan staff has been unbelievably easy to work with. I would also like to thank Christiane Marie Landry, who helped digitize sections of the Southampton Court records.

As I have tried to look at the material in a new way, several people have helped me in ways that have made *The Land Shall Be Deluged in Blood* better. At the University of Georgia, Peter Hoffer and Edward Larson both made me think not just about the evidence but also about the relationship of historians to their readers, something that has influenced my work from the conception of my project. Dave McGee and Jonathan Sarris were also always willing to talk about this project in its early stages. A college, as my friends who are classicists remind me, is at its core a collegium of its professors. Providence College's faculty understands that the relationship of collegiality and collegium is more than an etymological coincidence. The faculty in the history department and more broadly in the college have supported this project during lectures and lunches in ways that they will never know. I have also gotten support from administrators at the school, including history department chairs Connie Rousseau, Matt Dowling, and Margaret Manchester. While at Providence College, I also had the good fortune to be invited to a National Endowment for the Humanities Summer Institute, "Slaves, Soldiers, Rebels: Black Resistance in the Tropical Atlantic, 1760–1888," organized by Ben Vinson III, Natalie Zacek, and Stewart King. The presenters, especially Laurent Dubois, Douglas Egerton, Sylvia Frey, David Garrigus, Marjoleine Kars, Stewart King, Franklin Knight, Jane Landers, and James Sidbury, helped me think about slave resistance within a global framework. Zach Morgan, Sarah Roth, Brian Sinche, Lindsey Twa, and the others at the institute helped me process what I learned in those five weeks in Baltimore.

I am responsible for all the flaws in *The Land Shall Be Deluged in Blood*. There would have been more of them if so many people had not taken time from their work to save me from mistakes, both big and small. Earlier versions of my work have been commented upon by Daniel Crofts, Douglas Egerton, Melvin Patrick Ely, Robert Forbes, Kenneth Greenberg, Charles Irons, Anthony Kaye, Peter Kolchin, Nelson Lankford, Paul Levengood, Randall Miller, Randolph Scully, and James Sidbury. Sharon Murphy, who joined me in the history department at Providence College, has been everything one would want in a colleague. She has been a great sounding board when I needed someone to listen to me work my ideas out; as a reader who has read this book from start to finish, she has made this work better in style and substance. Douglas Egerton and James Sidbury also deserve thanks for putting me in contact with my editor, Susan Ferber, at Oxford University Press, who

agreed to work with a first-time author whom she did not know. She picked two anonymous readers whose thoughtful responses to an early version of this leave me with one regret, that I cannot thank them by name. Ferber's own editorial suggestions have improved this work as well. She kept her eye focused on what was most important. When facing a deadline, I sent her the revisions that I had made and asked if she wanted me to rush what I had left to do. She wrote back, "It's fine if it takes more time. I care most about the quality." I could not have asked for a more farsighted perspective. I am especially indebted to two teachers who have had an enormous influence on this project, my career, and my life. Emory Thomas has been nothing but supportive of *The Land Shall Be Deluged in Blood*. He has assisted this project in myriad ways and outdone any reasonable expectations a graduate student could have for his advisor. As much as I appreciate his advice, his friendship has given me a model that I can only hope to emulate with my own students. It is impossible to overestimate the importance that Eugene Genovese has had on my life. His wit, his erudition, and his Brooklyn charm are as clear in my mind as they were the day that I, as a sophomore, first walked into a seminar that he was teaching on the Old South. His approach to history was creative in ways that one would expect from the foremost historian of his generation, but even more compelling were the ways in which he showed how history was vitally important to the present. His urgency to get history right is one of the things that influenced my career choices, and it sustains me to this day in both my writing and my teaching.

I would like to thank my family for their help. My parents and sisters have always been supportive of me. My own children, Mary, Dorothy, Thomas, Peter, and Helen, have grown up with a father who must seem to them to be always at work on a computer. In fact, one of the reasons this project has taken me as long as it has is that I have learned the many ways in which the challenge of raising children is often in tension with writing books. I have learned that one can neither read nor write while changing a diaper or driving the kids to swim practice. Fortunately, as I have been working on this book, I have been lucky enough to cross the paths of several women, including Ellen Schlosser, Jen Cardulo, Emily Cass, Jessica Sweeney, April Lambert, and Mary Margaret Donovan, who have provided such loving care for my children that I could work without worry. My children have done little to relieve my worries, but they buoy my spirits and daily remind me about the unpredictability of life. My life and this book would be poorer without them.

My greatest debt in writing this book is to my wife, Katie. When we married, neither of us could have imagined how demanding our family life would

be. But my wife has always been a great wife and mother. From graduate school and the dissertation to Rhode Island and now this book, she has been with me every step of the way. Juggling the demands of her own successful career and our children, she has always supported my career. Perhaps her willingness to help me was most clear when she was eight months pregnant with Peter. I asked her if she would be able to balance her job, a new baby, and the three other kids while I went to Baltimore for five weeks during the NEH Summer Institute "Slave, Soldiers, Rebels." She told me to apply and then held together our household while I was away. When I returned, she treated me as if I had done something worthwhile, never reminding me that she was the one who made it possible. Maybe in her heart she knew that I knew that I would not have been able to do what I had done without her. Since that summer, my debt has only grown. In gratitude and love, I dedicate this book to you, Katie.

Chronology of the Revolt

(EXCEPT WHERE NOTED, events took place in Southampton County.)

November 7, 1775	Virginia governor Lord Dunmore issues a decree promising freedom to slaves of patriots who support the British during the American Revolution.
October 19, 1781	The British surrender at Yorktown, Virginia.
May 1782	Virginia passes a law making it possible for residents to manumit slaves.
August 1792	The slave revolution in Saint-Domingue (Haiti) begins.
1798	Antislavery advocate and Baptist minister David Barrow publishes a circular letter explaining his emigration to Kentucky from Virginia.
October 2, 1800	Nat Turner is born.
October 10, 1800	Gabriel is executed for plotting an August 30, 1800, uprising in Richmond, Virginia.
January 1, 1804	Haiti declares independence from France.
January 8–10, 1811	Slave revolt in Louisiana.
July 2, 1822	Denmark Vesey is executed in Charleston, South Carolina.
1825	Nat Turner runs away; he returns claiming that the Holy Spirit inspired his return.
December 1825	Jonathan Lankford refuses communion to slaveholders at Black Creek Baptist Church.
1826	Jonathan Lankford is excommunicated from Black Creek Baptist Church.
1827–1828	Turner baptizes himself and Etheldred T. Brantley.

1828	Thomas Moore dies. Six-year-old Putnam Moore inherits Nat Turner and five other slaves.
January 1, 1831	William Lloyd Garrison publishes the first issue of the *Liberator* in Boston, Massachusetts.
February 12, 1831	Solar eclipse.
May 1831	Possible allusion to revolt at Raccoon Meeting House in Sussex County, Virginia.
July 4, 1831	Originally scheduled starting date of revolt; Nat Turner postpones it.
August 13, 1831	The sun appears bluish green; the conspirators decide to launch their revolt the following weekend.
August 21–23, 1831	Nat Turner slave revolt takes place.
August 28, 1831	Virginia militia commander Richard Eppes proclaims martial law to prevent the killing of blacks without trial.
August 30, 1831	The trials of the slave rebels begin.
September 4, 1831	Executions of convicted slave rebels begin.
October 18, 1831	Conviction of the star witness Moses marks the completion of the trials of slaves arrested when the revolt was suppressed.
October 27, 1831	Nathaniel Francis spots Nat Turner, but Turner escapes.
October 30, 1831	Nat Turner is captured by Benjamin Phipps.
October 31, 1831	Nat Turner is examined by James Trezvant and James Parker and then committed to jail; Turner agrees to tell Thomas R. Gray his confessions.
November 1–3, 1831	Thomas R. Gray interviews Nat Turner.
November 5, 1831	Nat Turner is tried, convicted, and sentenced to death.
November 10, 1831	Thomas R. Gray applies for copyright for *The Confessions of Nat Turner* in Alexandria (then part of Washington, D.C.).
November 11, 1831	Nat Turner is hanged.
May 11, 1832	Free black Berry Newson is hanged.
November 1832	Mill Swamp Baptist Church, in Isle of Wight County, Virginia, dismisses ten whites who refuse fellowship with blacks.

November 1833 Mill Swamp Baptist Church rescinds dismissal of the ten whites after they agree to fellowship with blacks.

February 1835 Condemned Sussex rebel Boson is captured in Norfolk, Virginia; his execution is rescheduled for March 27, 1835, in Sussex, Virginia, but the governor commutes the sentence.

October 16–18, 1859 John Brown raid at Harpers Ferry, Virginia.

April 11, 1861 Confederate States of America attack Fort Sumter. Civil War begins.

January 1, 1863 Lincoln issues Emancipation Proclamation.

December 1865 Thirteenth Amendment adopted, abolishing slavery throughout the United States of America.

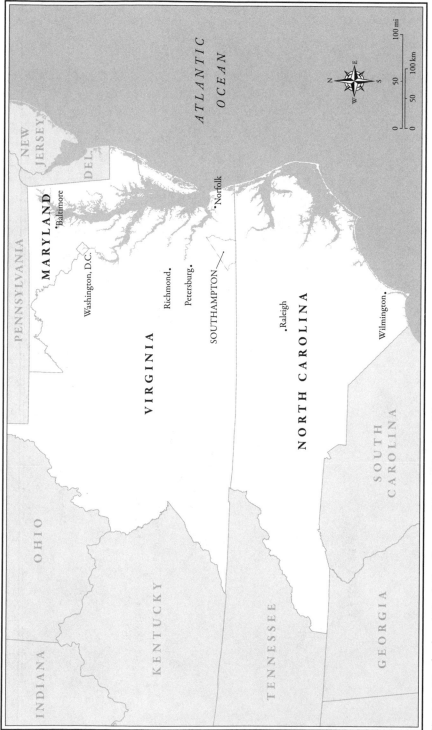

Virginia, Maryland, and North Carolina, 1831. Map by Glen Pawelski.

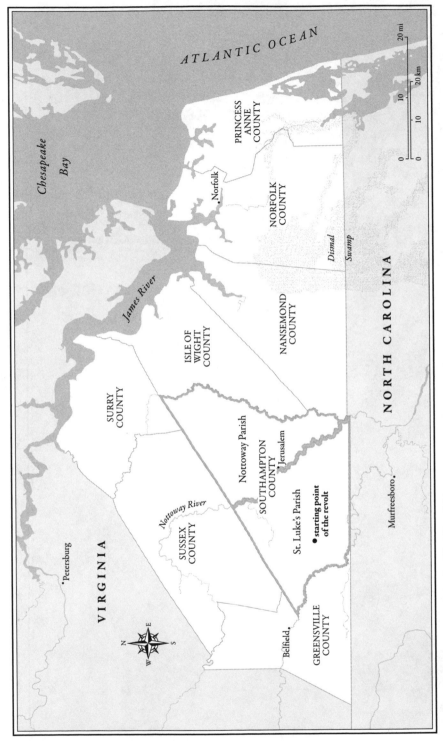

Southeastern Virginia, 1831. Map by Glen Pawelski.

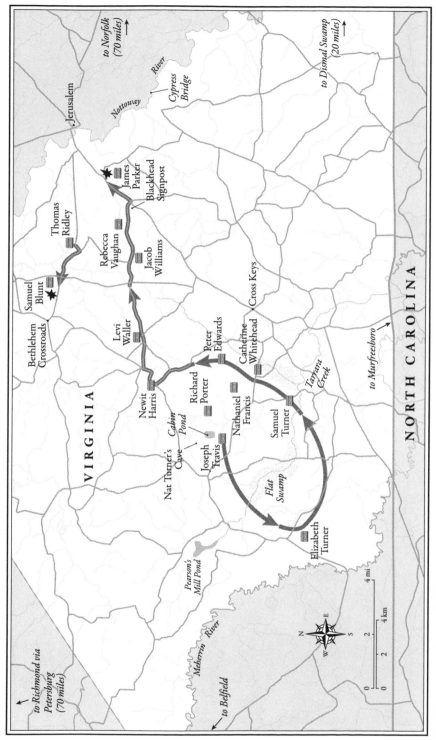

Nat Turner's Revolt, St. Luke's Parish, Southampton, Virginia, August 21–23, 1831. Map by Glen Pawelski.

*The Land Shall Be Deluged
in Blood*

Introduction

ON SUNDAY NIGHT, August 21, 1831, Nat Turner and four other men launched the bloodiest slave revolt in American history. During the planning stages, Turner had kept the conspiracy small, but once the rebels killed Joseph Travis and his family, they quickly swept through Southampton County, Virginia, killing whites and recruiting slaves to their ranks. At first the insurgents caught Southampton's whites completely by surprise. By the middle of the day on Monday, August 22, they had killed nearly five dozen whites, including men, women, and children. Never in American history had so many whites died in a slave revolt. The rebels also recruited several dozen men and older boys into their small army.

The rebels' initial successes were short-lived. By Monday afternoon, Turner's army suffered its first defeat, in a battle at James Parker's farm. The next morning, local whites dispersed the main rebel force. Over the course of the next week, whites captured or killed the remaining insurgents, with one exception: despite an intense search for the revolt's leader, Turner eluded his pursuers for almost two months. In mid-October he was spotted near the starting place of the revolt. A renewed manhunt led to his capture on October 31. The next day, Turner's white captors brought their prisoner to the jail in Jerusalem, the county seat. Thomas R. Gray, a white lawyer who was involved in the defense of other accused rebels, interviewed Nat Turner while he was awaiting trial. Gray published these interviews in *The Confessions of Nat Turner*, a unique narrative that may be the most important work on slavery written and published in the slaveholding South. On Saturday, November 6, 1831, Turner appeared in court, where he was charged with "conspiring to rebel and make insurrection." The court's judgment was never in doubt. Nat Turner was hanged on November 11, 1831.[1]

Although a hastily assembled group of local whites suppressed the revolt quickly, its repercussions reached far beyond the borders of Southampton County. Haunted by the visions of Nat Turner, the Virginia legislature took up the question of emancipation. For the first time since the eighteenth

century, when St. George Tucker circulated his emancipation plan, a number of people in Virginia urged that the state legislature adopt a plan of gradual emancipation and colonization for Virginia's slaves. In the 1831–32 legislative session, proslavery conservatives dominated the special committee charged to examine "the subject of slaves, free negroes and the melancholy occurrences growing out of the tragical massacre in Southampton." The committee recommended that "all petitions, memorials, and resolutions which have for their object the manumission of persons held in servitude under the existing laws of the Commonwealth" be refused. Thomas Jefferson Randolph, Thomas Jefferson's nephew, then led a floor fight to overturn the recommendations of this committee. Randolph saw the end of slavery as an eventuality. "It must come," he declared at the climax of one speech. The only question in Randolph's mind was whether emancipation would be done by legislative action "or by the bloody scenes of Southampton and St. Domingo." Many in the Virginia General Assembly interpreted the recent events in Southampton differently: Randolph's appeal fell on deaf ears, and the legislature narrowly rejected gradual emancipation. The topic was not to be revisited in the South before the Civil War.[2]

The nascent abolitionist movement also paid close attention to the revolt. Although most abolitionists carefully disavowed any connection to the revolt— "I do not justify the slaves in their rebellion," William Lloyd Garrison wrote in a letter two weeks after the revolt—some, including Garrison, used the revolt to validate their strategy of immediate emancipation. In an article published shortly after the rebellion, Garrison boasted: "What we have so long predicted,—at the peril of being stigmatized as an alarmist and declaimer,— has commenced its fulfillment." The claim had merit. In the inaugural issue of the *Liberator* on January 1, 1831, Garrison had predicted that slavery would lead to woe, and Nat Turner's revolt confirmed in Garrison's mind the prophetic truth of his statements on slavery.[3] In both the North and the South, Turner's revolt led significant figures to reject the type of gradual emancipation plans that had ended slavery in the North. In doing this, Nat Turner's revolt contributed to the radicalization of American politics that helped set the United States on its course toward the Civil War.

Despite the significance of Nat Turner's revolt as an important milestone for a nation that was on a path toward its greatest political crisis, what happened in Southampton County has inspired relatively little scholarly attention.[4] Following the publication of William Styron's Pulitzer Prize–winning novel, *The Confessions of Nat Turner*, there was a flurry of activity as scholars debated the historical accuracy of the novel. Most of this debate was limited

in its scope, as several scholars pointed to particulars in the historical record that Styron had mistaken. The frustration with Styron's novel also led to Stephen Oates's *The Fires of Jubilee: Nat Turner's Fierce Rebellion*. Ironically, for a historian writing in the wake of the controversy that focused on the liberties taken by a novelist, Oates, as one reviewer observed, made use of "many of the novelist's freedoms."[5]

Prior to Oates's effort, there had only been two other monographs on the rebellion: William Sidney Drewry's 1900 dissertation, *The Southampton Insurrection*, and Herbert Aptheker's 1937 master's thesis, *Nat Turner's Slave Rebellion*, both of which were eventually published. It would be hard to imagine two more different histories of Nat Turner's revolt. Educated at Johns Hopkins University, Drewry, a white from Southampton whose family had been involved in suppressing the rebellion, celebrated the virtues of the county's whites and the loyalty of the slaves. "Never in the history of slavery," he contended, "was there less danger to owners, more contentment among the slaves themselves, fewer runaways, and greater advantages, social, financial, and political, gained from this institution." Drewry also depicted the rebels as maniacal fools duped by "a wild, fanatical preacher" whose "earnestness and intellectual superiority impressed all the negroes who saw him."[6] Working several decades later at Columbia University, Aptheker—a radical who eventually joined the Communist Party—attacked Drewry's work. In a foreword that Aptheker added when his book was published, he asserted "that for the truth of the Turner event it would have been better if Drewry had never published." Aptheker disagreed vehemently with Drewry's account of the slaveholders, and he was particularly upset by Drewry's portrayal of the rebels. Aptheker ended the introduction to his master's thesis by demanding that the men who followed Turner should not be seen "as deluded wretches and monsters...but further examples of the woefully long, and indeed veritably endless, roll of human beings willing to resort to open struggle in order to get something precious to them—peace, prosperity, liberty, or, in a word, a greater amount of happiness."[7]

These two works on the revolt embody a fundamental split in the study of slavery in the United States. Drewry's work, which was not especially influential, represented the racist assumptions of early twentieth-century white America. According to Drewry—and also Ulrich Bonnell Phillips, the era's leading historian of slavery—most slaveholders were kind, most slaves were happy, and the institution of slavery was generally benevolent. Aptheker's work posed a major challenge to this understanding of slavery. He argued that slaves hated slavery and fought however they could to resist the oppressive

institution. In his most important publication, *American Negro Slave Revolts*, Aptheker tried to show how widespread overt resistance was. Aptheker's work was groundbreaking in his conceptualization of slavery, but a flaw in his argument—he presumed that the white community's fear of slave revolts was an accurate barometer of actual slave conspiracies—allowed an antagonistic profession to marginalize this important work. As a result, others, notably Kenneth M. Stampp, led most historians to view slavery as an oppressive institution that slaves hated and resisted however they could.[8]

Despite the ascendance of the resistance model, Phillips's view did not disappear. In *Roll, Jordan, Roll*, Eugene D. Genovese developed a sophisticated argument that allowed him to retain much of Phillips's understanding of slavery, albeit stripped of its racism. According to Genovese, slaveholders understood themselves to be a paternalistic people who were concerned with the well-being of their slaves. Genovese argued that this self-conception of whites gave slaves a way to ameliorate their awful situation. While some historians have balked at Genovese's terminology, he has given historians powerful tools to understand slavery. *Roll, Jordan, Roll* revived the idea that most slaves worked within the system to improve their lives. Historians usually describe such a negotiation as part of a program of accommodation.[9] As a result, since the publication of Genovese's book, historians who study slavery have questioned whether the actions of slaves should be understood fundamentally as part of a program of resistance or as accommodation. Those who follow Aptheker and Stampp—including most authors who write about slave plots and revolts in the United States—see small acts of resistance as part of a continuum with large-scale political resistance such as the Haitian Revolution. Those who follow Genovese, on the other hand, think that slaves worked for improvement in their situations, but believe that these incremental improvements ultimately made large-scale political resistance more difficult.[10]

Evidence from Nat Turner's revolt challenges both of these positions. When Drewry insisted that "slaves were the happiest laboring class in the world," he staked out an indefensible position. Even a cursory reading of the evidence from Southampton suggests that, at a minimum, dozens of young men were deeply unhappy, ready to join a revolt that would almost certainly end with their deaths. In order to avoid Drewry's error, Genovese accepted that Nat Turner and his men were revolutionaries who hated slavery, but he suggested that they were unlike most slaves in the United States. According to Genovese, the few slaves who had been involved in America's handful of slave revolts were unable to create "a revolutionary tradition." In other words, Nat Turner and the other rebels were revolutionaries, but their politics made

them anomalies in a world where most slaves looked for less dramatic ways to improve their lives.[11]

While resistance historians have celebrated Nat Turner as a hero, evidence from the revolt provides little support for the idea that historians should rely upon resistance as the central explanation of slaves' actions. In fact, the decisions of slaves and free blacks in Southampton demonstrate that the black community's responses to the call to revolt were not monolithic. Some slaves opposed the revolt, and at least a handful of slaves took up arms to defend their masters. Most slaves did not fight on behalf of the slaveholders, but several found other ways to help whites. Some saved their owners, including Catherine Whitehead's slave Hubbard, whose quick thinking saved Catherine's daughter Harriet from the fate that befell the rest of her family. Even among those who joined Turner's army, support for the revolt varied. While some enthusiastically supported the revolt, others claimed that they had been forced to join the rebels against their will. Some people may doubt the testimony of slaves who claimed to have been impressed into a rebel army—although it is worth noting that Southampton's court accepted some of these claims—but Nat Turner himself perceived different levels of commitment among his men. According to the *Confessions*, Turner remembered placing "fifteen or twenty of the best armed and most relied upon, in front." The implication of Turner's testimony was corroborated by the testimony of Moses, one of the most important witnesses during the trials. During the trials, Moses testified that some of the rebels were "constantly guarded by negroes with guns who were ordered to shoot them if they attempted to escape."[12]

The prominent examples of slaves who supported the rebels' attempt to seize power and those who supported the slaveholders' attempt to foil the revolt, however, made up only a small portion of Southampton's total slave population. The majority of slaves in Southampton did not get involved in the revolt. Women, old slaves, and children provided little support for the rebels, although their passivity may be attributed to the rebels' lack of interest in recruiting among such groups.[13] Others did not have the opportunity to join. But even among older boys and adult men who lived in the neighborhood, the rebels failed to win mass support. This can be seen in the rebels' recruiting rates. Nat Turner and the rebel army's efforts to recruit at several of the largest plantations in the county produced few volunteers. The rebels recruited successfully only at a handful of plantations, notably including places where the original members of the revolt lived. The rebels also failed to win much spontaneous support from those slaves who had heard about the revolt secondhand. As a result, a rebel army that traveled throughout St. Luke's

Parish in Southampton County, home to nearly twenty-five hundred slaves over age twelve, almost certainly never included as many as eighty men. To the extent that resistance historians ignore or deemphasize the varied, often unsupportive responses of blacks to the call to rebel, they are doing the same thing that Genovese did when he described Turner and his followers as anomalies: normalizing the responses of a certain group of slaves and deemphasizing the responses of those slaves that do not fit their model.[14] As a result, both resistance and accommodation models of understanding slavery ultimately are incomplete.

Fortunately, Nat Turner's revolt provides another way to think about slaves' responses to slavery. Historians accept that slaves worked to make their lives better, but the paths people took varied. Some developed a radical politics and were ready when Turner beckoned, even as others refused to believe that the Day of Judgment had arrived. The variety of responses did not simply exist in different people within the black community. Sometimes they existed in the same person. Some of the reluctant recruits became more enthusiastic as the revolt progressed, just as others who first thought the revolt was a good idea had second thoughts. For example, Billy Artis was one of the boldest of the rebels—like "a wolf let into the fold," according to one report—but even he "wept like a child" when he first joined the revolt.[15]

Other slaves found it hard to decide if they supported the revolt. For example, Jack and Andrew were on Catherine Whitehead's plantation when the rebels arrived early on Monday morning. Jack and Andrew did not know about the revolt in advance, so they had no plan to respond. When the rebels arrived at the farm, Jack and Andrew "retreated from Mrs. W[hitehead's] and separated without any understanding." Another slave who fled with them noted that "they seemed alarmed." Confused and perplexed, the two visited Thomas Haithcock, a free black in the neighborhood, asking him "what they should do." At the time, Jack and Andrew were of two minds about the revolt. On one hand, they understood why the revolt had happened, and when Thomas Haithcock said he would join, they willingly set off with him. When they were captured by whites, Jack confessed that they had been "in pursuit of the insurgents." Yet Jack and Andrew's support of the revolt was imperfect. Even Haithcock noted that they were "much grieved." Not surprisingly, the two young slaves expressed their qualms about the revolt more clearly to whites. When they went to a white man's house, they "told him of the massacre and said, 'Lord have mercy upon them for they know not what they do.'"[16] Jack and Andrew were neither ardent supporters of the revolt who fooled whites by citing the Gospel of St. Luke nor pious Christian slaves who

flatly rejected violent resistance. In this case, they understood the reasons for the revolt and why they should join it, even as they also understood why many, including some blacks, saw it as not just a mistake but wrong. They struggled to make up their minds about which way of thinking about the revolt was right. Those who have tried to reduce slaves' actions to resistance or accommodation have not allowed for this type of ambiguity in either the community or the individual.[17]

One way the ambiguities in Jack and Andrew's minds can be understood is through W. E. B. Du Bois's idea of double consciousness. In *The Souls of Black Folk*, Du Bois explained that American blacks experienced a "two-ness," an identity that was "American" and "Negro" at the same time. According to Du Bois, blacks were both a part of and apart from America.[18] While Du Bois used this phrase to explain the problem of living in a racist society, it can also help explain how slaves thought about their world. One can see in the revolt in Southampton the precursors of the thousands of slaves who joined the Union Army during the Civil War. One can also see people who would understand why, when Harriet Jacobs told her grandmother that she was going to run away, her grandmother's first response was to try to talk Jacobs out of the plan.[19] Double consciousness allows for ambiguities that appeared among people who were trying to think of ways to respond to a system that led to such incredible evils.

In addition to bridging the accommodation and resistance schools of scholarship, double consciousness also allows historians to explore the complex dynamics within the slave community. Consider the issues that Nat Turner faced as he recruited men to join his revolt. If, as Genovese insists, there was no "revolutionary tradition" in the black community, then Turner's plan, which depended upon getting black support, never had a chance. To the extent that Turner thought his revolt was anything other than a symbolic suicide, he was deluded. On the other hand, if the slaves were predisposed to support a call to arms, then Turner, who was unable to mobilize the slave community, failed as a leader. Double consciousness allows for a fairer appraisal of Turner's record. No slave revolt could succeed without the support of many slaves, but the same people it depended upon were a revolt's greatest vulnerabilities. Any plot that grew too large risked betrayal, a pitfall that destroyed many slave conspiracies. Of course, keeping a plot small, as Turner did, only made the rebels' mission more difficult once the revolt began, but Turner accepted that this was better than having his plot discovered in advance. Ultimately, Turner's plan did not work, but not because he was delusional or incompetent. Instead, the failure reflects something that many people

thinking about the history of slavery do not appreciate sufficiently: it is really hard for a slave revolt to succeed.[20]

Nat Turner's revolt also provides a surprisingly valuable vantage on the white community's relationship to slavery and especially the slaveholders' authority. Scholars have long puzzled over how slaveholders, who never made up a majority of the white population in the South, dominated an increasingly democratic society. One answer has been hegemony, which simply meant that the slaveholding elites in the South were able to figure out how to get people who did not own slaves themselves to accept and secure slave property without the slaveholders having to resort to violence or the threat of violence. Hegemony is an incredibly powerful concept, but its very nature makes it hard to see. After all, in a society where the dominant class is hegemonic, the ruling class exerts its power subtly, through ordinary institutions such as courts, churches, schools, and the media. How can hegemony be distinguished from the usual operation of a society? Hegemony is often used by those with a class-based view of society to understand a world where class divisions seem unimportant; those historians who do not view society through the lens of class conflict tend to ignore hegemony.[21]

The extraordinary heat of the slave revolt created the conditions that elucidated otherwise invisible hegemonic forces. The news that the slaves had revolted shocked Southampton County's whites. They were completely unprepared for such an uprising, and in the first few days whites were disorganized and white authority was decentralized. This allowed for a fluid response, which was sufficient to check the threat posed by the small rebel force. But a unique vulnerability in the slaveholding order in the aftermath of an insurrection soon became apparent. Following the killing of white men, women, and children, popular passions raged against blacks. Whites sought revenge, some calling for the "indiscriminate slaughter of the blacks who were suspected." Ellen Lewis, who had spoken with "several gentlemen who have visited" Southampton, described it even more clearly: "Should the blacks attempt to rise there again, they will be exterminated; the excitement is so great."[22]

Lewis was not the only person who alluded to a possible massacre of Southampton's slaves. Although Richmond lawyer John Wickham claimed that he had "no apprehensions" himself, he noted that "the Excitement was so strong among the more ignorant that there was reason to apprehend a reaction which if once begun might be carried to dreadful lengths." A correspondent in Petersburg agreed that "another such enterprise will end in the total extermination of their race in the southern county." William Henry Broadnax took pride in the work that he did to contain the antiblack response,

but he also clearly sensed that if the events at Southampton were repeated, he would be unable to do anything: "The whole [black] race will be swept from among us." John Hampden Pleasants, a newspaper editor who traveled to Southampton with other troops from Richmond, had much the same impression. "Let the fact not be doubted by those whom it concerns," he wrote, "that another insurrection will be the signal for the extermination of the whole black population in the quarter of the state where it occurs." Given this widespread fear, slaveholding petitioners from Hanover County, near Richmond, called on the legislature to act: "Will you wait until the land shall be deluged in blood and look alone to the fatal catastrophe, the extinction of the black races by force as the only remedy?"[23]

The prospects of terrified whites committing genocide posed a fundamental threat to the slaveholding class.[24] As long as the number of slaves killed during such a panic was limited, slave owners could carry the expense as part of the cost of holding slaves. But "the apprehension," as the conservative leader Benjamin Watkins Leigh described it, "was and is that repetitions of servile rebellion may result (in what all good men would lament) such a destruction of the slave race as may exceed the just measure of punishment and the necessity of example." The prospect that whites would undertake a pogrom that could wipe out the basis of the slaveholders' wealth was unnerving. The danger to which the slaveholders' property was exposed was only made worse by the fact that the legal system, which usually did so much to protect the slaveholders, was in no position to help those slaveholders recoup their losses. It seems improbable, for instance, that a Southampton jury would hold liable a white man who killed a slave if the killer sincerely believed that he was suppressing a slave revolt. Peter Edwards, a slaveholder who had lost three of his slaves when the Southampton revolt was put down, made just this point: "It is not to be supposed that juries would award damages against persons that they might think were acting under a sense of duty and with a view to the public safety."[25] As a result, if the slaveholders were to preserve their wealth, they had to figure out a way to stop vindictive whites before the killing got out of control.

The slaveholders in Southampton began their efforts to protect their enslaved property by turning to the most readily available force: the militia. In the days after the revolt, militia leaders limited the killings by extracting suspected rebels from angry crowds and putting them into jail. This reduced the killings, but militia leaders decided that they still needed to do more. A week after the revolt, General Richard Eppes issued an order prohibiting the killing of slaves. He commanded "all descriptions of person to abstain in

the future from any acts of violence to any" slaves. The order also threatened to bypass the legal institution that posed the single most serious threat to elite power, the jury. Eppes assured Southampton that those who disregarded his order would be subject to "the rigors of the articles of war." These concerted efforts to stop the killing of slaves were surprisingly successful. The vindictive popular impulse was contained, and I estimate that whites suppressing the revolt likely killed fewer than forty slaves, a number significantly lower than the estimates by most historians.[26]

The success of the militia meant that the county's court system would come to the fore as whites tried to decide how to handle those suspected of involvement in the revolt. All accused slave rebels were brought before a court of oyer and terminer. The court excluded the majority of Southampton's citizens because it met without a jury. Instead a panel, typically made up of five judges, decided the fate of the accused slaves. Only twenty judges—all slaveholders, mostly wealthy—served on these panels. The court's power was not absolute. It could convict and sentence to death, or find not guilty and release, but those whom it convicted needed the governor to commute their sentences. Since the governor usually followed the court's recommendation, the judges found themselves in the best position to determine the fate of the accused.

Simply having the court decide if a defendant was guilty was not, by itself, hegemonic. Even after the trials began, some whites remained committed to a policy of broad retribution. To make sure that these whites did not take the law into their own hands, the militia stayed in Southampton. Less than a week after the revolt, General Eppes wrote that "a sufficient force is now assembled ... to sustain and enforce the sentence of the Court, as well as to cause to be respected its judgments of dismissal." Eppes's concern for slaves who had been discharged was no idle concern. In a neighboring county, Eppes noted, "a negro had been examined, discharged and afterwards shot down." Given these dangers, it is not surprising that when a rumor spread that Eppes was about to discharge his forces, Southampton's court requested that he detail "fifty men as a guard," explaining that a strong guard was "necessary to the safe keeping of the prisoners now in jail."[27]

Despite the persistence of some opponents, the court had the ability to reshape the understanding of the revolt in ways that the militia simply could not. Prominent slaveholders used their positions as judges to take a measured response from the start of the trials. They ignored the calls for retribution and spared the lives of dozens of accused slaves. By the time the trials had ended, their view of the revolt, implicit in the trials, had become the closest thing to an official account of the slave revolt: the revolt was small, it had little support from the black community, and it posed no real threat to whites.

Most white people in Southampton County quickly adopted this view of the revolt. Mary Blackford, who was from a different part of Virginia, visited Southampton in the summer of 1832. On this trip, she met the daughter-in-law of Catherine Whitehead, who told her the story of her family, who had been "nearly all butchered by Nat Turner and his gang of ruffians." But what struck Blackford especially were the stories that she heard "of the fidelity of many slaves to their owners at that time." According to the stories that Blackford recorded, the slaves on the Whitehead plantation "did all they could to protect the family at the risk of their lives." A few slaves joined the rebels, but even their actions could be excused because they did not join "until they were intoxicated." The stories she heard about other families were much the same. The Porters "might all have been murdered" except for the quick thinking of their loyal slaves, who "contrived to direct the steps of the murders in another direction." A sick Mrs. Nicholson escaped "in arms of her slaves and [was] hidden in the woods."[28]

Some of those who had originally believed that the revolt was extensive changed their minds. In neighboring Sussex County, several slaves had been convicted and executed based upon evidence that the plot was broader than the Southampton court thought. But when one of the slaves who had been condemned in Sussex was caught several years later, eighteen prominent men from Sussex petitioned the governor to commute the sentence that the Sussex court had imposed, referring explicitly to how their decision had conflicted with "the evidence given at the Trials in Southampton."[29]

Perhaps the most remarkable evidence of the hegemonic power of the Southampton court's narrative comes from the region's interracial churches. In the aftermath of the revolt, some whites called for the churches to end interracial fellowship, but these efforts failed everywhere. In one case, a group of whites threatened to remove themselves from the church if blacks were not expelled, but the majority of whites at the church ignored the threat and let the separatist whites go.[30] This astonishing response only made sense because the majority of the congregation had accepted the idea that the revolt did not have broad support in the black community. The judges had created a narrative of the revolt that was so powerful that other whites decided that they could not only live alongside slaves but pray alongside them as well.

The Land Shall Be Deluged in Blood is a narrative of the revolt in Southampton County, Virginia. Despite brief excursions to other places such as Richmond, Raleigh, Washington, D.C., and Boston, this work focuses on the region where the revolt took place. Although there is much work to do on the importance of Nat Turner's revolt both within the state of Virginia and in the nation as a whole, this book pays most attention to the events in Southampton

County and, to a lesser extent, neighboring counties in Virginia and North Carolina. It begins with the precursors of the revolt, focusing most closely on Turner himself. Turner was, from all accounts, a sincere religious figure who believed that God ordered him to lead a slave revolt, but Turner's religiosity was not typical of the black community. Lacking mass support, Turner and a handful of followers had to figure out how to launch a slave revolt. They had a clear-eyed understanding of the challenges they faced, and they decided to keep the conspiracy small, at least until the revolt began. One advantage of this decision was that that they managed to keep the conspiracy out of the view of whites.

The biggest disadvantage of keeping it small, however, was that once the revolt began on Sunday night, August 21, the rebels had to figure out a way to recruit slaves and free blacks who were not aware of the revolt. This problem becomes a central issue in the second chapter, which focuses on the successful early stages of the revolt. Although the rebels encountered no organized opposition on the morning of August 22, the revolt faced serious problems getting support from slaves and free blacks. Even as the whites—who had been caught flatfooted by the revolt—abandoned the countryside, only a few blacks rallied to Turner's cause. The failure of the rebels to get more support in the hours before they faced an organized white opposition only made more certain the ultimate defeat of the revolt, which is the focus of Chapter 3. By Tuesday, August 23, the rebel force had been dispersed.

Whites quickly suppressed the revolt, but in the immediate aftermath, they had little appreciation for their power, and the terror that the defeated rebels had inspired remained. The fear led whites to congregate in a few central locations, which added to their uncertainty about what was really going on in Southampton County. This uncertainty, which is described in Chapter 4, and its gradual replacement by a confidence in Southampton's slaveholding leaders is a central theme of the second half of the book. Uncertainty led many whites to want to subject slaves and free blacks to a brutal response, but Southampton's slaveholders quickly realized that such a response could easily end in a bloodbath that would destroy the foundation of their wealth. As a result, leaders in Southampton such as Alexander P. Peete, William Henry Broadnax, and Richard Eppes used their positions as leaders of the militia to suppress the revolt. Once their confidence increased that the revolt had been extinguished, these leaders used their influence to limit the number of blacks who were killed without trials. In Chapter 5, I argue that fewer blacks were killed without trials following the revolt than most scholars have heretofore imagined.

Southampton's slaveholding leaders stopped enraged whites from killing more blacks, but immediately after the revolt, their power was based upon orders given to men with guns. To make their response last once the militiamen returned to their homes, the leaders had to change the minds of whites about the threat the larger black community posed. Chapter 6 explores how the trials that took place in Southampton over the two months following the revolt contributed to this interpretation of the revolt.

By late October, Southampton's court of oyer and terminer had adjudicated the cases of the slaves who had been arrested after the revolt and—except for a handful of free blacks who were awaiting trial—the trials seemed to be winding down. Then, as discussed in Chapter 7, Nat Turner, who had been missing for more than two months, reappeared in the neighborhood where the revolt had begun. Whites failed to capture the rebel leader for more than a week, until October 30, when Benjamin Phipps stumbled upon Turner's last hideout. Interest was high in the reclusive prophet whom whites saw as the source of the revolt. This led to an opportunity for Thomas R. Gray, who approached Turner on the day he was jailed to request that Turner tell Gray his confessions. Turner accepted. By the time his trial came, Turner had said what he needed to say. At his trial, he was condemned, and he died on November 11, 1831.

In a world before surveys, there is no easy way to track how important the accounts of the revolt implicit in the trials and corroborated by *The Confessions of Nat Turner* were, but there is evidence that people in the region changed their minds about the revolt. Chapter 6 describes the way that people connected to the Sussex County Court, which initially saw the revolt as extending beyond Southampton, had backed away from their initial views and accepted the viewpoint of the Southampton court. Chapter 8 describes the debates about interracial fellowship that took place in the Baptist churches in the region. In these debates, whites in the democratically organized churches also accept a view that is consistent with the Southampton court's interpretation of the revolt.

Information about Nat Turner's revolt is sketchy and often suspect. Much that the historian would like to know about the conspiracy cannot be known. The biases of surviving sources also present a problem. Everyone who described the event had biases, but most of the surviving records from the county came from a small group of men who supported the efforts of the county's leaders to limit the bloodshed. Few accounts of those white voices that demanded a more vigorous response survive. Also, almost no contemporary black voices survive that did not pass through a pen held by a white intermediary. My efforts

to cull reliable material from these biased sources have been influenced by an awareness of ongoing debates, most notably by the debate over the reliability of sources that were produced in response to the 1822 Vesey plot in Charleston, South Carolina. In 1964, Richard Wade argued that the slave scare had been manufactured by whites. He denied that there had been any evidence of a conspiracy, and he wondered if the convicted rebels had died for crimes they had not committed. Wade's thesis did not convince most historians, but in 2001 Michael P. Johnson resurrected it, noting problems with several historians' use of the Charleston trial records. Johnson's extended review of three books on Vesey ignited a controversy that reminds every historian of slavery who uses sources compiled by white sources to consider their merit.[31]

Although no one doubts that Nat Turner's revolt happened, concerns have grown that many of the sources describing the revolt may not be reliable. Many interesting sources—such as letters written in the midst of the panic—are clearly unreliable. Some reflect rumors, not the reality of the revolt. The best sources of information—the synoptic letters and newspaper reports written as whites in the area tried to describe what had happened, the accounts of the trials, and *The Confessions of Nat Turner* itself—are also subject to doubt. Did they get the basic events wrong? No one doubts that all of these accounts were incomplete and imperfect, but they described the basic events in ways that fundamentally agreed with each other. After the initial panic, most accounts estimated the number of rebels to be somewhere between forty and sixty. Most of the names on the lists of whites killed remained constant, and several accounts of the deaths of these people appeared. The usually small differences between the lists seem to suggest that the sources were independent of each other, further reinforcing one's confidence in these accounts. Most letters from the scene also described similar brutal reprisals taken against Southampton's slaves and free blacks in the aftermath of the revolt. Although all the letters are limited by their authors' parochialism, they included much valuable information about the events during the revolt.

Because members of the court were not fundamentally concerned with either truth or fairness, the court records are easy to dismiss. Nonetheless, they are invaluable sources. In an effort to differentiate the court hearings from the panic that immediately followed the revolt, the court emphasized the formality of the legal process, which led to, among other things, an official record of the trials. The man who composed this record, the county's clerk, James Rochelle, appears a reliable reporter of what was said during the trials, even if he freely abridged his accounts of the proceedings. The formal legal process also required evidence, and the judges at the trials demanded that the

prosecutor present the best evidence he could find. Usually this evidence was the testimony of witnesses who had observed the defendants' actions directly. With cases like these, there is always the possibility of tainted evidence, but the testimony of the witnesses who testified most often at these trials, Levi Waller and Moses, does not appear skewed against the accused, as each said things that helped different defendants' cases. The court also appears to have encouraged the defense attorneys to challenge the prosecution's case. As a result, the court records that Rochelle transcribed seem surprisingly reliable.[32]

The most important and intensely debated source on the revolt has been *The Confessions of Nat Turner*, published by Thomas R. Gray. Although Gray's account was initially accepted as a faithful account of Turner's own confession, over the last fifty years scholars have questioned its reliability. During the controversy over Styron's novel, both Styron's supporters and critics disparaged the trustworthiness of the *Confessions*, even if both sides still appealed to its authority when it supported their viewpoint. In 1992, Daniel Fabricant rejected such opportunistic uses of the *Confessions*. He argued that the *Confessions*, taken down and published by a white lawyer, could not be considered reliable. In 1999, the journalist Tony Horowitz wrote an article describing his exploration of the source material on the revolt. The title of the piece was "Untrue Confessions: Is Most of What We Know About the Rebel Slave Nat Turner Wrong?"[33] Such questions have forced historians to reevaluate the usefulness of the *Confessions*.

The most careful study of the *Confessions* suggests that it may be more reliable than its detractors suspect. In "The Construction of *The Confessions of Nat Turner*," David Allmendinger makes two important arguments in support of the reliability of the *Confessions*. First, the *Confessions* introduces much new information. Although it was possible that the source of this information was Thomas R. Gray, Allmendinger argues that it is more likely that Nat Turner himself provided most of the new details about the revolt. Second, Allmendinger notes that the *Confessions* retained Turner's perspective throughout the narrative. It would have been much easier (and perhaps marketable) to compose a narrative with an omniscient narrator who could have related everything that had happened during the course of the revolt. Instead, Nat Turner's narration left out so much material that Gray chose to add his own extended commentaries at the end of the *Confessions*.[34]

The Afterword to this book adds several new arguments in support of the reliability of the *Confessions*. Among other arguments, I have examined Gray's authorial interruptions of the text as evidence supporting the usefulness of the *Confessions*. The most likely explanation for the irregular presentation of

interruptions is that Gray was—as he claimed to be—in a dialogue with Turner. Furthermore, I have made a close textual analysis demonstrating that Gray preserved Turner's voice, even to the extent that Gray transcribed what he knew were erroneous comments from the revolt's leader. Those readers who are inclined to doubt the trustworthiness of Gray's *The Confessions of Nat Turner* may want to start with the Afterword, for much of the rest of this book depends on my reading of this work.

Accepting that the most important sources were not intentionally corrupted does not imply that historians can use any of the sources blindly. Even honest reporters can be confused, misled, and lied to. This work uses the evidence as carefully as possible, keeping in mind the distinction between what the various sources convey about the events and what they convey about their authors. Despite the obvious problems in approaching the sources, the sources reveal much about what happened in 1831 in Southampton. The French philosopher Paul Ricoeur uses the German word *Aneignen*, which means "to make one's [own] what was initially 'alien.'"[35] The move to make one's own what is different is at the core of the historical enterprise, and not just in terms of method. The lessons of the past itself are most meaningful when we stop thinking of the past as alien. But to do this when studying slavery, we must move beyond a Manichean view of the slaves and slaveholders. Restoring the uncertainty, confusion, and moral complexity to our view of the world that the slaves and slaveholders made makes it easier to see the ways in which the struggles of Nat Turner continue today.

Signs

ON A WINTER SUNDAY in February 1831, four men gathered in the woods of Southampton County, Virginia. Each made his way from a nearby plantation. Hark came from the house of Joseph Travis, a household that included at least seven other slaves. Joseph Travis's neighbor Nathaniel Francis owned at least ten slaves, including Sam, who joined Hark in the woods.[1] Nelson and Henry also came to the meeting, although it is unclear where they lived. Nelson may have belonged to Peter Edwards, who lived immediately next to Nathaniel Francis, close to the Travis place. If so, thirty-three-year-old Nelson was, according to one person, "uncommonly skilled and worth at least $400, and had he been mine I would not have taken $500 for him."[2] Where Henry lived is a mystery. Although not much is known about Henry, he was a man who had the ability to get liquor, and he may have provided the others drinks to stave off the cold.[3]

Nat Turner had called the four men together. According to the *Confessions* recorded by Thomas Gray, Nat Turner was born in Virginia on October 2, 1800, eight days before the state executed Gabriel. Gabriel had been convicted of "conspiracy and insurrection" for his part in inspiring a plot in which the rebels planned to attack Richmond and even capture Governor James Monroe, if everything went right. Nat Turner grew up near the North Carolina line in Southampton County, about fifty miles from Norfolk, seventy-five miles from Richmond.[4]

In 1831, Nat Turner was described as "5 feet six or 8 inches high." If he was a hair shorter than the average American male—the typical Civil War soldier stood approximately five feet eight inches—he was probably a little heavier. William Parker described Turner as "broad shouldered," weighing between 150 and 160 pounds. Although he was only thirty-one years old, his hair was already "very thin" on the top of his head. He wore a goatee. Unsympathetic whites described other notable things about Turner's appearance: He had "broad flat feet." He was "knock kneed." He had a "large flat nose" and "large eyes." Over the years he had been literally scarred working in the fields of

Southampton County. Some animal or person had bitten the back of his neck; perhaps it was the same mule that kicked his forehead. He had "a knot on one of the bones of his right arm near the wrist," an injury from "a blow," although the episode that led to the injury was not described in any record. When contemporary whites tried to classify Turner's skin color, they enigmatically described a man with a "bright complexion but not a mulatto."[5]

Historian Kenneth S. Greenberg has warned scholars about the dangers of accepting Parker's description of Nat Turner uncritically. After all, this description was composed and promulgated by people who hated and feared Turner. Nevertheless, the description was as accurate as the whites could manage at the time. Since Turner was still at large when this description was written, whites wanted to describe Turner as objectively as possible to help people in other parts of the state or country identify him if they encountered him. At least one person thought that the description fit the rebel leader. After Turner was captured, a correspondent to the *Richmond Enquirer* compared him to the description. He insisted that Turner fit the description "exactly," although he offered two caveats: that Turner was darker and had less prominent eyes than the correspondent had imagined.[6]

Portraits of Nat Turner's family are also imperfect. His family life when he was growing up seems relatively stable. He later recounted how both his parents influenced him in his youth and how he knew at least one grandmother, to whom he was "much attached."[7] Yet, as with countless other black families in the South, slavery played a role in the breakup of his family. His father ran away, as Turner later recalled, "to some other part of the country."[8] Although the protections of legal marriage were antithetical to the American system of slavery, Nat Turner married. Historians have disputed the identity of Turner's wife, with at least three different women—Fanny, Cherry, and Mariah—proposed by different people. The earliest reports of Turner's wife indicated that she also lived in the neighborhood, on the farm of Mr. Reese. Perhaps the most likely candidate of the three, Mariah, has been proposed by Thomas Parramore, although proof that would rule out any other candidate may never appear.[9] Contemporary evidence for Nat Turner's children is less clear even than the evidence about his wife. At the time of the revolt, no sources mentioned any of Turner's children, who would have been too young to participate in the revolt themselves. Southampton's oral tradition filled in a blank. According to William Sydney Drewry, Nat Turner had a son, Redric.[10] Because slave law ruled that Turner's children would belong to his wife's owner, Redric and any siblings he may have had would have lived with their mother on Mr. Reese's farm.

If Nat Turner arrived as he did at later meetings, he appeared after the four other slaves had gathered. No one will ever know what Henry, Hark, Sam, and Nelson discussed as they waited for Nat Turner, but it would not be surprising if they were talking about a solar eclipse that had occurred on Saturday, February 12, 1831. The line of maximum eclipse traveled from northeast to southwest, from east of Boston to west of New Orleans. Before the solar event, one newspaper reminded its readers that an eclipse was merely "caused by the regular operation of natural laws." Despite this newspaper's assurances to the contrary, one suspects that many Americans saw eclipses as meaningful, perhaps as "signs or forerunners of great calamities." The line tracing the moon's maximum shadow passed directly over Virginia between Norfolk and Richmond, and Virginians were as captivated as other Americans. The *Richmond Enquirer* reported that "every person in the city was star gazing, from bleary-eyed old age to the most bright-eyed infancy."[11] Slaves, who were told what to do and often what to think, had the chance to look and decide for themselves exactly what it meant. Perhaps as the men waited for Nat Turner they discussed the eclipse. If they had their own ideas, Nat Turner was going to suggest that the eclipse meant that God wanted him to launch a slave rebellion, one that became the most important slave revolt in American history.

When Nat Turner arrived, none of the four men would have been surprised to hear him explain that he believed the eclipse was a message from God. Nat Turner thought that God used the natural world as a backdrop in front of which he placed signs and omens. Turner believed that he had the gift of prophecy and was able to discern the meanings of these messages from God. For example, a few years before the eclipse, he told many in his neighborhood, "white and black" alike, that he had found "drops of blood on the corn as though it were dew from heaven." According to Nat Turner, this miracle meant that "the great day of judgment was at hand." Likewise, he interpreted the stars and leaves on which he found "hieroglyphic characters" as signs of the second coming of Jesus, who "was about to lay down the yoke he had borne for the sins of men."[12] The end of the world was near, and Nat Turner felt inspired by the Holy Spirit to share his knowledge.

People within Southampton's black community did not always accept Turner's confidence in his ability to prophesy. Turner's difficulties in convincing the black community of his divine inspiration date from no later than 1825, when Turner was placed under a new overseer and decided to run away. Many slaves supported running away as a way of voicing unhappiness about a specific grievance or as a response to the totalitarian system of slavery. Turner's own father had escaped slavery, and if Nat Turner could have successfully

followed his father's footsteps, his family, friends, and other black neighbors probably would have been happy for him. If he had failed in his bid for freedom, the slaves of St. Luke's Parish would have understood the obstacles.[13]

Nat Turner's bid for freedom ended in a way that seriously compromised his efforts to present himself as a prophet to the black community. After having been away a month, Nat Turner voluntarily returned to his plantation. According to the *Confessions*, the other slaves reacted with "astonishment" when he returned to bondage because they "thought I had made my escape to some other part of the country." Their surprise became disapproval when they found out why he returned. Nat Turner recounted how the Holy "Spirit appeared to me" and told him "that I should return to the service of my earthly master."[14]

In commanding Turner to return to bondage, Nat Turner's Holy Spirit echoed the message that slaves had rejected as long as white ministers and masters had employed religious texts in defense of slavery. For instance, Harriet Jacobs, who was a teenager at the time of the revolt, recalled a sermon that Episcopalian minister John Avery delivered sometime shortly after the revolt. "Hearken, ye servants!" he warned an audience of slaves in Edenton, North Carolina, roughly sixty miles from Jerusalem. "You are rebellious sinners," he scolded. "Instead of serving your masters faithfully, which is pleasing in the sight of your heavenly Master, you are idle and shirk your work....Obey your old master and your young master—your old mistress and your young mistress. If you disobey your earthly master, you offend your heavenly Master." Years later, Harriet Jacobs remembered the response of the slave audience to the minister's stern sermon: "We went home highly amused at brother [Avery's] gospel teaching."[15] Turner's Holy Spirit, who told him to return to slavery, sounded similar to Avery's God, and Turner's black audience was inclined to doubt anyone who told them that God's highest calling for them was to be loyal slaves.

The more Nat Turner told his fellow slaves about the Holy Spirit's message, the more astounding it sounded. The Spirit had criticized him for his concern about "the things of this world." Instead, his attention ought to have been on "the kingdom of Heaven." While that rebuke might have sounded plausible enough, the Holy Spirit then echoed Luke's gospel: "For he who knoweth his Master's will, and doeth it not, shall be beaten with many stripes, and thus I have chastened you." Nat Turner understood his master to be God, but in this context Turner did not avoid the unappealing implication that the slaveholders' whips were an important part of God's providential plan.[16]

Several sources describe how other slaves responded to those who preached this line from the Gospel of St. Luke. Lunsford Lane, a slave in North Carolina

who was three years younger than Nat Turner, recounted how white ministers in Raleigh preached, "He that knoweth his master's will and doeth it not, shall be beaten with many stripes." Lane wryly noted that he had become "quite familiar" with such verses from the Bible, to the extent that he commented, "The first commandment impressed upon our minds was to obey our masters, and the second was like unto it, namely, to do as much work when they or the overseers were not watching us as when they were." Despite the effort that slaveholders put into getting slaves to accept this version of Christianity, slaves rejected these teachings. Even kind and good-hearted ministers who taught this proslavery version of Christianity were rejected. Lane recalled how "one very kind hearted Episcopal minister…was very popular with the colored people" until he preached a similar sermon. At this point, "most of us left him."[17]

Perhaps Frederick Douglass best captured the kind of injustices that led the slave community to reject any religious authority who invoked this line from the Gospel of St. Luke. In his earliest book, Douglass famously remembered an episode when his master "tie[d] up a lame young woman, and whip[ped] her with a heavy cowskin upon her naked shoulders, causing the warm red blood to drip." Douglass was outraged by the act, but he wanted his audience to be at least as incensed by how such a sadist could use Christianity to defend his actions. To justify "the bloody deed," his master "would quote this passage of Scripture—'He that knoweth his master's will, and doeth it not, shall be beaten with many stripes.'"[18] When Turner relayed this line as part of his message from the Holy Spirit, Nat Turner ensured that most in the black community would doubt the authenticity of his inspiration.

Although Turner may have won a handful of disciples by the time of the revolt, the response of the black community to these early pronouncements was decidedly unsympathetic. According to Turner's *Confessions*, the reaction of Southampton slaves was similar to the response described by Jacobs, Lane, and Douglass: "The negroes found fault, and murmured against me, saying that if they had my sense they would not serve any master in the world."[19] The slaves thought that God, who had brought the Israelites from Egypt, wanted America's black slaves to be free. They refused to believe that God wanted any slave to return to slavery. They scorned and mocked Nat Turner, who voluntarily returned to bondage and who also acquiesced to southern brutality as part of God's plan. Future generations would describe such an apologist for slavery as an "Uncle Tom," and Nat Turner probably felt a similar stinging rebuke from the black community.

There is no reason to think that Henry, Hark, Sam, or Nelson thought more highly of Nat Turner in 1825 than did the nameless black slaves who

"found fault" with Turner. None of them became disciples when, in 1827 or the spring of 1828, he baptized himself. In fact, there is no reason to think that Nat Turner had any black disciples as recently as three years before the eclipse, despite Turner's assiduous efforts to cultivate his image. At some point between 1825 and 1828, Nat Turner's message that the "great day of judgment was at hand" had, by his own account, won him his first disciple: Etheldred T. Brantley, "a white man." Turner's insistence on his divine inspiration and stark message about the coming end times spurred Brantley to cease "from his wickedness" and reform his ways. The change in Brantley's behavior coincided with the outbreak of a nasty skin affliction. Brantley oozed blood from his skin, but after nine days of praying and fasting, "he was healed."[20]

After Nat Turner converted, reformed, and healed Brantley, the Holy Spirit reappeared. It reminded Nat Turner that Jesus had been baptized, and it ordered that "as the Saviour had been baptised so should we also." Prompted by the Holy Spirit, the two men petitioned one of the local churches to baptize them. The request was rejected. The "white people would not let us be baptised by the church."[21] No doubt the white people who controlled the church disapproved of Brantley's flouting the racial caste system, but if their only objective was to reinforce white supremacy, they could have achieved their goal simply by bringing Turner and Brantley under their control within the purview of church discipline.[22] Instead, they rejected the men's appeal for baptism, perhaps because they did not want to do anything that could be interpreted as validating Nat Turner's religious identity. They did not want to put an imprimatur on the extraordinary visions of a prophetic slave.

While whites—other than Brantley—rejected Turner's pronouncements, there is little reason to think that the black community had warmed to his religious inspiration. Several years after the baptism, a white correspondent from Southampton described the Turner-Brantley baptism in a way that supported much of Turner's own description of the event. In the *Confessions*, Turner remembered that he and Brantley "went down into the water together." The unnamed white correspondent, whose report was published before Turner was captured, agreed: Nat Turner, "in the company of a white man, did actually baptize himself."[23] Both of these independent records of the event mention only the two principals involved in the baptism, suggesting that no black disciples were involved.

Further detail added by the anonymous white correspondent in his letter to the *Richmond Enquirer* reinforced the idea that the black community looked askance at their local prophet at the time of his baptism. According to the letter, Nat Turner had "announced to the Blacks, that he should baptize

himself on a particular day, and whilst in the water, a dove would be seen to descend from Heaven [and perch on his head]." This story was plainly messianic, with Turner filling the role of a modern Christ. In an important respect, however, the story told to the white reporter was different from the Gospel accounts of Jesus's baptism. According to the Bible, the dove representing the Holy Spirit came down upon Jesus. In contrast, the prediction of a dove descending from heaven onto Nat Turner was recounted as an empty boast. When the dove failed to appear, the black community had even more reason to doubt Nat Turner's astounding claims about himself.[24]

Hearsay recorded by an unsympathetic reporter years after the event occurred must be treated carefully. That this story circulated does not mean that Nat Turner had predicted that a dove would land on his head. He might have simply said that there would be a sign. People familiar with the Bible may have misinterpreted his declaration that the Holy Spirit was with him as a claim that at his baptism everyone would see "the Spirit of God descending like a dove, and lighting upon him."[25] Or Turner might have said nothing about a dove appearing, and people used the idea of a dove to deride this messianic figure. Whatever Turner actually said, some black people's account of it recorded in a letter to the *Richmond Enquirer* reflected a continuation of the black community's skepticism about its would-be prophet.

On the day of the baptism, Turner's detractors turned out to watch the ceremony. According to the letter in the *Richmond Enquirer*, Nat Turner hoped to "collect a great crowd," but that "assemblage was prevented," possibly by whites, who sometimes tried to prohibit large gatherings of slaves. Despite this attempt to contain the event, Turner remembered that the baptism evolved into something of a spectacle: "many" gathered at Person's Mill Pond to watch as Turner and Brantley "went down into the water together." Turner was aware of the hostility toward him. The crowd followed Turner not because they hoped to see a holy event, nor even in amusement to watch two grown men make fools of themselves; they were there hoping that Nat Turner would fail. "In the sight of many who reviled us," Turner later recalled, he and Brantley "were baptised by the Spirit."[26]

Despite Turner's marginal place in the black community, Hark, Henry, Sam, and Nelson met with the prophet when he called them together in February 1831. They may have had a higher opinion of Nat Turner than the crowds who jeered him at Person's Mill Pond or those who told him he was a fool when he voluntarily returned to slavery. Perhaps they sensed the growing radicalism of his visions. According to the *Confessions*, Turner's visions suggesting a race war had begun on May 12, 1828, shortly after the baptism, but he

admitted that he did not share these visions with other slaves.[27] Although he did not speak about what he had seen, Turner's visions seemed to have made him noticeably less tolerant of the indignities of slavery. According to one record, he received a whipping in 1828 from his master for saying "the blacks ought to be free, and that they would be free one day or the other."[28] One whipping might not have made other slaves less dubious of Turner's divine inspiration, but some might have seen him in a more favorable light after he challenged slavery.

While it is tempting to focus on the few dramatic moments that enter into the historical record, mundane events may have played as large a role in changing the four men's opinion of Turner. At Thomas Moore's death in 1828, Turner and five other slaves were bequeathed to Putnam Moore, Thomas Moore's six-year-old son. In October 1829, Putnam's mother, the recently widowed Sally Francis Moore, married Joseph Travis, creating a complex new household for blacks and whites. The head of the family, Travis acted as guardian for Putnam Moore. Sally Travis also lived there and was soon pregnant with Joseph Travis's child. This marriage would have a significant effect on the situation of both the Moore and Travis slaves. Travis's slaves, including Hark, would have to find room on their farm for several new faces. The Moores' slaves, including Nat Turner, moved to the Travises' farm.[29]

Hark may have known Turner before he moved, but Hark may not have known the reclusive prophet well. When Turner recalled his life, one theme that emerged was his continual efforts to isolate himself. As a young man, he remembered, he "studiously avoided mixing in society, and wrapped myself in mystery." After Turner returned from running away, "I now withdrew myself as much as my situation would permit, from the intercourse of my fellow servants." Even when it came to his best friends, which the first conspirators were, he still hesitated "to mix with them," afraid that it would undermine his carefully developed image.[30]

Turner's attempt to distance himself from other slaves was always limited by an important caveat: "as much as my situation would permit." As a slave, he did not have final say over how he spent his time. Without too much difficulty, he could separate himself from someone such as Hark when they lived on different farms. After Nat Turner moved onto the Travises' farm, however, he and Hark worked, ate, and slept together. For almost two years they lived together and got a chance to judge each other independent of their public reputations. Turner's opinion of Hark was clear: Hark was invited to the February meeting as one of the "four in whom I had the greatest confidence."[31] As Turner developed his plan, Hark was a central character, included in every

decision and even bringing the first recruit from outside Turner's circle of confidence. As far as Hark's opinion of Nat Turner, Hark at least gave the reclusive prophet the benefit of the doubt. When Turner called the surreptitious meeting, Hark agreed to attend.

It is harder to find clues about how Henry, Nelson, and Sam came to accept Turner's invitation to meet. Some of them may have become disciples of the prophet sometime after Turner's baptism.[32] Or, like Hark, they may have come into contact with the reclusive prophet through their daily routine as slaves. Henry, Nelson, and Sam may have liked Nat Turner well enough to ignore his public reputation and accept his invitation to attend a secret meeting. Or they may have gone to the meeting at the prompting of Hark, not Turner.

Once the five men were gathered, Nat Turner told Hark, Henry, Nelson, and Sam about the most recent revelation from God. In the course of the discussions, Turner probably explained his entire messianic calling. At the end he told them that the eclipse was a sign from God that he should lead a slave revolt.[33] This statement, however Turner phrased it, created an opportunity for the slaves that Turner had brought into his confidence: any one of them could inform the whites about the nascent plot. For his act of loyalty to the whites and betrayal of Turner, such a slave would have at least earned the gratitude of the whites, who had at their disposal a plethora of possible rewards. Despite what their masters would have been able to give to an informant, Henry, Hark, Sam, and Nelson refused to reveal the plot. Even if they were not sure whether Nat Turner was the new messiah, none of them wanted to be a new Judas. For months after Turner told them about his intention to begin an insurrection, the conspirators kept the revolt completely hidden from whites.

Turner wanted more than silence from these men; he wanted them to risk their lives in this rebellion. But the rebellion itself faced incredible odds. If they all agreed to join, the conspiracy would consist of five unarmed slaves. How could they stand up to Southampton's whites, let alone the state's militia or the nation's regular army? If any of the men had not seen the risks associated with joining the revolt, practical considerations made clear the odds they faced. Each man understood that Turner was asking him to join a suicidal mission. Nevertheless, perhaps even before the end of the meeting, everyone had agreed to join the revolt.

Hark and Sam survived the revolt and faced trial for their actions. At their trials, the prosecution proved that the men participated in the revolt, which was an easy task, given the unsympathetic court and the men's long involvement in the revolt. But no one recorded why these men decided to follow Nat

Turner to their deaths. Some whites assumed that Turner's followers were simply deluded pawns who "acted under the influence of their leader."[34] Yet it remains possible that Henry, Hark, Sam, and Nelson decided to join because of the attractiveness of Nat Turner's proposal, not his personality. If the revolt succeeded, they would live as free men. If it failed, they would die fighting for their freedom. Either outcome was acceptable to these men, who otherwise faced life and death in slavery.

Beginning in February and throughout the spring, the five men discussed possible plans. God had shown Nat Turner "white spirits and black spirits engaged in battle" but had not revealed exactly how this vision would translate to the fields of Southampton. The five struggled to come up with the most sensible plan they could, but every plan faced overwhelming obstacles. According to Nat Turner's account, "Many were the plans formed and rejected by us." Their inability to decide upon a plan for the revolt did not diminish the conspirators' enthusiasm for the revolt, and at least two bragged about how bold they would be when the opportunity came to kill their white oppressors.[35]

Later investigations into the origins of the revolt suggested that the rebels had considered at least one option carefully. When a new recruit at the start of the revolt objected to the small number of conspirators, the rebels explained that the plot was not bigger because "the negroes had frequently attempted, similar things, and confided their purpose to several, and…it always leaked out."[36] It is unclear what "similar things" the rebels had heard about. They may have had in mind the failures of Gabriel's 1800 plot in Richmond or Denmark Vesey's 1822 plot in Charleston. According to the standard histories of these revolts, the rebels had brought several dozen—perhaps hundreds—of slaves into their circle of confidence. In each case, slaves who tipped off the whites undermined the plots. Or the rebels may have remembered an earlier plot in Southampton County. In February 1802, when Nat Turner would have been only sixteen months old, Southampton whites were alarmed to discover a letter that laid out an elaborate conspiracy based on the example of Haiti. The whites never discovered the provenance of the letter, but any plot that had been under consideration in the black community had been spoiled.[37] Whichever slave revolt the conspirators had in mind—and it is unclear how much they would have known about any of these conspiracies—they had decided against a large conspiracy.

Despite the men's failure to settle upon a plan, they agreed on a date to begin the revolt: the Fourth of July, 1831. Turner's *Confessions* do not say why the rebels settled on this date or even whose idea it was, but the date was clearly not arbitrary. Practically, Independence Day created opportunities for

mobilizing slaves who were given the holiday off. At the same time, the conspirators may have thought it would be a day when the whites were especially vulnerable, either because most whites would be congregated in a few places or because the whites' celebrations might leave them less prepared to respond to the news that the slaves had risen.

The rebels also understood the ideological significance of the date. The prophet may have seen this revolt as part of a religious war that would lead to the second coming, but the other rebels understood that this struggle coincided with the principles laid out by Thomas Jefferson in the Declaration of Independence. Two decades after the revolt, Frederick Douglass lambasted the failure of Americans to extend to African Americans the principles celebrated on the Fourth of July. He called Independence Day "a sham" and reminded his audience that "the blessings in which you this day rejoice are not enjoyed in common." Although the rebels were denied the podium available to Douglass, by selecting the Fourth of July to begin their revolt they implied that the revolt was not simply an event within Nat Turner's eschatology. They also wanted America to remember that "all men are created equal."[38] As the Fourth of July approached, however, Turner's unease grew. According to the *Confessions*, the rebels' inability to settle on a plan "affected my mind to such a degree, that I feel sick." Recounting the story months later, Turner recognized that his worries led to the illness that kept him from participating in an Independence Day revolt. Without a plan and lacking a fit leader, the other rebels allowed the Fourth of July to pass quietly.[39]

For the next five weeks, the five conspirators worked to devise a plan that made sense. Every time one of the rebels proposed a new plan, the others found reason to reject it. Despite his confidence in these four men, Nat Turner's vision was essentially prophetic. He wanted another sign from God to confirm what the Holy Spirit had already shown him. Exactly forty days after the Fourth of July, the sign appeared. On August 13, 1831, the midday sun appeared "silvery," as if it were "shining through a vanishing fog." Its light also cast a peculiar hue, giving people "an unusually ghastly appearance." By late afternoon, the sun's appearance had changed: "it assumed a greenish blue appearance." The sun also shone less brightly, and a sunspot appeared, visible to the naked eye. This phenomenon was observed from New York to Georgia, where the *Georgia Courier* reported that the sun appeared "shorn of its beams." It could be looked at directly "and shed a grayish-blue light on the earth." Near Richmond, one woman described the late afternoon appearance more dramatically: at "about 4 o'clock on looking up at the sun to our amazement, it was as *blue* as any cloud you ever saw."[40] Perhaps there was a natural

explanation for "the very unusual if not unexampled appearance of the sun," but Nat Turner saw this as the sign that he was waiting for. The odd appearance of the sun was confirmation that God wanted the revolt to begin. According to a newspaper account, Turner interpreted the black sunspot, which appeared over the silvery sun, as "positive proof, that he would succeed in his undertaking."[41] The hour to strike had arrived.

By August, the four other original rebels were fully familiar with how Nat Turner interpreted extraordinary phenomena. An eerie sun shining silver and then green-blue coupled with a sunspot visible to the naked eye were more remarkable than Turner's other celestial signs. Noticing the "extraordinary appearances connected with sun," they could not have been surprised that Nat Turner told them that he was determined "not to wait longer." According to Turner's testimony, on Saturday, August 20, Henry met Hark and Nat Turner to discuss the revolt. They agreed to gather the next day, Sunday, August 21, at Cabin Pond, on Giles Reese's plantation, only a few hundred yards from the plantation where Hark and Nat Turner lived.[42] The meeting adjourned, and the three men left to prepare themselves for their fateful day.

After they departed, someone told Nelson and Sam, who missed the Saturday meeting, that the revolt would begin the following day. The conspirators also contacted two new recruits who, unbeknownst to Turner, had been told about the plans. One of the new recruits, Will, was also on Nathaniel Francis's plantation. Whoever got word to Sam may have also told Will about the revolt. Given the remarkable secrecy that the conspirators sustained for six months, the person who informed Will probably was close to him and trusted him implicitly; perhaps it was Sam, who lived and worked with Will.

According to Turner, Hark had recruited his wife's brother Jack. Jack's owner, Joseph William Reese, lived in the immediate neighborhood with his mother, Piety Reese. His slave Jack, however, did not live in their home. He lived at Jordan Barnes's. Barnes owned eight slaves but still needed more workers. He hired a family of four free blacks and leased Jack from Reese. Barnes lived far enough from the Reeses that when Jack sought permission to return to the farm, he was granted approval for an extended visit.[43]

Exactly why Jack returned that weekend to the starting point of the revolt remains a mystery. According to Jordan Barnes, Jack asked to return home to see his master. Another possibility was that Hark got word to him that the revolt was imminent. Or perhaps, seeing the sunspot, Jack suspected that the revolt was likely to begin soon. Since Nat Turner had no idea that Jack had been recruited to join the revolt and since Jack later tried to beg his way out of the revolt, the timing of his visit was probably a coincidence. Jack's

brother-in-law Hark took advantage of Jack's unexpected presence to recruit another slave to the revolt that was about to begin. According to Jack's own confession, Hark found Jack at Piety Reese's house on Sunday morning and brought him to Cabin Pond, "where several other negroes were assembled and a dinner party prepared."[44]

On the morning of Sunday, August 21, Henry, Hark, Nelson, Sam, Will, and Jack met as planned at Cabin Pond. While they prepared a pig that Hark had brought and drank the apple brandy that Henry contributed, the four charter members of the revolt began explaining to the new recruits their plans to "rise and kill all the white people." At about three o'clock in the afternoon Nat Turner joined the small band. As he approached the group, he noticed the two new recruits. He recognized Jack and guessed how he had gotten there: Hark had brought him. Based upon his experiences as a scorned prophet, Nat Turner understood that most of the people in the black community would not spontaneously rise to rebel upon hearing that Turner had declared war on the slaveholders, even following the recent remarkable appearance of the sun. So he had to be prepared to welcome rebels who joined his force for reasons other than loyalty to him. One of the most important sources of recruiting would be when those who had already committed to the revolt persuaded their friends and family to join the army. Nat Turner knew both Hark and Jack and understood the influence that Hark had upon his brother-in-law. Even though Jack was never fully convinced of the wisdom of the revolt, Turner accepted him without question as "only a tool in the hands of Hark."[45]

In contrast, Turner questioned Will, asking "how he came to be there." Will did not respond by explaining how he had come to learn about the small, secretive plot; instead he told Turner the reasons he wanted to join Turner's army. This answer, preserved in the *Confessions*, is a remarkable piece of evidence. As Turner remembered it, Will responded that "his life was worth no more than others, and his liberty as dear to him."[46] In this response, Will appeared different from the clichés that contemporary whites told themselves about Turner's followers. One contemporary newspaper described how whites understood the rebels: the followers were a "few ignorant wretches" whose minds Nat Turner "deceive[d], delude[d] and overawe[d]." Another account described how Turner "had acquired the character of a prophet" who had "acquired an immense influence, over such persons as he took into his confidence." A correspondent at the time wrote to his brother that Turner "lied" to the blacks he was able to get to join him. A letter written about the revolt to North Carolina's governor explained how the rebels had been

deluded: "Religion has been brought to their aid." According to this letter, these rebels had even come to believe that their martyrdom would be rewarded with eternal salvation: "Many have said so when about to be put to death." Will, too, was ready to die, but his reason was different from the ones whites focused upon. Will wanted to fight for his freedom, and he indicated that he was ready to "lose his life" if the revolt failed. As revealing as what he said is what he did not say. He gave no hint that he was impressed by Turner's religion, expressed no confidence in Nat Turner as a prophet, and provided no reason to think that Turner had acquired "an ascendancy over [his] mind." In fact, if one considers the antagonism suggested by Turner's pointed questions directed only to Will, Will seems to have joined the revolt in spite of Turner, not because of him. Whatever tension that existed between Turner and Will eased once Will explained that he was ready to die fighting alongside Turner. According to Turner, Will's answers were "enough to put him in full confidence."[47]

The odds against the seven gathered at Cabin Pond were as daunting as they had been in February. Their greatest achievement over six months had been to keep the plot a secret from whites.[48] Most slave conspiracies in the United States never had the chance to begin, because as word spread, the risk that one of the blacks who heard about the plans would tell whites increased. Slave and free black conspirators lured by the strategic advantages of spreading word among the black population did not fully appreciate the risks of allowing a revolt to get too big. Turner, perhaps because of his experiences as an outsider, understood the fragility of racial and class solidarity among Southampton's slaves. As a result, Turner insisted that the conspiracy be kept extremely small, a decision that allowed the revolt to remain undetected.[49]

The decision to keep the conspiracy small was sensible, but it meant that the odds against the conspirators were unimaginably long.[50] In the lengthy history of slavery, there is only one unambiguously successful slave revolt, the Haitian Revolution, and it is unclear how widespread the conspiracy in Saint-Domingue was on the night in 1791 when Boukman and his allies gathered at Bois-Caïman to launch their attack on slavery. It is clear that Nat Turner and his six supporters had even more significant obstacles to overcome than the instigators of the Haitian Revolution did. In Saint-Domingue, as the French colony was known before the Haitian Revolution, the enslaved made up the vast majority of the population, both in the region where the rebellion began and throughout the colony as a whole. According to official figures from 1789, in the rural parish where the Haitian Revolution began, slaves outnumbered whites more than twenty-five to one, while the figures for the entire colony were only slightly less lopsided, with slaves outnumbering whites fifteen to

one. In Southampton, the population was much more balanced, with slaves outnumbering whites six to five. The demographic breakdown of the Tidewater region of Virginia was similar to Southampton County's, but the ratios flip for the state. Although more slaves lived in Virginia than any other state, whites constituted a majority of Virginia's population, outnumbering slaves by a ratio of three to two.[51]

If anything, a simple demographic comparison of Saint-Domingue and Southampton understates the difficulties facing Turner and his men. In August 1791, the slaves in Saint-Domingue faced a far less unified opposition than the Southampton rebels did. The elites in Saint-Domingue and in France itself were deeply divided by the French Revolution, which was ongoing as Boukman and his allies launched their war. Moreover, prominent slaveholders in Haiti included free people of color, who, even before the French Revolution, had been pressing for expanded rights as citizens, something that the colonial assembly was unwilling to grant. The most radical of the free blacks, Vincent Ogé, had launched his own failed rebellion against the colony just a year before the slaves began the Haitian Revolution. Finally, the turmoil in France had led the white colonists to think about how France's most valuable colony could use Great Britain and, to a lesser extent, Spain and the United States to limit France's power on the island. All of these divisions among those with power in Saint-Domingue created opportunities for Saint-Domingue's slave rebels.[52] In Southampton, on the other hand, it was hard to see how divisions among whites created any strategic opportunities for the Southampton rebels. When the slaves rebelled, the whites set aside their differences in order to put down the revolt.[53]

The enormous challenges facing slave rebels in Southampton made planning for the revolt understandably difficult. One early report said that the rebels had planned to reach the Dismal Swamp, a large low-lying area situated between the James River in Virginia and Albemarle Sound in North Carolina that was a refuge for some slaves who had escaped slavery. If so, it seemed that the rebels were trying to establish the type of maroon community that existed in the Caribbean and South America. John Hampden Pleasants, a newspaper editor from Richmond who went to Southampton after the rebellion, described a different plan. According to his earliest dispatch from Southampton, he reported that the plan may have been "to get to Norfolk, seize a ship and go to Africa," a plan that resembled what historian Douglas Egerton has argued Denmark Vesey hoped to do in Charleston in 1822. Even as Pleasants described the Norfolk plan, he questioned whether this was the rebels' plan. He decided that it was not, and concluded that Turner "had no

ulterior purpose." In later reports, Pleasants dropped all references to the Norfolk plan and reported that he heard no coherent plans described by the rebels who had been captured. "If there was any ulterior purpose," Pleasants concluded, "he [Nat Turner] probably alone knows it. For our own part, we still believe that there was none." A later report by an anonymous Southampton native likewise found no goal for Turner and the rebels beyond their immediate target, the county seat: "The seizure of Jerusalem, and the massacre of its inhabitants, was with him, a chief purpose, & seemed to be his ultimatum."[54]

In the weeks after the revolt, whites accepted that the blacks had no plan. Even after Turner was captured, whites did not examine him very closely on the details of what he had been trying to do. In fact, it was only because of whites' interest in the rebels' decision not to spare anyone, even women or children, that we have a record of a critical part of the rebels' strategic thinking. After the rebellion, whites were horrified by the murders, but they reserved a special scorn for the rebels' decision to kill everyone, even infants. Whites took these killings as a sign of the depravity of the rebels, but Turner implied that the decision to kill whites indiscriminately was an integral part of the rebels' plan to recruit slaves. In his confessions to Thomas R. Gray, Turner explained that the rebels had decided that "until we had armed and equipped ourselves, and gathered sufficient force, neither age nor sex was to be spared."[55]

Turner was not the only rebel who implied a connection between killing whites and recruiting blacks. When Jack was captured after the rebellion, he confessed to his role in the revolt, but told his captors that he had been an unwilling participant from the start. When Hark had told him about the plan, Jack balked, not because he disagreed with the mission or because he thought it was immoral, but because the revolt would fail. Specifically, he objected that the "number [of conspirators] was too few." Hark replied that as the rebels "went on and killed the whites[,] the blacks would join them."[56] Like Turner, Hark clearly hoped that killing whites would lead slaves to join the revolt.

Contemporary whites—who missed the significance of these comments—never asked those rebels who survived to explain their strategy, but Turner and the other rebels understood that they had no chance with a motley crew of poorly armed rebels. If the revolt was to succeed, they needed to get a large number of recruits quickly. Since they had already ruled out a general conspiracy, the rebels had to find a way to get many recruits to join who had not even heard about the revolt. How could they do that? Most slaves hated slavery, but the vast majority of slaves were disinclined to engage in overt resistance. Turner and the rebels apparently thought that this reluctance was in part because of the psychological power whites had in a world where white

skin was a prerequisite for power and privilege. By targeting whites indiscriminately, Turner and the rebels hoped to dispel the aura of power associated with whiteness. Killing whites was not simply an act of vengeance but an act that would free the multitude of blacks to join the rebellion.[57]

The plan to kill all the whites was only the first step in the rebels' strategy. Once the rebels gathered "sufficient force," the simple existence of a significant black army would be enough to draw black supporters, obviating the need for the indiscriminate murder of whites. In an interview after he was captured, Turner described how "women and children would afterwards have been spared, and men too who ceased to resist." This small army, Turner and the other rebels believed, could secure a small region, what he called "a foothold," although another report suggested that Turner envisioned conquering Southampton County itself. Whites, who did not see the sense in the revolt, never recorded any comments from Turner about what the rebels would do once they got their "foothold." Perhaps the most reasonable thing they could have done at that point would have been to negotiate with the whites, although there is no evidence that this was what the rebels hoped to do.[58]

The rebels' strategy was clearly a long shot. Even if everything worked exactly as the rebels hoped, it is hard to see how a significant slave army would survive in southern Virginia. But their plan may have been the best of many bad options for a group of slaves who had decided to rebel. It avoided the significant problems facing those conspirators who assumed the solidarity of slaves. Moreover, it also probed one of slavery's potential weaknesses. Slavery was as strong as it was not simply because the whites had all the power but also because most slaves saw no way to channel their unhappiness into a revolutionary program. The rebels hoped that their decision to kill whites indiscriminately would shock the other slaves out of their complacency and lead them to actively support the rebels. Anyone could see that this plan was unlikely to succeed, but it was not incoherent. The conspirators who had sensibly rejected so many other ideas in the months leading up to the revolt were willing to stake their lives on this plan.

One of the great benefits of the plan was that it took the pressure off the rebels during the planning stages, when conspiracies were vulnerable to being discovered. Turner, for instance, saw no need to stockpile weapons. When the revolt began, the rebels' "only arms were hatchets and axes." Whites were astonished at the decision to begin a rebellion without arms, which contributed to the sense that either the rebels were crazy or they had not thought carefully about what they were undertaking, but this was exactly as Turner envisioned the revolt, even before he recruited his first followers. In the *Confessions*,

Turner reported having seen how he would "slay my enemies with their own weapons."[59] Months of planning had not changed his decision to arm troops during the course of the rebellion.

The most important thing about the plan was that it allowed the rebels to keep their conspiracy small. After the revolt, whites found among the papers held by Turner's wife "a piece of paper, of a late date, which, all agree, is a list of his men." Turner may have had some potential rebels in mind, but even if all those men joined once the revolt had begun, the total number of rebels would be something "short of twenty." When Turner was captured, whites questioned him about the size of the rebellion. Turner convinced his interrogators that the revolt was even smaller that their earlier investigations had suggested. Thomas R. Gray concluded that the conspiracy "was entirely local, and his designs confided but to a few." Others who heard Turner describe the rebellion reported the same thing. One correspondent to the *Richmond Enquirer* noted that "there was no concert of an insurrection," noting in a footnote that the rebels numbered eight when the revolt began "and they, only, knew any thing of his plans." Another report contained much the same information: "his plan was not known out of the neighborhood, and was confided to only six persons," presumably not counting Turner himself.[60]

If Turner and the early conspirators had a better strategy than people realized at the time or since, there was one part of the plan that was not particularly well thought out: the rebels had not decided how the revolt was to begin. Perhaps because the recent change in the sun's appearance had been unexpected, the conspirators had not moved from their broad, strategic planning to considering the specific tactical question of how they would launch this war. According to Turner's *Confessions*, the rebels agreed on their first target— the farm where Hark and Nat Turner lived—only after Nat Turner joined the other six at the feast at Cabin Pond. Having decided to attack the whites on Joseph Travis's farm, the rebels then made one more decision: they would wait until nighttime to start the revolt.[61]

The feast at Cabin Pond lasted until about nine or ten o'clock. The small band then made its way to the Travis farm. The first person they encountered at the Travises' was Austin, another one of the eight slaves who lived on the farm. Since Austin lived and worked on a small farm with two of the revolt's leaders, they must have known him well. Yet Turner had not invited Austin to join the conspirators in February, nor had he joined the other rebels earlier in the day at Cabin Pond. Austin's distance from the rebels during the plotting stages is one of the strongest pieces of evidence that Turner initially kept the conspiracy small. The record leaves no evidence that Austin felt any slight at

the rebels' decision not to include him earlier. Instead, he and six other rebels headed over to the Travises' cider press.[62]

Jack, the most reluctant rebel, soon slipped away from the others. In the quiet of the night, sitting with his head held in his hands between knees, he tried to decide what to do. He could have easily awakened the Travis family and warned them about the imminent revolt. Just as easily, he could have fled, avoiding any involvement with the rebellion itself. But he did neither of these things. When Moses, a young slave on the farm, approached the unhappy man, Jack explained to him that he was "sick and wanted to go home." He had little confidence in the rebels' plan, even after Hark explained it to him, and he was not sure that he was ready to die in this revolt. As when Nat Turner noted that his worries "affected my mind to such a degree, that I feel sick," Jack soon felt ill. By the middle of the night, several hours after he complained about feeling poorly to Moses, Moses saw Jack again "in the yard sick."[63] While the others drank and Jack worried, Nat Turner remained by himself, alone, a position he would often find himself in during a revolt that he had begun and which would eventually best be known by his name.

2

The First Blood

THE REBELS HAD none of their initial assault scripted, so when Turner rejoined the others in the Travises' detached kitchen, they made their plans on the fly. Even though the rebels had nothing more than their everyday tools, an attack on the Travis family was relatively simple. The Travis house was undefended, and the white residents—an adult couple, two boys, and a baby—were all asleep. The biggest obstacle standing between the rebels and their targets was a locked door. This posed no significant challenge, something that the rebels clearly understood, and Hark "went to the door with an axe, for the purpose of breaking it open." At this point, someone stopped Hark. While battering down the door would be a dramatic way to begin the revolt, it was not the smartest approach. A moment's reflection led them to see the problems with breaking the door down: "it might create an alarm in the neighborhood." The revolt might be discovered in its first moment, and they would never have the advantage of surprise, which was and would remain throughout the night their greatest tactical advantage. The rebels sensibly decided "to enter the house secretly."[1]

Hark fetched a ladder. After Turner climbed through a second-story window, he quietly snuck downstairs and unbarred the Travises' door. According to the *Confessions*, before he exited the house, Nat Turner stole "four guns that would shoot, and several old muskets, with a pound or two of powder." Another account described the events differently: Hark "went into the house and brought out three guns." Whether Hark and Nat went in alone or together, they reappeared with the first guns of the rebellion, exactly as Turner had imagined it when he had seen that he would fight the whites "with their own weapons."[2]

Armed with a handful of weapons and now facing no barrier between themselves and their intended victims, the rebels had only one more question to answer: who would kill the white family? Before the rebellion had begun, the initial group of rebels had apparently talked about how intrepid they would be when the time came for revenge, but now that the moment had

arrived they realized how much easier it was to say, rather than do, what they vowed. When Turner—who had already showed his resolve by sneaking into the Travis house—challenged "two others to make good their valiant boasting…of what they would do," the two refused. Instead, one of the men "observed that Nat must spill the first blood." The revolt was Turner's idea, and the others would follow him only if he had no way to escape the death sentence that the rebels would face if and when the revolt failed. If Nat Turner struck the first blow, he could not turn back. Having attacked a white person, he would see the revolt through to its successful end, or he would die. This calculation by the original conspirators suggests that the rebels were not unaware of the likelihood that the revolt would fail. Moreover, it suggests even more strongly that Turner's closest friends were not people who would do his bidding or, as the whites later claimed, his "deluded followers."[3] Turner's supporters followed him to their deaths, but not because they did what he told them to do.

When the unnamed rebel challenged him to strike the first blow, Nat Turner accepted the assignment, but he did not go alone. Although some of the original conspirators were hesitating, one of the recent recruits was eager to join Turner. At the Travises' house and elsewhere, Will displayed an enthusiasm for the revolt that eventually led Turner to describe him as "the executioner." As Turner ascended the steps, Will took a broadaxe and followed him.[4] The two men silently entered the Travises' bedroom. Sensibly, Turner approached Joseph Travis, the man he called "my master," wanting to take advantage of the surprise to kill the person who could put up the fiercest resistance. With one swing of the hatchet, Turner launched his revolt.

The revolt may have begun with Turner's swing, but it did not begin with Travis's death. Instead, Turner's blow simply woke Travis. Somehow Turner had failed to kill his master. Whatever kept Turner from killing Travis did not stop Will. After Nat Turner delivered his glancing blow, Travis leapt from the bed, startled and awake. He called to his wife, but Will killed Travis with a single swing of his axe. Will then turned to Sally Francis Moore Travis. According to Turner's account, Sally Travis did not stir when her husband awoke. "As she lay in bed," Will slew her with his axe.[5]

After killing the Travises, Will turned to two others still asleep in the house: Turner's legal owner, the nine-year-old Putnam Moore, and Joel Westbrook, who had been hired to work at the farm. Although Westbrook was often described as a child by contemporary sources, he was included on the militia rolls, which listed white men who were at least sixteen years old. Will found Moore and Westbrook asleep in the same bed. According to

Turner's *Confessions*, Will struck them before either had a chance to try to make an escape. Turner called this assault that left four dead "the work of a moment," something that is supported by other accounts. A newspaper correspondent saw little evidence of resistance. According to the impressions of the whites who found the bodies at the Travises' house, "several [of the dead] never changed their positions," and "one blow seems to have sufficed for the two little boys, who were sleeping so close, that the same stroke nearly severed each neck."[6]

The assault was so quick, in fact, that the rebels had already left the house before they realized that one person was still alive: the family's infant child. At the start of the revolt, the rebels' plan was to kill all the whites. If the rebels hoped that the killings of whites would win them support from the black community, there really was no better opportunity for a dramatic killing than a "little infant sleeping in a cradle." Henry and Will went back to the Travises' home. When whites later arrived at the farm, they found the result of Henry and Will's work: "a little infant with its head cut off" unceremoniously dumped in the fireplace.[7]

After the murders at the Travises', the rebels made their way to the family's barn. According to Turner's account, "I formed them in a line as soldiers" and marched them through "all the manœuvers I was master of." He never explained where he learned maneuvers. Nat Turner was a literate slave, so he may have surreptitiously read books or articles on military affairs. Perhaps he had witnessed muster-day exercises in southside Virginia and had seen how the white officers commanded the militiamen. Nat Turner also never explained why he chose to spend time drilling his followers. Already the rebels had wasted hours while some of them drank and then sobered up. Every minute that they worked on marching cost them a minute of darkness. Dawn was approaching, and Nat Turner was spending the precious time they had marching the rebels from one side of the barn to the other.[8] He may have hoped that this practice would make his nine men into a more effective fighting force, but anyone could see that no matter how well they trained, if the army was not much bigger than this small force, the revolt would be suppressed quickly.

Perhaps the significance of this episode can best be understood as an attempt by Nat Turner and the rebels to change the dynamic of how the rebels interacted. During the planning stages, the rebels sought consensus. According to Turner's account, in the summer "it was intended by us to have begun the work of death on the 4th July last." Describing how they selected the Travises for the first attack, Turner recalled, "It was quickly agreed we should commence

at home (Mr. J. Travis') on that night." Even when it came time to decide who should strike the first blow, Turner's challenge to the others was seen more as a dare than as a command. After the first blood had been spilled, the dynamic changed. At the barn, Nat Turner gave the orders, and the rebels obeyed. "I formed them in a line," he said, and later he "marched them off."[9] The conspirators were becoming an army; Nat Turner was its commander.

A letter written in early September noted, "Their banner was a red-cross in a white field. Some of the wretches wore red caps, and others had their hats ornamented with red bands of various materials." William Sidney Drewry, whose 1900 *Southampton Slave Insurrection* recorded much of the region's oral tradition about the revolt, suggested that the rebels added these distinctive touches while they were at the barn. The unsympathetic Drewry mocked the rebels, who had "decorated themselves in the most ludicrous and fantastic style, with feathers in their hats and long red sashes around their waists and over their shoulders." To Drewry, the outfits seemed outlandish, but the rebels likely had a more practical goal. Ripping the red lining out of gigs for sashes and putting feathers in their hats, the rebels were consciously creating their own uniforms, as was appropriate for the members of a new army.[10] The red caps and sashes would also allow the rebels to immediately distinguish those blacks who had been part of the revolt since its inception.

The change in dynamic suggested by the marching in the barn and the fashioning of uniforms was at some point formalized by the assignment of rank. In the trials after the revolt, several blacks used a title when referring to Nat Turner, calling him either "General Nat" or "Captain Nat." The titles were interchangeable. In fact, one witness used the different titles describing the same episode in two different trials. While the exact titles were not important to the rebels, the idea of a title was. Titles conveyed prestige and authority, and the man who led the revolt adopted the use of a military title.[11]

The other rebel leaders also used titles. A letter written on Friday, five days after the revolt began, reported that Nelson was "called by the blacks, 'Gen. Nelson.'" Robert E. Lee, who was at Fort Monroe, across the James River from Norfolk, heard similar stories and wrote his mother-in-law about "Maj. Nelson." One early report printed in the *Richmond Enquirer* on August 30 described the capture of "Gen. Moore," which was what insurgents called Hark. Likewise, a newspaper story in early September noted that "Gen. Porter was taken." Henry was assigned the important position of paymaster. At some point the rebels also agreed on a pay scale that paid the leaders more. According to a newspaper report, the rebels had fixed the "pay of the General, say $10 a day, [$]5 to the paymaster, ... and $1 to each private per day."[12]

One other piece of evidence supports the idea that Nat Turner was trying to position himself as the leader of the revolt: by dawn, Turner had selected a sword as his weapon. This was not a weapon that he chose lightly, and he held on to the same sword for more than two months. In fact, it was the only weapon he kept with him while he tried to elude capture. Nevertheless, he must have retained it for a reason other than its usefulness. It failed him the two times he tried to use it, and Turner himself acknowledged that its blade was "dull." He had his choice of weapons, and he chose a dull sword. Despite its obvious drawbacks as a weapon, the sword was more important to Nat Turner for what it meant than for what it could do. The sword suggested authority, and Nat Turner held on to it as a symbol of his leadership.[13] Ordering the other rebels about on marching drills also reinforced Turner's newfound authority. As a general, Nat Turner enjoyed a position of prestige and leadership among blacks, a marked change from his earlier position as a lonely prophet.

As important as the marching was to Nat Turner—it was the only activity that he mentioned in his account of the events at the Travises' farm after the family had been killed—the rebels also took time after the murders to distribute the four guns and several muskets among themselves. They "deliberately cleaned and loaded them" in anticipation of the battles ahead. Likewise, once in the barn, they divided and saddled the horses. The rebels understood the advantages of having the horses—both for speed and for dramatic effect—so they brought them along.[14]

Finally, the rebels had to decide how to handle two of their number. The young slave Moses had witnessed most of what happened at the Travises' home. What would they do with him? When he was examined, Moses recalled "that he had been compelled to go with them." This may have been true, or he may have told this to the court hoping to escape the gallows. The latter seems likely, since Moses did not escape from the rebels during the revolt. On the other hand, no record suggested that he was involved in the fighting. Given his youth, it is plausible that, as a newspaper reported, he was brought "along to hold their horses."[15] By holding the horses, he could aid the revolt without killing anyone.

Jack posed a more vexing problem. Unlike young Moses, Jack was a fully grown man, exactly the type of person the rebels needed to recruit. But his actions, his testimony, and the testimony of others all indicate that from the start Jack did not think that the revolt would succeed. Jack's enthusiasm for the revolt did not increase once the bloodshed began. The other rebels may have realized that Jack was likely going to be useless as a soldier, but they

probably thought that letting him remain behind would be a mistake. By himself, Jack would be free to divulge what had happened, possibly giving the whites early warning. As important, if he deserted, he would have set a precedent that would ensure the destruction of the revolt: they could never build a significant rebel army if potential recruits could simply walk away, as Jack wanted to. Finally, Hark did not want his own brother-in-law to desert before they had left the first house. As a result, the rebels decided, as Moses later testified, to make Jack "go with them."[16]

With Nat Turner as their leader, the nine rebels marched beneath the light of a full moon "about six hundred yards" to Salathiel Francis's farm, where the unmarried Francis lived.[17] When the nine arrived, they had to decide how they would carry out their second nighttime raid. Rather than simply breaking down the door or sneaking in—the two options that the rebels had considered at the Travises' farm—they decided on a different tactic. Will and Sam, who both were owned by Salathiel's brother Nathaniel Francis, knocked at the door. When Salathiel asked who was there, Sam identified himself and explained that "he had a letter on him." Salathiel "got up and came to the door." Once he opened the door, Sam and Will grabbed him, "dragging him out a little from the door." Salathiel Francis died after "repeated blows on the head."[18]

Although Turner later insisted that "money was not my object," he admitted that the other rebels had their own ideas: "A general destruction of property and search for money and ammunition, always succeeded the murders." At this point, when the rebels did not have enough weapons for each man to have his own gun, one would expect the searching for arms to be especially thorough. The fighters also did not know how much ammunition and powder they would need over the hours and days ahead, so the prudent ones would take all that they could manage to carry. Those who had not yet gotten a horse would be able to pick from the four that Salathiel Francis owned.[19]

As important as it was for the rebels to equip themselves, they had an even more important job: they had to recruit new soldiers. Salathiel Francis owned four adult slaves—including two or three men—and a teenage boy. Moreover, Emory Evans, a free black, also lived on Francis's farm. After the rebels killed Francis, they turned their attention to these four or five potential recruits. Their recruiting efforts met with mixed success, at best. "Red" Nelson, a slave on the plantation, who later told some surprising stories about what had happened on the day of the rebellion, claimed to have fled during the initial assault. Even if Nelson had left before the rebels had the chance to try to recruit him, the rebels had the opportunity to recruit three or four of their neighbors, including Evans. Given the size of the rebel forces later, they could not have

gotten more than two, and it is possible that none of the slaves joined the rebellion. There is much more clarity about Emory Evans's decision. Unlike the free black Denmark Vesey, Emory Evans decided not to risk the limited freedom that he enjoyed, and he was still living in Southampton a year after the revolt. The inability of Turner and his men to enlist their free black neighbor was a bad omen in a county where one out of six blacks was free.[20]

After leaving Salathiel Francis's farm, Nat Turner and the rebels went to Piety Reese's farm, which belonged to the family that owned Jack, their most reluctant member. When they arrived at the Reese house, they found the doors unlocked. No contemporary account identified who was responsible for these murders, although Will, "the executioner," may have played a leading role. Will had been involved in every one of the six deaths to that point, and Piety Reese was "murdered...in her bed, while sleeping," much as Will had slain Sally Travis. Nat Turner was also in the house. He recalled that Piety's son, William, awoke as his mother was killed and with his last breath asked, "Who is that?" In an instant, Turner remembered, "he was no more."[21]

As usual, after the murders the rebels recruited and searched for useful items. Like many in the neighborhood, Piety Reese was a small slaveholder—she owned six adult slaves—and the rebels were apparently able to convince one of her slaves to join Jack and the rest of the rebels. One item taken after the murders suggests something about Jack's feelings about the revolt. When Jack was captured, one witness swore that Jack was wearing "a pair of shoes and socks which the witness believed to be William Reese's."[22] However distraught Jack was at the thought of joining a slave revolt, he was less distraught at the thought of his owner's death. Even in the moments after William was killed, Jack was able to remember to take some shoes and socks that he particularly coveted.

As the makeshift squad left the Reese farm and traveled along the dirt roads of St. Luke's Parish, the first morning light was starting to emerge behind them in the eastern sky. The group of a dozen slaves—plus or minus one—was making its way to the farm of Nat Turner's former mistress, the widow Elizabeth Turner.[23] In the *Confessions*, Nat Turner did not explain why they attacked Turner's house. Personal connections at his old mistress's plantation may have led him to believe that he would be able to recruit men from among the nine slaves old enough to work at Turner's plantation. (Two of Elizabeth Turner's slaves joined the revolt.) Or he might have wanted revenge against the woman who had been his mistress and who inherited his mother when his master died in 1822.[24] If he had wanted revenge, one should not be surprised that Turner did not tell his white interrogators about it. As

forthcoming as he was about the revolt, the *Confessions* sensibly protected his family, hiding any inspiration they may have provided to the revolt.

According to the *Confessions*, the rebels reached Elizabeth Turner's "at about sunrise," roughly 5:30 a.m. Up to this point, the rebels had been able to escape detection. Turner himself described how as they traveled to Piety Reese's house the rebels "maintain[ed] the most perfect silence on our march." If they rode the horses they had commandeered, the mounted men rode slowly and quietly, traveling with the men afoot.[25] More surprisingly, the rebels had been able to kill the white members of three households without being detected. Relying primarily on Will's axe, they had killed eight whites.

As the sky lightened, the rebels changed how they conducted their attacks. Instead of focusing on remaining undetected, during the day Nat Turner and the rebels traveled fast. Noise was no longer an anathema, and for the first time they divided into groups to attack and kill different targets. At Elizabeth Turner's farm, one group—including Henry, Sam, and Austin—went to the farm's still, where they found the overseer, Hartwell Peebles. Austin, the recruit who had joined the revolt at the Travis plantation, shot and killed Peebles.[26] For the first time in the records, one of the rebels used a gun. The silence maintained through the night was broken. From this moment, the rebels showed less interest in trying to muffle the sounds of revolt.

Meanwhile, at the main house, Elizabeth Turner and Sarah Newsome may have wondered who had fired a gun so early in the morning. When they looked out of the house, they saw a small contingent of black men—armed and on horseback—approaching. The women immediately tried to barricade themselves in the house, but their task was impossible. Aware that they had been seen and unconcerned about detection, the main force of rebels used the tactic that Hark had suggested at the Travises' house: Will approached the farmhouse and with a single swing broke down the front door.[27]

Against armed slaves, the women were defenseless. According to Nat Turner, the rebels found the white women in the middle of the large front room, "almost frightened to death." Will attacked Elizabeth Turner and killed her with "one blow of his axe." At the same time, Turner attacked Sarah Newsome. He grabbed her hand and "struck her several blows over the head" with his dull sword. Again, as with Joseph Travis, Turner could not kill his victim. Will, turning from Elizabeth Turner's lifeless body, realized that Nat Turner was struggling to kill Sarah Newsome, and Will "despatched her also."[28] Up to this point in the revolt, eleven whites had died, and Will had delivered the death blow to at least six. Moreover, Will had been accompanied by one other rebel when two others died. Two died without any source

noting who killed them, which means that only one of the first eleven deaths—Peebles's—was attributable to someone other than Will.

Once in control of Elizabeth Turner's farm, the rebels would have been able to take anything they wanted.[29] More important, the rebels were able to get two men, Jordan and Davy, to join the revolt. Davy was as surprised by the revolt as his mistress had been. When the rebels had arrived on the farm, they found Davy not even dressed for the day. If, as this evidence suggests, Davy had not known about the revolt in advance, this meant he had little time to decide if he wanted to join the dozen rebels in their quest. Apparently, when the rebels told him about their plan, he hesitated. At this point the rebels resorted to threats. According to the testimony of young Moses, the rebels told Davy "that if he did not join them he should die there." After weighing his options, Davy "put on his clothes and went off with the insurgents."[30]

With the two new recruits, Jordan and Davy, the nine who had left the Travis farm had increased in number to fifteen. They had increased their fire-power and had commandeered nine horses. No longer concerned about the noise made by men on horses, the rebels split up again. The mounted rebels went ahead directly to Catherine Whitehead's, while the six on foot stopped at the home of Henry Bryant on their way to rendezvous with the other rebels. Based upon the record, only one man—the new recruit Davy—can be placed among the six men who walked to Henry Bryant's. No account described what occurred at the Bryants' household, but before long the six had met up with the rest of the insurgents at Catherine Whitehead's. Nat Turner later remembered that the six "informed me they had done the work of death assigned to them." Henry Bryant, his young wife, Sally, her mother, and a child no older than a toddler were dead.[31]

Meanwhile, the main force of rebels on horseback arrived at the Whitehead house at about 6:30 a.m. As the nine men on horseback approached the house, they saw Richard Whitehead already at work in a cotton field. According to Turner's *Confessions*, the rebels beckoned to the minister, and Whitehead approached the insurgents. By the time that Richard Whitehead realized what was happening, there was no way for him to escape the force on horse-back: Will "with his fatal axe" decapitated him. Following Richard's execution, the rebels then headed toward the home of his mother. In addition to Catherine Whitehead, the white household included five of her daughters and a five-year-old grandson.[32]

Those in the household may have had an intimation of what was under way. As the rebel force approached the house, someone fled into the garden. While the small rebel army continued toward the house, Nat Turner chased

the person who was running away. When he caught the figure, he realized that it was not one of the Whiteheads but a "servant girl." He let her go and followed the others, who had already reached the house. By the time Turner made it back to the Whiteheads' plantation house, the rebels had already launched their attack and bedlam had broken out. As Nat Turner approached, he saw Will "pulling Mrs. Whitehead out of the house, and at the step he nearly severed her head from her body, with his broad axe." According to the family tradition, Catherine Whitehead was one of the first murdered. Two of the remaining daughters hid in a bedroom, while the oldest daughter, Margaret (also known as Peggy), made it out of the house.[33]

Margaret Whitehead had successfully evaded the first wave of the rebel assault by silently hiding behind a cellar cap on the side of the house. Although she had escaped the notice of the main rebel force, Nat Turner—who had separated from the main group—saw her as he approached the house. Once Margaret realized she had been spotted, she fled with Turner in close pursuit. He caught her on the edge of a field, where he tried to kill her with his sword. Just as when he attacked Sarah Newsome, Turner was unable to kill. In fact, despite "repeated blows" from the sword, Margaret would not die. Will was not at hand to strike the coup de grâce that he had already delivered twice for Turner, so Turner had to figure out how to kill her himself. Picking up a fence rail, Nat Turner delivered the death blow to Margaret Whitehead, the only person in the course of the revolt whom Turner killed with his own hands.[34]

The youngest of Catherine's daughters also made it out of the house before she was killed. According to the family tradition, which was recorded a year later, the youngest daughter, accompanied by a "young negro girl," Aggy, eluded the rebels and hid in a cornfield. Despite the relative safety of her hiding place, the girl was overwhelmed as she listened to the rebels kill her mother and sisters. Aggy tried to keep her young mistress quiet, but the stress was too much for the youngest Whitehead daughter and, "losing all presence of mind," she began to scream. Realizing that someone had escaped from the house, "the murderers rushed upon her." According to this account, Aggy fought to save her mistress's life, but her efforts were foiled by the rebels, who manhandled Aggy roughly enough to tear off "the strong Virginia cloth dress she had on."[35] While the rebels killed Margaret and her youngest sister, two other sisters hid in a bedroom. When the rebels searched the house, they found one of these sisters. The rebels killed her at the foot of the bed, leaving her corpse "lying dead in the fireplace of her chamber." While her sister was executed, the other sister, Harriet, remained undetected under a mattress. The rebels never found Harriet.[36]

After the Whitehead family had been killed, the six rebels who had been to Henry Bryant's house rejoined the group. Also, sometime shortly after the murders, two more slaves, Joe and another Nat, appeared from out of the woods. The two men had spent Sunday night hunting in the woods, and one of the slaves on the Whitehead plantation later mentioned that the two were carrying a raccoon, presumably in an effort to corroborate the story that they had simply been out hunting. If these two had been hunting, why did they go to the Whitehead plantation? Joe, who had family on the farm, may have regularly stopped at the Whiteheads' before he had to return to John C. Turner's plantation, which was about a mile away. Or, given the early morning commotion on the plantation where Joe's family lived, Joe and Nat may have stopped by to see if Joe's family was safe.[37]

When they arrived at the scene, they discovered the tumult. By this point, Davy, who had joined the rebels at Elizabeth Turner's only after a death threat, had become more enthusiastic about the revolt. One of Catherine Whitehead's slaves recalled that Davy tried to convince Joe to join. Davy explained that he had been "forced to join" but had no regrets. If Joe wanted Davy's advice, he would join, too. Despite vigorous recruiting, Joe hesitated. According to another one of Catherine Whitehead's slaves, Joe "appeared reluctant to go," but finally he acquiesced. Nat, Joe's friend who was owned by James and Elizabeth Turner, also agreed to join.[38] The rebels now numbered at least seventeen.

The Whitehead plantation offers a unique opportunity to examine the effectiveness of the rebels' recruiting. According to the 1830 census, twenty-seven slaves, including eleven children under ten, lived with Catherine Whitehead. The majority of the sixteen older slaves on the Whitehead plantation were women. While some slave women supported the revolt, there is no evidence that the rebels recruited any women to join their army. Because of this decision, the rebels were left with a pool of potential recruits made up entirely of men and older boys, roughly corresponding to the six oldest males listed on the 1830 census.[39]

Different accounts of the events at Catherine Whitehead's record the actions of seven male slaves. One report from North Carolina described how an unnamed Whitehead slave enthusiastically supported the rebels. After the rebels arrived on the Whitehead plantation, this man helped them "in murdering his mistress (Mrs. Whitehead)." He also accompanied the rebels as they traveled across Southampton County. He was with them when they arrived at Parker's farm, and he took an active part in the first battle between the rebels and the whites. When the whites who found him after the revolt back at the Whiteheads' plantation shot him, "he fell dead near the remains of his mistress."[40]

Three other Whitehead slaves were eventually tried for their participation in the revolt. Two of them, Jack and Andrew, left the plantation "before any murder was committed." They returned about an hour later and asked someone—probably one of the slaves—whether the insurgents were gone. According to the story that they told a free black later in the day, the rebels had departed but had left word that the two should follow behind and catch up; "if they did not[,] it should be death." Jack and Andrew apparently took this threat seriously, adding another factor they had to consider as they tried to decide what to do.[41]

Although Jack and Andrew were clearly in shock on the morning of the rebellion, they were not simply scared. Other slaves' testimony implied that Jack and Andrew were also attracted to the rebels' cause. While both whites who testified at the trials swore that the two defendants behaved in a subservient and docile manner, two of the black witnesses saw a different side of Jack and Andrew. When the two left the Whitehead plantation the second time, one of the slaves who remained on the plantation "thought [that] they went to join the insurgents." He was not alone in this belief. Andrew and Jack had followed the insurgents' trail to Richard Porter's house. When they arrived there, they asked Venus, a female slave, "where the black people were (meaning the negroes that had been there)." She explained that the rebels had left. Since Jack and Andrew "did not know what else to do," they told Venus that "they were going after" the rebels.[42] However firm their resolve to join the rebels, their initial indecision cost the rebel army two recruits, as Jack and Andrew never joined the rebel army.

Unlike Jack and Andrew, however, Tom was discharged by the court after his trial, and as was the practice with those released, the evidence used in his case was not recorded. Fortunately, Mary Blackford, an active supporter of the American Colonization Society, visited Southampton in 1832. In her memoir, she recorded the stories that she heard about the revolt, including stories about what had happened on the Whitehead plantation. According to her account, Tom, a young stable hand, was watering the horses when the insurgents arrived. Tom fled with Jack and Andrew, although he testified that he left the other two while all three were "without any understanding" of what was happening on the plantation. After Tom left the plantation, he told people—both white and black—what was happening. He eventually made it to a guardhouse at about noon, where he may have been arrested. Tom was exonerated at his trial, and by the time Mary Blackford made it to Southampton he had been rewarded with "much praise and a certificate testifying to his exertions in saving the lives of so many whites."[43]

While Tom, Jack, and Andrew fled the rebels, Nathan, Hubbard, and Wallace remained on the plantation. According to one report, Wallace, "an old negro man," showed the most incredible loyalty to Catherine Whitehead. When Will grabbed Whitehead, Wallace begged the rebel to spare the "life of his Mistress." The pleas had no effect on Will. After killing Whitehead, the rebels threatened Wallace, who reportedly answered that "he cared not to live now she was dead." Wallace's exclamations reported by the whites sound melodramatic. But he provided no support for the rebels, correctly surmising that the rebels were bluffing when they said that they were going to kill slaves who did not join the revolt. Since Wallace was old, the rebels might have simply decided to let the old man be. Nathan, another slave who was present after the rebels had killed the family, also appears not to have joined the revolt. (He later testified at Davy's trial, telling the court what the band who had been to Mr. Bryant's said they had done there.) It is unclear what Nathan did exactly, but whatever he did, he survived and the whites saw no reason to try him after the revolt.[44]

While Wallace and Nathan refused to join the revolt, the "old man" Hubbard "assisted in saving Miss Harriet." During the murders, Harriet Whitehead had remained hidden beneath the mattress next to the spot where her sister had been killed, and the rebels never found her. Once the rebels left the plantation, Hubbard and some of the other slaves decided to secrete Harriet away from the house in case the rebels returned. As it turned out, the decision was prudent. Sometime after the rebels left the Whitehead plantation, they realized that Harriet had survived. Recognizing their oversight, the rebels sent two unnamed men back to the Whitehead plantation to kill Harriet.[45]

While the two assassins were walking back toward the Whitehead house, the slaves who were trying to help Harriet had placed her in a disguise and were carrying her away from the house. When they saw the two rebels returning, some of the Whitehead slaves "went immediately to meet them & contrived by some means to turn their course." The rebels assigned to kill the last Whitehead were delayed and misdirected until the other slaves could get Harriet to "a swamp near the house."[46] Foiled by the slaves at the Whitehead plantation, the rebels never found Harriet, the only white member of her household who survived the revolt.

Of the seven identifiable potential recruits at the Whitehead plantation, one joined the rebels and three fled, two of whom, Jack and Andrew, later spent some time trying to join the rebel army. Even if Jack and Andrew ultimately made a firm decision to join the rebels, one result of their initial indecision was that they never found the insurgent army. Even more ominously

for the rebel cause, which had gained only one soldier at the Whiteheads', two of the six potential recruits worked against the revolt, in one case saving Harriet and in another spreading the word among the whites that the slaves had risen.

Alliances that transcended race and class have always been a prominent feature of slave revolts, and the numerous and larger slave revolts in the Caribbean give ample support for the idea that many slaves thought that the most reasonable course to pursue during an insurrection was to ally with the people who enslaved them. Even the most prominent leader of the most successful slave rebellion in history, Toussaint Louverture, was undone by an unfortunate alliance he made with a French army that had been sent to Saint-Domingue to reestablish French control and reinstitute slavery.[47] When enslaved and free blacks in Southampton heard about Nat Turner's revolt, a number cast their lot with Southampton's whites, just as Hubbard did.

After the raid on the Whitehead plantation, the rebels again split up. One wing, including Nat Turner, went to Richard Porter's. When they arrived on the farm, they found that the whites "were gone." For the first time in the course of the revolt, the rebels arrived at a farm that had already heard about the uprising. Because of this warning, the two families of whites who lived on the plantation were able to escape, apparently without a minute to spare: "a negro woman ran from a distance to warn them just in time for them to escape to the woods in the sight of the house." Whites later speculated that the rebels might have been able to kill the Porters if the rebels had gotten even the slightest support from the family's slaves. "By a point of the finger of any slaves there, the family might all have been murdered, but so far were they from betraying them they contrived to direct the steps of the murderers in another direction."[48]

The effort by contemporary whites to portray the Porter plantation as another place where the rebels found no support, however, is misleading at best. Unlike at the Whitehead plantation, where the Whitehead slaves actually foiled the rebels' attempts to kill Harriet Whitehead, at Richard Porter's plantation the rebels had significant success in their most important task, recruiting. Thirteen adult slaves lived on Porter's farm, at least five of whom were men. Nat Turner and his army were able to get four of these slaves—Daniel, Jacob, Moses, and Aaron—to join their small force. Recruiting four young men at one plantation made the raid on the Porter plantation the single most successful recruiting effort to this point of the revolt. The rebels had increased the size of their force by roughly 20 percent on just one plantation. Moreover,

these recruits were not simply people who had been cowed into joining the revolt; they appear to have been active rebels. Later that afternoon, when the original conspirator Sam chased and killed two whites who were trying to flee from the rebels, he was joined by Daniel and Aaron, two of the slaves who lived on Richard Porter's plantation. Jacob and Moses likewise were captured after the revolt and confessed that "they were engaged in the late insurrection in this country."[49]

From this point, the exact number of slaves in revolt is impossible to ascertain. At least twenty-one slaves had joined the rebels, not counting Catherine Whitehead's Jack and Andrew, who never found the rebel army. Others not named in the historical record also joined. At the same time, some of the less committed rebels started to melt away. The most reluctant rebel, Jack, for instance, left the rebels sometime in the morning. Knowing that his owner was dead, Jack fled to the farm where he worked. Jordan Barnes had been at work that morning and had already heard about the insurrection when Jack told him that the Whitehead family had been massacred. Jack may have accompanied the rebels to Richard Porter's, but he made his escape before the rebels had met any organized resistance.[50] Others may have also escaped, evading both the rebels and any record suggesting who was involved in the revolt. Even if the rebels lost a few reluctant soldiers, the force that left Richard Porter's was larger, stronger, and more enthusiastic than it had been when it arrived.

Although whites at the time often described Turner as crazy, Turner's decisions as a commander during the revolt itself regularly showed both quick thinking and good sense. As the rebels left Richard Porter's, Nat Turner understood that the rebels' mission had gotten more difficult. They had lost their greatest tactical advantage, surprise. No doubt the alarm that had allowed the Porters to escape was spreading from farm to farm. While the rebels might catch some families unaware, as time passed the chances of this grew increasingly less likely. More important, now that the whites knew about the revolt, they would certainly rally and at some point counterattack. Realizing this, Nat Turner sensibly revisited the decision to divide the forces. He never explained the original rationale, but with two forces the rebels could get to more plantations, increasing the pool of potential recruits and the amount of devastation they could inflict. Now that the whites had begun to assemble their own forces, the small wings of Turner's army would be vulnerable to counterattack. Understanding that the dynamic of the revolt had changed, Turner decided to reunite the two wings of his small army. The main squad of the rebel army left Porter's home with their new recruits and continued on to

Nathaniel Francis's farm. At the same time, Nat Turner headed back to "bring up those sent to Mr. Doyles, and Mr. Howell Harris."[51]

Nat Turner found the group that had been sent to Trajan Doyle's and Howell Harris's out on the road. By the time Turner located this group, they had taken it upon themselves to go to the house of John R. Williams. "Choctaw" Williams, as he was called, had heard the commotion at the Whitehead house and decided to investigate it, leaving "his wife [Louisa] + Deare little child at home while he went to assist his neighbors." After seeing the carnage at the Whitehead plantation, Williams returned to his own farm, but he had been gone too long: "he was met by one of his own negro boys with the horrible tidings that his wife and children had been murdered in his absence." While he was away "they had killed his wife + cut his child's head off."[52]

After killing Louisa Williams and her child, this group of rebels then encountered Trajan Doyle. Doyle was out on the road away from his house when the rebels found him. They killed him on the spot. Hark, who had Doyle's pocketbook with him when he was captured at the end of the revolt, probably led this group. Once Nat Turner found Hark and this group of rebels, he received more intelligence. "Some" men from the neighborhood had joined the rebels, and they told Turner that "Mr. Harris was from home."[53] If Turner had not already decided to skip Howell Harris's plantation, this added piece of information convinced him to keep his wing of the rebel army moving.

Meanwhile, the group of rebels that Turner had left at Porter's had made their way to Nathaniel Francis's farm, where Sam, one of the original conspirators, and Will, the executioner, lived. According to William Sidney Drewry, before the rebels arrived at the Francis farm, a "little negro boy" had come from the Travises' home and told Nathaniel Francis that the rebels "'had killed all the white folks.'" Apparently not understanding that the Travis deaths marked the start of a slave revolt, Nathaniel Francis left his family and went to his neighbor's place to investigate. Soon his mother followed her son, according to Drewry, "to see if she could be of any assistance," although it is also possible that she was looking for a safer place. When Nathaniel Francis's mother departed, she left behind only four whites on the farm: Nathaniel Francis's wife, Lavania Francis; the overseer, Doyle; and John and Samuel Brown, two young orphaned nephews who lived with Francis's family.[54]

Historians have often noted the fear of slaves that slaveholders felt, but what is perhaps more remarkable at this point in the revolt was the nonchalance that some whites showed amid the rumors of murders and rebellion. Even though Nathaniel Francis had gone to investigate the deaths of an entire

family, the remainder of his family was completely unprepared for the rebels when they arrived. According to Drewry, the two young Brown boys were out in the lane when the rebels rode up. The rebels killed them on the spot. When Doyle, the overseer, realized what was happening, he ran into the house and warned Lavania Francis. After telling her about the threat, Doyle tried to flee the house, but the rebels shot him as he fled. All the whites at the house except Lavania Francis were dead. With only moments to prepare herself, Lavania Francis had to decide whether to hide or flee. She decided to hide. Above the first floor in the Francis home, the building had a high roof with a steep pitch. The attic had a low dark area between the room's wall and the roofline, which Thomas R. Gray later described as "a closet." She hid in this closet and hoped for the best.[55]

Sam and Will must have realized that three people who lived in the house had not been killed, so the rebels began searching to see if they could find any other whites. When they got to the closet where Lavania Francis hid, Red Nelson, who was at the farm, told the rebels that she was not there. According to Drewry, Nelson then suggested that she had escaped from the house and told the rebels to look "in the garden concealed by the tall cabbage." The story—probably first told by Nelson to the whites, and confirmed by Lavania—meant that Nelson can be added to the list of slaves who worked to foil the rebels in their efforts to kill whites.[56]

While Red Nelson helped save his late master's sister-in-law, other slaves on the Francis farm showed less concern about their white owners. Two used the chaos brought on by the revolt as an opportunity to take some of the goods denied to slaves. While Lavania Francis was hiding undetected in the closet, two of her slaves, Lucy and Charlotte, took her clothes for themselves. According to Allen Crawford, a former slave born after the revolt who heard about these events as he was growing up in the neighborhood, "They thought...their missus [was] kilt after nobody could find her. Ha, ha, ha so dem gals was standing dar 'viding her clothes and things—argueing who should have dis and dat like you 'omen folks do."[57]

That women were fighting over their mistress's clothes reveals something about the dissatisfaction created by the system of slavery, but for any clear-thinking rebels such a quarrel was a distraction from their mission. The rebels needed more recruits, and on Nathaniel Francis's farm they were able to get several to join the revolt. Before they left the Francis farm, the rebels enlisted four more men, although Moses later testified that three of the recruits were kept under guard. The three unwilling recruits—Nathan, Tom, and Davy— were also young, the oldest "not more than fifteen years, the other two much

younger." On the other hand, the rebels also enlisted Dred, "a negro man slave," a more willing soldier. Before noon, he was "mounted and armed with a gun or rifle." By the time the rebels had left the Francis farm, six of Nathaniel Francis's slaves—including Sam and Will, who had both been part of the revolt from the start—had joined the revolt, making the rebels from this plantation the single largest cohort among Turner's troops.[58]

The advance wing of the rebel force then left the Francis plantation and headed to Peter Edwards's nearby plantation, north of the Francises' home. The Edwardses had heard about the revolt and had fled. Without any potential victims, the rebels ransacked the plantation and built upon their recent recruiting successes. Peter Edwards owned seventeen slaves old enough to join the revolt, and the majority of these slaves were men.[59] As at the Travis and Francis farms, the rebels had more success recruiting where they knew the recruits well. Aided by Nelson, an original member of the revolt who was probably from the plantation, the rebels enlisted three slaves into their growing army. Sam was tried and convicted for his part in the revolt, although he was not an eager participant. Levi Waller, a white who from a hiding spot witnessed much of the carnage at his own home, testified that he "did not see the prisoner [Sam] engaged" in the massacre. Nevertheless, Sam stayed with the rebels for the rest of the day. Two other men belonging to Peter Edwards seem to have been more active rebels. Joseph Joines swore that "he had no doubt that" nineteen-year-old Jim "was guilty of insurrection as charged against him." Better evidence linked twenty-two-year-old Austin to the revolt. After Austin was killed, John Womack remembered finding that "he had a powder guard in his pocket."[60]

With three new recruits, this wing of the rebel army left Peter Edwards's and headed to John T. Barrow's home, less than a mile away. Like others in the neighborhood, the Barrows had been "apprised" that a slave revolt had begun, but they had not made their escape. Although the Barrows had not left, Tom Barrow apparently took advantage of the warning to prepare for an assault, and when the rebels rode up to his house, they found themselves under fire. At first Barrow fired his rifle, but there is no evidence that he hit anyone. Nat—the slave who had been hunting with Joe before they joined the revolt at Catherine Whitehead's—returned fire, aiming at a man who ran the farm where Nat had worked a year earlier. The other insurgents probably added to the barrage, but Tom Barrow survived the volley. By the time Barrow took his last shot from his musket, the rebels were almost on top of him. Tom Barrow tried to hold off the rebels with the back end of his musket, but one man had no chance against dozens of rebels.[61]

Meanwhile, Mary Barrow was making her own escape when the slave Lucy grabbed her and "held her about one minute." Lucy's bold action—for which she would lose her life—is a rare example in the record of a slave woman playing an active role during the killings. In this case, however, Lucy's efforts were foiled by another female slave, who freed Mary Barrow from Lucy and led her mistress to the woods, where she hid. Mary's brother George Vaughn was not as fortunate, and he died on the farm, although no contemporary source described his death.[62]

Having killed these two men, this wing of the rebel army continued north to an obvious destination: the home of Captain Newit Harris. Harris lived on the road that led east, toward Jerusalem. Equally important to the rebels was that Harris was one of the larger slaveholders in the parish. Out of the roughly nine hundred households in St. Luke's Parish, only twenty-two were headed by slave owners who owned at least twenty adult or adolescent slaves. Newit Harris owned thirty-one, which made his the eighth-largest plantation in the parish.[63] Harris's extensive holdings of slaves made him an important man in the neighborhood—evidenced by his title—and made his plantation an important target for the rebels, who desperately needed recruits.

3

To Jerusalem

THE DETACHMENT OF the rebels who killed Trajan Doyle, now led by Nat Turner, followed the destruction left in the wake of the rebel army. At Newit Harris's plantation, they finally rejoined the main rebel force, which had found Harris's plantation abandoned by the whites. When Nat Turner approached the rest of the rebel army, he later recounted, the men "shouted and hurraed as I rode up." The general was back with his army. Flush from their victories, the rebels were enthusiastic about the ease of their revolt. Up to this point late Monday morning, they had met no resistance, except the futile defense put up by thirty whites. Nat Turner—who had been reviled as a pariah when he first told the black community about his messages from the Holy Spirit—was basking in the glory of what appeared to be an incredibly successful revolt. Seven rebels had grown into a small army of about forty men.[1] Perhaps the men who had joined the revolt, whose actions would surely cost them their lives if they failed, wondered if it would really continue to be as easy as it had been so far. All one had to do to overturn slavery, it seemed, was fight.

While easy victories buoyed the rebels' confidence, less obvious issues already suggested some of the problems with the rebels' plan. Turner's assurance that the rebels would "slay my enemies with their own weapons" meant that the revolt was able to begin undetected, but it put the rebels at a disadvantage as the revolt continued. Lacking sufficient guns and ammunition for the battles ahead, the rebels had to spend time trying to collect whatever arms they could find at abandoned plantations. Turner afterward remembered that when he arrived at the Harris plantation, "some were in the yard, loading their guns." At least those who were finding and loading guns were doing what they could to prepare themselves for the battles ahead. Other rebels were more interested in exercising their newfound freedom in ways that did not help the revolt. At Newit Harris's plantation, for example, some rebels "destroyed the house, robbing him [Newit Harris] of money or other valuables." Still "others [were] drinking."[2]

As significant as the practical problems facing the small army were, Turner and the other rebels faced an even greater problem when they tried to get support from other blacks. After the revolt, whites celebrated the "true fidelity" displayed by many slaves during the uprising. When the antislavery writer Mary Blackford visited Southampton less than a year after the revolt, she recorded several "instances of faithfulness" by "the poor negro." With these examples, Blackford hoped to "prove how much goodness and kindness there is in his nature."[3] One need not presume that blacks were especially good or kind to understand why many of them did not join Nat Turner and the other rebels. Some may have thought that murder was no way to respond to bondage or recoiled at the thought of killing people with whom they lived. Others may have thought a revolt foolhardy, not worth the vengeance that the whites would inflict upon innocent black bystanders. Others still may have been cowards. Certainly some thought that the revolt was a tactical mistake, unlikely to attain its ends. For a slew of reasons, then, the rebels struggled to win the support of the black community.

The rebels understood the multiplicity of views of the revolt, even within the black community. Even among those whom the rebels persuaded to join the rebel army, several were unenthusiastic about the revolt. During their trials, many accused rebels suggested that they were unwilling soldiers who had been impressed against their will. This defense was a natural one for men who had been seen with the rebels but hoped to live. What else could they say? But just because it was a sensible defense did not mean that it was always untrue. Joseph William Reese's Jack, Nathaniel Francis's Nathan, Tom, Davy, Benjamin Blunt's Nathan, and Peter Edwards's Sam each offered witnesses who testified at their trials that these men were neither willing recruits nor active rebels. While some of these six may have tried to appear reluctant to the whites only after the revolt failed, the actions of the rebels implied the existence of double consciousness within their ranks during the revolt. The rebels kept the least reliable recruits in the rear of their army accompanied by an armed guard, which was "ordered to shoot them if they attempted to escape."[4] While the men who had been forced to join the rebel army did not help the rebels' cause, the rebels apparently understood that bringing these unwilling recruits along with them meant that the men would have the opportunity to rethink their stance on the revolt and at some point might become more enthusiastic about the revolt, as Elizabeth Turner's Davy had.

A bigger problem for the rebels was their trouble getting slaves on the plantations they visited to join them in the first place. Roughly half of the rebels came from four farms. Fifteen of the rebels came from three farms on which one

of the original five conspirators lived. Richard Porter's farm, where they enlisted four men, was the only other farm where the rebels had any significant success recruiting. Other than those four plantations, the rebels' recruiting efforts were disappointing. At Catherine Whitehead's, for instance, they failed to enlist more than one person. At Newit Harris's large plantation, the rebels' recruiting problems continued. William Sydney Drewry believed that "not one [Harris] slave joined the insurgents," a contention that cannot be easily dismissed. A newspaper article from the time of the revolt noted that "from the chief settlement among them," possibly an allusion to Harris's large slaveholdings, "not a man was obtained." No slave belonging to Harris was ever tried for involvement in the revolt. None were mentioned in any account, and if any were killed, no compensation was sought from the Virginia legislature. Finally, the year after the revolt, more slaves lived on Harris's plantation than had been there the year before. It is possible that a few slaves joined the revolt from Harris's plantation unbeknownst to white investigators, but even that seems unlikely. On the plantation belonging to the eighth-largest slaveholder in St. Luke's Parish, the failure to enlist slaves into the rebel army was a tremendous setback.[5]

The difficulty the rebels had recruiting among the slaves they encountered was overshadowed by a more ominous but less obvious failure: the refusal of slaves who had not encountered the rebels to join the revolt. Although some blacks in Southampton County had a clearer idea of what was happening than some whites, few black men spontaneously joined the revolt. Even those closest to and most supportive of the revolt did not join. Consider, for example, the slaves at Benjamin Edwards's farm. Four adult enslaved men and at least two free black males lived on his farm. These six men were not part of the revolt, but they were among the small group of blacks who heard about it the day before it got under way. (Possibly this was because of close connections to the blacks on Peter Edwards's farm. Berry Newsom, a free black indentured to Peter Edwards, was on Benjamin Edwards's farm the day the revolt began.) When Henry heard "that Capt. Nat was going to collect his company and rise and kill all the white people," he "declined" to join the revolt. Others, however, were more enthusiastic. Later that week, multiple witnesses testified that Hardy, Isham, and Berry Newsom "said that they would join" the rebels when they returned on Wednesday or Thursday. Hardy stated that the blacks had been "punished long enough." Newsom vowed that he would "be a revered soldier." Despite a clear willingness to join the revolt if asked, no one from this farm took the initiative to join the revolt on his own.[6]

With only a few potential exceptions—Thomas Haithcock; Joe and Nat, who joined at Elizabeth Turner's; and Thomas Barrow's Moses, who would

join the rebels as they were on the road—blacks did not join the revolt spontaneously. Whites at the time boasted about this pattern. Less than a month after the revolt, one correspondent from Southampton noted that "there was not an instance of disaffection, in any section of our country; save on the plantations which Capt. Nat visited."[7] The contrast to the whites' ability to muster a force is striking. Those whites who believed the stories of the revolt fled to any safe haven they could find. White refugees flooded towns, crossroads, bridges, and stronghouses. As a result, many white men were able to take the field in a relatively short time. Against white forces that would mass from throughout Southampton County and many parts of Virginia and North Carolina, a rebel army that could recruit only as fast as it could travel was doomed.

Despite these bad omens, the troops of the unified army were in high spirits as they left Harris's plantation. Heading east toward Jerusalem, they next went to Levi Waller's plantation, which included a home, an ironworks, and a school. Like other whites on nearby plantations, Waller had already heard about the revolt, but he did not flee. Instead, when he heard the news that there was a rebel army in the neighborhood, Waller sent his son Thomas to the schoolhouse to warn William Crocker, the schoolmaster, about the insurrection and to tell "his [other] children to come home." As directed, the children left the schoolhouse. After the schoolchildren arrived at Waller's house, Waller sent Crocker to the house to load the guns. Before Crocker could assemble the weapons, however, he spotted the rebel army. Crocker ran to the still where Waller was and announced the frightful news.[8]

When the rebel army came into view, Waller and Crocker found themselves in an impossible situation: not only did they face a large rebel army that had already killed dozens, but they were split off from the rest of Waller's family and the other students from Crocker's school. Any hopes they had of defending the children disappeared when Waller and Crocker themselves were spotted by the rebels and forced to flee for their lives. Despite some close calls, both Crocker and Waller escaped from the rebels.[9] Waller's wife and the children in the house were not so lucky. His wife and a child were killed when three rebels trapped them in a log house that was on the property. Another child was killed when Peter Edwards's Nelson "knock[ed] one of the family's brains out with the but[t] of a musket." As at the Travises', the rebels remained steadfast in their original decision to spare no one, and Waller's youngest child died from injuries two days after the attack. All told, eleven whites, including ten children, died during the attack. Although this was the bloodiest single raid staged by the rebels, at least one girl managed to survive. According

to a letter written by James Hampden Pleasants, who visited the homestead two days after the raid, "One small child in the house at the time, escaped by concealing herself in the fireplace, witnessing from her place of concealment, the slaughter of the family, and her elder sisters among them."[10]

Waller himself fled only far enough to escape. Once he eluded his pursuers, he circled back toward his home. From a patch of weeds "in the corner of fence," he witnessed the slaveholders' worst nightmare: he watched "his whole family murdered in the yard within two rods of him." Not many people have ever found themselves in the situation that Levi Waller was in late in the morning of August 22, 1831, and it is not surprising that a letter written soon after the revolt described how Waller was "ra[vin]g distracted." But on the day of the revolt, he was a persistent witness. Even after being spotted and chased a second time, Waller doubled back and hid in a plum orchard to watch the rebels celebrate their successful raid. His own slave Davy, who had not been around when the rebels struck, returned to the plantation and appeared pleased with what was happening. According to Waller, after Davy returned to the plantation, he "dressed himself clean—drank with them—rode his master's horse off in good spirits—was called brother *Clements* by one of the company—left there in great glee."[11]

While most of the rebels celebrated, at least one was having second thoughts. Sam, who had been enlisted on Peter Edwards's plantation, seemed upset at the developments at Waller's plantation. Waller had not seen Sam involved in the murders, and afterward Waller noticed Sam "some distance" away "wiping his eyes." When the rebels got ready to leave Waller's plantation, Sam "seemed disposed to remain," but Nat Turner went over and told Sam "to get on his horse." After hesitating, Sam obeyed the order; he "did get up and go off with them." Even reluctant recruits respected the authority of General Turner. Turner was not simply one of the principals of the revolt; he was its leader. According to Waller, he "seemed to command the party... [and] gave the command to the party to 'go ahead,' when they left his [Waller's] house."[12]

As the rebels resumed their path east toward Jerusalem, Turner ordered that his men bypass "a house where some very poor people lived," adding that these whites "thought no better of themselves than they did of the negroes." The decision to spare this family, however, seems to have been an exception, in part because the way the rebels traveled left little opportunity for Turner to make such judgments. In order to prevent whites from escaping, Turner placed the men who were "best armed and most to be relied, in front." These enthusiastic soldiers then executed quick raids, killing any whites they found. At many of the farms, the people who were around in the middle of a workday

were women and children. At Caswell Worrell's, the rebels found Worrell's wife and child. At Jacob Williams's, the rebels killed Williams's wife and two young sons. The rebels also killed Edward Drewry, who was working in Jacob Williams's barn.[13]

At one house, William Williams's, Turner's assault troops surprised the entire family. While the rebels killed Williams and two boys, Mrs. Williams tried to make her escape. Although she made it "some distance" from the house, Mrs. Williams did not get away. When the rebels captured her, they decided not to kill her on the spot. Instead, they brought her back to her farm. "After showing her the mangled body of her husband, she was told to get down and lay by his side, where she was shot dead." It is unclear why the rebels did this. Perhaps they had a personal animus toward Williams, but it may have just been the way that the rebels decided to handle the killings as the revolt went on. At Waller's, the rebels piled the bodies of their victims "in one bleeding heap on his floor." Turner himself, whose *Confessions* provided the best insight into the rebels' thinking, offered no explanation, but that might have been simply because Turner was not there. According to the *Confessions*, "I never got to the houses, after leaving Mrs. Whitehead's, until the murders were committed, except in one case."[14]

As the rebels traveled, they kept recruiting. When the rebels found Edward Drewry measuring corn, he was working with Stephen, a slave, and the rebels were able to convince Stephen to join them. They also ran into Moses, who belonged to the recently killed Thomas Barrow. Moses was out on the road. He claimed that Newt Drew had sent him to Rebecca Vaughn's to "see what the news was," although Drew disputed that, saying that he had "ordered him [Moses] to go home." Whatever the reason Moses was on the road, there is little doubt about what happened when he encountered the rebels: Hark remembered "that the prisoner [Moses] joined them voluntarily."[15]

The rebels also enlisted Jacob Williams's Nelson. Caswell Worrell, Jacob Williams's overseer, believed that Nelson had known about the revolt before it began. On the Thursday before the revolt, Nelson had told Worrell to "look out and take care of themselves that something would happen before long." Moreover, on the morning of the revolt, Worrell found that Nelson was not at home when everyone else went off to work. When Nelson eventually showed up on Monday, he complained to Worrell that he was too sick to work. He asked Worrell to take him home, which Worrell later interpreted as a ruse to deliver Worrell into the rebels' hands "that he might be killed." Nelson's owner, Jacob Williams, also had the odd sense that "the prisoner had some intention of attacking him."[16]

Whatever Nelson's connection to the revolt, his actions indicate that enthusiasm did not necessarily translate into meaningful support for the revolt.[17] If Williams and Worrell were right about Nelson's intent to kill them, then the most remarkable thing was that both men lived, even though the rebel army actually showed up on Williams's farm. Even worse than Nelson's inability to kill was his inability to recruit. Worrell mentioned that Nelson went out to get Caswell Worrell at "the new ground where the rest of the negroes were at work," but there is no indication that Nelson did anything to get these other blacks to join the rebellion. It is impossible to say exactly why Nelson was unable to kill either of the men or why he did not even try to convince other slaves to join in the revolt, but the detailed testimony about Nelson's actions describe how he spent most of his energy doing things tangential to the rebels' mission. Like some other rebels, he used the rebellion as an opportunity to eat the whites' food and drink their cider. Unlike the other rebels, he decided that the rebellion was the opportunity to wear "his best clothes," something so remarkable that all four people who testified at Nelson's trial commented upon it.[18]

With their new recruits, the insurgents traveled to Rebecca Vaughn's house. It was midday when the vanguard of the rebel army approached Vaughn's house. At the time, Rebecca Vaughn was on her front porch giving "directions to a servant who was peeling peaches for dinner." When Vaughn and her slave saw the cloud of dust raised by the approaching army, Vaughn asked "what it could mean." As the company of mounted men emerged from the cloud, Vaughn's question was answered, but there was little she could do to escape. She ran into the house. After the rebels dismounted and surrounded the house, Vaughn appeared at the window and begged that the rebels spare her life. The rebels responded unambiguously: the first shot missed, but another killed Vaughn just as she was "inviting them to take everything that she had." Rebecca Vaughn's daughter, Eliza Ann Vaughn, was also trapped in the house. She, too, implored the rebels to spare her life, but when she burst from the house, twenty-one-year-old Marmaduke shot her. When Rebecca Vaughn's teenage son heard the commotion at home, he left the still where he was working to investigate. As he climbed a fence that separated the still from the house, the rebels shot him, too.[19]

After celebrating another successful raid, the rebels—who now numbered fifty or sixty—mounted their horses. Nat Turner was eager to get to Jerusalem, where he thought he could "procure arms and ammunition," but the rebels would be able to take the county seat only if they got to the town soon. If the whites had time to organize and prepare a defense, there was no way a few

dozen poorly equipped and untrained men would be able to take the town. As a result, as the rebels rode toward Jerusalem, Turner wanted to bypass the farms that had been abandoned by whites, but when the rebels got to James Parker's place some of them wanted to stop. They had relatives among Parker's slaves, and these rebels thought that they could get their relatives to join the revolt. With at least four young men on the farm, the opportunity to add to the rebel army was compelling, so Turner relented. He agreed to let the main force of rebels head to the farm, which was situated about half a mile from the road. Eager to continue the advance toward Jerusalem, Turner remained at Parker's gate with seven or eight of the rebels.[20]

The fact that Nat Turner did not join the recruiting party at Parker's farm fits a surprising pattern that has gone unnoticed.[21] After the meetings of the five first conspirators in early 1831, there is no account—even in the *Confessions*—of Turner recruiting any of the rebels himself. During the revolt, Turner's ability to recruit was limited by his position. As the small force wended its way toward Jerusalem, its general rode in the rear of the army. As a result, Turner was not among those rebels who first encountered the potential recruits. Although some of the new recruits may have joined simply because they heard that Nat Turner was leading the revolt, the fact that he was not with the rebels who first asked slaves to join them increases the likelihood that the recruits joined for different reasons. Like Will, some may have joined out of their hatred of slavery. Like Jack and the potential recruits at Parker's farm, some may have joined at the instigation of family and friends. They may have joined for the chance to carry guns, to dress and eat well. They may have seen the revolt as a path that led to freedom, whether permanent or just long enough to get drunk. Some may have even joined to save themselves from the retribution that the rebels threatened. Whatever inspired the new recruits to join this revolt, one thing is clear: at Parker's place and elsewhere, the new recruits did not join because Nat Turner asked.[22]

While Turner and the others at the gate waited for the larger part of the rebel army, the main force failed to reappear. As it turned out, when the rebels had arrived at the farm, they splurged on Parker's brandy, apparently forgetting that Turner wanted to get to Jerusalem as soon as possible. Time was slipping away, and Nat Turner, back at the gate, was becoming increasingly "impatient." Eventually he could wait no longer. He left the small group of rebels at the gate and headed across a hill to rally the larger contingent of rebels who had been waylaid at the farm.[23]

Soon after Turner left the road, a force of about sixteen to eighteen whites under the command of Alexander P. Peete arrived at Parker's gate. Not from

the immediate neighborhood of the revolt, Peete lived in St. Luke's Parish near enough to the revolt that he was among the first to respond. Although no sources describe how this force assembled or organized itself, it is not surprising that the man who assumed command of the first white forces to respond to the revolt was himself a major slaveholder. Peete owned thirty-one slaves, not counting the two free blacks who also lived on his plantation. (None of Peete's slaves seems to have participated in the revolt.) Peete was also a magistrate. Although he does not seem to have had any formal authority in the Virginia militia when the revolt took place, a month later Southampton's court commissioned Peete "as Captain of Cavalry in fourth Regiment."[24] Peete and the men who joined him had followed the rebels' trail from Newit Harris's plantation along the road to Jerusalem.

When Alexander Peete and his forces arrived at Parker's gate, they came within sight of the small group of rebels who had been left by Turner when he went to rally the group at Parker's farm. When these rebels spotted the approaching armed whites, they scattered. Given the numerical advantage that the whites enjoyed, this made sense, but since none of the men headed back to the main rebel force, it seems that the rebels were not simply making a tactical retreat. A generation later, Civil War soldiers would describe the awesome experience of entering battle metaphorically as "seeing the elephant," and the rebels seem to have responded as did many people who found themselves in battle for the first time: they ran away.[25]

The confidence of the white militiamen must have been buoyed by the ease with which they dispersed the first rebel force they encountered. They turned off the road and headed down toward the main rebel army, hoping that the revolt could be put down in just a matter of minutes. Peete, however, apparently understood a real danger. After his men fired their guns at the main rebel force, his force would be vulnerable to a counterattack before they could reload. He ordered his men to hold their fire until they were within thirty yards of the rebels, hoping both to get maximum effect from the volley and to buy enough time to reload their weapons.[26] If the rebels—who had a force twice the size of Peete's—rallied before the whites could reload their guns, there was little the whites could do to prevent their force from being destroyed.

The battle on Parker's field began badly for the whites. Peete's intelligent order to hold fire was ignored by one of his men, who fired at the rebels from about a hundred yards. With the shot, any of the rebels who had not yet seen the militia that was heading their way looked up and realized that a new phase of the revolt had begun. The first response of men on both sides—none of whom had ever "seen the elephant"—was the same: they panicked. Many fled.

In one of the earliest surviving descriptions of this battle, an anonymous author noted obliquely that "very few" of the whites "came into action." Likewise in the *Confessions*, Nat Turner observed that as he ordered the rebels forward, he "discovered about half of them [the whites] retreating."[27] The fleeing of these whites meant that a remnant of the white force was left facing a rebel force several times its size.

Many rebels were no less terrified than the whites; Nat Turner acknowledged that his men "appeared to be alarmed." A white force was approaching, and the rebels were unready for battle. Turner quickly assumed his position as the leader of the revolt and ordered his men to halt and form ranks. Some of the main rebel force probably fled at the first sight of the whites, but the steady influence of the bravest and most committed rebels ensured that their army was not routed by a smaller force that had fired only a single shot. The efforts to rally the rebels worked. Sampson Reese, one of the white soldiers at the battle, remembered seeing the rebels fighting "in a body" together.[28]

After the rebels collected, Nat Turner called for his troops to attack. They advanced toward the handful of white militiamen who held their ground. When the rebels came to within about fifty yards of the whites, the whites fired a volley. It is unclear how effective that volley was, but the white force— with no time to reload—now faced an organized and deadly rebel army. The white soldiers had no option but to retreat, and the rebels began pursuit. The rebels won the field and caught several militiamen, whom, as Turner recalled, "we thought we left dead."[29] As the rebels chased the whites back toward Parker's gate, they must have hoped that they had a chance of annihilating the entire white force.

The rebels' hopes were groundless. As the rebels chased the white militia back toward the road, the slaves ran into an ambush. Apparently, when the battle began at Parker's field, a second white force in the area heard the sounds of fighting. They had previously arrived at Parker's gate and set up a line. As the first white force was forced to flee from the rebels, this second group of whites was able to stop the rebels' pursuit, saving the life of at least one of the white militiamen who had been unseated by the rebels. The rebels were shocked by the ambush from this second group. In fact, even months after the battle, Nat Turner still had not figured out what happened. He thought the ambush had been prepared by the militia that he saw first, which had "fallen back to meet the others with am[m]unition," and he never suspected that a second group of whites had arrived.[30]

Because Turner misinterpreted what had happened, he made a critical mistake. Not realizing that the rebels were now fighting two different groups,

he did not understand that the rebels had defeated the first contingent of whites. He thought the rebels had done little more than witness a tactical retreat of half of Peete's men. In fact, between the militiamen who fled as soon as the rebels saw them and those who fought the rebels, the first white force had been soundly defeated. Underestimating the rebels' initial victory and overestimating the discipline of his opponents, Nat Turner saw the effect of the ambush by the second group of whites and decided that his men could not dislodge the whites. While the rebels fled, Turner remembered, "the white men pursued and fired on us several times." Turner escaped the white pursuit and even saved the life of Hark, who was in danger of being captured by whites when the horse he was riding was killed.[31]

While a letter written a month later reported that seven blacks died during the battle, Nat Turner recalled that no rebels were "left on the field." Even if Turner's assessment was right, the defeat was damaging enough to the rebels' cause: since the first white force appeared at Parker's gate, the rebels had lost most of their men. A crew of fifty to sixty men had been reduced to a force of about twenty in a matter of minutes. Yet as bad as the defeat was for the rebels, the simple headcount probably overstates the damage to the rebel force. One suspects that some who had been separated from the main rebel force wanted to continue fighting and would when they had another chance. Some of the losses also included those who had joined the revolt under duress and had never fully committed themselves to the rising. Moses, the young slave who had been brought along from the Travises' plantation, admitted that he left the rebel army after "the insur[ge]nts were repulsed by force to retreat from Parker's field." Sam—the rebel who had been crying at Levi Waller's before Nat Turner ordered him to rejoin the rebels—also made it home to Peter Edwards's plantation a couple of hours after the battle, leading the whites to conclude that he likely left the rebels "at Parkers field after the insurgents retreated."[32] Perhaps Turner had similar thoughts, because he seemed more discouraged by the wounds suffered by "several of my bravest men" than by the decrease in the size of his force.[33]

Even after the defeat at Parker's farm, Nat Turner did not give up on his hope of reaching Jerusalem. If he could quickly reassemble his force, Turner believed, the rebels could cross the Nottoway River and "attack that place [Jerusalem] in the rear." Since the whites were focused upon the road from Parker's, the rebels would be able to enter the poorly defended town. Turner's revised plan gauged the white response perfectly. After the news of the battle reached Jerusalem, most of the white men in Jerusalem made their way west toward Parker's farm. This left the town full of women and children "guarded

by only a few men." The only problem with this plan was that Turner thought that the rebels needed to gather "a sufficient force" to launch the attack on Jerusalem. Turner hoped that he would be able to rally those rebels who had fled at Parker's farm, but his efforts that afternoon were largely unsuccessful. At one point the rebels came across "two or three" stragglers who told them that the others had "dispersed in every direction." Unable to reunite his army, Turner decided that his plan "to proceed to Jerusalem" was "in vain," and he called off the attack.[34]

For a second time since the defeat at Parker's farm, Nat Turner revised his plans. Instead of executing a flanking maneuver and attacking Jerusalem from the southeast, Turner decided that the rebels should return to the places where they had first found those who joined the rebellion. Turner guessed that many of those who had joined the rebel army would return to their homes. As a result, if the main rebel force went away from Jerusalem, he believed, the former rebels who had fled "would rejoin me" and others who had not been a part of the revolt would enlist.[35] Amid the chaos that followed the first battle, Turner planned to rebuild his army before returning to Jerusalem.

As Turner and the remaining men turned away from Jerusalem, their retreat took them through a part of Southampton County that they had not visited. Despite the opportunity that being in a new place provided, the rebels were unable to accomplish their two most important goals: either killing more whites or recruiting enough rebels to take the place of those whom they had lost. Following the battle at Parker's farm, the rebels were unable to find any whites to kill. Turner himself recalled that the rebels stopped at "Mrs. Spencer's house and several other places," but he admitted that they killed no one, "the whites having fled." Turner did not know that the rebels came close to catching some whites—including, ironically, the future Union general George Thomas—but, unlike earlier in the revolt, all the whites whose paths crossed the rebels' were able to escape.[36]

The rebels had more success recruiting, but that was also limited. When they left Parker's field on Monday afternoon, the rebels numbered about twenty; when they arrived at Thomas Ridley's slave quarters on Monday night, there were about three dozen. Even an estimate of sixteen recruits, however, may overstate the ability of the rebels to enlist new men, since some of those who had been separated during the confusion after the battle at Parker's farm may have found their way back into the rebel fold.[37] The rebels' difficulties with recruiting continued at Thomas Ridley's plantation. Ridley owned 150 slaves, a large holding anywhere in the South and the second-largest in St. Luke's Parish. Ridley's slaves included more than forty young men, but the rebels were only able to convince four of them to join.[38]

The failure of the rebels to win many recruits is not surprising. From the start of the revolt, recruiting had been difficult, and recent developments had done nothing to make recruiting easier. The ragtag group of about three dozen sleep-deprived rebels, including some who were wounded, must have been less impressive than it had been earlier in the day, especially to those potential recruits who had seen armed white men organized in pursuit. Also, the news of the militia's victory at Parker's gate must have been included among the confused stories that spread around the neighborhood on the day of the revolt. Finally, after an exhausting first day in revolt, the rebels themselves may have put less energy into recruiting. Taken together, these developments made it less likely that new recruits would join.

Despite these problems, Turner still commanded a dangerous force, and he decided that Ridley's large slave quarters provided a sanctuary where the rebels could rest. Coincidentally, many whites who had fled from their farms when the news came of the rebellion had also fled to Ridley's plantation house, so this meant that on Monday night the rebels and whites had each set up a base on different parts of the same plantation. Turner—whose intelligence during the revolt was generally reliable—confessed that he knew that there was "a company of [white] men there," but he guessed that the whites were no more ready to attack than he was. Turner ordered that the rebels set up pickets, and then he went to sleep. At some point, the whites at the plantation house realized that the rebels were on the plantation, just a few hundred yards away. As Turner predicted, the whites at the main house decided not to attack the rebels. Reports of the rebels' camp also made it to Jerusalem early Tuesday morning, but when someone proposed that they attack the rebels, "families" in Jerusalem "were strongly opposed to it." The white forces remained in Jerusalem overnight.[39]

Not long before dawn, one of the rebel pickets detected something beyond the perimeter. He sounded "the alarm that we were about to be attacked," a pronouncement that led to "great confusion." When Turner awoke, he found some rebels panicking and others mounted and ready to fight. Turner settled his men down and ordered a contingent on horseback to go see if there was cause for the alarm. This sensible order backfired: after finding no reason for panic, the search team returned, but the nervous rebels in the camp mistook the returning rebels for a white force. Many rebels fled. Between the two false alarms, the rebels lost half their men. Again, Nat Turner's army was reduced to a force of twenty stalwarts.[40]

With those rebels who remained, Turner decided to resume his campaign. He understood that they had to find more men, so, under a full moon, the small rebel army struck camp and left Ridley's plantation heading west, toward the

places where they had been more successful in recruiting. Shortly before dawn on Tuesday, his army arrived at Samuel Blunt's plantation, where there may have been as many as twenty potential recruits. Nat Turner and the rebels assumed that Blunt and his family had fled—perhaps, as Turner guessed, to the main house on Ridley's plantation.[41]

Unlike so many of Turner's guesses, this one turned out to be wrong. The rebels probably had their first sense that things were not quite as they expected even before they got to the house. As they approached Blunt's house, a pair of figures darted from the house. Moses, one of the men who had joined the rebels shortly before the battle at Parker's farm, rode ahead of the other rebels and chased the two shadows. He caught one but found out that it was Mary, one of the family's slaves. The other figure, probably the Blunts' daughter, escaped. While Moses chased Mary and the child into the garden, the rebels—with Hark in the lead—approached the house. No longer convinced that the house had been abandoned by the whites, Hark fired a shot at the house. The shot was answered in kind. Unfortunately for the rebels, six men— the three white men who lived at the plantation and three neighbors—had gathered to defend the house. Each of the six men had his own gun, and they had "plenty of powder and shot." Although Blunt himself was sickly, he kept the last gun for himself, "resolved[,] if the house was forced[,] to sell his life as dearly as he could." The other five engaged the rebels, each taking his turn to shoot while the others reloaded. By the time each of the five had fired once, Hark had been shot and the rebels—who had gotten within fifteen or twenty steps of the house—pulled back.[42]

The unexpected skirmish was a serious setback for the rebels. To make matters worse, as they retreated, the rebels were pursued by a new opponent: the slaves whom the rebels had intended to recruit. As the rebels reeled back, Blunt's slaves—who according to one account had been "armed," perhaps with farm tools—counterattacked. Several contemporary correspondents emphasized the importance of Blunt's slaves. One described how Blunt's slaves "repelled the brigands." Another hyperbolic report suggested that when the rebels arrived "they were met by the Doctor's own servants, who resolutely opposed their entrance, declaring that they would lose every drop of blood in defense of their master and his family." Blunt's own account gave his slaves less credit but acknowledged their support after the rebels had been forced to retreat. He admitted that his slaves enthusiastically pursued the rebels "with shouts and execrations."[43]

The rebels, who were surprised to find any whites at all, had no intention of renewing a fight with a group of armed whites supported by Blunt's slaves.

The rebels' losses were mounting. Nat Turner recalled that his force had lost several men at Blunt's. A slave who saw some of the rebels later that day recalled that they told him that two of their number had been shot at Blunt's. An early newspaper report reduced the number of the rebels' casualties, describing how the rebels "were finally routed, leaving one of their party and two horses," presumably those of Moses and Hark, "behind them." What one might expect to be the most reliable account—the one that Blunt and his son told John Hampden Pleasants, the editor of the Richmond *Constitutional Whig*—tentatively described the results of the attack. The rebels retreated after the fifth shot, "leaving one killed (we believe) and one wounded (a fellow named Hark)."[44] It is a measure of the confusion of the time that an account from one of the principals could not say whether a rebel was killed, even as it specified the number of shots fired and Hark's name.

The revolt was entering its final stages, but the only contemporary evidence of the rebels' state of mind at this point suggests that Nat Turner and his men had not lost their bravado. One black man who encountered the insurgents during the day on Tuesday recalled them describing for him their defeat at Blunt's. Instead of cursing the misfortune, the rebels looked forward to revenge. They boasted that they would return to Blunt's that night "and they would see if he and his company could keep them out of his house."[45] Perhaps they hoped to revisit Blunt's when they had recruited enough men to renew their attack on Jerusalem.

For the time, the rebels continued heading west, retracing their steps toward Newit Harris's, knowing that they needed to recruit more men to augment their dwindling numbers. It seems unreasonable to think that a defeated rebel army could expect to recruit any better at Harris's than they had on Monday, but the rebels now had a small number of options, none of which were very good. More and more armed white men were looking to fight the rebels. The whites had even enlisted some other blacks in the fight to suppress the revolt. Against these much larger forces, the rebels needed more soldiers quickly, and on Tuesday they focused their efforts on recruiting at the largest plantations in the parish. It was probably still morning when the small rebel force arrived at Harris's. When they arrived, they found a "party of men at the house." The rebels immediately fled, with the white men in pursuit. No contemporary account described the ensuing events at Harris's plantation, although William Sidney Drewry reported that the Greensville cavalry killed Will there.[46]

Even after suffering multiple defeats, those who were not killed or captured had not yet given up on the revolt. Stephen and Curtis, two of the rebels

who had joined at Ridley's, were captured later that day and testified that "the leader of the insurgents" told them "to go to Newsoms and Allens quarter to get other negroes to join them." This testimony, which was given by the man who captured Stephen and Curtis, has no other confirmation in any other source. Yet the story is believable in light of the rebels' actions on Tuesday. The three plantations that the rebels visited on Tuesday—those of Ridley, Blunt, and Harris—were, respectively, the second-, sixth-, and eighth-largest in St. Luke's Parish. According to this story, Curtis and Allen were sent to recruit at Newsom's and Allen's, the fourth- and first-largest slaveholdings in the parish. Allen—an absentee plantation owner—owned more than one hundred working-age slaves on his plantation in St. Luke's Parish.[47]

Stephen and Curtis were drunk when they were captured on Tuesday, but another detail from their testimony makes their stories appear believable. After they confessed to their mission, John C. Turner—the owner of the rebel Joe—remembered asking Curtis "how he expected to get to Mr. Newsom's." Curtis replied that Nat Turner "had told him the white people were too much alarmed to interrupt them." (Evidently, Turner was wrong: John Turner detained Stephen and Curtis when he realized that they were not on their "way home" but were heading "in the opposite direction.")[48] Nat Turner may have been wrong, but this was exactly the kind of gamble that he had made when he and his men spent the night at Ridley's slave quarters. He apparently understood that the odds were against him, but he believed that white confusion and fear created opportunities for the rebels.

After Nat Turner escaped from the whites at Harris's plantation, he found himself with only two other rebels: Jacob, who had been recruited at Richard Porter's plantation, and Nat, who had emerged from out of the woods after the rebels had attacked Catherine Whitehead's. The three spent Tuesday afternoon evading white patrols, and that evening Turner came up with his final and least sensible plan. He told Jacob and Nat to find Henry, Sam, Nelson, and Hark and bring them and "all they could" rally to Cabin Pond, where Turner promised to meet them. With his closest allies and new recruits, he hoped to begin the revolt all over again. Obeying Turner's final order, Jacob and Nat left.[49] Nat Turner, who had been briefly the unquestioned leader of one of the largest armies of slave rebels that the United States had ever seen, was now alone. The revolt was over, but it left Southampton County in chaos.

4

Where Are the Facts?

AS THE REBELLION was collapsing on Tuesday morning, Stephen and Curtis—the two slaves whom John C. Turner had detained—provided whites with some of their earliest intelligence. When Stephen and Curtis confessed, they admitted that they had been commissioned by the "leader of the insurgents" to recruit at two of the largest plantations in the county. Then they added that they had been ordered to meet up with the rest of the rebels that evening at Samuel Blunt's plantation, where the rebels wanted to avenge the morning's ambush. Although Stephen and Curtis were intercepted before they could recruit anyone, whites who heard their confessions surmised that the other rebels were planning a renewed attack on Blunt's plantation, perhaps even with reinforcements if some rebels had succeeded where Stephen and Curtis had failed. Given this possibility, the whites decided to reinforce the men already at the plantation. Alexander Peete—the man who led the first group of white militiamen to encounter the rebels—took about ten men to go "to Blunt's home and defend it if it should be attacked."[1] These reinforcements brought the total number of white men defending Blunt's plantation to sixteen, not counting the plantation's rheumatic owner.

This force was significantly stronger than the one that had repelled the rebels on Tuesday morning, but the whites still feared that even these reinforced defenses might not be strong enough to hold off the rebel army. Perhaps drawing on their experience from the first attack at Blunt's plantation, the whites did one more thing to prepare their defense: they decided to arm Blunt's slaves. Although whites would later use the events at Blunt's plantation to tout the loyalty of the slaves, during the revolt itself whites saw black support as uncertain. Blacks on the plantation swore fidelity to the whites, but whites at the time understood that this loyalty was conditional. And while concerns with black loyalty were not enough to prevent whites from arming these slaves—it is a fair sign of the confusion and uncertainty that a day after whites had defeated the rebel army, whites were still so afraid of rebel slaves that they armed slaves they did not trust completely—the whites were

not oblivious to the possibility that Blunt's slaves would join the rebellion after the whites handed out the guns. To reduce the opportunity for the armed slaves to defect, the whites restricted the blacks' access to the guns to those times when they thought an attack was about to happen. At all other times, the whites kept the arms that they had set aside for the slaves under guard near the front door.[2]

The rebel army never returned to Blunt's plantation, but that did not mean that the guns remained neatly stacked through the night. Several times word came that the rebels were near. In response, the whites armed the slaves and waited. Nothing happened. When the whites were satisfied that their fears of an impending attack were unfounded, they collected the slaves' weapons and reestablished the guard that kept the guns. Early Wednesday morning, just before dawn, the alarm sounded again. The blacks on the plantation went to pick up their guns and took their places as they waited for the rebel army to appear. It was at this point that one of the whites, "a young man by the name of Harris," spotted a slave belonging to J. Drew Fitzhugh with a gun in his hand. Harris shot and killed Fitzhugh's slave.[3]

In this episode at Blunt's plantation, one can see one of the most important things about the time immediately after the revolt: no one knew what was going on. An early account in the *Richmond Enquirer* noted, "Nothing is known with certainty." Another frustrated newspaper editor from Richmond complained, "There are reports in abundance—but where are the facts to be relied on? A thing is stated at one moment—the next, it is confirmed—and then again it is contradicted." No one should be surprised that reports arriving in Richmond were confused, but this editor insisted that the uncertainty was "even the case in Jerusalem, where there are almost as many rumors as there are facts."[4]

Prussian military theorist Carl von Clausewitz—who, coincidentally, died less than a week after Nat Turner—used the metaphor of "fog" in his posthumously published classic *On War* to describe the difficulties facing military commanders who had to make decisions based upon incomplete and faulty information. In the aftermath of Turner's revolt, everyone—white and black—in Southampton operated in such a fog. Although some people had some reliable information, everyone's information was limited. Even eyewitnesses were often confused about what they had seen. For example, when she was much older Lavania Francis recalled how "a flock of sheep running down the road was taken for the insurgents, and in a moment women and children, many of whom had collected at Pate's Hill, were flying to the swamps." Although no surviving account explains the false alarms at Blunt's plantation

on the night that the unnamed slave died, the type of mistake that Francis recalled would easily explain the alarms.[5]

While the metaphorical fog kept everyone in Southampton uncertain about what was happening, people were even more uncertain than usual about the future. If Fitzhugh's slave made a pragmatic calculation to cast his lot with the whites at Blunt's plantation, he did not know that his decision to take up "arms in defense of the family of Doct.r Saml. Blunt," as the whites later described it, would cost him his life.[6] In fact, the unnamed slave may have thought that supporting the whites would have increased the chances that he would survive, but in this case, at least, it meant that he would have a gun in his hands at the exact moment that an armed young white man most feared an attack by a mass of armed black men.

In addition to the uncertainty about what had happened and what would happen, there was still another, more fundamental form of uncertainty. In Southampton, whites who reasserted control over society had to decide how to understand Nat Turner's revolt.[7] Slave resistance, even rising to the level of slaves killing their masters, was not uncommon in the American South, but no one in Southampton had lived through a slave revolt. So what did this revolt mean? Was it a fundamental threat to Southampton's social structure? Or was it a small, localized challenge analogous to an occasional murder that posed little long-term danger to Southampton society?[8] Along the same lines, whites asked themselves about the relationship of the larger black community to the revolt. Did the slave revolt have the active support of the black community? Was the black community sympathetic to the rebels' goals, even as they disapproved of the tactics? Or was the black community actually hostile to the rebellion? Over the ensuing weeks, months, and years, Southampton's whites would answer these questions. The armed whites who suppressed the revolt, the magistrates who sat in judgment of the accused rebels, and even the congregations of the regions' interracial churches all had to decide the relationship of the larger black community to the rebels.

As the whites reasserted their power over Southampton, blacks faced an additional uncertainty connected to how whites conceived of the revolt. Had the slave revolt fundamentally transformed the relations of whites and blacks in Southampton? Eugene D. Genovese describes how many slaves were able to use affection and common interests with powerful whites as a way to improve their situation in slavery. This strategy depended on bonds between whites and blacks, but the fears that the revolt engendered in the white community brought the efficaciousness of such tactics into doubt. After all, if whites saw the slave revolt as an incredibly dangerous moment that displayed

the true feelings of the black community, then blacks—even those professing loyalty to and affection for whites—would not be able to count on sympathy from whites. The danger of losing this power may have played a part in Fitzhugh's slave's decision to take up arms in support of the whites at Blunt's plantation. His family lived on Blunt's plantation, and the unnamed slave may have thought that it would be best for his family if the rebels did not take over the plantation.

The same night that Fitzhugh's slave was shot, a similar event happened in North Carolina. On Tuesday, August 23, the Roanoke Blues, a North Carolina militia unit, were traveling through Northampton County on their way to Southampton. When night fell and the men prepared for the night, their leaders, who had little idea of the scale of the revolt, set up defenses against potential attacks from the rebels. They ordered the men to sleep "on their guns" and posted sentries to make sure that the group would not be surprised by rebellious slaves. In the middle of the night, these sentries heard unknown horses riding by. Fearing that they heard an approaching rebel army, they sounded the alarm, which set off a "bustle of confusion." One man, "supposing that the negroes had entered the house and then were engaged in fight, seized his musket and fired." While one member of the Roanoke Blues was "slightly wounded by some buck-shot in the shoulder," Sheppard Lee, who was trying to stop the panicked militiaman, was shot in the leg. The soldiers called a surgeon, but it was too late; Lee had lost too much blood. He died on Thursday, August 25.[9]

These panicked killings were not the only episodes during the revolt when people made life-or-death decisions blindly. When a militia unit from Greensville County, Virginia, arrived at Catherine Whitehead's plantation, they found the family's corpses. Enraged, they turned against the only people left on the plantation, the slaves. Realizing the gravity of the situation, the slaves pleaded for their lives. No records describe what the slaves on the Whitehead plantation said to the Greensville militia, but at another time, when white forces from North Carolina arrived at the Whiteheads', one slave "came to meet them with a smile on his face, and began to tell them how roughly the negroes," meaning the rebels, "had treated him."[10] It is likely that the other slaves on the Whitehead plantation explained to the Greensville militia that they had not supported the revolt and told the whites what they had done to save the family. Although their pleas to the rebels to spare the Whiteheads had fallen on deaf ears, the slaves surely recounted how they saved Harriet Whitehead.

At this point, the men from the Greensville militia did not know what to believe. Perhaps, as the Whiteheads' slaves claimed, the blacks who had

remained on the plantation had been loyal to their owners. In this case, the militia would not want to punish those most loyal to their mistress's family.[11] On the other hand, whites understood that the slaves' story of loyalty could have been a lie. It appears that this was the case for the slave who greeted armed men from North Carolina "with a smile on his face." Unfortunately for this man, "some Southampton gentlemen who were with" the Carolinians "as guides" recognized him as one of the rebels who had been involved in the battle at Parker's farm. In fact, the "Southampton gentlemen" told the Carolinians that the slave had "headed the gang in Parker's Old Field." Convinced that the slave's obsequious behavior was a charade, the whites "all fired on him," killing him on the spot.[12] With the bodies of the Whitehead family strewn across the plantation, the Greensville militia was likewise disinclined to believe the blacks, especially since their story implied that Harriet Whitehead should have been able to confirm the remarkable account.[13]

Harriet Whitehead was not able to tell the Greensville militia what really happened on her mother's plantation because she also was uncertain about her safety. She had narrowly escaped both the initial assault and the assassination squad that the rebels had sent back to the plantation. Even if these men had stopped looking for her, the rebel army that had killed her entire family was at large, and she did not want to be found if it reappeared. An account of her escape written decades after the revolt suggested that her uncertainty was even more profound than just an understandable fear of the rebels. According to this account, Harriet wondered if the slaves who had twice already saved her life would keep her safe. Maybe they would change their minds, she feared, and turn her over to the rebels. Harriet decided that the risk was too great, so she moved from the spot where Hubbard had hidden her. When Hubbard returned to the spot where he had left Harriet, she was gone. Understandably perplexed by her disappearance, Hubbard incorrectly concluded that she had been killed by the rebels.[14]

Harriet Whitehead's doubts and Hubbard's confusion almost had a fatal result. Because the men in the Greensville militia were unwilling to believe what the slaves on the Whitehead plantation had told them, they decided to execute Hubbard "as one of the murderers." When Harriet Whitehead heard this, she "ran out and saved him by relating the circumstances of his conduct in aiding to save her life."[15] As the person in the best position to convince the Virginia militia that Hubbard deserved to be spared, Harriet saved his life no less certainly than he had saved hers.

Harriet Whitehead's dramatic reappearance made it clear to the Greensville militia that Hubbard and the other slaves had told the truth about what had

happened on the Whitehead plantation, but most of the whites in the region did not have anyone like Harriet Whitehead who could dispel the uncertainty. About five miles south of the border with Virginia, an observer in Winton, North Carolina, noted, "We are all in a state of confusion here." In neighboring Murfreesboro, North Carolina, whites operated in a similar fog. Refugees from Southampton arrived with stories of the rebellion, and soon the town was abuzz with news about the rebellion. Some of these stories were accurate, including John Williams's account of what had happened on his and Catherine Whitehead's farms, but no one in Murfreesboro had any way to distinguish the accurate stories from other, less reliable accounts. One story, for instance, was that the revolt had begun with "2 negroes + 3 white men." The same correspondent who relayed this story also included a fairly reasonable initial estimate of the size of the rebel army; he said it was forty men, although it did not take long for the rumor mill to increase that number to 150, a number more than twice as large as the rebel army at its peak.[16]

Whites who were uncertain about what was happening in Southampton were terrified by stories of interracial alliances and a growing slave army. Even more frightening to the residents of Murfreesboro was the news that the rebels had made their way into North Carolina. One report, for instance, said that the rebels were still at large and "were bending their course toward the Boro." This intelligence set off a panic so intense that one man, "Old Thos. Weston," died, "frightened to death by a false alarm given us by a man from Northampton."[17]

A month after the revolt, Murfreesboro resident J. Borland wrote to North Carolina governor Montfort Stokes and described an alarm that he had witnessed. Borland had been at the home of "a gentleman who was very sick" where about a dozen women had gathered. "Whilst I was there a man rode up in great speed, in the rain, informing us that the negroes were in considerable number at Boon's bridge, marching on. This was within a mile + a half of the house." This news led to a panic in the household, "and the frantic distress depicted in each face, gave me feelings I have not words to express." Borland admitted that "these added to my own fears, for hearing the report made by the well dressed and sober person who rode up I certainly believed it." There was no way that the household could defend itself—they "had no arms"—so the whites were left "in this state of fear and great anxiety." The panic subsided only when another messenger arrived, assuring them that the initial report was wrong.[18]

The uncertainty about what was happening made many whites in Murfreesboro more likely to overreact, just as Harris had when he killed Fitzhugh's

slave. On Thursday, an unnamed black man from Ahosky Ridge, about a dozen miles south of Murfreesboro, was heading north. Although the rebel army in Southampton had collapsed more than two days before, the residents of Murfreesboro did not know this. They believed that the revolt was on-going and feared that the man was trying to join the revolt. The whites in Murfreesboro were not about to let this happen. Eight or ten guardsmen opened fire upon their unsuspecting target. "Then they cut off his head, stuck it on a pole and planted the pole at the cross streets, near Old Wm. Rosa's storehouse; his boddy was thrown in the bottom, between Mr. Manney's office and the academy, or not far from where the bridge was."[19]

Murfreesboro blacks also suffered as a result of the uncertainty, which heightened white anxieties and led the whites to overreact to any threat. The same day that whites killed the man from Ahosky, a slave drove his mistress and her family to Murfreesboro. During the trip, the woman thought that the slave "behaved impudently." After she arrived in town, she told the defenders of Murfreesboro what had happened during her trip. Although the man had delivered the woman and her family safely, the white men in Murfreesboro were unwilling to tolerate any hint of disloyalty at a time of such great uncertainty, so they "put [the slave] to death."[20]

In Southampton County itself, the whites were no less affected by the uncertainty than their neighbors to the south were. Even those whites who had the best information—those who had actually seen and defeated the rebels in battle—would not be able to answer with any degree of certainty a number of obvious questions: Was the rebel force that had been defeated at Parker's farm the main contingent of rebels? Was it the same group that had been repelled at Blunt's? Or were these two different parts of the same army? The lack of reliable information about what was happening put whites at a disadvantage as they tried to plan their response to the revolt.

With the hopes of dispelling the uncertainty, whites resorted to torture. It was not unprecedented for whites in Southampton to torture slaves as a part of an investigation. Ten years before the revolt, Ben, a Southampton slave, was arrested under suspicion of burglary. Although the court thought he was guilty, the investigators were not certain what had happened. Ben refused to admit to the burglary, so the court was stuck with a suspicion about what had happened but no way to know for sure. Foiled by Ben's refusal to confess to the charges, the court decided to take Ben out and "with small cords Suspended [him] by the thumbs for about one minute." When this failed to elicit a confession, Ben was "then tied by the toes and drawn up but not entirely off the ground." Ben still refused to admit to the crime. Unable to make

Ben confess, the court turned Ben over to a young man who—using unnoted methods—was finally able to get Ben to confess.[21]

In some cases, the torture after Nat Turner's revolt produced useful intelligence. For example, when the whites interrogated Turner's wife "under the lash," she surrendered the papers she had, including a list of fewer than twenty names, "which, all agree, is a list of his men." The only account of the tortures that was preserved among the local black community also suggested that torture was generally effective. Allen Crawford—who was born on Peter Edwards's plantation a few years after the revolt—recalled that those who were tortured had told the whites what they knew: "every one dat was Nat's man was taken bodily by two men who catch you and hold yer bare feet to dis blazing fire 'til you tole all you know'd 'bout dis killing."[22]

Although torturers often can get reluctant people to talk, torture compromises the value of the confessions that are made. Consider Ben's trial. It was possible that Ben confessed to the burglary not because he had stolen anything but simply to stop increasingly sadistic tortures. In Ben's case, the whites ignored the problematic nature of his confession, mainly because he told them what they wanted to hear. After Nat Turner's revolt, however, the investigators did not hear what they wanted to hear from the men they tortured. According to one account, the whites wanted "to make them disclose the plot," but none of the accused men disclosed the master plan. "Not one [shr]ed of information can be extorted from any [of] them, they will stand with a red hot iron [burn?]ing their flesh until they die!!" When John Hampden Pleasants praised the rebel Marmaduke for "the magnanimity with which he bears his sufferings," the implication of such stoicism was possibly even more frightening for whites than it would have been had Marmaduke and the others described an extensive plot.[23] Was it possible that the blacks not only were part of a large plot but were so committed that a dozen or more men were willing to endure torture to the point of death without disclosing what they knew?

Fear of a larger conspiracy led some whites to discount another reason those who were tortured would not tell them more: perhaps those men did not have much to tell. Some who were tortured, including Marmaduke, joined the revolt well after it had begun; others had not even joined the revolt. Emma Mordecai, who lived near Richmond, told her sister about one black man who had his foot "burnt off" before his interrogators "found at last that he was innocent." Likewise, Allen Crawford described the torture of a black man named Cordell. An "old white devil had him [Cordell], holding him to the blaze. He said 'Cordell, what do you know?'" Cordell claimed not to know anything, but the white man was not satisfied: "Well, stick him closer

[to the fire]! Dam you! I'll make you tell."[24] Because the whites were so afraid that blacks were hiding something, they were reluctant to accept that those who were tortured had told the whites everything they knew. Ironically, then, the use of torture had the opposite effect from the one whites had desired. While they hoped that torture would force the blacks to reveal the full extent of the plot, the confusing and uninformative confessions that the whites heard made them even less confident that they knew what was happening.

Uncertainty was unsettling for the whites, and some were immobilized by the fears that such uncertainty produced. O. M. Smith, a tutor from New Hampshire working along Southampton's northern border in Sussex County, noted, "One young Lady and two men to my knowledge, are frightened out of their senses, so that they have been perfectly deranged for four days."[25] Other whites felt compelled to act. Most often, when whites first heard the stories of the slave rebellion, they ran. By Monday afternoon, Nat Turner himself noted that the rebels found no whites in their homes, "the white families having fled." At the end of the week, one of the men who had come from Norfolk to help suppress the revolt described houses abandoned by people who feared a dangerous rebel army: "The country we have passed through is completely deserted and the inhabitants have absolutely left their doors unbarred."[26]

For those who fled their homes, the woods provided the nearest cover, and many, like Harriet Whitehead, hid there. One family spent the night on Monday "out in a thick cluster of pines, with a blanket to each, and a pallet [f]or the children." A report from North Carolina described the same response: "Many Lady's fled to the woods and remained out all night, several of whom with the children have since been extremely sick." While the woods provided a temporary place to hide, living in the woods indefinitely was not a solution for most. As a result, many eventually left the safety of the woods for the central defended locations where other whites had congregated. A letter written on Wednesday afternoon described how Jerusalem had been inundated with such people: "Every house, room and corner in this place is full of women and children, driven from home, who had to take to the wood, until they could get to this place."[27]

By Thursday, one account asserted that more than "15 hundred women and children" had taken refuge in Jerusalem. John Hampden Pleasants, who had left his newspaper in Richmond and traveled to Jerusalem, reported on Thursday that "ladies from the adjacent country, to the number of 3 or 400, have sought refuge from the appalling dangers by which they were surrounded." Since there were fewer than two thousand white women in the entire county,

Pleasants's estimate meant that one-fifth of the county's white female population sought shelter in the county's small seat. As Pleasants noted, "Jerusalem was never so crowded from its foundation."[28]

Jerusalem was the single largest refuge in Southampton County, but other places also filled once the news came of the rebel attacks. Smith, the tutor from New Hampshire, wrote to his parents that "about every Female in the two Counties of South-Hampton and Sussex are assembled at four different places and strong guards of soldiers set around them night and day!" Vicksville, eight miles north of Jerusalem, was one of the places to which people in the northern parts of Southampton County fled. Following the Civil War, W. O. Denegre recalled the flight of his family to Vicksville after his aunt had warned his family about the revolt. At the side of a well on Denegre's family's farm, she "burst into tears" and told his mother what she had heard. "Lamentations by both and cries of distress were heard." Denegre and his family accompanied his aunt to Vicksville. When they arrived in the town, Denegre saw "all the families for some miles around assembled at Vicksville." Denegre did not provide an estimate of the numbers at Vicksville, but the place was full. Sixty years later he recalled, "I know I slept on the floor." A letter written in the days after the rebellion estimated that two hundred women had found refuge at "Vix's".[29]

Across Southampton County's western border, families also fled to the most secure place they could find. Brigadier General William Henry Broadnax, leader of the troops in Greensville County, Virginia, wrote to Governor Floyd about the response of those who lived to the west of the rebels' path. He reported, "I found every hovel at Hicks' Ford literally filled with women and children, with no way to lodge but in heaps on the floors, without an article of food or the means of procuring cooking provisions." Others fled south across the North Carolina border. Troops heading through Northampton County found "upwards of 200 women and children, who had come in from Southampton and part of Northampton" collected at the county's courthouse.[30] The pattern of heading to defended places was for many a panicked response to the uncertain stories that circulated after the rebellion, but whites would have been hard pressed to come up with a better strategy. By collecting together, whites were in a much better position to defend themselves than when they were separated. As the rebels' failed raid at Blunt's plantation made clear, it did not take many armed white men to create a defense that the rebels could not breach.

Although whites who had come together in the aftermath of the revolt were in a position of strength, they did not recognize their power. For example,

early on Tuesday morning, when word came to Jerusalem that Turner and his men were at Ridley's plantation, former congressman James Trezvant, the leader of Jerusalem's defenses, did not make a move. By his own account, he had sixty men under arms—which was half again as many as Turner reported having the same night—but the whites thought that the rebels "were there with a force of about 200." The initial report was wrong, and a week later Trezvant confessed, "Could I have been correctly informed of their numbers when they were at Ridley's quarter, we could [have] in all probability destroyed or taken most of them."[31]

Because of the confusing and often exaggerated stories about the rebels, the whites were not sure that they would survive, let alone be able to put down the insurrection. Even at Vicksville, far from the neighborhood that had witnessed the revolt, whites were on edge. When Denegre wrote his reminiscences about the rebellion, he included one salient detail about his time in Vicksville: "The firing of shotguns was almost incessant." Closer to the scenes of revolt, whites' fears were as great. Lavania Francis, who had hidden from the rebels during the revolt, fled after the rebels left her farm. She was eventually found by some neighbors and brought to Patc's Hill, a place where the whites in the neighborhood had gathered. The whites were safe, but they did not feel secure. Instead, Francis recalled that she "had little opportunity to rest from her trials and excitement. People there were much too alarmed to allow anyone to rest."[32]

In the days after the revolt, whites learned the answers to some of their initial questions about the revolt, but the answers often led to new questions and new bouts of uncertainty. For example, whites wondered who was leading the revolt. At first their answers were vague and contradictory. Some of the earliest reports indicated that the rebels were "led by a fellow called Capt. Nat Turner (a black)." Another report said that "the ringleader" was "an old grey headed man." An early rumor that made it way to Brunswick said that the rebels were "headed by some few whites." When John Hampden Pleasants arrived in Southampton, he heard that Hark, who had been captured, was "the reputed leader."[33] Nevertheless, within a few days of the revolt, the best-informed people in Southampton had concluded that "Gen. Nat Turner" was "at the bottom of this infernal brigandage." This view was quickly adopted throughout Southampton County. In the first report that Pleasants filed once he returned to Richmond, he observed that "the universal opinion in that part of the country is that Nat, a slave, a preacher, and a pretended prophet was … the actual leader."[34]

Identifying Nat Turner as the leader of the revolt only led to more questions. "Who is this Nat Turner?" asked a writer in the *Richmond Compiler*.

"Where is he from?" As important as his biographical details were, another question loomed even larger: where was he? One rumor said that Turner had been killed. Others said that he had been captured. The fact that whites had absolutely no idea did not mean they were silent. In October, the editor of the *Edenton Gazette and Farmer's Palladium* described the difficulties of producing a newspaper amid "the thousand bugbear rumors." He examined the basis for one report that Turner had been taken. The report of Turner's capture came from "a good old farmer from Southampton [who] went to Smithfield and told a Mr. Somebody there, and Mr. S told a young man who was going to Norfolk, and he told Mr. Broughton that Nat was taken in a swamp and borne of[f] in triumph to Jerusalem." After describing several other similar rumors, the editor asked, "What do you think of it[,] reader?" His conclusion was that all his work was pointless, "as some folks would tell *fibs*, and we of course were obliged to follow the fashion."[35]

At first Southampton's whites did not seem to make much of the fact that they had no idea where Turner was. When William Henry Broadnax, the leader of the militia west of Southampton, dismissed as "ungrounded" a report that Turner had been killed, he noted that Turner was among the handful of rebels "not yet taken." Still, Broadnax opined, "It is believed he cannot escape." As the rest of the rebels were captured, however, whites became increasingly befuddled by their inability to find Turner. A letter written by someone from Suffolk, Virginia, who had "just returned from Jerusalem" noted that although all the other rebels had been captured, "the ringleader, Nat," was still "at large...All are at a loss to know where he has dropped to." Eventually, the inability of whites to find Turner led some to consider the possibility that Turner had escaped. "The ringleader, Nat Turner...is not yet taken," wrote one man in Petersburg, Virginia, who then added, "And my impression is *will never be.*"[36]

The uncertainty about Turner's whereabouts led some of Southampton's whites to redouble their efforts to find Southampton's most wanted man. Hoping that Turner's wife might have an idea of where he was, whites questioned her. She provided the interrogators no clues about where her husband had gone. In fact, after interrogating her, whites could not even say if he remained in Southampton. "Many believe him to be yet lurking in his neighborhood," reported the man who had in his possession papers that Turner's wife had handed over once whites had beaten her. But the same man admitted, "My own impression is, he left the State."[37]

Beyond Southampton, people had even less reliable sources of information, but that did not deter them from jumping to conclusions. Some imagined that the famous rebel leader had escaped to their neighborhoods. Since

these whites had no idea what Turner looked like—other than that he was a black man—the grounds for identifying suspects as Nat Turner were incredibly flimsy. In early September, for instance, whites arrested a black man in Baltimore because he offered to sell a horse for "a price which excited suspicion."[38] Likewise, in western Virginia, two whites stopped and searched an itinerant black preacher. When they found that he was carrying a knife, the black man fled, leaving behind his Bible. Although the Bible identified him as "Zephenira Turner, Richmond," whites in Botetourt County were convinced that they had just missed apprehending the fugitive leader of the revolt. In fact, one man asserted that the suspect "doubtless would have been taken if the Governor's Proclamation [which included a description of Nat Turner's appearance] had fortunately reached this part of the country a few days sooner than it did."[39]

Perhaps if the governor's proclamation had circulated sooner, the men who stopped Zephenira Turner would have realized that he was not the rebel leader, but they did not have this information.[40] In part, this was because Governor John Floyd was also unaware of what was happening in Southampton. Based upon early reports from Southampton, he believed that Turner would fall "into the hands of some of our troops." He was wrong. Turner was not captured by militia forces that massed in Southampton, and by mid-September Governor Floyd decided to announce a five-hundred-dollar reward for the fugitive's capture. To do this, Floyd needed more information from people in Southampton, including specifically a description of Turner. Floyd wrote to Richard Eppes, who was still on the scene in Southampton, asking for a description of the rebel leader. Eppes forwarded the request to William Parker, who supplied Floyd with a description of Turner:

> He is between 30 & 35 years old—5 feet six or 8 inches high—weighs between 150 & 160 rather bright complexion but not a mulatto—broad-shouldered—large flat nose—broad flat feet rather knock kneed—walk brisk and active—hair on the top of the head very thin—no beard except on the upper lip and the tip of the chin. A scar on one of his temples produced by the kick of a mule—also one on the back of his neck by a bite—a large knot on one of the bones of his right arm near the wrist produced by a blow.[41]

Over a little less than a month, Southampton's whites had learned much about Turner—down to the granular detail of what animal had once kicked him in the head—but nothing they learned helped them find the elusive rebel leader.

In one way, the responses of whites in Southampton to the uncertainty created an opportunity for most of the blacks. When whites abandoned the countryside, few blacks accompanied them to the refuges.[42] Most slaves and free blacks remained away from the central gathering places beyond white supervision and were free to do what they wanted. But this freedom was not without consequences. Blacks may have been free from white supervision, but it did not mean that they were free from danger. By the middle of the day on Monday, groups of armed white men were traveling across the countryside, trying to find the rebels and suppress any sign of subversion. Moreover, if the whites were able to regain control of the county, no one could predict how they would treat Southampton's black community.

Blacks, uncertain about both the status of the revolt and how whites would respond, had to decide what to do. A few may have taken advantage of the whites' disappearance to set out and try to join the revolt themselves, but—given how quickly the rebel army disappeared—that must have been an unusual response. Even those who supported the revolt waited for recruiters to come get them. Benjamin Blunt's Ben, for instance, seemed to be ready to support the revolt, but he did not join the rebel army on Monday, when recruiters came to the plantation and his brother joined. On Tuesday morning, however, Billy Artis returned to Blunt's place to recruit. According to another slave on the plantation, Ben joined Artis without even being asked.[43]

Others, who did not actually head off with the rebels, promised the recruiters who were trying to revitalize the rebellion that they would join later. Hardy and Isham, who both belonged to Benjamin Edwards, said they would be willing to join when Turner and the rebels returned to the neighborhood, which they had been told would be on Wednesday or Thursday. On Wednesday, Berry Newsom, a young free black, made a similar promise. He said that "if Capt. Nat called on[,] he would join him and be a revered soldier." Isaac did not even need a recruiter to get him to decide that he would join the rebels if they showed up. He bragged to a white woman that "he would join them & assist in killing all the white people." Isaac, however "headstrong" he appeared to whites, still awaited the rebels.[44]

If some blacks had decided to support the rebellion, others had decided to do what the whites told them to do. Even on the same plantation, people in the black community disagreed about how they should respond. Henry was there when the recruiters got Hardy and Isham to promise to join the revolt, but he apparently had no interest in joining himself. Instead, he had decided to follow the orders of the whites, who had commanded him and three others to go to Levi Waller's to bury the dead.[45] Others were doing even more important jobs

for the whites. At a time when many whites were too scared to travel through the countryside, they used slaves to communicate. For example, Bolling Barrett had sent the slave Burwell to Lemuel Story's, James Story's, and William Vick's "to request them with their families to go to Mrs. Gurley[']s to keep guard." Burwell delivered the message, but not without incident. He later testified that when he arrived at Vick's, the free black Exum Artist "interrupted him." Artist's attempt to cut the whites' line of communication failed when Burwell told Artist "not to interfere with him." Artist's inability to convince Burwell to stop helping the whites in the middle of a slave revolt made Artist "very mad." When Burwell headed back to Mrs. Gurley's, as he had been instructed, Artist followed him and threatened Burwell "with a pistol."[46]

The clash between the slave Burwell and the free black Exum Artist embodied the dramatic differences that existed in the black community as some, including Artist, decided to support the revolt, while others elected to support the whites. But perhaps the most interesting and representative characters in this episode were the unnamed blacks who witnessed the escalating fight between Burwell and Artist. When Artist caught up to Burwell, he began yelling, threatening Burwell. As Burwell recalled, Artist "made considerable noise." At this point, the blacks at Mrs. Gurley's farm told Artist to quiet down. They told him that "if he kept such a noise[,] the white people would come + shoot them or carry them to jail."[47] Much like the white response to the uncertainty, the larger black community adopted a pragmatic response, focusing on survival. Most blacks thought that the best way to stay alive was to avoid doing anything that might draw attention to themselves.

Lying low made sense for most, but it was not a perfect strategy, as one free black man found out. According to the one of the earliest reports from Jerusalem, whites had gone in search of this man, whom they suspected of supporting the revolt. When the whites arrived at the man's house, the unnamed free black man did not appear. Before they left, however, one of the whites spotted him hiding in the yard. Taking the man's decision to hide as proof that their suspicions were right, they shot him on the spot.[48] They never considered the possibility that the free black man hid only out of fear of being mistakenly associated with the revolt. In a world of uncertainty, where no one really knew what was happening, any choice that blacks made was fraught with danger and liable to misinterpretation.

5

The Coolest and Most Judicious Among Us

ALFRED, A BLACKSMITH who belonged to Levi Waller, had been on Waller's plantation when the rebels arrived. Like most blacks, he was surprised by the rebels' appearance at the start of the revolt, and his initial response was to run away. Unfortunately for Alfred, the rebels spotted him. Thinking the fleeing figure was Waller, the rebels set off in pursuit. When they caught Alfred, they brought him back to the plantation, where Alfred joined in the drinking as the rebels celebrated the revolt's most deadly raid. When the rebels left Waller's, Alfred went along with them.[1] Alfred did not remain long with the men whom Waller called his "misguided associates." According to Drewry, a drunk Alfred fell from his horse as the rebels made their way toward Jerusalem. Instead of trying to catch up to the rebel army, Alfred decided to return home. He never reached Waller's farm. As he was making his way there, he was spotted again, this time by the contingent of whites under Alexander Peete that would later catch up to the rebels at Parker's field. Peete and his men had seen the havoc caused by the rebels along the road to Jerusalem. Not knowing how deeply implicated Alfred was and having no ability to "secure him otherwise," they decided to cripple Alfred. They cut both of his Achilles tendons, which meant that he would no longer be able to walk, let alone rejoin the rebel army that was still at large.[2] Once the revolt was put down, the whites would be able to determine Alfred's fate.

Peete and his men left the maimed blacksmith and resumed their pursuit of the rebel army, but Alfred was not to remain on his own for long. According to Drewry, Alfred's owner, Levi Waller, happened upon the wounded slave. Waller was bandaging Alfred's legs when a contingent of Greensville cavalry under the command of Dr. Scott appeared. Even though Peete and those under his command had obviously gone to some trouble to spare Alfred's life, Scott believed that they had made a mistake. Scott "ordered the negro," who could not stand, "to be tied to the tree and shot."[3]

The story of Alfred's death provides a window into the white community in its earliest efforts to understand the meaning of the revolt. At first blush, the two militia groups were remarkably similar. They were both led by prominent whites on Monday morning when the first news of the revolt made its way across southern Virginia. It was likely that the first stories that each group heard were confused. Although neither group knew exactly what was happening, both headed to the neighborhood where the rebels had been sighted. When they reached the plantations that had been attacked, both groups found the bodies of whites who had been killed by the rebels. At this point, they would have realized that the revolt was real, but much, including how large the revolt was, remained unclear. Both groups also met blacks who had not joined the rebels, many of whom presumably declared their loyalty to whites, but both groups of whites understood that the slaves and free blacks who said this may have been simply trying to save their lives.

If both groups had similar origins and access to much the same information, why did the men from Southampton try to spare Alfred, only to be foiled by the Greensville militia?

In part, the different responses reflected the different ways the two groups understood the revolt. For instance, the Greensville militia seems to have concluded that a contributing factor in the revolt was the leniency of Southampton's slaveholders. When the Greensville militia found Waller "binding up" Alfred's legs, Scott saw a perfect example of the failure of Southampton's slaveholders to hold their slaves accountable. According to Drewry, "It very much incensed this gentleman [Scott] to see a man binding up the wounds of one of the murderers of his own family when their bodies were still unburied." So Scott gave "a severe reprimand to the master."[4]

In addition to blaming Southampton's slaveholders for being too lenient, Scott and his men concluded that the revolt had significant support in Southampton's black community. According to an early letter written from Belfield after the Greensville militia had left for Southampton, the departing men swore that they would pursue the rebels "until every man of them was taken or destroyed." The possibility of capturing the rebels suggests that the Greensville militia initially imagined a revolt was limited to a small contingent. (If the revolt had been general, there would have been no feasible way for a small group of men on horseback to detain hundreds or potentially thousands of rebels.) By the time the Greensville militia saw the destruction in Southampton, however, they had given up on the idea of detaining any suspected rebels. One can see this most clearly when they decided to execute Hubbard, the slave who had saved Harriet Whitehead's life.[5]

Although Harriet Whitehead's dramatic appearance saved Hubbard's life, Scott and his men did not extrapolate from this encounter and reconsider their sense that the revolt had significant support in the black community. They remained convinced that Southampton was extremely volatile and that sparing suspected rebels was the wrong message to send to the rebel army's silent sympathizers. Although the maimed Alfred posed no threat—either to rejoin the rebel army or to escape—Scott and his men "deemed," as Levi Waller wrote, "that his [Alfred's] immediate execution would operate as a beneficial example to the other Insurgents."[6] Since the summary execution would only make those who had taken up arms less likely to surrender, it seems that by "insurgents," Scott really meant those blacks who had not joined the revolt. Scott did not want blacks thinking they could support the revolt and then escape white retribution by claiming that their involvement was limited or coerced.

While Scott and his men envisioned broad support in the black community for the rebel army, Alexander Peete interpreted the revolt differently. Unlike the Greensville militia, which was skeptical even of Hubbard, Peete saw the revolt as limited, with little support from the larger black community. Peete believed that many blacks did not support the revolt, and he would be a leader of the men at the Blunt plantation the following day when the whites decided to arm loyal slaves. Because he believed that the revolt had little support among the black community, Peete focused on how to keep Alfred from rejoining the rebellion, rather than on making sure that Alfred's punishment would send the right message to others. No less than Scott, Peete wanted to punish the rebels, but he clearly saw fewer people as "insurgents." Unlike Scott, he even was open to the idea that someone who traveled with the rebels was an unwilling participant who might not deserve to die.

Peete and the men from Southampton were also more sympathetic to the interests of the slave owners in Southampton County than were the men from Greensville. In the decision to kill Hubbard and Alfred, for example, the Greensville militia decided to do something that would cost two Southampton slave owners dearly. Peete—a Southampton slaveholder himself—was more protective of his neighbor's property. When the Southampton troops maimed Alfred, they clearly hoped that Alfred would survive. Even if Southampton's whites later sentenced Alfred to die, the decision—if made in a court of law— would mean that Alfred's owner, Levi Waller, would be entitled to compensation. This concern for their neighbor's property was not absolute: the decision to maim Alfred meant that Waller would no longer benefit from the skills of his blacksmith, a significant loss if Alfred was eventually released. But Peete and his men pursued what they believed was a prudent option when they

maimed Alfred, even as they preserved the possibility of Waller being compensated if the courts later decided to execute the slave.[7]

Finally, while Scott was hesitant to defer to Southampton's slaveholders, as can been seen in his decision to execute Alfred even as Levi Waller tended to him, whites in Southampton had not lost their confidence in the ability of Southampton's slaveholding elite to handle the crisis. In fact, in the immediate aftermath of the revolt, Southampton's whites turned to the slaveholding elite for leadership. Alexander Peete, the leader of the group of whites who maimed Alfred, likely emerged as the leader of the group because he was already an important figure in Southampton. A slaveholder who owned more than thirty slaves, he was also a magistrate who played an active role in the county's affairs.[8] When Peete and his men spared Alfred's life, they also implicitly expressed their confidence in the ability of Southampton's court to mete out the proper punishment to Alfred. Such confidence probably came easily to someone like Peete, who, as an active magistrate, was to some extent deferring to himself.

Peete's belief that the revolt required a less draconian response ultimately did nothing for Alfred, who was still executed by men who wanted a more vigorous response. But Alfred's case was unusual. More often, the white men who were reestablishing white control in Southampton followed the lead of people like Peete, who urged a more cautious approach to suspected rebels. Especially as the white's armed response became more organized and leaders like Peete were given formal control of the militia units, the kind of indiscriminate and retributive killings that Scott championed became less common.[9] The power of Southampton's slaveholders to restrain those like Scott and others who shared his view of the revolt can best be seen in the total number of blacks who were killed in Southampton as the rebellion was suppressed. While some have thought that the number of blacks killed without trial was at least a hundred, in fact about three dozen blacks were killed as the revolt was put down.

Despite the success of the elite in limiting the killing of blacks, there was widespread support in Southampton's white community for a more draconian response. When John Hampden Pleasants traveled from Richmond to Southampton with a cavalry unit that had been dispatched to help suppress the revolt, he found that "the people are naturally enough, wound up to a high pitch of rage." Whites were infuriated at what had happened, and many wanted revenge. Pleasants described the mood of local whites as "sanguinary" and noted that "the population...evinced a strong disposition to inflict immediate death on every prisoner." Jerusalem's postmaster, Theodore Trezvant, described how whites who were looking for rebels were "determined to shew

no mercy." Months after the rebellion, William Henry Broadnax, who had been a leader of troops that went to Southampton after the revolt, described "the public mind" as "excited, almost to a frenzy."[10]

Exhibiting "a spirit of vindictive ferocity," whites took their revenge on blacks who had been suspected of supporting the revolt. In his earliest dispatch from Southampton, John Hampden Pleasants described how in the neighborhood around Cross Keys, "one or more prisoners" had faced "summary justice in the form of decapitation." Later he noted "the slaughter of many blacks." One man claimed that "he himself killed between 10 and 15," yet even he showed more restraint than others. When whites decided that they wanted to kill a black woman, this unnamed white man "narrowly escaped losing his own life in an attempt to save a negro woman whom he thought innocent but who was shot by the multitude in despite of his exertions." William Sidney Drewry also mentions Charlotte, a slave who threatened her mistress, Lavania Francis, with a knife. When Francis told her husband what had happened, Nathaniel Francis took Charlotte out of the makeshift jail where suspects had been held, tied her to an oak tree, and shot her. According to Drewry, the tree died as a result of the massive barrage from others who also took the opportunity to get revenge.[11]

As enraged as Southampton's whites were, many of the whites who came to Southampton from other locales were, if anything, even more set on revenge. Thomas Wentworth Higginson recounted one story about how troops from Richmond hoped to kill "every colored person they saw in Southampton County." Nearing the scene of the revolt, some whites stopped to ask "a free colored man, who was hoeing by his little field," if they had reached Southampton. When he told them that they had just crossed the line, "they shot him dead and rode on." Even if Higginson's story was unreliable, there were other cases, in addition to Alfred's, in which blacks who had been spared by locals were killed by men from outside Southampton. Richard Porter's slaves Jacob and Moses had been captured by Southampton residents and confessed that they had joined the revolt. At the time, the whites from Southampton decided to keep the two in custody. Later, however, the rebels were "given up to a company of armed men from the State of North Carolina," who killed the two suspects. Perhaps these two were among the eight killed by a company that came to Southampton from Murfreesboro. According to the letter that described the actions of that Murfreesboro company, the Governor's Guards "took prisoners and shot 8," a quote worded to suggest that those killed may have been summarily executed after they were captured.[12]

This "sanguinary" temper of whites led to what John Hampden Pleasants admitted were killings "hardly inferior in barbarity to the atrocities of the insurgents." Emma Mordecai related to her sister one particularly grotesque episode described by the Richmond soldiers returning from Southampton. One slave, who was "guilty of murdering his master in a most barbarous manner," had his ears cut off. "After rubbing the wound with sand, they [the whites] tied him on [she crossed out "under"] a horse, had the horse mounted and rode, + then turned loose into the woods." The *Boston Christian Herald* published a letter from a northerner traveling through tidewater Virginia who described the stories he heard from people who had been in Southampton. According to his source, slaves' "noses and ears were cut off, the flesh of their cheeks cut off, their jaws broken asunder, and then set up as a mark to shoot at!" Another letter described a similar fate for a rebel who was thought to have killed his own master. The whites "burned him with red hot irons— [cut] off his ears and nose—stabbed him, cut his [ham]strings, stuck him like a hog, and at last, [cut] off his head."[13]

In several instances after the suspected rebels were killed, whites cut off the rebels' heads. In part, this was an expression of the whites' hope for revenge, but it also served as a crude but effective form of social communication. Whites displayed the heads of the fallen blacks as a warning to other blacks, whom they feared were sympathetic to the rebels. After the rebel who was thought to have killed his master was decapitated, whites took his head and "spiked it to the whipping [post] for a spectacle and a warning for other negroes!!!!!!" Other rebels' heads were likewise put on display and left for weeks. Black Head Sign Post was a crude name that stuck to one place in the neighborhood of the revolt where whites displayed the heads of dead blacks. Other rebels' heads were paraded. According to Drewry, one of the marines heading through Vicksville "bore on his sword the head of a rebel." Contemporary reports tell similar stories. One of the men who came from Norfolk to help suppress the revolt wrote that his company would be returning with an unusual prize, "the skull of Nelson, taken by us."[14]

While many whites believed that the rebellion called for a harsh retribution, both to exact revenge and to serve as a warning to the blacks who had not joined the rebel army, leaders among Southampton's white community believed that the rebellion called for a more restrained response. At the time of the greatest uncertainty—Monday and Tuesday—these leaders struggled to get others to defer to their judgment. Peete and his men may have decided to spare Alfred, but that counted for little when Scott and the Greensville cavalry found the crippled man. Enraged whites with guns found it relatively

easy to kill blacks, and in the immediate aftermath of the revolt whites killed blacks indiscriminately, in the words of Richard Eppes, "even without knowing who they were."[15] As a result, during the day or two after the revolt, dozens of blacks were killed without trial.

By midweek, however, the dynamic began to change. White leaders grew less concerned about the danger posed by the rebels and more confident that their forces were more than a match for any surviving rebels. On Wednesday, August 24, 1831, for instance, troops in Southampton heard a report that seven rebels had been spotted making their way north, and "one hundred and twenty five men were dispatched immediately in pursuit of these negroes." Given the great disparity in the size of the forces, General Richard Eppes, the militia leader who replaced Trezvant as the leader of the forces in Jerusalem, began the process of demobilizing. On Wednesday, Eppes asked that an artillery company that was making its way to Southampton's county seat return to their homes. "I have to request you will direct the troops to return—perfectly satisfied they cannot be wanting, as the party are dispersed and from the best information no probability of their reassembling—certainly not for some time." Eppes was not the only one who believed that the revolt was over. The following evening, John Hampden Pleasants ended his first dispatch from Jerusalem noting that "the insurrection may be considered as already suppressed." North Carolina troops in Southampton agreed: "The negroes are dispersed."[16]

Confident that the whites had reestablished control of the country, white leaders turned their attention to stopping an enraged white population from killing blacks without trials. As late as Saturday, August 27, 1831, one minister reported that *"many negroes are killed every day,"* but by the weekend, the most vindictive whites had already been restrained. When John Hampden Pleasants wrote his first dispatch from Southampton on Thursday, August 25, he alluded to the killing of blacks, but he clearly got his information about these killings secondhand. After two days in Southampton, however, he had more reliable information and reported that the number of executions of blacks had declined. "Since writing the accompanying letter," he reported, "in one or two instances" prisoners have been "put to death forthwith by the enraged inhabitants." Pleasants credited militia general Richard Eppes for stopping the bloodbath. "To the great honor of General Eppes, he used every precaution in his power, and we hope and believe with success, to put a stop to the disgraceful procedure." Eppes agreed with Pleasants's assessment, boasting, "I put an end to this inhumane butchery in *two* days." To the west, William Henry Broadnax, the leader of the militia who patrolled the region where the

rebellion began, also worked to stop the extralegal killings. He later bragged that he was among those who exerted their "influence" and were able to "restrain an indiscriminate slaughter of the blacks who were suspected."[17]

As Broadnax implied, protecting suspected blacks in the days after a deadly slave rebellion was unpopular among the majority of Southampton's whites, but Eppes and Broadnax acted decisively to stop the killings. They used their authority as the leaders of the response to take custody of the prisoners. Included among those who were being held were individuals who had taken part in the rebellion, but others were held simply to keep them away from vindictive whites. Jesse H. Simmons, an officer who came to Southampton from North Carolina, noted that many blacks were in custody, but he added that "the chief part" had been held "only for safe keeping." From the perspective of Pleasants, such protection was imperfect. "Precaution," he observed, "is even necessary to protect the lives of the captives."[18]

Keeping blacks suspected of supporting the revolt away from the public slowed the rate of killings dramatically, but some whites still wanted revenge, even if it meant killing innocent blacks. This posed a difficulty for Broadnax and Eppes. As military leaders in Southampton, they could arrest the whites who killed blacks, but what would that accomplish? Given that many whites—perhaps an overwhelming majority—supported those who killed blacks, Broadnax and Eppes realized that there was no chance that a jury of whites would indict, let alone a convict, a white who killed a black in the days after a revolt. Even holding a person who killed a suspected rebel responsible for damages to the slave's owner would be impossible, as Peter Edwards pointed out in a petition to the Virginia legislature: "It would be vain for the owners of slaves so destroyed to look to the individual who destroyed them for redress."[19]

Unable to count on a court system that relied on juries to hold whites who killed blacks accountable, the military leaders decided to act unilaterally. On Sunday, August 28, 1831, a week after the rebellion commenced, Richard Eppes issued an order intended to stop the extralegal killing of blacks. In this order, he announced to "the troops under his command, and to the citizens of Southampton, and particularly to that portion of the citizens residing in the neighborhood where the violence has been done, that there no longer exists any cause of apprehension for the public safety or the security of individuals." Since safety had been restored, he recommended "to all descriptions of persons to abstain in the future from any acts of violence to any personal property whatever"—in other words, slaves—"for any cause whatever." While Eppes called this a recommendation, he made clear that anyone who disobeyed

these orders would be treated severely. "No excuse will be allowed to any other acts of violence after the promulgation of this order, and [I] further declare in the most explicit terms that any who may attempt the resumption of such acts shall be punished, if necessary, by the rigors of the articles of war."[20] In other words, those whites who killed blacks would no longer be protected by their right to a trial by a jury of their peers.

Eppes and Broadnax's efforts to stop the summary executions of blacks were remarkably effective. The best evidence for their success is the total number of blacks killed in Southampton without trial, a subject of much speculation. In the first academic history of the revolt, William Sidney Drewry, a Southampton native and an apologist for the slaveholding South, observed that "there was far less of this indiscriminate murder than might have been expected." He also guessed that "as many guilty negroes escaped as innocent ones perished." Drewry never quantified the numbers involved in any of his guesses: How much indiscriminate murder should have been expected? How many guilty people escaped? How many innocent blacks perished? Drewry's sense was that the whites were less barbaric than he expected, but this comment is less meaningful when one realizes that Drewry published the book in 1900, when lynching was common, even for minor offenses against the racial order.[21]

When the young radical historian Herbert Aptheker began his study of the Turner revolt in the 1930s, he disagreed with almost everything that Drewry had written about the revolt and especially Drewry's sympathetic portrayal of Southampton's whites. Taking Drewry to task for sugarcoating the white population's response, Aptheker commented, "How much 'indiscriminate murder' should be 'expected' is not known," and he insisted that Drewry's assertion that "as many guilty negroes escaped as innocent ones perished" was wrong. Aptheker, however, struggled to replace Drewry's estimates with his own. In his 1937 master's thesis written on the revolt, Aptheker recognized the wide range of the estimates of the numbers of blacks killed without trials—from "no more than forty" to "more than One Hundred"—and put forth what he considered a conservative estimate: "It appears safe to say that at least as many Negroes were killed without a trial as whites had perished due to the Revolt [a number that Aptheker had estimated as at least fifty-five] and probably the number in the former case was considerably more than the latter." When he revisited this question six years later in his seminal *American Negro Slave Revolts*, Aptheker's estimate was less timid. Citing a report published in Huntsville, Alabama, that estimated the number of blacks killed in Southampton as over one hundred, Aptheker concluded, "It seems

accurate to say that at least twice as many Negroes were indiscriminately slaughtered in that county, as the number of white people" who had died. Decades later, in a 1982 encyclopedia entry on Nat Turner, Aptheker jettisoned the caution in his early work that he thought had led him to understate the amount of bloodshed. In this entry, Aptheker's only comment on the scale of the bloodshed was a remark that "perhaps as many as 200 Negroes were killed in Southampton."[22]

Aptheker was not the only one to suggest that the bloodshed was far more widespread than Drewry imagined. In an 1861 account of the revolt, Thomas Wentworth Higginson cited a report that "'one hundred and twenty negroes have been killed,' this being little more than one day's work." This report may be the basis for several twentieth-century estimates of the number of blacks killed. In a 1920 article about the revolt, John Cromwell agreed with Higginson that "in little more than one day 120 Negroes were killed." Most contemporary historians agree. Despite admitting that the number of blacks "killed is unknown," Eric Foner insists that "the number certainly ranges into the hundreds." In the 1975 *The Fires of Jubilee,* Stephen B. Oates estimates that "at least 120" innocent blacks "perished in the reign of terror," although unlike the other estimates, his guess includes the entire country, not just those killed in the area of the revolt. Kenneth S. Greenberg also accepts Higginson's number as "a minimum," concluding as a result that "many more African Americans were killed than actually participated in the rebellion." Thomas C. Parramore estimates that "in the ten days of rebellion and retribution, at least 100 blacks, and possibly several times that figure were killed, though no more than a handful had taken any part in the uprising."[23]

While not enough evidence exists to yield an exact number of blacks who died as the revolt was suppressed, it is possible to determine a more precise range, based on surviving sources. In law, slaves were property. As property, Virginia slaves over the age of twelve were subject to taxes, just as horses, gigs, and carriages were. In the spring of each year, tax collectors enumerated the property on each farm, dutifully counting the slaves who were old enough to work and collecting the appropriate taxes. When John Gurley and George Gray counted the Southampton slaves in 1831, their tally was 4,145. The following year, they counted 3,967 slaves. This meant a net of 178 slaves who were counted on the 1831 tax list had died, moved, escaped, been sold away, been emancipated, or otherwise disappeared. Since the number of slaves in Southampton County had been declining after reaching a high point of 4,262 in 1827, presumably because of ordinary demographic changes, one can reasonably use the number of 178 as a maximum for the casualties among

Southampton's slave population during and after the revolt.[24] (See Appendix.) How many of the 178 uncounted slaves were among the dead after the revolt? Nat Turner and twenty-nine others were found guilty by the white courts for their involvement in the revolt. They were all sentenced to die. Although some had their sentences reduced to transportation, all thirty convicted slaves were absent from the 1832 tax survey. As a result, it is likely that fewer than 148 Southampton slaves lost their lives during the period of panic and uncertainty that followed the revolt.

Primary sources, including *The Confessions of Nat Turner*, newspaper articles, letters from Southampton, trial notes, and petitions to the Virginia General Assembly, mention between thirty-seven and thirty-nine slaves who were involved in the revolt. Of these, at least twenty-one survived long enough to be tried.[25] Among the rebels never tried, nine men had their deaths documented: their owners or executors for their owners' estates sought compensation for the property they lost when their slaves were killed without trial. (Since slave owners in Virginia were compensated for slaves who were executed or transported by the state, these owners argued that the owners of slaves who had been killed as the revolt was being suppressed also should have received compensation from the state.) Two other rebels were mentioned as prisoners, but their serious injuries—one newspaper described Tom as "desperately wounded and about to die"—meant that they did not survive long enough to stand trial. Add to the list three prominent rebels—Henry, Will "the executioner," and Austin (who killed Hartwell Peebles)—whose disappearance from the record following the revolt is most readily explained by their deaths, and one can identify fourteen rebels who almost certainly died as the revolt was put down. Two more slaves—the unnamed slave who died at Samuel Blunt's plantation and Nathaniel Francis's Charlotte—were also killed after the revolt, bringing the minimum number of slaves who died without trial to sixteen.[26]

While counting the people who died or were missing from the tax records produces a broad range, there are other approaches that produce a narrower range for the number of Southampton slaves killed without trials. For example, it would be incredible if the number of slave casualties after the revolt approached 148. The killing of blacks was only one way that slaves who were in Southampton in 1831 would not have appeared on the 1832 tax list. Some slaves may have been sold out of the county, as several farms had to be dismantled when a larger than usual number of estates had to be settled after the revolt. These slaves may have been joined on their migration from Southampton by other slaves as some slaveholders moved their household out of Southampton or sold slaves to traders eager to take them south. In October,

the *New Orleans Advertizer* printed a letter from a Virginian noting that "many Southampton blacks were presently for sale in New Orleans and many more would be arriving in the city shortly."[27]

Other slaves left the county heading east, when slaveholders manumitted their slaves and sent them to Liberia. Shortly after the revolt, the American Colonization Society decided to charter the *James Perkins* to take emigrants to Liberia. John McPhail, the agent of the American Colonization Society based in Norfolk, traveled to Southampton in October 1831 to see if he could find people willing to go. On October 28 he reported to the American Colonization Society headquarters in Washington that he had collected the names of 245 people, and he predicted that "300 [emigrants] will come from Southampton." One does not need to read many of McPhail's reports to realize that he often failed to deliver on his promises, but in this case his estimate was surprisingly accurate. In late November, a few days before the *James Perkins* was scheduled to leave, Southampton's emigrants started to appear in Norfolk. On November 25 the *Norfolk and Portsmouth Herald* reported, "At least eighty emigrants arrived [in Norfolk] yesterday from Southampton... principally manumitted slaves." On December 9, John McPhail wrote to the Colonization Society of Virginia in Richmond that nearly three hundred passengers were aboard the ship and that "274 of these free people of color are from Southampton county." As suited the American Colonization Society's demographic purpose, many of these emigrants were children, but the estimated "60 families and individuals" on board the *James Perkins* meant that at least sixty adults had agreed to go to Liberia. Given that some families would have included two or more adults, it is likely that a majority of the slaves who did not appear on the 1832 tax list showed up instead on the *James Perkins*'s manifest.[28] As a result of these migrations, it is unlikely that the whites killed fifty slaves following the revolt.

Estimates based upon the casualty rates of the known rebels suggest that it is unlikely that whites killed more than forty rebels while the revolt was being suppressed. Many of the rebels survived, including three of the original five conspirators. Looking at the rebels as a whole, a death toll of fourteen out of the thirty-eight rebels who were identified in contemporary sources suggests that roughly 37 percent of the rebels died during the suppression of the revolt. If that was the same proportion for all of the rebels and there were a total of sixty rebels—the maximum number Nat Turner estimated to be a part of his band—then that would suggest that about twenty-two rebels died when the revolt was crushed. Another approach with a slightly different method yields a similar estimate: twenty-eight rebels died as the revolt was suppressed.[29]

To accept a relatively large contemporary estimate for the number of blacks killed—such as the report in the *Edenton Gazette and Farmer's Palladium* that "there have been killed in South Hampton county upwards of one hundred negroes, consequent of the late insurrection"[30]—one would have to believe that most of the victims of white retribution had not been involved in the revolt. Many historians have accepted this, and most have even put the death toll of blacks uninvolved in the revolt in the hundreds. These historians do not explain why whites killed dozens of innocent blacks and, at the same time, spared a majority of those most deeply involved in the revolt. Obviously many whites were enraged, but it is not clear how the death toll among those not involved in the revolt would be large when roughly half of the known rebels lived long enough to stand trial.

Slavery, by its very nature, limited the nearly unrestrained terrorism that occurred in the South against blacks after the Civil War. "While slaves were scourged mercilessly, and in countless cases inhumanely treated in other respects," the great anti-lynching campaigner Ida B. Wells observed, "still the white owner rarely permitted his anger to go so far as to take a life."[31] No doubt the anger of Southampton's whites was at a peak in the days after the revolt. Whites wanted to punish those slaves who rebelled, and many whites were willing to kill some who had not been involved in the revolt. Yet even at this point, the economic reality of slavery tempered the white community's wrath. As slaves, black people were property. Whenever a slave was killed, his owner's wealth was significantly reduced. The owners of slaves understood that they could not afford to have a mass killing of slaves. Their slaves were "too valuable." Ida B. Wells saw this in retrospect, but the danger was every bit as clear to the wealthy slaveholders on the scene in Southampton. In the order threatening military justice to those whites who killed blacks, Richard Eppes reminded the citizens of Southampton County that every extralegal killing "must be attended with a total loss to their neighbors, and friends, of the value of the property."[32] The slaveholders of Southampton County and those who supported them had a vested interest in keeping slaves alive until they were tried. At that point, those convicted would be executed, but the slaveholders would be compensated based upon the court's estimation of the value of the convicted slave.

Economic self-interest may have moderated the response of some whites, but if one looks at the free black community in St. Luke's Parish, one can see that economic self-interest was not the only thing that prevented a more widespread bloodbath. Unlike slaves, free blacks lived beyond the pale, unprotected by white owners. Nevertheless, according to the tax records, free blacks—even those free blacks who lived in St. Luke's Parish, the immediate

neighborhood of the revolt—were unlikely to be killed in its aftermath. In the 1830s, tax records from St. Luke's Parish recorded the number of free black men. Between 1831 and 1832, the number of free black men in St. Luke's Parish declined from 193 to 191. Comparing the tax lists, 84 percent of the parish's free black men can be identified on both tax lists, including Thomas Haith-cock, Exum Artis, and Isham Turner, men whose cases were first heard during the slave trials and later bound over to the county court. Most of those who cannot be traced after the revolt are lost because the remaining records are sloppy, identifying the enumerated black men as "Kircher Hicks son" or "free boy at Spratley Pope." These imperfections also prevent the identification of the free black Billy Artis, a notorious suicide who killed himself rather than face capture. (The difficulty identifying him is compounded because roughly one in four free blacks in St. Luke's Parish had Artis as a surname.)[33] The gen-eral sloppiness of the records makes it likely that most of the individuals who cannot be traced from 1831 to 1832 were lost to the record keepers, not to vengeful whites.

Even assuming that vengeful whites were responsible for the deaths of the handful of free black men who died after the 1831 St. Luke's tax list was com-posed is problematic. After all, the decline between 1831 and 1832 equaled the decline from 195 in 1830 to 193 in 1831. Moreover, of the four free black men whose deaths can be documented, only one was killed by whites seeking re-venge. Two died as a result of the revolt, but not at the hands of white mobs: Billy Artis took his own life to avoid being taken alive, and Berry Newsom was executed, but only after he was tried and convicted for his role in the revolt.[34] The fourth free black whose death has been documented appears to have died from causes unrelated to the revolt. Aaron Norfleet owned 181 acres and a horse, an estate that made him among the richest free blacks in Virginia. Although he lived in the immediate neighborhood of the revolt—the 1830 census taker visited him five doors after Elizabeth Turner, six after visiting Catherine Whitehead—he survived the initial reaction. On September 20, 1831, four weeks after the revolt, the seventy-five-year-old man sat down to write his last will and testament. "Know all men by these presents that I Aaron Norfleet of Southampton County and State of Virginia," he began, "now sound in mind though infirm in body do make this my last will and testament." He was dead within two months. A relative studying his family's history has found Norfleet's death, so close to the Southampton revolt, "suspicious" and suggested that the ailments of the old man may have been triggered by "a 'vigorous' interrogation." It seems more likely that less malicious forces were at work. A few days before Norfleet composed his will, another ailing seventy-five-year-old, Thomas Gray—the father of the Southampton

lawyer who would publish Nat Turner's *Confessions*—signed his own deathbed will. Apparently the elderly in Southampton County were struck by some unknown pathogen in the weeks after the revolt. One letter from Southampton written a month after the revolt noted a "remarkable Occurrence:...within a period of a few weeks and in the compass of a few miles," eight whites between the ages of seventy-five and ninety had died. "The instances of longevity which it presents are remarkable, but their occurring so nearly together, and within so small a space, make them worthy of particular notice."[35]

If vindictive whites killed few free blacks, then the reports implying that whites killed a hundred or more blacks seem unreliable. This is not surprising given their provenance. For example, in an account of the revolt written in New York even before Nat Turner was captured, Samuel Warner estimated that "the number of blacks slain is supposed to amount to more than One Hundred." The best source for the most commonly cited figure, 120—which is used by Higginson, Cromwell, Oates, and Greenberg—was the account of the revolt told by "passengers by the Fayetteville stage." (Fayetteville, North Carolina, is 170 miles from the scene of the revolt.) Other accounts that reached Fayetteville were also high: one estimated that "about 100 and another that 250 negroes have been put to death." In Hillsborough, North Carolina, 120 miles from the scene of the revolt, William Pettigrew told his father that 150 blacks had been killed, although that guess was no worse than his other information, that the rebels "have killed seventy white familys."[36]

Even as close to the revolt as Tarboro, North Carolina, only sixty miles from Southampton, the whites were every bit as uncertain about what had happened. When the editor of the *Tarboro Free Press and Southerner* first wrote how many blacks had been killed, he allowed himself enormous range, initially reporting "from 40 to 270." Two weeks later, he corrected his earlier estimates: "About 30 negroes were killed." This lower estimate coincides with the earliest reports from people closest to Southampton. On August 25, 1831, John Wheeler, the postmaster of Murfreesboro—the place where so many refugees from Southampton had fled—sent a letter to Norfolk that contained an estimate of the number of blacks killed during the revolt. "From the best information," he wrote, "nearly 30 negroes have been killed." Jesse H. Simmons, colonel of the Roanoke Blues, reported that he had heard the same number when he traveled to Cross Keys: "We were informed that about 30 negroes had been killed." Another correspondent writing from Jerusalem guessed, "Something like thirty or forty negroes have been shot." James Trezvant, the former congressman who initially had been in charge of the forces in Jerusalem, had a similar estimate: "I suppose not less than thirty have been slain." John Hampden Pleasants, the editor who traveled to Southampton as a member

of the Richmond troops, phrased his estimate differently. He thought that "probably however some five and twenty and from that to 40" blacks died, although he acknowledged that forty may have underestimated the total.[37]

From those closest to the scene of the revolt, only one estimate of the fatalities produced a number greater than forty. O. M. Smith, a tutor from New Hampshire who lived in Sussex County, wrote to his family about the stories he heard of the revolt. Just after he explained to his parents the delay in sending out his letter—he "had not an opportunity to send it, Postmaster has been killing negroes"—he assured his parents that that "not less than 95 and not over 100 lives have been taken here the past week." Given the context, one might read this as a much higher estimate of black deaths, but that does not seem to be what Smith meant. When Smith said "lives," he apparently meant people, white and black. Since he believed sixty-four whites had died, this meant he felt confident estimating that between thirty-one and thirty-six blacks died as the revolt was being put down.[38]

The estimates of those closest to the scene of the revolt are close to the four reports of those who tried to count the number of blacks who died. Paradoxically, as a postscript to the letter in which John Wheeler estimated that "nearly 30 negroes" died, he added in a footnote: "It is said 31 exactly." The same day that Wheeler's estimate was published in the *Norfolk and Portsmouth Herald*, a rival paper, the *American Beacon*, had a different number, thirty-eight, as counted by Commodore Elliot, who had returned from Southampton with the marines. The next day, the Fayetteville *North Carolina Journal* printed a report from troops returning to Winton that noted, "32 dead bodies [negroes] have been seen." More than a week later, Jerusalem postmaster Theodore Trezvant had a lower count: "The scouting parties through the county have killed 22, without law or justice, as they were determined to shew no mercy."[39]

Systematic problems run through these enumerations. First, the information that these people had was not always reliable. For example, Commander Elliot, whose high count suggests that his troops may have done the best job counting, seems less credible when one considers that he overestimated the number of whites who had died—he said seventy-five—and he called Nat Turner "Ned." Likewise, it is possible that some of the tallies compiled in the midst of such confusion may have been skewed by enraged whites exaggerating the total number of black people they killed. Second, even reliable information was not always complete. When Theodore Trezvant counted those killed by scouting parties, it seems likely that there were other deaths that he did not include in this tally. Likewise, the correspondent from Winton acknowledged that his guess did not include "a number [of blacks who] are

supposed to have died in the woods of their wounds." The tallies also failed to include any blacks killed after the reports were written. For instance, the Winton letter was written on August 24, so it would not include the "one or two" killings that Pleasants reported took place after August 25, 1831.[40] Despite the problems, these counts of the blacks killed in Southampton were close to the estimates made by those people who had been in Southampton after the revolt. The consensus of the best-informed contemporaries was that the number of blacks killed without trials was in the thirties, something that seems likely given both the demographic trends in Southampton and the casualty rates of the rebels mentioned in contemporary sources.

Although the leaders of society were able to stop the killings, many whites still questioned whether the danger was as limited as the leaders believed it to be. When William Henry Broadnax described to the Virginia House of Delegates his success at stopping the slaughter of blacks, he noted that "it was with the greatest difficulty, and at the hazard of personal popularity and esteem, that the coolest and most judicious among us" were able to stop the killings. The leaders may have decided that the revolt was a small affair that posed little danger, but many—given Broadnax's language, perhaps even a significant majority of whites—believed that the revolt indicated a greater threat that required a more rigorous response.[41]

Despite the assurances from Broadnax, Richard Eppes, and other leaders that whites were now safe in Southampton, many whites worried that the blacks still posed a danger. Specifically, some whites doubted the prudence of Eppes's decision to let the federal soldiers and sailors who had come to Southampton return to Norfolk. Concerned for the safety of whites, some whites asked Eppes to reconsider his decision. He refused. Hoping to override Eppes's decision, they appealed to the officers of the troops who were leaving, but the officers said that they "could not comply with the request without order, from the Gen[era]l." Having been unable to get what they wanted from the officers, on Monday, August 29, 1831, "a Committee of the Citizens of Southampton" decided to go over Eppes's head. They wrote a petition to President Andrew Jackson, asking him to order "a Detachment of the U. States troops as a Guard." Unfortunately for the petitioners, Jackson told Lewis Cass, his newly installed secretary of war, to ask Governor John Floyd if the president should order the soldiers and sailors back to Southampton. At this point, the appeal of the Southampton County residents had come full circle. Floyd, who just after the rebellion told Eppes that "in all these matters I rely with confidence upon your judgment and discretion," was asked if there were a reason to overrule Eppes's decision. Eppes's decision stood.[42]

Although this attempt to bypass Eppes failed, the petition did not escape the notice of Southampton leaders. On Wednesday, August 31, 1831, two days after the petition to Jackson had been signed, former congressman James Trezvant, the man whom Eppes had replaced as the leader of the defenders in Jerusalem, wrote to the *Richmond Compiler* about the events in Southampton. After describing the revolt, he commented upon the petition. "We are sorry to learn," he wrote, "that a paper signed by a few names in Southampton, should have been addressed to the President of the United States requesting the continuance of some of the U. S. troops in that quarter." The petition, he complained, showed a lack of confidence in Governor Floyd, General Eppes, and "all the Citizens of Virginia," who had proven themselves "ready to stand by each other." With the white Virginians united, he hoped that "we might have been able to dispense with the future services of the regular troops."[43]

Trezvant was right that there would be no more need for regular soldiers in Southampton. Under the leadership of elite slaveholders including Peete, Trezvant, Eppes, and Broadnax, the whites had secured the county against the threat posed by Nat Turner and his men. More than that, these leaders had manipulated the levers of authority in such a way that the whites who lacked confidence in what the leadership had done to restore safety were blocked from acting on their fears. But Trezvant was wrong in his hope that the episodes of the week following the rebellion had done enough to instill confidence in the approach that Southampton's leaders had taken. Insecure whites may have been prevented from killing more blacks, but that did not mean that they thought the orders of the militia leaders that stopped the bloodbath were right. The leaders, acting only with the authority of their positions, were able to suppress the immediate threats—first posed by the rebels, then by vengeful whites—but they were not able to change the hearts and minds of those whites who could not forget the vulnerabilities that Turner's revolt revealed. Trezvant ended his letter to the *Richmond Compiler* urging vigilance but nevertheless insisted that "we see little room for danger." Those who wrote the petition to Jackson disagreed: "In the bosom of almost every family this enemy still exists."[44] The persistence of this disagreement—even after the most serious threat from the rebels had been suppressed—shows that the successes of the militia leaders in reestablishing order had not reassured Southampton's most fearful whites. It would be up to Southampton's court—to whom the militia delivered up the suspected rebels—to use its investigations and trials to end the uncertainty and establish the narrative that described Nat Turner's revolt as a relatively minor threat.

6

Long and Elaborate Arguments

THE LEADING SLAVEHOLDERS—who had struggled to rein in those whites who wanted vengeance during the armed response—had incredible advantages once the trials began. During the first week after the revolt, the leaders had to act decisively to stop enraged whites from attacking blacks. It took a firm response, eventually backed by the imposition of martial law, to make those whites set on revenge answerable to the authorities. On Wednesday, August 31, the whites began holding trials for the slaves who had been arrested as the revolt was put down. At this point, it became much easier for the leaders to consolidate their power. The few whites who had any role in the trials were drawn in large part from Southampton's elite, and in some cases they were the same men who had tried to restrain the reprisals after the revolt. Alexander P. Peete and James Trezvant, prominent leaders during the armed response, were both among the most active judges during the trials. In contrast, most whites, even the whites touched most deeply by the revolt, had no formal role in the trials. Instead, they were reduced to mere spectators, watching the machinations of a legal process that never asked for their input.

While all courts limit the influence of public opinion, the court that heard the cases of the accused rebels was especially insulated from popular sentiment. The court of oyer and terminer—literally, "hear and determine"—was an ancient English institution that stood apart from the common-law legal system. As Virginia's most important legal scholar described it, it was for "the special purpose of trying persons accused of treason, or rebellion, the judges of which, are frequently some of the great officers of state." In this court, the power of the judges was magnified because there was no jury. These judges did not need a grand jury indictment, nor did they have to defer to a jury on questions of fact. Because of the power that judges on these courts had, the famous English jurist William Blackstone celebrated the rules that limited the use of these courts, which otherwise "might then, as in France or Turkey, imprison, dispatch, or exile any man that was obnoxious to the government, by an instant declaration, that such is their will and pleasure." His editor in Virginia

agreed that such authority could be "dangerous to the lives and liberties of the people."[1]

Despite the perils, American colonists imported the court of oyer and terminer in the colonial period. Most notoriously, a court of oyer and terminer in Salem, Massachusetts, hanged nineteen suspected witches in response to a witchcraft scare that swept Salem Village in 1692. The same year, the Virginia legislature passed "an act for the more speedy prosecution of slaves commiting Capitall Crimes." Believing "the sollemnitie of jury" unnecessary in slave trials, the Virginia House of Burgesses created the courts of oyer and terminer. The legislature's intent was clear: it wanted to expedite slave trials. "The expense and delay involved were…unnecessary to secure substantial justice, and…accordingly provided that the Governor should issue commissions of Oyer and Terminer for the trial of any slaves accused of capital offenses."[2]

Ironically, a court that the Virginia legislature created to avoid bestowing on slaves the due process of the common law evolved into an institution that the slaveholding magistrates used to shelter their slaves. In 1772, Landon Carter, himself one of the dozen wealthiest slaveholders in Revolutionary Virginia, complained about a reform to Virginia's courts of oyer and terminer that required four magistrates, including one who was a lawyer. "By the New law, a negro now cannot be hanged, for there must be 4 Judges to condemn him, and such a court I am persuaded will never be got." Carter exaggerated the difficulties involved in convicting a slave, but he identified an important reason that judges were reluctant to convict slaves: there would be "too many Slaves to be paid for." Consistent with Carter's observation, southern courts of oyer and terminer found frequently for accused slaves. According to a survey of Southampton County trial records by historian Philip J. Schwarz, courts convicted roughly a third of those slaves who had been charged with attacking whites in the thirty years prior to Nat Turner's revolt.[3]

As a protection for enslaved property, each of the accused slaves faced a bench of five magistrates. By law, the magistrates on Virginia's courts of oyer and terminer were all slaveholders, and most of the twenty magistrates who judged the accused rebels were wealthy slaveholders. According to the 1830 census records, the judges owned an average of twenty-five slaves, which means that the typical judge headed a household that was among the wealthiest 5 percent in Southampton. If the wealthy were well represented on the court, they were especially well represented when one looks at the magistrates who judged the largest number of trials. The three most active judges—James Trezvant, Carr Bowers, and Orvis Browne—each participated in at least twenty trials, and the three lived on plantations with an average of thirty-nine slaves.

(They were the sixteenth-, fifty-sixth-, and eighteenth-largest slaveholders in Southampton.) Each of the seven most active judges owned more than twenty slaves; the poorest among the seven headed a family that was still among the wealthiest 6 percent of households in Southampton. Courts were never intended to be a representative system, but even so, the degree to which power had been consolidated among the wealthiest slaveholders was remarkable. In contrast to the seven most active magistrates, who came exclusively from the seventy Southampton households with the largest slaveholdings, only two judges came from the county's nine hundred poorest households.[4]

Even these statistics may understate the extent to which the elite dominated the court. Two judges on the court held fewer than eight slaves, but one of them, Thomas Pretlow, had once owned more slaves. Born to a Quaker family, Pretlow supported colonization and had emancipated several of his slaves with the hope that they would go to Liberia. In 1830, the census taker counted twelve free blacks with the six slaves on Pretlow's plantation; the same year, three of Pretlow's former slaves traveled to Liberia.[5] As a result, only one judge, Jepthro Darden, who owned one slave and took part in a single trial, represented Southampton's typical small slaveholder.[6] No judge represented the views of the more than four in ten households in Southampton without slaves.

The decisions about the ultimate fate of the accused slave rebels in Southampton rested with only twenty slaveholders, but even including the others who had official positions in the court left the dominance of Southampton's largest slaveholders unchallenged.[7] The clerk, James Rochelle, produced the court records; the owner of forty-seven slaves, he was also one of Southampton's wealthiest slave owners. His brother Clement Rochelle, who as the county's sheriff was responsible for the prisoners brought to the court, owned thirty-three slaves. The lawyers for the slaves were not as wealthy or as prominent as the judges, but one—Thomas R. Gray—had been a magistrate himself until an unknown financial setback forced him to resign as a magistrate and turn to the law to make money. Another of the defense lawyers, William Parker, was an aspiring member of the elite who focused much of his attention on securing an appointment as the leader of Southampton Grays, a militia unit formed in the months after the revolt. Perhaps the most important figure in court who was not a judge was Meriweather Broadnax, the commonwealth's attorney. Although Broadnax was not from Southampton, his position as the prosecuting attorney in all the cases might have allowed him to become a spokesman for those whites who feared a larger conspiracy that Southampton's leaders had ignored, except that, as the son of William Henry Broadnax,

he too was firmly allied with the elite slaveholders who tried to limit the bloodshed during the reprisals.[8]

Firmly in control of the court's proceedings, Southampton's elite used the trial to promote their interpretation of the revolt: it was a small affair involving only a few slaves. Most slaves did not support the revolt and, perhaps most important to such large slaveholders, the revolt did not show the unsustainability of the county's system of slavery. To demonstrate these things to the larger white community, the judges decided to do something that may seem surprising: they decided to give the accused slaves' court-appointed lawyers a chance to make the case for their clients' lives. When it came time to judge the accused, the judges condemned fewer than they could have had they decided to rule to the letter of the law, which permitted capital punishment even for what historian Thomas J. Davis calls "loose talk by aggrieved and embittered men."[9] By the time the trials were over, the interpretation of the court was that Nat Turner and a few others had launched a revolt that garnered little support from the black community and never really posed any long-term threat to Southampton.

From the first trials, the judges ensured that the accused slaves had many of the same legal protections that a white criminal defendant in a common-law court would have. For example, the courts respected the rebels' right not to have to testify against themselves. Every defendant pleaded not guilty, and none of the accused testified at his own trial. For free blacks who were accused of being involved in the revolt, the protection against self-incrimination may have even included the common-law privilege of not being convicted on the testimony of one's spouse. Questions about the actions of one free black led white investigators to his house, where his wife told them many things that led to her husband's arrest. However, when Meriweather Broadnax needed a witness for the indictment, he called the free black man's daughter to the stand.[10]

Another protection that the rebels had was that the judges required that each of the accused slaves be formally charged. On the first day of the trials, nine slaves were "charged with feloniously counselling, advising and conspiring with each other and divers[e] other slaves to rebel and make insurrection and making insurrection and taking the lives of divers[e] free white persons of the Commonwealth."[11] In most cases, the requirement that the accused face formal charges probably made little difference to the final verdict, but there was one trial where the defendants were released after the court decided that the formal charge against them was faulty. On September 28, 1831, Jack and Shadrach appeared before the court charged "with treason against the Commonwealth." Up to this point of the trials, no slaves had been charged

with treason, so the judges postponed the trial. When court resumed three weeks later, the judges decided that because slaves were not citizens of the country, they "cannot be tried in this court for Treason." The judges then ordered that the two slaves be "discharged from further prosecution in this behalf." Broadnax could have leveled new charges, but he did not. Jack and Shadrach were released on a technicality, a result that may have infuriated those whites who most wanted revenge.[12]

Although the requirement that the accused face formal accusations did not usually change the outcome of the cases that made it to the court, the requirement of a formal charge was an important protection for slaves and free blacks who had come under suspicion. Since only the commonwealth's attorney had the standing to level charges, Meriweather Broadnax limited the number of people tried by refusing to charge people on the periphery of the revolt. Broadnax used this prosecutorial discretion broadly, in one case refusing to charge someone who had joined the rebels. When Stephen testified at Nelson's trial, he described what had happened at William Williams's and then added details about what had happened later in the day at Rebecca Vaughn's. Even though the implication of Stephen's testimony was clear—Stephen had traveled with the rebels at least briefly on Monday—Broadnax refused to charge Stephen.[13]

While Stephen seems to be exceptionally lucky, other blacks also benefited from Broadnax's discretion. Henry, for example, described how he had been asked to join the revolt on Saturday night, the day before the revolt began. When he testified in some trials, he insisted that he had refused to join, but even Henry had to admit that he "made no communication to anyone." In the trials of Jack and Andrew, Venus described how the two slaves arrived at Richard Porter's house after the rebels had left. Nevertheless, "the negroes had left word for them to go on after them." A more zealous prosecutor might have accused the person who refused to disclose the plot about to get under way and the person who passed on the rebels' messages as accomplices in the conspiracy, but Broadnax decided not to. Likewise, he also refused to prosecute Nat Turner's wife, even though whites had evidence that she was a confidant of her husband.[14] Sometimes, too, charges were initially filed but then dropped. For example, Jacob and Isaac, both slaves owned by George H. Charlton, were charged at the same time, but after Isaac's trial, Jacob disappeared from the court records. Thomas R. Gray noted at the end of the *Confessions* that Jacob was "disch'd without trial."[15]

Formal legal procedures were important during the trials because they provided some protection for accused rebels at the same time as they excluded

most whites from deciding the fates of the slaves, but there were times when the busy court used shortcuts in the trials. Even in these cases, the judges made sure that people who had only tangential connections to the revolt were not subject to draconian sanctions. For example, the panel of judges occasionally changed in the middle of the trial. Once, in Jack and Shadrach's treason case, none of the judges before whom the accused slaves appeared in September were on the bench three weeks later, but Jack and Shadrach—who had been discharged—had no reason to object.[16]

In another, more problematic trial, different witnesses testified on Saturday, September 3 and Monday, September 5, even though one of the five judges who was part of the original court on Saturday had been replaced by Carr Bowers on Monday. One of the most active judges, Bowers had been at court for most of the day on Saturday, so it is possible that he heard the two witnesses for the prosecution who testified on Saturday. Still, he was not officially a member of the court during the first day of the trial. If Thomas R. Gray, the defense attorney in this case, noticed the change in the composition of the court, he may have concluded that the court's verdict—which included a recommendation for clemency—was the best he could hope for. Or perhaps Gray thought that objecting to the judges' actions was unlikely to end well for him in future interactions with the judges. However he rationalized it to himself, Gray made no objection to Bowers joining the court midtrial.[17]

Perhaps the clearest case of the court failing to follow the usual procedures occurred in the trial of Nathan, Tom, and Davy. The three slaves had joined the rebellion when Turner's army arrived at Nathaniel Francis's farm. After the court heard the prosecution's star witness linking the three to the revolt, one of the judges decided to take on the role of defense counsel. Someone on the bench asked how old the three accused rebels were. He was told that "the oldest was not more than 15 years, the other two much younger, the oldest very badly grown." The court decided that the three were too immature to have been fully responsible for their actions. So, after finding the three guilty, the judges recommended that the governor commute their sentences, something that the governor did.[18]

The judge's question in Nathan, Tom, and Davy's trial was unusual. More often the judges left it to the court-appointed attorneys to earn the ten dollars that the defendants' owners were required to pay the lawyers who defended their slaves.[19] One of the ways that defense attorneys argued for their clients was by making what one contemporary called "long and elaborate arguments of counsel." James Rochelle, the court's busy clerk, did not record these speeches in the official records, but in about one-third of the cases he alluded

to what were likely the defense counsels' closing arguments, noting that the court had "heard" or, more often, "fully heard" the defendants' representatives.[20] Defense attorneys also tried to undermine the evidence that was marshaled against the accused. The defense was able to question these witnesses, and one observer noted that the "court has manifested great clemency in listening with unwearied patience to the examination of a multitude of witnesses." In addition, defense attorneys called their own witnesses, who cast doubt upon the credibility of those who testified against the defendant and provided exculpatory views of the defendant's actions. The court allowed for such active defenses, and in the case where Bowers joined the court on Monday, it suspended a trial because the judges decided it was "necessary for the prisoner[']s defense that the witness should be in attendance."[21]

With the tacit support of the court, defense attorneys made good arguments for their clients. For example, in the first trial of an accused rebel, Meriweather Broadnax called two witnesses who saw Richard Porter's slave Daniel with the rebels. Levi Waller said that he observed Daniel go into the cabin where Waller's wife was hiding and where Waller later found his wife's dead body. Sampson Reese placed Daniel with the rebels at Parker's gate when the men under Alexander P. Peete arrived. Since multiple credible witnesses saw Daniel with the rebels at different points during the revolt, the defense attorney, William Parker, would have had a hard time arguing that Daniel was not a rebel. Instead, Parker looked for something that would mitigate Daniel's offense. Reese, perhaps under cross-examination from Parker, admitted that he did not see Daniel with any weapons. When Parker had the chance to call his own witnesses, he questioned Daniel's owner, Richard Porter. Porter testified that "he saw nothing uncommon about the prisoner" before the revolt, implying that Daniel was someone who had not known about the conspiracy in advance. Porter also noted that the man who captured Daniel mentioned that he surrendered himself and added that at that point Daniel "was going to his[,] the witness[',] house."[22] Parker hoped that the court would see Daniel as someone who was not a committed rebel, but only someone who was swept into the revolt for a short time. In this case, Parker's defense did not work, but it is hard to see what he could have done to make a better defense.

This type of active defense was not unusual. James French, the youngest and least experienced of the defense attorneys, defended Jack and Andrew, two young slaves who had fled from Catherine Whitehead's when the rebels arrived. The commonwealth's case against the two was simple: Jack and Andrew tried to join the rebels. To establish this, Broadnax called two of Catherine Whitehead's slaves, who both testified that Jack and Andrew left Whitehead's

plantation twice on the day of the revolt, the second time intending, as one of the witnesses described it, "to join the insurgents." Since no one testified that Jack and Andrew had actually joined the rebels, French argued that Broadnax's witnesses had misread Jack and Andrew's intentions. Rather than committed revolutionaries, Jack and Andrew were stunned by the developments during the revolt. They were in shock, and as the prosecution's first witness admitted, when they set off from the plantation a second time, they did so only because "they did not know what else to do." The prosecution's second witness also admitted that Jack "appeared to be much disturbed."[23]

When French called his own witnesses, he tried to develop the picture of two confused slaves who were traumatized by the events of the day. French countered testimony of the prosecution's two witnesses with testimony from Wallace, another slave from the Whitehead plantation, who said that Jack and "Andrew appeared much disturbed[,] greatly grieved." French also called three people who could testify about Jack and Andrew after they left Whitehead's the second time. Thomas Haithcock, a free man of color whose house they visited, also said that they were "much grieved." James Powell, a white witness called by French, said that "they came when called very humble and much grieved." The testimony of another white man, John Booth, did not use the same language but made much the same point. When Jack and Andrew stopped at his house, they "told him of the massacre and said 'Lord have mercy upon them for they know not what they do.'" The court found both Jack and Andrew guilty but, considering French's defense, recommended that the governor commute their death sentences.[24]

Not surprisingly, the defenses that the inexperienced lawyers made with little time to prepare sometimes backfired. On the third day of trials, Meriweather Broadnax brought charges against Davy, a slave whose owner, Elizabeth Turner, had died early on the morning of the revolt. To make the case, Broadnax called Hubbard, the slave who had nearly been killed by the Greensville militia after saving Harriet Whitehead's life. Hubbard, who "had known him [Davy] well for several years," testified that Davy was with the insurgents when they arrived at the Whitehead farm. In fact, Hubbard recalled, he "spoke to" Davy when the rebels were at the Whitehead plantation. When the defense had a chance to call its own witnesses, Thomas R. Gray launched an attack on Hubbard's credibility. He called two rebels to the stand, and each testified that Hubbard was wrong. Moses testified that Davy had gone with the group to Henry Bryant's, so he "was not at Mrs. Whitehead[']s," something that Nathan confirmed: Davy "was with the company who went to Mr. Bryant's."[25] If this testimony brought Hubbard's credibility into question,

then whatever specifics Hubbard had testified to about Davy's actions during the attack on the Whitehead plantation could not be believed.

There was one obvious problem with Gray's defense. To show that Davy had not been with the rebels who visited the Whitehead plantation, Gray had conceded that Davy had been with a different group of rebels. As a result, Gray still had to find something exculpatory. To do this, Gray focused on the moment when Davy joined the rebels. One of the people who was with the rebels when Davy joined testified that Davy had joined the revolt, but only because he had been "told by the insurgents that if he did not join them he should die." Another witness, Nathan, had not seen Davy join, but he told the court that he heard Davy tell John C. Turner's slave Joe that "he had been forced to join." Unfortunately for Davy, Nathan then added that Davy then told Joe that he "should join also."[26] Until that bombshell, Gray's defense had been excellent, attacking only the evidence presented by the prosecution and providing the best excuse possible for Davy's actions. Nathan's testimony, however, undermined Gray's argument and doomed Davy.

Since one of the smartest strategies used by the defense attorneys was to attack the prosecution's witnesses, Meriweather Broadnax tried to make sure that his witnesses were credible. After the first trial, where he called several people to testify that a revolt had happened, he only called people who were able to testify about what they had seen firsthand. In part Broadnax was able to do this because he had found two witnesses who would become the stars of the trials. Levi Waller had survived the most deadly single raid during the revolt. Unlike other whites who escaped, however, Waller did not simply flee from the rebels. Once he eluded his pursuers, he doubled back to his plantation, where he watched what happened. Moses, a young slave who lived on Joseph Travis's farm, also had a distinctive vantage on the revolt. According to his own confession, he had been forced to join the rebels just as the revolt was getting under way. Another account described how he was tasked with holding the rebels' horses during the actual raids. He was with the rebels throughout the day on Monday until the skirmish at Parker's farm.[27] Between these two witnesses, Broadnax could document much of what happened during the day on Monday.

As important as what Waller and Moses had seen was how effectively they testified. Both were willing to limit their testimony to what they knew. When Moses appeared in Lucy's trial, he only said that "after the murder was committed, he saw the prisoner [Lucy] in company with the insurgents at the door." They also were willing to offer exculpatory observations, even when they testified for the prosecution. For example, Broadnax called on Moses to

testify against the youths Nathan, Tom, and Davy. Moses said that the three had been with the rebels through most of the day Monday, but he also observed "that they went unwillingly" and that they "were constantly guarded by negroes with guns who were ordered to shoot them if they attempted to escape." When Levi Waller testified against Dred, he told the court two things about him: he had seen Dred "with a gun or a rifle," and he remembered Dred looking for him as he hid behind a fence. With such strong evidence, the question turned on the reliability of Waller's identification of Dred. Waller told the court that he had been "near him [Dred] and knew him well." When Dred's lawyer, James French, asked Waller if he could have been mistaken, Waller wryly admitted that he "does not know which witness cannot be mistaken." Waller's modest answer convinced not only the court, who convicted Dred on Waller's testimony alone, but also French, who in a later case called Waller as a witness for the defense.[28]

No one testified as often or as effectively as Waller and Moses did, but the court found other witnesses compelling, as demonstrated by its willingness to convict on a single individual's testimony. Mary Barrow, for instance, was the only person who testified against Edwin Turner's Nat. She said that he "was one of the negroes that came to her husband's home on the day that her husband was murdered." She even added the detail that Nat "fired off a gun in the yard." In this case, the actions that she described were unambiguously those of an active rebel. As a result, the issue in Nat's trial became how certain Mary Barrow was that Nat was the same person who she had seen firing the gun during the attack. Could the court be sure that she had seen Nat and not someone else whom she mistook for Nat? When asked about this, Barrow insisted that she could not have made such a mistake: "she knows the prisoner—he lived at her house the last year." Moreover, she was close, "within thirty steps of him when he fired off the gun." The court was convinced. Nat was sentenced to die.[29]

The prosecution's careful handling of testimony extended to confessions made by suspected rebels. In several cases, whites testified to the court about confessions made by slaves who had been arrested after the revolt. No one ever questioned the reliability of the white witnesses who described what the defendants had said, but on two different occasions the white witnesses swore that the defendant's confession was a "voluntary" one. Likewise, in the trials of Stephen and Curtis, John C. Turner, the only person who testified against the two, insisted that their confessions had not been made to end or avoid torture. He told the court that in both cases "no promises or threats were made to them." In the case of the trials' star witness, Moses, "divers[e] witnesses" insisted that Moses's "evidence was given freely and voluntarily after being

told that he was not compelled to give testimony." In this case, the issue was slightly different from the issue for the other rebels: had Moses testified against the other rebels because he had been promised favorable treatment when it came time for his own trial? The witnesses who heard Moses's confession insisted that Moses had been told "that nothing which he said would be of any advantage to him."[30]

Broadnax was even more cautious with confessions reported by other blacks. In fact, confessions reported by other blacks rarely made it into those trials that ended in a conviction. In the two cases where such witnesses did appear, neither witness was a suspected rebel who might be trying to curry favor with the court.[31] Instead, Broadnax called blacks who were not looking for mercy from the court. In the trial of one suspected rebel, Broadnax called Frank—a slave who had supported the whites during the raid at Blunt's plantation—to relay to the court what Moses had said when Frank caught him. Similarly, in Nathan's trial, Daniel told the court that Nathan admitted that he had been with the rebels. Daniel was also in jail when Nathan made this confession, but Daniel was unlikely to appear before the court himself because he was a captured runaway, not a rebel.[32]

Although some defendants were convicted upon a single witness's testimony, the ongoing attention to the potential problems with testimony meant that Broadnax tried to show that his witnesses' testimony was credible. One way to do this was to have witnesses describe physical evidence that supported the charges. Nathan, for instance, was wearing stained clothes. After Daniel recounted what Nathan had said while he was being held in the Greensville County jail, Daniel added that Nathan "had blood on his breeches which he said he told the white people was cider." Nat Turner's right-hand man, Hark, was implicated by physical evidence that had been found on him when he was captured. Thomas Ridley told the court that Hark had money, shot, and even "a pocketbook…which he believed to have been Trajan Doyle's." The one woman tried for involvement in the revolt was also convicted after she was tied to the revolt by physical evidence. In Lucy's case, Bird, a slave, testified that weeks after the rebellion, some people found "four pieces of money in a bag of feathers and covered with a handkerchief" in a room where Lucy had lived with another rebel. Blood, gunpowder, and money were all compelling, but so were more mundane items. For example, one of the slaves was convicted after the court heard that he had been captured wearing "shoes and socks" that had belonged to his dead owner.[33]

Since physical evidence was usually not available, Meriweather Broadnax often strengthened his case by calling multiple witnesses to testify against

the accused. Even in cases where Broadnax's best witnesses appeared, he did not let their testimony stand by itself if he could avoid it. On Saturday, September 3, the trials began with the trial of Sam, whom Waller had seen with the rebels during the revolt. In this case, Waller's testimony was the only evidence upon which Sam was condemned. In the next trial, Waller again appeared as a witness, and he told the court that Hark was at his farm, adding that the others acknowledged him as a leader, calling him "Captain Moore." This testimony was even stronger than Waller's testimony against Sam, but Broadnax still called another witness, Thomas Ridley. Ridley told the court that Hark had "admitted that he was in the company that went to Dr. Blunt's." Blacks were also called on to confirm what whites described in the confessions that they relayed to the court. In Davy's trial, for instance, after Jarell W. Jenkins recounted Davy's confession, Broadnax called Jacob, a slave, who told the court that he "saw the prisoner at Wm. William's," one of the places that Davy admitted to Jenkins that he had visited with the rebels.[34]

The use of multiple witnesses inevitably led to confusion as witnesses described the happenings during the chaos differently, often contradicting each other. The lawyers went to considerable lengths to resolve these ambiguities. For example, Broadnax called three witnesses in the trial of Moses, who was captured at Samuel Blunt's. The first witness, Shadrach Futrell, placed Moses at the head of the group that approached Blunt's on Tuesday morning. Futrell told the court that he was "positive that the prisoner is the man" he saw, noting that Moses had been "within thirty feet of the porch" when he dismounted and went into the garden. The second witness, Frank, also identified Moses as the man he captured.

Despite this testimony, Moses's defense attorney, William Parker, found a problem with the prosecution's case: Futrell testified that Moses "charged... into the garden" and Frank said that Moses "jumped" a fence to get into the garden, but Frank admitted that Moses "was lame and could not run." Could the prosecution's two witnesses have been mistaken? Perhaps someone else had been at the head of the rebels and jumped the fence. Frank rejected this, testifying that "it is impossible that the person who jumped into the garden could have been the one who was shot," an allusion to Hark. Broadnax apparently decided that Futrell and Frank's testimony was right. He called Mary, a slave who had been in the garden at Blunt's. She swore that she saw "a small man with a light colored cap on," which Frank, when he returned to the stand, said sounded like the cap that Moses was wearing when Frank captured him. In his second round of testimony, Frank also added details

including the observation that Moses was wearing "light breeches," which "corresponded with those which the foremost man [among the rebels] had on."[35]

Moses's attorney, William Parker, already had his work cut out for him by the time that he had his chance to call his first witness, but in selecting that witness, Parker made a mistake. Perhaps based upon a theory that Futrell and Frank had really seen Hark at the front of the rebels, William Parker called Hark to the stand. Unfortunately for Moses, Hark said nothing that helped Moses's defense. Hark told the court that "the prisoner joined them voluntarily." Moses had been with the rebels "some time," and Hark even added that Moses had been "in the company that went to Dr. Blunt[']s." At this point, the court had uncovered much about Moses's actions: Moses had joined the rebels on Monday afternoon at Mrs. Vaughn's. He remained with them overnight and was one of the rebels at Dr. Blunt's during the raid on Tuesday morning, when he was captured. Most likely, as Futrell and Frank swore, he was the man who had been in the front of the rebels as they approached the plantation's main house.

Even though Hark's testimony settled the most important questions, one remained: had, as Hark contended, Moses joined the revolt "voluntarily"? Or, as Moses told Frank, had the rebels "forced him to join them"? To convince the court of the latter, Parker called one of Mrs. Vaughn's slaves to the stand. Delsy testified that Moses had come to Mrs. Vaughn's and that the rebels "required the prisoner to go with them." When asked if Moses had any opportunity to escape, Delsy admitted that she thought that the "prisoner could have escaped while the insurgents were coming up." Broadnax was not content to suggest that Moses had not fled when he had the chance; he wanted to show that Moses had hoped to join the rebels. According to Frank's testimony, Moses had said the reason he was at Vaughn's in the first place was "that Newt Drew had sent him to Mrs. Vaughn[']s to see what the news was." But when Drew came to the stand, he contradicted Moses's account. Drew stated "that he gave no such orders to the prisoner as he spoke of but on the contrary that he the witness met with the prisoner shortly before he was at Mrs. Vaughn[']s and ordered him to go home." Newit Drew's testimony cast doubt upon the reliability of Moses's original confession and suggested that Moses went to Mrs. Vaughn's with the goal of joining the revolt.[36]

In retrospect, the decision to prolong what was already a relatively lengthy trial with an exploration of Moses's motives seems odd. Why were the attorneys so interested in Moses's intentions, especially since multiple witnesses had already identified Moses as an active rebel? Did Parker really think there

was any chance the court would do anything other than sentence Moses to death? Did Broadnax? Given the behavior of the lawyers, this seems to be exactly what the defense attorney hoped and the prosecutor feared might happen. Parker was an energetic defense attorney, but he was perfectly willing to remain seated during a hopeless trial. For example, two days after Moses's trial, William Parker defended another accused rebel, Hark. In this trial, the evidence that Broadnax used against Turner's second in command was over-whelming: Waller saw Hark during the raid on his plantation. After his cap-ture, Hark admitted to one of his white captors that he had been among the rebels who had attacked Dr. Blunt's. He was also one of the rebels impli-cated by physical evidence. When Hark was captured, whites found him with "powder and shot and some silver in his pockets." Moreover, even if Broadnax did not allude to Moses's trial, anyone who had been following the trials—including, significantly, three of the judges who sat in judgment of both Moses and Hark—also knew that Hark had implicated himself two days earlier when Parker had called him as a witness in Moses's trial. Seeing no plausible defense for Hark, Parker apparently neither called any witnesses nor made a closing argument.[37] Given this approach to an open-and-shut case, Parker seems to have been as active as he was in Moses's trial because he believed that it was a case where his defense mattered.

Broadnax also seemed to think that the court might spare Moses's life. Despite being an enthusiastic rebel who remained with Turner after many of the rebels fled, Moses had not been part of the original conspiracy. Since Moses joined the rebels only after their raid at Mrs. Vaughn's—which was the last place that any whites died—he could not have had any role in killing any whites. Finally, he was lame.[38] Given these mitigating factors, Broadnax wanted to establish that Moses freely joined the revolt. He called Newit Drew to the stand, and the testimony of one of Southampton's wealthiest planters was more than enough to secure the death sentence that, up to that point, both lawyers had thought was in doubt.

Moses's trial was one of the earliest, which suggests that from the begin-ning the lawyers understood that the death penalty was not a foregone con-clusion. As it turned out, their sense of the judges' disposition toward the accused slaves was borne out over the course of the trials. The judges re-stricted the use of the death penalty not only more than an enraged white population, which had hoped "to inflict immediate death on every prisoner," might have, but even more than Meriweather Broadnax, who had used his discretion to release prisoners for whom the suspicion of involvement in the revolt could not be substantiated. Even after Broadnax limited prosecution to

the forty-five slaves against whom he could make the strongest cases, the court still discharged a third of the accused.

The court trial records in these cases were even more abbreviated than the records for those found guilty. For example, Thomas Ridley's Matt was charged with conspiracy to rebel, but after "sundry witnesses being sworn in and examined and the prisoner by William C. Parker[,] his Counsel[,] fully heard. It is the opinion of the Court and accordingly ordered that the prisoner is not guilty."[39] This record answers few of the questions that anyone might ask about Matt's relationship to the revolt. Was Matt someone who was closely tied to the rebellion but found not guilty because of some problem in the case? Or was Matt someone who had almost no connection to the revolt and was indicted on weak evidence? When the rebels arrived at Ridley's plantation on Monday night, how did Matt respond? If he joined the rebels, was it just briefly or for a longer time? If he joined, was it freely or under duress? In the case of Matt, as in the cases of most of those who were discharged from further prosecution, such questions are impossible to answer using the surviving court records.

In a few cases where the defendants were discharged from further prosecution, other evidence suggests that the slaves who were released could have been convicted by a less sympathetic court. In 1832, Mary Blackford visited Southampton, where she heard about Tom's actions. According to her sources, Tom sounded the alarm after he fled from the rebels when they raided Catherine Whitehead's plantation. To Blackford and to the whites who told her about how Tom warned the whites, Tom's actions were heroic. Tom had even been given "a certificate testifying to his actions in saving the lives of so many whites." Yet this story of a loyal slave was one that appeared later. Immediately after the revolt, Tom had been arrested and jailed. While some blacks were kept in jail for safekeeping, some whites—including the prosecutor, Meriweather Broadnax—thought Tom may have been guilty of supporting the revolt. The reason Broadnax decided to prosecute Tom is unknown, but one detail that Blackford recorded may have contributed to Broadnax's decision. According to Blackford, at a farm where Tom had informed the residents about the rebellion, "the Master gave him a hatchet to defend himself should the insurgents attack him."[40] It is possible that a white man armed a young black slave during a revolt, although it is obvious that a hatchet would not have been of much use if Tom encountered the rebel army. Another possibility is that Tom had been seen on the run with a hatchet and that some whites inferred that he wanted to join the rebel army. If so, the story of a white man giving the weapon to Tom to defend himself was an alibi that exonerated someone who

had tried but failed to join the rebels. Broadnax apparently did not believe this alibi, but he was unable to sway a court that refused to reject the possibility that Tom was a loyal slave.

At the trial of Jack and Shadrach, the defendants who were charged with treason before the court dismissed the charges as faulty, the judges made clear the willingness of the court to discharge defendants who faced serious accusations. According to the information prepared by Broadnax, Jack and Shadrach had aided and abetted two different rebels more than a week after the revolt began. Broadnax charged that over the course of several days—including on August 30—Jack and Shadrach "maliciously and traitorously did receive [?] and feed and aid and abet" Sam. He also noted that they had received "one watch and a large sum of money" from Sam "for the purpose of promoting the escape + safety of the devil Sam." Broadnax then charged that on the same day, the two also did "feloniously + traitorously receive believe [?] and comfort Davy...well knowing that the said Davy had been guilty of insurrection and treason."[41] Given the specificity of the charges, Broadnax must have had at least one witness who could testify that Jack and Shadrach had harbored these fugitives. But the court's decision to dismiss the charges on a legal technicality meant that, in order to preserve the integrity of the court proceedings, the judges were willing to let Jack and Shadrach avoid legal sanction for helping Sam and Davy.

Not surprisingly, given the court's willingness to discharge slaves who helped rebels, the court also limited the number of slaves who were executed. Of the forty-five slaves charged in connection to the revolt, eighteen were hanged. All eighteen of these accused had encountered the rebels. All except Lucy, the only woman executed after the revolt, had accompanied the rebels.[42] The court apparently decided that being with the rebels was necessary but not sufficient to lead to a conviction and an execution. In the trials of those who were hanged, the court looked for some additional evidence that suggested that the defendants had actively or willingly supported the revolt.

One obvious way of confirming the complicity of rebels was to look for those who killed the whites. For example, Nat Turner admitted that he had killed Margaret Whitehead, but his was the only trial in which a single defendant could be tied to a specific killing. Daniel and Nathaniel Francis's Sam, who had each been seen entering the cabin where Levi Waller's wife died, were tied more loosely to a killing, but this circumstantial evidence was strong enough for Southampton's judges. Moses and Edwin Turner's Nat were also convicted after witnesses testified that the two were actively involved in raids. At Nelson's and Lucy's trials, white witnesses described how they came close

to dying when the accused tried to turn them over to the rebels. The court decided that all of these active rebels should die. Other, less dramatic actions could also put a defendant on the road to the gallows. In at least five of the trials that led to executions, witnesses claimed that the defendants had tried to get others to join the revolt. Even in cases where no witness described any particular actions of a defendant during the revolt, the court decided that some—including Dred, Joe, and Peter Edward's Sam—were willing and active rebels at least in part because they had been seen carrying weapons while they were with the rebels.

Most of those executed were convicted after strong evidence placed them with the rebels and other evidence—which was not always as strong—led the court to think of the defendants as active rebels. In four cases where the defendants were executed, however, the court was unable to find any evidence of the rebels fighting in the revolt, carrying arms, or recruiting. In these cases, the judges revealed the limits of their sympathy for people who had been with the rebels. For example, Nathan was convicted after Daniel told the court that Nathan "said he had been present when the murders were committed by the insurgents." The defense called the trials' star witness, Moses, who testified "that the prisoner went unwillingly—that he committed no murder and he [Moses] thinks [Nathan] had no opportunity to escape and remained with the insurgents till they dispersed." Having heard from both prosecution and defense witnesses that Nathan had been with the rebels but not participated in any of the killings, Nathan was nonetheless convicted and sentenced to die. In this case, it is unclear why the judges did not recommend that the governor commute Nathan's sentence. Perhaps the judges focused on the fact that Nathan had bloodstains on his clothes, suggesting that he was more involved than those slaves who had been coerced into joining the revolt and who tended to stay away from the killings. Or maybe it was something else, something that did not make the record. Whatever the reasons, the judges sentenced Nathan to die.[43]

Two others defendants were also hanged although the evidence in the trial records did not show that they contributed to the revolt in any meaningful way. In the trials of both Ben and Levi Waller's Davy, Broadnax suggested that the two had been conspirators who knew about the rebellion before it began. On Monday morning, as the revolt was already under way, Ben told another slave who had yet to hear about the revolt that "there was going to be a war." Levi Waller heard Davy called "brother *Clements*" by one of the rebels. In both cases, this evidence hardly proved foreknowledge, but the prosecution's case was also supported by much stronger evidence that the defendants joined

the revolt freely. According to Waller, when Davy returned to the farm, he found the rebels in control. Waller described how Davy responded to the situation: he "drank with them, rode his master's horse off in good spirits… [he] left there in great glee." Perhaps the most damning testimony in Ben's trial came from Luke, who described how on Tuesday, August 23, when Southampton was in chaos, Billy Artis and a small contingent of rebels made their way to the farm where Ben and Luke both were. According to Luke, Artis "asked the witness [i.e., Luke] to go with him, but witness refused." In contrast, "Artist [*sic*] said nothing to prisoner but prisoner went off with him." Because Luke's refusal made clear that Artis was not forcing recruits to join, the court concluded that even if Ben had not known about the plot in advance, he freely chose to join. In these cases, the recruits' eagerness to join the revolt cost them their lives.[44]

The accusations made against those who were discharged indicate that in some cases the court was willing to dismiss even serious charges; the cases of those executed suggest that the court was trying to restrict the death penalty to those who had a direct and active connection to the rebels. A third group of trials may be the most revealing when it comes to the efforts of the court to minimize the threat posed by the revolt. Thirty of the forty-five slave trials ended in conviction, but only eighteen slaves tried in Southampton were hanged for their involvement in the revolt. For the rest of those convicted, their sentences were reduced by the governor to transportation from Virginia.

As historian Michael Nicholls explains in *Whispers of Rebellion*, the option of having the governor commute the sentences of convicted rebels originated in a fiscal crisis following Gabriel's 1800 conspiracy. After hearing about a slave conspiracy on the outskirts of Richmond, white investigators unearthed evidence of a relatively large plot. Many suspected conspirators were charged, tried, and condemned. Over the course of a month, from September 10 until Gabriel himself was hanged on October 10, the state executed twenty-five slaves. According to Virginia law, the owners of the slaves executed by the state were entitled to compensation, but the large number of executions meant that the state had spent all the money it had set aside for compensation, a problem that became an issue at the top levels of state government.[45]

One way to cut these expenses was to pardon those who had been convicted. Beginning in early October, Governor James Monroe did that, pardoning a dozen slaves convicted as part of Gabriel's conspiracy. Although these pardons lowered the total cost of compensation significantly, this did not solve the crisis entirely. What could be done with those conspirators whose roles in the conspiracy disqualified them from a pardon? In mid-October,

Governor Monroe began delaying scheduled executions, hoping that the upcoming legislature would add a new sentencing option that would enable him to commute death sentences without granting a full pardon. The slaves who had their death sentences commuted would still be punished—they would be transported from the state, unlikely to see family or friends ever again—but they avoided the ultimate, and expensive, death penalty.[46] According to a law passed by the Virginia legislature in January 1801, those who had been sentenced to die could have their sentence reduced to transportation by the governor. Under the provisions of this law, which was retroactive, eight men, including the man who first told Gabriel about the plot, were sold to slave traders who were required to remove them from Virginia. For these eight slaves, slave traders paid the state $2,617.34, which helped offset the state's compensation to owners of slaves who were condemned.[47]

The procedure for commuting death sentences had not changed significantly by the time Nat Turner and his men were tried. The court that condemned the defendant was required to send along a copy of the trial records to John Floyd, the sitting governor of Virginia. Floyd then reviewed the case. If he believed that the case merited commutation, he was required by the Virginia constitution to get "the advice of the Council of State." The requirement that the governor receive advice was purely formal. Once advised, the governor was able, as Floyd described it, to "do as I please."[48]

Governor Floyd understood that he was the only person who could reprieve the condemned, but the constitutional requirement that he get the advice of the council turned out to be a significant limitation. On Monday, September 19, Lucy and Joe were tried separately for their roles in the trials. Both were sentenced to die, Lucy probably because of her attempt to stop Mary Barrow from escaping as the rebels approached her farm, Joe on testimony that he was armed and recruiting, even though the one person he recruited had "returned [to the farm where he lived] shortly after" the rebels had left. The two were sentenced to hang on September 26, one week after their trials. As required by statue, Southampton clerk James Rochelle copied the two trial records and sent them on September 22 by express to the governor. Governor Floyd received the trial records on Friday, September 23. Upon reading them, he was convinced that Joe and Lucy "were of the insurgents." Nevertheless, he was "disposed to reprieve [them] for transportation." At the time, however, no member of the council was in Richmond. Floyd complained to his diary that the constitutional requirement that he get "the advice of the Council...endangers the lives of these negroes." He held out hope that one of the councilors might return to Richmond in time for Floyd

to consult and then send out the commutation, but it did not happen. On Monday, September 26, Lucy and Joe were hanged, unable to be saved by the one man vested with the power to prevent their execution.[49]

While Floyd failed to save Lucy and Joe's lives, he spared two others, Jim and Isaac. But these cases were unusual. Most of those whom Floyd reprieved were those whom the Southampton court recommended for commutation.[50] In nine trials involving eleven slaves, the court recommended that the governor reduce the punishment to transportation from the state. Floyd deviated from the recommendation of the court in only one case, perhaps because the court that unanimously convicted Jack split (three for, two against) when it recommended mercy.

The verdict in Jack's case is an interesting one because the disagreement among the judges suggests that they saw this case close to the line dividing those who deserved to die from those who deserved clemency. In this case, there was little dispute about the facts. Jack was Hark's brother-in-law who had been brought to the feast at Cabin Pond before the revolt began. He had been with the rebels on Sunday night as the revolt began and stayed with them until some point on Monday morning. Although he was an early recruit, he was not an enthusiastic one. After Jack was hanged, Nat Turner described Jack as "only a tool in the hands of Hark," and the evidence from both whites and blacks at the trial painted a portrait of a reluctant rebel. Moses, the prosecution's first witness, placed Jack with the rebels, but his testimony described how the rebels "made the prisoner [Jack] go with them." According to Moses, when Jack told the rebels that he was "sick and wanted to go home…Hark would not let him go." Thomas Jones, one of the white men who heard Jack's confession, also described a reluctant rebel. He noted that Jack had said that he objected upon first hearing the plan for the revolt. Jordan Barnes, the man for whom Jack worked, testified that Jack was in the neighborhood of the revolt with permission. Barnes added that Jack returned to Barnes's farm early in the day on Monday, implying that Jack left the rebels before they were defeated at Parker's farm.[51] Put together, these details convinced a majority of judges that Jack, though guilty, did not deserve to die.

Two judges, however, disagreed with their colleagues about Jack's sentence. Since the prosecution's own witnesses had described how Jack had been unwilling to join the revolt, the two judges who wanted to execute Jack probably accepted the argument that Jack was not a committed rebel. But these judges apparently believed that he was not as reluctant as Jack and his lawyer, Thomas R. Gray, suggested. In particular, the two judges were probably troubled by one detail in the testimony of Sampson Reese. Most of Reese's testimony was

repetitive, and James Rochelle abridged the record of Reese's testimony by simply saying that Reese "confirms the evidence in the case given by Thomas C. Jones." But then Rochelle added an important aside from Reese, who stated that Jack, "when arrested[,] had on a pair of shoes and socks which the witness believed to be William Reese's who had been murdered."[52] Clearly Sampson Reese thought that Jack had stolen his owner's shoes, possibly from Reese's corpse. For two of the judges, this action offset the reluctance that Jack had shown when the revolt began.

Although the court's recommendation of mercy was not enough to save Jack from the gallows, it was enough to save the lives of ten slaves, whose sentences John Floyd commuted. For four of the slaves, the commutation came even though they had traveled with the rebels. In the trial of Nathan, Tom, and Davy, Moses testified that the three had joined the revolt, but only under duress. According to his testimony, the three were "constantly guarded by negroes with guns who were ordered to shoot them if they attempted to escape." It was at this point that one of the judges interrupted the trial, asking how old the slaves were. When told that they were young, the court decided that these unwilling rebels should be banished from Virginia.

The only other person who traveled with the rebels and had his sentence reduced was Moses, the star witness at many trials, including Nathan, Tom, and Davy's. At the end of Moses's trial, the court recommended that the governor commute Moses's sentence. Although a newspaper report had minimized Moses's role in the revolt, the testimony at the trial focused more on his willingness to testify during the trials. Whites claimed that there was no formal deal to commute Moses's sentence in exchange for his testimony, but Moses apparently benefited from an unstated arrangement in which he was recommended for mercy in exchange for cooperating with the whites' investigations.[53]

Six others also had their sentences commuted by the governor following the recommendation of the court.[54] In each of these cases, the accused were people who had agreed to join the revolt. For instance, Broadnax brought charges against Hardy and Isham, both of whom were owned by Benjamin Edwards. According to Henry's testimony at their trials, each of the defendants "said they would join" the rebels when recruiters asked them in the chaotic days after the revolt. The defense's own witness in Hardy's case, the free black Eliza Cratherton, also admitted that Hardy told her that he "meant to join Genl. Nat." On its own, this was clearly enough to convict a slave under the laws of conspiracy. Yet there is no evidence that Hardy ever joined the rebels. In part this was because the rebels never returned, but the defense also

argued that Hardy's intentions changed. After testifying that Hardy and two others had promised to join the revolt, Cratherton then noted that "she dissuaded them from it." Since the court reserved the death sentence for those who had actually been with the rebels, Hardy might have had his life spared anyway. Nevertheless, the idea that those who had agreed to support the rebels were simply making an unconsidered and temporary decision fit well with the court's view that the black community really did not support the revolt.[55]

It is unclear if Broadnax prosecuted every slave who he could show had promised to join the revolt or if he limited prosecutions. In two of the cases, the slaves who had promised to join had also made particularly inflammatory comments. For instance, when Hardy first heard that "the English were in the County killing white people...[he] made light of it and said that it was nothing and ought to have been done long ago." Isaac's comments were even more provocative. On Monday, the day the revolt was at its peak, Nancy Parsons passed a group of George Charlton's slaves along the road that ran next to Charlton's plantation. Parsons and the slaves were on the western edge of the county, away from the rebels, who were then making their way east toward Jerusalem. At that point, the whites on the western side of Southampton did not know what was happening—like Hardy, Parsons had heard that the "British were in the County"—so Parsons asked Isaac, who was some distance away from the others, "if he was not afraid." Parson later testified that Isaac replied "he was not," and then he added that "if they came by he would join them and assist in the killing—that if they succeeded[,] he would have as much money as his master."[56]

Facing testimony that Isaac had wanted to join the revolt, Isaac's lawyer, James French, decided upon an unorthodox defense strategy, one that could work only in a court where the judges were trying to limit the scope of the retribution. French accepted that Isaac had said what Parsons claimed, and argued that Isaac had said this because he was, as the defense's lone witness testified, "very headstrong." This witness also noted that Isaac had expected his freedom, and said that "if he had been set free two courts ago[,] this would not have happened." No one recorded why Isaac thought that he was going to be freed, but the idea of a disgruntled slave certainly fit with the picture that French was trying to paint of his client.[57]

The exchange between Isaac and Nancy Parsons is one of the more remarkable conversations that took place during the revolt. Parsons was understandably afraid when she heard of the killings, even if she attributed the bloodshed to British forces rather than rebel slaves. Isaac, on the other hand, savored this moment when the bottom rail was on the top. In the course of

the exchange, he considered what would happen if the revolt succeeded. Parsons and the other whites would die, he figured, but, playing out this possibility, Isaac "offered to take Miss Parsons['s] child and preserve it and father it." Isaac's dark humor here crossed boundaries involving both race and sex in ways that could have been threatening even absent a slave revolt. In the wake of Nat Turner's revolt, the comments were astonishing. But the fact that Isaac would say anything actually supported French's defense. Isaac's statement that he would join the rebels had to be understood as spoken by a slave who did not respect the conventions of slavery—even making risqué jokes to a white woman about her impending death. These comments were clearly threatening, but French likely drew the court's attention to the contrast between Isaac's words and actions. Had Isaac actually done anything? Had he tried to hurt Parsons? Had he tried to join the rebels? Broadnax presented no evidence of any of these things. In fact, Isaac had done little more than use the revolt as an opportunity to take a break from his toils. When Parsons saw Isaac, he "was lying some distance off outside of the field kicking up his heels." It is hard to imagine that either Parsons or the court found Isaac's comments amusing, but French believed that the court could distinguish a truculent slave from an actual rebel. As it turned out, French's strategy worked. Isaac was convicted, but the court recommended that the governor commute his sentence.[58]

The court's insistence on proper procedure also helped free blacks. Unlike slaves—who were charged, tried, and sentenced directly by the court of oyer and terminer—free blacks were brought before the county court. The Southampton County Court was indistinguishable in its composition from the county's court of oyer and terminer—the judges were the same men and the records for the two institutions were interwoven in the same book—but where slaves were judged by the court of oyer and terminer, the free blacks faced a court that simply decided if there was sufficient evidence to try them. In one case, the Southampton County Court heard enough to make its decision, declaring that Arnold Artis "ought to be discharged from further prosecution."[59] The charges against four other free blacks were more serious, and the court ordered that the defendants be brought before the next Superior Court. The simple delay meant that unlike the slave trials, which were held when passions were at a peak, the trials of free blacks took place in the spring of 1832, more than eight months after the revolt.

Free blacks in Virginia enjoyed more formal legal protections than slaves, but because free blacks were not property they were vulnerable in one way that accused slaves were not: convicting a slave under Virginia law meant that

taxpayers had to compensate the slave's owner, while convicting a free black did not entail these extra costs.[60] Yet the judges and the juries in Southampton appear to have approached the defenses of free blacks much as they had approached those of slaves. Just like the militia leaders who had protected free blacks from retribution, the juries required that the prosecutor make a strong case against the accused free blacks. Even when he did, it was not always enough to secure a conviction. Of the four free blacks who were remanded to jail to await the next Superior Court, only one was convicted.

Berry Newsom, who had been indentured to Peter Edwards, had the misfortune to be the only free black in Southampton found guilty for his actions during the revolt. On the day of the revolt, Newsom was at Benjamin Edwards's, and one witness later described how Newsom had declared that he would get revenge against Edwards. During the tumult, Henry asked Newsom if he had seen Edwards. Newsom replied, "Yes he had seen the d—— Rascal + would have him before night." As it turned out, Newsom never made good on his threat against Benjamin Edwards, who was back on his plantation the next day. Nevertheless, a few days later, Newsom remained enthusiastic about the revolt. When rebel recruiters appeared on the plantation in the days after the rebel army had been dispersed, Newsom and two others promised to join the rebels, who the recruiters said would come by on Wednesday, August 24 or Thursday, August 25. Based upon this evidence, the jury decided that Newsom was more than a disgruntled apprentice who resented Edwards; he was someone who had agreed to join the revolt. The jury convicted Newsom, and the judge sentenced him to death.

Although the verdict was justifiable according to the law, it was harsh relative to the punishments that had been meted out to slaves convicted of similar things. Hardy and Isham, Benjamin Edwards's slaves who had done almost exactly what Newsom had, were also sentenced to die, but the governor followed the court's recommendation and commuted their sentences. It is impossible to know the reason for this disparity. Had the court not considered commutation? No free black had his sentence commuted, presumably to banishment. Had Newsom's defense attorney failed him? Eliza Cratherton's testimony at Hardy's trial suggested that she persuaded both Hardy and Newsom not to join the revolt after they promised that they would join, but it is unclear if she testified at Newsom's trial. Newsom was hanged on May 11, 1832, the nineteenth and last person in Southampton County executed for involvement in the revolt.[61]

Three free blacks avoided Newsom's fate and were acquitted by the Superior Court. Records do not exist for one of these trials, but records from

the other two cases indicate that the acquitted free blacks had faced serious charges. As has been discussed, when the slave Burwell attempted to deliver Bolling Barrett's message to whites in the neighborhood, telling them where to gather, Exum Artist tried to convince Burwell not to help the whites. Burwell ignored Artist's plea for racial solidarity, which incensed Artist. So when Burwell, still following Barrett's directions, went to Mrs. Gurley's to deliver the message to more whites, Artist followed him. By the time the two reached Gurley's, Artist had a gun and threatened to shoot Burwell. Although the prosecutor did not present any evidence that Artist had joined the rebels or shot anyone, his attempt to cut the whites' lines of communication—using a gun—made him an obvious target for prosecution. Fortunately for Artist, by the time the Superior Court heard the case, it interpreted the evidence as indicative of an internecine dispute, not as proof of involvement in the revolt. Artist survived his trial and even remained on William Vick's plantation in 1832.[62]

Even more than Exum Artist's trial, Thomas Haithcock's trial makes clear that the court was willing to dismiss charges against free blacks who had been implicated in the revolt. On the day of the revolt, Haithcock was at his home when Jack and Andrew, the slaves who fled Catherine Whitehead's plantation, appeared. Unsure of what they should do, Jack and Andrew asked "Haithcock which they must do, whether they must go or not." Haithcock's response was unambiguous: "they must go." He added "that he would go with them as soon as he could get something to eat." Haithcock then "told his wife to make haste and get him something to eat." Haithcock's unnamed wife may have fed her husband, but not before she told him what she thought of his plan. She "entreated him not to go," but her pleas fell on deaf ears. Thomas Haithcock "went off" with Jack and Andrew in pursuit of the rebels.[63]

At some point in the twenty-four hours after the encounter at Parker's farm, Haithcock found Nat Turner and the rebels. They told Haithcock what had happened, including that "Capt. Nat and company had a fight with the white people at Parker's Field." Following the rebels' defeat, Turner himself was making his way west "toward Belfield," which would take him back to the neighborhood where the rebels had been. Haithcock was charged with finding out if there was anyone at Benjamin Edwards's farm who would be willing to join the army that Turner was trying to reassemble. Despite this evidence against Haithcock, he was acquitted. He appears on the 1832 tax list, although by the time the tax collector came by, Thomas Haithcock did not live on the same farm as his wife and daughter.[64]

Haithcock's acquittal in the spring of 1832 was remarkable. Two witnesses in his own family described a man who decided freely and almost instantly to

join the rebels. When his wife tried to talk him out of it, he refused to listen to her. Others had been tried and convicted for saying that they would join the revolt, but Haithcock did more than merely state that he would join. Once he found Nat Turner, Haithcock started recruiting for him. Perhaps the ultimate incongruity is that Hardy, Isham, and Berry Newsom were convicted for saying they would join the revolt, while the court ultimately released the person who asked them to join it. Unfortunately, the record does not provide enough evidence to determine why the court released Thomas Haithcock—was it a procedural problem? A botched prosecution? Extralegal factors? —but since Berry Newsom was hanged, one suspects that it was not because the whites were unwilling to impose the death sentence on free blacks who they thought deserved it. Whatever the reasoning, the court let Haithcock go, another example of how far the legal system tilted to the benefit of blacks who were accused of supporting the revolt.

The judges' efforts to find ways to recommend mercy for many of those that they convicted were intrinsically connected to the judges' view of the revolt as a minor event, one that posed little real threat to the social structure in which they wielded so much power. The vast majority of the evidence that appeared in the investigations and trials supported this interpretation, but there was one witness who challenged this way of seeing the revolt. Beck—also called Becky—testified that the revolt was larger than the whites had realized. According to Beck, the conspiracy had reached north to Solomon Parker's farm, which was near Sussex County and otherwise removed from the people and places associated with the revolt. Beck claimed that the slaves who had gathered at Parker's farm during the revolt discussed what they would do when they got the chance. Frank, for example, was eager to get revenge. He told the others that "his master had crop[p]ed him and he [the master] would be crop[p]ed before the end of the year," a boast that got three other slaves to promise to do the same to their masters. Even more startling, word of the revolt had spread among blacks beyond Southampton County. Beck claimed to know of "some eight or ten slaves" at a Sussex church who had agreed to "join and help kill the white people." Perhaps the most surprising claim Beck made was that the Sussex conspiracy had been organized well before Nat Turner and his men struck. She claimed that she had learned of the revolt at a meeting at "Raccoon Meeting house" in May 1831, when "some eight or ten expressed their determination to unite in the scheme."[65] Beck's testimony that several conspirators from Sussex had joined Turner months before the revolt began challenged the Southampton court's understanding of both the scale and the timing of the revolt.

Given this, the Southampton court was initially skeptical of Beck's testimony. Beck was young—a newspaper article described her as "about 16 or 17 years of age," while defense attorney James French later described her as even younger, between "twelve and fifteen years of age"—and one of the reasons the accounts of her testimony may have been confused was that there were problems with it. One of the mistakes was relatively easy to see. At Jim and Isaac's trial, she described what the defendants had done "on the 15th day of August last." Later the same day, at Frank's trial, Beck described what Frank had said, also "on the 15th day of August last." The date, the Monday a week before the revolt, was notable, and in the second trial, someone may have asked Beck about the date, which she then described as "the day on which the insurrection broke out in the Country."[66] In this case, the mistake posed a trivial problem for the court, as the judges likely figured that Beck had mistaken the date of the rebellion, which had actually taken place on August 22.

Other problems with her testimony were more troubling. Beck had claimed that she had found out about a full-fledged revolt ready to be launched by slaves from her neighborhood, but she had not told anyone at the time. When asked why she did not tell whites first, Beck claimed that the conspirators compelled her to silence: they told Beck that what she heard "was a secret and if she told white people they would shoot her." Later Beck offered another account. After explaining how she came to tell her mistress about the plot, Beck then added that "the reason of her not telling before was that she did not understand it."[67] The second explanation—while perhaps less compelling than her first—was still plausible by itself, but it seems to be at odds with her initial claim that she was silent because of threats from the conspiring slaves. If she had been told to keep quiet, as she initially claimed, it would be harder to believe that she did not have some idea that something serious was afoot.

Like so much of the detailed testimony that the court heard, Beck's testimony was problematic. So Meriwether Broadnax—who initially credited Beck's testimony at least enough to bring charges based upon it—sought confirmation of her story. Since the accused Sussex conspirators had not amassed weapons or any other physical evidence that would have implicated them, Broadnax looked for other witnesses. The best witness he could find was Bob, a slave who lived on the same plantation as Isaac. According to Bob, Isaac told him that he had been at Solomon Parker's, the farm where Beck lived, on the day that she claimed to have heard Isaac promise to join the revolt. Bob observed that "Jim frequently went to Solomon Parker[']s," but he added nothing substantive to support Beck's testimony about the conspiracy.[68] Since Bob's testimony was the best that Broadnax could produce,

one suspects that he could not find anyone else who would corroborate Beck's account.

The judges in the trials understood that there were at least two different explanations for Beck's singular testimony. On one hand, it was possible that Beck described a branch of the conspiracy that had not been discovered by whites. Whites could not find another witness because the slaves who knew about this plot realized that their lives depended upon them keeping silent. If this was the case, then everyone other than Beck who knew about the plot was smart enough to keep his or her mouth shut. On the other hand, it was also possible that there was no other conspiracy. Beck, who had found two different conspiracies in Sussex, could have been lying. Or maybe the simplest explanation was that Beck "did not understand" what she had heard.[69]

Having to make a judgment based upon Beck's testimony, the Southampton court "disregarded" her testimony. On September 8, Temperance Parker's Bob and Joseph Parker's Davy were brought to trial, but after hearing Beck testify, the court found them not guilty. Solomon Parker's Daniel, who had been arraigned on the same evidence, had the charges against him dropped. As usual in the case of those who were found not guilty, the court records did not record the evidence, but a short newspaper article that described the cases noted that "all who were arraigned upon it [Beck's testimony] were acquitted."[70] The newspaper did not mention why the court released these defendants, but later descriptions of the examinations in Jerusalem suggested that Beck had recanted the most damning part of her testimony. Defense attorney James French testified that "to the best of his recollection, Beck stated in Jerusalem upon being examined by him, that no conversation occurred at the May Negro meeting among the Slaves" about the revolt. The prosecutor, Meriweather Broadnax, who had called Beck to the stand, agreed. In Southampton, Beck "stated that she heard no conversation at the May meeting by anybody relative to the insurrection." Broadnax added that he was "not mistaken as he attended particularly to her evidence."[71]

The Southampton court ultimately rejected Beck's initial claims, but her charge that the plot reached north to Sussex County meant that Southampton's court would not have the last word on Beck's accusations. Because Beck claimed that she had overheard a group of slaves in Sussex discussing uniting "to murder the white people," the Sussex court of oyer and terminer had jurisdiction. Changing jurisdiction may seem relatively unimportant, but the change meant that these defendants faced a different dynamic than those in Southampton. In Southampton, the judges were looking to minimize the scale of the revolt, something that led the court to ignore serious charges that

were not substantiated as well as less serious charges. This saved several accused, but it could not save those who were tried in Sussex. In Sussex, the judges wanted to show that they were able to root out any hint of rebelliousness, which meant that they were much more likely to convict accused slaves, even if the accusation came from a young woman whose problematic testimony had been disregarded by a different court. Of the nine slaves condemned in Sussex for involvement in the revolt, most were convicted on Beck's testimony. After Governor John Floyd pardoned one and commuted the sentences of two more, six slaves were sentenced to be hanged.[72]

People in Southampton knew about the successful prosecutions in Sussex, and this may have influenced the deliberations of the Southampton court in the ensuing trials of Jim, Isaac, and Frank. Like Bob, Davy, and Daniel, the three were brought to trial simply upon the evidence of Beck, but unlike the earlier trial, Beck's testimony had been endorsed by the judges in Sussex. Beck, whose testimony had initially been "disregarded" by the Southampton court, now returned to court as someone whom other prominent whites had found credible. In an attempt to discredit Beck again, defense attorney James French, who clearly did not believe her, launched a vigorous attack on her integrity. During the Sussex investigations, Jim had been asked about Beck, and he denied knowing her. French referred to this, likely because he thought that this made Beck seem unreliable. After all, it did not seem likely that a large conspiracy could have remained undetected for a significant time if the conspirators shared the details with people they did not know. When confronted with the fact that Jim denied knowing her, however, Beck did not challenge Jim's assertion. Instead, she explained that "she is a house servant and seldom in the outhouses." French's question and Beck's answer raised new doubts about Beck's testimony, but the Southampton judges switched their position anyway and found Jim, Isaac, and Frank guilty on Beck's testimony alone. All three had their sentences commuted and were sold out of the state.[73]

The trials of Jim, Isaac, and Frank were clearly exceptional. These were the only trials where the Southampton court reversed course and allowed that the revolt might have been larger than first acknowledged, but acting on evidence that the revolt was larger and more dangerous was clearly anomalous. Even in Sussex County, where the court accepted Beck's most astonishing testimony, the leading figures in the county backtracked and ultimately accepted the Southampton court's view of the revolt. The view of leading figures in Sussex is known because in the days before Sussex was supposed to hang the slaves who had been sentenced to death, the condemned slaves staged a jailbreak. When a jailer came with their meals, they rushed him. The break was not

entirely successful: one of the condemned slaves, Frank, died, and another was "seriously injured," but one convict, Boson, escaped.[74] For more than three years, Boson remained at large.

As time passed, the whites in Sussex treated Boson less as a dangerous slave rebel and more as an unfortunate slave unfairly convicted. Although he stayed "in the same neighborhood" and the state issued a one-hundred-dollar reward for his capture, he was never arrested. It does not seem that capturing him would have been particularly hard. While Boson was at large, he repeatedly approached prominent whites to negotiate his surrender to the authorities. According to defense attorney James French, Boson "has frequently been seen, sought several conversations with respectable gentlemen, protested his innocence and professed himself ready to deliver himself up at any time that he could be assured he would not be hung."[75]

From this tenuous position, Boson was unable to negotiate a commutation of his sentence, so he came up with an unusual plan to avoid his death sentence. He enlisted the help of an unnamed white man, who took Boson to Norfolk, where Boson's unnamed conspirator would put him up for sale. Presumably, the unnamed man would sell Boson out of state, putting him safely out of the reach of Virginia's legal system. When Boson and the unnamed white man got to Norfolk, however, the sale that they had planned fell through. Even worse for Boson, someone in Norfolk recognized him as the escaped convict from Sussex. He was arrested and sent back to Sussex, where the court confirmed his identification and set the new date for his execution, March 27, 1835. Then, in an act that historian Scot French described as "a stunning display of humility and self-condemnation," the court asked the governor to commute Boson's sentence.[76]

The court's request was accompanied by a petition from Sussex planter and magistrate George Blow, which he, Boson's owner, and sixteen others signed. In this petition, Blow attacked Beck's credibility. Blow argued that Beck's description of the May 1831 meeting at Raccoon Swamp Meeting House was critical to the conviction of the accused in Sussex, but he argued that no one could now believe this story. Specifically, her testimony against Solomon, who had been executed in 1831, "was certainly not correct in one material fact." According to Beck, at the May 1831 meeting where Boson said "he would join the Negroes to murder the white people," Solomon said "God damn the white people[;] they have reigned long enough." But Blow and the others now believed that Solomon was not even at Raccoon Swamp on the day in question. According to an early draft of Blow's petition, Mr. and Mrs. Laine claimed that on the day of the meeting, "Solomon came out of the millpond

(contiguous to Mr. Laine's, where *he had been fishing*), that he brought to them a fine string of fish, *just caught*, that he remained on the plantation some time, and that they saw him there until after the meeting had broken up when they saw him depart from the plantation in an *opposite direction*." The final draft of the petition then described what Solomon had done before he left the Laines': Solomon "*remained* on the Plantation until long after the meeting had broken up; that he had assisted Mr. Laine's servants in taking the horse of those who rode to the meeting to Mr. Laine's; that he Mr. Laine saw him, Solomon, there until nearly or quite sun down; and that he did not leave there until after that time, so as to render it impossible that he could have been at the meeting house during the day and time of the meeting." While testimony about the exact timing of mundane events on an ordinary day almost four years earlier is itself problematic, Blow believed the testimony of the Laines, whom he described as "two highly respected inhabitants of that immediate neighborhood." Blow was convinced that the testimony of these "two white witnesses, persons of intelligence, of unblemished reputation and standing as part of our society," showed that the court had made a mistake in convicting Solomon. Since Beck was not reliable in the case of Solomon, it was easy for Blow to argue that it was unwise to trust her in the case of Boson. If Beck "was essentially mistaken in all that she said about Solomon and which led to his execution... [c]an you consent to the execution of another condemned on that identical testimony?"[77]

The Laines' testimony led the members of the Sussex court to change their opinion of Beck's testimony, but Blow's petition to the governor made clear that the Sussex judges' perspective on Boson himself had also changed. In the days following the revolt, the "exasperation" of the judges "blinded our unbiased judgment." According to Blow, "time has mellowed our feelings and given full exercise to our reason." By the time that Boson was returned to Sussex, the judges were making the kinds of distinctions that the judges in Southampton had been making throughout the trials. Blow was willing to "admit that Boatswain [Boson] was perhaps a discontented spirit and perhaps a refractory slave, that he might have indulged in threats amongst his fellow slaves, against the whites: that he might have been tempted to join the murderers had they for a time proved successful," but none of these was the same as saying Boson had joined the revolt. "We cannot see one suffer the penalty of *Death*, who, we believe not to have been a participant in it.... [W]e surely will not now hang the vilest wretch for what he might probably be induced to commit, when there is not one tittle [?] of evidence to prove that he did commit any such crime."[78]

Not only had the petitioners in Sussex changed their views of Beck, Boson, and Solomon, but by the time Boson was apprehended, they had also adopted the Southampton court's view of the revolt as limited in size. Blow treated it as a settled fact that "the Insurrection had its *origin*, and was confined exclusively to a *neighborhood* in Southampton." Even in that neighborhood, the number of slaves involved was small. According to the Sussex petition, Nat Turner "induce[d] *a very few desperadoes* to *commence*." Ironically, at the point where the Sussex petition referred explicitly to the Southampton trials as the ultimate authority on the revolt, the petition veered from the evidence that had been presented in court. According to the Southampton investigations, Turner first told people about the revolt in February 1831, so it was possible that the revolt could have been discussed at Raccoon Swamp Meeting House in May 1831. The Sussex petition, however, noted that "the evidence given at the Trials in Southampton, left the mind *convinced* that it [the revolt] was not an affair of Premeditation but *suddenly* gotten up by a fanatic."[79]

The Sussex petition, supported by the recommendation of the Sussex County Court and a strong letter from defense attorney James French, succeeded. Boson escaped the hangman's noose. No one asked for a full pardon, so Boson was soon sold out of the state. But Boson's story reveals something about the success of the Southampton court. By 1835, the uncertainty that had existed in the days and weeks following the revolt had been dispelled. At least in the area around Southampton, the court was able to create an account of the revolt that minimized the threat posed by slaves. This hegemonic narrative restored the confidence of the region's whites, which was essential in relieving the slaveholders from the danger that poorer whites posed to the slaveholders' property.

7

Willing to Suffer the Fate That Awaits Me

BY THE MIDDLE of October, whites in charge of Southampton's court proceedings had gained a tremendous amount of confidence. Clausewitz's fog had lifted, and the uncertainty that had marked the immediate aftermath of the revolt had been replaced with a fairly clear picture in the magistrates' minds of what had happened on the day of the revolt. The whites in charge of the trials had also settled upon an implicit understanding of the meaning of the revolt: they saw that the revolt was a small affair, that it was inspired by a religious fanatic, that several of those who joined the rebels were reluctant, that many slaves had been loyal to their masters, and that most slaves had ignored the calls to rebel. They concluded that the revolt was not a fundamental threat to their power, at least as long as the reaction of non-slaveholding whites could be kept in check. No one could eliminate the uncertainty about what the future might bring, but the whites in charge of the Southampton trials had decided that they were prepared to face that future. In fact, they were so confident that they decided they no longer needed to be able to speak to their best source, Moses, the person who had told them more than anyone else about what happened from the start of the revolt until the battle at Parker's farm. On October 18, 1831, the whites brought Moses to trial. Given the handling of the other rebels' cases, the verdict in Moses's was a foregone conclusion: Moses was condemned as a rebel but, as recommended by the court, the governor commuted the sentence to sale from the state. On October 30, Moses arrived at the penitentiary in Richmond.[1] The same day, Benjamin Phipps captured Nat Turner.

At the time of Moses's trial, Nat Turner remained a fugitive, and whites still had no idea where he was. In a Richmond *Constitutional Whig* article that was published just days after Moses's trial, a report from western Virginia informed readers that "this ferocious, merciless butcher of women and children is no more." Another report in the same paper said that "*Nelson* (a fellow

servant of the leader of the late insurrection)…had seen Nat Turner in the woods." According to the newspaper story, Turner called out, but Nelson "was afraid and ran from the villain." Although John Hampden Pleasants, the man who published the two reports, had no way to know it, the second report was right: Nelson's sighting was the first reliable information that whites had heard about Turner since August. Following the revolt, Turner had been in Southampton all along. For nearly six weeks, Turner remained hidden, "never leaving my hiding place but for a few minutes in the dead of night." Turner's hiding place near where the revolt began was excellent, "a hole" that he dug "under a pile of fence rails," a place that the best efforts of whites failed to uncover. But by the start of October, he was taking bigger risks. He "began to go about in the night and eaves drop the houses in the neighborhood." The trips turned up "little or no intelligence," Turner admitted, but one of these trips set off the series of events that led to his discovery.[2]

One night in the middle of October, while Turner was out doing his reconnaissance, a dog—likely smelling Turner's food supply—went into Turner's hideout. The dog stole some meat, getting away just as Turner returned from his nocturnal perambulations. A few nights later, Nelson and another slave were out hunting with the same dog. Even with Turner still on the loose, the fact that slaves had resumed night hunting shows that blacks' uncertainty had abated as well—Nelson and his friend believed that white confidence had been restored to such an extent that they were not risking their lives by going out in the middle of the night. As the party passed by Turner's hideout, the dog went to see if it could find some more food. Instead, Turner later recalled, it "discovered me and barked." The commotion drew the slaves to Turner, who then begged that the two slaves not tell the whites where he was, but the two, as Turner recalled, "fled from me." Turner judged correctly that they would betray him as soon as they found whites. He fled the place where he had hidden for forty-one days.[3]

As soon as the news of the sighting of Turner spread, "five or six hundred persons" set off in pursuit of both the rebel leader and the reward for his capture, which had grown to over a thousand dollars. Nonetheless, Turner eluded the manhunt. Once he abandoned the hideout that Nelson had discovered, Turner was unable to stay more than one step ahead of the whites. Turner himself noted, "I had many hair breadth escapes." One of the places where he hid was Nathaniel Francis's farm, not far from where the revolt had begun, but it was not long until he was spotted again. On Thursday, October 27, Nathaniel Francis "was riding through his fields, examining the condition of his fodder stack, when to his astonishment, Nat stepped out from between

two of the stacks." Francis was shocked to see the rebel leader, but he reacted quickly and shot at Turner "with a pistol" from less than "fifteen yards." The shot sailed high and "passed through the crown of his hat," something that Turner later "exhibited to shew how narrowly he had escaped being shot." Turner fell down, but he was not injured. He made a quick escape, abandoning everything he had gathered except a sword and "a ham of bacon." Francis's news of his close encounter with Southampton's most-wanted fugitive led to another intense search for Turner. "About fifty men turned out immediately and kept up the pursuit two or three days."[4]

Turner was in a tough spot. He was sought "almost incessantly" by whites. Moreover, he suffered from the meager conditions of his time in hiding. When he was captured, even the whites who considered him a terrible monster noted his wretched condition: he was "indeed one of the most miserable objects." This anonymous author noted that he was "emaciated," something that was not surprising given that the challenges Turner had been facing. Once he had been flushed him from his initial hiding place, it became even harder for him to eat. Turner may have escaped Nathaniel Francis with "a ham of bacon" in one hand, but he left behind "another [ham] together with some sweet potatoes." Turner's clothing was also "ragged." As bad as his clothing was, the situation of his footwear was even worse. When Francis surprised Turner, Turner fled, leaving behind his shoes.[5]

Not surprisingly, given the difficulties that Turner faced, he may have considered giving himself up. Lavania Francis, one of the longest-living survivors of the revolt, described one moment when she claimed Turner came close to surrendering. Francis recalled that one night, when her husband had already gone to sleep, she and her mother heard a knock on the door. Remembering that Salathiel Francis had been killed answering the door, she decided neither to answer it nor to wake up her husband. Nothing came of the knock, but after Turner was captured, he was asked about the night and admitted that "he was the person, and he came to surrender to Mr. Francis."[6] Maybe Turner wanted to surrender to Francis, but the fact that he fled when Francis encountered him gives one reason to doubt this story.

Although the whites were closing in on him, Turner remained at large on Friday and Saturday. After he fled from Francis's, Turner made his way into the woods. Not far from the starting place of the revolt, he found a large overturned pine tree. He dug a lair under what had been the top of the tree. The hiding place was again good, and when whites searched this plantation on Saturday, they, as a report described it, "could see nothing of him." In part this was because Turner had a knack for finding great hiding places. Although he was

improvising, Turner's resourcefulness impressed at least one white who examined Turner's hideaway on Francis's farm. This person described how Turner, "by drawing the fodder from the bottom of both sticks lay with his head under one and his feet under the other." He admitted that this hiding place was "very ingeniously contrived."[7]

Turner also managed risk well. For example, his first hiding place, which served him so well, was particularly good because, as Turner noted, water "was very near." In making sure that he would not be easy to find, Turner paid attention to more than logistics. He also ensured that no one who might reveal his hiding place to whites knew where he was. In one way, remaining in his own neighborhood may have helped him because it meant that he knew the slaves in the area, so he probably had an idea of who would be willing to help him and who could not be trusted. It is possible that Turner had not spoken to anyone—after the revolt, Turner claimed that "he was afraid to speak to any human being"—but it seems more likely that he told whites this to protect those blacks who had supported him. According to the black oral tradition, Turner "came out [at] night fur food dat slaves would give him from his own mistress' plantation." Since Turner's mistress had died in the revolt, it is unclear who was stealing from whom, but the story of Turner knowing whom he could trust to get him food and not turn him in would explain the hams and other food Turner had with him.[8]

Nat Turner's good decisions helped him evade whites, but the odds against his escape remained incredibly long. Turner's luck ran out on Sunday, October 30, when Benjamin Phipps was out by himself walking across Nathaniel Francis's farm. Phipps spied the overturned pine tree under which Turner hid. According to one account, a "slight motion" caught Phipps's eye. Another account said Turner had peered out "as if he was in the act of reconnoitering" when Phipps happened upon him. Whatever Phipps saw, he went over to investigate more closely. Under the treetop, he found "some brushwood collected in a manner to excite suspicion." When he moved the branches, he discovered "the opening of a newly dug cave, in which the Captain was concealed." Phipps called for assistance from other whites who were in the area, but none could hear him. "He raised his gun to fire; but Nat hailed him and offered to surrender." Turner decided that "it was impossible for him to escape as the woods were full of men." He "threw away an old sword, which it seems was the only weapon he had." He then emerged from his hiding place and made clear that he would not try to escape. He did not make "the least resistance" as Phipps ordered him to the ground. Once he had his prisoner "securely tied," Phipps took the bound Turner "nearly a mile alone" to Peter Edwards's farm, where Phipps found whites who could help him.[9]

The news of Turner's capture spread quickly through the county. "Less than an hour" after Phipps and Turner arrived on Edwards's farm, "a hundred persons had collected at the place." The crowd wanted to see the man who they believed was responsible for so many deaths. Upon "beholding the blood-stained monster," as one report labeled Turner, the crowd nearly killed him: "it was with difficulty he could be conveyed alive to Jerusalem." Reports at the time did not describe specifically what happened to Turner while he was on Edwards's farm, but William Sidney Drewry's 1900 history reported that Turner was "persecuted with pinpricks and soundly scourged." In a footnote, where Drewry put the material that he received directly from interviews, he added an even more interesting claim. Mrs. Musgrave's cook "Aunt Viney," whose son was killed as the revolt was suppressed, "asked to be allowed to whip him for causing her son's death." Given its provenance, the story in the footnote seems the kind of self-serving story that postbellum whites told themselves about loyal slaves, but better sources describe a similar event. Allen Crawford, who was born a slave on Peter Edwards's farm in 1835, told an interviewer a century after the revolt that when Turner was brought to Edwards's farm, "Grandma ran out and struck Nat in the mouth, knocking the blood out and asking him, 'Why did you take my son away.'"[10]

Turner's capture led to an impromptu celebration at Peter Edwards's in which whites and perhaps some blacks rejoiced over the capture of the notorious rebel leader. Before the news of Turner's capture had reached everyone in Southampton, however, the sounds of celebration may have tapped some of the latent fear that still existed, if Drewry's report is to be believed, especially among white women in Southampton. According to Drewry, some whites marked the news of Turner's capture with gunshots. For those who did not realize that Turner had been captured, this was particularly distressing because in the weeks after the revolt, no guns had been fired. Whites had agreed to refrain from firing guns because they wanted "a signal of danger for the women and children to assemble at places of refuge." Horsemen riding around the neighborhood added to fears, and some concluded upon hear the commotion that "Nat had assembled another force and was laying waste to the country." Even the cry "Nat is caught" was misheard by some as "Nat is coming." These fears, however, were all based upon a misunderstanding, and as whites learned what really happened, the "alarm gave way to rejoicing."[11]

It is unknown what Benjamin Phipps thought about the growing celebration. Perhaps he joined in, but—no less than the slaveholders in Southampton after the revolt—he might have thought about how much the response to Nat Turner's capture could cost him. He may have feared that incensed whites

would lynch the rebel leader, an action that would have jeopardized his claim on the reward that he was in line for. At some point on Sunday, Benjamin Phipps left Peter Edwards's farm with Turner, heading toward Jerusalem. As they made their way, following the path that the rebels had followed two months before, they went "from house to house in the neighborhood, where the females, who made such narrow escapes from him and his gang, expressed a curiosity to see him." Delayed by visits to curious whites, the group did not make it to Jerusalem on Sunday night. Instead, Phipps and Turner spent the night at Phipps's own house, which was roughly halfway between Peter Edwards's and Jerusalem. On Monday morning, October 31, Phipps and Turner set out from Phipps's house. Unlike the rebel army, though, the two men were accompanied by a large crowd of curious onlookers as they arrived in Jerusalem at a little after one o'clock in the afternoon.[12]

According to the reward offered by the state, Phipps needed to "convey [Nat Turner] to the Jail at Southampton." But to get Turner into jail, Phipps needed someone with the authority to decide that he belonged there. As a result, when Phipps arrived in Jerusalem, he immediately brought Turner to two of the most prominent magistrates, James Trezvant and James W. Parker, both of whom had been among the most active judges during the trials. Simply transferring Turner from Phipps's custody (and implicitly that of the large crowd that accompanied him) to the judges' led to a change in how Turner was treated. Just as the leaders of Southampton used their power as military and legal officials to stop the massacre of suspected blacks, the judges put an end to the extralegal tormenting of Turner. One person, apparently oblivious to what the people of Southampton had done to Turner on Sunday at Peter Edwards's, praised "the People of Southampton for their for-bearance...not the least personal violence was offered to Nat." Trezvant and Parker also made clear that Turner would receive the same legal protections as the other accused slaves. As a result, the judges held a formal hearing to see if there was enough evidence to send Turner to jail pending his trial. At this hearing, the judges asked Turner what he had done, but as in the earlier trials, "no threats or promises were held out to him to make any disclosures."[13]

Although the judges insisted that Turner had the legal right not to testify, he spoke at length. According to Theodore Trezvant, the postmaster in Jerusalem, the judges' examination of Turner lasted "1½ or 2 hours" in part because Turner was willing to answer "every question" that the judges asked. Several whites in Southampton noted Turner's willingness to tell whites what he knew about the revolt. One person, whose letter ended up in the *Richmond Enquirer*, wrote that Turner "seems quite communicative" about the rebellion.

Another letter written from Southampton on the day that Turner was brought to Jerusalem used similar language: Turner appeared "willing to answer any questions, indeed [he was] quite communicative." Someone else wrote that he was "very free in his confessions."[14]

Turner was also willing to talk outside the formal inquiry. On Monday evening, probably only a few hours after Turner arrived at the jail in Jerusalem, Thomas R. Gray approached Turner with a proposition. Gray wanted to know if he could take down and publish Turner's "history of the motives which induced [Turner] to undertake the late insurrection." Gray wrote that Turner agreed "to make a full and free confession." A letter in the *Richmond Enquirer* described the encounter similarly. Turner agreed to make "a voluntary confession of the motives which induced him to commence the insurrection to Mr. Thomas R. Gray." He then asked Gray to return the next day for the interview. When Gray arrived at the jail the next day, "without being questioned at all, [Turner] commenced his narrative."[15]

Turner was able to speak freely in part because he did not appear especially concerned about implicating others. Perhaps his ease was connected to a sense that the court's investigations had wound down, but some blacks were clearly still vulnerable. Whites knew that Turner's wife had hidden Turner's papers, but Broadnax had decided not to prosecute her. If Turner said the wrong thing about her, perhaps Broadnax would be forced to revisit this decision. The four free blacks who were in jail awaiting trial were also vulnerable, but Turner did not worry about what would happen to their cases if he spoke. Perhaps this can be seen most clearly in an exchange that happened in the jail when someone asked him about the money the rebels had stolen. Turner answered the question by saying he had only received four shillings, six pennies, and then, "turning to one of the prisoners (a free negro) who stands over for further trial, said to him[,] you know money was not my object."[16]

Fascinated by Turner's motives in launching the revolt, Southampton's whites were less interested in why Turner was so eager to talk than in what he had to say. Part of the problem was that as they listened to his confessions, many had a simplistic view of the man. As one correspondent judged, Turner "was instigated by the wildest superstition and fanaticism...He still pretends that he is a prophet." Although more sympathetic to Turner, Gray ultimately accepted this point of view. After Turner described one revelation, Gray asked him, "Do you not find yourself mistaken now?" According to the *Confessions*, Turner replied, "Was not Christ crucified?" Turner's bold response was theologically orthodox—God's plans often work out in ways that humans do not understand—but his attempt to compare his impending

execution to Jesus's only made it harder for Southampton's whites to see him as anything other than completely deluded.[17]

The fact that most whites saw Turner as a maniacal religious figure made it hard for them grasp one of the main reasons that he was so willing to talk: he wanted to make a religious confession in which he let everyone know that he had not lost his faith. Like the prophets of the Old Testament, Turner had done what he believed that the Lord demanded that he do, but the result was not what Turner had hoped for. Did the failure of the revolt mean that he had not been inspired by "the Spirit that spoke to the prophets in former days"? If God really had spoken to Turner, was it possible that Turner somehow misinterpreted God's instructions? Or was this failed revolt exactly what God had desired? If so, why had God wanted him to launch a slave revolt that He knew would fail? In the only evidence that suggests something of the religious turmoil that Turner faced as he awaited his execution, Turner admitted to one interrogator that "he may have possibly been deceived," but his misfortune was not enough to make him despair. Even though the revolt had failed, Turner still thought that "he was right.... [H]e seems of the opinion that if his time were to go over again, he must necessarily act in the same way." When Gray offered to publish Turner's confessions, Turner saw that he had the chance to make a final statement about his fidelity, and it is no coincidence that his statement ended with a strong affirmation: "I am here loaded with chains, and willing to suffer the fate that awaits me."[18]

While Turner was grappling with questions connected to his eternal fate, more mundane motives led his white amanuensis to volunteer to take down Turner's confession. Thomas R. Gray needed to make some money. Gray had been born to a prominent and wealthy family. As a seven-year-old child, he had inherited a slave named Hertwell. Fourteen years later, in 1821, Gray's father gave his son his own four-hundred-acre farm. By 1827, the year that Gray became a magistrate, his holdings had included a plantation, eight horses, and twenty-three slaves. At this point, the younger Gray appeared well on his way to filling the shoes of his relatives, who had represented Southampton in the colonial House of Burgesses, at the Virginia Constitutional conventions, and in Congress. Glimpses of Gray that exist in surviving documents reveal a rising member of the planter elite, but some unknown financial setback in the late 1820s changed this trajectory. By the time of the revolt, an indebted Gray had sold his land and slaves, resigned his commission as a magistrate, and begun practicing law.[19]

After the revolt, Gray's bad financial situation took a turn for the worse. In a deathbed will written a week after the trials of the slave rebels began, Thomas R. Gray's father, Captain Thomas Gray, who was already "weak and feeble in

body, but of sound mind and memory," disinherited his son. Although Thomas C. Parramore, the historian who first distinguished the two Thomas Grays, suggested that the seventy-five-year-old father did this "in order to spite his son," Captain Thomas Gray almost certainly had a different goal: he wrote his will in such a way as to limit the amount of money that his son's creditors could claim from the elder Thomas Gray's estate. One debt, however, was inescapable. Captain Gray had given a "deed of trust"—a promissory note—to secure payment from his son to a creditor in Portsmouth, Virginia. To satisfy that deed, Captain Gray agreed to pay his son's debt out of his estate, and in his one bequest to Thomas R. Gray, the ailing father directed his executor not to make any claim against his son for the debt that the son should have paid. Captain Gray then divided the remainder of his estate into thirds. He bequeathed one-third to each of Thomas R. Gray's two siblings. The last third, however, needed to be handled carefully. If Captain Gray bequeathed it directly to Thomas R. Gray, the property might have been attached by the son's creditors. To avoid that, Captain Gray bequeathed the final third of his estate to Thomas R. Gray's daughter, Ellen Douglas Gray. This was not a perfect solution—the thirty-one-year-old Thomas R. Gray and any future children he might have had were effectively disinherited—but it did keep the property in the family. Moreover, it put the assets in the hands of Thomas R. Gray, who, as his father's executor and Ellen Douglas Gray's father, would have control of any property inherited by his daughter.[20] Thomas R. Gray's father had done what he could do to protect the family's wealth, but now Gray saw in the capture of Turner a way to straighten out his own financial situation.

Brought together for markedly different reasons, Thomas R. Gray and Nat Turner met in Southampton's jail on Tuesday, November 1. The manacled rebel leader, held in the "condemned hole of the prison," was ready to speak as soon as Gray arrived. The moment Gray was ready to write, Turner launched into a soliloquy. Most likely, Gray transcribed Turner's account as Turner spoke. Turner's narrative was powerful and fairly coherent, but even Gray, who had been active during the trials, interrupted him at least ten times. Once, as mentioned above, Gray asked if Turner was "mistaken," but most of his interruptions were questions in which Gray asked Turner for clarification, as when Gray asked Turner who were the first four who learned about the plot. Gray did not write down his questions, but he put Turner's answers in parenthesis. Gray implied that it took two or three days for the two men to finish a draft of Turner's confessions. "Except in the cases noted in parenthesis," Gray claimed that he did not interrupt Turner's statement.[21]

After Gray had Turner's statement written out, Gray examined Turner to make sure that he could be trusted.[22] Gray was not the only person in Southampton to consider the possibility that Turner was lying. One white man, who may have attended the judges' examination of Turner on Monday, October 31, described how he thought about Turner's reliability. He noted that "Turner seems very humble." But like other whites, he was unwilling to trust Turner simply because of how he appeared. In this case, the man heard Turner speak for "more than an hour." After listening to Turner's testimony, this longtime neighbor of Turner's concluded, "I am disposed to think [he] tells the truth." This disposition was not simply an act of faith. In this case, the writer recognized that Turner's "account of the plot exactly corresponds with that of the other leading men who were apprehended."[23]

This unnamed correspondent's initial skepticism toward Turner's account was not unusual. In fact, one white thought that Turner's "pretended prophecies" proved "his insanity." But when whites listened to Turner's account and then cross-examined him, they found Turner credible. For example, the first people to interview Turner in Jerusalem, the magistrates James Parker and James Trezvant, noted that Turner answered the questions he was asked "clearly and distinctly, and without confusion or prevarication." Turner's willingness to answer questions and his ability to do so precisely made him seem reliable, but it did not stop the two prominent men from examining him. As two of the most active judges, Parker and Trezvant had a large font of knowledge about the revolt, and what they heard from Turner did nothing to make them doubt his story. Another person who witnessed the magistrates' examination of Turner and who also claimed to have "examined him closely" came to the same conclusion. He said that Turner spoke "with great candour."[24]

Like the other whites, Thomas R. Gray accepted Turner's "full and free confessions"; unlike the other whites, Gray recorded some details about the way that he cross-examined Turner. At the end of Turner's narrative, Gray commented that he had asked Turner if the conspirators included anyone beyond the immediate neighborhood. Turner said no. Then Gray asked Turner about rumors of a slave revolt from Wilmington, North Carolina. The panicked reports of a slave revolt to the south had subsided, but Gray—hundreds of miles away from Wilmington—was unsure if Turner had some better insight than the sporadic newspaper reports. Turner again said no, and as Gray paused, Turner commented, "I see sir, you doubt my word; but can you not think the same ideas, and strange appearances about this time in the heaven's might prompt others, as well as myself, to this undertaking."[25]

Gray dropped the line of inquiry about Wilmington, but he continued questioning Turner's veracity. On Thursday evening, he had finished writing Turner's narrative. With it in hand, Gray began "a cross examination." He asked Turner about his most astounding claim, that he knew how to manufacture paper and gunpowder. Turner's responses impressed Gray, who found him "well informed on the subject." After having pored over the transcript and asked his interlocutor about everything he said, Gray concluded that Turner's testimony was "corroborated by every circumstance coming within my own knowledge or the confessions of others whom had been killed or executed, and whom he had not seen nor had any knowledge since 22d of August last."[26] Gray compared Turner's account to things that Gray knew about, which included the events at Parker's farm, the evidence from the court cases he had attended, and also the testimony of some of those killed immediately after the revolt without trial. A careful lawyer, Gray checked before he concluded that Turner's story was true.

On Saturday, November 5, Southampton gathered in Jerusalem for Nat Turner's trial. The court was much the same as the courts that tried the other accused rebels, with one notable exception. As required by law, the other accused rebels had their cases heard by a panel of five judges. Ten judges served on the trial of Nat Turner, including Jeremiah Cobb, who served as "the presiding Magistrate of the court," and the committing magistrates, James Trezvant and James Parker. The ten also included all but one of the most active judges from the trials. The most notable change in the makeup of the court was the appearance of Richard A. Urquhart and Samuel B. Hines, two men who had not participated in any earlier trials. Both of the new judges fit the profile one would expect for such a prominent case. A member of one of the "two wealthiest families in the county," Richard Urquhart owned thirty slaves. Samuel Hines was even richer, owning forty-nine slaves. These changes did nothing to change the court's makeup as an institution that was dominated by a handful of the wealthiest slaveholders in the county.[27]

No account of the crowd exists, but the number of those attending must have been large. Emotions were running high, and the first thing that the judges did at the start of the trial was to order Southampton's sheriff, Clement Rochelle, "to summon a sufficient additional guard to repel any attempt that may be made to remove Nat alias Nat Turner from the custody of the Sheriff."[28] Presumably, the judges ordered the additional men to prevent the crowd of whites from grabbing Turner. Whether he was tried or lynched, the end result would be the same for Turner, but the judges understood that a lynch mob

would undermine their authority, defying their attempt to have an orderly trial, and—in a greater threat—suggesting that the elite-dominated legal system was incapable of handling the most dangerous slave rebel in Southampton.

Having secured the courtroom, Jeremiah Cobb assigned William Parker to serve as Nat Turner's defense counsel and then turned the floor over to the prosecuting attorney, Meriwether Broadnax. Once the charges were read and Turner—like every other rebel—pleaded not guilty, Broadnax called his first witness, Levi Waller. Waller described the moving events on his farm in detail. He said he had seen Turner, whom he claimed "he knew very well," but what he could say about Turner himself was less compelling than his testimony in other cases. Turner arrived "on Dr. Musgrave's horse." He "seemed to command the party," he made Peter Edwards's Sam travel with them, and he gave the order to go. At the end of this testimony, he was asked by someone if he could be mistaken in his identification of Turner, and Levi Waller insisted "that he cannot be mistaken in the identity of the prisoner."[29]

Waller's testimony was clearly enough for the Southampton court to condemn Turner, but Broadnax wanted another witness. At this point, he could have called Thomas R. Gray, who was at the court and known to have taken down Turner's confessions, but Broadnax decided instead to call James Trezvant to testify. One of the judges who heard Turner's initial examination and who also happened to be sitting in judgment of Turner, Trezvant told the court the most relevant things that he learned during his interview with Turner: Turner was not just a rebel but "the Chief among them," he struck "the first blow" of the revolt, "he killed Miss Peggy Whitehead," and he remained with the rebels through Tuesday morning. Although the official trial records never mentioned Gray or the *Confessions* explicitly, Trezvant also recounted "a long history of the motives which led him finally to commence the bloody scenes which took place," which Gray claimed he did by reading the manuscript Gray prepared to the court. At the end of Trezvant's testimony, Broadnax rested his case. William Parker, who was an active counsel in cases that were not hopeless, did not call a witness. His "case was submitted without argument to the court."[30]

When the judges returned from their deliberations, Jeremiah Cobb announced that Turner had been found guilty. He then asked Turner if he had "any thing to say why sentence of death should not be pronounced against you." At this point, both the official record of the trial that James Rochelle wrote and the account of the trial that appeared in Gray's *Confessions* agree that Turner said he did not want to speak. Cobb then sentenced Turner to death, likely adding a brief but impassioned speech so emotionally wrought that

James Rochelle left the majority of it out of the official records. Turner was ordered back to jail to await his execution the following Friday, November 11.[31]

After Turner had spent six days in jail, Clement Rochelle brought him to the place of execution, a tree where the other rebels had been hanged. Two accounts described the event, but they did not agree about exactly what happened. One report, published in the *Norfolk and Portsmouth Herald*, said that Turner died "precisely at 12 o'clock." An account in the *Petersburg Intelligencer* suggested that it was closer to one o'clock. They also disagreed about the size of the crowd: the *Herald* reported that "there were but few people there to see him hanged," while the *Intelligencer* claimed that an "immense crowd assembled on the occasion." The differing accounts did agree about one thing: Nat Turner, the man who told whites in the days before his trial that he would not change what he had done if he had a chance to do it again, remained poised throughout the proceedings. According to the *Herald*, "he betrayed no emotion," and the *Intelligencer* agreed: "He exhibited the utmost composure throughout the whole ceremony." On the gallows, the *Intelligencer* reported that he refused the chance to speak and "told the Sheriff in a firm voice, that he was ready." The *Herald* added that Turner "even hurried the executioner in the performance of his duty."[32]

Once Nat Turner had been killed, whites had to figure out how to dispose of his body. Later reports said that Turner's body was dissected, which would not be surprising given the way that white doctors in Virginia turned to black subjects for experimentation.[33] Considering the stories saved prominently in the oral histories, historians also suspect that Turner's body was desecrated. William Sidney Drewry, for instance, claimed that following the dissection, doctors "skinned" Turner's body and "made grease of the flesh." John Cromwell noted that Turner "was skinned to supply such souvenirs as purses…and his bones divided as trophies to be handed on as heirlooms." Although the only two contemporary sources that describe Turner's execution omit references to such grotesqueries, references to items purportedly made from the remains of Nat Turner have surfaced repeatedly in the past hundred years.[34]

The most problematic part of the earliest report of the execution is the statement in the *Norfolk and Portsmouth Herald* that Turner sold his body "for ginger cakes." Almost immediately, this notice drew criticism. Insisting that "it is the policy of the Southern press to make the black race appear despicable," William Lloyd Garrison rejected the report that Turner sold the rights to dissect his body as "improbable." Historian Kenneth S. Greenberg adopts an even stronger stance when he asserts that "the report that Turner sold his body for 'ginger cakes' is certainly false."[35]

Certainty is a quality in short supply when studying history, and there is reason to think that the report that Turner sold his body for cookies could be true. This report appeared in a debate where the question focused upon the punishment of slave rebels. Ten days before Turner's capture, Thomas Ritchie, the editor of the *Richmond Enquirer*, responded to an account of Gabriel's 1800 plot printed in the *Albany Evening Journal*, which Ritchie lambasted as "a vile tissue of fabrications." Among many other assertions, the Albany article claimed that the slave rebel Gabriel had been drawn and quartered. This did not sound right to Ritchie, so he turned to the official records in Richmond, which showed that the *Albany Evening Journal* was wrong and Gabriel had been hanged. The anonymous author of the report on Turner's death that appeared in the *Herald* had read Ritchie's rebuttal (or at least the *Herald's* coverage of it) and saw the chance to help Ritchie's attack on this northern antislavery "libeller." As a result, the admission that Turner sold his body for dissection appeared in a letter that was trying to show that Virginians were humane executioners. Since this argument was based upon the premise that hanging was the model form of execution, the concession that Southampton's whites veered from this norm by buying and dissecting Turner's body should not be dismissed simply because it is bizarre.[36]

While Turner was left to his gruesome fate, Gray had been busy working on the *Confessions*. Since interviewing Turner, Gray had collected and composed material that he thought would make the publication better. At some point he wrote an afterword in which he described some of what he had asked Turner about after Turner made his confessions. Also, claiming that he did not want to "shock the feelings of humanity, nor wound afresh the bosoms of the disconsolate sufferers in this unparalleled and inhuman massacre, by detailing the deeds of their fiend-like barbarity," he included the stories of six whites who had nearly been killed by the rebels but nonetheless escaped. On the day of Turner's trial, Gray—who had neither served as Turner's defense attorney nor appeared as a witness—composed his own account of the trial. The way that it tracked the official records suggests that Gray was actually at the trial, but unlike the official records, Gray used his account of the trial records to help what was essentially a private conversation appear officially sanctioned. He noted that Trezvant read his manuscript to the court. He even added that when Turner himself declined the chance to speak before sentencing, he said, "I have made a full confession to Mr. Gray, and I have nothing more to say."[37]

Aware that some readers might think he had exaggerated the importance of his transcript during the trial, Gray wrote a statement that attested to the authenticity of his account of the trial, which he asked Turner's judges to endorse.

The six judges who signed it certified that "the confessions of Nat, to Thomas R. Gray, was read to him in our presence, and that Nat acknowledged the same to be full, free, and voluntary." They also acknowledged that when Turner was asked if there was any reason that the court should not sentence him to death, he replied that "he had nothing further than he had communicated to Mr. Gray." To authenticate the document that the judges signed, Gray asked James Rochelle, the clerk of the court, to write his own statement, which Gray claimed was stamped with the seal of the court, that said that "full faith and credit are due, and ought to be given to their acts as Justices of the peace." While Gray was at court, Rochelle may have also given him access to court records, which would have helped Gray produce the list of the slave trials that he included in the *Confessions*. Adding a list of the whites who had been killed to the information from Turner's trial, Gray collected the material and added his final thoughts in a letter addressed "To the Public."[38]

Gray knew that Turner's execution would be only six days after the trial, but his impatience to get the *Confessions* published meant that he would not be in Southampton to witness Turner's execution. On November 10, the day before Nat Turner was executed, Thomas R. Gray appeared in Alexandria (then part of the District of Columbia) with the manuscript of *The Confessions of Nat Turner*. He approached Edmund Jennings Lee, clerk of the District of Columbia and uncle of the man who would become the Confederacy's most famous soldier, and asked him to register the formal, ninety-two-word title of the *Confessions*. After Lee registered the title, he gave Gray an official letter notifying him what he had done.[39] Adding Lee's letter to the rest of the material he had compiled, Gray went off to find a printer who was interested in publishing the *Confessions*. He found one in Baltimore, and by the end of November notices of the publication of the *Confessions* appeared in the papers.

Unfortunately for Gray, his achievement in publishing *The Confessions of Nat Turner* did not produce the change in fortunes that he had envisioned when he took out copyright. Gray was still in a difficult financial position more than a decade later. In December 1844, John A. Chandler wrote a recommendation of Gray to John Young Mason, the secretary of the navy and Southampton's most prominent politician. After praising Gray's abilities, Chandler added, "If poverty is a recommendation, he has this to a very great extent." Even Captain Gray's scheme to put his granddaughter's money in Thomas R. Gray's hands failed. Less than a year after Captain Thomas Gray died, the Southampton court removed Gray's daughter, Ellen Douglas Gray, from the guardianship of Thomas R. Gray and made her a ward of the man who had been Nat Turner's defense counsel, William Parker.[40]

8

Communion

THIRTY YEARS AFTER Nat Turner's Revolt, another crisis forced South-
ampton's deeply divided political community to fall into line under the lead-
ership of the county's elite. During the secession crisis, Southampton "cast not
a single vote against secession six weeks after the war started." Historian Daniel
W. Crofts notes, however, that this consensus was an anomaly; it stood in
contrast to the county's "long tradition of disagreement among whites."[1]
According to Crofts, this history of intense party politics emerged in the
1830s, but there is no evidence that the political fights he studies ever addressed
the elite-dominated responses to Nat Turner's revolt. The forum where ordi-
nary whites were able to question—at least indirectly—the court's moderate
response was in the county's churches.

Southampton's church history had roots extending to the religious fer-
ment of mid-seventeenth-century England. In the 1640s, George Fox began
preaching a radical new version of Christianity. The Society of Friends—whom
their many enemies ridiculed as "Quakers"—was soon a target of persecution.
Many Quakers left England, famously for Pennsylvania, but they also went
to other English colonies. Some went to Southampton County, where they es-
tablished its first meeting even before George Fox's death in 1691. Throughout
the eighteenth century, tension developed between the society and this rad-
ical church as Virginia grew more dependent upon slavery and the Quakers
grew increasingly uncomfortable with it. By 1776, Southampton's Black Creek
Friends Meeting had renounced slaveholding. Revolutionary ideology con-
tributed to the passage of Virginia's first manumission law, and some of
Southampton's Quakers were among the first to free their slaves. For example,
in 1782—the same year that Virginia first allowed the manumission of slaves—
prominent Southampton Quaker Thomas Pretlow, father of one of Nat Turner's
judges, freed eighteen slaves.[2]

Quakers were not the only ones in Southampton to object to slavery. In
1774, nineteen-year-old David Barrow began preaching at Southampton's newly
established Black Creek Baptist Church. Although he owned two slaves, he

came to the conclusion that slaveholding was "contrary to the laws of God and nature." In 1784, he freed his slaves and encouraged his brethren to do the same. In 1786, Black Creek, influenced by the example of its antislavery minister, declared slavery "unrighteous." What one historian calls "the clearest position any Virginia congregation would take in opposition to slavery in the Revolutionary era" led at least three church members to free their slaves over the winter of 1787–88. David Barrow's antislavery ministry extended even beyond the handful of regional churches that he ministered to. In 1790, Barrow was in attendance when the General Committee of the Baptist Associations passed a resolution that described slavery as a "violent deprivation of the rights of nature" and called for Baptists to do everything legally allowable "to extirpate the horrid evil from the land."[3]

The extraordinary antislavery activities of David Barrow, however, can easily obscure the tenacity of proslavery Christianity, even within Barrow's own churches. The pronouncement that slavery was "unrighteous" followed extensive debate. Even after the decision, more than a third of the members of Black Creek continued to own slaves. In 1787, the antislavery contingent at the church forced another debate, this time on the propriety of hiring slaves. The antislavery forces lost this debate. By the early 1790s, the momentum of the opponents of slavery had been checked. Frustrated at a church growing increasingly willing to countenance slavery and unable to muster a majority to use church discipline to reprove the slaveholders, the opponents of slavery were reduced to protest. They decided to boycott communion—the moment when the entire church was supposed to come together, as St. Paul wrote, "perfectly joined together in the same mind and in the same judgment"—to make clear their belief that the slaveholders did not belong with them at the altar. In 1791, five members, including David Barrow's wife, refused to attend Black Creek's remembrance of the Lord's Supper.[4]

Efforts to reinvigorate opposition to slavery at Black Creek Baptist Church failed. In 1798, David Barrow—who had preached at the church since its establishment and been at the heart of Black Creek's antislavery movement—left Virginia. While Barrow continued to witness against slavery in Kentucky, the antislavery voices in Southampton grew quiet. After a quarter century of quiescence, however, another minister at Black Creek reignited the debate over slavery. Jonathan Lankford had been a member since at least 1802, so it is possible that he had known David Barrow. In 1816, Lankford was called to Black Creek's pulpit. He served nine years with little sign of discord until December 1825, when Lankford shocked the church by announcing that he "could not, nor would not administer the ordinances of the Gospel to the church any longer—because a Part of the church were slave holders."[5]

Lankford's pronouncement that slaveholding itself was a sin that disqualified members from communion rankled the church. To reconcile the factions, the church hosted a debate on the question. The debate, which the secretary described as "lengthy but brotherly and affectionated," was one-sided. The slaveholders remained in communion; Lankford ended up losing his position as minister and was expelled from the church. A church committee, headed by Carr Bowers, was created to report the church's actions. It concluded that Lankford had "yielded too much to the delusion of Satan." When the report was submitted to the church, the minutes noted that it "was read and *unanimously* received."[6] This church, which had a tradition of antislavery as strong as any other evangelical church in Virginia, had made the church's position clear: antislavery advocacy was the work of the devil.

The consensus on excommunicating an overt opponent of slavery apparently lasted. In fact, Nat Turner's revolt confirmed, at least for some whites, the wisdom of their decision to excommunicate the outspoken antislavery minister. While the revolt did not reinvigorate the old debates triggered by Lankford, it did lead to a new fault line among white members of David Barrow's Virginia churches, specifically on the question of how to deal with black church members. Realizing that some—or maybe even most—slaves held seditious desires in their hearts, many whites in the area began to question the entire project of interracial fellowship. When Christian whites asked themselves if they could love slaves as their brothers in Christ, several had their doubts. In May 1832, the Baptist Portsmouth Association's Corresponding Letter questioned the future of interracial fellowship, although it did allow, "Whether…a union can ever be restored between our white and coloured members, or whether they must be separated entirely…are questions which can be decided only by the great Head of the church."[7]

Christians believed that they would learn God's will when Jesus returned. In the meantime, however, southern Virginia's white Christians had to decide if they could remain in fellowship with blacks. The first thing that the Baptist churches did was to call off all communion services. In September 1831, Black Creek cancelled communion services indefinitely "in consequence of the unpleasant feeling the white Brethren have towards the black Brethren." In December 1831, after the court had finished the slave trials, the church formed a committee to undertake its own investigation of the blacks who were a part of the church to see if they should be "restored to the privileges of the church."[8] For the next four months, the church examined its black members to determine who should be readmitted to the church.

At this point, the democratically organized church could dissent from the military and legal settlement reached by a relatively small number of elite

men. Nothing could stop the whites in the church, a majority of whom were not slaveholders, from deciding to hold their black brethren to a higher standard of loyalty than the court had demanded. The court had refused to condemn people who traveled with the rebels; it had recommended mercy for several people who had actually been part of the revolt; it had acquitted some who tried to join the revolt; it had dismissed charges against two who sheltered rebels after the revolt; and it had refused to prosecute those tangentially involved in the revolt. In contrast, the church could dismiss any slave who expressed any sympathy for the revolt. In fact, the whites, had they been inclined, could have expelled all blacks from the church. The church did none of these things. Instead—taking its cue from the court of oyer and terminer—the church brought back into fellowship every black member who had been examined. A democratic church that had once been a beacon for antislavery in the South had deferred to Southampton's slaveholding judges.[9]

This decision was consistent with the expulsion of Jonathan Lankford in 1826. When Lankford preached against slaveholding, the congregation rejected its minister. Instead of accepting its minister's rebuke, the church accepted the guidance of its leading slaveholders. Perhaps it was not coincidental that two prominent judges in the Southampton trials—Carr Bowers and Benjamin Griffith—were active in the efforts to replace Jonathan Lankford. Carr Bowers was the emissary the church sent to Robert T. Daniel to ask him if he would be willing to replace Lankford. Bowers and Griffith also played important roles as the church tried to explain to itself what had happened during the Lankford episode. The men were permanent members of the committee established to write a report on the Lankford incident. Presumably Carr Bowers, who would later be the second-most-active judge in the trials, had an especially important role on this committee. As the clerk, he composed the report pronouncing that "Satan" had sway over Lankford. Griffin's role was no less prominent. When the church's new minister prudently absented himself from the church's quarterly conference at which the final report on Lankford was adopted, Griffin was "chosen" to take the minister's place as "Moderator."[10] Given the importance of Bowers and Griffith to the church, it is not surprising that when the church responded to the revolt, it chose not to discipline its black members. Instead, it accepted that the slaveholding judges in Southampton had done enough.

Nat Turner's revolt also led to divisive debates about race and Christianity among the whites at another one of David Barrow's former churches, Raccoon Swamp Baptist Church in Sussex. Raccoon Swamp was the church where Beck claimed that she had overheard rebels plotting in May 1831. The charge,

which had been accepted by the Sussex court, demanded immediate action from the church, and the church records from October 30, 1831, describe its first response to the news. One of the church's members, William Archer, had been jailed for his suspected involvement "in the horrid Insurrection." Although Archer was not among those who were convicted, the accusation was enough for the church to expel Archer immediately.[11]

It is unclear how divisive the debate over expelling Archer was, although the fact that it was done quickly may indicate that this decision was relatively easy for the church. The harder question, apparently, was how to handle those black church members who had not been arrested. After all, if, as Beck claimed, there was a long-standing conspiracy among blacks at the church, it was possible that others not named in court by Beck were part of the conspiracy. Moreover, even if Beck's testimony identified all of the conspirators, other blacks in the church could have known about the plot. The possibility of a conspiracy among the larger black community at Raccoon Swamp weighed on the white members of the church, who, like the whites at Black Creek, decided that they were unable to hold an interracial communion. On the same day that Archer was expelled, the church decided that "in the present perplexed situation, it is thought best to forbear the Administration of the Lord[']s Supper, till next May meeting."

Two weeks later, Raccoon Swamp formed a committee of five white men to examine the "coloured Brethren...relative to the general course pursued, in the time of the Horrid Insurrection and the character they supported as profes[s]ers of Holyness." Church minutes do not reveal the ultimate outcome of these investigations, although it is clear that blacks were not excommunicated as a bloc from the church. In fact, there is no report of any additional blacks being expelled for their part in the rebellion, even as a handful of blacks were expelled for the typical infractions against church discipline.[12] Perhaps some were excommunicated from the church for their roles in the revolt, but most blacks remained in the church.

The decision to keep most blacks in the church irritated many of the church's whites. In May 1832, a letter to the Portsmouth Association described how the white members at Raccoon Swamp had "been in a very dissatisfied condition on account of the coloured members. They report an entire loss of confidence in their religious feeling." Many whites stopped coming to the church; of the 150 whites who attended before the revolt, only forty-two remained through the spring of 1832. A number of factors influence decisions to stop attending a church, including an "affliction of their pastor," so the decline in white attendance cannot be attributed solely to the unhappiness with allowing blacks into

fellowship at Raccoon Swamp. Nevertheless, the fact that more than 70 percent of the whites stopped attending a biracial church that some believed was a recruiting ground for rebels suggests something about the percentage of ordinary whites who, unlike the Southampton court, saw the threat as extending beyond a handful of blacks from Nat Turner's neighborhood.[13]

Unfortunately, surviving evidence does not indicate how the church managed to keep its black congregation in the face of such strong opposition from many of the church's whites. Nonetheless, Raccoon Swamp resisted the attempts to expel the church's black congregants. By following this path, the church rejected the perspective of those who believed that the revolt fundamentally changed race relations in southern Virginia. Instead, Raccoon Swamp, like the church at Black Creek, pursued a limited response to the revolt. In so doing, the church at Raccoon Swamp followed the pattern established by the Southampton court in which individual rebels were punished but the larger black community was not.

The most protracted and revealing debate over black church membership occurred at a third church with which David Barrow had formerly been associated, Mill Swamp Baptist Church in Isle of Wight County. Mill Swamp was the farthest of the three churches from the site of the revolt, but no less than Black Creek or Raccoon Swamp, it was deeply divided in the aftermath of the revolt. As at the other churches, the whites at Mill Swamp decided to exclude all blacks from communion until the church made a formal decision to restore them to fellowship. This decision meant that blacks and whites would not worship in the same church, but it did not mean that blacks were barred from all church attendance. Except on communion days, when the entire church gathered together, blacks had their own segregated meetinghouse.[14]

In March 1832, the debate about blacks at Mill Swamp began with a question about the separate meetinghouse. Josiah Holleman asked: "Is it expedient or right to allow slaves, Free negroes and mulattoes to hold meetings by themselves in the day or night?" The white members of Mill Swamp decided that the black meetinghouse could continue, but it must be supervised. This response fit within a broad consensus that emerged in the white community after the Southampton revolt. State officials and the Baptist association agreed: blacks should not be allowed to preach to themselves unsupervised. In this case, the Portsmouth Association went one step further than the legislature. When this organization recommended that the churches "refuse license to coloured persons to preach, and to interdict their holding meeting," it also advised "the Churches composing this Association, and particularly that of Mill Swamp, to appoint a committee or committees, whose duty it shall be to notify all coloured members to meet on some Sabbath day...to undergo

examination and receive instruction in relation to Church Government and their duty to their owners, and in case they refuse the instruction and government of the Church, the Association advises that they shall be expelled."[15]

In the aftermath of a deadly slave revolt led by someone whites believed to be a religious fanatic, it is not surprising that Virginia's Baptists agreed on the necessity of white supervision of a quasi-independent black church, or even that they suggested that whites renew their quixotic attempts to catechize blacks into believing that God approved of Virginia's social order. What is perhaps most surprising is that in making these recommendations the Portsmouth Association presumed that blacks would continue to attend Mill Swamp and that—as long as the blacks accepted white supervision and politely listened to the whites drone on about the justice of slavery—they would continue to be a part of the church. At least on the level of association, the vision of a biracial church survived the revolt.

Within the white community at Mill Swamp itself, however, the idea of a biracial church remained in doubt. Some whites thought that whites and blacks could fellowship with each other in church, while others rejected the possibility of interracial communion. The different visions were not readily reconcilable. The church ended up embroiled in "considerable debate," one that continued for more than a year.[16] Sketchy church records make it impossible to re-create the debate precisely, but a note put into the June 1832 minutes, following a discussion of the future of the black church, suggested one line of argumentation used by those who wanted to excommunicate the blacks from Mill Swamp. Immediately after the postponement of the debate, Josiah Holleman asked for clarification on a question: "Is it disorderly for a member of the church, who knew a Felony being committed, to keep it to himself?" Given the context, it seems likely that Holleman—who had been among those who excluded blacks from the church in October and who had pushed to increase the supervision of the semiautonomous black church—wanted a justification for expelling blacks from the church.[17] His question implied a sin of omission: those slaves and free blacks who had heard about the revolt and did nothing deserved to be kicked out of the church.

Holleman's question put his opponents, those willing to accept the type of resolution reached by the Southampton court, into a difficult spot. Holleman's implicit analogy—that the blacks who did nothing to help whites during the revolt were essentially accessories to murder—revealed one part of the black response to the revolt that the Southampton court of oyer and terminer willfully ignored. Slaves had not joined the revolt in great numbers, but—with a handful of exceptions celebrated by whites as signs of slaves' loyalty—they had not rushed

to the aid of the whites, either. Holleman's opponents understood the implications of the question. Accepting this principle would create an ideological litmus test of loyalty to the slaveholding regime that few blacks would pass. A strict adherence to this principle would decimate the black church at Mill Swamp. Understanding the implications of this question for the ongoing debate, the church postponed answering this question. It would be answered only when the church figured out how it was going to handle its black communicants, something that it was unable to do in June, already ten months after the revolt.[18]

To avoid the danger of allowing the divisions within the church to linger and perhaps ossify, the church decided at the June meeting to appoint a five-man committee, including Josiah Holleman and likely a representative from among those who wanted to bring blacks back into communion, to "go into examination of their coloured members at their meeting house...and adjourn to any other time and place they think it proper to do so."[19] Having full authority to investigate the black church members, this committee was ordered to report back to the church at the next quarterly meeting, where the church hoped this debate would finally be settled.

When the members of Mill Swamp gathered in August 1832, the white communicants remained divided on the question of black church members. The investigatory committee, which had been established to end the impasse, was unable to resolve the debate. In fact, its report, delivered at the quarterly meeting that month, led to "much debate on the subject."[20] The church minutes did not record the substance of the report, but the fact that there was a debate suggests something about the committee's findings. Since some whites still argued against expelling the church's black members, one can infer that the church's examining committee did not discover a smoking gun—some sort of evidence that the black members had been conspirators or participants in the revolt in Southampton. Likewise, since Holleman and his allies did not stop their effort to excommunicate the black members, one can infer that the church's examining committee did not find evidence that the black members had actively worked to help the authorities suppress the revolt.

Unable to find any evidence that would lead to a consensus, the church had to act to heal the divisions in the church. In the end, the church—like the other churches that had already faced this issue—allowed blacks to remain in the church. While the church clearly rejected the arguments made by those who opposed black members, it did it best to make concessions to those who opposed black membership. First, even before the debate had been resolved, the church addressed Josiah Holleman's question about the responsibility of church members to report felonies. The church decided that God required

more from Christians than the judges had demanded of the black people in Southampton. Church members had a responsibility to inform authorities about any crime under way. Accepting this rule, the church staked out a new position. While Virginia's Baptist churches had a traditional antipathy to state power, some had held members responsible for obeying the law. Mill Swamp went a step farther in its alliance with the temporal authority. Christian responsibilities extended beyond obeying the law and included actively supporting secular order.[21] Moreover, given the context of this question, this responsibility extended to all church members, including the enslaved.

Holleman and his allies were also able to extract two concessions related to the protocol for the communion service itself. Blacks, who had just been welcomed back to communion, were henceforth to be prohibited from joining the rest of the congregation in the communion lines. Instead the resolution required "that the coloured members of this Church at all future lines of Communion, seat themselves in the part of the House that they now occupy," and they would receive communion there.[22] This resolution formalized the already segregated seating patterns at Mill Swamp and then extended them one step: the communion line itself was going to be segregated.

The church also ended a subversive moment during the communion service. No longer would white ministers and deacons serve the slaves and free blacks. Instead, "the present Deacons [shall] carry the bread and the wine and deliver it to one or more of the Black members who shall distribute it to the balance."[23] The reasons for these Byzantine instructions were not included in the minutes, but the whites in the church may have feared the results if blacks had even a fleeting vision of whites serving blacks. By adopting these strict racial guidelines, the church's white members tailored Mill Swamp's communion service to fit their ideas of proper race relations.

The segregation of the communion table was a major step—theologically even more important than the segregated meetings—and most of the church's members probably understood what it meant. Although there is no account of the response of black church members to these degrading restrictions, at least one former slave described his response when he encountered similar rules. When Frederick Douglass arrived in New Bedford, Massachusetts, he wanted "to become united with the church." He decided to join the Elm Street Methodist Church, but when he found out that the church had segregated its communion service, Douglass was incensed. He "found it impossible to respect the religious profession of any who were under the dominion of this wicked prejudice." Douglass, who had been willing to countenance segregated seating "as an accommodation of the unconverted," refused to join the church.[24]

While it is unclear how much resentment these new restrictions engendered among Mill Swamp's black members, it is clear that these concessions were not enough to satisfy those white members who objected most strenuously to the restrained response to Nat Turner's revolt. Several who wanted to expel the blacks refused to accept the provisions that allowed blacks to remain in communion with the whites at Mill Swamp. In November 1832, ten men petitioned to withdraw from the church, because they did "not fellowship the Coloured members." This threat may have been intended to get the church to revisit its decision to revive interracial communion after Nat Turner's revolt, but if so, it failed. In November 1832, the church directed the clerk to give the ten whites their "letters of dismission." Five months later, on April 6, 1833, the church reaffirmed this decision when it "resolved that all connection with the aforementioned Brethren is this day dissolved and that the church in the future is not responsible for their conduct." Eighteen months of argument about black communion produced a result both ironic and familiar to southern Virginia's Baptist churches: divisions among whites. In this case, however, the division was not permanent. Once the ten men who left Mill Swamp realized that the church would not respond to an appeal to racial solidarity, they returned to the church. In November 1833, the church welcomed them back to full fellowship, rescinding the resolution that had severed their connection. More than two years after Nat Turner's revolt, Mill Swamp had finally achieved an imperfect communion, united not only "by the name of our Lord Jesus Christ" but also by an understanding of the Nat Turner revolt championed by Southampton's slaveholding elite.[25]

Conclusion

MY RESEARCH ON Nat Turner began longer ago than I care to admit. As a young graduate student at the University of Georgia, I read Ken Greenberg's compilation of sources, *The Confessions of Nat Turner and Related Documents*. At the end of the introductory essay, Greenberg concluded, "We are ready for a new retelling of the Nat Turner story. Perhaps some reader of this volume will begin the project."[1] Greenberg's plea struck me, in part because I needed a dissertation topic. Could I write on Nat Turner? I spoke to my advisor, Emory Thomas, who was immediately enthusiastic about the project. He knew the major works that had been done on the topic, and he was convinced, no less than Greenberg, that a new retelling of the story was necessary. He thought that I could do it.

Thomas's enthusiasm and guidance were critical at several points as I approached this unusual dissertation topic. Prudent graduate students focus their research on narrow topics. The hope is that they will write something that is analytic, a work that makes arguments, based ideally on heretofore untapped sources. A dissertation on Nat Turner's revolt was different. My goal was always a carefully documented narrative account. I hoped for new sources, but I understood that scholars knew the vast majority of my sources, many of which had even been published. Nevertheless, I still saw an opportunity for handling the sources differently than earlier accounts of the revolt had. The sources, especially Thomas R. Gray's *The Confessions of Nat Turner*, had been used inconsistently. Since the 1960s, scholars have been aware of the problems with relying so heavily on white sources. In particular, scholars understood the dangers of treating Gray as someone who accurately transcribed Turner's confessions, but no one had developed a coherent way of distinguishing Turner's voice from Gray's. I planned to use the *Confessions*, but initially I thought that the main thing I would be able to use them to document was Gray's opinions. Perhaps Turner's voice was in there somewhere, but distinguishing it from Gray's manipulations seemed to me—as it has seemed to others—an impossible task.

As with any project of this type, one is bound to run into difficulties, but one of the unexpected problems that I had was that I kept being surprised by

the quality of the sources. As is clear from the Afterword, the more I thought about the *Confessions*, the more reliable Gray appeared. It was much the same for other sources. Some of the black oral histories taken down during the Great Depression from old people born after the revolt and even the white oral histories that William Sydney Drewry used in his racist *The Southampton Slave Insurrection* appeared sound. As a result, I moved away from the original task I had imagined for myself, which was debunking some sources and recounting a narrative based upon the remaining sources, to the task of using a variety of sources to tell a new history of the revolt.

One way that *The Land Shall Be Deluged in Blood* differs from earlier accounts of the revolt is that it emphasizes divisions in the black community. Perhaps the account that is closest to this, at least in its portrayal of a divided black community, is Drewry's 1900 *The Southampton Slave Insurrection*. But that account was doomed by an author who was unable to see the blacks who joined the revolt as anything other than deluded fools. Drewry also could not imagine how attractive the slave revolt was to those who did not join it. In this work, I do my best to document as sympathetically as possible the variety of responses in the black community: from those who thought the revolt was exactly the right thing to do, to those who hated slavery but thought Turner was making a terrible mistake, to those who supported the slaveholders outright.

The black community is not the only place for which *The Land Shall Be Deluged in Blood* highlights divisions that earlier accounts of the revolt overlooked. Whites in Southampton were divided after the revolt. Although Southampton has a fascinating history as an early hub of white antislavery activity in Virginia, I found no hint that any whites actually supported the revolt, even abstractly. This is not surprising. Even if some of Southampton's antislavery whites thought that Nat Turner was right, this was not the type of observation that would likely be saved in a court hearing or a newspaper article. The smartest and safest thing to do with such an observation would have been to keep it to oneself. But one does not have to imagine Turner's secret white supporters to see divisions in Southampton's white community following the revolt. Some whites wanted retribution against what they saw as a dangerous black population. The wealthiest slaveholders—using the power they held as militia leaders and judges—understood that such retribution could easily get out of hand, and they did not want this to happen.

My attention to the dynamics within both the white and black communities has led me to trace the differences that emerged in Southampton to the different ways of thinking about the revolt. To understand the variety of black responses to Turner's call to rebel, I turn to W. E. B Du Bois's idea of double consciousness. Likewise, to understand how the elite whites overcame the

divisions within the white community, I invoke Antonio Gramsci's idea of hegemony. The two concepts have long and important roles in the historiography of race and slavery in America, and *The Land Shall Be Deluged in Blood* demonstrates how useful these ideas are when one is trying to make sense of what happened in Southampton.

The success that *The Land Shall Be Deluged in Blood* has in describing the events in Southampton immediately raises the question of what these findings mean with respect to different times and different places. If some blacks in Southampton County experienced double consciousness, does that mean that all American slaves experienced the same thing? If the leading slaveholders in Southampton asserted hegemonic power through the courts, does that mean that all courts exerted the same power? In short, my answer is no. There is no reason to think that people in South Carolina, Louisiana, or even another part of Virginia had to follow the Southampton script. Historians place actors within contexts, so without paying close attention to the context of the events in these other places, one cannot hope to understand why the actors did what they did.[2]

That said, *The Land Shall Be Deluged in Blood* challenges us to look at the history of slavery anew. Because historians of slavery are interested in learning about slavery itself, too often they treat the fundamental categories of slavery—slave, master, free black, non-slaveholding white—as essential.[3] While these categories are undeniably important, *The Land Shall Be Deluged in Blood* reminds us that people's actions are not determined by their social positions. While readers may choose to cheer a heroic figure such as Nat Turner, presuming that slaves in Southampton did the same ultimately distorts the challenge that Turner faced. In Southampton, slaves disagreed with other slaves; slaveholders disagreed with other slaveholders. Free blacks and non-slaveholding free whites disagreed among themselves and with each other. And members of all of these groups sometimes acted in ways that are completely surprising and unexpected.

Since individuals' social positions did not necessarily lead to the creation of unified classes, the only way that classes could be created was through a historical process. In *The Land Shall Be Deluged in Blood*, it becomes clear that leaders in Southampton used their power to propagate the idea that Southampton's slaves posed little threat to the white community. As whites adopted this interpretation of the revolt, it became much easier for them to accept the continuation of slavery. What does this imply about classes elsewhere? Did all slaveholding elites always act hegemonically? Or was it simply an unprecedented threat that led to an anomalous class formation in Southampton? Either is possible, but the fact that the extraordinary heat of the slave revolt made visible otherwise invisible hegemonic forces makes me wonder if those who examine

more quotidian subjects miss the importance of hegemony. If so, then we should think more about hegemony even when it is hard to see.

The Land Shall Be Deluged in Blood also contributes to the conversation about race in American history. This work suggests that race, no less than class, is a historical product and that racial categories do not determine actions. In Southampton, blacks and whites interacted in a variety of often surprising ways. At the same time, there can be no doubt that the revolt strained relations between most whites and blacks. Elite slaveholders averted a disaster by limiting the number of blacks who were killed following the revolt. Perhaps one way of thinking about this episode is to see it as a moment when class trumped race, but that view seems too simple. The slaveholders stopped other whites from killing blacks, but they did not stop those whites who wanted to segregate communion lines at Mill Swamp Baptist Church. A better way of understanding this moment may be to see it as a time when slaveholders stood firm against the versions of racism that most directly threatened their wealth, but they did not stop more insidious forms of racism. At this point, one might ask if the festering racism simply deferred the problem, creating new problems that would appear later. One might also ask what this history suggests about a world after the institution of slavery was destroyed. What happens to race relations when elite whites no longer have a financial interest in protecting and securing their black workers?

In many ways, our world seems far removed from the world of Nat Turner and Alexander P. Peete, Boson and Josiah Holleman. We live in a world of remarkable health and wealth, with the richest of us spending our lives in ways that people who lived two centuries ago could not have imagined. America has also made legal progress, nowhere more clearly than with the abolition of slavery 150 years ago. Although the observation is already a cliché, a black man has twice been elected president of the United States. Despite these changes, we make a mistake by focusing only upon the differences between our world and that of Nat Turner. After all, we are the inheritors of the country that slaves and slaveholders made. Their history is an important part of our patrimony.[4] Moreover, like Turner, we live in a country that continues to be beset by oppression and racism. Like Turner, we live in a world where many of the greatest injustices are easier to spot than to solve. By overemphasizing the importance of slavery as the root of the inhumanity of the era, it becomes harder for us to see the ways that we—who are not slaveholders—also fail to respect the fundamental dignity of others. No less than the black and white congregants of Mill Swamp Baptist Church, we must strive together to achieve a stronger and more just community.

Afterword

THE PROBLEMATIC NATURE of the authorial voice in *The Confessions of Nat Turner* poses the single most significant interpretative problem for people interested in the revolt. Thomas R. Gray, the man who wrote the *Confessions*, claimed that the confession contained in the document was "a faithful record" of Turner's words. If so, the *Confessions* is one of the great sources on American slavery. Few sources provide access to the minds of slaves, let alone the mind of the man who may be the most famous American to live and die in slavery. To have the reflections of Turner as he awaited his trial and ensuing execution seems almost too good to be true, and scholars have wondered if Gray's incredible claim that he faithfully recorded Turner's confessions can be taken seriously. After all, Gray abhorred Turner. When Gray "looked on him," he admitted, "my blood curdled in my veins."[1] What would stop Gray from putting his own words in Turner's mouth?

Scholars' desire to find Turner's authentic voice has led some to compare the *Confessions* to other contemporary sources. In this case, the grail they seek is a letter written by Gray about the revolt before Nat Turner was captured. Scholars could compare and contrast such a letter, which would presumably represent Gray's viewpoint about what had happened, to the *Confessions*. Parts of the *Confessions* that resembled too closely what was written before Turner was captured would be suspect; the original parts of the *Confessions* would be understood to be Turner's own voice. Of the many problems with this approach, none is greater than that there is little reason to think Gray wrote any of the letters that people have attributed to him. The most important letter that appeared on the revolt—a lengthy account that was published in the Richmond *Constitutional Whig* on September 26, 1831—was dated September 17. At that time, the anonymous author noted, "Professional duties prevent me, from bestowing as much attention to the drawing up of this narrative as I would wish." Some have latched onto this point, figuring that Gray,

one of the three most active defense lawyers, may have been the anonymous letter's author. Unfortunately for those who suggest that Gray wrote this letter, Gray was not active at court on September 17, when this letter was composed. He did not appear as defense counsel for any accused slave between September 6 and October 18, perhaps because of his father's death in mid-September, perhaps because he himself was sick at the time the letter was written.[2]

Paying close attention to the similarities between the texts does nothing to bolster the case that the letter was written by Gray. "The most striking similar[it]y," according to David F. Allmendinger Jr., is that the two have nearly identical lists of the whites killed in the revolt, although that evidence is not especially persuasive, especially since the spelling of the names on the list differed in four of the fifty-five cases. Other differences between the letter and Gray's preface to the *Confessions* are even clearer. In the letter, for instance, the author chastised whites for indulging black preachers and even attacked white preachers who "fill their discourses with a *ranting cant* about equality"; Gray's *Confessions* never mentioned white preachers or egalitarian ideology. Likewise, the letter in the *Constitutional Whig* referred to papers that Turner's wife turned over after she was beaten; Gray never mentioned Turner's wife, let alone the papers. The differences extend beyond what was included in the letter but omitted from the *Confessions*. These sources also discussed the same events differently. For example, the author of the letter in the *Constitutional Whig* decided to "pay a passing tribute to our slaves" who remained loyal to their white masters and mistresses. Nowhere was that loyalty clearer than at Dr. Blunt's farm, where "many in number, joined heart and hand in defence of their master." Gray, on the other hand, ignored the role of loyal slaves, even in his discussion of the events at Blunt's farm. According to Gray, Blunt's farm was defended only by five whites: "two men and three boys."[3] Given the significant differences between the accounts, it is likely that someone other than Gray wrote this anonymous letter, which means that this article provides no support for the theory that Gray was working on a draft of the *Confessions* more than a month before Turner was captured.

Instead of undermining the *Confessions*, the best evidence from contemporary letters actually supports Gray's claim to having reliably recorded Turner's words. When Scot French cited an anonymous letter that appeared in the Richmond newspapers shortly after Turner's capture, he concluded that "the style—if not the content—of Turner's 'confessions' might have differed dramatically had another author taken them down."[4] In coming to this conclusion, French downplayed the importance of the most relevant comment this

anonymous correspondent made about Gray: "I had intended to enter into further particulars, and indeed to have given you a detailed statement of his [Turner's] confessions, but I unde[r]stand a gentleman is engaged in taking them down verbatim from his own lips, with a view of gratifying public curiosity."[5] This comment, written by an anonymous white correspondent in Southampton on the same day that Gray began his interview with Turner, showed that at least some whites in Southampton County thought it impor- tant to preserve Turner's own words. Moreover, at least one of Gray's neigh- bors thought that Gray understood as much, too.

The most powerful attacks on the *Confessions* based upon contemporary sources have contrasted an account of Turner's trial that Gray included in his pamphlet to the official records from the trials after the rebellion. According to this argument, one would be foolish to put one's faith in Gray's account unless Gray properly represented Turner's trial. But several historians do not believe Gray's account of what happened during Turner's trial. In particular, historians cast a jaundiced eye on the prominent place that Gray assigned to the *Confessions* during his account of the trial. According to Gray, "Col. Trezvant was then introduced, who being sworn, narrated Nat's 'Confession' to him, as follows: (*his Confession as given to Mr. Gray.*)" Later, when Turner was asked if he wanted to say anything, he responded, "I have made a full con- fession to Mr. Gray, and I have nothing more to say." The official records of the trials, in contrast, included no mention of either Gray or the *Confessions*. This has led Kenneth S. Greenberg to conclude that "the entire document that Gray presents as a trial record was very likely his own creation."[6]

Although it is possible that Gray embellished his account, nothing signif- icant in the court records contradicts Gray's version of Turner's trial. Moreover, the similarities between the two accounts of the trial suggest that Gray attended the trial. Both the account of the trial in the *Confessions* and the official trial records agreed on all of the important things that happened during the trial. Both said that Nat Turner pleaded not guilty. Both accounts said that that Levi Waller testified first, followed by James Trezvant. Both identified Jeremiah Cobb as the spokesman for the court who delivered the court's judgment. Both accounts said that Turner was asked if he wanted to speak before he was sentenced, and both accounts said that he did actually speak, if only to say that he did not need to say anything more than what he had already said. Finally, in both trial records, Cobb sentenced Turner to be hanged on Friday, November 11, 1831.[7]

Although Gray was likely at the trial, his account differed from the official one recorded by James Rochelle, Southampton's clerk. While the people who

spoke are described as speaking in the same order, they did not always say the same thing. In one case, the difference was a detail that one of the men wrote down incorrectly. When Cobb sentenced Turner to death, both Gray and Rochelle agreed that Turner was supposed to be hanged sometime after ten o'clock in the morning, but they disagreed about when the execution had to be completed. Gray wrote that the sentence was to be carried out by two o'clock; Rochelle wrote that the execution was supposed to be completed by four o'clock.[8]

Other minor differences in the accounts seem to be the result of two different writers independently describing the same event. Consider how each recorded Cobb's sentencing speech. Both accounts included similar directions from Cobb. In the official records, Rochelle wrote that Cobb ordered Turner back "to the Jail from whence he was taken," and then the sheriff was ordered to take Turner "to the usual place of execution" on the day scheduled for the execution. According to Gray, Cobb ordered Turner back "to the jail from whence you came" and then taken "to the place of execution." The actual pronouncement of sentence was also remarkably similar. According to Rochelle, Cobb ordered that Turner was to "be hanged by the neck until dead"; according to Gray, Cobb sentenced Turner to "be hung by the neck until you are dead! dead! Dead."[9]

Since the similarities in these statements suggest that both were transcribing the same speech, the differences between the two versions show how each author made different editorial decisions. In the official records, Rochelle left out the dramatic. Rochelle's account of Cobb's sentencing speech was short. Between Turner's refusal to speak and the pronouncement of sentence, Rochelle included only 74 words from Cobb. The same section of Gray's account was 343 words, including an impassioned soliloquy with Cobb speaking in the first person directly to Turner, whom he addressed in the second person. Apparently Rochelle did not think that the official records needed to preserve a dramatic personal statement from the court's spokesman.[10] Because the official court records omitted things that did not seem pertinent to Rochelle, it is possible that the *Confessions* was read in court but Rochelle just did not note it.

Gray included details that Rochelle left out, but he also left out some of what Rochelle included. For example, Rochelle included Cobb's valuation of Turner, so that his owner's estate could be compensated for property executed by the state, and the court's order to pay William Parker for his service as defense council. Gray did not bother to note either, probably thinking that his audience would not care. Likewise, at the end of the *Confessions*, Gray summarized James Trezvant's testimony "as follows: (*his Confession as given to Mr. Gray.*)" In the court records, James Rochelle wrote more. According to

Rochelle, Trezvant, a magistrate at the court and one of the men who first examined Turner, told the court that he had examined Turner, who testified freely. Gray also left out the next section of Trezvant's testimony, where Trezvant made five points: (1) that Turner was an insurgent, (2) that Turner was "the Chief among them," (3) that Turner struck "the first blow," (4) that Turner killed Margaret Whitehead, and (5) that Turner was with the rebels throughout the revolt.[11] While this summary does not contradict anything in the manuscript that Gray claimed Trezvant read, this record is not a short summary of the narrative that would be composed by someone who had listened to a reading of Gray's manuscript. Gray clearly left out some of Trezvant's testimony.

At this point, Gray's claim that the *Confessions* had been read in court appears suspect, but the next line of the court record can be read in a way that would support Gray's contention that Trezvant actually read Gray's manuscript to the court. After describing the five most incriminating points Trezvant had learned when he examined Nat Turner, Rochelle then noted "that he [probably Turner] gave a long account of the motives which lead him finally to commence the bloody scenes which took place." In this case, it is unclear whether Trezvant or Rochelle shortened Turner's "long account." If the long account was retold to the court, Trezvant may have testified extemporaneously about Turner's motives based upon his own examination of Turner. On the other hand, it is also possible that Trezvant read Gray's narrative, which is portrayed from its first line as "a history of the motives which induced me to undertake the late insurrection."[12]

Other evidence suggests that Trezvant read a draft of Gray's manuscript of Turner's confession to the court. Gray had no reason to think that readers would compare his account of the trial to the official records, but he apparently understood that his audience might doubt that the *Confessions* had been "acknowledged by" Turner to be his full and voluntary confessions "when read before the Court of Southampton." To convince readers that the manuscript had been part of the trial, Gray included a copy of an affidavit from six of the magistrates who served on the court that judged and sentenced Nat Turner. In this affidavit, dated the same day as Turner's trial, these judges certified three things: first, that "the confessions of Nat, to Thomas R. Gray, was read to him in our presence," second, "that Nat acknowledged the same [i.e., the confessions] to be full, free, and voluntary," and third, that when Turner was asked "by the presiding Magistrate of the Court, to state if he had anything to say, why sentence of death should not be passed upon him, [Turner] replied he had nothing further than he had communicated to Mr. Gray." This

affidavit was then followed by another affidavit from James Rochelle, the clerk of the court and the author of the official records. In this document, also dated the same day as the trial, Rochelle swore that the magistrates who had signed the first affidavit were "acting Justices of the Peace...and were members of the Court...for the trial of Nat *alias* Nat Turner." Rochelle then added "that full faith and credit are due, and ought to be given to their acts as Justices of the peace aforesaid."[13] If these are authentic documents, then the man who produced the official court records that have served as the linchpin of the best arguments against Gray's reliability validated an affidavit certifying that Gray's manuscript had been read to the court and that Turner not only acknowledged it but referred to it when asked if he wanted to say anything in his own behalf.

Although scholars have been understandably skeptical of these affidavits, there are two reasons to think that the officials at the court confirmed the details from Gray's version of the trial.[14] First, as a junior member of the bar, Thomas R. Gray would have been taking a significant risk by forging documents from some of Southampton County's most prominent officials. Professionally, he risked sanction from the court, which was the source of his livelihood, for misrepresenting the actions of the court. Even if the court might decide not to sanction Gray formally, it would be foolhardy for him to antagonize the men in Southampton County who were in the best position to help Gray professionally and personally.[15] Given the risks—and the certainty that the forgery would be discovered—it seems unlikely that someone in Gray's situation would falsify the affidavits.

Second, even if Gray had been willing to risk the repercussions that could come with falsifying official records, a careful reading of the magistrates' affidavit itself suggests that Gray did not forge the judges' signatures. According to both affidavits, the two affidavits were signed on the same day as the trial, but the magistrates' affidavit was signed by only six of the ten members of the court. The six men who signed the affidavit were—as Rochelle attested— members of the court that convicted Nat Turner, and Rochelle was the clerk of the court, so Gray did not commit a sloppy forger's mistake and include the name of someone who was not on the court. What about the other four, including James Trezvant, who did not sign the document? Would a forger include an incomplete list of judges to certify his forgery? Would a forger leave off the name of James Trezvant, the judge who Gray claimed read the *Confessions* to the court? More likely, Gray simply failed to get all of the judges to sign the affidavit after Turner's trial. It is worth noting that three of the four men who did not sign the affidavit left the bench immediately following Turner's trial, while four of the five judges who remained for the next trial signed the

affidavit.[16] Whatever the reason that the four judges did not sign the affidavit, Gray appears scrupulous, making sure that he only included those members of the court who actually were willing and able to sign the affidavit once he had prepared it. As a result, the likelihood that these are in fact authentic signatures makes more likely Gray's most surprising claims, that Gray's manuscript was read in court at Turner's trial and that Nat Turner publicly endorsed Gray's work as accurately representing his confession.

While contemporary sources tend to corroborate Gray's claim, there is another way to assess the reliability of the *Confessions*: one can do a close textual analysis of the document. This technique was pioneered by Seymour Gross and Eileen Bender, who argued against the reliability of Gray's work in part because Turner's language was not what they expected. At its weakest, this argument is little more than the type of speculation that Thomas Ritchie, the editor of the *Richmond Enquirer*, made when he objected in an early review that the "language is far superior to what Nat Turner could have employed."[17] But because of the complexity of the *Confessions*, it is possible to compare the sections that Gray acknowledged composing to the sections where Gray claims to have written Turner's own words. A close review of these different parts of the *Confessions* allows one to distinguish Gray's voice from Turner's.

This argument depends on the structure of the *Confessions*. At the heart of the *Confessions* is Turner's version of the events from his birth until his capture. Gray introduced this narrative with a single line: "Agreeable to his own appointment, on the evening he was committed to prison, with permission of the jailer, I visited NAT on Tuesday the 1st November, when, without being questioned at all, he commenced his narrative in the following words." Turner's account continues for 5,200 words—eleven pages in the first edition—with the statement interrupted only by occasional comments and questions from Gray. It ends with Turner stating that "I am here loaded with chains, and willing to suffer the fate that awaits me."[18] To this, Gray added supplementary material nearly as long as Turner's original statement. Several things that Gray added were written or signed by others, including the affidavit from the judges at Turner's trial and the affidavit from James Rochelle. He also included a certified copy of the copyright registry from Edmund Jennings Lee, the clerk of the Court of the District of Columbia. At the end of the pamphlet, Gray included a list of the whites who died during the revolt and a summary of the verdicts against the blacks who were tried. In addition to this material, Gray included three things that he wrote: an introduction to Turner's statement, his own 1,084-word reflection upon the revolt and its leader, and a description of Turner's trial.[19]

A careful comparison of Turner's narrative to Gray's writing can be used to support the idea that Gray preserved parts of Turner's testimony, even some of Turner's language. For example, people disagreed about how to describe the place where Turner had hidden. Some called it "a den." Gray called the place "a cave." Turner called his first hiding place "my cave," but he described the place that he was captured as "a little hole I had dug out with my sword...under the top of a fallen tree."[20] The distance in perspective between Turner's narrative and Gray's writing can be seen even more clearly in their different accounts of the same events. For example, in the *Confessions* Turner described how, as a child, he had miraculously learned to read without having ever been taught. Gray faithfully recorded this story even though he did not believe it. In the material that Gray added at the end, he offered a simpler explanation of how Turner learned how to read: "it was taught him by his parents." Because Gray's *Confessions* is the only document that purports to capture Turner's own voice, it is impossible to know how heavily Gray edited Turner's language. On one hand, scholars must keep in mind that Gray's "faithful record" of Turner's "own words," with "little or no variation," allowed Gray some leeway to amend Turner's testimony. On the other hand, scholars should be wary of dismissing something that someone in Southampton described as a "verbatim" transcription of Turner's *Confessions* on mere suspicion.[21]

The idea that the five-thousand-word narrative at the heart of the *Confessions* was a reliable account of what Turner said is supported by careful attention to the text. The first published version appeared less than a month after Nat Turner's capture. Yet the work was finished even sooner, given that Gray applied for copyright on November 10, less than two weeks after Turner's capture. Gray completed the *Confessions* quickly, but the manuscript containing Nat Turner's narrative was composed within days. By the third day Gray visited Turner, Thursday, November 3, Gray said that he had a manuscript copy of Turner's testimony, which Gray claimed that he used during his cross-examination of Turner. The speed with which Gray produced the manuscript of Turner's narrative makes it likely that Gray copied the narrative down while Turner spoke.[22]

Even if the statement was not transcribed as Turner spoke, other elements that Gray added to the *Confessions* increase one's confidence in Gray's work. Although Turner's testimony began as a soliloquy, Gray interrupted Turner's narrative at least sixteen times. Three times he interrupted the story to ask questions that Gray included in the *Confessions*. At other points, Gray asked unrecorded questions and noted Turner's response parenthetically. For example, in

the *Confessions*, Turner described interpreting the signs in the skies. According to Turner's narrative, the Holy Spirit "would make it known to me when I should commence the great work—and until the first sign appeared, I should conceal it from the knowledge of men—And on the appearance of the sign, (the eclipse of the sun last February) I should arise and prepare myself." Since Gray described himself as "having forborne" asking questions "except in the cases noted in parenthesis," it seems clear that when Turner mentioned "the sign," Gray asked him, what sign? Then Gray recorded Turner's response, the February eclipse, in parentheses.[23]

Seven of the twelve parenthetical interruptions were comments of this kind: answers to unrecorded questions asked by an active listener trying to follow Turner's story. Did Turner act as a conjurer to get the support of the other slaves? Who was the white man Turner baptized? What was the sign that allowed Turner to begin telling others about the revolt? Who were the four rebels in whom Turner "had the greatest confidence"? Where did the revolt begin? If fifteen slaves were part of the revolt and the nine mounted men rode off, what did the other six do? Who were the last two slaves with Turner after the revolt ended? Gray apparently asked these questions—or something like them—to help him and his readers follow Turner's confession.[24]

Gray also used parenthetical comments to make remarks in his own voice. Twice Gray inserted his editorial comments. At one point Gray noted that Turner's head and chest had "a parcel of excrescences which I believe are not uncommon, particularly among the negroes." Gray also commented parenthetically that the rebels' policy of killing the young, the old, and women was "invariably adhered to." Three of the five comments by Gray occurred in the description of the battle at Parker's place. When Turner stated that the whites fired from long range, Gray responded that such an action—which he did not deny—was "against the positive orders of Captain Alexander P. Peete." When Turner mentioned some of the whites whom he thought the blacks had killed, Gray insisted that the rebels had not killed any whites during the battle. Finally, when Turner described how the whites at the gate had rallied with Peete's men who had retreated to ambush the rebels, Gray explained that this was actually a new party from Jerusalem that knew nothing of the party led by Captain Peete.[25]

Despite Gray's insistence that he wanted to let Turner tell his own story, Gray was not willing to allow mistakes in Turner's narrative to stand. When Turner misrepresented what the whites had done, Gray corrected these mistakes with parenthetical comments. Few editorial decisions could be more fortunate for scholars: since Gray would not need to correct a narrative that

was "his own creation," the existence of parenthetical corrections suggests that Gray was not making substantive changes to Turner's testimony as he wrote it down. The fact that Gray published what he saw as a seriously incomplete and flawed description of the events at Parker's farm supports his contention that he was trying to publish Turner's recounting "from his own words."[26] Like others in Southampton, Gray apparently recognized the importance of Turner's narrative—even when Gray knew that it was wrong—and the decisions to include Turner's mistakes increases one's confidence in Gray.

The twelve parenthetical comments—both Turner's short responses to Gray's questions for clarification and Gray's asides—were apparently written into the text as Gray wrote it. On Thursday evening, November 3, Gray began a cross-examination of Turner. According to the text, Gray commented that he was glad to have "the advantage of his [Turner's] statement before me in writing." In addition to Gray's aside, there is reason to think that as Gray cross-examined Nat Turner, he had a written copy of Turner's narrative including all of the parenthetical interruptions. In the course of the cross examination, Gray asked Turner about one extraordinary revelation: in his confession, Nat Turner described doing many experiments, including involving the production of paper and gunpowder. It is hard to imagine southern whites ignoring this statement, and Gray asked him about these experiments. Turner's answers—which were not given—satisfied Gray to the extent that he commented in the *Confessions'* only footnote: "When questioned as to the manner of manufacturing these different articles, he was found well informed on the subject."[27] Why was this comment put in a footnote when the other comments by Gray were put into parenthetical notes? One explanation is that, as Gray stated, he had already composed the manuscript of Turner's account. Having no place on the handwritten page for a parenthetical comment, Gray added this comment in the margin.

The evidence that Turner's testimony was written quickly poses problems for those who want to focus on Gray's role in constructing the manuscript. As David F. Allmendinger Jr. argued in his defense of the reliability of the *Confessions*, Gray was able to maintain Turner's perspective throughout. That may seem inconsequential, but many of the most significant events during the revolt took place outside of Turner's sight. Turner traveled at the rear of the rebels—this was how he spotted Margaret Whitehead when the others could not see her—but this meant he did not witness many interesting things that had happened during the revolt. Nonetheless, the first-person account of the revolt was always consistent with Turner's limited perspective instead of with the stories that Gray wanted to tell. For example, Gray wanted to relate the

story of John Barrow's heroic death, so it was one of the stories he added at the end of the *Confessions*. Gray described how "John T. Baron [*sic*]...told his wife to make her escape, and scorning to fly, fell fighting on his own threshold." But this flattering story of a fallen hero was omitted from Turner's narrative. Why? The simplest explanation is that Gray was recording what Turner said and Turner had not witnessed Barrow's death. According to the *Confessions,* Turner arrived at Barrow's house after the other rebels had left. Turner discovered that "they had been here and murdered him [Barrow]. I pursued on their track to Capt. Newit Harris." In keeping with Turner's limited perspective, other stories of escapes—of a girl at Levi Waller's, of Harriet Whitehead, and of Lavania Francis—were likewise excluded from the text. Gray, who was the attorney for the reluctant rebel Jack and the star witness Moses, also excluded the interesting details from their stories.[28] In all of these cases, perspective trumped all other considerations, making Gray's claims that he allowed Turner to speak "from his own words" that much more believable.

The questions that scholars have raised about the *Confessions* have led many to conclude that assigning authorship to the work is impossible. The leading scholar of slave narratives, William L. Andrews, argued that handling this work as one with two authorial voices where each cannot be distinguished from the other "may do more justice to the significance of the *Confessions* than has been done by anyone who claimed to have recuperated the real Nat Turner from history." In a book on representations of Nat Turner in literature, Mary Kemp Davis likewise concluded that it is not "possible to determine beyond a shadow of a doubt if Gray's *Confessions* is, on the whole, authentic," and thus she left this question "unanswered." Scot French observed that "we will have to confront and embrace uncertainty rather than imposing a false order on it....The Rashomon version may be the best narrative we have." Given the state of scholarship, it is not surprising that Tony Horowitz surveyed the field and wrote an article entitled "Untrue Confessions," asking in his subtitle, "Is most of what we know about the rebel slave Nat Turner wrong?"[29] As it turns out, such modesty is not necessary, at least when it comes to interpreting *The Confessions of Nat Turner*. The most reasonable reading of this document is that Gray faithfully transmitted the confessions of America's most famous slave rebel.

Slave Population of Southampton County, 1824–1839

Year	Number of slaves over twelve years old
1824	4214
1825	4251
1826	4176
1827	4262
1828	4221
1829	4235
1830	4157
1831	4145
1832	3967
1833	3836
1834	3835
1835	3825
1836	3818
1837	3525
1838	3636
1839	3590

Source: Southampton County Tax List

Notes

LV	Library of Virginia
NCDAH	North Carolina Department of Archives and History
SCLP	Southampton County Legislative Petitions
SCCMB	Southampton County Court Minute Book
SCCCJ	Southampton County, County Court Judgments
SHC	Southern Historical Collection, University of North Carolina
VBHS	Virginia Baptist Historical Society

INTRODUCTION

1. Nat Turner's trial, Southampton County Court Minute Book (henceforth SCCMB), in Henry Irving Tragle, comp., *The Southampton Slave Revolt of 1831: A Compilation of Source Material* (Amherst: University of Massachusetts Press, 1971) (henceforth Tragle, *Revolt*), "conspiring to rebel" on 221. See also Thomas R. Gray, *The Confessions of Nat Turner, the Leader of the Late Insurrection in Southampton, VA* (Baltimore, 1831). Although there are many fine anthologies containing material related to the Nat Turner revolt, I cite Henry Irving Tragle's *The Southampton Slave Revolt* as much as possible. (The exception to this rule is Thomas R. Gray's *The Confessions of Nat Turner.*) Tragle's book has more typographical errors than some other anthologies, but the quantity of sources, including the transcripts of all the slave trials, means it remains the standard sourcebook on the revolt. When I have found mistakes in Tragle's version, I quote the original source and note the difference between Tragle's version and the original source in the notes. For an even more accessible online collection of documents, see www.natturnerproject.org.

2. *Richmond Enquirer*, January 10 and 19, 1832. For the description of the debates, see Christopher M. Curtis, *Jefferson's Freeholders and the Politics of Ownership in the*

Old Dominion (New York: Cambridge University Press, 2012), esp. 1–16, 126–56; Christopher M. Curtis, "Reconsidering Suffrage Reform in the 1829–1830 Virginia Constitutional Convention," *Journal of Southern History* 74 (2008): 89–124; Alison Goodyear Freehling, *Drift Toward Dissolution: The Virginia Slavery Debate of 1831–1832* (Baton Rouge: Louisiana State University Press, 1982); and Dickson D. Bruce Jr., *The Rhetoric of Conservatism: The Virginia Convention of 1829–30 and the Conservative Tradition in the South* (San Marino, CA: Huntington Library Press, 1982). For an alternative view of the debate, see William G. Shade, *Democratizing the Old Dominion: Virginia and the Second Party System, 1824–1861* (Charlottesville: University Press of Virginia, 1996), esp. 50–77. Randolph used "St. Domingo," which was one way that some Americans referred to Saint-Domingue, the French colony that became Haiti.

3. Eric Foner, ed., *Nat Turner: Great Lives Observed* (New Brunswick, NJ: Prentice Hall, 1971), 83; *The Liberator*, September 3, 1831, in Tragle, *Revolt*, 62.

4. Kenneth S. Greenberg makes a similar point about the relative inattention to the Nat Turner revolt in his introduction to a reader of documents on the revolt. See Greenberg, "*The Confessions of Nat Turner:* Text and Context," in *The Confessions of Nat Turner and Related Documents*, ed. Kenneth S. Greenberg (Boston: Bedford Books, 1996), 31. There is hope that the pattern of receiving little scholarly attention is changing. In addition to this work, David F. Allmendinger Jr.'s *Nat Turner and the Rising in Southampton* (Baltimore: Johns Hopkins University Press, 2014) has recently been published. Unfortunately, Allmendinger's book came out after I submitted this manuscript to Oxford University Press, so I have neither benefited from his thorough research nor pointed out the places where we disagree. For my review of *Nat Turner and the Rising in Southampton*, see Patrick H. Breen, review of *Nat Turner and the Rising in Southampton* by David Allmendinger Jr., *Journal of the Civil War Era* 5 (September 2015).

5. Willie Lee Rose, review of *The Fires of Jubilee* by Stephen B. Oates, *New York History* 58 (April 1977): 240; William Styron, *The Confessions of Nat Turner* (New York: Random House, 1967); Stephen B. Oates, *The Fires of Jubilee: Nat Turner's Fierce Rebellion* (New York: Harper Perennial, 1990).

6. William Sidney Drewry, *The Southampton Insurrection* (1900; repr., Murfreesboro, NC: Johnson Publishing, 1968), 18, 26, 30.

7. Herbert Aptheker, *Nat Turner's Slave Rebellion: Together with the Full Text of the So-Called "Confessions" of Nat Turner Made in Prison in 1831* (New York: Humanities Press, 1966), i, 5.

8. Aptheker's work on Nat Turner and other slave revolts was groundbreaking in its approach to slavery, but it was in important ways indebted to work by black scholars, especially W. E. B. Du Bois's prior work on Reconstruction, which challenged the dominant interpretation that Reconstruction was a failure because too much power had been given to the freedmen and -women. Although Du Bois had not written about Nat Turner specifically, in 1904 he had been in negotiation with a publisher to write a book about Frederick Douglass. When the publisher offered the Douglass

title to Du Bois's rival Booker T. Washington, Du Bois offered to write instead on Nat Turner. Unfortunately, the publisher rejected Du Bois's counteroffer. See W. E. B. Du Bois, *Black Reconstruction in America, 1860–1800* (New York: Free Press, 1935, 1998); W. E. B. Du Bois, *Selections from the Correspondence of W. E. B. Du Bois*, ed. Herbert Aptheker (Amherst: University of Massachusetts Press, 1973), 1:64. In addition to facing opposition for his revisionist views on slavery, Herbert Aptheker also endured persecution as a Communist. As a result, he never got the full-time academic appointment that he deserved. For more on Aptheker's career, see Herbert Aptheker, "An Autobiographical Note," *Journal of American History* 87 (June 2000): 147–50; Robin D. G. Kelley, "Interview of Herbert Aptheker," *Journal of American History* 87 (June 2000): 151–67; Herbert Aptheker and Greg L. Michel, "Letters to the Editor," *Journal of American History* 88 (December 2001): 1227–8.

9. See Eugene D. Genovese, *Roll, Jordan, Roll: The World the Slaves Made* (New York: Vintage, 1976). For Genovese's appraisal of Phillips, see Genovese, "Race and Class in Southern History: An Appraisal of the Work of Ulrich Bonnell Phillips," *Agricultural History* 41 (1967): 345–58. While Genovese deemphasizes slave resistance in the United States, he does find a revolutionary tradition in the Caribbean. See Genovese, *From Rebellion to Revolution: Afro-American Slave Revolts in the Making of the New World* (Baton Rouge: Louisiana State University Press, 1979). For a posthumous assessment of Genovese's legacy, see J. William Harris, "Eugene Genovese's Old South: A Review Essay," *Journal of Southern History* 80 (2014): 327–72. For criticisms of Genovese, see Walter Johnson, "On Agency," *Journal of Social History* 37 (2003): 113–24, and Walter Johnson, "A Nettlesome Classic Turns Twenty-Five," *Common-Place* 1 (2001); Steven Hahn, *A Nation Under Our Feet: Black Political Struggles in the Rural South from Slavery to the Great Migration* (Cambridge, MA: Belknap Press, 2003); Steven Hahn, *The Political Worlds of Slavery and Freedom* (Cambridge, MA: Harvard University Press, 2009); George M. Frederickson, "The Skelton in the Closet," *New York Review of Books,* November 2, 2000, 61–66; and James Oakes, *The Ruling Race: A History of America Slaveholders* (New York: Norton, 1982). Michael Wayne has influenced my thinking on the term "paternalism" and explains the problems with the term from the point of view of someone who appreciates its explanatory power. See Wayne, *Death of an Overseer: Reopening a Murder Investigation from the Plantation South* (New York: Oxford University Press, 2001), 85.

10. Most historians of slave revolts and plots have a conceptualization of slavery that draws on Aptheker's work, but Robert Paquette, who has written on the Vesey affair and is working on a project on the 1811 German Coast uprising in Louisiana, is the historian studying slave resistance in America who is most sympathetic to Genovese. See Robert L. Paquette, "From Rebellion to Revisionism: The Continuing Debate About the Denmark Vesey Affair," *Journal of the Historical Society* 4 (Fall 2004): 291–334; Robert L. Paquette, "The Drivers Shall Lead Them: Image and Reality in Slave Resistance," in *Slavery, Secession and Southern History*, ed. Robert Louis Paquette and Louis A. Ferleger (Charlottesville: University of Virginia Press, 2000), 31–58.

11. Drewry, *The Southampton Insurrection*, 110; Genovese, *Roll, Jordan, Roll,* esp. 587–98.

12. L. Minor Blackford, *Mine Eyes Have Seen the Glory: The Story of a Virginia Lady, Mary Berkeley Minor Blackford, 1802–1896, Who Taught Her Sons to Hate Slavery and to Love the Union* (Cambridge, MA: Harvard University Press, 1954), 27; Gray, *The Confessions of Nat Turner*, 14; Nathan's, Tom's, and Davy's trials, SCCMB, in Tragle, *Revolt*, 200–201.

13. An effort to open the question of female involvement in Nat Turner's revolt has been made by Mary Kemp Davis in " 'What Happened in This Place?': In Search of the Female Slave in the Nat Turner Slave Insurrection," in Kenneth S. Greenberg, ed., *Nat Turner: A Slave Rebellion in History and Memory* (New York: Oxford University Press, 2003), 162–76. See also Thavolia Glymph, "Rose's War and the Gendered Politics of a Slave Insurgency in the Civil War," *Journal of the Civil War Era* 3 (December 2013): 501–32; Natasha Lightfoot, " 'Their Coats Were Tied Up like Men': Women Rebels in Antigua's 1858 Uprising," *Slavery and Abolition* 31 (2010): 527–45.

14. Looking at resistance studies theoretically, Sherry B. Ortner observes that "resistance studies are thin," by which she means that they do not produce Geertzian "thick descriptions" that capture the rich contexts of actions. Applying this observation to the topic of slave rebellions, Marjoleine Kars, who is working on the Berbice slave revolt of 1763, observes that those slaves who have not joined slave rebellions "have been little studied." See Ortner, "Resistance and the Problem of Ethnographical Refusal," *Comparative Studies in Society and History* 37 (1995): 190; Marjoleine Kars, "Opting Out," *Common-place* 14 (Spring 2014). In a broader discussion of slavery historiography, Joseph C. Miller makes a similar point highlighting the difference between a history based upon sociological categories and a "historicized alternative." See Joseph C. Miller, *The Problem of Slavery as History: A Global Approach* (New Haven: Yale University Press, 2012), 39.

15. Richmond *Constitutional Whig*, September 26, 1831, in Tragle, *Revolt*, 97. One of the great problems for historians of slavery is sources. Because the lives of slaves are often poorly documented, historians of slavery (perhaps more than historians in other fields) tend to generalize from very little material. If a slave cheered Nat Turner's revolt, for example, it is easy to presume that this judgment would translate into action. But thought and action are different. Not every slave who thought Turner's revolt was a good idea was ready to join; some who said it was a bad idea joined anyway.

16. In this allusion to Luke 23:24, Jack and Andrew signaled to whites their loyalty and their sympathy for the people killed in the revolt. This rhetoric worked, as George Powell, the person they addressed, appeared as a witness for the defense at Jack's trial. At the same time, it is interesting to note that Jack and Andrew picked a quote that distanced themselves from the rebels' actions without necessarily distancing themselves from their cause. It is possible that Jack and Andrew spoke sincerely, rejecting the rebels' methods but supporting their cause. See Jack's trial, SCCMB,

in Tragle, *Revolt*, 180–81; "retreated," "alarmed," and "in pursuit" are from Daniel's trial, 1831 Box 95, Southampton County, County Court Judgments (henceforth SCCCJ), Library of Virginia (henceforth LV).

17. Many other historians have explored situations producing the ambiguities that I describe here. One of the places that the ambiguity is most readily seen is in works on privileged slaves and free blacks. For examples of this from recent scholarship focusing on Virginia, see Eva Sheppard Wolf, *Almost Free: A Story About Family and Race in Antebellum Virginia* (Athens: University of Georgia Press, 2012); Annette Gordon-Reed, *The Hemingses of Monticello: An American Family* (New York: Norton, 2008); Melvin Patrick Ely, *Israel on the Appomattox: A Southern Experiment in Black Freedom from the 1790s Through the Civil War* (New York: Knopf, 2004); Joshua D. Rothman, *Notorious in the Neighborhood: Sex and Families Across the Color Line in Virginia, 1787–1861* (Chapel Hill: University of North Carolina Press, 2003). Perhaps the fullest explorations that I have read of the ambiguities of living in a slave society come from literature, not history. Edward Jones's *Known World* (New York: Amistad, 2003), for instance, describes generational divisions in one (imagined) free black family. Even closer to my assessment is James McBride's *The Good Lord Bird* (New York: Riverhead, 2013), which present a farcical bildungsroman about Henry Shackleford, a runaway slave who learns that John Brown's plan "weren't no lunacy" (415).

18. W. E. B. Du Bois, "Strivings of the Negro People," *Atlantic Monthly*, August 1897; W. E. B. Du Bois, *The Souls of Black Folk*, ed. Henry Louis Gates Jr. and Terri Hume Oliver (1903; New York: Norton, 1999), esp. 9–16.

19. Interestingly, her grandmother was not the only one who initially tried to talk Harriet Jacobs out of running away. Sally, who lived with Jacobs's grandmother, had much the same response. See Ira Berlin et al., *Free at Last: A Documentary History of Slavery, Freedom, and the Civil War* (New York: New Press, 1991); Harriet Jacobs, *Incidents in the Life of a Slave Girl*, ed. Jean Fagan Yellin (Cambridge, MA: Harvard University Press, 1987), 91, 96. Despite the divide between resistance and accommodation historiographical traditions, many historians have drawn on both traditions in their work. See, for example, Erskine Clarke's award-winning *Dwelling Place: A Plantation Epic* (New Haven: Yale University Press, 2005), which tells story of a group of whites and blacks in Liberty County, Georgia. Clarke notes that the slaves' actions included "not only open resistance to slavery but also acculturation and relentless negotiations" (x).

20. Haiti's slave rebellion is unique in its success, but recent scholarship has emphasized that the success of that revolt was contingent upon many external factors. See Jeremy D. Popkin, *You Are All Free: The Haitian Revolution and the Abolition of Slavery* (New York: Cambridge University Press, 2010). For my comparison of Nat Turner's revolt to the Haitian Revolution, see Chapter 1.

21. My discussion on hegemony draws most directly on the work of Eugene D. Genovese, who in turn draws of the work of the Italian theorist Antonio Gramsci.

See Genovese, *Roll, Jordan, Roll*, esp. 25–49, 658–60; Genovese, "On Antonio Gramsci," in *In Red and Black: Marxian Explorations in Southern and Afro-American History* (Knoxville: University of Tennessee Press, 1984), 391–422; Genovese, "Farmers in a Slaveholders' Democracy," *Agricultural History* 49 (April 1975): 331–42; Antonio Gramsci, *The Prison Notebooks*, ed. and trans. Joseph A. Buttigieg (New York: Columbia University Press, 1991). Although I am indebted to Genovese for his work on hegemony, my use of "hegemony" differs from his in two important ways. First, my conceptualization of double consciousness in the black community implies that blacks retained a critical perspective on slavery, even if they also sometimes viewed the rules of slavery as ones they had to live under. As a result, when I use the term "hegemony," I am referring specifically to the way that white slaveholders were able to get neighboring white non-slaveholders to support and protect slave property. Second, although Genovese rightly points to the legal system as a critical place where hegemony is created, in "Eugene Genovese's Old South" J. William Harris suggests that Genovese pays little attention to "how actual people achieved, held, and exercised power in the South's 'slaveholders' democracy.'" Influenced by theorists such as Jean-François Lyotard, Michel Foucault, and Hayden White, I see the hegemonic power of the Southampton courts in their ability to create a narrative of the revolt that the rest of society accepted. Although influenced by postmodernism's skepticism of narrative, I remain hopeful that historians can escape the postmodern funhouse and write about the past. Because Michel-Rolph Trouillot adopts postmodern critiques of the historical project yet still points to historical conclusions, I consider his *Silencing the Past: Power and the Production of History* (Boston: Beacon Press, 1995) a model for my argument. For the postmodern account of Nat Turner's revolt, see Scot French, *The Rebellious Slave: Nat Turner in American Memory* (Boston: Houghton Mifflin, 2004).

22. William Henry Broadnax, quoted in *Richmond Enquirer*, January 24, 1832; Ellen P. Lewis to Harrison Gray Otis, October 17, 1831, in Samuel Eliot Morison, *The Life and Letters of Harrison Gray Otis, Federalist, 1765–1848* (Boston: Houghton Mifflin, 1913), 270.

23. John Wickham to Littleton W. Tazewell, October 10, 1831, Francis Jerdone Papers, Miscellaneous Microfilm 675, LV; "swept from among us," William Henry Broadnax, quoted in *Richmond Enquirer*, January 24, 1832; "extermination," Boston's Universalist *Christian Register*, October 1, 1831; Richmond *Constitutional Whig*, September 3, 1831, in Tragle, *Revolt*, 69; Hanover County petition, December 14, 1831, in J. H. Johnson, "Antislavery Petitions Presented to the Virginia Legislature by Citizens of Various Counties," *Journal of Negro History* 12 (1927): 678–79. Many of these figures, including Broadnax, were describing a point of view that they opposed, although the Petersburg correspondent confessed, "Bloody as the remedy may be, it will be better thus to rid ourselves of, than longer endure[,] the evil." For a response to John Pleasants's article that echoed his viewpoint, see *Norfolk and Portsmouth Herald*, September 7, 1831.

24. Frequently I refer to slaves as property. Although some may object that this is dehumanizing—some say that the term "slave" is itself objectionable—I see no workable way to avoid such language because I do not think one can understand the responses of whites without understanding that some people were seen as property. Still, this does not mean that I am not aware of how odd it is to raise the specter of genocide and then in the next paragraph discuss the slaveholders' immediate focus upon its financial implications.

25. "Appomattox," *Richmond Enquirer*, February 4, 1832; Peter Edwards petition, December 12, 1831, Southampton County Legislative Petitions (henceforth SCLP), LV. See Curtis, *Jefferson's Freeholders*, esp. 113–15, for Leigh's importance as a leading conservative, and 146–48 for an analysis of this letter.

26. Lynchburg *Virginian*, September 8, 1831, in Tragle, *Revolt*, 74. Although many historians have inflated the number of killings during the white reaction, Christopher Curtis and other have noted the "profound significance" of the fact that Nat Turner was "not lynched." See Curtis, *Jefferson's Freeholders*, 127. For my discussion, see Chapter 5.

27. *Richmond Constitutional Whig*, August 29, 1831, in Tragle, *Revolt*, 54; Eppes was quoted in James McDowell's speech to the Virginia legislature, Richmond *Constitutional Whig*, March 26, 1832; September 6, 1831, SCCMB, in Tragle, *Revolt*, 201.

28. Blackford, *Mine Eyes Have Seen the Glory*, 25, 27, 28.

29. George Blow Petition, Executive Papers, Littleton Tazewell, January-April 1835, LV.

30. Although I am using this case to support my idea of hegemony, this episode remains a great example of slaveholders doing exactly what Frederick Douglass accused them of doing: controlling the churches of the South. Most historians over the past generation agree with Douglass's reading, although Eugene D. Genovese and Elizabeth Fox-Genovese have rejected the corollary that southern Christianity was warped by the slaveholders. See Elizabeth Fox-Genovese and Eugene D. Genovese, *The Mind of the Master Class: History and Faith in the Southern Slaveholders' World View* (New York: Cambridge University Press, 2005). For examples of the consensus position, see Donald G. Mathews, *Religion in the Old South* (Chicago: University of Chicago Press, 1977); Christine Leigh Heyrman, *Southern Cross: The Beginnings of the Bible Belt* (New York: Knopf, 1997); Mark Noll, *The Civil War as a Theological Crisis* (Chapel Hill: University of North Carolina Press, 2006); and Charles F. Irons, *The Origins of Proslavery Christianity: White and Black Evangelicals in Colonial and Antebellum Virginia* (Chapel Hill: University of North Carolina Press, 2008). Unlike these works, however, this case suggests that the slaveholders' capture of the churches was not inextricably linked to racism. Although the meaning of race was likely not as fluid in nineteenth-century Virginia as it was in the eighteenth-century Moravian world, the racial alliances in the churches after Nat Turner calls to mind the more fluid racial categories that one sees in Jon F. Sensbach's *Rebecca's Revival: Creating Black Christianity in the Atlantic World* (Cambridge, MA: Harvard University Press, 2005). On the other hand, the inability of the slaveholders' churches to

resist racism within the church service itself foreshadows the problems that elite southerners would have maintaining an antiracist stance when it was no longer in their interest.

31. Richard C. Wade, "The Vesey Plot: A Reconsideration," *Journal of Southern History* 30 (1964): 143–61; Michael P. Johnson, "Denmark Vesey and His Co-Conspirators," *William and Mary Quarterly*, 3rd ser., 58 (October 2001): 915–76; and the responses in the forum "The Making of a Slave Conspiracy," *William and Mary Quarterly*, 3rd ser., 59 (January 2002): 135–202. For other defenses of the reliability of the records concerning the Denmark Vesey case, see Paquette, "From Rebellion to Revisionism," and James O'Neal Spady, "Power and Confession: On the Credibility of the Earliest Reports of the Denmark Vesey Slave Conspiracy," *William and Mary Quarterly*, 3rd ser., 68 (2011): 287–304. Similar questions also appeared following Winthrop D. Jordan's *Tumult and Silence at Second Creek: An Inquiry into a Civil War Slave Conspiracy* (Baton Rouge: Louisiana State University Press, 1993), a study of a possible slave conspiracy that occurred at the start of the Civil War.

32. In situations like this, one tends to worry about the problem of people being convicted upon unreliable evidence, but I believe that the systematic problem with these records was an underreporting of black support for the revolt. Since the court tried to minimize the revolt, some evidence was not presented simply because the judges or the prosecutor decided that the evidence did not establish that the accused's actions did not reach the level of commitment that the court wanted to punish. In other cases, when the judges heard ambiguous or limited evidence against defendants who were accused of supporting the revolt, the court sometimes discharged the accused. In the cases where the defendant was found not guilty, the clerk, James Rochelle, omitted any discussion of evidence from the record. As a result, it is almost certain that weak or ambiguous evidence pointing to broader support of the revolt in the black community was not recorded. In making this point, I am not arguing that the court ultimately was turning a blind eye to strong evidence implicating many blacks in the revolt. Since we have the record of the evidence that led to a conviction during the trials, any evidence that was not as strong must have had serious problems.

33. Daniel S. Fabricant, "Thomas R. Gray and William Styron: Finally, a Critical Look at the 1831 *Confessions of Nat Turner*," *American Journal of Legal History* 37 (July 1993): 332–61; Tony Horowitz, "Untrue Confessions: Is Most of What We Know About the Rebel Slave Nat Turner Wrong?" *New Yorker*, December 13, 1999, 80–89.

34. David F. Allmendinger, "The Construction of *The Confessions of Nat Turner*," in *Nat Turner: A Slave Rebellion in History and Memory*, ed. Greenberg, 24–42. Although Vincent Carretta has raised doubts about the reliability of Equiano's discussion of his place of birth, the tendency among scholars lately has been to find reliable texts that had once been seen as dubious. See Vincent Carretta, "Olaudah Equiano or Gustavus Vassa? New Light on an Eighteenth-Century Question of Identity," *Slavery and Abolition* 20 (1999): 96–105. For examples of recent works that have argued for

the reliability of specific slave narratives, see Paul E. Lovejoy, "Olaudah Equiano or Gustavus Vassa—What's in a Name?" *Atlantic Studies* 9 (2012): 165–84; Jean Fagan Yellin, "Introduction," in Harriet Jacobs, *Incidents in the Life of a Slave Girl*, ed. Jean Fagan Yellin (Cambridge, MA: Harvard University Press, 1987); Jean Fagan Yellin, *Harriet Jacobs: A Life* (New York: Basic Civitas Books, 2004); Robert E. Desrochers Jr., " 'Not Fade Away': The Narrative of Venture Smith, an African American in the Early Republic," *Journal of American History* 84 (1997): 40–66; Hank Trent, ed., *Narrative of James Williams, An American Slave, Annotated Edition* (Baton Rouge: Louisiana State University Press, 2013).

35. Paul Ricoeur, "Appropriation," in *Hermeneutics and the Human Sciences*, ed. and trans. John B. Thompson (Paris: Cambridge University Press, 1981), 182–93.

CHAPTER 1

1. See Virginia Auditor of Public Accounts, Personal Property Tax, Southampton County, LV (henceforth Southampton County Tax List), 1831. In Southampton County, slave owners were taxed on various forms of personal property including horses, coaches, stages, carryalls, and gigs. They were also taxed twenty-five cents on each slave over twelve that they owned. The resulting list produced by the tax collector yielded an annual tally of the working-age slaves in Southampton County. Although the tax records do not count children or distinguish men from women, as the census did, the tax records allow a window into slave ownership immediately before and after the slave revolt. Because the tax records do not include children, in many cases the total number of slaves could be significantly higher on places with young families. See also U.S. Census, Southampton County, Virginia, 1830, http://www.usgwarchives.net/va/southampton/census/1830 (henceforth Southampton County Census, 1830).

2. Joseph Joines quoted in Peter Edwards, December 12, 1831, SCLP. Historians disagree on the identity of Nelson. Drewry calls him "Nelson Williams," although he never specified which Williams owned Nelson. Drewry may have thought that Nelson belonged to Jacob Williams, who owned a slave named Nelson who was tried for involvement in the revolt. Henry Irving Tragle agrees, identifying William's Nelson as "one of those who met at Cabin Pond on the 21st." Stephen B. Oates states specifically that Nelson was "the property of Jacob Williams." In support of this identification, Nelson apparently knew about the revolt as early as four days before it occurred. The evidence against Nelson, however, described how the rebels "told Nelson to go with them" when they arrived at his plantation long after the revolt began, suggesting that Nelson had not been a part of the revolt from the start. See William Sidney Drewry, *The Southampton Insurrection* (1900; repr., Murfreesboro, NC: Johnson Publishing, 1968), 33; Nelson's trial, SCCMB, in Tragle, *Revolt*, 193–94, quote from n. 61; Stephen B. Oates, *The Fires of Jubilee: Nat Turner's Fierce Rebellion* (New York: Harper Perennial, 1990), 53. More likely,

Nelson belonged to Peter Edwards, as Thomas Parramore suggests. Nelson actively fought for the cause (see Peter Edwards petition, December 12, 1831, SCLP) and, unlike Jacob Williams's Nelson, no evidence suggests that Edwards's Nelson joined later in the revolt. Moreover, living on Peter Edwards's plantation, Nelson would have lived on land abutting Nathaniel Francis's farm and near to Joseph Travis's. Jacob Williams, on the other hand, lived miles away. Finally, Edwards's Nelson was killed as the revolt was suppressed, as was one of the slave leaders named Nelson. One report written from Southampton four days after the revolt admitted that the white had the severed "head of the celebrated Nelson, called, by the blacks, 'Gen. Nelson.'…The skull of Nelson, taken by us, is in the possession" of a local doctor. This strong evidence that the leader Nelson had already been killed undermines the candidacy of Jacob Williams's Nelson, who was tried on September 3, 1831, to be General Nelson. The only other plausible candidate to be General Nelson would be an unknown third Nelson who joined the revolt. See Norfolk *American Beacon*, August 29, 1831, in Tragle, *Revolt*, 50 (the same report is also quoted in the September 2, 1831, *Richmond Enquirer*); Thomas C. Parramore, *Southampton County Virginia* (Charlottesville: University Press of Virginia, 1978), 78, 247 n. 42.

3. William Drewry identifies this man in one place as Henry Edwards and at another point as Henry Porter. Stephen Oates and Thomas Parramore each use the latter designation. Unfortunately for someone trying to reconstruct the story of the revolt, the most likely owners who shared those names can be ruled out. Almost certainly Henry was not owned by either Peter Edwards, one of the larger slaveholders in the immediate neighborhood, who held seventeen slaves over the age of twelve, or Richard Porter, who held thirteen slaves older than twelve years old. These men lived on plantations visited by the rebels early in the revolt. Both of these men later made claims for compensation for slaves who were killed without trial, but neither asked for compensation for Henry. According to the black oral tradition, which was recorded a century after the revolt but is accurate about other specific episodes, Henry's mother lived on Peter Edwards's farm, although that record also suggested that "Henry" was tried. According to the trial records, no Henry was tried. See Drewry, *The Southampton Insurrection*, 25, 33; Oates, *The Fires of Jubilee*, 53; Parramore, *Southampton County*, 78; Peter Edwards and Richard Porter petitions, December 12, 1831, SCLP; Southampton County Tax List, 1831; Allen Crawford, interviewed by Susie R. C. Byrd, in *Weevils in the Wheat: Interviews with Ex-Virginia Slaves*, ed. Charles L. Perdue Jr., Thomas E. Barden, and Robert K. Phillips (Charlottesville: University Press of Virginia, 1992), 76. On the suggestion that Henry had access to brandy, see Thomas R. Gray, *The Confessions of Nat Turner, the Leader of the Late Insurrection in Southampton, VA* (Baltimore, 1831), 11.

4. Gray, *The Confessions of Nat Turner*, 7. On Gabriel, see Michael L. Nicholls, *Whispers of Rebellion: Narrating Gabriel's Conspiracy* (Charlottesville: University Press of Virginia, 2012); Philip J. Schwarz, ed., *Gabriel's Conspiracy: A Documentary History* (Charlottesville: University Press of Virginia, 2012); and Douglas R. Egerton, *Gabriel's*

Rebellion: The Virginia Slave Conspiracies of 1800 & 1802 (Chapel Hill: University of North Carolina Press, 1993). On Nat Turner's owners, see Drewry, *The Southampton Insurrection*, 26–27; Herbert Aptheker, *Nat Turner's Slave Rebellion: Together with the Full Text of the So-Called "Confessions" of Nat Turner Made in Prison in 1831* (New York: Humanities Press, 1966), 36–37; F. Roy Johnson, *The Nat Turner Story* (Murfreesboro, NC: Johnson Publishing, 1970), 38, 48, 55, 67; F. Roy Johnson, *The Nat Turner Slave Insurrection* (Murfreesboro, NC: Johnson Publishing, 1966), 14, 28, 51–52; Oates, *Fires of Jubilee*, 8–10, 13–15; 29–32, 51–53; Parramore, *Southampton County*, 76–77.

5. W[illiam] C. Parker to John Floyd, September 14, 1831, in Tragle, *Revolt*, 420–21. See *Richmond Enquirer*, November 8, 1831, in Tragle, *Revolt*, 136–38. On the question of Turner's complexion, Kenneth S. Greenberg suggests that historians must consider the possibility that Turner was in fact a mulatto but that this was denied because of its awkward implications. See Kenneth S. Greenberg, "Name, Face, Body," in *The Confessions of Nat Turner and Related Documents*, ed. Kenneth S. Greenberg (Boston: Bedford Books, 1996), 2–23, esp. 17–18. I find this interesting hypothesis unconvincing since it suggests that Turner's own account of his father that appears in *The Confessions* is fabricated. For Turner's references to his father, see Gray, *The Confessions of Nat Turner*, 7, 9.

6. Greenberg, "Name, Face, Body," 14–18; *Richmond Enquirer*, November 8, 1831, in Tragle, *Revolt*, 136–38.

7. Gray, *The Confessions of Nat Turner*, 7–8. Nat Turner's own description of his family has been the focus of much speculation by historians. For example, Nat Turner clearly referred to—but did not name—his grandmother in his *Confessions*. F. Roy Johnson accepted this and left her unnamed in his first volume on the revolt, *The Nat Turner Slave Insurrection,* 16. Four years later Johnson revisited this issue and, assuming that Turner's grandmother probably lived on the same plantation, identified Bridget as "presumably Nat's grandmother"; Johnson, *The Nat Turner Story*, 37. Steven B. Oates accepts Johnson's presumption about Turner's grandmother without any qualification. See Oates, *Fires of Jubilee*, 8–13.

8. Gray, *The Confessions of Nat Turner*, 9. Perhaps because of the lack of documentation about Nat Turner's father, he has been much contested. In the *Confessions*, Nat Turner recounts how the black community believed that his father was a slave who ran away. Historians have been inclined to believe this, although (as mentioned above) Kenneth S. Greenberg insists that historians consider an interpretation, proposed by a black man in Southampton, that Turner's father was a white man. In the 1930s, Joseph Cephas Carroll develops the story that Turner's father had run away from slavery, presumably using the black oral tradition, suggesting that after Turner's father escaped, he emigrated to Liberia; Joseph Cephas Carroll, *Slave Insurrections in the United States, 1800–1865* (1938; repr., New York: Negro Universities Press, 1968), 120. A more recent account from the black oral tradition suggests that Turner's father never ran away but rather was secretly taken from the county and sold to slave

traders. See Johnson, *The Nat Turner Story*, 50. Despite the various provocative ideas proposed about Turner's father, I see no reason to doubt or add anything to Turner's own account of his father's fate. On slavery's role in breaking up families, see Michael Tadman, *Speculators and Slaves: Masters, Traders, and Slaves in the Old South* (Madison: University of Wisconsin Press, 1989); Stephen Deyle, *Carry Me Back: The Domestic Slave Trade in American Life* (New York: Oxford University Press, 2005). For a discussion of slavery's effect on Virginia's slave families focusing, see William Dusinberre, *Strategies for Survival: Recollections of Bondage in Antebellum Virginia* (Charlottesville: University of Virginia Press, 2009), 73–84.

9. Early evidence for Turner's wife includes a letter written from Jerusalem less than a month after the revolt that refers to a whipping she received; Richmond *Constitutional Whig*, September 26, 1831, in Tragle, *Revolt*, 92. Samuel Warner also states that Turner had a wife and identifies Turner's wife's owner as "Mr. Reese"; *Authentic and Impartial Narrative of the Tragical Scene Which Was Witnessed in Southampton...*, in Tragle, *Revolt*, 296. Thirty years later, Thomas W. Higginson also referred to Turner's wife in "Nat Turner's Insurrection," *Atlantic Monthly*, August 1861. With the notable exception of Eugene D. Genovese, who saw Higginson's piece as the only evidence for Turner's wife, historians have generally accepted that Turner was married. William Sidney Drewry refers to an unnamed wife. More recently people have tried to identify Nat Turner's wife. Fanny was proposed by Lucy Mae Turner, who claimed to be Turner's granddaughter, but this has been not given credence by historians. See Eugene D. Genovese, "The Nat Turner Case," in *The Nat Turner Rebellion*, ed. John B. Duff and Peter M. Mitchell (New York: Harper and Row, 1971), 203–16, esp. 212, for a discussion of "Turner's alleged black wife." See also Scot French, *The Rebellious Slave: Nat Turner in American Memory* (Boston: Houghton Mifflin, 2004), 226–28, and Mary Kemp Davis, "'What Happened in This Place?': In Search of the Female Slave in the Nat Turner Slave Insurrection," in *Nat Turner: A Slave Rebellion in History and Memory*, ed. Kenneth S. Greenberg (New York: Oxford University Press, 2003), 173. In 1970, F. Roy Johnson, focusing on women who belonged to Giles Reese, speculated that Reese's slave Cherry "seems to have become Nat's wife." This speculation appears to be the result of a process of elimination and is presented as little more than a best guess based upon Southampton County property records. He never explains how he concluded that "Mr. Reese" was Giles Reese and not some other Reese. According to the 1830 census, there were four men named Reese heading households in Southampton County alone, including Joseph William Reese, owner of Hark's brother-in-law Jack. See Southampton County Census, 1830. See also Johnson, *Nat Turner Story*, 55. Steven B. Oates accepts Johnson's guess without reservation and describes elements from an undocumented wedding ceremony; see Oates, *The Fires of Jubilee*, 29–30. The likelihood that Cherry was Turner's wife is diminished by other evidence uncovered by Thomas Parramore, which suggests that Mariah is the best candidate based upon indirect evidence about her and Cherry's ages and the fact that Mariah had a child and Cherry did not. See Parramore,

Southampton County, 243–44 n. 43. For fuller background on the lively debate about Nat Turner's wife, see Albert E. Stone, *The Return of Nat Turner: History Literature, and Cultural Politics in Sixties America* (Athens: University of Georgia Press, 1992), 327; French, *The Rebellious Slave*, 450–51; and Charles Joyner, "Styron's Choice: A Meditation on History, Literature, and Moral Imperatives," in *Nat Turner: A Slave Rebellion*, ed. Greenberg, 195–96.

10. Drewry, *The Southampton Insurrection*, 28.

11. Southampton County Tax List, 1831; Louis P. Masur, *1831: Year of Eclipse* (New York: Hill and Wang, 2001), 3.

12. Gray, *The Confessions of Nat Turner*, 10, 10–11. Turner's unusual religious views have been the source of speculation among historians. Anthony Santoro places Turner in a biblical framework, while Walter C. Rucker sees him in the context of African religious beliefs. Peter Rodgers Brown even noted some similarities between Turner's thoughts and Millerism. See Anthony Santoro, "The Prophet in His Own Words: Nat Turner's Biblical Construction," *Virginia Magazine of History and Biography* 116 (2008): 114–49; Walter C. Rucker, *The River Flows On: Black Resistance, Culture, and Identity Formation in Early America* (Baton Rouge: Louisiana University Press, 2006), esp. 180–98; Peter Rodgers Brown, "The Theology of Nat Turner as Reflected in the Insurrection," master's thesis, Oberlin Graduate School of Theology, 1949, 6, 46, 72. For the influence of millenialism on another iconic antislavery activist, see Paul E. Johnson and Sean Wilentz, *The Kingdom of Matthias: A Story of Sex and Salvation in 19th-Century America* (New York: Oxford University Press, 1994).

13. Gray, *The Confessions of Nat Turner*, 9. William Kauffman Scarborough notes that the placement of a new overseer "invariably" would be followed by "a period of testing as the slaves sought to determine the disciplinary parameters of the new regime." If that happened in this case, it would explain why Nat Turner fled when he did. See William Kauffman Scarborough, *The Overseer: Plantation Management in the Old South* (1966; repr., Athens: University of Georgia Press, 1984), viii. For a more complete treatment of runaways, see John Hope Franklin and Loren Schweninger, *Runaway Slaves: Rebels on the Plantation* (New York: Oxford University Press, 1999).

14. Gray, *The Confessions of Nat Turner*, 9.

15. Harriet Jacobs, *Incidents in the Life of a Slave Girl*, ed. Jean Fagan Yellin (Cambridge, MA: Harvard University Press, 1987), 68–69. Yellin identifies the "Rev. Mr. Pike" as John Avery; Jacobs, *Incidents in the Life of a Slave Girl*, 270 n. 1. The Nottoway River, which traverses Southampton County, becomes the Chowan River at the North Carolina line. At Edenton, the Chowan empties into Albemarle Sound.

16. Gray, *The Confessions of Nat Turner*, 9–10. According to Eric J. Sundquist, "Turner appropriates and overturns one of proslavery's favorite passages, transfiguring a text of racist subjugation into his own prophetic call to revolt." This reading ignores the context of the quote. At this point in his life, Turner has not become a political

revolutionary, which he says only happens in 1831, so there is no way that Turner's fellow slaves would have seen his invocation of the line from St. Luke's Gospel as subversive. Given that it was used to justify a return to slavery, it was seen as submissive. It is not surprising, then, that other blacks greeted his pronouncement with disdain, a point that Sundquist ignores. See Eric J. Sundquist, *To Wake the Nations: Race in the Making of American Literature* (Cambridge, MA: Harvard University Press, 1993), 59. For when Turner become more politically radical, see Gray, *The Confessions of Nat Turner*, 11.

17. Lunsford Lane, *The Narrative of Lunsford Lane, Formerly of Raleigh, N.C. Embracing an Account of His Early Life, the Redemption by Purchase of Himself and Family from Slavery, and His Banishment from the Place of His Birth for the Crime of Wearing a Colored Skin* (1842), DocSouth, http://docsouth.unc.edu/neh/lanelunsford/lane.html.

18. Frederick Douglass, *Narrative of the Life of Frederick Douglass, an American Slave, Written by Himself,* ed. David W. Blight (1845; repr., Boston: Bedford/St. Martin's, 1993), 70. Mrs. Joseph Smith, who escaped from slavery in Maryland sometime before 1835, also commented on how the message to slaves to obey their masters was so common that "I never heard anything else." Most damningly, "I didn't hear any thing about obeying our Maker." See John W. Blassingame, ed., *Slave Testimony: Two Centuries of Letters, Speeches, Interviews, and Autobiographies* (Baton Rouge: Louisiana University Press, 1977), 411.

19. Gray, *The Confessions of Nat Turner*, 10. For more on the relation of resistance within the black community to black Christianity, see Albert J. Raboteau, *Slave Religion: The "Invisible Institution" in the Antebellum South* (New York: Oxford University Press, 1978), esp. 212–318; Eugene D. Genovese, *Roll, Jordan, Roll: The World the Slaves Made* (New York: Vintage, 1976), esp. 232–84; John W. Blassingame, *The Slave Community: Plantation Life in the Antebellum South*, rev. ed. (New York: Oxford University Press, 1979), 130–48; Donald G. Mathews, *Religion in the Old South* (Chicago: University of Chicago Press, 1977), 185–236; and Sylvia R. Frey, *Water from the Rock: Black Resistance in a Revolutionary Age* (Princeton: Princeton University Press, 1991), 284–325.

20. Gray, *The Confessions of Nat Turner*, 11. On the time frame, see also *Richmond Enquirer*, September 27, 1831, in Tragle, *Revolt*, 100.

21. Gray, *The Confessions of Nat Turner*, 11. Stephen B. Oates envisions another reason the whites refused to baptize Turner and Brantley: "When the word was out, it created a sensation in the neighborhood. A white man baptized by a Negro! Well, it was unheard of, even in tidewater Virginia, and white Christians absolutely refused to let Nat perform the ceremony at their altars." Unfortunately for this interpretation, Brantley and Turner asked to "be baptised by the church." Had the church agreed to baptize the two men, there is no reason to think that they would not have been baptized by the church's minister. See Oates, *Fires of Jubilee*, 40. Even

if Oates is not right in the particulars with this case, the question of black power in the church is an important issue at the time. For a more thorough treatment of these issues, see Chapter 8 in this book.

22. On examples of antebellum church discipline, see Mathews, *Religion in the Old* South, 225–28; Herbert G. Gutman, *The Black Family in Slavery and Freedom, 1750–1925* (New York: Random House, 1977), 286–87; Jon F. Sensbach, *A Separate Canaan: The Making of an Afro-Moravian World in North Carolina, 1763–1840* (Chapel Hill: University of North Carolina Press, 1998), 263; Jean E. Friedman, *The Enclosed Garden: Women and Community in the Evangelical South, 1830–1900* (Chapel Hill: University of North Carolina Press, 1985), 76–78; and Christine Leigh Heyrman, *Southern Cross: The Beginnings of the Bible Belt* (New York: Knopf, 1997), 69. There has been some great work done recently on interracial churches that look specifically at colonial and antebellum Virginia. See Charles F. Irons, *The Origins of Proslavery Christianity: White and Black Evangelicals in Colonial and Antebellum Virginia* (Chapel Hill: University of North Carolina Press, 2008), and Randolph Ferguson Scully, *Religion and the Making of Nat Turner's Virginia: Baptist Community and Conflict, 1740–1840* (Charlottesville: University of Virginia Press, 2008).

23. Gray, *The Confessions of Nat Turner*, 11; *Richmond Enquirer*, September 27, 1831, in Tragle, *Revolt*, 100. The stories of the baptism from the *Confessions* and the *Enquirer* both name only two men baptized. Despite their similarities on this particular detail, they tell the story of the baptism in different ways, suggesting that they are independent sources. In part because the correspondent clearly identifies what Turner "announced to the Blacks," I think it most likely that the sources for the *Enquirer* letter came from the black community. For evidence that Turner's religious beliefs and actions were not well understood by whites, see Richmond *Constitutional Whig*, September 26, 1831, in Tragle, *Revolt*, 93.

24. *Richmond Enquirer*, September 27, 1831, in Tragle, *Revolt*, 100. For evidence against my argument that Turner had little support in the black community and that the dove did not appear, Frank Roy Johnson, a folklorist from near Southampton County, found that some in the black community recalled the story that a dove had appeared. In the 1960s, Percie Claud and James Kelly Woodley told Frank Roy Johnson that some of Nat Turner's supporters "were made party to a vision in which a white dove came down and alighted on the 'prophet's' shoulder." See Johnson, *The Nat Turner Story*, 66. I reject this story as inconsistent with contemporary reports (including the *Confessions*) that describe the event but omit this crucial detail. The notion that Turner was seen in a favorable light by the black community in Southampton County following the Civil War has been fairly clearly established. For the best evidence of this, see Daniel Crofts, *Old Southampton: Politics and Society in a Virginia County, 1834–1869* (Charlottesville: University Press of Virginia, 1992), 243–44.

25. Matthew 3:16. For the other gospel accounts, see Mark 1:10, Luke 3:22, and John 1:32.

26. *Richmond Enquirer*, September 27, 1831, in Tragle, *Revolt*, 100; Gray, *The Confessions of Nat Turner*, 11. For other details not included in contemporary reports of the baptism, such as the location of the event, see Drewry, *The Southampton Insurrection*, 33; Johnson, *The Nat Turner Story*, 66.

27. Gray, *The Confessions of Nat Turner*, 11. Gray's account of a deeply religious figure who came to a radical political position relatively late is consistent with other accounts of interviews with Turner after he was captured. One interviewer wrote that "it was not until rather more than a year ago that the idea of emancipating the blacks entered his mind." *Richmond Enquirer*, November 8, 1831, in Tragle, *Revolt*, 137.

28. Richmond *Constitutional Whig*, September 26, 1831, in Tragle, *Revolt*, 92. Thomas C. Parramore misdates this beating. See Parramore, *Southampton County Virginia*, 77.

29. Johnson, *The Nat Turner Story*, 67; Drewry, *The Southampton Insurrection*, 26–27; Parramore, *Southampton County*, 76–77; Southampton County Tax List, 1831.

30. Gray, *The Confessions of Nat Turner*, 8–9, 10, 12.

31. Ibid., 11.

32. See Solon Borland to Roscius Borland, August 31, 1831, in North Carolina Governor's Papers, Montfort Stokes, v. 62, North Carolina Department of Archives and History (henceforth NCDAH).

33. The details of this meeting are drawn from a September 17, 1831, report from Southampton County that was printed in the Richmond *Constitutional Whig*, September 26, 1831 (reprinted in Tragle, *Revolt*, 91). The correspondent had looked into the revolt and hoped to undermine the "many rumors afloat." According to his report, the day before the revolt, at the first meeting of conspirators, Nat Turner met each of the individuals alone, a sensible precaution for men discussing revolt. Knowing that Nat Turner's own account described at least two separate meetings, the *Whig's* correspondent may have conflated the first meeting in February 1831 and the August 1831 feast. Many of the details of the first meeting suggest how the February meeting may have been handled.

34. Richmond *Constitutional Whig*, August 29, 1831, in Tragle, *Revolt*, 54. For other examples of contemporary whites who assumed that the revolt was carried out by fanatical disciples of Turner, see the sentencing described by Gray, *The Confessions of Nat Turner*, 21; Richmond *Constitutional Whig*, September 26, 1831, in Tragle, *Revolt*, 92.

35. Gray, *The Confessions of Nat Turner*, 11. On the boasting, see Richmond *Constitutional Whig*, September 3, 1831, in Tragle, *Revolt*, 67.

36. Richmond *Constitutional Whig*, September 26, 1831, in Tragle, *Revolt*, 93. According to this account, Nat Turner responded to the unnamed rebel. I suspect that the newspaper had the wrong people named; in fact, Hark probably explained to his brother-in-law Jack the reasons the plot was not bigger. Either way, a large-scale plot had been a plan considered and rejected by the rebels.

37. On the excitement in Southampton in 1802, see Parramore, *Southampton County*, 67. For background on Gabriel, see Nicholls, *Whispers of Rebellion*; Schwarz, *Gabriel's Conspiracy*; Egerton, *Gabriel's Rebellion*; James Sidbury, *Ploughshares into Swords: Race, Rebellion, and Identity in Gabriel's Virginia, 1730–1810* (New York: Cambridge University Press, 1997). On Vesey, see John Oliver Killens, ed., *The Trial Record of Denmark Vesey* (Boston: Beacon Press, 1970); Douglas R. Egerton, *He Shall Go Out Free: The Lives of Denmark Vesey* (Madison, WI: Madison House, 1999); James O'Neal Spady, "Power and Confession: On the Credibility of the Earliest Reports of the Denmark Vesey Slave Conspiracy," *William and Mary Quarterly*, 3rd ser., 68 (2011): 287–304; Michael P. Johnson, "Denmark Vesey and His Co-Conspirators," *William and Mary Quarterly*, 3rd ser., 58 (October 2001), and the responses to Johnson in the forum "The Making of a Slave Conspiracy," *William and Mary Quarterly*, 3rd ser., 58 (January 2002): 135–202. Some whites in Southampton were familiar with what had happened in Haiti, as can be seen in an aside in one of the early reports from Southampton, which blamed free blacks for giving rise to the great Haitian Revolution. See Richmond *Constitutional Whig*, September 26, 1831, in Tragle, *Revolt*, 91.

38. Fredrick Douglass, "What to the Slave Is the Fourth of July?" in *My Bondage and My Freedom* (1855), 441–45, DocSouth, http://docsouth.unc.edu/neh/douglass55/douglass55.html. For more examples of an ideological understanding of the relationship of the Fourth of July to slavery, see Edward Bartlett Rugemer, *The Problem of Emancipation: The Caribbean Roots of the American Civil War* (Baton Rouge: Louisiana State University Press, 2008), 224–28. Abraham Lincoln also saw the tension and commented, "It is still a great day—*for burning firecrackers*." See John Burt, *Lincoln's Tragic Pragmatism: Lincoln, Douglas, and Moral Conflict* (Cambridge, MA: Harvard University Press, 2013), 101.

39. Gray, *The Confessions of Nat Turner*, 11. Perhaps one of the other conspirators suggested that the revolt begin on Independence Day. If one of the others proposed the date, this would explain how Turner had gone from too scared to act on July 4 to intrepid after one more sign from God. He seemed to have had less confidence in the proposals of the other rebels than he did in his own ability to discern God's wishes. This interpretation of the significance of the date follows Eric J. Sundquist's interpretation, although he presumes that Independence Day was selected by Turner. See Sundquist, *To Wake the Nations*, 65–66.

40. Benjamin Hallowell, "The Solar Phenomena," *Niles Weekly Register*, October 1, 1831, 96. This letter was dated August 20, 1831, two days before the revolt began. For other descriptions of the solar phenomenon, see the Baptist Philadelphia *Christian Index*, September 10, 1831, which published reports from Georgia, Richmond, and Washington, D.C., and also noted that "the same aspect of the sun was exhibited in this city [Philadelphia], New York, and other places north." Emma Mordecai to Ellen Mordecai, August 14, 1831, Mordecai Family Collection, Southern Historical Collection, University of North Carolina, Chapel Hill (henceforth SHC), emphasis

in original. No evidence suggests that anyone at the time of the revolt noticed that the eclipse was forty days after the Fourth of July.

41. Richmond *Constitutional Whig*, September 26, 1831, in Tragle, *Revolt*, 93.

42. Gray, *The Confessions of Nat Turner*, 11.

43. Ibid., 12; Jack's trial, SCCMB, in Tragle, *Revolt*, 228, 195–96, 197–98; Johnson, *The Nat Turner Story*, 85; Parramore, *Southampton County*, 79. For Jordan Barnes's holdings, see Southampton County Tax List, 1831, and Southampton County Census, 1830.

44. Jack's trial, SCCMB, in Tragle, *Revolt*, 196. Even if Jack did not seem to be an especially enthusiastic supporter of the revolt, his freedom to be in the neighborhood shows how the dual mastery of a hired slave created an opportunity for slaves to exploit, as Jonathan D. Martin has argued. On the other hand, there is no evidence that hired or self-hired slaves played a significant role in this revolt, something that distinguishes this revolt from Gabriel's and Vesey's conspiracies. See Jonathan D. Martin, *Divided Mastery: Slave Hiring in the American South* (Cambridge, MA: Harvard University Press, 2004), esp. 178.

45. Gray, *The Confessions of Nat Turner*, 12. On the relationship between Hark and Jack, see Jack's trial, in Tragle, *Revolt*, 196.

46. Gray, *The Confessions of Nat Turner*, 12.

47. *Norfolk and Portsmouth Herald*, November 4, 1831, in Tragle, *Revolt*, 134; Richmond *Constitutional Whig*, September 26, 1831, in Tragle, *Revolt*, 92; J[ohn] T. Brown to Henry Brown Jr., September 26, 1831, Brown-Coalter-Tucker Papers, Special Collections, Earl Gregg Swem Library, College of William and Mary; Solon Borland to Montford Stokes, August 31, 1831, Governor's Papers, NCDAH; *Richmond Enquirer*, September 27, 1831, in Tragle, *Revolt*, 100; Gray, *The Confessions of Nat Turner*, 12.

48. One white, Caswell Worrell, believed that he had heard a veiled allusion to the race war days before the revolt began, when Nelson, a slave under his supervision, warned him to "look out and take care of themselves—that something would happen before long." Looking back on it after the rebellion, Worrell thought that this was an allusion to the revolt, but this was only in hindsight. Like the rest of the white community, he was caught completely unaware when the revolt began. Since the number of people who knew about the plot seems to have been very small, evidenced by Turner's surprise at seeing more than four people at the dinner that launched the revolt, it is possible that Worrell was reading more into Nelson's frustrated threat than was really there. Nelson's trial, SCCMB, in Tragle, *Revolt*, 193.

49. Peter Charles Hoffer exaggerated when he wrote that some slave "always informed on" the larger slave conspiracy, but the danger Hoffer described was real. Although there were clearly examples where conspiracies were kept secret—most notably Gabriel's conspiracy, which was not betrayed until after it was supposed to have begun—expanding the scale of the conspiracy made it harder to keep secret. See Hoffer, *Cry Liberty: The Great Stono Slave Rebellion of 1739* (New York: Oxford

University Press, 2010), 72. For a great example of the difficulty in keeping a secret among sympathetic slaves, see Michael Wayne, *Death of an Overseer: Reopening a Murder Investigation from the Plantation South* (New York: Oxford University Press, 2001).

50. The biggest problem with keeping a slave revolt small is that it is presumed that the rebels will not be able to get a significant number of recruits. But it is not impossible that a slave revolt that begins with only a handful of conspirators could become large. The clearest example of this is the 1823 slave revolt in Demerara. Although the Demerara revolt failed, it was one that managed to get a large number of slaves to join even though "most slaves were ignorant of the plan until the day before the uprising." The governor's own estimate was that nine thousand slaves joined that rebellion. See Emilia Viotti da Costa, *Crowns of Glory, Tears of Blood: The Demerara Slave Rebellion of 1823* (New York: Oxford University Press, 1994), 202, 222.

51. For the statistics on Saint-Domingue's population, see Laurent Dubois, *Avengers of the New World: The Story of the Haitian Revolution* (Cambridge, MA: Belknap Press, 2004), 30. For the statistics on Southampton County, the Tidewater, and Virginia as a whole, see Alison Goodyear Freehling, *The Drift Toward Dissolution: The Virginia Slavery Debate of 1831–1832* (Baton Rouge: Louisiana State University Press, 1982), 265–69. I use the figures for slaves rather than slaves and free blacks because no one knew how free blacks in either place would respond to the call to join a war against slavery. Including the free blacks with the slaves would make the ratio of blacks to whites in Southampton and the Tidewater closer to three to two; for Virginia as a whole, whites outnumbered blacks roughly four to three. Throughout the United States, whites outnumbered blacks by more than five to one, while whites outnumbered slaves more than six to one.

52. Vincent Ogé revolted to try to get political rights for free people of color. He did not support a slave revolt. In fact, Laurent Dubois observes that he "assiduously avoided mobilizing slaves to join him." See Dubois, *Avengers of the New World*, 88. See also Jeremy D. Popkin, *You Are All Free: The Haitian Revolution and the Abolition of Slavery* (New York: Cambridge University Press, 2010).

53. To see the division in Southampton's white community, see Crofts, *Old Southampton*.

54. *Petersburg Intelligencer*, August 26, 1831, in Tragle, *Revolt*, 39; Richmond *Constitutional Whig*, August 29, September 3, and September 26, 1831, in Tragle, *Revolt*, 53, 70, and 95; Egerton, *He Shall Go Out Free*, 136. This tradition of seeing the killings as senseless is one that has endured. In a work on another slave rebellion, *Cry Liberty*, Peter Charles Hoffer described the Southampton Revolt as "Nat Turner's murder spree" (73 n. 13). One contemporary author, who had no access to the rebels, had a different view of the Great Dismal Swamp strategy. He opined that escaping to the Great Dismal Swamp was the rebels' goal only if they failed. See Samuel Warner, *Authentic and Impartial Narrative of the Tragical Scene,* in Tragle, *Revolt*, 297. For a discussion of the maroon community in the Dismal Swamp, see Daniel O. Sayers,

P. Brendan Burke, and Aaron M. Henry, "The Political Economy of Exile in the Great Dismal Swamp," *International Journal of Historical Archaeology* 11 (March 2007): 60–97, esp. 71–75.

55. Gray, *The Confessions of Nat Turner*, 12.

56. Jack's trial, SCCMB, in Tragle, *Revolt*, 196.

57. By linking violence to freedom, the rebels' thought prefigures the analysis of Frantz Fanon, who argues, "At the level of individuals, violence is a cleansing force. It frees the native from his inferiority complex and from his despair and inaction; it makes him fearless and restores his self-respect." See Frantz Fanon, *The Wretched of the Earth*, trans. Richard Philcox (New York: Grove Press, 2004), 51.

58. *Richmond Enquirer*, November 8, 1831, in Tragle, *Revolt*, 137. The idea that Turner hoped that the rebels would conquer Southampton County was expressed in a letter printed in the *Norfolk and Portsmouth Herald*, November 4, 1831, reprinted in both the *Richmond Enquirer*, November 8, 1831, and in Tragle, *Revolt*, 135. For the white response to the plan, see the aside—"what miserable ignorance!"—by the correspondent who described the plan to conquer Southampton County.

59. *Richmond Enquirer,* November 8, 1831, in Tragle, *Revolt*, 137; Gray, *The Confessions of Nat Turner*, 11. One should not interpret the fact that the rebels began without any weapons as a sign that the rebels were unaware of the importance that weapons would play in course of the revolt. As the revolt developed, Turner focused on getting to Jerusalem. He later described how "I had a great desire to get there to procure arms and ammunition." See Gray, *The Confessions of Nat Turner*, 16.

60. Richmond *Constitutional Whig*, September 26, 1831, in Tragle, *Revolt*, 92; Gray, *The Confessions of Nat Turner*, 5; *Richmond Enquirer*, November 8 and 15, 1831, in Tragle, *Revolt*, 138–39. The account that counted eight rebels also included Austin, who would join them after the feast but before the Travis house was attacked; the one that counted six did not. It is certainly possible that Turner had a slightly larger band than he was willing to admit to his white interrogators. Moreover, he himself acknowledged in one interview that it was possible that the others rebels may have told others, saying that "if they had communicated it to any others it was more than he knew." But the evidence—especially the evidence of the small number of people who join the conspirators at their feast and the difficulties that the rebels faced recruiting later—suggests that the scale of the plot was on the order of magnitude that Turner claimed. Transcribing the article from November 8, 1831, Tragle wrote "anything" as a single word, but I follow the original newspaper article.

61. Gray, *The Confessions of Nat Turner*, 12.

62. Ibid., 12.

63. Jack's trial, SCCMB, in Tragle, *Revolt*, 196. For a discussion of similar calculations made by reluctant rebels in Brazil, see João José Reis, *Slave Revolt in Brazil: The Muslim Uprising of 1835 in Bahia,* trans. Arthur Brakel (Baltimore: Johns Hopkins University Press, 1995), 66.

CHAPTER 2

1. Thomas R. Gray, *The Confessions of Nat Turner, the Leader of the Late Insurrection in Southampton, VA* (Baltimore, 1831), 12. Turner recalled that "we knew we were strong enough to murder the family," evidence that the rebels properly understood the challenge. As Turner described it, Hark actually went to the barred door and then was called back, which strongly suggests that the rebels really had not thought carefully about their initial attack in the months that they had discussed the rebellion.

2. Ibid.; *Richmond Enquirer*, November 8, 1831, in Tragle, *Revolt*, 137. It is possible that the rebels got seven guns, or the two versions conflated Hark and Nat. Both versions are based upon Turner's testimony.

3. Richmond *Constitutional Whig*, September 3, 1831, in Tragle, *Revolt*, 67, 70; Gray, *The Confessions of Nat Turner*, 12. Although it is unclear from the records which of the rebels he challenged to strike the first blow, since the boasts had been "often repeated," it probably was two of the original four conspirators. If Hark was as willing to start the rebellion as he appears, this means the most likely boasters were Nelson, Sam, and Henry. Tragle mistakenly transcribes "followers" as "followerers."

4. Richmond *Constitutional Whig*, September 26, 1831, in Tragle, *Revolt*, 95; Gray, *The Confessions of Nat Turner*, 12, 13.

5. *Richmond Enquirer*, November 8, 1831, in Tragle, *Revolt*, 137; Gray, *The Confessions of Nat Turner*, 12. Since William Styron placed so much psychological importance on Turner's single killing, many people have been interested in why Turner was unable to kill anyone other than Margaret "Peggy" Whitehead. There are several different possible explanations for Turner's inability to kill Travis; Turner himself later blamed the darkness. Other factors may have contributed to Turner's difficulty in killing Travis. The hatchet, which was significantly less dangerous than an axe, was not an ideal weapon for killing someone. Turner's own lack of strength may have also hindered his ability to kill his master and others. Finally, as Styron suggested, Turner might have had second thoughts that made him hesitate as he struck his master. Perhaps one of the reasons that he had challenged two others to strike the first blows that night was that he was queasy at the idea of killing someone. After all, a month earlier Turner had grown physically ill at the thought of beginning the revolt. Given Turner's willingness both to sneak into the house and to strike the first blow, I see a psychological explanation as both unnecessary and unlikely. See William Styron, *The Confessions of Nat Turner* (New York: Random House, 1967).

6. Southampton County Tax List, 1831; William Sidney Drewry, *The Southampton Insurrection* (1900; repr., Murfreesboro, NC: Johnson Publishing, 1968), 37; Gray, *The Confessions of Nat Turner*, 12; Richmond *Constitutional Whig*, September 26, 1831, in Tragle, *Revolt*, 95–96.

7. Gray, *The Confessions of Nat Turner*, 12; Richmond *Constitutional Whig*, September 26, 1831, in Tragle, *Revolt*, 96.

8. Gray, *The Confessions of Nat Turner*, 12. On the drinking, see Richmond *Constitutional Whig*, September 26, 1831, in Tragle, *Revolt*, 95. Turner was clearly aware of the preciousness of time, and he would later describe himself as "impatient" at the delays that kept the rebel army from moving quicker. See Gray, *The Confessions of Nat Turner*, 15.

9. Gray, *The Confessions of Nat Turner*, 11, 12.

10. This letter appeared in Boston's *Christian Register*, October 1, 1831, after being published in the *New York Courier*, and it was cited in Thomas C. Parramore, *Southampton County Virginia* (Charlottesville: University Press of Virginia, 1978), 245 n. 4; Drewry, *Southampton Slave Insurrection,* 37. More than sixty years ago, Peter Rodgers Brown proposed that the color red was chosen to evoke a sacrificial blood offering. In an article on the Stono revolt, Mark M. Smith discusses how the white color adopted by the South Carolina rebels may have had theological significance with roots in the Congolese Catholic tradition. Michael A. Gomez's work suggests a similar reading of the color choice: in Congolese symbolism, the color red was associated with both heroism and death. One should also consider the possibility that the red material from the gigs was simply the most readily available material. See Peter Rodgers Brown, "The Theology of Nat Turner as Reflected in the Insurrection," master's thesis, Oberlin Graduate School of Theology, 1949, 107; Mark M. Smith, "Remembering Mary, Shaping Revolt: Reconsidering the Stono Rebellion," *Journal of Southern History* 67 (2001): 529–30; and Michael A. Gomez, *Exchanging Our Country Marks: The Transformation of African Identities in the Colonial and Antebellum South* (Chapel Hill: University of North Carolina Press, 1998), 204–7.

11. For references to Nat Turner as "General Nat," see the testimony of Henry and free black woman Eliza Cratherton at Hardy's trial, SCCMB, in Tragle, *Revolt*, 202–3. For references to "Captain Nat," see *Richmond Enquirer*, August 30, 1831, in *The Confessions of Nat Turner and Related Documents*, ed. Kenneth S. Greenberg (Boston: Bedford/St. Martin's, 1996), 67, 68; Jarrell Judkins during Davy's trial, SCCMB, in Tragle, *Revolt*, 195; and Henry at Isham's trial, SCCMB, in Tragle, *Revolt*, 203–4. (Henry was the person who used "Captain" and "General" interchangeably.) Newspaper reports also often gave Nat Turner a military title. One newspaper reported that Turner had a new name, in addition to the title: "The leader of the band Nat. or Gen. Cargill as he styled himself, has not yet been taken." *Richmond Compiler*, September 3, 1831, in Tragle, *Revolt*, 61. This nom de guerre was also noted in a letter printed in Boston's *Christian Register*, October 1, 1831. Interestingly, I have not found evidence of contemporary Southampton blacks bestowing on Nat Turner any religious titles such as "Prophet," "Reverend," "Minister," or even "Brother" Nat. White correspondents to newspapers often followed the blacks and described Nat Turner as "General" or "Captain," although they also paid more attention to his religious background, as did Samuel Warner's *Authentic and Impartial Narrative of the Tragical Scene . . .* , in Tragle, *Revolt*, 283.

12. For references to General Nelson, see *Norfolk American Beacon*, August 29, 1831, in Tragle, *Revolt*, 50; Robert E. and Mary Lee to Mary Fitzhugh Custis, August 28, 1831, Lee Family Papers, Virginia Historical Society. Not surprisingly, Lee, who was far from the scene of the action, made several mistakes, among them conflating Nelson and Nat Turner and misidentifying Nelson's owner as Catherine Whitehead. For General Porter, see *Richmond Enquirer*, September 2, 1831. At Hark's trial, Levi Waller testified that he heard the insurgents call Hark "Captain Moore." See Hark's trial, SCCMB, in Tragle, *Revolt*, 192. Another early letter, from Southampton on Thursday, August 25, reported, "A negro, called captain Moore, and who it is added is a preacher, is the reputed leader." This correspondent mistakenly conflated Nat, the leader and preacher, and Hark, a leader called "Captain Moore," an easy mistake in the confusion immediately after the revolt. A postscript added two days later corrected the mistake, referring to "their leader Nat, a preacher and a prophet." See *Norfolk American Beacon*, August 29, 1831, in Tragle, *Revolt*, 52–53. On the paymaster and the pay scale, see *Norfolk American Beacon*, August 29, 1831, in Tragle, *Revolt*, 52; *Richmond Compiler*, September 3, 1831, in Tragle, *Revolt*, 62. For the traditional use of military titles by whites in Virginia, see Rhys Isaac, *The Transformation of Virginia, 1740–1790* (New York: Norton, 1988), 104–10.

13. Gray, *The Confessions of Nat Turner*, 13. Parramore makes a similar point about the symbolism of Turner's sword. See Thomas C. Parramore, "Covenant in Jerusalem," in *The Confessions of Nat Turner and Related Documents*, ed. Kenneth S. Greenberg (Boston: Bedford Books, 1996), 61. For a discussion of the association of swords and authority in Gabriel's conspiracy, see James Sidbury, *Plowshares into Swords: Race, Rebellion, and Identity in Gabriel's Virginia, 1730–1810* (New York: Cambridge University Press, 1997), 68–69.

14. Richmond *Constitutional Whig*, September 26, 1831, in Tragle, *Revolt*, 96; Nat Turner's trial, SCCMB, in Tragle, *Revolt*, 222. Turner himself was spotted on a horse belonging to "Dr. Musgrave," a nearby neighbor whose house was never attacked. Travis had five horses. Robert Musgrave had six slaves over the age of twelve and three horses; Southampton County Tax List, 1831. Robert Musgrave died at some point during 1831, leaving the farm to his son, George Musgrave. None of the Musgraves' slaves appear in any of the accounts of the revolt. For the location of Robert Musgrave's farm, see Fred Calvin, "Dr. Robert T. Musgrave's Home," Virginia Historical Inventory, Southampton County Homes, LV, http://image.lva.virginia.gov/VHI/html/26/0743.html.

15. Moses's trial, SCCMB, in Tragle, *Revolt*, 220; Richmond *Constitutional Whig*, September 3, 1831, in Tragle, *Revolt*, 67. While Moses was identified not by name but as "a negro boy," the information that he described to investigators must have come from someone who was with the rebels on Travis's farm.

16. Jack's trial, SCCMB, in Tragle, *Revolt*, 196.

17. Gray, *The Confessions of Nat Turner*, 12. For information of the phase of the moon, see U.S. Naval Observatory, "Sun or Moon Altitude / Azimuth Table for One Day,"

http://aa.usno.navy.mil/data/docs/AltAz.php. In the *Confessions*, Nat Turner did not explain why they selected Salathiel Francis as the second target. Historians have speculated that he decided not to go to Giles Reese's because Turner's wife and family may have lived there. On the other hand, Drewry's sources recalled that "on the gallows" Nat Turner explained to Giles Reese that the rebels had not gone to his house because "Marse Giles, you were too powerful a man to begin with, and besides we were afraid of your two fierce bulldogs." The part of this quote flattering Reese seems too self-serving to be given much credence, especially since it comes from such a questionable source, but the dogs would have been a factor that the rebels would have been smart to consider. If the dogs were especially vicious or loud—and the rebels would have known which neighbors had aggressive dogs—they could have provided Reese enough warning that the rebels would have lost a crucial tactical advantage, surprise. Of course, the rebels may have decided to go to Salathiel Francis's instead of Reese's for some other reason. On his wife living on Giles Reese's farm, see Samuel Warner, "Authentic and Impartial Narrative of the Tragical Scene," in Tragle, *Revolt*, 296.

18. Gray, *The Confessions of Nat Turner*, 12–13. Drewry records a remarkably different story about the death of Salathiel Francis. In his story, Red Nelson, "known to be loyal," escaped while Salathiel Francis called to him for a gun to defend himself. According to this story, Nelson was shot by the rebels as he tried to escape, but he survived. This story seems unlikely—in part because it has the rebels shooting for the first time at a fellow slave—but even more because it implies that the rebels broke their silence during the night. Turner himself recalled that even after the rebels left Salathiel Francis's, the rebels still were "maintaining the most perfect silence." See Drewry, *The Southampton Insurrection*, 38; Gray, *The Confessions of Nat Turner*, 13. For further discussions of the reliability of Nelson's account, see the discussion of the raid on the Francis farm later in this chapter.

19. *Richmond Enquirer*, November 8, 1831, in Tragle, *Revolt*, 138; Gray, *The Confessions of Nat Turner*, 13; Southampton County Tax List, 1831.

20. Southampton County Tax List, 1831, 1832; Southampton County Census, 1830; Alison Goodyear Freehling, *Drift Toward Dissolution: The Virginia Slavery Debate of 1831–1832* (Baton Rouge: Louisiana State University Press, 1982), 266. For Red Nelson's story, see Drewry, *The Southampton Insurrection*, 38, 46 n. 1. The year after the revolt, Emory Evans lived on Elizabeth Harris's farm, but the rebels did not attack her farm after they left Salathiel Francis's nearby home. Seventy years later, Bettie Powell Barnes, who was an eight-year-old in the house on the night of the revolt, told a story that suggested that the rebels had intentionally spared Harris and her family. According to Barnes's story, Joe, one of Harris's slaves, joined the rebels. Joe only joined the revolt on pain of death, yet even then he extracted one concession from the rebels: he would join them only if "they promised to spare his 'white people.'" The story is deeply problematic, in part because the story does not appear until so long after the revolt. It is also problematic because it fits too neatly

within a problematic paradigm, the myth of the loyal slave. Even Drewry, who recorded the story, had trouble believing it, suggesting that it sounded to him like the type of story that might be told "as a means from rescuing Joe from the gallows," although Joe was not tried. Finally, the tax records reveal that the slave population on Elizabeth Harris's plantation had not changed from 1831 to 1832. In both years, five adults and two teenage slaves lived on her farm. It seems most likely that this is an example of a case of a mythic account of a loyal, affectionate slave. For a sensitive recent exploration of a much more fully documented mythic case of slave loyalty to whites, see Mark Auslander, *The Accidental Slaveowner: Revisiting a Myth of Race and Finding an American Family* (Athens: University of Georgia Press, 2011). If Barnes's account were right, this would be an example of a case where the rebels deviated from their strategy of killing everyone, including women and children, in favor of recruiting a single individual, which would suggest that they were not exceptionally dogmatic as they executed their original strategy. See Drewry, *The Southampton Insurrection*, 38–39; Southampton County Tax List, 1831, 1832.

21. Jack's trial, SCCMB, in Tragle, *Revolt*, 196; Gray, *The Confessions of Nat Turner*, 13; Piety Reese, deceased, December 29, 1831, SCLP. After the revolt several Southampton slave owners petitioned the Virginia legislature to compensate them for slaves killed as the revolt was put down. (Virginia law required reimbursement for owners whose slaves were transported or executed by the state.) In one of these petitions, another person named Piety Reese or someone writing on behalf of the late Piety Reese sought compensation for "a negro boy of hers nearly grown" who joined the revolt and died without trial. Since none of her slaves were tried and this was the only claim on her behalf, it seems likely that this unnamed man was the only slave who joined the revolt for any length of time. The possibility that Piety Reese actually survived the revolt and wrote this petition herself seems incredibly remote, in part because of the *Confessions*, in part because she is included on every list of people who were killed during the revolt.

22. Jack's trial, SCCMB, in Tragle, *Revolt*, 197, 228; Southampton County Tax List, 1831. Joseph William Reese apparently went by "William," so he was identified as "William" by Thomas R. Gray in the *Confessions,* in newspaper articles that listed the whites who died, and in court records. Only months later did the courts note that Jack's owner's full name was "Joseph William." Because Piety Reese cannot be traced on the 1830 census, there is no way to know how many of her slaves were men and how many were women.

23. Drewry suggested that the insurgents left Reese's house and headed "three miles south of the Reese farm." According to this story, after marching three miles, the slaves arrived at Wiley Francis's home at least a half hour before the sun rose. Nevertheless, the entire household was up. The women had escaped into the woods, but a manly Wiley Francis challenged the insurgents, "Here I am, boys; I will not go from my home to be killed!" At the same time, loyal slaves "declared that they would die for the whites." According to Drewry's account, after coming this far, the

insurgents fled, retracing their path "several miles" to the north, wasting an hour of darkness marching for no good reason at all. Lavania Francis, who told this story, might not have invented it out of whole cloth, but almost certainly Wiley Francis and his slaves did not encounter Nat Turner and the main rebel forces at this early stage of the revolt. See Drewry, *The Southampton Insurrection*, 40.

24. F. Roy Johnson, *The Nat Turner Story* (Murfreesboro, NC: Johnson Publishing, 1970), 96; Parramore, *Southampton County*, 83. Parramore argues that Elizabeth Turner's Sam also joined. According to an allegation, two slaves gave Sam aid on August 30, 1831, in exchange for "a gold watch and a 'large sum of money,' which he had 'received by robbery during the insurrection.'" In my mind, however, this allegation does not outweigh the evidence that no other slaves of Elizabeth Turner were involved. If one of Elizabeth Turner's slaves had survived the revolt and been accused of taking money during the events of that day, he would have been tried. On the other hand, if he had been involved and died, Turner's executor could have easily added him to the petition that he submitted to the legislature for compensation. See Parramore, *Southampton County*, 245 n. 11; Elizabeth Turner, deceased, December 29, 1831, SCLP. While Turner did not speak about his reasons for attacking the house, it seems that this was a meaningful target. Once the rebels left, they changed their direction. Until the attack on the Turner house, the rebels traveled southwest, away from Jerusalem; after the attack, the rebels reversed course, heading northeast toward Jerusalem.

25. Gray, *The Confessions of Nat Turner*, 13. Not all of the rebels had their own horses; the dozen rebels had only nine horses after they left for Catherine Whitehead's. It is unclear if this decision to remain afoot was a result of a lack of access to horses or if it was a preference of some of the rebels.

26. Ibid.

27. Ibid. The task of securing the house would have been impossible in any circumstance, but Fred Calvin's description of the home, which had eleven windows, suggested that the home would have been particularly vulnerable. See Fred Calvin, "Elizabeth Turner Home," Virginia Historical Inventory. Southampton County Homes, http://image.lva.virginia.gov/VHI/html/26/0851.html.

28. Gray, *The Confessions of Nat Turner*, 13.

29. Bettie Powell Barnes's problematic stories of Elizabeth Harris's slave Joe implied that one of the newest recruits used this opportunity to acquire some goods. After the revolt, Barnes said that Joe was identified wearing the clothes of Hartwell Peebles. See Drewry, *Southampton Insurrection*, 39.

30. Davy's trial, 185; Elizabeth Turner, decedent, December 29, 1831, Legislative Petitions. It is possible that there was another slave Sam, who was enlisted at Elizabeth Turner's. In one trial, there is reference to "Sam the property of Elizabeth Turner," who was "one of the party of slaves who were then + there engaged in open insurrection and treason." But no Sam belonging to Elizabeth Turner was ever tried. Since only Jordan was mentioned in the petition for compensation from the executors

of Elizabeth Turner's estate, it seems likely that the Sam referred to did not actually belong to Elizabeth Turner. See Information Against Jack and Shadrach, October 17, 1831, Box 95, SCCCJ, LV.

31. Gray, *The Confessions of Nat Turner*, 13; Davy's trial, SCCMB, in Tragle, *Revolt*, 185. According to the 1830 census, Henry Bryant was between twenty and thirty years old, and his wife was still a teenager. Her mother was in her forties. When the 1830 census was taken, the Bryants had not had children, suggesting that their first child was an infant during the revolt. Southampton County Census, 1830, 257. For the identification of Sally Bryant, see Parramore, *Southampton County*, 83.

32. Joe's trial, SCCMB, in Tragle, *Revolt*, 207; F. M. Capehart to Benajah Nicholls, August 23–26, 1831, Benajah Nicholls Papers, NCDAH; Gray, *The Confessions of Nat Turner*, 13. The names of Catherine Whitehead's daughters—Margaret (also apparently known as Peggy), Minerva, Marion, Morning [?], Ann, and Harriet— were mentioned in a January 6, 1844, diary entry by Hugh Blair Grigsby. See Diary, November 13, 1843–April 17, 1847, Hugh Blair Grigsby Papers, Virginia Historical Society. See Nat Turner's trial, SCCMB, in Tragle, *Revolt*, 222. On Richard's decapitation, see *Norfolk and Portsmouth Herald*, August 26, 1831. In 1830, Catherine Whitehead's daughters ranged in age from a teenager over fifteen to a woman in her thirties. See Southampton County Census, 1830.

33. Gray, *The Confessions of Nat Turner*, 13; L. Minor Blackford, *Mine Eyes Have Seen the Glory: The Story of a Virginia Lady, Mary Berkeley Minor Blackford, 1802–1896, Who Taught Her Sons to Hate Slavery and to Love the Union* (Cambridge, MA: Harvard University Press, 1954), 26.

34. Gray, *The Confessions of Nat Turner*, 13–14. For the description of Margaret as the oldest daughter of Catherine Whitehead, see *Richmond Enquirer*, November 15, 1831. Not surprisingly, Grigsby listed Margaret "Peggy" Whitehead first when he wrote the names of the sisters. As the oldest daughter, Margaret was already in her thirties in 1830. See Hugh Blair Grigsby, Diary; Southampton County Census, 1830, 260. Since the publication of William Styron's *The Confessions of Nat Turner*, the murder of Margaret Whitehead has been the subject of much speculation. In the novel, Styron imagines that Whitehead was a love interest of Turner's. Historians have recoiled at such a provocative idea but struggled to explain why this was the one person Turner killed. For example, Thomas C. Parramore suggests that Turner "may have been forced to kill Margaret Whitehead because he had black witnesses." This explanation seems unlikely to me. Black witnesses did not make him kill anyone at the Travises' or at Elizabeth Turner's, two times earlier in the revolt when he struggled to kill someone. In fact, the presence of other rebels explains why Turner did not have to deliver the death blow in these other cases. I believe that Turner's unique perspective apart from the main group of rebels is sufficient to explain both his killing of Margaret Whitehead and his lack of involvement in any other murders. Because Turner was so often apart from the main rebel force over the course of the revolt, he did not witness the majority of the killings, but this

distance allowed him to spot Margaret Whitehead when she had eluded the others. It is notable how often Turner is apart from the main rebel force over the course of the revolt. See Styron, *The Confessions of Nat Turner*, 336–40, 413–15; Parramore, "Covenant in Jerusalem," 61. For a description of the criticism of Styron, see John Henrik Clarke, ed., *William Stryon's Nat Turner: Ten Black Writers Respond* (Boston: Beacon Press, 1968); Albert E. Stone, *The Return of Nat Turner: History Literature, and Cultural Politics in Sixties America* (Athens: University of Georgia Press, 1992); and Scot French, *The Rebellious Slave: Nat Turner in American Memory* (Boston: Houghton Mifflin, 2004).

35. Blackford, *Mine Eyes Have Seen the Glory*, 26.

36. Ibid., 27; *Norfolk and Portsmouth Herald*, August 26, 1831.

37. Gray, *The Confessions of Nat Turner*, 14; Joe's trial, SCCMB, in Tragle, *Revolt*, 207.

38. Davy's trial, SCCMB, in Tragle, *Revolt*, 185–86; Nat's trial, SCCMB, in Tragle, *Revolt*, 196–97; and Joe's trial, SCCMB, in Tragle, *Revolt*, 207. For the identification of Nat's owners, see Parramore, *Southampton County*, 84, 246 n. 13.

39. Southampton County Census, 1830, 260. On women's role in the revolt, see Mary Kemp Davis, "'What Happened in This Place?': In Search of the Female Slave in the Nat Turner Slave Insurrection," in *Nat Turner: A Slave Rebellion in History and Memory*, ed. Kenneth S. Greenberg (New York: Oxford University Press, 2003), 162–76. For a recent article that describes a more active role that women could play in insurgencies, see Thavolia Glymph, "Rose's War and the Gendered Politics of a Slave Insurgency in the Civil War," *Journal of the Civil War Era* 3 (December 2013): 501–32; Natasha Lightfoot, "'Their Coats Were Tied Up Like Men': Women Rebels in Antigua's 1858 Uprising," *Slavery and Abolition* 31, no. 4 (December 2010): 527–45.

40. *Norfolk and Portsmouth Herald*, August 29, 1831.

41. Jack and Andrew's trial, SCCMB, in Tragle, *Revolt*, 180–82; Jack and Andrew's trial, 1831, Box 95, SCCCJ, LV; Southampton County Tax List, 1831. The testimony of Powell and Wallace, one of the slaves who remained on Catherine Whitehead's plantation who also testified in Jack's trial, disagree about one point. Wallace claimed that the defendants returned to the plantation after visiting Booth and Powell. Powell testified that when Jack and Andrew came to his house he detained them. Later he turned them over to the custody of the forces assembled at Cross Keys. Given the other testimony, I suspect that Jack and Andrew probably returned to the Whitehead plantation after the rebels left and then set out to Thomas Haithcock's, eventually ending at Powell's.

42. Jack and Andrew's trial, SCCMB, in Tragle, *Revolt*, 180–82.

43. Tom's trial, SCCMB, in Tragle, *Revolt*, 179; Blackford, *Mine Eyes Have Seen the Glory*, 26–27; Jack and Andrew's trial, 1831, Box 95, SCCCJ, LV. The ages of the six are not given in the records. If one of the six slaves mentioned, perhaps young Tom or Nathan, was ten years old or younger, then there might have been one unnamed slave who joined the rebels. If so, he did not live long enough to be tried. This

would be consistent with the accounts that suggest that three slaves from the plantation—perhaps Andrew, Jack, and the unnamed man—joined the rebels.

44. Blackford, *Mine Eyes Have Seen the Glory*, 26. For Catherine Whitehead's Nathan as a witness, see Davy's trial, 186. One rebel named Nathan was tried, but he belonged to Benjamin Blunt's estate. If Catherine Whitehead rented Nathan from Blunt's estate, then Nathan did join the revolt, albeit unwillingly. But this seems especially unlikely given that no evidence of his actions on the Whitehead plantation was used against Nathan at his trial despite the number of witnesses available. See Nathan's trial, SCCMB, in Tragle, *Revolt*, 200. Although, in the case of Drewry's account of Joe who belonged to Elizabeth Harris, I ultimately ended up discounting the story of a loyal slave as mythic creation, in this case, there is enough corroborating evidence to suggest that the main points of Mary Blackford's account is reliable. Mary Blackford had an active involvement in the political questions around slavery and colonization and even penned a colonization petition. For more on Mary Blackford, see Patrick H. Breen, ed., "The Female Antislavery Petition Campaign of 1831–32," *Virginia Magazine of History and Biography* 110 (2002): 377–98, and Elizabeth R. Varon, *Disunion! The Coming of the American Civil War, 1789–1859* (Chapel Hill: University of North Carolina Press, 2008), 81.

45. Blackford, *Mine Eyes Have Seen the Glory*, 27.

46. Ibid.

47. According to Laurent Dubois in *Avengers of the New World: The Story of the Haitian Revolution* (Cambridge, MA: Belknap Press, 2004), esp. 265–79, Louverture's acceptance of French authority was triggered by the defection of several of his close associates, including Henri Christophe. For a study of slaves who refused to join a larger slave rebellion, see Emilia Viotti da Costa, *Crowns of Glory, Tears of Blood: The Demerara Slave Rebellion of 1823* (New York: Oxford University Press, 1994), 202, who estimates that about 10 percent of the slaves in Demerara refused to follow the slave rebels. In the United States, there were fewer and smaller revolts than elsewhere in the Americas, but the pattern of some slaves deciding to actively assist their masters was something that happened even in what may have been the largest slave revolt to happen in the United States when the slaveholders were not at war. See Daniel Rasmussen, *American Uprising: The Untold Story of America's Largest Slave Revolt* (New York: Harper, 2011), 104, 107–108.

48. Gray, *The Confessions of Nat Turner*, 14; Jack and Andrew's trial, SCCMB, in Tragle, *Revolt*, 180–81; Blackford, *Mine Eyes Have Seen the Glory*, 27–28. The two white families on the Porter plantation consisted of two adult couples and eight children. See Southampton County Census, 1830, 256. By the time that Drewry wrote his history of the revolt, he identified the person who warned the Porters as "Mary, a mulatto girl." See Drewry, *The Southampton Slave Insurrection,* 45.

49. Southampton County Tax List, 1831; Richard Porter petition, December 12, 1831, SCLP. For Daniel and Aaron's involvement, see Levi Waller's testimony in Daniel's trial, SCCMB, in Tragle, *Revolt*, 178. It is unlikely that Waller saw a different slave

Aaron. No other Aaron was tried. Furthermore, at the time that Waller saw Aaron, he was with Daniel, another slave from the Porter plantation. Aaron actually belonged to Richard Porter's ward, Jesse J. Porter. On the ages of the recruits, Jacob was twenty-two; Moses was nineteen. If this was a plantation where the rebels found significant support, how can one explain the fact that the Porters survived? There are three explanations that seem most likely. First, some of Richard Porter's slaves may have saved the family even as other slaves joined the rebellion. This story of a diversity of responses to the news of the revolt then could have simply been silenced as the story was retold. In this case, the story that Mary Blackford recounts describing a plantation where all the slaves were loyal is wrong, an example of the kind of silencing that one sees as history is made. Second, like Davy, who joined at Elizabeth Turner's but was not at first enthusiastic about the rebellion, the several slaves who joined at Porter's farm may not have been enthusiastic about the revolt until later. Finally, it is possible, as Eugene D. Genovese suggests, that there might have been a personal connection between the slaves and their masters that could make a slave who was willing to fight for his freedom less enthusiastic about killing the person who owned him. For silencing, see Michel-Rolph Trouillot, *Silencing the Past: Power and the Production of History* (Boston: Beacon Press, 1995), 31–69; for Genovese's discussion of personal loyalty, see Genovese, *Roll, Jordan, Roll: The World the Slaves Made* (New York: Vintage, 1976), 133–49, and especially the Rhodesian anecdote on 137.

50. Jack's trial, SCCMB, in Tragle, *Revolt*, 197.

51. Gray, *The Confessions of Nat Turner*, 14. Although a prophetic figure, he seemed to have a clear perception of what was happening during the revolt and was able to focus on the most important developments. In this case, he was able to respond to the more important development—that the news was out—without being distracted by the more obvious but less important news that the rebels recruited well on Porter's plantation.

52. F. M. Capehart to Benajah Nicholls, August 23, 24, 25, and 26, 1831, Benajah Nicholls Papers; Parramore, *Southampton County,* 85. Parramore implicitly, and I believe correctly, identifies Williams as the source of Capehart's account. See also *Norfolk and Portsmouth Herald*, August 26, 1831. For Louisa's name, see Parramore, *Southampton County,* 246 n. 14. I assume that the contingent that left the Whitehead's without Nat Turner was responsible for these deaths, since he included no record of it in the *Confessions*. Drewry reports a different detail about Louisa Williams's death. According to Drewry, who had Lavania Francis as a source, Williams was killed on her way to the Francis plantation, where she "had decided to spend the day." If this is true, it seems clear that Louisa Williams had not yet gotten to the Francis farm, since she was not killed by the contingent of rebels who first went to the Francis house. Moreover, when the accounts of those who died in the rebellion were produced, she was listed on her own line, not with the Francises. (George Vaughn is an example of someone who was killed visiting a household, and he was

included on the same line with the others who died in this household.) For an example of how deaths were listed, see Richmond *Constitutional Whig*, August 29, 1831, in Tragle, *Revolt*, 53. For Drewry's account, see Drewry, *The Southampton Slave Insurrection*, 47.

53. Hark's trial, SCCMB, in Tragle, *Revolt*, 192; Gray, *The Confessions of Nat Turner*, 14.

54. Drewry, *The Southampton Slave Insurrection*, 45, 47; Southampton County Tax List, 1831. For the identification of the Brown boys, see Parramore, *Southampton County*, 87.

55. Fred Calvin, "Lavania Francis Home," Virginia Historical Inventory, Southampton County Homes, http://image.lva.virginia.gov/VHI/html/26/0623; Gray, *The Confessions of Nat Turner*, 19; Drewry, *The Southampton Slave Insurrection*, 47. Drewry's account of the details of the events at the Francis Home also agrees with the stories that were told in the black community. Allen Crawford, who was born on Peter Edwards's plantation a few years after the revolt, later recounted how "Miss Venie Francis...hid herself in a closet between the lathes and plastering." See Allen Crawford, interviewed by Susie R. C. Byrd, in *Weevils in the Wheat: Interviews with Ex-Virginia Slaves*, ed. Charles L. Perdue Jr., Thomas E. Barden, and Robert K. Phillips (Charlottesville: University Press of Virginia, 1992), 76. The fact that whites could be surprised by a rebellion even after hearing that a neighboring family had been killed suggests that some slaveholders at least were fairly complacent about the possibility of a slave revolt.

56. Drewry, *The Southampton Slave Insurrection*, 47. Since Lavania Francis was Drewry's source for the story, the part of the story where Nelson saved Francis seems reliable, but much of the rest of Nelson's story seems highly embellished and generally unreliable. As mentioned above, Nelson's story that he was also shot when Salathiel Francis died contradicts Turner's own account that the rebels maintained silence during the night. Moreover, the story that Nelson was the first person shot in the revolt leads to another problem for this story: Nelson claimed to go to the house of Nathaniel Francis after he fled Salathiel Francis's home. If his story is true, how is it possible that a wounded slave could show up at Nathaniel Francis's plantation without the whites figuring out that there was a slave rebellion going on? Even after the Francises heard reports of the murders at the Travis farm, they still were caught unaware when the rebels showed up. There is one more serious problem with Nelson's account. If the rebels shot Nelson, would not the rebels—who were his close neighbors, two of whom even belonged to his owner's brother—know it? If they shot Nelson as he fled, why would they trust him enough a few hours later to lead their search for Lavania Francis? Ultimately, the story of the loyal slave that Nelson developed seems to be a fanciful tale built upon a momentary decision to save a white woman. Drewry himself provides the evidence that Nelson may have had reason to spin such a dramatic tale. According to Drewry, Nelson used this story to ease the weight of his bondage: "He was the real master of the plantation, receiving and entertaining gentlemen who visited his master. A gentleman who

knew him well relates that he has seen him drink with whites, and that he went wherever he pleased, from one section of the county to another, hospitality received at every home, where his deeds were fully esteemed and commended" (Drewry, *The Southampton Insurrection*, 46 n. 1). In part because this was a story of a loyal slave, whites apparently did not worry about the problems with Nelson's story. Given the problems with this story, I see no more reason to think that Nelson was inexorably opposed to the rebels than that he joined the rebels at Salathiel Francis's farm and got cold feet by the time he got to Nathaniel Francis's farm and decided to switch his allegiance from the rebels to their owners.

57. Allen Crawford interview, 76. See also Drewry, *The Southampton Insurrection*, 47. Resistance and accommodation historians have disagreed on the meaning of slave women's interest in clothing. Stephanie Camp tries to dissolve the distinction between "day-to-day resistance and mass action," focusing in part on the example of slave women and clothing. On the other hand, Elizabeth Fox-Genovese argues that the appropriation of white clothing by slave women could be seen "as a source of stability rather than a threat to the social order." The record of Lucy and Charlotte's action during Turner's revolt is ambiguous, and it is not possible to eliminate what Stephanie Camp calls the "trivial" interpretation of their actions. If Lucy and Charlotte really wanted their mistress' dresses more than they wanted to support the revolt, it does not help us understand them or the challenges of resisting slavery to insist that their primary goal was to support Turner's revolt. See Stephanie M. H. Camp, *Closer to Freedom, Enslaved Women and Everyday Resistance in the Plantation South* (Chapel Hill: University of North Carolina Press, 2004), "day-to-day," 9, "trivial," 86, and discussion of clothing, 78–87; Elizabeth Fox-Genovese, *Within the Plantation Household: Black and White Women of the Old South* (Chapel Hill: University of North Carolina Press, 1988), esp. 216–23; "stability" on 222.

58. Drewry, *The Southampton Insurrection*, 48; Gray, *The Confessions of Nat Turner,* 20; Nathan, Tom, and Davy's trial, SCCMB, in Tragle, *Revolt*, 200–201; Southampton County Census, 1830, 259; Dred's trial, SCCMB, in Tragle, *Revolt*, 198; Southampton County Tax List, 1831. The success of the rebels at the Francis plantation may indicate that Sam was an especially effective recruiter for the rebels. Sam is the most likely candidate to have been the person who brought Will into the revolt, and it is likely that the two of them convinced the others on the Francis plantation to enlist. The success of the rebels at the nearby Porter plantation may also be associated with Sam as two of the four recruits from the Porter plantation were later seen with Sam. See Daniel's trial, SCCMB, in Tragle, *Revolt*, 177–78.

59. Southampton County Tax List, 1831; Southampton County Census, 1830, 259. According to the 1830 census, five of the nine adult slaves were men, as were eight of the thirteen slaves between the ages of ten and twenty-four.

60. Sam's trial, SCCMB, in Tragle, *Revolt*, 218; Joseph Joines's affidavit, SCLP. The rebels themselves seem to have recognized Sam's doubts. They placed him "rather in the rear" of their group, significant since Nat Turner remembered positioning

his best troops in the front. See Gray, *The Confessions of Nat Turner*, 14. Berry Newsom, a free black, was also indentured to Peter Edwards, but Newsom does not appear to have joined the rebels at this point. (He was indicted and later tried and convicted for his involvement in the revolt, but no witness testified that Newsom actually joined the rebel army.) This may be because when the rebels arrived at Peter Edwards's, Newsom was at Benjamin Edwards's farm. See my discussion of Berry Newsom's case in Chapter 6.

61. Richmond *Constitutional Whig*, September 26, 1831 in Tragle, *Revolt*, 96; Nat's trial, SCCMB, in Tragle, *Revolt*, 196. A letter written Wednesday, two days after the attack, reported that the Barrows had "received some notice in the course of the morning of the murderous deeds that were going on; but placed no confidence in the story"; *Richmond Enquirer*, August 30, 1831, in Tragle, *Revolt*, 44–45. The tradition, recorded by Drewry in 1900, supplied one reason that they may not have been able to escape. According to this account, Mary Barrow "did not wish to appear beyond her home in her daily costume, and was making her usual preparations." Drewry, *The Southampton Insurrection*, 50. Tom Barrow became a heroic figure in the aftermath of the revolt. In the neighborhood of the revolt, whites told themselves that the rebels supposedly assured themselves that "there were no more Tom Barrows to contend with." By the time the story of Barrow's manly defense reached Robert Parker in North Carolina, the story had grown more heroic. In a "desperate battle V. S. 5 he [Barrow] kill'd 3"; Robert S. Parker to Mrs. Rebecca Mannet, John Kimberly Papers, SHC. For the most remarkable example of the immediate glorification of Thomas Barrow's death, see the ode "To the Memory of Thomas Barrow," *Tarboro Free Press and Southerner*, November 15, 1831.

62. Gray, *The Confessions of Nat Turner*, 20; Lucy's trial, SCCMB, in Tragle, *Revolt*, 208; Drewry, *The Southampton Insurrection*, 51; Southampton County Census, 1830, 259. Drewry actually identified the slave woman who saved Mary Barrow as "Aunt Easter," but no female slave on the farm would have been old enough to have been called "Aunt." At the time, the oldest female slave on the farm was less than twenty-five years old. Drewry also mentions that George Vaughn was heading "to his sister's for a fox hunt." For evidence that Vaughn was killed at the Barrow farm, note how contemporary reports grouped him with Barrow on the following lists of whites killed: Gray, *The Confessions of Nat Turner*, 22; Richmond *Constitutional Whig*, August 29, 1831; *Norfolk American Beacon*, September 14, 1831; Richmond *Constitutional Whig*, September 26, 1831, all in Tragle, *Revolt*, 53, 78, 97.

63. Southampton County Tax List, 1831.

CHAPTER 3

1. Thomas R. Gray, *The Confessions of Nat Turner, the Leader of the Late Insurrection in Southampton, VA* (Baltimore, 1831), 14.

2. Ibid., 11, 14.

3. Richmond *Constitutional Whig*, 26 September 1831, in Tragle, *Revolt*, 95; L. Minor Blackford, *Mine Eyes Have Seen the Glory: The Story of a Virginia Lady, Mary Berkeley Minor Blackford, 1802–1896, Who Taught Her Sons to Hate Slavery and to Love the Union* (Cambridge, MA: Harvard University Press, 1954), 28.

4. Nathan, Tom, and Davy's trials, SCCMB, in Tragle, *Revolt*, 200–201 ("shoot them"), 195–98, 200; Jack, Nathan, and Sam's trials, SCCMB, in Tragle, *Revolt*, 217–19; Gray, *The Confessions of Nat Turner*, 14.

5. William Sidney Drewry, *The Southampton Insurrection* (1900; repr., Murfreesboro, NC: Johnson Publishing, 1968), 54; Richmond *Constitutional Whig*, September 26, 1831, in Tragle, *Revolt*, 95; Southampton County Tax Lists, 1831, 1832. The argument that few, if any, slaves joined at the Harris plantation is also supported by the idea that some people had joined the rebel force during the morning but were not noted in any historical record. By the time the rebels reached Harris's, thirty-one men can be identified as having joined the revolt. That leaves fewer than ten rebels who left Harris's unidentified. While Drewry might be right about the failure of the slaves to recruit at Harris's, his story exaggerated the loyalty of the Harris slaves in ways that were common among whites after the revolt: "Armed with pitch-forks and hoes, they prepared to defend their master in case an attempt was made to find him." Later in the revolt, the rebels later returned to the plantation. The rebels were smart enough to avoid recruiting at a plantation where they had already faced hostile slaves.

6. See Southampton County Census, 1830, 257; Hardy and Isham's trial, SCCMB, in Tragle, *Revolt*, 202–204 ("declined," 204; "punished," 202); "revered" from Berry Newsom's trial, 1831, Box 95, SCCCJ, LV. For my suggestion that at first some blacks had better information than the whites, compare Nancy Parson's testimony at Isaac's trial to Isaac's sense of the revolt. Also compare the information of Berry Newson, Hardy, and Isham to the rumors that Nancy repeated. See Isaac's trial, SCCMB, in Tragle, *Revolt*, 189–90.

7. Richmond *Constitutional Whig*, September 26, 1831, in Tragle, *Revolt*, 95. For my discussion of Thomas Haithcock, see Chapter 6.

8. Nat Turner's trial, SCCMB, in Tragle, *Revolt*, 221; Drewry, *The Southampton Insurrection*, 56. The schoolteacher owned no slaves. See Southampton County Tax Lists, 1831.

9. Nat Turner's trial, SCCMB, in Tragle, *Revolt*, 221; Drewry, *The Southampton Insurrection*, 56. According to the story that Crocker's daughter told Drewry, Crocker fled through a cornfield. In the field, he stopped, dropped his sword, and prepared to shoot the rebel who had chased him. At that moment, however, a girl ran across the lane and distracted Crocker's would-be assassin. Crocker then fled to a safer location, but not before he had picked up a gold watch that he had dropped, which he feared might provide the rebels a clue about the direction he went.

10. Nat Turner's trial, SCCMB, in Tragle, *Revolt*, 221; Daniel's trial, SCCMB, in Tragle, *Revolt*, 178; Levi Waller affidavit, November 21, 1831, which was included in

Peter Edwards's petition, December 12, 1831, SCLP; Richmond *Constitutional Whig*, August 29, 1831, in Tragle, *Revolt*, 51. For other accounts of the girl who survived, see *Richmond Enquirer*, August 30, 1831, in Tragle, *Revolt*, 44, and Gray, *The Confessions of Nat Turner*, 19. In his 1900 history of the revolt, Drewry described the story of how one white girl was killed as she was torn from a chimney, while another white girl was wounded by shotgun pellets as she tried to flee. Thomas Parramore implied that Drewry mixed up the story of the two sisters. See Drewry, *The Southampton Insurrection*, 58; Thomas C. Parramore, *Southampton County Virginia* (Charlottesville: University Press of Virginia, 1978), 90. Tax records suggests that two older sons of Waller's may have also survived, in addition to Crocker and Waller. See Southampton County Tax List, 1832. The numbers who died at Waller's place are somewhat unclear. Before the mortally wounded infant died, John Hampden Pleasants reported that there were ten children killed. If the total of ten children did not include the child who died on Wednesday, then eleven children would have died at the farm.

11. Nat Turner's trial, SCCMB, in Tragle, *Revolt*, 221; *New Hampshire Post*, September 14, 1831 ("two rods" and "distracted"); Davy's trial, SCCMB, in Tragle, *Revolt*, 194. See also John H[ill] Wheeler, *Historical Sketches of North Carolina from 1584 to 1851* (Philadelphia, 1851), 2:210. According to the letter in the *New Hampshire Post*, Waller seems to have suffered a mental breakdown: "[H]e goes about saying how [the]y killed them!! and then shakes his sides [&] laughs!!!!" Thomas Parramore identifies Waller as the person who had had the mental breakdown described in the *New Hampshire Post* letter. See Parramore, *Southampton County*, 90. Two rods is about thirty feet. In the court records, Waller testified that he "crept within about 60 yards of the house." See Dred's trial, SCCMB, in Tragle, *Revolt*, 198.

12. Sam's trial, SCCMB, in Tragle, *Revolt*, 218; Nat Turner's trial, SCCMB, in Tragle, *Revolt*, 222. The rebels seem to have accepted not only the authority of Nat Turner but the entire system of rank among the rebels. Even as Sam was accepting a direct order from Nat Turner, the other rebels had taken to addressing Turner's right-hand man as "Captain Moore," not Hark. See Hark's trial, SCCMB, in Tragle, *Revolt*, 192.

13. Davy's trial, SCCMB, in Tragle, *Revolt*, 195; Gray, *The Confession of Nat Turner*, 14; Nelson's trial, SCCMB, in Tragle, *Revolt*, 193–94; Drewry, *The Southampton Insurrection*, 61. Early reports describe three children dying on Williams's plantation, but that number was revised down. According to the 1830 census, Jacob Williams had four children, two boys and two girls, all under five years old. No record from the time explained how the two daughters who survived managed to do so. See Southampton County Census, 1830, 259. For an example of an early estimate, see Richmond *Constitutional Whig*, August 29, 1831, in Tragle, *Revolt*, 53. For the "corrected statement of the names and numbers of persons murdered," see *Norfolk American Beacon*, September 14, 1831, in Tragle, *Revolt*, 78–79, and Gray's list of those killed in *The Confessions of Nat Turner*, 22.

14. Gray, *The Confessions of Nat Turner*, 14–15; Richmond *Constitutional Whig*, August 29, 1831, in Tragle, *Revolt*, 51. The intentional collection of bodies was a change for the rebels. At the Travis home, the bodies were left where they were killed. The raid on William Williams's home preceded the raid on the homes of Jacob Williams and his overseer, Caswell Worrell.

15. Nelson's trial, SCCMB, in Tragle, *Revolt*, 194; Moses's trial, SCCMB, in Tragle, *Revolt*, 183.

16. Nelson's trial, SCCMB, in Tragle, *Revolt*, 193–94. Jacob Williams described his suspicion as weird because he had not yet heard about the slave revolt. After he heard about the revolt, Williams took the hostile vibes as a sign that Nelson was a willing rebel.

17. Ibid. The evidence that Nelson knew about the revolt in advance is ambiguous. Worrell heard what he believed in retrospect to be a vague allusion to the revolt, but he might have been reading more information into the enigmatic line than was really there. If Nelson spoke about the revolt to his overseer, he clearly was sharply different from the other conspirators, who were able to keep the revolt secret. Evidence suggesting that Nelson supported the revolt is also countered by evidence suggesting that he did not. Stephen, who was with Edward Drewry when he died, recalled that Nelson was told by the rebels "to go with them" and that he "seemed unwilling to go." According to Stephen, the rebels finally "forced" Nelson "to go with them." Even then, Nelson was not among those who carried out the assaults; he "lagged behind" with those rebels who were "guarded." While Worrell thought that Nelson was feigning sickness on the day of the revolt, Cynthia, a slave, observed that he really had appeared "very sick" when he came home on Monday morning. If something made Nelson seem reluctant, it apparently was not the fact that whites were being killed, and Cynthia also noticed that when he came into the kitchen to get some food, he "stepped over the dead bodies without any manifestation of grief."

18. Ibid. There is no indication in any other trial that any other rebel put on his best clothes. Because of the number of witnesses who described Nelson's actions on Williams's farm and the court's interest in specific details about Nelson, it seems likely that the reason no one mentioned Nelson recruiting was that he did not do it.

19. Emma Mordecai to Ellen Mordecai, undated, perhaps September 1, 1831, Mordecai Family Collection, SHC; Richmond *Constitutional Whig*, September 3, 1831, in Tragle, *Revolt*, 68; Moses's trial, SCCMB, in Tragle, *Revolt*, 183. Interestingly, John Hampden Pleasants described Marmaduke as someone "who might have been a hero, judging from the magnanimity with which he bears his suffering." See Richmond *Constitutional Whig*, August 29, 1831 in Tragle, *Revolt*, 52.

20. Gray, *The Confessions of Nat Turner*, 15–16. Parker owned thirteen working-age slaves; probably seven or eight were men, and of those, four were between sixteen and thirty-five years old. See Southampton County Tax List, 1831, and Southampton

County Census, 1830, 259. For the discussion of the rebel celebration at Vaughn's, see Richmond *Constitutional Whig*, September 3, 1831, in Tragle, *Revolt*, 68–69, and Nelson's trial, SCCMB, in Tragle, *Revolt*, 194.

21. The idea that Nat Turner was personally responsible for the involvement of other rebels was asserted in contemporary accounts. According to Gray's description of Turner's sentencing, Jeremiah Cobb described Nat Turner as the "author of their [the other rebels'] misfortune," who "forced them unprepared, from Time to Eternity." Gray, *The Confessions of Nat Turner*, 21. More recent historians have also emphasized Turner's sway in the black community, although no evidence for this can be seen in the recruiting patterns during the revolt. Eric Foner insists that "Turner had acquired an immense reputation and influence among the county's slaves.... [I]t is certain that Turner's position as a preacher made him a leader of the slave community." *Nat Turner: Great Lives Observed*, ed. Eric Foner (Englewood Cliffs, NJ: Prentice Hall, 1971), 2. Kenneth S. Greenberg agrees that Turner's talents and persona "marked him as a leader in the community." See Kenneth S. Greenberg, ed., *The Confessions of Nat Turner and Related Documents* (Boston: Bedford/ St. Martin's, 1996), 2. I first developed the argument that Nat Turner was not active in recruiting in my essay "A Prophet in His Own Land: Support for Nat Turner and His Rebellion Within Southampton's Black Community," in *The Confessions of Nat Turner*, ed. Greenberg, 103–18.

22. Interestingly, if Turner was as savvy as I and contemporary whites suggest, then his decision not to accompany the rebels when they were recruiting suggests that he may have understood that his presence would probably not sway many who were trying to decide if they should join the rebellion.

23. Gray, *The Confessions of Nat Turner*, 15. For evidence of the drinking at Parker's, see Drewry, *The Southampton Insurrection*, 63. Although I generally take William Sidney Drewry's reports of missteps by the rebels with a grain of salt, the contemporary evidence from newspaper reports and trials of regular drinking among the rebels makes this an occasion where Drewry's account is more believable. In addition to the enjoyment that the rebels may have gotten from drinking, it is also possible that drinking was used to facilitate recruiting and increase the willingness and enthusiasm of those who were reluctant.

24. Southampton County Tax List, 1831; Southampton County Census, 1830, 257. For the commission, see September 19, 1831, SCCMB.

25. For an explanation of "seeing the elephant," see James M. McPherson, *For Cause and Comrade: Why Men Fought in the Civil War* (New York: Oxford University Press, 1997), esp. 30–34. In the *Confessions*, Turner said that "I [k]new nothing of [what happened at the gate], not having been at that time rejoined by any of them" (15). Given that the whites had apparently not told Turner what had happened at Parker's place by the time he gave his confession, the reports that the blacks had been fired upon likely got to Turner when he found some of the rebels who had been among those at Parker's gate later in the revolt. For my discussion of the

distance between Gray and Turner's perspective in the battle at Parker's farm, see the Afterword.

26. Gray, *The Confessions of Nat Turner*, 15.

27. *Richmond Compiler*, September 3, 1831, in Tragle, *Revolt*, 60; Gray, *The Confessions of Nat Turner*, 15. William Sidney Drewry reported that Hartie Joyner fired the shot. See Drewry, *The Southampton Insurrection*, 65.

28. Gray, *The Confessions of Nat Turner*, 15; Daniel's trial, 1831, Box 95, SCCCJ, LV.

29. Gray, *The Confessions of Nat Turner*, 15. Turner was apparently mistaken about the white fatalities. None of the white casualties during the rebellion included anyone killed at Parker's farm.

30. Ibid., 16. See also Gray's parenthetical explanation of the arrival of the other troops. David F. Allmendinger Jr. argues that although Gray's *Confessions* is generally reliable, it is not trustworthy on the events at Parker's farm. There, he argues, Gray's perspective trumps Turner's. I disagree, for reasons I explain in my discussion of the *Confessions* in the Afterword. See Allmendinger, "The Construction of *The Confessions of Nat Turner*," in *Nat Turner: A Slave Rebellion in History and Memory*, ed. Kenneth S. Greenberg (New York: Oxford University Press, 2003), 32.

31. Gray, *The Confessions of Nat Turner*, 15–16. Turner was also wrong about the white casualties, something that Gray noted parenthetically.

32. J[ohn] T. Brown to Henry Brown Jr., September 26, 1831, Brown-Coalter-Tucker Papers, Special Collections, Earl Gregg Swem Library, College of William and Mary; Gray, *The Confessions of Nat Turner*, 15–16; Moses's trial, SCCMB, in Tragle, *Revolt*, 220; Sam's trial, SCCMB, in Tragle, *Revolt*, 218. In *The Southampton Insurrection*, 68, William Sidney Drewry also reports that another slave, who belonged to Mrs. Gideon Bell, who was completely invisible to the contemporary historical record, used the confusion surrounding the battle as a chance to escape the rebels, "leaving his pursuers far behind, he spread far and wide the intelligence of the movements of the blacks." It is unclear from Southampton County's 1831 list and the 1830 census who Mrs. Gideon Bell could have been.

33. Gray, *The Confessions of Nat Turner*, 16. Those who were injured cannot be identified. Stephen B. Oates guesses that Nathaniel Francis's Dred lost his arm during the battle. Oates bases his identification on Drewry, who notes that a slave who worked for Nathaniel Francis had returned to his home after the revolt, "one arm having been shot off." Unfortunately for Oates's interpretation, it seems unlikely that Dred had been shot. The report that described Dred's capture noted that he "surrendered himself to his master, in the apprehension, no doubt of starving in the swamps or being shot by the numerous parties of local militia." See Richmond *Constitutional Whig*, September 3, 1831, in Tragle, *Revolt*, 70; Stephen B. Oates, *The Fires of Jubilee: Nat Turner's Fierce Rebellion* (New York: Harper Perennial, 1990), 89; Drewry, *The Southampton Insurrection*, 67 n. 1.

34. *Richmond Compiler*, August 29, 1831, in F. Roy Johnson, *The Nat Turner Story* (Murfreesboro, NC: Johnson Publishing, 1970), 121; Gray, *The Confessions of Nat*

Turner, 16. Drewry also suggests that the rebels changed plans when they found that Cypress Bridge was guarded; Drewry, *The Southampton Insurrection*, 67.

35. Gray, *The Confessions of Nat Turner*, 16.

36. Ibid. For an account of the rebels travels after the battle at Parker's farm, including George Thomas's actions, see Drewry, *The Southampton Insurrection*, 67–69. At the end of the day, the rebels also nearly caught Jacob Williams, who had already escaped from them once, when they passed his farm a second time. See Nelson's trial, SCCMB, in Tragle, *Revolt*, 193. Fred Calvin is another individual who recounts the events at Henry Vaugh's plantation. See Fred Calvin, "Walnut Grove," Virginia Historical Inventory, Southampton County Homes, http://image.lva .virginia.gov/VHI/html/26/0870.html.

37. Gray, *The Confessions of Nat Turner*, 16; Southampton County Census, 1830, 243; Southampton County Tax List, 1831. Presumably, the "two or three" that Turner "overtook" as he was still thinking about attacking Jerusalem were among the former rebels who rejoined the rebel army when Turner found them.

38. Gray, *The Confessions of Nat Turner*, 16. According to the testimony of another slave, Stephen, one of the recruits who joined at Ridley's, was forced to go with the rebels: "He did not appear to go willingly." See Stephen's trial, SCCMB, in Tragle, *Revolt*, 188.

39. Gray, *The Confessions of Nat Turner*, 16; *Richmond Compiler*, 3 September 1831, in Tragle, *Revolt*, 61.

40. Gray, *The Confessions of Nat Turner*, 16.

41. Southampton County Census, 1830, 243; Southampton County Tax List, 1831, 264; Gray, *The Confessions of Nat Turner*, 16. William Drewry says Blunt's given name was "Simon," but there was no Simon Blunt on the tax list or the census; Drewry, *The Southampton Insurrection*, 70. Drewry's identification is accepted by Parramore, *Southampton County*, 94; Oates, *The Fires of Jubilee*, 94; Johnson, *The Nat Turner Story*, 124; and Henry Irving Tragle, "Styron and His Sources," *Massachusetts Review* 11 (1970): 135–53, reprinted in Tragle, *Revolt*, 413. Contemporary reports, on the other hand, agreed with the government records. According to one newspaper report, the final battle was at "Dr. Saml. Blunt's house." See Richmond *Constitutional Whig*, September 26, 1831, in Tragle, *Revolt*, 96. According to Drewry, Blunt's son was named Simon, so he may have mistakenly thought that they shared the same given name.

42. Moses's trial, SCCMB, in Tragle, *Revolt*, 182–84; Gray, *The Confessions of Nat Turner*, 16; Richmond *Constitutional Whig*, September 3, 1831, in Tragle, *Revolt*, 68. The whites with Samuel Blunt included the two white men who lived on the farm, his son Simon Blunt and his overseer Shadrack Futrell, who testified against Moses at Moses's trial. One of the neighbors, D. W. Fitzhugh, can also be identified. See Richmond *Constitutional Whig*, September 26, 1831, in Tragle, *Revolt*, 96. Drew Fitzhugh was the only Fitzhugh in Southampton in 1830, and he lived near Blunt. See Southampton County Census, 1830, 243. See also A. P. Peete's petition, December 20, 1831, and January 18, 1832, SCLP.

43. *Richmond Enquirer*, August 30, 1831, in Tragle, *Revolt*, 45; *Norfolk and Portsmouth Herald*, August 26, 1831; Richmond *Constitutional Whig*, September 3, 1831, in Tragle, *Revolt*, 68. I believe that the story of Blunt's arming his slaves conflates a later episode at the Blunts', when he would arm slaves with guns, with the events on the morning of August 23, 1831. While it is not unreasonable to think that Blunt had armed his slaves with guns before the rebels attacked, the reports contradict Blunt's story as told to John Hampden Pleasants.

44. Gray, *The Confessions of Nat Turner*, 16–17; *Norfolk and Portsmouth Herald*, August 26, 1831; and Richmond *Constitutional Whig*, September 3, 1831, in Tragle, *Revolt*, 68. See also A. P. Peete's petition, December 20, 1831, and January 18, 1832.

45. A. P. Peete's petition, January 18, 1832. Drewry, on the other hand, reported that Turner "was very much discouraged"; *The Southampton Insurrection*, 73.

46. Gray, *The Confessions of Nat Turner*, 17; Drewry, *The Southampton Insurrection*, 73.

47. Curtis's trial, SCCMB, in Tragle, *Revolt*, 187; Southampton County Tax List, 1831.

48. Curtis's trial, SCCMB, in Tragle, *Revolt*, 187.

49. Gray, *The Confessions of Nat Turner*, 17.

CHAPTER 4

1. A. P. Peete affidavit, January 18, 1832, in petition of the executor widow and legatees of Thos. Fitzhugh, dec[ease]d, December 1831, SCLP; Curtis's and Stephen's trials, SCCMB, in Henry Irving Tragle, *Revolt*, 186–88 ("leader of insurgents" on both 187 and 188).

2. A. P. Peete affidavit, January 18, 1832. History contains many examples of masters arming slaves. The best single survey of slaves fighting for their owners is Christopher Leslie Brown and Philip D. Morgan, ed., *Arming Slaves: From Classical Times to the Modern Age* (New Haven: Yale University Press, 2006). Similar alliances can be seen even on the plantation level in Jamaica during Tacky's 1760 revolt. According to Trevor Bernard's study of Thomas Thistlewood, "Even though he suspected his slaves of complicity in the rebellion, Thistlewood was forced to rely on their assistance.... [W]hen things were most desperate; Thistlewood armed most of his slaves." In the same revolt, the maroon community played a key role in the suppression of the revolt. In fact, the maroons were the ones who killed Tacky. See Trevor Burnard, *Mastery, Tyranny, and Desire: Thomas Thistlewood and His Slaves in the Anglo-Jamaican World* (Chapel Hill: University of North Carolina Press, 2004), 172–73; Bryan Edwards, *The History ... of the West Indies* (1807) in *Maroon Societies: Rebel Slave Communities in the Americas*, ed. Richard Price (Baltimore: Johns Hopkins University Press, 1996), 242–45. Likewise, after the 1812 Aponte revolt in Cuba, the authorities looked to reward those slaves who supported the colony during that period of slave uprisings. See Matt D. Childs, *The 1812 Aponte Rebellion in Cuba and the Struggle Against Atlantic Slavery* (Chapel Hill: University of North Carolina Press, 2006), 173–79.

3. A. P. Peete affidavit, January 18, 1832. I describe this killing as different from a similar killing described by Drewry or Robert E. Lee, because (1) it happened on a different day, (2) the slaves were doing different things, and (3) different owners of the dead slaves were identified. It is possible that these three all refer to the same killing, in which case I believe that Peete's petition, written by someone who was at Blunt's plantation, is the best source. Compare to William Sidney Drewry, *The Southampton Insurrection* (1900; repr., Murfreesboro, NC: Johnson Publishing, 1968), 85 n. 1; Robert E. Lee to Mary Fitzhugh Custis, [September 1831], Lee Family Papers, Virginia Historical Society.

4. *Richmond Enquirer*, August 30, 1831; *Richmond Compiler*, Saturday, [August 27, 1831], in *Richmond Enquirer*, August 30, 1831. Portions of the *Enquirer* article are quoted in Tragle, *Revolt*, 43–46, but the excerpts from the *Compiler*, including the quote, are omitted.

5. Drewry, *The Southampton Insurrection*, 78, 48–49. No less than the whites, the rebels operated in Clausewitz's fog, especially after the defeat at Parker's farm. As a result, it is not surprising that many rebels panicked after alarms on the night that the rebels camped at Thomas Ridley's slave quarters. For Clausewitz's discussion, see Carl von Clausewitz, *On War*, trans. J. J. Graham (1832; repr., London: Routledge & Kegan Paul, 1962), 106. For a movie that explores the limitations of knowledge about war, see *The Fog of War,* dir. Errol Morris (2003; DVD, Sony Pictures Classic, 2004).

6. Petition of the executor widow and legatees of Thos. Fitzhugh, dec[ease]d, December 1831, SCLP.

7. The conceptualization of the slave rebellion is something that is different from Clausewitz's fog, as most people who are involved in a war know what is happening more broadly, even if they are not clear on all the details. However, the events associated with the terrorist attacks in America and elsewhere have brought up a similar type of question: should the attacks such as those on the World Trade Center and the Pentagon be treated as acts of war or as simple lawbreaking? Different conceptualizations of the attacks led to different ideas about the appropriate responses, including how to handle those allied to the attackers. Analogously, the story of the response to revolt that I tell describes a struggle (primarily among the whites) to settle on a workable understanding of the slave revolt.

8. This type of uncertainty was not confined to Southampton. Two months after the revolt, Mr. Lewis in Prince George County, Virginia, was strangled and his house burnt to the ground by his slaves. "Many are of the opinion that it had some connection with the Southampton tragedy," William S. Simpson observed, "but I rather look on it as an isolated instance of murderous excitement from fanaticism and perhaps drunkenness." W. S. Simpson to Mrs. Hooper, October 26, 1831, Mr. and Mrs. William S. Simpson Letterbook, 1830–1834, William S. Simpson Papers, LV.

9. *Norfolk and Portsmouth Herald*, September 5, 1831.

10. Ibid., August 29, 1831.

11. This assertion is borne out by the developments at the Whitehead plantation, when the militia found out that the Whiteheads' slaves had been loyal to their white masters.

12. *Norfolk and Portsmouth Herald*, August 29, 1831.

13. On the mangled bodies at Catherine Whitehead's, see Fayetteville *North Carolina Journal*, August 31, 1831.

14. Drewry, *The Southampton Insurrection*, 44. After the revolt, the elites would work hard to pretend that the concerns about slave loyalty were baseless, but at the time of the revolt, whites' actions suggested that they may have suspected what I have termed the "double consciousness" of slaves. At least until whites had reestablished control over the county, whites suspected even the most loyal slaves—the very ones whose actions would be used to establish a narrative that the revolt was only a minor threat.

15. L. Minor Blackford, *Mine Eyes Have Seen the Glory: The Story of a Virginia Lady, Mary Berkeley Minor Blackford, 1802–1896, Who Taught Her Sons to Hate Slavery and to Love the Union* (Cambridge, MA: Harvard University Press, 1954), 27.

16. *Richmond Enquirer*, August 30, 1831; F. M. Capehart to Benajah Nicholls, August 23, 24, 25 and 26, 1831, Benajah Nicholls Papers, NCDAH.

17. Robert S. Parker to Rebecca Mannet, August 29, 1831, John Kimberly Papers, SHC; Solon Borland to Roscius C. Borland, August 31, 1831, NCDAH. In the letter to Rebecca Mannet, Parker also noted that "Old Tommy Weston actually got scared or alarm.d to death."

18. J. Borland to Governor [Montfort] Stokes, September 18, 1831, North Carolina Governor's Papers, v. 62, NCDAH.

19. Robert S. Parker to Rebecca Mannet, 29 August 1831, John Kimberly Papers, SHC.

20. Ibid.

21. Ben's trial, 1821, quoted in Thomas D. Morris, *Southern Slavery and the Law, 1619–1860* (Chapel Hill: University of North Carolina Press, 1996), 241. My focus on the investigative dimension of torture is not intended to downplay the "performative and ritualistic aspect of torture, whether as a means of inflicting humiliation upon the body of the subject or enacting the sovereignty of the torturer," as Malick W. Ghachem describes it. The whites in Southampton did both of these things, even as the torture was also part of an investigative process led by whites trying to figure out what happened during the revolt. See Malick W. Ghachem, "Prosecuting Torture: The Strategic Ethics of Slavery in Pre-Revolutionary Saint-Domingue (Haiti)," *Law and History Review* 29 (November 2011): 1027.

22. Richmond *Constitutional Whig*, September 26, 1831, in Tragle, *Revolt*, 92; Allen Crawford interviewed by Susie R. C. Byrd, in *Weevils in the Wheat: Interviews with Ex-Virginia Slaves*, ed. Charles L. Perdue Jr., Thomas E. Barden, and Robert K. Phillips (Charlottesville: University Press of Virginia, 1992), 76.

23. *New Hampshire Post*, September 14, 1831; Richmond *Constitutional Whig*, August 29, 1831, in Tragle, *Revolt*, 52.

24. Emma Mordecai to Ellen Mordecai, September 1, 1831, Mordecai Family Collection, SHC; Allen Crawford interview, 76.

25. *New Hampshire Post*, September 14, 1831.

26. Thomas R. Gray, *The Confessions of Nat Turner, the Leader of the Late Insurrection in Southampton, VA* (Baltimore, 1831), 16; *Norfolk American Beacon*, August 29, 1831, in Tragle, *Revolt*, 50.

27. *Richmond Enquirer*, August 30, 1831, both "thick cluster" and "every house"; J. Borland to [Montfort] Stokes, September 18, 1831, North Carolina Governor's Papers, v. 62, NCDAH. Excerpts from the *Richmond Enquirer* article are included in Tragle, *Revolt*, 43–46. This first quote, however, is omitted; the second quote is included, but Tragle substitutes "woods" for "wood."

28. *North Carolina Journal*, August 31, 1831; Richmond *Constitutional Whig*, August 29, 1831, in Tragle, *Revolt*, 51. According to the 1830 census, 1,931 white women over fifteen lived in Southampton County.

29. *New Hampshire Post*, September 14, 1831; Drewry, *The Southampton Slave Insurrection*, 79; *Richmond Enquirer*, August 30, 1831. The number 200 in the *Richmond Enquirer* letter could possibly refer to total refugees. The full quote: "Jerusalem is full of women, most of them from the other side of the river—about 200 at Vix's or Bivin's."

30. Drewry, *The Southampton Insurrection*, 78; Richmond *Constitutional Whig*, August 29, 1831, in Tragle, *Revolt*, 55; John L. Laughter and E. W. Best, August 24, 1831, North Carolina Governor's Papers, Montfort Stokes, v. 62, NCDAH.

31. *Richmond Compiler*, September 3, 1831, in Tragle, *Revolt*, 61. In an earlier essay, I suggested that Congressman James Trezvant was the initial leader of the Jerusalem defenses. More recently, David F. Allmendinger Jr. argues that William C. Parker "was undoubtedly" the initial leader of the forces in Jerusalem. Both candidates fit the internal evidence from the letter that described the leader as among the twenty-seven whites most involved in the trials. Parker's candidacy is supported by Drewry, who notes that Parker had been the head of "thirty or forty men." Parker also was elected captain of the Southampton Grays when they were organized in September 1831. On the other hand, Trezvant was the most prominent man in Jerusalem. According to one source, he was a colonel, outranking the then uncommissioned Parker. Trezvant also was active on the scene in Jerusalem. Allmendinger eliminates Trezvant as the leader of the troops in Jerusalem on the grounds that he had left with an express to inform the rest of Virginia about the revolt. Unfortunately for this interpretation, Trezvant did not travel with an express. Instead, he sent a note that had been delivered by an express. In fact, in Petersburg they spent time deciphering the letter, which "Col. Trezvant" had "written in great haste…To remove any doubt of its authenticity, Mr. Gilliam of Petersburg had certified that he knew Col. T.'s handwriting and that it was genuine." Drewry also identified someone else, "Mr. Thomas Jones," as the rider who killed two horses on the express to the governor. If Trezvant had not left on an express but been one who dispatched them,

then he was likely in charge of the forces in Jerusalem until Eppes arrived. See
Patrick H. Breen, "In Terror of Their Slaves: White Southern Women's Responses
to Slave Insurrections and Scares," in *Warm Ashes: Issues in Southern History at the
Dawn of the Twenty-First Century*, ed. Winfred B. Moore Jr., Kyle S. Sinisi, and
David H. White (Columbia: University of South Carolina Press, 2003), 73; David
F. Allmendinger Jr., "The Construction of *The Confessions of Nat Turner*," in *Nat
Turner: A Slave Rebellion in History and Memory*, ed. Kenneth S. Greenberg
(New York: Oxford University Press, 2003), 29–30; Drewry, *The Southampton
Insurrection*, 86, 77 n. 1. For the evidence that Trezvant dispatched the expresses,
see *Richmond Compiler*, August 24, 1831, in Tragle, *Revolt*, 36. For the letter describ-
ing a trip on the express that Allmendinger attributes to Trezvant, see *Raleigh
Register*, September 8, 1831. By Wednesday at the latest, Richard Eppes took charge
of the forces in Jerusalem. See *Richmond Enquirer*, August 30, 1831, which quotes a
letter Eppes sent that was published in the *Richmond Compiler*, August 27, 1831, in
Tragle, *Revolt*, 47–48.

32. Drewry, *The Southampton Insurrection*, 78, 48–49.

33. "Capt. Nat Turner," and "grey headed man," both from different reports in *Richmond
Enquirer*, August 30, 1831; "headed by some few whites" in *Richmond Enquirer*,
August 26, 1831, in Tragle, *Revolt*, 46; "the reputed leader," Richmond *Constitutional
Whig*, August 29, 1831, in Tragle, *Revolt*, 52.

34. *Richmond Enquirer*, August 30, 1831; Richmond *Constitutional Whig*, September 3,
1831, in Tragle, *Revolt*, 67. Scot French argues that "as the other suspected ringlead-
ers fell, the stature of Nat Turner rose." French then adds that "within two weeks of
the uprising, an image of the rebel leader as a 'fanatic preacher' with extraordinary
powers of persuasion had already begun to take form." The idea that Nat Turner
was initially seen as one among several rebel leaders whose historical prominence
was a product of white reporting is an important argument, but it is not the most
likely explanation for Turner's historical prominence. First, even in the earliest
reports of whites who were trying to figure out who the leader was, Nat Turner—
sometimes referred to as a preacher or a prophet—was already the most prominent
figure. There was no confusion in the mind of the editor of the *Richmond Enquirer*
about who the leader was. The editor prefaced the August 30, edition of the paper,
which compiled as many of the conflicting early reports as any other paper, with an
admonition that "the case of Nat Turner warns us." Second, evidence from other
sources also described Turner as the supreme leader of the revolt. In addition to the
portrait drawn by Thomas R. Gray in *The Confessions of Nat Turner*, witnesses at
the trials suggested Turner's importance was clear at the time of the revolt. For ex-
ample, Eliza Cratherton testified at Hardy's trial, noting that during the revolt he
had "told her that they meant to join Genl. Nat." Likewise, Levi Waller's testimony
for the prosecution in the trials of the two most important rebels, Hark and Nat
Turner, also implied that they exercised different levels of authority. Although
Hark was called "Captain Moore," Waller simply said that Hark had "a gun in his

hands" and "acted as one of the company." In his testimony against Nat Turner, Waller stated that Turner "seemed to Command the party." He was the one who "gave command to the party to 'go ahead' when they left" Waller's farm. Finally, French's timing is off. Saying that the picture of Turner as a fanatical religious figure emerged within two weeks, French suggests that the idea of multiple co-leaders of the revolt lasted. In Southampton, at least, the early reports positing others as leaders were debunked fairly quickly: Pleasants himself probably misspoke when he called Hark "the reputed leader." Later in the same report, he noted that "the Preacher-Captain has not been taken." He made it clear in each of his next two reports that he believed that Turner was the revolt's leader. "My own impression," Pleasants wrote while still in Southampton on Saturday, August 27, "is, that they acted under the influence of their leader Nat, a preacher and prophet among them." The report of whites being involved, which was repeated in a few different sources, was likewise rejected within days. A week after the revolt, James Trezvant reported from Jerusalem, "Only *one free negro* was in arms with them, and *no white persons.*" See Scot French, *The Rebellious Slave: Nat Turner in American Memory* (Boston: Houghton Mifflin, 2004), 2; *Richmond Enquirer*, August 30, 1831, in Tragle, *Revolt*, 44; Hardy's trial, SCCMB, in Tragle, *Revolt*, 203; Hark's trial, SCCMB, in Tragle, *Revolt*, 192; Nat Turner's trial, SCCMB, in Tragle, *Revolt*, 222; Richmond *Constitutional Whig*, August 29, 1831, in Tragle, *Revolt*, 53; *Richmond Compiler*, September 3, 1831, in Tragle, *Revolt*, 61 (emphasis in original). For the most frequently recorded rumor about the revolt beginning with three whites, see *Richmond Enquirer*, August 30, 1831; F. M. Capehart to Benajah Nicholls, August 23, 24, 25, and 26, 1831, Benajah Nicholls Papers, NCDAH.

35. *Richmond Compiler*, August 27, 1831, in Tragle, *Revolt*, 49; *Edenton Gazette and Farmer's Palladium*, October 19, 1831. For an example of a rumor that Turner had been killed, see *Petersburg Intelligencer*, August 26, 1831, in Tragle, *Revolt*, 40. For examples of rumors that Turner had been arrested, see *Norfolk American Beacon*, August 29, 1831, in Tragle, *Revolt*, 49; *Lynchburg Virginia*, September 8, 1831, in Tragle, *Revolt*, 74.

36. "Ungrounded" and "not yet taken," *Richmond Enquirer*, August 30, 1831, in Tragle, *Revolt*, 45 (for Broadnax's identify as the source for this report, see Richmond *Constitutional Whig*, August 29, 1831, in Tragle, *Revolt*, 54); "ringleader" in *Norfolk American Beacon*, September 9, 1831, in Tragle, *Revolt*, 75; *Boston Christian Register*, October 1, 1831.

37. Richmond *Constitutional Whig*, September 26, 1831, in Tragle, *Revolt*, 93.

38. *Norfolk and Portsmouth Herald*, September 19, 1831. See also *Niles Weekly Register*, September 10, 1831, and *Richmond Enquirer*, September 20, 1831, both in Tragle, *Revolt*, 76–77, 88. To get some sense of how little people outside of Southampton knew about Turner, Governor Floyd, whose information was as good as anyone's, noted in mid-September that he had "not seen any description of" Turner. See John Floyd to Richard Eppes, September 13, 1831, in Tragle, *Revolt*, 274.

39. Richmond *Constitutional Whig*, October 6, 1831; *Richmond Enquirer*, October 4, 1831, in Tragle, *Revolt*, 117.

40. This lack of information led to a bad result for at least one slave. Since whites thought Nat Turner had been in Botetourt County, they began investigating a man named "Billy, belonging to Mr. Kennelly." A report notes that "the testimony against Billy was not very clear," and it seems likely the case would have fallen apart if the whites had understood that the person who was thought to be Nat Turner was really someone else. See *Richmond Enquirer*, October 18, 1831, in Tragle, *Revolt*, 123.

41. John Floyd to Richard Eppes, September 13, 1831, and William C. Parker to Governor John Floyd, September 14, 1831, both in Tragle, *Revolt*, 274, 420–21.

42. There was at least one exception: Robert Nelson's family's nurse traveled with the children to Thomas Ridley's plantation house, where the white men were preparing for a fight with Turner's men. The nurse was nearly killed by the guard when, according to Drewry, she declared that she hoped that the rebels "would come along, as she wished to see them fight." Only the intervention of the white women prevented the nurse from "being thrown from the window." See Drewry, *The Southampton Insurrection*, 71 n. 1.

43. According to Moses, Ben's brother Nathan went with the rebels "unwillingly." Since Moses himself fled from the rebels on Monday afternoon, the fact that he had witnessed the recruiting at Blunt's means that Nathan joined on Monday, before the rebels had run into any resistance. See Ben's trial, SCCMB, in Tragle, *Revolt*, 223, 227, and Nathan's trial, SCCMB, in Tragle, *Revolt*, 200.

44. Hardy and Isham's trial, SCCMB, in Tragle, *Revolt*, 202–4; Isaac's trial, SCCMB, in Tragle, *Revolt*, 189–90; Berry Newsom's trial, 1831, Box 95, SCCCJ, LV.

45. Hardy's trial, SCCMB, in Tragle, *Revolt*, 202.

46. Exum Artist's trial, 1831, Box 95, SCCCJ, LV.

47. Ibid.

48. *Richmond Enquirer*, August 30, 1831, in Tragle, *Revolt*, 45.

CHAPTER 5

1. Nat Turner's trial, SCCMB, in Tragle, *Revolt*, 222; Thomas Porter and A. P. Peete's affidavits, November 22, 1831, and Levi Waller petition, December 12, 1831, SCLP.

2. Levi Waller petition, December 12, 1831, SCLP; William Sidney Drewry, *The Southampton Insurrection* (1900; repr., Murfreesboro, NC: Johnson Publishing, 1968), 64 n. 2.

3. Drewry, *The Southampton Insurrection*, 64 n. 2. See also Thomas Porter affidavit, November 22, 1831, SCLP.

4. Drewry, *The Southampton Insurrection*, 64 n. 2.

5. *Petersburg Intelligencer*, August 26, 1831, in Tragle, *Revolt*, 40. The pattern of the Greensville militia not taking prisoners can also be seen the one time Greensville militia engaged a small rebel force as the revolt was being suppressed. In a battle on

Tuesday, the Greensville militia "killed nearly all" of the rebels they encountered. See Drewry, *The Southampton Insurrection*, 73.

6. Levi Waller petition, December 12, 1831, SCLP.

7. What may at first glance seem neighborly concern for another person's slave could also have been a case of calculated self-interest. Because none of the Greensville men would have owned Southampton slaves, a vigorous response in Southampton (likely seen by many whites as the safest response) cost the Greensville militia nothing. Because the Southampton men owned slaves who lived near the scene of the revolt, they realized that a response involving the killing of many slaves in the area might mean that they would lose some of their own slaves, which would be a significant burden for even the richest slaveholders. If they thought about it this way, it made sense that the slaveholders from Southampton were more willing to risk a more cautious, less vigorous response to the revolt.

8. Southampton County Census, 1830. For Peete's role on the court, see SCCMB.

9. Peete, the informal leader of the men who chased the rebels on the first day, was later put in charge of his troops by "the order of Col. Meahan." This would have given him a formal authority if his men disagreed with his approach to the rebels. A. P. Peete affidavit on behalf of Richard Darden, January 18, 1832, SCLP. The formalizing of Peete's authority, however, does not seem to have changed much, because he seemed to have been recognized as the leader of the group pursuing the rebels from the start. The only example of someone saying someone other than Peete was in charge of the troops pursuing Turner was Drewry, who said that the men pursuing Turner were "under the command of Captains Alexander P. Peete and James Bryant." Bryant would have been less than twenty years old, something that makes me suspect that he may have been one of Drewry's sources who perhaps exaggerated his own role in suppressing the revolt. See Drewry, *The Southampton Insurrection*, 64. For contemporary reports that identify Peete as the leader of the group, see Levi Waller petition, December 12, 1831, SCLP, and Thomas R. Gray, *The Confessions of Nat Turner, the Leader of the Late Insurrection in Southampton, VA* (Baltimore, 1831), 15.

10. Richmond *Constitutional Whig*, August 29 and September 3, 1831, in Tragle, *Revolt*, 52, 69; Fayetteville *North Carolina Journal*, August 31, 1831; *Richmond Enquirer*, January 24, 1832. The parenthetical insertion "[sic]" in Trezvant's letter was added by the newspaper editor.

11. Richmond *Constitutional Whig*, August 29 and September 3, 1831, both in Tragle, *Revolt*, 52, 69; Drewry, *The Southampton Slave Insurrection*, 85 n. 2. Lavania Francis was one of Drewry's sources. Interestingly, the consideration of finances that might have led neighbors not to kill one another's slaves would not have applied to someone like Francis, who would have had to bear the cost of murdering his own slave.

12. Thomas Wentworth Higginson, "Nat Turner's Revolt," *Atlantic Monthly*, August 1861; *North Carolina Journal*, August 31, 1831. The stories about the actions of some

of the Murfreesboro men, which included taking money and a gold watch off the bodies of the three blacks that they killed on the Wednesday after the revolt, was so egregious that in October, fifteen members of the company published an open letter to the citizens of Southampton that included "A PUBLIC DENIAL OF ALL KNOWLEDGE OF THIS *TRANSACTION* UNTIL OUR RETURN HOME, and to DECLARE OUR UNEQUIVOCAL AND UNQUALIFIED DISAPPROBATION AND ABHOR[R]ANCE OF THE *ACT*." See *Roanoke* (NC) *Advocate*, October 13, 1831 (emphasis in original).

13. Emma Mordecai to Ellen Mordecai, September 1, 1831, Mordecai Family Collection, SHC; *Boston Christian Herald*, quoted in the *New York Constellation*, October 8, 1831; *New Hampshire Post*, September 14, 1831. This report is also quoted with three minor differences in the *Liberator*, October 1, 1831, in Tragle, *Revolt*, 115.

14. Drewry, *The Southampton Insurrection*, 85; *Norfolk American Beacon*, August 29, 1931, in Tragle, *Revolt*, 50. For a reference to Black Head Sign Post by a South-ampton resident more than a century after the revolt, see Frances Lawrence Webb, *Recollections of Franklin and Historical Sketches of Southampton County* (1963), in Tragle, *Revolt*, 397.

15. Richard Eppes's August 31, 1831, letter that described incidents where blacks were killed "without knowing who they were" is quoted in James McDowell's speech before the Virginia legislature, Richmond *Constitutional Whig*, March 26, 1832.

16. Th. J. Cooper, August 24, 1831, North Carolina Governor's Papers, Montfort Stokes, v. 62, NCDAH (both "negroes are dispersed" and "one hundred and twenty five men"); *Richmond Compiler*, August 27, 1831; Richmond *Constitutional Whig*, August 29, 1831, both in Tragle, *Revolt*, 47–48, 52. It is unclear exactly when Cooper com-mented that "the negroes are dispersed." Most likely he made this observation on either August 24 or 25, 1831.

17. G. W. Powell, quoted in Herbert Aptheker, *Nat Turner's Slave Rebellion: Together with the Full Text of the So-Called "Confessions" of Nat Turner Made in Prison in 1831* (New York: Humanities Press, 1966), 61 (emphasis in original); *Constitutional Whig*, August 29 and September 3, 1831, both in Tragle, *Revolt*, 52, 69; Richard Eppes's letter, August 31, 1831, quoted in James McDowell's speech to the Virginia House of Delegates, Richmond *Constitutional Whig*, March 26, 1832 (emphasis in original); William Henry Broadnax's speech to the Virginia House of Delegates, January 19, 1832, in *Richmond Enquirer*, January 24, 1832.

18. *Roanoke Advocate*, September 8, 1831; Richmond *Constitutional Whig*, August 29, 1831, in Tragle, *Revolt*, 52. When Eppes described his force in the order issued on August 28, 1831, he described his force as "sufficient...for the security of the prisoners." See *Lynchburg Virginian*, September 8, 1831, in Tragle, *Revolt*, 75.

19. Peter Edwards petition, December 12, 1831, SCLP.

20. *Lynchburg Virginian*, September 8, 1831, in Tragle, *Revolt*, 73–74.

21. Drewry, *The Southampton Slave Insurrection*, 86. Although Drewry never guessed at exact numbers involved, he gave an example of two "guilty negro[s] who escaped": two slaves belonging to James Parker were apparently "discharged on his evidence

that they had been of good character and if they were guilty it was due to evil persuasion. They were sent South." Apparently, to Drewry guilt meant any even tangential connection to the revolt and "escaped" simply meant that the accused slave was not killed.

22. Aptheker, *Nat Turner's Slave Rebellion*, 60–62; Herbert Aptheker, *American Negro Slave Revolts: Nat Turner, Denmark Vesey, Gabriel and Others* (1943; repr., New York: International Publishers, 1974), 301; Aptheker, "Nat Turner," in *Dictionary of American Negro Biography*, ed. Rayford W. Logan and Michael R. Winston (New York: Norton, 1982), 612.

23. Higginson, "Nat Turner's Insurrection"; John Cromwell, "The Aftermath of Nat Turner's Insurrection," *Journal of Negro History* 5 (1920): 212; Eric Foner, "Introduction," in *Nat Turner: Great Lives Observed*, ed. Eric Foner (Englewood Cliffs, NJ: Prentice Hall, 1971), 5; Stephen B. Oates, *The Fires of Jubilee: Nat Turner's Fierce Rebellion* (New York: Harper Perennial, 1990), 100; Kenneth S. Greenberg, "*The Confessions of Nat Turner:* Text and Context," in *The Confessions of Nat Turner and Related Documents*, ed. Kenneth S. Greenberg (Boston: Bedford Books, 1996), 1; Thomas C. Parramore, "Covenant in Jerusalem," in *The Confessions of Nat Turner and Related Documents*, ed. Kenneth S. Greenberg (Boston: Bedford Books, 1996), 70. These high estimates have been widely accepted in both academic and popular sources. For instance, Ashraf H. A. Rushdy, a historian studying lynching, noted that at least 150 slaves and free blacks were killed after the revolt, "presumably lynched." Similarly, the current Wikipedia entry notes, "Mobs attacked blacks in the area killing an estimated total of 100–200, many not involved at all with the revolt." Ashraf H. A. Rushdy, *American Lynching* (New Haven: Yale University Press, 2012), 54; "Nat Turner's Slave Rebellion," *Wikipedia*, en.wikipedia.org/wiki/Nat_Turner's_slave_rebellion, accessed May 25, 2014. While most people have accepted that a large number of slaves were killed, Alfred L. Brophy is a notable exception to the consensus. Drawing in part on arguments that I made in my dissertation about the lower numbers (which he describes as "persuasive"), Brophy suggests that "twenty-five to forty" blacks were killed without trials. See Alfred L. Brophy, "The Nat Turner Trials," *North Carolina Law Review* 91 (June 2013): 1817–80, esp. 1831–2 and n. 109.

24. Southampton County Tax Lists, 1824–1839.

25. Four of the thirty-nine rebels mentioned in sources may have been double-counted: Nat and Jacob were mentioned in the *Confessions* as being the last rebels Nat Turner saw. One Nat was tried and convicted on evidence provided by Mary Barrow, who identified Nat as "one of the negroes that came to her husband's home on the day that her husband was murdered." One Jacob confessed about his involvement to John Edmunds before he was shot by troops from North Carolina. See Gray, *The Confessions of Nat Turner*, 17; Nat's trial, SCCMB, in Tragle, *Revolt*, 196; John Edmunds affidavit, November 28, 1831, SCLP. Given this ambiguity, I use thirty-eight as the number of identifiable rebels for my estimates.

26. For the petitions, see those of Peter Edwards, Levi Waller, and Richard Porter, December 12, 1831, SCLP; Piety Reese, deceased, December 29, 1831, SCLP. See also *Norfolk American Beacon*, August 29, 1831; Richmond *Constitutional Whig*, August 29, 1831, both in Tragle, *Revolt*, 49, 52. Henry, Will, and Austin may have disappeared from the contemporary record, but Drewry reports that in a battle that took place near Captain Harris's following the ambush at Blunt's, "the Green[]sville cavalry charged the few who still clung together and killed nearly all of them, among the killed being Will, the savage executioner." See Drewry, *Southampton Insurrection*, 73.

27. Quoted in Judith Kelleher Schaffer, "The Immediate Impact of Nat Turner's Insurrection in New Orleans," *Louisiana History* 21 (1980): 372–73. The slaves sold in Louisiana could have been the slaves who had been convicted and whose sentences had been reduced to banishment, or other slaves whose departure from Southampton had not been documented. I have not found any evidence of private sales of slaves from Southampton, but evidence of such sales from people from the area near the revolt suggests that this type of transaction happened. For example, Richard Blow of Portsmouth, Virginia, sold ten slaves to a man establishing a plantation in the Red River district of Louisiana. See Richard Blow to George Blow, October 24, 1831, Blow Family Papers, Virginia Historical Society.

28. See John McPhail to R. R. Gurley, September 22, 23, and 30, 1831; October 10 and 28 (the latter citing the number 274), 1831; November 23 and 27, 1831; December 7, 1831 (citing the number 60), American Colonization Society Papers, Library of Congress, Reel 12; *Norfolk and Portsmouth Herald*, November 25, 1831. For McPhail's letter to the Colonization Society of Virginia, see *Richmond Enquirer*, December 15, 1831. The departure of the *James Perkins* was delayed by a snowstorm and paperwork problems, which allowed about forty more people to board the ship, but I do not know if any of these emigrants came from Southampton County. The final total of passengers was 339. See John McPhail to R. R. Gurley, December 7, 1831, American Colonization Society Papers, Reel 12. See also Douglas R. Egerton, *Charles Fenton Mercer and the Trial of National Conservativism* (Jackson: University Press of Mississippi, 1989), 241–42. Some of the blacks who boarded the *James Perkins* may have been free, but the analysis of the decline in the free black population below makes it more likely that the vast majority of the blacks boarding the ship were slaves who had been included on the 1831 property tax list.

29. The sources are not perfect indicators of the death rate among the rebels. Everyone who was tried must have survived the white reaction long enough to go before the court. On the other hand, every owner who petitioned for reimbursement owned a slave who did not live long enough to stand trial. To correct for this, one can look at the number of slaves whose death is known from a source that does not depend upon whether the rebel lived or died—in other words, disregarding those rebels identified in their own trials and those identified by owners seeking compensation. Of those killed after the revolt, eight are mentioned in sources other than petitions.

Disregarding the same types of sources would leave only seventeen rebels who could be identified. This suggests that twenty-eight rebels (nearly half, using Turner's estimate of sixty rebels) died as the revolt was suppressed. Although I do not include this in the chapter, one can also extend this type of analysis to estimate the total number of slaves killed as the rebellion was suppressed. One can multiply the number of rebel deaths by the ratio of known slave deaths, sixteen, to known rebel deaths, fourteen. Given a range of twenty-two to twenty-eight rebel deaths, this would suggest that a total of twenty-five to thirty-two Southampton slaves died as the revolt was put suppressed. Since at least two free blacks died during the reaction, this would mean that the total estimate for the number of deaths in the black community was between twenty-seven and thirty-four, although this estimate may be a little low, depending on the casualty rate among free blacks, something that I discuss below. None of these statistical methods is perfect, in part because they depend upon imperfect sources, but these estimates agree well with both a rough estimates based upon analysis of demographic patterns, that has already been discussed, and the best primary accounts of the numbers of blacks killed, which will be discussed below.

30. *Edenton Gazette and Farmer's Palladium*, September 7, 1831.

31. Ida B. Wells, *A Red Record* (1895), in *Southern Horrors and Other Writings: The Anti-Lynching Campaign of Ida B. Wells, 1892–1900*, ed. Jacqueline Jones Royster (Boston: Bedford/St. Martin's, 1997), 75. Historians have long understood and accepted the existence of racial violence in the years after the Civil War. Since C. Vann Woodward's *Origins of the New South* (Baton Rouge: Louisiana State University Press, 1951) and *The Strange Career of Jim Crow*, 3rd ed. (New York: Oxford University Press, 1974), the central question about racial violence has not been whether it happened but when it happened. More recently, Steven Hahn's award-winning *A Nation Under Our Feet: Black Political Struggles in the Rural South from Slavery to the Great Migration* (Cambridge, MA: Belknap Press, 2003) puts racial violence at the center of the story of American political development. A list of works connected to this topic could be incredibly long, but some of the recent work that highlights the importance of racial violence in the South after the Civil War includes Christopher Waldrep, *The Many Faces of Judge Lynch: Extralegal Violence and Punishment in America* (New York: Macmillan, 2002); James G. Hollandsworth, *An Absolute Massacre: The New Orleans Race Riot of July 30, 1866* (Baton Rouge: Louisiana State University Press, 2004); Mark Elliott, *Color-Blind Justice: Albion Tourgée and the Quest for Racial Equality from the Civil War to Plessy v. Ferguson* (New York: Oxford University Press, 2006); Nicholas Lemann, *Redemption: The Last Battle of the Civil War* (New York: Farrar, Straus and Giroux, 2006); Amy Louise Wood, *Lynching and Spectacle: Witnessing Racial Violence in America, 1890–1940* (Chapel Hill: University of North Carolina Press, 2009); Michael Fellman, *In the Name of God and Country: Reconsidering Terrorism in American History* (New Haven: Yale University Press, 2010); and Rushdy, *American Lynching*.

32. *Lynchburg Virginian*, September 8, 1831, quoted in Tragle, *Revolt*, 74–75.

33. Benjamin Gurley began tracking the totals of free blacks in St. Luke's Parish in 1830, a practice continued throughout the 1830s. Unfortunately, total numbers for the entire county cannot be determined because the tax collectors in Nottoway Parish did not count free black men as regularly. This inconsistency is especially unfortunate because the tax collector failed to count the free black male population in 1831 and 1832, the two years most relevant to the revolt. It is unlikely, though, that free blacks in the neighborhood of the revolt were largely spared while those farther away were killed. Likewise, this list only enumerates the number of men, although it seems unlikely that free black men were spared while free black women and children were murdered. See Southampton County Tax Lists, 1830–1839.

34. *Norfolk American Beacon*, September 9, 1831, in Tragle, *Revolt*, 75; Berry Newsom's trial, Box 95, SCCCJ, LV; *Richmond Enquirer*, August 30, 1831, in Tragle, *Revolt*, 45.

35. Southampton County Tax List, 1830–1832; Phil Norfleet, "Aaron Norfleet and the Nat Turner Revolt," http://pcn2051.tripod.com/aaron.htm, accessed May 25, 2014; *Fredericksburg Virginia Herald*, November 2, 1831.

36. Samuel Warner, *Authentic and Impartial Narrative of the Tragical Scene...* (1831), in Tragle, *Revolt*, 288; Higginson, in Tragle, *Revolt*, 337; Fayetteville *North Carolina Journal*, August 31, 1831; William Pettigrew to Ebinezer Pettigrew, September 3, 1831, Pettigrew Family Papers, SHC.

37. *Tarboro Free Press and Southerner*, August 30 and September 13, 1831; *Norfolk and Portsmouth Herald*, August 29, 1831; Halifax (NC) *Roanoke Advocate*, September 8, 1831; *Raleigh Register*, September 8, 1831; *Richmond Compiler*, September 3, 1831, in Tragle, *Revolt*, 61; Richmond *Constitutional Whig*, September 3, 1831, in Tragle, *Revolt*, 69. The first estimates from Tarboro were written by an author who admitted that he had no direct source on the revolt. Tarboro's troops had only gone as far as Enfield, North Carolina, before they were told to return to Tarboro.

38. *New Hampshire Post*, September 14, 1831. Smith's letter was written over several days, so his total of whites killed in the revolt changed. At first he estimated that fifty-four whites died. Then he heard about eleven more fatalities, bring his temporary total to sixty-five. His estimate of sixty-four was at the end of the letter, several lines before his estimate that between ninety-five and "100 lives have been taken."

39. *Norfolk and Portsmouth Herald*, August 29, 1831; *Norfolk American Beacon*, August 29, 1831, in Tragle, *Revolt*, 49; Fayetteville *North Carolina Journal*, August 31, 1831; *Raleigh Register*, September 15, 1831. The parenthetical assertion in the quote from the Fayetteville *North Carolina Journal* is in the newspaper.

40. *Norfolk American Beacon*, August 29, 1831, in Tragle, *Revolt*, 49; Fayetteville *North Carolina Journal*, August 31, 1831; Richmond *Constitutional Whig*, August 29, 1831, in Tragle, *Revolt*, 52.

41. William Henry Broadnax's speech to the Virginia House of Delegates, January 19, 1832, in *Richmond Enquirer*, January 24, 1832.

42. Anonymous note, c. 1832, James McDowell Papers, series 3.1, folder 75, SHC; part of the petition to Jackson is quoted in James McDowell's speech before the Virginia legislature, Richmond *Constitutional Whig*, March 26, 1832; John Floyd to Brig. General Richard Eppes, August 25, 1831, in Tragle, *Revolt*, 266. The anonymous note in James McDowell's Papers describes Jackson's actions.

43. *Richmond Compiler*, September 3, 1831, in Tragle, *Revolt*, 62.

44. Ibid.; Richmond *Constitutional Whig*, March 26, 1832.

CHAPTER 6

1. St. George Tucker, "Volume 1, Appendix, Note D, Section 9," in William Blackstone, *Blackstone's Commentaries: With Notes* (Philadelphia, 1803), www.constitution. org/tb/t1d10000.htm; William Blackstone, *Commentaries on the Laws of England* 4 (Oxford, 1765–69), 344, http://avalon.law.yale.edu/18th_century/blackstone_ bk4ch27.asp. For the quote from Blackstone, I have changed the *f* to the modern *s*.

2. "An act for the more speedy prosecution of slaves committing Capitall Crimes," quoted in A. Leon Higginbotham Jr. and Anne F. Jacobs, "The 'Law Only as an Enemy': The Legitimization of Racial Powerlessness Through the Colonial and Antebellum Criminal Laws of Virginia," *North Carolina Law Review* 70 (1992): 985; Thomas D. Morris, *Southern Slavery and the Law, 1619–1860* (Chapel Hill: University of North Carolina Press, 1996), 214. See also Daniel J. Flanigan, "Criminal Procedures in Slave Trials in the Antebellum South," *Journal of Southern History* 40 (1974): 537–64; Michael S. Hindus, "Black Justice Under White Law: Criminal Prosecution of Blacks in Antebellum South Carolina," *Journal of American History* 63 (1976): 575–99. For a description of the court of oyer and terminer in Salem, Massachusetts, see Peter Charles Hoffer, *The Devil's Disciples: Makers of the Salem Witchcraft Trials* (Baltimore: Johns Hopkins University Press, 1996), esp. 131–41. For a contrasting example where witchcraft accusations did not end up in a full-fledged witch hunt, the court of oyer and terminer in Stamford, Connecticut, acted as a brake on popular passions during a scare. See Richard Godbeer, *Escaping Salem: The Other Witch Hunt of 1692* (New York: Oxford University Press, 2005).

3. Carter quoted in Morris, *Southern Slavery and the Law*, 214; Philip J. Schwarz, *Twice Condemned: Slaves and the Criminal Laws of Virginia, 1705–1865* (Baton Rouge: Louisiana State University Press, 1988), 255. By attacking, Schwarz means any form of attack. Out of twenty-six cases, he found nine convictions, a rate of 34.6 percent. A. E. Kier Nash, in a study of another southern institution insulated from public pressure, state supreme courts, finds a similar pattern of finding for slaves. Perhaps more "astonishing" is that Diane Miller Sommerville finds legal support for black men convicted of raping white women, even in Southampton County a few years before Nat Turner's revolt. See A. E. Kier Nash, "Fairness and Formalism in the Trials of Blacks in the State Supreme Courts of the Old South," *Virginia Law Review* 56 (1970): 64–100; Diane Miller Sommerville, "The Rape Myth in the Old

South Reconsidered," *Journal of Southern History* 61 (1995): 481–515. For background on Landon Carter, including the estimate of his relative wealth at the time of his death in 1778, see Rhys Isaac, *Landon Carter's Uneasy Kingdom: Revolution and Rebellion on a Virginia Plantation* (New York: Oxford University Press, 2004), esp. xvii.

4. All of the figures for slaveholding among this group come from Southampton County Census, 1830. The total number of slave trials in Southampton was thirty-nine, in which forty-five slaves were tried. My tally of the judges who judged the accused slaves includes only James W. Parker for the trial of Peter Edward's Sam, because it is unclear from the records who the other four judges in that trial were. See Sam's trial, SCCMB, in Tragle, *Revolt*, 217–19. The only other significant anomaly is that Nat Turner's trial included ten judges, not the usual five. See Nat Turner's trial, SCCMB, in Tragle, *Revolt*, 221.

5. Southampton County Census, 1830. See also John McPhail to R. R. Gurley, September 22, 1831, American Colonization Society Papers, Library of Congress, reel 12; Daniel W. Crofts, *Old Southampton: Politics and Society in a Virginia County, 1834–1869* (Charlottesville: University Press of Virginia, 1992), 189. In December 1830, Thomas's brother Joseph wrote a character reference for Moses Pretlow, a free black "who conducts himself better than the generallity of free Negroes and is under a good character." The character reference was addressed to the Southampton court as part of an application for Moses "to obtain a license to keep a gun." See Joseph Prettlow, "Moses Prettlow Character Reference," December 18, 1830, Southampton County Court Records, Free Negro and Slave Records, LV. Despite Thomas Pretlow's dislike of slavery and his family's support for free blacks, there is no evidence that Pretlow saw the rebels differently than the other magistrates did. Pretlow judged ten trials, which made him the eighth-most-active judge. All these trials led to unanimous decisions, with three of the ten trials resulting in not-guilty verdicts. Of the seven who were convicted, only one was recommended for clemency. See SCCMB, in Tragle, *Revolt*, 177–228.

6. Jepthro Darden was the head of one of 111 Southampton households that held only one slave. Among families that owned slaves, one was, by far, the most common slaveholding, only outnumbered by the 534 households with no slaves. Looking at all of the free households in Southampton, the median slaveholding was also one slave. See Southampton County Census, 1830, and SCCMB.

7. The ease with which elite men shifted from position to position suggests that the differences in status implied by the positions were not especially important for the most prominent men. Consider the two most active judges, James Trezvant and Carr Bowers. Over the course of the year of the revolt, James Trezvant was a congressman, a militia leader, and the most active judge. He also was one of the two magistrates to interview Nat Turner when he first arrived in Jerusalem, and Trezvant was the one who recounted Turner's confession during the trial. On January 16, he resigned his position as magistrate to become the commonwealth's attorney. Carr Bowers.

was the second-most-active judge during the trials and an important figure in his church. In January 1832 he became Southampton's sheriff. For appointments, see January 16, 1832, SCCMB, LV; for Carr Bowers's role at his church, see Chapter 8.

8. Southampton County Tax List, 1831. For background on the lawyers, see David F. Allmendinger, "The Construction of *The Confessions of Nat Turner*," in *Nat Turner: A Slave Rebellion in History and Memory*, ed. Kenneth S. Greenberg (New York: Oxford University Press, 2003), 26–28. For more on Gray in particular, see the Afterword to this book. William Parker's enthusiasm for his commission as a captain of the Southampton Grays, a cavalry unit organizing in September 1831, can be seen in an episode that happened a few months after the revolt. In January 1832, Parker received a note from Governor John Floyd that he misconstrued as a command to mobilize his unit. Floyd had no idea what Parker was doing, and it took the governor a week to countermand the order. Afterward Parker halfheartedly apologized to Floyd for his expensive mistake: "My regret at having misconceived the true impact of the Governor's first order is considerably diminished by the manifest improvement of the Troops in soldiering exercise and appearance whilst they were in regular service. Regular guards were established and we drilled four or five hours every day." Apparently the courts were not the only venue in which the elites worked on consolidating their authority. See William C. Parker to John Floyd, January 14 and 22, 1832, Executive Papers, LV. (At the time I read these letters, I found the January 14, 1832, letter in the April 16–30, 1832, folder, March-April 1832 Box, Executive Papers, LV.)

9. As Thomas J. Davis makes clear in comments on the Denmark Vesey's 1822 conspiracy, the law gave courts the ability to punish many people for actions for actions far short of actually joining a revolt. According to Davis's book on the 1741 New York slave conspiracy, among the condemned were "perpetrators who were liable under the law for the death they received." See Thomas J. Davis, "Conspiracy and Credibility: Look Who's Talking, About What—Law Talk and Loose Talk," *William and Mary Quarterly*, 3rd ser. 59 (January 2002): 167–74, quote on 168; T. J. Davis, *Rumor of Revolt: The "Great Negro Plot" in Colonial New York* (New York: Free Press, 1985), xii.

10. Investigators went to Thomas Haithcock's home to look for evidence that he was involved in the revolt. They took depositions from both Haithcock's unnamed wife and his daughter, Martha, but when the list of witnesses was written on the bottom of Haithcock's wife's deposition, it noted that "Martha was called as a witness for her father's trial, as were Judkins, Howell Harris and Thomas Ridley." The omission of Haithcock's wife from the list is notable. If the whites were respecting Haithcock's rights against self-incrimination, the move did not do much to compromise their case, as the other thing noted at the bottom of Haithcock's wife's deposition was "This was also attested by Prisoner[']s daughter." These depositions are in the folder marked "Trial of Sam, Property of James W. Parker," 1831, Box 95, SCCCJ, LV.

11. Trials, August 31, 1831, SCCMB, in Tragle, *Revolt,* 177. The emphasis on formal charges also served to insulate the court from popular pressures. Although most whites in Southampton had a clear idea why they wanted the accused rebels punished, drawing up proper charges could only be done by someone with some legal training. Even among capable lawyers, only one lawyer, the state's attorney, Meriweather Broadnax, had the standing to levy the charges against slaves.

12. Jack and Shadrach's trial, SCCMB, in Tragle, *Revolt,* 216, 217; Information Against Jack and Shadrach, October 17, 1831, Box 95, SCCCJ, LV. According to *Black's Law Dictionary,* an information differs "from an indictment only in the it is preferred by a prosecuting officer instead of by a grand jury." *Black's Law Dictionary,* quoted in Philip J. Schwarz, *Gabriel's Conspiracy: A Documentary History* (Charlottesville: University Press of Virginia, 2012), 31 n. 16. The court's decision to dismiss the treason charges in this case was based upon a nuanced understanding of the law. For a fuller discussion of the relationship of slavery and treason, see Morris, *Southern Slavery and the Law,* 262–75. The Southampton court's line of thought would be developed most infamously in the Supreme Court's *Dred Scott* decision. See Don E. Fehrenbacher, *The Dred Scott Case: Its Significance in American Law and Politics* (New York: Oxford University Press, 1978), and also Mark Graber, *Dred Scott and the Problem of Constitutional Evil* (New York: Cambridge University Press, 2006), esp. 47–57.

13. Nelson's trial, in SCCMB, in Tragle, *Revolt,* 194. A man named Stephen was tried for involvement in the revolt, but I believe this was probably not the same man who testified against Nelson. If I am wrong, then Stephen's case does not support my argument here for prosecutorial discretion but would support the larger argument in the chapter about judicial leniency.

14. Isham, Jack, and Andrew's trials, in SCCMB, in Tragle, *Revolt* ("no communication," 203; "left word," 180, 181). For whites' view of Nat Turner's wife, see Richmond *Constitutional Whig,* September 26, 1831, in Tragle, *Revolt,* 92. For another example of someone who claimed to hear about the revolt without disclosing it to whites, see the discussion of Becky at the end of this chapter.

15. Isham's trial, in SCCMB, in Tragle, *Revolt,* 203; Thomas R. Gray, *The Confessions of Nat Turner, the Leader of the Late Insurrection in Southampton, VA* (Baltimore, 1831), 22. According to the list at the end of Gray's *Confessions,* four other slaves who had been charged were also released without trial. Notes in the trial of Jacob, owned by G. H. Charleton, 1831, Box 95, SCCCJ, LV, seem to describe what Isaac had done during the revolt. It was possible that a description of Isaac's actions made it into the notes about Jacob, or it could have been notes from Isaac's trial that were put in the wrong place. (Isaac and Jacob lived on the same farm.) It seems unlikely, however, that Jacob said almost exactly what Isaac was accused of saying and was discharged without a trial, while Isaac was convicted.

16. Jack and Shadrach's trial, in SCCMB, in Tragle, *Revolt,* 216, 217. Interestingly, Philip J. Schwarz finds the same pattern in the courts of oyer and terminer that met

in the wake of Gabriel's conspiracy: "Sometimes a justice would sit on a trials begin-
ning but not on a trial's ending. This sometimes happened when a trial was adjourned
to a later time. But someone always filled the absent justice's place." See Schwarz's
Gabriel's Conspiracy, 30.

17. Jack's trial, SCCMB, in Tragle, *Revolt*, 195–96, 197–98.

18. Nathan, Tom, and Davy's trial, SCCMB, in Tragle, *Revolt*, 200. Because this was a
court of oyer and terminer, the actions of the unidentified judge were not a mistake.
In a court of oyer and terminer, the judges are allowed to ask the witnesses questions.

19. In comparison, slaves condemned by the Southampton court were valued anywhere
from one hundred to six hundred dollars. There is little direct evidence about the
motivation of the defense lawyers. As will be discussed in the Chapter 7, Thomas
R. Gray was facing a financial crisis, so it seems that he may have been particularly
focused on the money, but that was clearly not the only inspiration for all the de-
fense lawyers. As the case of Boson demonstrates, at least one of the defense lawyers
felt a responsibility to accused slaves that was not connected to payment. Defense
attorney James S. French appeared as a witness in the case of Boson, but Boson
was nonetheless sentenced to be hanged. At the time, French did not believe the
charges, and when Sussex finally got around to carrying out the execution several
years later, French took the time to write the governor himself. Although French
thought that the citizens of Sussex were organizing their own petition, French
explained his petition to the governor, writing, "I could not forbear doing it
[i.e. petitioning] myself." See James S. French to Governor [Littleton W. Tazewell],
February 14, 1835, Executive Papers, Box January–April 1835, LV. The discussion of
Boson's case can be found at the end of this chapter.

20. Richmond *Constitutional Whig*, September 26, 1831, in Tragle, *Revolt*, 98. In four-
teen trials and hearings, Rochelle used some version of a statement that the defen-
dants were "heard." In eight trials and one hearing, Rochelle used the "fully heard"
formulation. See trials, SCCMB, in Tragle, *Revolt*, 177–228. The dependability of
Rochelle's account, even when he was using formulaic language, is supported by the
evidence from the one trial of which there exists a second account. Describing Nat
Turner's trial, Thomas R. Gray wrote, "The prisoner introduced no evidence, and
the case was submitted without argument to the court." In this case, Rochelle
omitted his comment that the defendant had been heard, simply writing, "The
Court after hearing the testimony and from all the circumstances of the case were
unanimously of opinion that the prisoner is guilty." Compare Gray, *The Confessions
of Nat Turner*, 20, to Nat Turner's trial, SCCMB, in Tragle, *Revolt*, 222.

21. Richmond *Constitutional Whig*, September 26, 1831, in Tragle, *Revolt*, 98; Jack's
trial, SCCMB, in Tragle, *Revolt*, 196. Usually when the court suspended a trial
Rochelle wrote something less revealing, such as in Hardy's trial, which was sus-
pended for "good cause." Thomas Barrow's Moses also had his trial continued,
although in this case it was clearly on a motion from his defense attorney, William
C. Parker. When the trial was resumed, he called two witnesses for the defense.

See Hardy's trial, SCCMB, in Tragle, *Revolt*, 202; Moses's trial, SCCMB, in Tragle, *Revolt*, 179.

22. Daniel's trial, SCCMB, in Tragle, *Revolt*, 178.

23. Jack's and Andrew's trials, SCCMB, in Tragle, *Revolt,* 180–82.

24. Ibid. In James Powell's quote, Henry Irving Tragle used "/and/" to signify interlineation, something I omit. Since Jack and Andrew were being tried for the exact same action, leaving the farm a second time, the second trial was an abbreviated version of the first. In Andrew's trial, Broadnax called the same two witnesses he had called in Jack's trial. In Rochelle's summary, the testimony against Andrew was remarkably close to the testimony against Andrew; in the case of the first two quotes in this paragraph, it was exactly the same. The difference between the trials was in French's defense. In Jack's trial, French called four witnesses to show that Jack had not been a committed revolutionary. In Andrew's trial, Rochelle noted no defense witnesses but did refer to French's closing argument, in which French may have rehashed the points that he had made only moments before to the exact same court. He acted as if Jack's sentence had been a victory and appealed to the court's sense of fairness to recommend that the governor also commute Andrew's sentence. Either moved by French's defense or unwilling to punish Andrew for his lawyer's shortcut, the court made the same recommendation for Andrew that it had made for Jack. In later cases, the court would combine trials for defendants accused on the same evidence, avoiding this potential problem.

25. Davy's trial, SCCMB, in Tragle, *Revolt*, 185–86.

26. Ibid.

27. For Waller's perspective, see the trials of Daniel, Sam (Nathaniel Francis), Hark, Dred, Sam (Peter Edwards), and Nat Turner, SCCMB, in Tragle, *Revolt,* 177–79, 191–93, 198–99, 217–19, 221–23. For Moses's perspective, see Moses's trial, SCCMB, in Tragle, *Revolt,* 220. For the account of holding the horses, see Richmond *Constitutional Whig*, September 3, 1831, also in Tragle, *Revolt*, 67. According to court records, Moses—like Turner—belonged to the estate of Putnam Moore. See December 19, 1831, SCCMB.

28. Waller's appearance for the defense in Sam's case meant that he joined Moses as the only witnesses who had been called by both the prosecutor and defense attorneys. Other witnesses also displayed notable modesty during their testimony. During Lucy's trial, Mary Barrow described how Lucy "held her for about a minute," but when asked why Lucy held her, Barrow responded that "she does not know certainly what her intentions were but thought it was to detain her." Likewise, at Sam's trial, Ben said he saw Sam with the rebels as they arrived on Newit Harris's farm. Ben added that Sam "had something which he does not know whether it was a gun or a stick." See trials of Lucy; Nathan, Tom, and Davy; Dred; and Sam, SCCMB, in Tragle, *Revolt*, 208, 200–201, 198, 218.

29. Nat's trial, SCCMB, in Tragle, *Revolt*, 196. Waller was the sole witness whose eyewitness testimony was the basis for two slaves' convictions; Moses was the only witness whose testimony was the basis for three slaves' convictions.

30. For "voluntary confession," see Davy's and Jack's trials, SCCMB, in Tragle, *Revolt*, 194, 196; Curtis's and Stephen's trials, SCCMB, in Tragle, *Revolt*, 187, 188 (quote); Moses's trial, SCCMB, in Tragle, *Revolt*, 220. Whites also made this claim in the trial of Nat Turner: James Trezvant claimed that "no threats or promises were held out to him [Nat Turner] to make any disclosures." See Nat Turner's trial, SCCMB, in Tragle, *Revolt*, 222.

31. For a discussion of the problems that can be created by relying on the testimony of people who themselves were accused of participating in a slave conspiracy, see Michael P. Johnson, "Denmark Vesey and His Co-Conspirators," *William and Mary Quarterly*, 3rd ser., 58 (October 2001), esp. 945–53, and J. William Harris, *The Hanging of Thomas Jeremiah: A Free Black Man's Encounter with Liberty* (New Haven: Yale University Press, 2009), 98, 141. For the witness whose testimony seems most likely to have been given in the hope of turning attention away from his own role in the revolt, see Henry's testimony in the trials of Hardy and Isham. Henry admitted that he had heard about the revolt Saturday night. Although he claimed not to have joined, he also failed to tell whites. This confession would have been enough to convict Henry as part of the conspiracy. As part of the effort to minimize the response, the court both refused to pursue Henry and only convicted Hardy and Isham after multiple witnesses confirmed other parts of Henry's account. The court recommended that the governor commute both Hardy and Isham's sentences. See Hardy's and Isham's trials, SCCMB, in Tragle, *Revolt*, 202–4.

32. Moses's trial, SCCMB, in Tragle, *Revolt*, 182–83; Nathan's trial, SCCMB, in Tragle, *Revolt*, 200. Interestingly, there were no jailhouse confessions reported from the dozens of suspected rebels held in the Southampton County jail presented in court.

33. Nathan's, Hark's, Lucy's, and Jack's trials, SCCMB, in Tragle, *Revolt*, 200, 192, 208, 197.

34. Sam's, Hark's, and Davy's trials, SCCMB, in Tragle, *Revolt*, 191, 192, 194, 195.

35. Moses's trial, SCCMB, in Tragle, *Revolt*, 182–83.

36. Ibid., 182–84. Although the handwriting is unclear, it appears that Drew's given name was spelled two different ways, Newt and Newit, in the trial records. While the defense's decision to call Hark backfired, it shows that defense attorneys did not avoid the testimony of accused slaves, as the prosecutor did. Defense witnesses included both the star witness, Moses, and Thomas Haithcock, one of the four free blacks who were tried.

37. Parker also made no defense in the case of Nat Turner. But these cases stand out as unusual. In a majority of his cases, Parker either got his client acquitted or a note of his actions as defense council—such as asking for a postponement, calling witnesses, making a closing statement—entered the record. In at least two of the five cases where there was no explicit mention of Parker's actions in the court records, it seems that this was because of abbreviated records. (In the trial of Edwin Turner's Nat, Parker likely cross-examined Mary Barrow on her identification of Nat, and in Isham's trial, Parker was able to get Isham the same recommendation of commutation that Hardy had just received when tried with much the same evidence.) As a

result, in only three of Parker's trials—those of Hark, Lucy, and Nat Turner him-self—is there not even indirect evidence of a defense. In any or all of the three trials, this could be because of faulty records, but since Thomas R. Gray noted that in Nat Turner's trial "the prisoner introduced no evidence, and the case was submitted without argument to the court," it seems more likely that, at least in the cases of Turner and Hark, Parker simply saw no point in trying to defend the admitted leaders of the revolt. See SCCMB, in Tragle, *Revolt*, 177–228; ("powder" from Hark's trial, SCCMB, in Tragle, *Revolt*, 192); Gray, *The Confessions of Nat Turner*, 20.

38. Disability was clearly a mitigating factor for the judges. In the case of Nathan, Tom, and Davy, the court was looking for a reason to recommend a commutation. For two of them it was their youth, while the court recommended mercy for the older one in part because he was "very badly grown." Nathan, Tom, and Davy's trial, SCCMB, in Tragle, *Revolt*, 201.

39. Matt's trial, SCCMB, in Tragle, *Revolt*, 209.

40. L. Minor Blackford, *Mine Eyes Have Seen the Glory: The Story of a Virginia Lady, Mary Berkeley Minor Blackford, 1802–1896, Who Taught Her Sons to Hate Slavery and to Love the Union* (Cambridge, MA: Harvard University Press, 1954), 26.

41. Information Against Jack and Shadrach, October 17, 1831, Box 95, SCCCJ, LV.

42. Of the forty-five slaves who were tried in Southampton, the court sentenced thirty to death, although, as will be discussed below, in eleven of those cases the court recommended that the governor reduce the death sentence to transportation. In one of these cases, the governor did not go along with the recommendation of the court, while two other convicted slaves had their death sentences commuted.

43. Nathan's, SCCMB, in Tragle, *Revolt,* 200. Another possibility is that the whites could have seen Nathan's trial lies to investigators as impeding the white response. If so, this could also explain why Lucy was the only woman who was sentenced to die, for she had told investigators "that she had fled through the kitchen and concealed herself in the cornfield," while Moses recalled seeing her "in the company with the insurgents at the door." Given the situation, however, it is likely that many people lied, including Nat Turner's wife, who did not turn over any of his papers until she was tortured. But there was no trial for impeding the investigations or lying to the court. In this, Turner's revolt was different from Gabriel's conspiracy, which did include slaves sentenced to receive thirty-nine lashes for lying to the court. See Lucy's trial, SCCMB, in Tragle, *Revolt*, 208; Schwarz, *Gabriel's Conspiracy*, 129, 131.

44. The willingness of the court to condemn Ben, the last slave tried, suggests that the Southampton trials did not have the same dynamic as those following Gabriel's conspiracy. In Richmond the legal process became more merciful over time, while in Southampton Ben was condemned even though he joined Billy Artis after the rebels had been dispersed. See Davy's trial, SCCMB, in Tragle, *Revolt*, 194–95, and Ben's trial, SCCMB, in Tragle, *Revolt*, 223, 227.

45. According to Michael L. Nicholls, Governor James Monroe sent to the state's treas-urer, William Berkeley, a letter asking him to ask attorney general Philip Norborne

Nicholas for advice on how to handle compensation claims, since the fund had run out. Nicholls notes that Peter, who was executed on October 24 despite being tried in a different county than the other conspiracy suspects, may have been the twenty-sixth and final slave executed for involvement in the conspiracy. Because Peter's records did not make it to Governor James Monroe, Peter lost his chance to have his sentence commuted, as Monroe would have almost certainly done. See Michael L. Nicholls, *Whispers of Rebellion: Narrating Gabriel's Conspiracy* (Charlottesville: University Press of Virginia, 2012), 106 and Appendix B, 156–59. For a broader survey of the history of transportation in Virginia, see Philip J. Schwarz, *Slave Laws in Virginia* (Athens: University of Georgia Press, 1996), 97–119.

46. See Nicholls, *Whispers of Rebellion*. While there is no written record from any slave who had been transported discussing the advantages and disadvantages of the commutation, one clear advantage was that slaves who were not executed had more opportunity to escape to freedom, something that happened to two of the first slaves who had their sentences commuted. According to a petition from the slave traders who had bought those who were to be transported from the state following Gabriel's conspiracy, two of the reprieved slaves were being transported along the Ohio River when they made their escape north into the Ohio Territory. See "Petition of John G. Brown and William Morris," December 24, 1801, in Schwarz, ed., *Gabriel's Conspiracy*, 234–35.

47. Nicholls notes that Monroe's thirteen pardons saved Virginia $4,572. The first person pardoned, Ben Woolfolk, was granted his pardon in return for his service as the state's best witness in the conspiracy trials, two weeks before the fiscal crisis led to the other pardons. See Nicholls, *Whispers of Rebellion,* 118, 25, 130, and Appendix B.

48. Virginia Constitution of 1830, www.wvculture.org/history/government/1830 constitution01.html. The constitutional provisions limiting the free action of the governor trace back to the original Virginia Constitution of 1776, and reflect the American revolutionaries' fear of executive power. John Floyd Diary, in Tragle, *Revolt,* 255.

49. Lucy's and Joe's trials, SCCMB, in Tragle, *Revolt,* 207–9; John Floyd Diary, in Tragle, *Revolt,* 255. It is unclear why John Floyd wanted to intervene in these cases. All of the people sentenced to die were, as Floyd described them, "of the insurgents," but if one goes by the evidence alone, Nathan would be the slave convicted without a recommendation of mercy who, based upon the information that had been sent to Floyd, had the weakest case presented against him. As a result, I suppose that Floyd may have intervened in this case because he was uncomfortable with his role in executing a woman who was on the periphery of the revolt.

50. In this pattern of granting reprieves, Governor Floyd followed the pattern of earlier Virginia governors, who usually followed the recommendations of the sentencing court. For the patterns of executive deference, see Nicholls, *Whispers of Rebellion*, 130. Jim and Isaac were sentenced to die, but they were not hanged. To be transported, as they were, they must have had their sentences commuted by the

governor, but I could not find why the governor did this. It is possible that the clerk, James Rochelle, left this recommendation out of the formal notes but included it in the copy of the records sent to the governor. Or it is possible that the governor commuted the sentences for some other reason. I find it unusual that the court did not recommend pardon for these two when later the same day the court heard even more damning evidence against Frank but recommended that the governor commute Frank's sentence. I will discuss these cases further below. See Jim and Isaac's trial and Frank's trial, SCCMB, in Tragle, *Revolt*, 214–17.

51. Gray, *The Confessions of Nat Turner*, 12; Jack's trial, SCCMB, in Tragle, *Revolt*, 196, 197.

52. Jack's trial, SCCMB, in Tragle, *Revolt*, 196, 197. Although Jack's owner was called William Reese in the trial, his full name was Joseph William Reese. See November 21, 1831, SCCMB, in Tragle, *Revolt*, 228.

53. Moses's trial, SCCMB, in Tragle, *Revolt*, 220–21; for the newspaper report on Moses, see Richmond *Constitutional Whig*, September 3, 1831, in Tragle, *Revolt*, 67.

54. The six include Catherine Whitehead's Jack and Andrew, whose trials have been already discussed. It is possible that my reading here is wrong. At their trials, James Powell testified that after they came to his house, he took Jack and Andrew "to the Cross Keys and [they] were taken into custody." On the other hand, Wallace testified that after the two had been to Mr. Powell's they returned to Catherine Whitehead's, took a horse, and rode off, most likely to Thomas Haithcock's. If James Powell was mistaken about what Jack and Andrew did after they left his farm, then Jack and Andrew may have been among the "four boys" who recruited for the rebels at Benjamin Edwards's farm. If that was the case, the fact that Broadnax did not call witnesses such as Henry or Hark who elsewhere testified about the recruiters' actions at Peter Edwards's farm would only strengthen my larger point in this chapter. See trials of Jack, Andrew, Hardy, and Isham, SCCMB, in Tragle, *Revolt*, 180–82, 202–204.

55. Hardy's and Isham's trials, SCCMB, in Tragle, *Revolt*, 201–203. Every witness in Isham's trial also appeared in Hardy's trial. The testimony in these cases was similar, but Hardy's trial includes more detail and an additional witness. It seems likely that Isham's trial was an abridged version of the Hardy's more thorough trial, although it is possible that the trials were similar and only the records were abridged.

56. Hardy's, Isham's, and Isaac's trials, SCCMB, in Tragle, *Revolt*, 201–4, 189–90. The rumor that the British had invaded may have just been panic and confusion, but it also may have referred to an old fear in Virginia that American slaves might ally with the British. From the time of Lord Dunmore's proclamation in 1775, which promised freedom to slaves who joined the British, the danger slaves posed to their masters increased when the British army was nearby. Following the Battle of Yorktown, the danger of such an alliance dissipated, but during the War of 1812, the worries about this alliance reappeared in Virginia. Given this history, the news of a British invasion, which was clearly wrong in 1831, may have spread because some

Virginians had already associated a British invasion with the danger of a slave insurrection. See John Fabian Witt, *Lincoln's Code: The Laws of War in American History* (New York: Free Press, 2012), 74. For more on the alliance between the British army and Virginian slaves, see Alan Taylor, *The Internal Enemy: Slavery and War in Virginia, 1772–1832* (New York: Norton, 2013).

57. Isaac's trial, SCCMB, in Tragle, *Revolt,* 189–90. Another account of Isaac's story can be found in the trial of Jacob, owned by G. H. Charleton, 1831, Box 95, SCCCJ, LV.

58. Isaac's trial, SCCMB, in Tragle, *Revolt,* 189–90.

59. Examination of Arnold Artis, SCCMB, in Tragle, *Revolt,* 199. Tragle transcribes Artis's name as "Artes."

60. One of the formal protections enjoyed by free blacks would be removed by the Virginia legislature in 1832, when, as part of a program to tighten restrictions after the revolt, it decided that free blacks accused of noncapital cases would have their cases heard by the courts of oyer and terminer. See Eva Sheppard Wolf, *Almost Free: A Story About Family and Race in Antebellum Virginia* (Athens: University of Georgia Press, 2012), 95–96.

61. Examination of Berry Newsom, SCCMB, in Tragle, *Revolt,* 211; Berry Newsom's trial, 1831, Box 95, SCCCJ, LV; Thomas C. Parramore, *Southampton County, Virginia* (Charlottesville: University Press of Virginia, 1978), 116.

62. Examination of Exum Artist, SCCMB, in Tragle, *Revolt,* 212; Exum Artist's trial, 1831, Box 95, SCCCJ, LV; Southampton County Tax list, 1832. For my discussion of the clash between Exum Artist and Burwell, see Chapter 4.

63. The notes on the examination of witnesses for Thomas Haithcock's trial were mistakenly filed in a folder listed as the trial of Sam, owned by James W. Parker, 1831, Box 95, SCCCJ, LV. Interestingly, the description of the unnamed wife's pleas comes not from the examination of Haithcock's wife but from the examination of his daughter.

64. Isham's trial, SCCMB, in Tragle, *Revolt,* 203–4; Southampton County Tax List, 1832.

65. For "crop[p]ed," see Frank's trial, SCCMB, in Tragle, *Revolt,* 215; "some eight or ten," *Richmond Compiler,* quoted in *Norfolk and Portsmouth Herald,* October 5, 1831. The *Richmond Compiler* expressed ambiguity about the timing of the meeting, suggesting both that the scheme had been under way for eighteen months and that the meeting may have been in August, but other sources agree that the meeting at Raccoon Swamp Meeting House took place in May 1831. See Jim and Isaac's trial, SCCMB, in Tragle, *Revolt,* 214, which also includes a version of the "cropped" quote; draft petition by George Blow, February 1835, Box 7, Blow Family Papers, College of William and Mary. The final version of the petition, which is in the Executive Papers, Littleton Tazewell, Box January–April 1835, LV, is slightly different from the draft in the Blow Papers at the College of William and Mary. In this case, I use the draft because Blow noted in the margin of the draft that the meeting in question was in May 1831.

66. *Richmond Compiler*, quoted in *Norfolk and Portsmouth Herald*, October 5, 1831; James S. French to Governor [Littleton W. Tazewell], February 14, 1835, Executive Papers, Box January-April 1835, LV; Jim and Isaac's trial, SCCMB, in Tragle, *Revolt*, 214; Frank's trial, SCCMB, in Tragle, *Revolt*, 214, 215.

67. Frank's trial, SCCMB, in Tragle, *Revolt*, 215–16. Beck's testimony was almost exactly the same in Jim and Isaac's trial, SCCMB, in Tragle, *Revolt*, 214.

68. Jim and Isaac's trial, SCCMB, in Tragle, *Revolt*, 214.

69. Beck claimed not to have understood the conspiring of slaves until the revolt made it clear to her what they were doing; Jim and Isaac's trial, SCCMB, in Tragle, *Revolt*, 214. Although Beck's own owner admitted that he believed that "she was disposed to tell the truth," some whites were skeptical about Beck's testimony against other slaves. After Beck testified in Sussex that Squire told her that "he meant to join" the rebels, Squire's defense attorney called seven witnesses, both white and black, who tried but failed to convince the Sussex court that Squire had not been in the kitchen where Beck claimed that he had been when he made the statement. Even if these witnesses were lying to save Squire and Beck's testimony was true, she probably misunderstood Squire's comment. At the time he made the comments, Squire and three other slaves were tasked with taking care of the Richmond troops' horses. As a result, the comment that he would join the rebels and even the assertion that the whites on the plantation "were not safe" seems to be less a factual statement by Squire than the boastings or dark humor of a slave who wanted another slave to know that he thought that the rebels were right, not that he was prepared to actually join the revolt. See trials of Solomon and Squire, September 13, 1831, Sussex County Order Book, 1827–35, LV.

70. *Richmond Compiler*, quoted in *Norfolk and Portsmouth Herald*, October 5, 1831. According to Gray's list of the slaves tried, Daniel was "Disch'd without trial." See Gray, *The Confessions of Nat Turner*, 22.

71. Solomon's trial, September 13, 1831, Sussex County Court Records, LV.

72. For "to murder the white people," see George Blow petition, Executive Papers, Littleton Tazewell, Box January-April 1835, LV. Sources suggest that Beck was the most important witness to appear in Sussex. According to the *Richmond Compiler*, "in Sussex five or six were convicted upon the same testimony," while George Blow's petition noted that "on her evidence *alone* nearly all the condemnations in Sussex were made." *Richmond Compiler*, quoted in *Norfolk and Portsmouth Herald*, October 5, 1831; George Blow petition, Executive Papers, Littleton Tazewell, Box January-April 1835, LV. Trial records from Sussex put Beck's testimony at the heart of at least five trials: those of Ned, Fed [?], Solomon, Boson, and Squire. See Sussex County Court Records. The problem with the condemnation of the slaves was clear at the time. One Privy Council member, when asked for his advice for the governor, noted that the specifics of the charges leveled against the convicted slaves had been brought by a slave whose testimony was "contradicted by the unimpeachable testimony of Mssrs. French and Broadnax." He believed that the men convicted were

inclined "to mischief," but that did not change the facts that the prosecutor had not proved "*advising, consulting* nor *conspiring....* Nothing is shewn but the declaration of an intention or will." See M Daniel (or McDaniel) to John Floyd, September 15, 1831, Executive Papers, LV. Emphasis in original.

73. Jim and Isaac's trial, SCCMB, in Tragle, *Revolt,* 214. The sentencing of Jim and Isaac has already been discussed, but because it is unclear who decided that the two should be recommended for mercy, it is hard to interpret their sentences. According to the court records, the Southampton court did not recommend the two for commutation, but in a later trial that same day with three of the same judges, Frank was recommended for commutation, even though he was the one who first threatened to crop his master. (Isaac and Jim then agreed to do the same.) If the court had intended to recommended the two for mercy, then their sentences could have fit in the sentencing pattern already established where people who promised to join the ongoing revolt but who were relatively far from the location of the rebellion, such as Hardy, Isham, and Isaac, were sentenced to death but recommended for mercy. On the other hand, if the court had sentenced Jim and Isaac to death and the governor acted on his own to intervene, then the sentence suggests that Jim and Isaac were being sentenced as rebels who had known about the revolt before the revolt began. The evidence is insufficient to settle this, but my sense is that court's pattern would have been to recommend Jim and Isaac for mercy.

74. See *Norfolk and Portsmouth Herald,* October 31, 1831. See also *Fredericksburg Political Arena,* November 1, 1831, in Tragle, *Revolt,* 132.

75. James S. French to Governor [Littleton W. Tazewell], February 14, 1835, Executive Papers, Box January-April 1835, LV. On the reward, see John Cargill, Sussex, to John Floyd, Richmond, October 22, 1831, Box September-October 1831, Executive Papers, LV.

76. James S. French to Governor [Littleton W. Tazewell], February 14, 1835, Executive Papers, Box January-April 1835, LV; Scot French, *The Rebellious Slave: Nat Turner in American Memory* (Boston: Houghton Mifflin, 2004), 61.

77. Draft of George Blow petition; George Blow petition.

78. Ibid.

79. Ibid.

CHAPTER 7

1. Moses's trial, SCCMB, in Tragle, *Revolt,* 220–21. For Moses's arrival in Richmond, see David F. Allmendinger, "The Construction of *The Confessions of Nat Turner,*" in *Nat Turner: A Slave Rebellion in History and Memory,* ed. Kenneth S. Greenberg (New York: Oxford University Press, 2003), 40.

2. Richmond *Constitutional Whig,* October 24, 1831; Gray, *The Confessions of Nat Turner,* 17. When James Hampden Pleasants published the reports on October 22, 1831, he was likewise uncertain about which was true. After multiple independent

reports informed Pleasants that Turner had been captured in Southampton, Pleasants still received reports that Turner had been seen in other places. Instead of printing one of these, Pleasants noted, "The Kanawha Banner has a long and minute account of the negro, supposed to be Nat Turner, who was drowned in the New River, from a late examination of the body clothing, &c. by Gen. Daniel Smith of that county. The certainty of the apprehension of Nat deprives it of all interest." Richmond *Constitutional Whig*, November 7, 1831.

3. Thomas R. Gray, *The Confessions of Nat Turner, the Leader of the Late Insurrection in Southampton, VA* (Baltimore, 1831), 17. For the time that Turner had been hiding in his first hiding place, see *Norfolk and Portsmouth Herald*, November 7, 1831.

4. "Hair breadth escapes," Gray, *The Confessions of Nat Turner*, 18; "five or six hundred," *Richmond Enquirer*, October 25, 1831; "about fifty men turned out" and reward size, *Richmond Enquirer*, November 8, 1831, in Tragle, *Revolt*, 136, 138; "fifteen yards," Richmond *Constitutional Whig*, November 3, 1831; "astonishment" and "a ham of bacon," Richmond *Constitutional Whig*, November 7, 1831; "hat" and "escaped being shot," *Norfolk and Portsmouth Herald*, November 4, 1831, in Tragle, *Revolt*, 134, although Tragle transcribed "shew" as "show."

5. "Almost incessantly," Gray, *The Confessions of Nat Turner*, 17; "miserable objects" and "ragged," *Richmond Enquirer*, November 8, 1831, in Tragle, *Revolt*, 136; "sweet potatoes" and lost shoes, Richmond *Constitutional Whig*, November 7, 1831.

6. William Sidney Drewry, *The Southampton Insurrection* (1900; repr., Murfreesboro, NC: Johnson Publishing, 1968), 90. Francis's story of Turner mulling his surrender is supported by accounts written at the time of Turner's capture, although one white who noted this then insulted Turner by saying that he "could never summon sufficient resolution!" The story that Turner was a coward was apparently common enough that Thomas R. Gray decided it would be one of the three points that he would contradict in the *Confessions*. See *Richmond Enquirer*, November 8, 1831, in Tragle, *Revolt*, 136; Gray, *The Confessions of Nat Turner*, 18.

7. "Could see nothing of him," *Richmond Enquirer*, November 8, 1831, in Tragle, *Revolt*, 138; "pile of fence rails," Gray, *The Confessions of Nat Turner*, 17; "fodder" and "ingeniously," Richmond *Constitutional Whig*, November 7, 1831.

8. Gray, *The Confessions of Nat Turner*, 17; Allen Crawford interviewed by Susie R. C. Byrd, *Weevils in the Wheat: Interviews with Ex-Virginia Slaves*, ed. Charles L. Perdue Jr., Thomas E. Barden, and Robert K. Phillips (Charlottesville: University Press of Virginia, 1992), 76. It is possible that the black oral tradition was less confused that it appears at first glance. Turner's late mistress, Sally Francis Moore Turner, was the sister of Nathaniel Francis, so one possibility is that Turner was given food by slaves who belonged to his late mistress's brother.

9. "Slight motion," "raised his gun," "old sword," "the least resistance," "securely tied," *Richmond Enquirer*, November 8, 1831, in Tragle, *Revolt*, 135; "act of reconnoitering," *Norfolk and Portsmouth Herald*, November 4, 1831, in Tragle, *Revolt*, 134; "some

brushwood," "Captain was concealed," Richmond *Constitutional Whig*, November 7, 1831; "the woods were full of men," Gray, *The Confessions of Nat Turner*, 18; "nearly a mile alone," *Richmond Enquirer*, November 15, 1831, in Tragle, *Revolt*, 139.

10. *Norfolk and Portsmouth Herald*, November 4, 1831, in Tragle, *Revolt*, 134; Drewry, *The Southampton Insurrection*, 94, 95 n. 1; Allen Crawford interview, 76. Historians have argued that WPA interviewees spoke more freely and honestly to black interviewers than to white interviewers about many things, including "their admiration of Nat Turner." If this is true, this makes the story that Allen Crawford told Susie Byrd, a black interviewer, even more interesting. See John W. Blassingame, "Using the Testimony of Ex-Slaves: Approaches and Problems," in *The Slave's Narrative*, ed. Charles T. Davis and Henry Louis Gates Jr. (New York: Oxford University Press, 1984), 78–98 ("admiration" on 91).

11. Drewry, *The Southampton Insurrection*, 93.

12. Richmond *Constitutional Whig*, November 4, 1831. Drewry described the celebration at Edwards's as a "feast." Drewry also claims that Phipps took Turner to David Westbrook's for the night, but one of the earliest accounts said that "Mr. P took Nat to his own residence, where he kept him until Monday morning." This letter was also the one that noted "a considerable party accompanied him and his prisoner to Jerusalem." See Drewry, *The Southampton Insurrection*, 93–94; *Richmond Enquirer*, November 8, 1831, in Tragle, *Revolt*, 135. The time Turner arrived in Southampton was noted by Southampton's postmaster, Theodore Trezvant, in an October 31, 1831, letter. See *Richmond Enquirer*, November 8, 1831, in Tragle, *Revolt*, 132. Phipps lived near Newit Harris and Levi Waller. The 1830 census taker visited only six houses after Harris's before he arrived at Phipps's. Levi Waller's house was eight doors past Phipps's. See Southampton County Census, 1830, 263. For the requirements to collect the reward, see Governor's Proclamation, Executive Papers, LV, in Tragle, *Revolt*, 421–23.

13. Governor's Proclamation; 421–23; *Richmond Enquirer*, November 8, 1831, in Tragle, *Revolt*, 136; Nat Turner's trial, SCCMB, in Tragle, *Revolt*, 222. Parker, who took part in fifteen trials, was the fourth-most-active judge; Trezvant, who took part in twenty-three trials, was the most active judge.

14. "Every question," *Richmond Enquirer*, November 8, 1831, in Tragle, *Revolt*, 132; "seems quite communicative," *Richmond Enquirer*, November 15, 1831, in Tragle, *Revolt*, 139; "willing to answer any questions," Richmond *Constitutional Whig*, November 7, 1831; "very free," *Norfolk and Portsmouth Herald*, November 4, 1831, in Tragle, *Revolt*, 134. One letter called the initial hearing "a brief examination," but since multiple different letters, including accounts that were much more specific, described the meeting as thorough, and since James Trezvant, the committing magistrate, was called as the witness who could tell the court what Turner had said at this examination, the report that the meeting was brief seems mistaken. See *Richmond Enquirer*, November 15, 1831, in Tragle, *Revolt*, 139.

15. "Late insurrection," "full and free," "without being questioned," Gray, *The Confessions of Nat Turner*, 7, 3, 7; "voluntary confession," *Richmond Enquirer*, November 8, 1831, in Tragle, *Revolt*, 138.

16. *Richmond Enquirer*, November 8, 1831, in Tragle, *Revolt*, 138. It is unclear which of the four free blacks who were in jail Turner was speaking to. If Turner was speaking to Thomas Haithcock, the one free black who had found Turner during the revolt, then Haithcock's ultimate discharge would only add to the evidence that whites were using the trials to try to minimize the involvement of blacks in the revolt. If Turner was speaking to Berry Newsom, this might help explain Newsom's relatively harsh punishment, although it would leave a question of why the courts did not produce better evidence against Newsom.

17. *Norfolk and Portsmouth Herald*, November 4, 1831, in Tragle, *Revolt*, 134–35; Gray, *The Confessions of Nat Turner*, 11. Gray concluded that the revolt was "the offspring of gloomy fanaticism." See Gray, *The Confessions of Nat Turner*, 5. For two examples of the biblical basis for the inscrutability of Providence, see Isaiah 55:8–9 and Romans 11:33.

18. Richmond *Constitutional Whig*, November 7, 1831; Gray, *The Confessions of Nat Turner*, 18.

19. Thomas C. Parramore, *Southampton County, Virginia* (Charlottesville: University Press of Virginia, 1978), 105–107, and 250–51n.; Allmendinger, "The Construction of *The Confessions of Nat Turner*," 26–27; Scot French, *The Rebellious Slave: Nat Turner in American Memory* (Boston: Houghton Mifflin, 2004), 46; SCLP, December 16, 1811. Unless otherwise identified, all references to Gray are to the author/son.

20. Draft of the will of [Captain] Thomas Gray, Cocke Family Papers, University of Virginia; Parramore, *Southampton County*, 105. On Captain Thomas Gray's age, see *Fredericksburg Virginia Herald*, November 2, 1831. While I do not know how common such estate planning strategies were in the 1830s, in 1839 the Mississippi legislature passed a landmark law that allowed women to hold property after marriage. This law allowed families to shield familial property from the husbands' creditors. Unless otherwise identified, all references to Gray are to the author/son.

21. Gray, *Confessions of Nat Turner*, quotes on 19, 11, 18. In addition to the parenthetical insertions of Turner's answers to Gray's unrecorded questions, Gray also added parenthetical comments in his own voice to the text. Some of these were mere editorials, such as when he noted that the rebels' policy of killing the young and women "was invariably adhered to." He also used parenthetical insertions to correct mistakes in Turner's account, such as when Turner noted that the rebels thought they had killed two whites in the encounter at Parker's field and Gray informed his readers that "they were not killed." Gray, *Confessions of Nat Turner*, 12, 15. For a discussion of the interpretative significance of Gray's insertions, which among other things suggests that Gray actually transcribed Turner's confessions, see the Afterword to this book.

22. The arguments about the difficulty in approaching Turner as an honest narrator of his own confessions has been clearly identified in Eric J. Sundquist, *To Wake the Nations: Race in the Making of American Literature* (Cambridge, MA: Harvard University Press, 1993), esp. 43; Kenneth S. Greenberg, "*The Confessions of Nat Turner*: Text and Context," in *The Confessions of Nat Turner and Related Documents*, ed. Kenneth S. Greenberg (Boston: Bedford Books, 1996), 11. For a terrific book on the manipulations of an autobiography by another icon in African American history, see Manning Marble, *Malcolm X: A Life of Reinvention* (New York: Viking, 2011). For another thought-provoking book that approaches this question from a more theoretical angle, see Michel-Rolph Trouillot, *Silencing the Past: Power and the Production of History* (Boston: Beacon Press, 1995).

23. Richmond *Constitutional Whig*, November 7, 1831. It is worth noting that the other leading rebels had all been killed before Turner was captured, so Turner and the other rebels had no opportunity after they were captured to make sure that their stories were consistent.

24. *Norfolk and Portsmouth Herald*, November 4, 1831, in Tragle, *Revolt*, 134; *Richmond Enquirer*, November 8, 1831, in Tragle, *Revolt*, 132, 137. Interestingly, while the correspondent to the *Norfolk and Portsmouth Herald* thought Turner was insane, he dismissed the specifics that Turner provided as of little import but did not question the reliability of Turner's account.

25. Gray, *The Confessions of Nat Turner*, 3, 18.

26. Ibid., 18.

27. Nat Turner's trial, SCCMB, in Tragle, *Revolt*, 221–23; Gray, *The Confessions of Nat Turner*, 5; Daniel W. Crofts, *Old Southampton: Politics and Society in a Virginia County, 1834–1869* (Charlottesville: University Press of Virginia, 1992), 12. Alexander P. Peete was the only one of the seven most active judges who did not judge this case.

28. Nat Turner's trial, SCCMB, in Tragle, *Revolt*, 221.

29. Ibid., 221–22.

30. Ibid., 222; Gray, *Confessions of Nat Turner*, 20. The discrepancies between Gray's account of the trials and the official records have led some historians to discount Gray's account. In the Afterword of this book, I argue that consistency between Gray's account of the trial and the official records makes it likely that Gray's manuscript of Turner's confessions was read by Trezvant to the court. Broadnax could have called Gray to testify. As early as the first day of Turner's interview with Gray, others in Southampton were deferring to Gray as the source on Nat Turner. For example, one person "who had intended to enter into further particulars, and indeed to have given you a detailed statement of his [Turner's] confessions," heard that Gray "is engaged in taking them down" and decided "I will not therefore forestall him." See *Richmond Enquirer*, November 8, 1831, in Tragle, *Revolt*, 137.

31. Gray, *Confessions of Nat Turner*, 20–21; Nat Turner's trial, SCCMB, in Tragle, *Revolt*, 221–23.

32. *Norfolk and Portsmouth Herald*, November 14, 1831, in Tragle, *Revolt*, 140; *Petersburg Intelligencer*, November 15, 1831, in French, *The Rebellious Slave*, 50.

33. *Norfolk and Portsmouth Herald*, November 14, 1831, in Tragle, *Revolt*, 140. For examples of early historian who accepted the story of whites giving doctors Turner's body, see Drewry, *The Southampton Insurrection*, 102, who reported that Turner's "body was delivered to the doctors," and John W. Cromwell, "The Aftermath of Nat Turner's Insurrection," *Journal of Negro History* 5 (1920), 218, who reported that Turner's body "was given over to surgeons for dissection." For a discussion of the relationship of Virginia's medical community to blacks, see Todd Savitt, *Medicine and Slavery: The Diseases and Health Care of Blacks in Antebellum Virginia* (Urbana: University of Illinois Press, 1978), 290. For a contemporaneous discussion of grave robbing, see Richmond *Constitutional Whig*, March 2, 1832. This issue was a persistent problem in southern Virginia. Twenty years after Turner's revolt, a graverobbing organization had been set up in Norfolk. Lewis W. Minor, a doctor at the Norfolk Naval Yard Hospital, arranged for Thomas White to steal recently buried cadavers and send them (packed in bran) to Charlottesville. The criminal activity was uncovered when the barrel holding the corpse of Daniel Stubbs, a free black man, was improperly addressed. See Tommy L. Bogger, *Free Blacks in Norfolk Virginia, 1790–1860: The Darker Side of Freedom* (Charlottesville: University of Virginia Press, 1997), 129–31.

34. Drewry, *The Southampton Insurrection*, 102; Cromwell, "The Aftermath of Nat Turner's Insurrection," 218. For the reports of the fate of Turner's body, see Kenneth S. Greenberg, "Name, Face, Body," in *The Confessions of Nat Turner and Related Documents*, ed. Kenneth S. Greenberg (Boston: Bedford Books, 1996), 18; French, *The Rebellious Slave*, 278–82.

35. *Norfolk and Portsmouth Herald*, November 14, 1831, in Tragle, *Revolt*, 140; *Liberator*; December 3, 1831; Greenberg, "Name, Face, Body," 19. According to the comment in the *Liberator*, there were actually three reasons to think that Nat Turner did not sell his body: first, "a slave cannot make a bargain nor own anything. In the next place it is the policy of the Southern press to make the black race appear despicable. In the third place the fact is totally inconsistent with the heroism with which he met death." While I tend to agree with Garrison's judgment of the often racist southern press, it is not the case that everything they printed about blacks was wrong. Garrison's other arguments based upon ownership and the way heroes think about their bodies after their deaths are much weaker arguments.

36. *Richmond Enquirer*, October 22, 1831. See also *Norfolk and Portsmouth Herald*, October 26 and November 14, 1831, the latter of which is in Tragle, *Revolt*, 140. One way to imagine a sane Turner actually giving his body away for ginger cakes is if Turner believed that whites would do with his body as they wished whatever he said, in which case he could have simply decided that getting ginger cakes was better than not getting ginger cakes. Of course, imagining this possibility does not preclude the possibility that the report was wrong.

37. Gray, *Confessions of Nat Turner*, 19–21.

38. Ibid., 3–6, 22–23.

39. Gray, *The Confessions of Nat Turner*. In 1831, Alexandria was a part of the District of Columbia. It was retroceded to Virginia in 1846.

40. Parramore, *Southampton County*, 119; John A. Chandler to John Young Mason, December 6, 1844, Mason Family Papers, Virginia Historical Society.

CHAPTER 8

1. Daniel W. Crofts, *Old Southampton: Politics and Society in a Virginia County, 1834–1869* (Charlottesville: University Press of Virginia, 1992), xi.

2. Ibid., 90–91; Stephen B. Weeks, *Southern Quakers and Slavery: A Study in Institutional History*, Johns Hopkins University Studies in Historical and Political Science, vol. 15 (Baltimore: Johns Hopkins Press, 1896), 84–85. For a description of the Quaker encounter with slavery in the North, see Jean R. Soderlund, *Quakers and Slavery: A Divided Spirit* (Princeton: Princeton University Press, 1985).

3. J. Stephen Kroll-Smith, "Transmitting a Revival Culture: The Organizational Dynamic of the Baptist Movement in Colonial Virginia, 1760–1777," *Journal of Southern History* 50 (1984): 555 n. 20; Carlos R. Allen Jr., ed., "David Barrow's Circular Letter of 1798," *William and Mary Quarterly*, 3rd ser. 20 (1963): 445; Minute Book of Black Creek Baptist Church, 1774–1804, November 24, 1786, Virginia Baptist Historical Society (henceforth VBHS); Jewel L. Spangler, "Becoming Baptists: Conversion in Colonial and Early National Virginia," *Journal of Southern History* 67 (2001): 259; Minutes of the General Committee, 1790, quoted in Charles F. Irons, *The Origins of Proslavery Christianity: White and Black Evangelicals in Colonial and Antebellum Virginia* (Chapel Hill: University of North Carolina Press, 2008), 69. For more on David Barrow, see also Vivien Sandlund, "'A Devilish and Unnatural Usurpation': Baptist Evangelical Ministers and Antislavery in the Early Nineteenth Century, A Study of the Ideas and Activism of David Barrow," *American Baptist Quarterly* 13 (1994): 262–77; James David Essig, "A Very Wintery Season: Virginia Baptists and Slavery, 1785–1797," *Virginia Magazine of History and Biography* 88 (1980): 170–85; and James D. Essig, *The Bonds of Wickedness: American Evangelicals Against Slavery, 1770–1808* (Philadelphia: Temple University Press, 1982), 74–78.

4. Spangler, "Becoming Baptists," 261; Crofts, *Old Southampton*, 92; Thomas C. Parramore, *Southampton County, Virginia* (Charlottesville: University Press of Virginia, 1978), 52–53; 1 Corinthians 1:10. In her study, Spangler compellingly makes the point about the tenacity of proslavery religion, even at Black Creek Baptist Church. More broadly, Sylvia R. Frey looks at how in the post-Revolutionary era whites accepted a version of Christianity that was able to strengthen slavery. See Sylvia R. Frey, *Water from the Rock: Black Resistance in a Revolutionary Age* (Princeton: Princeton University Press, 1991), esp. 243–83.

5. Minute Book of Black Creek Baptist Church, 1818–1862, September 1827, VBHS. See also Parramore, *Southampton*, 62–64; Crofts, *Old Southampton*, 92–93, Essig, "A Very Wintery Season," 74–78.

6. Minute Book of Black Creek Baptist Church, 1818–1862, September 1826, March 1826, September 1827; Crofts, *Old Southampton*, 92–93; Parramore, *Southampton*, 62–64. See also W. Harrison Daniel, "Virginia Baptists and the Negro in the Antebellum Era," *Journal of Negro History* 56 (1971): 6. The clerk, Carr Bowers, added the two words "brotherly and" after he had composed the original draft of the minutes. He also added the word "unanimously" with emphasis, suggesting that the newly added word was not simply a procedural addendum.

7. Virginia Portsmouth Corresponding Letter, May 1832, *Portsmouth Association Minutes, 1801–1840*, VBHS. Most of this letter, including this concluding question, was also quoted in Randolph Ferguson Scully, *Religion and the Making of Nat Turner's Virginia: Baptist Community and Conflict, 1740–1840* (Charlottesville, VA: University of Virginia Press, 2008), 222–23. After the revolt, some whites blamed in part preachers, who "fill[ed] their discourses with a ranting cant about equality." See Richmond *Constitutional Whig*, September 26, 1831. For speculation about the possible authorship of this article, including the possibility that this remark may have been a direct comment upon the Lankford debate, see my Afterword.

8. Minute Book of Black Creek Baptist Church, 1818–1862, September 1831–April 1832.

9. Ibid., January 1832–April 1832. In the report written on the Jonathan Lankford episode, Carr Bowers noted that while the church always contained slaveholders, a "small majority was non slave holders." See the church's Minute Book for September 1827. Although southern Virginia's Baptist churches were much more democratic than Southampton's government, this power was not shared across racial lines.

10. Southampton County Census, 1830; Minute Book of Black Creek Church, 1818–1862, March 1827, June 1827, September 1827, October 1826. The committee initially included Bowers, Griffith, and the new minister, Robert T. Daniel. Daniel wisely begged off the committee that was writing the report that had expelled his predecessor, and two church members replaced him. Crofts also notes the role played by Bowers in this episode; see Crofts, *Old Southampton*, 93. Benjamin Griffith served as a judge on three trials and the evidentiary hearing for Arnold Artis. Griffith also was the tax collector in Nottoway Parish in the 1820s.

11. Antioch [or Raccoon Swamp] Baptist Church, Minute Book, 1772–1837, October 30, 1831, VBHS; George Blow to Governor [Littleton Waller Tazewell], February 1835, Blow Family Papers, College of William and Mary. Another slave, Williamson's Isaac, also had his name in the church minute book, although tears make the entry illegible. Like William Archer, whose entry immediately preceded his, Isaac could have been accused of taking part in the revolt, although it is also possible that he was like Atkinson's Austin, whose entry was next, censured for a common infraction against church discipline (Austin was censured for theft). For David Barrow's

connection to the church, see E. M. Morrison, *Isle of Wight County, 1608–1907: A Brief History of Isle of Wight County, Virginia* (1907), http://tdcweb.com/tdfhs/histories/islewight/islewight16.htm, accessed May 26, 2014.

12. Antioch [or Raccoon Swamp] Baptist Church, Minute Book, 1772–1837, November 12, 1831.

13. Ibid., October 30, 1831; *Portsmouth Association Minutes, 1801–1840*, May 1832. French reads the rejection of Beck's testimony entirely as a function of society shaping memory. French remains steadfastly agnostic on whether blacks at Antioch knew about Nat Turner's revolt in advance. See Scot French, *The Rebellious Slave: Nat Turner in American Memory* (Boston: Houghton Mifflin, 2004), 37–41, 60–64.

14. Minute Book of Mill Swamp Baptist Church, 1812–1840, October 1, 1831. For the reference to the "coloured members" and "their meeting house," see ibid., June 2, 1832. A letter from Mill Swamp Baptist Church to the Portsmouth Association also noted that "coloured persons are not permitted to attend our Regular Church Meetings." *Portsmouth Association Minutes*, 1801–1840, May 1832. For another example of racially divided churches in Virginia, see James Lindsay Smith's *The Autobiography of James L. Smith* (Norwich, CT, 1881), http://docsouth.unc.edu/neh/smithj/smithj.html, 31. Smith recalled how in his Northern Neck church there were essentially two separate services under one roof: "The white people occupied the part next to the altar, while the colored people took the part assigned them next to the door, where they held a protracted meeting among themselves. Sometimes, while we were praying, the white people would be singing, and when we were singing they would be praying; each gave full vent to their feelings, yet there was no discord or interruption with the two services." Smith escaped slavery in 1838.

15. Minute Book of Mill Swamp Baptist Church, 1812–1840, March 2, 1832. For the Portsmouth Association's prohibition of black preachers, see *Portsmouth Association Minutes*, 1801–1840, May 1832. This recommendation was made by Mill Swamp Baptist Church and was adopted unanimously. The General Assembly passed a law against black preachers as the first part of an omnibus bill on slaves and free blacks. See *Journal of the House of Delegates of the Commonwealth of Virginia Begun and Held at the Capitol, in the City of Richmond, on Monday, the Fifth Day of December, 1831* (Richmond, 1832), 3.

16. Minute Book of Mill Swamp Baptist Church, 1812–1840, March 2, 1832 (including the "considerable debate" quote), June 2 and August 31, 1832. Immediately after the debate over the black members ended at the quarterly meeting in June 1832, the church decided to "dispense with Communion on next Sabbath." Nothing in the church notes explained the reason for this, but it seems possible that the unsettled questions about the church's black members prevented the church from coming together in communion.

17. Ibid., June 2, 1832 (quote); on Holleman's role in this debate, see ibid., October 1, 1831, and March 2, 1832.

18. Ibid., June 2, 1832.

19. Ibid.

20. Ibid., August 31, 1832.

21. Ibid. For the revolutionary tradition of the Baptists segregating themselves from the world, see Rhys Isaac, *The Transformation of Virginia, 1740–1790* (New York: Norton, 1988) and Donald G. Mathews, *Religion in the Old South* (Chicago: University of Chicago Press, 1977), esp. 56–58. Peter Butler, who was censured by Black Creek Baptist Church in February 1778 for "rejecting civil authority," is an example of a Southampton Baptist disciplined for not obeying the laws. See Spangler, "Becoming Baptists," 257.

22. Minute Book of Mill Swamp Baptist Church, 1812–1840, August 31, 1832.

23. Ibid.

24. Frederick Douglass, *My Bondage and My Freedom* (New York: Arno Press, 1968), 350, 353, 351. For a discussion of how southern evangelicals imbued the communion service with intense symbolic significance, see Christine Leigh Heyrman, *Southern Cross: The Beginnings of the Bible Belt* (Chapel Hill: University of North Carolina Press, 1998), 101. Thanks to my friend and colleague Dana Dillon for reminding me that Douglass's objection to the church in New Bedford focused specifically on the church's segregated communion practices.

25. Mill Swamp Church Minute Book, 1812–1840, Nov. 30, 1832, Apr. 6, 1833, Nov. 29, 1833; 1 Corinthians 1:10. Interestingly, Josiah Holleman was not among the ten who left the church. At a Southern Historical Association Conference, where I presented an early version of this work, Randolph Scully gently pointed out that I had missed the denouement of the debate on black church membership at Mill Swamp. Darlene Slater Herod of the Virginia Baptist Historical Society provided transcripts of the minutes that I had missed.

CONCLUSION

1. Kenneth S. Greenberg, ed., *The Confessions of Nat Turner and Related Documents* (Boston: Bedford Books, 1996), 31.

2. C. Vann Woodward is the most important historian who challenged other historians to look for continuities in the South even after the abolishment of slavery. For a recent brief in favor of contextualization in one's understanding of slavery, see Brett Rushforth, "Making Slavery in New France," *Common-place* 14 (Summer 2014). See also Brett Rushforth, *Bonds of Alliance: Indigenous and Atlantic Slaveries in New France* (Chapel Hill: University of North Carolina Press, 2012).

3. I have been influenced by the way that Joseph C. Miller conceptualizes his opposition to modern slave studies. See *The Problem of Slavery as History: A Global Approach* (New Haven: Yale University Press, 2012), esp. 18–29.

4. Most recently, Edward E. Baptist integrates the story of slavery into the story of national development. See *The Half Has Never Been Told: Slavery and the Making of American Capitalism* (New York: Basic Books, 2014).

AFTERWORD

1. Thomas R. Gray, *The Confessions of Nat Turner, the Leader of the Late Insurrection in Southampton, VA* (Baltimore, 1831), 4, 19.

2. Richmond *Constitutional Whig*, September 26, 1831, in Tragle, *Revolt*, 90. See also the trial records, SCCMB, in Tragle, *Revolt*, 173–245. For examples of scholars attributing this letter to Gray, see David F. Allmendinger, "The Construction of *The Confessions of Nat Turner*," in *Nat Turner: A Slave Rebellion in History and Memory*, ed. Kenneth S. Greenberg (New York: Oxford University Press, 2003), 33; Greenberg, ed., *The Confessions of Nat Turner and Related Documents* (Boston: Bedford Books, 1996), 78. The letter to the *Whig* was dated September 17, 1831, but it seems that at the same time Thomas R. Gray may have been suffering from a serious illness, perhaps a version of the same disease that killed his father sometime between September 6 and 19, 1831. Allmendinger found doctor's bills for visits to a Thomas Gray for each day from September 12 to 20, 1831. He argued that since Gray's father's will was probated on September 19, 1831, those visits must have been to attend to the son. This inference would also explain why Gray did not make any appearances in court in either Sussex or Southampton at any point in September after the sixth of that month. If Allmendinger is correct that Thomas R. Gray was the patient—which is certainly a possibility—this illness would further reduce the likelihood that Gray authored the letter. See Allmendinger, "The Construction of *The Confessions of Nat Turner*," 35, 256 n. 50.

3. Allmendinger, "The Construction of *The Confessions of Nat Turner*," 33 (Allmendinger noted the differences in the spellings of names on the list); Richmond *Constitutional Whig*, September 26, 1831, in Tragle, *Revolt*, 90 ("*ranting cant*," though Tragle does not italicize "ranting cant," as the original article did), 95 ("passing tribute"), 96 ("defence of their master"); Gray, *The Confessions of Nat Turner*, 4; Kenneth S. Greenberg, "*The Confessions of Nat Turner*: Text and Context," in *The Confessions of Nat Turner and Related Documents*, ed. Kenneth S. Greenberg (Boston: Bedford Books, 1996), 9. See also the trial records, SCCMB, in Tragle, *Revolt*, 173–245; Allmendinger, "The Construction of *The Confession of Nat Turner*," 33. Another suggested similarity between the two accounts, on closer inspection, also suggests that Gray did not write the letter to the *Richmond Constitutional Whig*. One of the characteristics that the writer of the letter in the *Constitutional Whig* and Gray shared, according to David F. Allmendinger Jr., is that they both "ridiculed the notion of a general conspiracy from beginning to end." A closer reading of the *Confessions*, especially Gray's account of his persistent questions to Turner about the connection of his revolt to the reports from North Carolina, suggests that Gray did not dismiss these reports, even after taking down Turner's *Confessions*. See Allmendinger, "The Construction of *The Confessions of Nat Turner*," 35; Gray, *The Confessions of Nat Turner*, 18. Absent some additional evidence, it is impossible to assign authorship of the September 26, 1831, article except to say that it was probably written by someone who was busy at the court: one of the most active judges, the lawyers, or even the Rochelle brothers.

Still, the concern with white preachers is suggestive. After all, it is something one would not be surprised to see from Carr Bowers, Benjamin Griffith, or someone else involved in the Jonathan Lankford debate at Black Creek Baptist Church. See Chapter 8.

4. Scot French, *The Rebellious Slave: Nat Turner in American Memory* (Boston: Houghton Mifflin, 2004), 47; *Richmond Enquirer*, November 8, 1831, in Tragle, *Revolt*, 137; Gray, *The Confessions of Nat Turner*, 3. Although Daniel Fabricant's claim that "the letter's language and the circumstances it recounts tract that of the *Confessions* almost verbatim" is overstated, there are striking similarities between the letter and Gray's letter appended to the opening of the *Confessions*. Five times the letter and the *Confessions* have at least three of the same words strung together in the same order: "in a cave near the residence of his late owner," "a small light sword," "a shot gun well charged," "the operations of [a/his] mind," and "the first blow." Twice it has phases that share three of four words: "which he [immediately] surrendered," and "a [more] gloomy fanatic." As strong as these similarities are, there are also real differences between the accounts. For example, both accounts mentioned that Benjamin Phipps captured Turner, but only the anonymous letter noted that Phipps was poor. Likewise, the letter writer compared Nat Turner's appearance to the description included in Governor Floyd's proclamation, which announced a reward for Turner's capture. Gray never mentioned the description that had been contained within the proclamation. The anonymous author also noted specific physical characteristics, such as Turner's eyes, which Gray failed to mention. Even when describing characteristics that both included, their language sometimes differed sharply: the Southampton correspondent described Turner as "of a darker hue" than he expected. (The governor's proclamation described Turner as having a "bright complexion, but not a mulatto.") Gray, in contrast, described Turner simply as having "the true negro face." When the Southampton correspondent and Gray discussed Turner's motivations, both saw him as inspired by a religious fanaticism, but the details that each included about Turner's religion differed. In the introduction to the *Confessions*, Gray was vague, but the anonymous correspondent had several specifics about Turner's religion, including the astounding claim that among Turner's powers was "controlling the weather," something not mentioned in Gray's pamphlet. In addition to the differences in details, the letter writer and Gray also came away from their interviews with the rebel leader with different ideas of how much the testimony had clarified about Turner and the rebellion. According to the correspondent, Turner's account of his religious motivations "alway[s] seemed to mystify." Gray, on the other hand, did not see Turner as mysterious. In fact, Turner was the one who could resolve the mysteries that surrounded the rebellion. "Every thing connected with this sad affair was wrapt in mystery, until Nat Turner...was captured." Given the differences between the accounts, a possible explanation for the similarities in these short phrases is that the phrases had been in currency among the crowd that went to see Turner examined. See Daniel S. Fabricant, "Thomas R. Gray and

William Styron: Finally, a Critical Look at the 1831 *Confessions of Nat Turner*,"
American Journal of Legal History 37 (July 1993): 344–45; *Richmond Enquirer*,
November 8, 1831, and "Governor Floyd's Proclamation," September 17, 1831, both
in Tragle, *Revolt*, 137, 422; Gray, *The Confessions of Nat Turner*. The letter that was
published in the *Richmond Enquirer* on November 8, 1831, was also published on
November 5, 1831 in the *Richmond Compiler*. See French, *The Rebellious Slave*, 47,
314 n. 33.

5. *Richmond Enquirer*, November 8, 1831, in Tragle, *Revolt*, 137. The original news-
 paper article omitted the *r* in "understand"; Tragle silently corrected the typo. This
 letter was not the only one that endorsed Gray as Turner's amanuensis. See also
 Richmond *Constitutional Whig*, November 7, 1831, which noted that Turner "is
 making a full confession of the motives which prompted, and the means by which
 he carried his plans into operation to Thomas R. Gray, who is taking them down
 and will publish them shortly."

6. Gray, *The Confessions of Nat Turner*, 20; Greenberg, "The *Confessions of Nat Turner*:
 Text and Context," 13. For other examples of scholars who attack Gray based upon
 the trial record, see Henry Irving Tragle, "Styron and His Sources," *Massachusetts
 Review* 11 (1970), reprinted in Tragle, *Revolt*, 405–6; Fabricant, "Thomas R. Gray
 and William Styron," 343–46. In Tragle's quotation from the *Confessions*, Tragle
 spelled "Trezvant" with an *e* between the *z* and the *v*, which is one of the ways
 Trezvant's name was spelled. I follow the 1831 edition of the *Confessions*, which spells
 "Trezvant" with only one *e*.

7. Gray, *The Confessions of Nat Turner*, 20–21; Nat Turner's trial, SCCMB, in Tragle,
 Revolt, 222–23.

8. Gray, *The Confessions of Nat Turner*, 21; Nat Turner's trial, SCCMB, in Tragle,
 Revolt, 223.

9. Gray, *The Confessions of Nat Turner*, 20–21; Nat Turner's trial, SCCMB, in Tragle,
 Revolt, 222–23.

10. Nat Turner's trial, SCCMB, in Tragle, *Revolt*, 223; Gray, *The Confessions of Nat Turner*,
 21. Although there no evidence that reveals whether Cobb addressed Turner in the
 second person, as Gray recorded it, or in the third person, as Rochelle recorded it,
 it is easily imaginable that Rochelle silently changed Cobb's words. If Cobb spoke
 in the first person, Rochelle may have altered Cobb's speech so that it would match
 the formulaic language of the rest of the court records.

11. Gray, *The Confessions of Nat Turner*, 20; Nat Turner's trial, SCCMB, in Tragle,
 Revolt, 222.

12. Nat Turner's trial, SCCMB, in Tragle, *Revolt*, 222; Gray, *The Confessions of Nat
 Turner*, 7.

13. Gray, *The Confessions of Nat Turner*, 5–6.

14. Tragle, "Styron and His Sources," 402, 405; Fabricant, "Thomas R. Gray and
 William Styron," 343; Greenberg, "*The Confessions of Nat Turner*: Text and
 Context," 13.

15. In addition to the significant legal issues involved in a lawyer falsely representing the actions of a court before which he regularly appeared, Gray also faced the extra-legal risks of falsely representing more powerful figures in the community. For a wonderful book about how men of honor jealously guarded their public personas, see Kenneth S. Greenberg, *Honor and Slavery* (Princeton: Princeton University Press, 1996).

16. Gray, *The Confessions of Nat Turner*, 5–6; Nat Turner's trial, SCCMB, in Tragle, *Revolt*, 221 (for the list of judges at Turner's trial), 226 (for the list of judges at the ensuing trial).

17. Seymour L. Gross and Eileen Bender, "History, Politics and Literature: The Myth of Nat Turner," *American Quarterly* 23 (1971), esp. 497; for the review of Gray's *Confessions*, see *Richmond Enquirer*, November 25, 1831, in Tragle, *Revolt*, 143. Kenneth S. Greenberg accepted Gross and Bender's argument that much of the language on the *Confessions* has "the marking of Gray's editorial voice." See Greenberg, "*The Confessions of Nat Turner:* Text and Context," 9.

18. Gray, *The Confessions of Nat Turner*, 7, 18. For word counts and word searches, I used the hypertext edition of the *Confessions of Nat Turner* from the University of North Carolina's wonderful Documenting the South website, http://docsouth .unc.edu/neh/turner/turner.html.

19. Gray, *The Confessions of Nat Turner*.

20. Ibid., 3 ("cave"), 17 ("hole"). For another "cave," see *Norfolk American Beacon*, November 2, 1831, and *Richmond Enquirer*, November 8, 1831, in Tragle, *Revolt*, 132; *Richmond Enquirer*, November 4, 1831, in Tragle, *Revolt*, 133; *Petersburg Intelligencer*, November 4, 1831, in Tragle, *Revolt*, 135; *Richmond Enquirer*, November 8, 1831 (two different letters), in Tragle, *Revolt*, 136, 138. For "den," see *Norfolk Herald*, November 4, 1831, in Tragle, *Revolt*, 134. As discussed above, Fabricant argued that the letter in the *Richmond Enquirer* was published by Gray. He points to several similarities in phrases but does not mention that both use the word "cave." See Fabricant, "Thomas R. Gray and William Styron," 344–45.

21. Gray, *The Confessions of Nat Turner*, 8 (Turner's story of how to read), 18 ("taught him by his parents"), 4 ("faithful record," "own words," and "little or no variation"). For a more ambitious attempt to distinguish Turner from Gray, see M. Cooper Harriss, "Where Is the Voice Coming From? Rhetoric, Religion and Violence in *The Confessions of Nat Turner*," *Soundings* 89 (Spring/Summer 2006): 135–70. Harriss's reading of Turner's authentic voice revives the argument of Eric J. Sundquist's *To Wake the Nations: Race in the Making of American Literature* (Cambridge, MA: Harvard University Press, 1993), 27–83, esp. 48–50, although Sundquist suggested that the millennialism of Turner may have been insincere.

22. Gray applied for copyright on November 10, 1831, and *The Confessions* was published later that month. On November 29, 1831, the *Richmond Enquirer* noted its publication. An early advertisement for it appeared in the *Washington Globe*, November 22, 1831. Gray, *The Confessions of Nat Turner*, 18. One should be careful

before discounting black narratives because they do not sound authentic. North Carolina's John Chavis's correspondence with his protégé, North Carolina congressman Willie P. Mangum, clearly shows that there was an incredible range in the linguistic abilities among antebellum southern blacks. Even if one still wants to doubt the source simply because it sounds implausible, one should remember the lesson of scholars' examinations of slave narratives. John Blassingame used a similar argument to make the case that Harriet Jacobs's *Incidents in the Life of a Slave Girl* was "not credible." Although he was certainly right that much in Jacobs's autobiography seems implausible, it turns out that a surprising amount of the material can be checked against other sources, and Jean Yellin has used external sources to show that Jacob's autobiography is a reliable source. See Henry T. Shanks, ed., *Willie Person Mangum Papers*, vols. 1–2 (Raleigh, NC: State Department of Archives and History, 1950–52); John W. Blassingame, *The Slave Community: Plantation Life in the Antebellum South*, rev. ed. (New York: Oxford University Press, 1979), 234; Jean Fagan Yellin, "Introduction," in Harriet Jacobs, *Incidents in the Life of a Slave Girl*, ed. Jean Fagan Yellin (Cambridge, MA: Harvard University Press, 1987); and Jean Fagan Yellin, *Harriet Jacobs: A Life* (New York: Basic Civitas Books, 2004).

23. Gray, *The Confessions of Nat Turner*, 11, 18.

24. The parenthetical comments from which I infer Gray's questions are in ibid., 9, 11, 12, 13, 17.

25. Ibid., 7 ("excrescences"), 12 ("invariably adhered to"), 15–16 (on the encounter at Parker's). David F. Allmendinger Jr., who has made some strong arguments defending Gray's reliability, attacked the reliability of the "account of the skirmish at Parker's field, which Gray tried clumsily to present in the voice of Nat Turner. He failed to disguise the true perspective as that of a white man riding with the first party of volunteers." This reading seems to me insupportable. Gray's constant interruptions and clarifications of Turner's story made this section awkward. If Gray had hijacked "the voice of Nat Turner," the section would likely have been far less "clumsy." See Allmendinger, "The Construction of *The Confessions of Nat Turner*," 32.

26. Gray, *The Confessions of Nat Turner*, 4.

27. Ibid., 18, 8.

28. Allmendinger, "The Construction of *The Confessions of Nat Turner*," 40; Gray, *The Confessions of Nat Turner*, 20. For an example of a historian who focused on the role of Gray in constructing *The Confessions*, see Greenberg, "*The Confessions of Nat Turner*: Text and Context," 9–10. Gray, *The Confessions of Nat Turner*, 20. Gray knew about the escapes because he included accounts in his commentary at the end of the Gray's *Confessions*. "Baron," which can be indistinguishable from a handwritten "Barrow," is how the printer incorrectly transcribed Barrow's name in the first edition of the *Confessions*. The argument for the reliability of the *Confessions* based upon the difficulties of both composing the *Confessions* quickly and keeping track of the different characters' perspectives certainly does not rise to the level of proof, but it would make Gray's accomplishment remarkable.

29. William L. Andrews, *To Tell a Free Story: The First Century of Afro-American Autobiography, 1760–1865* (Urbana: University of Illinois Press, 1986), 77; Mary Kemp Davis, *Nat Turner Before the Bar of Judgment: Fictional Treatments of the Southampton Slave Insurrection* (Baton Rouge: Louisiana State University Press, 1999), 63; Scot French, quoted in Tony Horowitz, "Untrue Confessions: Is Most of What We Know About the Rebel Slave Nat Turner Wrong?" *New Yorker*, December 13, 1999, 89.

Bibliography

FEDERAL RECORDS

Southampton County Census, 1830, http://www.usgwarchives.net/va/southampton/
census/1830.

MANUSCRIPTS COLLECTIONS

Library of Congress

American Colonization Society Papers

Library of Virginia

Francis Jerdone Papers, Miscellaneous Microfilm 675
William S. Simpson Papers
Legislative Petitions
Southampton County
Executive Papers
 John Floyd
 Littleton Tazewell
Virginia Auditor of Public Accounts, Personal Property Tax, Southampton County,
 1824–39
Southampton County Court, Minute Book, 1830–35

Southern Historical Collection, University of North Carolina

Mordecai Family Collection
John Kimberly Papers
Pettigrew Family Papers
James McDowell Papers

Virginia Historical Society

Hugh Blair Grigsby Papers
Lee Family Papers
Mason Papers

Earl Gregg Swem Library, College of William and Mary

Brown-Coalter-Tucker Papers
Blow Family Papers

North Carolina Department of Archives and History

Governors Papers
Benajah Nicholls Papers

NEWSPAPERS

Niles Weekly Register
Boston *Christian Register*
Edenton (North Carolina) *Gazette and Farmer's Palladium*
Fayetteville *North Carolina Journal*
Fredericksburg *Virginia Herald*
Haverhill *New Hampshire Post*
The Liberator
Norfolk and Portsmouth Herald
Norfolk American Beacon
Philadelphia *Christian Index*
Raleigh Register
Richmond Enquirer
Richmond *Constitutional Whig*
Halifax (North Carolina) *Roanoke Advocate*
Tarboro (North Carolina) *Free Press and Southerner*
Washington Globe

BOOKS AND ARTICLES

Allen, Carlos R., Jr., ed. "David Barrow's Circular Letter of 1798," *William and Mary Quarterly*, 3rd ser. 20 (1963): 440–51.
Allmindinger, David F. "The Construction of *The Confessions of Nat Turner*." In *Nat Turner: A Slave Rebellion in History and Memory*, edited by Kenneth S. Greenberg. New York: Oxford University Press, 2003.

Andrews, William L. *To Tell a Free Story: The First Century of Afro-American Autobiography, 1760–1865*. Urbana: University of Illinois Press, 1986.

Aptheker, Herbert. *American Negro Slave Revolts: Nat Turner, Denmark Vesey, Gabriel and Others*. 1943. Reprint, New York: International Publishers, 1974.

Aptheker, Herbert. *Nat Turner's Slave Rebellion: Together With the Full Text of the So-Called "Confessions" of Nat Turner Made in Prison in 1831*. New York: Humanities Press, 1966.

Aptheker, Herbert. "An Autobiographical Note." *Journal of American History* 87 (June 2000): 147–50.

Aptheker, Herbert. "Nat Turner." In *Dictionary of American Negro Biography*. Edited by Rayford W. Logan and Michael R. Winston. New York: Norton, 1982.

Aptheker, Herbert, and Greg L. Michel. "Letters to the Editor." *Journal of American History* 88 (December 2001): 1227–28.

Auslander, Mark. *The Accidental Slaveowner: Revisiting a Myth of Race and Finding an American Family*. Athens: University of Georgia Press, 2011.

Baptist, Edward E. *The Half Has Never Been Told: Slavery and the Making of American Capitalism*. New York: Basic Books, 2014.

Berlin, Ira. *Many Thousand Gone: The First Two Centuries of Slavery in North America*. Cambridge, MA: Harvard University Press, 1998.

Berlin, Ira, Barbara J. Fields, Stephen F. Miller, Joseph P. Reidy, and Leslie S. Rowland, eds. *Free at Last: A Documentary History of Slavery, Freedom, and the Civil War*. New York: New Press, 1991.

Blackford, L. Minor. *Mine Eyes Have Seen the Glory: The Story of a Virginia Lady, Mary Berkeley Minor Blackford, 1802–1896, Who Taught Her Sons to Hate Slavery and to Love the Union*. Cambridge, MA: Harvard University Press, 1954.

Blackstone, William. *Commentaries on the Laws of England* (1765–1769) avalon.law.yale.edu/18th_century/blackstone_bk4ch27.asp.

Blassingame, John W. *The Slave Community: Plantation Life in the Antebellum South*. New York: Oxford, 1972.

Blassingame, John W., ed. *Slave Testimony: Two Centuries of Letters, Speeches, Interviews, and Autobiographies*. Baton Rouge: Louisiana University Press, 1977.

Breen, Patrick H. "A Prophet in His Own Land: Support for Nat Turner and His Rebellion within Southampton's Black Community." In *Nat Turner: A Slave Rebellion in History and Memory*, edited by Kenneth S. Greenberg. New York: Oxford University Press, 2003.

Breen, Patrick H. "In Terror of Their Slaves: White Southern Women's Responses to Slave Insurrections and Scares." In *Warm Ashes: Issues in Southern History at the Dawn of the Twenty-First Century*. Edited by Winfred B. Moore, Jr., Kyle S. Sinisi, and David H. White. Columbia: University of South Carolina Press, 2003.

Breen, Patrick H., ed. "The Female Antislavery Petition Campaign of 1831–32." *Virginia Magazine of History and Biography* 110 (2002): 377–98.

Brooks, Peter. *Troubling Confession: Speaking Guilt in Law and Literature*. Chicago: University of Chicago Press, 2000.

Brown, Christopher Leslie, and Philip D. Morgan, eds. *Arming Slaves: From Classical Times to the Modern Age*. New Haven: Yale University Press, 2006.

Brown, Peter Rodgers. "The Theology of Nat Turner as Reflected in the Insurrection." Master's thesis, Oberlin Graduate School of Theology, 1949.

Bruce, Dickson D., Jr., *The Rhetoric of Conservatism: The Virginia Convention of 1829–30 and the Conservative Tradition in the South*. San Marino, CA: Huntington Library Press, 1982.

Burnard, Trevor. *Mastery, Tyranny, and Desire: Thomas Thistlewood and His Slaves in the Anglo-Jamaican World*. Chapel Hill: University of North Carolina Press, 2004.

Burt, John. *Lincoln's Tragic Pragmatism: Lincoln, Douglas, and Moral Conflict*. Cambridge, MA: Harvard University Press, 2013.

Calvin, Fred. "Elizabeth Turner Home." Virginia Historical Inventory. Southampton County Homes. http://image.lva.virginia.gov/VHI/html/26/0851.html.

Calvin, Fred. "Lavania Francis Home." Virginia Historical Inventory. Southampton County Homes. http://image.lva.virginia.gov/VHI/html/26/0623.html.

Calvin, Fred. "Dr. Robert T. Musgrave's Home." Virginia Historical Inventory. Southampton County Homes. http://image.lva.virginia.gov/VHI/html/26/0743.html.

Calvin, Fred. "Walnut Grove," Virginia Historical Inventory, Southampton County Homes, http://image.lva.virginia.gov/VHI/html/26/0870.html.

Camp Stephanie M. H., *Closer to Freedom: Enslaved Women and Everyday Resistance in the Plantation South*. Chapel Hill: University of North Carolina Press, 2004.

Carretta, Vincent. "Olaudah Equiano or Gustavus Vassa? New Light on an Eighteenth-Century Question of Identity." *Slavery and Abolition* 20 (1999): 96–105.

Carroll, Joseph Cephas. *Slave Insurrections in the United States, 1800–1865*. 1938. Reprint, New York: Negro Universities Press, 1968.

Childs, Matt D. *The 1812 Aponte Rebellion in Cuba and the Struggle Against Atlantic Slavery*. Chapel Hill: University of North Carolina Press, 2006.

Clarke, Erskine. *Dwelling Place: A Plantation Epic*. New Haven: Yale University Press, 2005.

Clarke, John Henrik, ed., *Ten Black Writers Respond*. Boston: Beacon Press, 1968.

Clausewitz, Carl von. *On War*. Translated by J. J. Graham. 1832. London: Routledge & Kegan Paul, 1962.

Crofts, Daniel. *Old Southampton: Politics and Society in a Virginia County, 1834–1869*. Charlottesville: University Press of Virginia, 1992.

Cromwell, John W. "The Aftermath of Nat Turner's Insurrection." *Journal of Negro History* 5 (1920): 208–34.

Curtis, Christopher M. *Jefferson's Freeholders and the Politics of Ownership in the Old Dominion*. New York: Cambridge University Press, 2012.

Curtis, Christopher M. "Reconsidering Suffrage Reform in the 1829–1830: Virginia Constitutional Convention." *Journal of Southern History* 74 (2008): 89–124.

da Costa, Emilia Viotti. *Crowns of Glory, Tears of Blood: The Demerara Slave Rebellion of 1823*. New York: Oxford University Press, 1994.

Daniel, W. Harrison. "Virginia Baptists and the Negro in the Antebellum Era." *Journal of Negro History* 56 (1971): 1–16.

Davis, Charles T., and Henry Louis Gates Jr., eds. *The Slave's Narrative*. New York: Oxford University Press, 1985.

Davis, Mary Kemp. *Nat Turner Before the Bar of Judgment: Fictional Treatments of the Southampton Slave Insurrection*. Baton Rouge: Louisiana University Press, 1999.

Davis, Mary Kemp. "'What Happened in This Place?': In Search of the Female Slave in the Nat Turner Slave Insurrection." In *Nat Turner: A Slave Rebellion in History and Memory*, edited by Kenneth S. Greenberg. New York: Oxford University Press, 2003.

Davis, Thomas J. *Rumor of Revolt: The "Great Negro Plot" in Colonial New York*. New York: Free Press, 1985.

Davis, Thomas J. "Conspiracy and Credibility: Look Who's Talking, About What-Law Talk and Loose Talk." *William and Mary Quarterly* 59 (January 2002): 167–74.

Desrochers, Robert E., Jr. "'Not Fade Away': The Narrative of Venture Smith, an African American in the Early Republic." *Journal of American History* 84 (1997): 40–66.

Deyle, Stephen. *Carry Me Back: The Domestic Slave Trade in American Life*. New York: Oxford University Press, 2005.

Douglass, Frederick. *Narrative of the Life of Frederick Douglass, an American Slave, Written by Himself*, edited and introduced by David W. Blight. 1845. Boston: Bedford Books, 1993.

Douglass, Frederick. *My Bondage and My Freedom*. 1855.http://docsouth.unc.edu/neh/douglass55/douglass55.html.

Douglass, Frederick. "What to the Slave is the Fourth of July?" In *My Bondage and My Freedom*. 1855. http://docsouth.unc.edu/neh/douglass55/douglass55.html.

Drewry, William Sidney. *The Southampton Insurrection*. 1900. Reprint, Murfreesboro, NC: Johnson Publishing, 1968.

Dubois, Laurent. *Avengers of the New World: The Story of the Haitian Revolution*. Cambridge, MA: Belknap Press, 2004.

Du Bois, W. E. B. *Black Reconstruction in America, 1860–1800*. 1935; New York: Free Press, 1998.

Du Bois, W. E. B. *Selections from the Correspondence of W. E. B. DuBois*, Vol. 1. Edited by Herbert Aptheker. Amherst: University of Massachusetts Press, 1973.

Du Bois, W. E. B. *The Souls of Black Folk*. Edited by Henry Louis Gates, Jr. and Terri Hume Oliver. 1903; New York: Norton, 1999.

Du Bois, W. E. B. "Strivings of the Negro People." In *The Atlantic Monthly,* August 1897, www.theatlantic.com/magazine/archive/1897/08/strivings-of-the-negro-people/305446.

Dusinberre, William. *Strategies for Survival: Recollections of Bondage in Antebellum Virginia*. Charlottesville: University of Virginia Press, 2009.

Edwards, Bryan. *The History... of the West Indies*. 1807. In Richard Price, ed., *Maroon Societies: Rebel Slave Communities in the Americas*. Baltimore: Johns Hopkins University Press, 1996.

Egerton, Douglas R. *Charles Fenton Mercer and the Trial of National Conservativism*. Jackson: University Press of Mississippi, 1989.

Egerton, Douglas R. *Gabriel's Rebellion: The Virginia Slave Conspiracies of 1800 & 1802*. Chapel Hill: University of North Carolina Press, 1993.

Egerton, Douglas R. *He Shall Go Out Free: The Lives of Denmark Vesey*. Madison: Madison House, 1999.

Egerton, Douglas R. "Forgetting Denmark Vesey; Or, Oliver Stone Meets Richard Wade." *William and Mary Quarterly* 59 (January 2002): 143–52.

Elliott, Mark. *Color-Blind Justice: Albion Tourgée and the Quest for Racial Equality from the Civil War to* Plessy v. Ferguson. New York: Oxford University Press, 2006.

Ely, Melvin Patrick. *Israel on the Appomattox: A Southern Experiment in Black Freedom from the 1790s Through the Civil War*. New York: Knoft, 2004.

Escott, Paul D. *Slavery Remembered: A Record of Twentieth-Century Slave Narratives*. Chapel Hill: University of North Carolina Press, 1979.

Essig, James David. *The Bonds of Wickedness: American Evangelicals Against Slavery, 1770–1808*. Temple University Press, Philadelphia, 1982.

Essig, James David. "A Very Wintery Season: Virginia Baptists and Slavery, 1785–1797." *Virginia Magazine of History and Biography* 88 (1980): 170–85.

Fabricant, Daniel S. "Thomas R. Gray and William Styron: Finally, A Critical Look at the 1831 *Confession of Nat Turner*." *American Journal of Legal History* 37 (July 1993): 332–61.

Fanon, Frantz. *The Wretched of the Earth*. Translated by Richard Philcox. New York: Grove Press, 2004.

Fellman, Michael. *In the Name of God and Country: Reconsidering Terrorism in American History*. New Haven: Yale University Press, 2010.

Fehrenbacher, Don E. *The Dred Scott Case: Its Significance in American Law and Politics*. New York: Oxford University Press, 1978.

Flanigan, Daniel J. "Criminal Procedures in Slave Trials in the Antebellum South." *Journal of Southern History* 40 (1974): 537–64.

Foner, Eric, ed. *Nat Turner: Great Lives Observed*. New Brunswick, NJ: Prentice Hall, 1971.

Foucault, Michel. *Discipline and Punish: The Birth of the Prison*. Translated by Alan Sheridan New York: Vintage, 1979.

Foucault, Michel. *The History of Sexuality: An Introduction*. Vol. 1. Translated by Robert Hurley. New York: Random House, 1990.

Fox-Genovese, Elizabeth. *Within the Plantation Household: Black and White Women of the Old South*. Chapel Hill: University of North Carolina Press, 1988.

Fox-Genovese, Elizabeth, and Eugene D. Genovese. *The Mind of the Master Class: History and Faith in the Southern Slaveholders' World View*. New York: Cambridge University Press, 2005.

Franklin, John Hope, and Loren Schweninger. *Runaway Slaves: Rebels on the Plantation.* New York: Oxford University Press, 1999.

Fredrickson, George M. "The Skelton in the Closet." *New York Review of Books,* November 2, 2000, 61–66.

Freehling, Alison Goodyear. *Drift Toward Dissolution: The Virginia Slavery Debate of 1831–1832.* Baton Rouge, Louisiana State University Press, 1982.

Friedman, Jean E. *The Enclosed Garden: Women and Community in the Evangelical South, 1830–1900.* Chapel Hill: University of North Carolina Press, 1985,

French, Scot. *The Rebellious Slave: Nat Turner in American Memory.* Boston: Houghton Mifflin, 2004.

Frey, Sylvia R. *Water From the Rock: Black Resistance in a Revolutionary Age.* Princeton: Princeton University Press, 1991.

Genovese, Eugene D. "Farmers in a Slaveholders' Democracy." *Agricultural History* 49 (April 1975): 331–42.

Genovese, Eugene D. *From Rebellion to Revolution: Afro-American Slave Revolts in the Making of the New World.* New York: Vintage, 1981.

Genovese, Eugene D. "The Nat Turner Case." *The Nat Turner Rebellion.* Edited by John B. Duff and Peter M. Mitchell. New York: Harper and Row, 1971.

Genovese, Eugene D. "On Antonio Gramsci." *In Red and Black: Marxian Explorations in Southern and Afro-American History.* Knoxville: University of Tennessee Press, 1984.

Genovese, Eugene D. *Roll, Jordan, Roll: The World the Slaves Made.* New York: Pantheon, 1974; New York: Vintage, 1976.

Genovese, Eugene D. "Race and Class in Southern History: An Appraisal of the Work of Ulrich Bonnell Phillips." *Agricultural History* 41 (1967): 345–58.

Ghachem, Malick W. "Prosecuting Torture: The Strategic Ethics of Slavery in Pre-Revolutionary Saint-Domingue (Haiti)." *Law and History Review* 29 (November 2011): 985–1029.

Glymph, Thavolia. "Rose's War and the Gendered Politics of a Slave Insurgency in the Civil War." *Journal of the Civil War Era* 3 (2013): 501–32.

Godbeer, Richard *Escaping Salem: the Other Witch Hunt of 1692.* New York, Oxford University Press, 2005.

Gomez, Michael A. *Exchanging Our Country Marks: The Transformation of African Identities in the Colonial and Antebellum South.* Chapel Hill: University of North Carolina Press, 1998.

Gordon-Reed, Annette. *The Hemingses of Monticello: An American Family.* New York: Norton, 2008.

Graber, Mark. *Dred Scott and the Problem of Constitutional Evil.* New York: Cambridge University Press, 2006.

Gramsci, Antonio. *The Prison Notebooks.* Edited and translated by Joseph A. Buttigieg. New York: Columbia University Press, 2007.

Gray, Thomas R. *The Confessions of Nat Turner, the Leader of the Late Insurrection in Southampton, VA.* Baltimore, 1831.

Greenberg, Kenneth S. *Honor and Slavery*. Princeton: Princeton University Press, 1996.

Greenberg, Kenneth S. "*Confessions of Nat Turner:* Text and Context." In *The Confessions of Nat Turner and Related Documents*, edited by Kenneth S. Greenberg. Boston: Bedford Books, 1996.

Greenberg, Kenneth S. "Name, Face, Body." In *Nat Turner: A Slave Rebellion in History and Memory*, edited by Kenneth S. Greenberg. New York: Oxford University Press, 2003.

Greenberg, Kenneth S. "Nat Turner in Hollywood." In *Nat Turner: A Slave Rebellion in History and Memory*, edited by Kenneth S. Greenberg. New York: Oxford University Press, 2003.

Greenberg, Kenneth S., ed. *Nat Turner: A Slave Rebellion in History and Memory*. New York: Oxford University Press, 2003.

Gross, Seymour L., and Eileen Bender. "History, Politics and Literature: The Myth of Nat Turner." *American Quarterly* 23 (1971): 487–518.

Gutman, Herbert G. *The Black Family in Slavery and Freedom, 1750–1925*. New York: Random House, 1976.

Hahn, Steven. *A Nation under Our Feet: Black Political Struggles in the Rural South from Slavery to the Great Migration*. Cambridge, MA: Belknap Press, 2003.

Hahn, Steven. *The Political Worlds of Slavery and Freedom*. Cambridge, MA: Harvard University Press, 2009.

Hairston, Loyle. "William Styron's Nat Turner—Rogue-Nigger." In *Ten Black Writers Respond*. Edited by John Henrik Clarke. Boston: Beacon Press, 1968.

Harris, J. William. *The Hanging of Thomas Jeremiah: A Free Black Man's Encounter with Liberty*. New Haven: Yale University Press, 2009.

Harris, J. William. "Eugene Genovese's Old South: A Review Essay." *Journal of Southern History* 80 (2014): 327–72.

Harriss, M. Cooper. "Where is the Voice Coming From? Rhetoric, Religion and Violence in *The Confessions of Nat Turner*." *Soundings* 89 (Spring/Summer 2006): 135–70.

Heyrman, Christine Leigh. *Southern Cross: The Beginnings of the Bible Belt*. New York: Knoft, 1997.

Higginbotham, A. Leon Jr., and Anne F. Jacobs. "The 'Law Only as an Enemy': The Legitimization of Racial Powerlessness through the Colonial and Antebellum Criminal Laws of Virginia." *North Carolina Law Review* 70 (1992): 969–1070.

Higginson, Thomas Wentworth. "Nat Turner's Revolt." *Atlantic Monthly*, August 1861.

Hindus, Michael S. "Black Justice Under White Law: Criminal Prosecution of Blacks in Antebellum South Carolina." *Journal of American History* 63 (1976): 575–99.

Hoffer, Peter Charles. *Cry Liberty: The Great Stono Slave Rebellion of 1739*. New York: Oxford University Press, 2010.

Hoffer, Peter Charles. *The Devil's Disciples: Makers of the Salem Witchcraft Trials*. Baltimore: Johns Hopkins University Press, 1996.

Hollandsworth, James G. *An Absolute Massacre: The New Orleans Race Riot of July 30, 1866*. Baton Rouge: Louisiana State University Press, 2004.

Horowitz, Tony. "Untrue Confessions: Is Most of What We Know About the Rebel Slave Nat Turner Wrong?" *New Yorker* 75 (13 December 1999): 80–89.

Irons, Charles F. *The Origins of Proslavery Christianity: White and Black Evangelicals in Colonial and Antebellum Virginia.* Chapel Hill: University of North Carolina Press, 2008.

Isaac, Rhys. *Landon Carter's Uneasy Kingdom: Revolution and Rebellion on a Virginia Plantation.* New York: Oxford University Press, 2004.

Isaac, Rhys. *The Transformation of Virginia, 1740–1790.* New York: Norton, 1988.

Jacobs, Harriet. *Incidents in the Life of a Slave Girl.* Edited by Jean Fagan Yellin. Cambridge, MA: Harvard University Press, 1987.

Johnson, F. Roy. *The Nat Turner Slave Insurrection.* Murfreesboro, NC: Johnson Publishing, 1966.

Johnson, F. Roy. *The Nat Turner Story.* Murfreesboro, NC: Johnson Publishing, 1970.

Johnson, J. H. "Antislavery Petitions Presented to the Virginia Legislature by Citizens of Various Counties." *Journal of Negro History* 12 (1927): 678–79.

Johnson, Michael P. "Denmark Vesey and his Co-Conspirators." *William and Mary Quarterly* 3rd ser. (Oct. 2001): 915–76.

Johnson, Michael P. "Reading Evidence." *William and Mary Quarterly* 59 (January 2002): 193–202.

Johnson, Paul E., and Sean Wilentz. *The Kingdom of Matthias: A Story of Sex and Salvation in 19th-Century America.* New York: Oxford University Press, 1994.

Johnson, Walter. "A Nettlesome Classic Turns Twenty-Five." *Common-Place* 1 (July 2001). www.common-place.org/vol-01/no-04/reviews/johnson.shtml

Johnson, Walter. "On Agency." *Journal of Social History* 37 (2003): 113–24.

Jones, Edward P. *Known World: A Novel.* New York: Amistad, 2003.

Jordan, Winthrop D. "The Charleston Hurricane of 1822; Or, the Law's Rampage." *William and Mary Quarterly* 59 (January 2002): 175–78.

Journal of the House of Delegates of the Commonwealth of Virginia Begun and Held at the Capitol, in the City of Richmond, on Monday, the Fifth Day of December, 1831. Richmond, 1832.

Joyner, Charles. "Styron's Choice: A Meditation on History, Literature, and Moral Imperatives." In *Nat Turner: A Slave Rebellion in History and Memory*, edited by Kenneth S. Greenberg. New York: Oxford University Press, 2003.

Kars, Marjoleine. "Opting Out." *Common-place* 14 (Spring 2014).

Kelley, Robin D. G. "Interview of Herbert Aptheker." *Journal of American History* 87 (June 2000): 151–67.

Killens, John Oliver, ed. *The Trial Record of Denmark Vesey.* Boston: Beacon Press, 1970.

Kroll-Smith, J. Stephen. "Transmitting a Revival Culture: The Organizational Dynamic of the Baptist Movement in Colonial Virginia, 1760–1777." *Journal of Southern History* 50 (1984): 551–68.

Lane, Lunsford. *The Narrative of Lunsford Lane, Formerly of Raleigh, N.C. Embracing an Account of His Early Life, the Redemption by Purchase of Himself and Family from*

Slavery, and His Banishment from the Place of His Birth for the Crime of Wearing a Colored Skin. 1842, http://docsouth.unc.edu/neh/lanelunsford/lane.html.

Lemann, Nicholas. *Redemption: The Last Battle of the Civil War*. New York: Farrar Straus and Giroux, 2006.

Lightfoot, Natasha. "'Their Coats Were Tied Up Like Men': Women Rebels in Antigua's 1858 Uprising." *Slavery and Abolition* 31 (Dec. 2010): 527–45.

Lovejoy, Paul E. "Olaudah Equiano or Gustavus Vassa—What's in a Name?" *Atlantic Studies* 9 (2012): 165–84.

Marble, Manning. *Malcolm X: A Life of Reinvention*. New York: Viking, 2011.

Martin, Jonathan D. *Divided Mastery: Slave Hiring in the American South*. Cambridge, MA: Harvard University Press, 2004.

Masur, Louis P. *1831: Year of Eclipse*. New York: Hill and Wang, 2001.

Mathews, Donald G. *Religion in the Old South*. Chicago: University of Chicago Press, 1977.

McBride, James *The Good Lord Bird: A Novel*. New York: Riverhead, 2013.

McPherson, James M. *For Cause and Comrade: Why Men Fought in the Civil War*. New York: Oxford University Press, 1997.

Miller, Joseph C. *The Problem of Slavery as History: A Global Approach*. New Haven: Yale University Press, 2012.

Morgan, Philip D. *Slave Counterpoint: Black Culture in Eighteenth-Century Chesapeake and Low Country*. Chapel Hill: University of North Carolina Press, 1998.

Morgan, Philip D. "Conspiracy Scares." *William and Mary Quarterly* 59 (January 2002): 159–66.

Morison, Samuel Eliot. *The Life and Letters of Harrison Gray Otis, Federalists, 1765–1848*. Boston: Houghton Mifflin, 1913.

Morrison, E. M. *Isle of Wight County, 1608–1907: A Brief History of Isle of Wight County, Virginia*. 1907. http://tdcweb.com/tdfhs/histories/islewight/islewight16.htm, accessed May 26, 2014.

Morris, Errol. *The Fog of War*. Directed by Errol Morris. 2003. Culver City, CA: Sony Pictures Classic, 2004. DVD.

Morris, Thomas D. *Southern Slavery and the Law, 1619–1860*. Chapel Hill: University of North Carolina Press, 1996.

Nash, A. E. Kier. "Fairness and Formalism in the Trials of Blacks in the State Supreme Courts of the Old South." *Virginia Law Review* 56 (1970): 64–100.

"Nat Turner's Slave Rebellion." *Wikipedia*. en.wikipedia.org/wiki/Nat_Turner's_slave_rebellion. Accessed May 25, 2014.

Nicholls, Michael L. *Whispers of Rebellion: Narrating Gabriel's Conspiracy*. Charlottesville: University Press of Virginia, 2012.

Noll, Mark. *The Civil War as a Theological Crisis*. Chapel Hill: University of North Carolina Press, 2006.

Norfleet, Phil. "Aaron Norfleet and the Nat Turner Revolt." *Norfleet Family Geneaology*. http://pcn2051.tripod.com/aaron.htm. Accessed May 25, 2014.

Oakes, James. *The Ruling Race: A History of America Slaveholders.* New York, Norton, 1982.

Oates, Stephen B. *The Fires of Jubilee: Nat Turner's Fierce Rebellion.* New York: Harper Perennial, 1990.

Ortner, Sherry B. "Resistance and the Problem of Ethnographic Refusal." *Comparative Studies in Society and History* 37 (1995): 173–93.

Paquette, Robert L. "From Rebellion to Revisionism: The Continuing Debate about the Denmark Vesey Affair." *Journal of the Historical Society* 4 (Fall 2004): 291–334.

Paquette, Robert L. "The Drivers Shall Lead Them: Image and Reality in Slave Resistance." In *Slavery, Secession and Southern History*, edited by Robert Louis Paquette and Louis A. Ferleger. Charlottesville: University of Virginia Press, 2000.

Paquette, Robert L. "Jacobins of the Lowcountry: The Vesey Plot on Trial." *William and Mary Quarterly* 59 (January 2002): 185–92.

Parramore, Thomas C. *Southampton County, Virginia.* Charlottesville: University Press of Virginia, 1978.

Parramore, Thomas C. "Covenant in Jerusalem." In *Nat Turner: A Slave Rebellion in History and Memory*, edited by Kenneth S. Greenberg. New York: Oxford University Press, 2003.

Perdue, Charles L. Jr., Thomas E. Barden, and Robert K. Phillips, eds. *Weevils in the Wheat: Interviews with Ex-Virginia Slaves.* Charlottesville: University Press of Virginia, 1992.

Popkin, Jeremy D. *You Are All Free: The Haitian Revolution and the Abolition of Slavery.* New York: Cambridge University Press, 2010.

Raboteau, Albert J. *Slave Religion: The "Invisible Institution" in the Antebellum South.* New York: Oxford University Press, 1978.

Rasmussen, Daniel. *American Uprising: The Untold Story of America's Largest Slave Revolt.* New York: Harper, 2011.

Reis, João José. *Slave Revolt in Brazil: The Muslim Uprising of 1835 in Bahia.* Translated by Arthur Brakel. Baltimore: Johns Hopkins University Press, 1995.

Ricoeur, Paul. "Appropriation." In *Hermeneutics and the Human Sciences.* Edited and translated by John B. Thompson. Paris: Cambridge University Press, 1981.

Rothman, Joshua D. *Notorious in the Neighborhood: Sex and Families Across the Color Line in Virginia, 1787–1861.* Chapel Hill: University of North Carolina, 2003.

Rucker, Walter C. *The River Flows On: Black Resistance, Culture, and Identity Formation in Early America.* Baton Rouge: Louisiana University Press, 2006.

Rugemer, Edward Bartlett. *The Problem of Emancipation: The Caribbean Roots of the American Civil War.* Baton Rouge: Louisiana State University Press, 2008.

Rushdy, Ashraf H. A. *American Lynching.* New Haven: Yale University Press, 2012.

Rushforth, Brett. *Bonds of Alliance: Indigenous and Atlantic Slaveries in New France.* Chapel Hill: University of North Carolina Press, 2012.

Rushforth, Brett. "Making Slavery in New France," *Common-place* 14 (Fall 2014).

Sandlund, Vivien. "'A Devilish and Unnatural Usurpation': Baptist Evangelical Ministers and Antislavery in the Early Nineteenth Century, A Study of the Ideas and Activism of David Barrow," *American Baptist Quarterly* 13 (1994): 262–77.

Santoro, Anthony. "The Prophet in His Own Words: Nat Turner's Biblical Construction." *Virginia Magazine of History and Biography* 116 (2008): 114–49.

Scarborough, William Kauffman. *The Overseer: Plantation Management in the Old South.* 1966. Reprint, with new preface, Athens: University of Georgia Press, 1984.

Schaffer, Judith Kelleher. "The Immediate Impact of Nat Turner's Insurrection in New Orleans." *Louisiana History* 21 (1980): 361–76.

Schwarz, Philip J. *Slave Laws in Virginia.* Athens: University of Georgia Press, 1996.

Schwarz, Philip J. *Twice Condemned: Slaves and the Criminal Laws of Virginia, 1705–1865.* Baton Rouge: Louisiana State University Press, 1988.

Schwarz, Philip J., ed. *Gabriel's Conspiracy: A Documentary History.* Charlottesville: University Press of Virginia, 2012.

Scott, James C. *Domination and the Arts of Resistance: Hidden Transcripts.* New Haven: Yale University Press, 1990.

Scully, Randolph Ferguson. *Religion and the Making of Nat Turner's Virginia: Baptist Community and Conflict, 1740–1840.* Charlottesville: University of Virginia Press, 2008.

Sensbach, Jon F. *Rebecca's Revival: Creating Black Christianity in the Atlantic World.* Cambridge, MA: Harvard University Press, 2005.

Sensbach, Jon F. *A Separate Canaan: The Making of an Afro-Moravian World in North Carolina, 1763–1840.* Chapel Hill: University of North Carolina Press, 1998.

Shade, William G. *Democratizing the Old Dominion: Virginia and the Second Party System, 1824–1861.* Charlottesville: University Press of Virginia, 1996.

Shanks, Henry T., ed. *Willie Person Mangum Papers.* Raleigh: State Department of Archives and History, 1950–52.

Sidbury, James. *Ploughshares into Swords: Race, Rebellion, and Identity in Gabriel's Virginia, 1730–1810.* New York: Cambridge University Press, 1997.

Sidbury, James. "Plausible Stories and Varnished Truths." *William and Mary Quarterly* 59 (January 2002): 179–84.

Smith, James Lindsay. *The Autobiography of James L. Smith…* Norwich, CT. 1881. http:// docsouth.unc.edu/neh/smithj/smithj.html.

Smith, Mark M. "Remembering Mary, Shaping Revolt: Reconsidering the Stono Rebellion." *Journal of Southern History* 67 (2001): 513–34.

Soderlund, Jean R. *Quakers and Slavery: A Divided Spirit.* Princeton: Princeton University Press, 1985.

Sommerville, Diane Miller. "The Rape Myth in the Old South Reconsidered." *Journal of Southern History* 61 (1995): 481–515.

Spady, James O'Neal. "Power and Confession: On the Credibility of the Earliest Reports of the Denmark Vesey Slave Conspiracy." *William and Mary Quarterly*, 3rd ser. 68 (2011): 287–304.

Spangler, Jewel L. "Becoming Baptists: Conversion in Colonial and Early National Virginia," *Journal of Southern History* 67 (2001): 243–86.

Stone, Albert. *The Return of Nat Turner: History Literature, and Cultural Politics in Sixties America*. Athens: University of Georgia Press, 1992.

Styron, William. *The Confessions of Nat Turner*. New York: Random House, 1967.

Styron, William. "This Quiet Dust," *Harper's Magazine* (April 1965), 134–46.

Sundquist, Eric J. *To Wake the Nations: Race in the Making of American Literature*. Cambridge, MA: Harvard University Press, 1993.

Tadman, Michael. *Speculators and Slaves: Masters, Traders, and Slaves in the Old South*. Madison: University of Wisconsin Press, 1989.

Tragle, Henry Irving, comp. *The Southampton Slave Revolt of 1831: A Compilation of Source Material*. Amherst: University of Massachusetts, 1971.

Tragle, Henry Irving. "Styron and His Sources," *Massachusetts Review* 11 (1970): 135–53. Reprinted in *The Southampton Slave Revolt of 1831: A Compilation of Source Material*. Compiled by Henry Irving Tragle. Amherst: University of Massachusetts Press, 1971.

Trent, Hank, ed. *Narrative of James Williams, An American Slave*. Annotated Edition. Baton Rouge: Louisiana State University Press, 2013.

Trouillot, Michel-Rolph. *Silencing the Past: Power and the Production of History*. Boston: Beacon Press, 1995.

Tucker, St. George, ed. "Volume 1, Appendix, Note D, Section 9." In *Blackstone's Commentaries with Notes*. By William Blackstone. Philadelphia, 1803. www.constitution.org/tb/t1d10000.htm.

Varon, Elizabeth R. *Disunion! The Coming of the American Civil War, 1789–1859*. Chapel Hill: University of North Carolina Press, 2008.

Wayne, Michael. *Death of an Overseer: Reopening a Murder Investigation from the Plantation South*. New York: Oxford University Press, 2001.

Wade, Richard C. "The Vesey Plot: A Reconsideration." *Journal of Southern History* 30 (1964): 143–61.

Waldrep, Christopher. *The Many Faces of Judge Lynch: Extralegal Violence and Punishment in America*. New York: Macmillan, 2002.

Warner, Samuel. "Authentic and Impartial Narrative of the Tragical Scene…" In *The Southampton Slave Revolt of 1831: A Compilation of Source Material*. Compiled by Henry Irving Tragle. Amherst: University of Massachusetts, 1971.

Webb, Frances Lawrence. *Recollections of Franklin and Historical Sketches of Southampton County*. 1963. In *The Southampton Slave Revolt of 1831: A Compilation of Source Material*. Compiled by Henry Irving Tragle. Amherst: University of Massachusetts, 1971.

Weeks, Stephen B. *Southern Quakers and Slavery: A Study in Institutional History*. Volume 15 of Johns Hopkins University Studies in Historical and Political Science. Baltimore, 1896.

Wolf, Eva Sheppard. *Almost Free: A Story about Family and Race in Antebellum Virginia*. Athens: University of Georgia Press, 2012.

Wood, Amy Louise. *Lynching and Spectacle: Witnessing Racial Violence in America, 1890–1940*. Chapel Hill: University of North Carolina Press, 2009.

Woodward, C. Vann. *Origins of the New South*. Baton Rouge: Louisiana State University Press, 1951.

Woodward, C. Vann. *The Strange Career of Jim Crow*. 3rd edition. New York: Oxford University Press, 1974.

Yellin, Jean Fagan. *Harriet Jacobs, A Life*. New York: Basic Civitas Books, 2004.

Yellin, Jean Fagan. Introduction to *Incidents in the Life of a Slave Girl*. By Harriet Jacobs. Edited by Jean Fagan Yellin. Cambridge, MA: Harvard University Press, 1987.

Index

Aaron (slave), 50–51, 211–12n49
abolitionist movement, 2
accommodation model, 4, 6, 7, 214n57
Aggy (slave), 46
Ahosky Ridge, 79
Albany Evening Journal, 152
Albemarle Sound, 31
alcohol, 1, 11, 29, 35, 57, 64, 72, 89, 219n23
Alexandria, District of Columbia (now Virginia), 153
Alfred (slave), 89–92, 94–95
Allen (slave), 72
Allmendinger, David F., Jr., 15, 170, 178, 225–26n31, 257–58n3
ambush, 66–67, 177
American Beacon, 104
American Colonization Society, 48, 100
American Negro Slave Revolts, 4, 97–98
American Revolution, 244–45n56
Andrew (slave)
 commutation, 244n54
 flees rebels, 48
 and Haithcock, 131
 joins revolt, 6–7, 186–87n16
 rebel trials, 113–14
 trial of, 111, 240n24
Andrews, William L., 179
anti-lynching campaign, 101
antislavery movement, 155–57, 166

Aptheker, Herbert, 3–4, 97–98, 184–85n8
Archer, William, 159
Artis, Arnold (free black), 129, 254n10
Artis, Billy (free black), 6, 86, 102, 124
Artis, Exum (free black), 87, 102, 131
Aunt Viney, 143
Austin (slave), 34–35, 44, 54, 99, 232n26, 254–55n11
Avery, John, 20–21, 195n15

baptism, 22–23, 177, 196–97n21
Baptist Portsmouth Association, 157
Barnes, Bettie Powell, 206–7n20, 208n29
Barnes, Jordan (owner), 28, 51, 126
Barrett, Bolling (owner), 87, 131
Barrow, David, 155–58, 160, 254–55n11
Barrow, John T. (owner), 54, 179, 261n28
Barrow, Mary (owner), 55, 116, 125, 215n61, 231n25, 240n28, 241–42n37
Barrow, Thomas (owner), 54, 59, 62, 215n61
Battle of Yorktown, 244–45n56
Beck (Becky) (slave), 132–36, 138, 158–59, 246–47n72
Ben (slave), 79–80, 86, 123–24, 240n28
Bender, Eileen, 175
Berkeley, William, 172, 242–43n45
Bird (slave), 117

black community
 attitude toward Turner, 21–23, 219n21
 Black Head Sign Post, 94
 black preachers denied licenses, 160–61
 conspiracy at Raccoon Swamp
 church, 159
 corpses used for experimentation, 151
 double-consciousness, 7, 58, 166–67,
 187–88n21, 224n14
 interracial churches, 11, 157, 159–61
 linguist ability of, 260–61n22
 massacre of whites as means to
 recruit, 39–40
 oral history, 142, 166, 192n3, 193–94n8
 pragmatism of, 75, 87
 race relations after revolt, 160
 rebel trials, 118, 190n32
 Turner as prophet, 19–20
 Turner hiding place, 142
 uncertainty within, 77, 86–87
 See also free blacks; revolt; slavery
Black Creek Baptist Church, 155–59,
 257–58n3
Black Creek Friends Meeting, 155
Blackford, Mary, 11, 48, 58, 121, 211n44
Black Head Sign Post, 94
Blackstone, William, 107
Blassingame, John, 260–61n22
bloodbath, 94–96
Blow, George, 136–37, 246–47n72
Blunt, Benjamin (owner), 58, 72, 86,
 211n44
Blunt, Samuel (owner)
 arming Blunt's slaves, 91
 battle at farm, 79, 99, 117, 232n26
 failed raid, 82
 false alarms, 74–75
 loyalty of slaves, 70, 73–74, 170
 Moses captured, 118–19
 rebel trials, 118
 recruitment, 70, 73
 slave death, 76

Bob (slave), 133–35
Bois-Caïman, 30–31
Booth, John, 114
Borland, J., 78
Boson (slave), 136–38, 239n19, 246–47n72
Botetourt County, 85
Boukman (slave), 30–31
Bowers, Carr (owner), 108–9, 112–13,
 157–58, 236–37n7, 254n10, 257–58n3
Brantley, Etheldred T., 22–23
Broadnax, Meriweather
 Beck's testimony, 133
 Ben and Davy's trial, 123–24
 confessions of blacks, 117
 credibility of witnesses, 115, 118
 discretion in prosecuting, 111, 120–21
 does not prosecute Turner's wife, 145
 Jack and Andrew's trial, 240n24
 as prosecuting attorney, 109–10,
 113–14, 128
 Turner trial prosecution, 150, 251n30
Broadnax, William Henry (owner)
 antiblack response, 8–9
 Meriweather's father, 109–10
 militiamen, 12, 82
 rage of whites after revolt, 93
 rumors about Turner, 84
 stops extralegal killings, 95–97, 105
Brown, Samuel and John, 52–53
Browne, Orvis, 108–9
Bryant, Henry (owner), 45, 47, 49, 114
Bryant, Sally (owner), 45
Burwell (slave), 87, 131

Cabin Pond, 28–30, 34, 72, 126, 191–92n2
Camp, Stephanie M. H., 214n57
Caribbean, 31, 50
Carter, Landon (owner), 108
Cass, Lewis, 105
casualties
 black community, 12, 89–105, 231n23,
 231n25, 232–33n29, 232n26

free blacks, 101–3, 232–33n29
 whites, 1, 32, 61–62, 104, 153, 170, 175,
 234n38
census (slaves). *See* slaves
Chandler, John A., 153
Charleston, South Carolina, 14, 26, 31
Charlotte (slave), 53, 93, 99, 214n57
Charlton, George H. (owner), 111, 128
Chavis, John, 260–61n22
Christianity, 20, 155–64, 189–90n30,
 196–97n21. See also *individual
 denominations*
Civil War, 2, 7, 65, 155
class conflict, 8–10, 92, 105–10
Clausewitz, Carl von, 74, 139
clothing, 43, 53, 63, 117, 127, 141, 146
Cobb, Jeremiah, 149–50, 171–72,
 219n21
Columbia University, 3
Committee of the Citizens of
 Southampton, 105–6
common law, 107–8
communion, 155–64, 168
Communist Party, 3, 184–85n8
commutation
 Boson (slave) failure to attain, 136
 Frank (slave), 135, 243–44n50,
 247n73
 governor Floyd pardons, 10, 125–27,
 135, 243–44n50
 Hark (slave), 241–42n37
 Isaac (slave), 129, 135, 243–44n50
 Isham (slave), 241–42n37
 Jack (slave), 244n54
 Jim (slave), 135, 243–44n50
 Moses (slave), 127, 139
 Nathan (slave), 127
 Newsome, Berry (free black), failure
 to attain, 130
 rebel trials, 10, 124–28, 243–44n50
 Sussex County Court, 11
 Tom (slave), 127

compensation
 Alfred's death, 91–92
 defense attorneys, 112, 239n19
 extralegal killings and lack of, 101
 slaveholders, 99, 124, 192n3, 207n21,
 239n7, 242–43n45
The Confessions of Nat Turner
 (novel), 2–3, 15
*The Confessions of Nat Turner, the Leader
 of the Late Insurrection in
 Southampton, VA*
 accuracy of, 13–15
 affidavit for, 173–75
 afterward to, 152
 authenticity of, 169, 171, 176–78,
 261n28
 authorial voice in, 169
 casualties of blacks after revolt, 99
 certification of, 153
 copyright for, 175
 ending comments, 179, 261n28
 evidence for, 170–71, 258–59n4
 Gray interview, 1, 15–16
 list of white deaths during revolt, 153
 parenthetical interruptions in, 177–78
 publication of, 153, 260–61n22
 read by Trezvant during trial, 171, 173
 rebel trials, 15
 reliability of, 148, 175
 sources for, 165
 "To the Public," 153
 Turner interview, 250n21
 Turner's reading ability, 176
 Turner trial, 175–76
 See also Gray, Thomas R.
conspirators, 17, 24–26, 34. *See also* revolt
Constitutional Whig, 139, 169–71,
 249n12, 257n2, 257–58n3,
 258–59n4
"The Construction of *The Confessions of
 Nat Turner*," 15, 257–58n3
Cordell (slave), 80–81

court of oyer and terminer
 Beck's testimony, 135
 black response to revolt, 161
 hegemonic power of, 138, 187–88n21
 jury and, 107–8
 magistrates for, 108, 149
 mercy for defendants, 158
 purpose of, 107
 reliability of records, 14
 Rochelle as clerk, 109
 scope of revolt, 138
 Sussex County Court trials, 134–37
 Turner trial, 149–50
 witch trials, 108
 See also commutation; rebel trials
court system, 9–11. *See also* court of oyer
 and terminer
Cratherton, Eliza (free black), 127–28,
 130, 226–27n34
Crawford, Allen (slave), 53, 80, 143
Crocker, William, 60, 216n9
Crofts, Daniel W., 155
Cromwell, John, 98, 103, 151
Cross Keys, 93, 103, 210n41, 244n54
Curtis (slave), 71–73, 116
Cynthia (slave), 218n17

Daniel (slave), 50–51, 113, 117, 122–23,
 134–35, 211–12n49
Daniel, Robert T., 158, 254n10
Darden, Jepthro (owner), 109
Davis, Mary Kemp, 179
Davis, Thomas J., 110
Davy (slave of Nathaniel Francis)
 commutation, 127
 judge as defense council, 112
 rebel trials, 58
Davy (slave of Elizabeth Turner)
 as conscript, 45, 47, 61
 trial of, 49, 114–16
Davy (slave of Joseph Parker)
 acquitted, 134

Beck's testimony, 135
Davy (slave of Levi Waller)
 death sentence, 123–24
 trial of, 118
 Waller plantation deaths, 61
death penalty, 120–21, 124, 130, 132, 150–51,
 171–72. *See also* commutation
defense attorneys
 arguments, 112–13
 attack on witnesses, 115
 compensation for, 112, 239n19
 judge as, 112
 Moses' trial, 118–19
 rebel trials, 15, 109
 Turner trial, 150, 153
Delsy (slave), 119
Demerara revolt, 201n50
Denegre, W. O., 82, 83
Dismal Swamp, 31, 201n54
District of Columbia, 153, 175
dogs, 205–6n17
double-consciousness, 7–8, 58, 77, 166–67,
 187–88n21, 224n14
Douglass, Frederick, 21, 27, 163, 184n8,
 189–90n30, 256n24
Doyle, Trajan (overseer), 52–53, 57, 117
Dred (slave), 54, 116, 123, 220n33
Drew, Newit (owner), 62, 119, 120
Drewry, Edward (overseer), 62, 218n17
Drewry, William Sidney
 Greensville cavalry, 71, 89–90
 Jerusalem defenses, 225–26n31
 killing of blacks after revolt, 93–94,
 97–98, 232n26
 Lavania Francis, 208n23, 212n52
 myth of the loyal slave, 207n20,
 211n44, 213–14n56
 oral history, 166
 rebel recruitment, 59, 191n2, 192n3, 216n5
 "Red" Nelson (slave), 206n18
 The Southampton Insurrection, 3, 40
 Turner capture, 143

Turner's body, 151
Turner's wife, 194n9
DuBois, W. E. B., 7, 166–67, 184–85n8
Dunmore (Lord), 244–45n56

Edenton Gazette and Farmer's Palladium,
 84, 101
Edwards, Benjamin (owner), 59, 130–31,
 214–15n60, 244n54
Edwards, Peter (owner)
 concern over protection of slave
 property, 9, 96
 escape of, 54
 family deaths, 60
 Nelson (slave), 191–92n2
 and Newsom, 214–15n60
 rebel trials, 58
 recruitment at plantation, 59, 61,
 244n54
 Sam (slave), 67, 236n4
 Turner capture, 142–44, 249n12
Egerton, Douglas, 31
Elliot (commander), 104
Elm Street Methodist church, New
 Bedford, Massachusetts, 163
emancipation, 1–2, 168
Emory, Thomas, 165
Eppes, Richard, 9–10, 12, 85, 95–97, 101,
 105–6, 225–26n31
Evans, Emory (free black), 42–43,
 206–7n20
evidence. *See* rebel trials

Fabricant, Daniel, 15, 258–59n4
father (Turner's), 19–20
Fayetteville, North Carolina, 103
February meeting, 17
Fed (slave), 246–47n72
*The Fires of Jubilee: Nat Turner's Fierce
 Rebellion*, 3, 98
Fitzhugh, J. Drew (owner), 74–76, 78–79,
 223n3

Floyd, John
 commutation of rebel slave, 10, 125–27,
 135, 243–44n50
 commuications of, 105–6, 227n38
 revolt, 82, 85
 Southampton Grays militia
 mobilization, 237n8
"fog" of war, 74–78, 139, 223n5, 223n7
Foner, Eric, 98, 219n21
Fort Monroe, 40
Fox, George, 155
Fox-Genovese, Elizabeth, 189n30, 214n57
Francis, Lavania (owner)
 Charlotte threatens mistress, 93
 escape of, 52–53, 83, 179, 212–13n52,
 213–14n56
 "fog" of war, 74
 report on Wiley Francis
 encounter, 207–8n23
 Turner almost surrenders, 141
Francis, Nathaniel (owner)
 Charlotte (slave), death of, 93, 99
 investigates rumors, 52
 rebel trials, 58, 112
 recruitment, 53–54, 214n58
 Sam (slave), 17
 Turner hiding place, 140–41
 Will (slave), 28
Francis, Salathiel (owner), 42–43, 141,
 205–6n17, 206n18
Francis, Wiley (owner), 207–8n23
Frank (slave), 117–19, 132–33, 135–36
free blacks
 acquittal of, 130–31
 on Barnes farm, 28
 casualties among during revolt, 102–03,
 132, 232–33n29
 census of, 109, 234n33
 colonization of, 100, 109
 death penalty, 130, 132
 double-consciousness, 187n17
 in Haiti, 31

free blacks (*continued*)
 killing of after revolt, 102
 loyalty of, 90
 recruitment among, 5–6, 12, 50,
 226–27n34
 and slavery, 28
 support whites during revolt, 50
 survival of, 101–2
 tax records, 102
 trials of, 13, 110, 129–32, 145
 Turner capture, 145, 250n16
 Vesey plot 1822, 43
 See also *individual persons*
French, James S., 113–14, 116, 128–29,
 133–36, 138, 239n19
French, Scot, 136, 170–71, 179, 187–88n21,
 226n34, 258–59n4
French Revolution, 31
Futrell, Shadrach, 118–19

Gabriel's conspiracy, 17, 26, 124–25, 152
Gabriel (slave), 17, 152
Garrison, William Lloyd, 2, 151, 251n35
General Committee of the Baptist
 Associations, 156
genocide, 9, 168, 189n24
Genovese, Eugene D., 4–5, 7, 75–76,
 185n9, 187–88n21, 189–90n30,
 194n9, 211–12n49
ginger cakes, 151–52
Gospel of St. Luke, 6, 20–21
Gramsci, Antonio, 167, 187–88n21
Gray, Ellen Douglas (daughter), 147, 153
Gray, George, 98–99
Gray, Thomas R. (author)
 applies for copyright, 260–61n22
 authenticity of *Confessions*, 15–16, 169,
 174–75
 Blunt's farm events, 170
 comments on Turner confession,
 250n21
 compensation for, 239n19

Constitutional Whig letter, 169–71
cross examination of Turner, 148–49,
 176, 178
Davy's trial, 114–15
as defense attorney, 109, 170
editorial comments in *Confessions*, 177
financial difficulties of, 146–47, 153
illness of, 170, 257n2
Jack's trial, 126, 179
revolving door for judges, 112
transcribes Turner confession, 165, 176,
 178–79
Turner as leader, 226–27n34
Turner capture, 147
Turner interview, 1, 13, 145, 147
Turner trial, 152, 171–73, 251n30
 See also *The Confessions of Nat
 Turner, the Leader of the Late
 Insurrection in Southampton, VA*
Gray, Thomas (owner), 102–3, 146–47,
 257n2
Greenberg, Kenneth S., 18, 98, 103, 151,
 165, 171
Greensville militia, 71, 76–78, 82, 89–91,
 94–95, 232n26, 239n7
Griffith, Benjamin (owner), 158, 254n10,
 257–58n3
Gross, Seymour, 175
Gurley, John (owner), 87, 98–99, 131–32,
 234n33

Haithcock, Thomas (free black), 6, 59,
 102, 114, 131–32, 244n54, 250n16
Haitian Revolution, 2, 4, 26, 30–31,
 201n51
Hanover County, 9
Hardy (slave)
 conviction of, 132
 recruitment, 59, 86
 sentencing, 247n73
 trial of, 127–28, 130, 226–27n34,
 241n31

Hark (slave)
 attitude toward Turner, 21–22, 25–26
 August 20 meeting, 28
 battle at Blunt farm, 70–71
 Cabin Pond meeting, 29, 126
 as Captain Moore, 118, 226–27n34
 capture of, 83
 conspirators, 17
 Doyle killing, 52
 February meeting, 19, 23
 first blood, 37–38, 203n1
 as "Gen. Moore," 40
 killing of whites, 32
 meets Turner, 24–25
 Moses' trial, 119, 120
 recruitment for revolt, 72
 relationship to Jack, 28–29, 32, 35,
 42, 126
 as revolt leader, 83
 saved by Turner, 67
 trials, 25–26, 62, 117–20, 226–27n34,
 241–42n37, 244–45n56
Harris, Elizabeth (owner), 206–7n20,
 211n44
Harris, Howell (owner), 52
Harris, Newit (owner), 55, 57, 59, 71–72,
 179, 216n5, 240n28
hegemony, 8, 10–11, 167–68, 187–88n21,
 189–90n30
Henry (slave-rebel)
 alcohol for rebels, 17
 attitude toward Turner, 21–22
 August 20 meeting, 28
 Cabin Pond meeting, 29
 conspirators, 17
 death of, 99, 232n26
 Elizabeth Turner raid, 44
 February meeting, 19, 23, 25–26
 identity of, 192n3
 as paymaster, 40
 recruitment, 72
 Travis massacre, 39

Henry (slave-witness)
 lack of trial, 111, 192n3
 rebel trials, 127–28
 testimony in rebel trials, 241n31
Hertwell (slave), 146
Hicks' Ford, 82
Higginson, Thomas Wentworth, 93, 98,
 103, 231n23
Hillsborough, North Carolina, 103
Hines, Samuel B., 149
Holleman, Josiah, 160–63, 168
Horowitz, Tony, 15, 179
horses, 41, 42
Hubbard (slave), 5, 49–50, 77, 90–91,
 114–15

*Incidents in the Life of a Slave
 Girl*, 260–61n22
Independence Day, 26–27, 39
insurrection, 8–9
interracial churches
 and the black community, 75, 157,
 160–64
 Christianity and, 155–56
 communion segregation, 163, 168
 communion suspension, 156–57, 159,
 255n16
 fault lines among whites in, 157
 hegemony of whites, 11
 supervision of black preachers, 160–61
 support for secular order after
 revolt, 163
Isaac (slave of Samuel Champion)
 Beck's testimony, 133, 135
 pardons for, 126, 129
 recruitment, 86, 128
 sentencing, 247n73
 trial of, 111, 128–29, 133, 244–45n56
Isaac (slave of Williamson), 254–55n11
Isham (slave)
 conviction of, 132
 recruitment, 59, 86

Isham (slave) (*continued*)
 sentencing, 247n73
 trial of, 127–28, 130, 241n31, 241–42n37,
 244–45n56
Isle of Wight County, 160

Jack (slave of Joseph William Reese)
 Cabin Pond meeting, 29
 capture of, 32, 43
 as conscript, 41–42, 64
 execution of, 126
 Gray as attorney, 126, 179
 recruitment, 28–29
 as reluctant rebel, 35, 51
 trial of, 58
Jack (slave of Catherine Whitehead)
 flee rebels, 48
 and Haithcock, 131
 recruitment, 6–7, 186–87n16
 trial of, 111, 113–14, 240n24
Jack (slave of Nathaniel Simmons)
 released on technicality, 111
 revolving door for judges, 112
 treason charge, 110–11
 trial of, 122,
Jackson, Andrew, 105–6
Jacob (slave of Richard Porter), 50–51, 72,
 93, 211–12n49
Jacob (slave of George Charlton), 111
Jacob (executed slave), 231n25
Jacob (slave witness), 118
Jacobs, Harriet (slave), 7, 20, 260–61n22
jailbreak, 135–36
James Perkins (ship), 100 232n28
Jefferson, Thomas, 27
Jenkins, Jarell W., 118
Jerusalem
 Eppes assumes command, 95, 225–26n31
 as refuge for whites after revolt, 81–82
 rumors in, 74
 as target of revolt, 32, 55, 63–64, 67–68,
 71, 89, 128

Trezvant as initial leader, 83, 103, 106,
 225–26n31
Turner capture, 144
Turner incarcerated, 1, 144–45
Turner trial, 149–50
Jim (slave of Peter Edwards), 54
Jim (slave of Samuel Champion), 126, 133,
 135, 247n73
Joe (slave of Elizabeth Harris)
 Harris family, 206–7n20
 loyalty of, 211n44
Joe (slave of John C. Turner)
 capture of, 72
 Davy's trial, 115
 death sentence, 125
 execution of, 126
 joins revolt, 47, 59
 trial of, 123
Johns Hopkins University, 3
Johnson, Michael P., 14
Joines, Joseph, 54
Jones, Thomas C., 126–27, 225–26n31
Jordan (slave), 45
judges, 14, 108–13, 120–23, 126–30, 132,
 134–37, 144, 149–50
 certify Gray's *Confessions*, 152–53,
 173–74
 power of 10–11, 158, 166
 See also defense attorneys; jury;
 magistrates; rebel trials;
 prosecuting attorneys
jury, 10, 96, 107–8

Kentucky, 156

Laine (Mr. and Mrs.), 136–37
Lane, Lunsford (slave), 20–21
Lankford, Jonathan, 156–58,
 257–58n3
Lee, Edmund Jennings, 153, 175
Lee, Robert E., 40, 223n3
Lee, Sheppard, 76

Leigh, Benjamin Watkins (owner), 9

Lewis, Ellen, 8

Liberator, 2

Liberia, 100, 109

Louverture, Toussaint, 50

Lucy (slave Nathaniel Francis)
slave women and clothes, 53, 214n57

Lucy (slave of Thomas Barrow)
attacks Mary Barrow, 55
death sentence, 125, 242n43
execution of, 122, 126
trial of, 115–17, 122–23, 241–42n37

Luke (slave), 124

lynching, 231n23

magistrates, 108–9. *See also* judges

Mangum, Willie P., 260–61n22

manumitted slaves, 100

Marmaduke (slave), 63, 80

maroon community, 31

martial law, 96–97, 107

Mary (slave), 70, 118

Mason, John Young, 153

Matt (slave), 121

McPhail, John, 100

Meahan, 239n9

militiamen, 9–10, 12–13, 64–67, 73–78,
90–93, 106, 228–29n5

Mill Swamp Baptist Church, 160–64,
168, 255n14, 255n16

Monroe, James, 17, 124–25,
242–43n45

Moore, Putnam (owner), 24,
38–39

Moore, Sally Francis. *See* Travis, Sally
Francis Moore Travis

Moore, Thomas (owner), 24

Mordecai, Emma, 80, 94

Moses (slave of Joseph Travis)
commitment of slaves in the
revolt, 5
as conscript, 41–42, 45

defection from the ranks, 67
Jack's trial, 126, 179
Lucy's trial, 242n43
Nathan's trial, 123
rebel trials, 15, 115, 240n28
recruitment, 35
trial, 116–20, 139

Moses (slave of Richard Porter)
age of, 211–12n49
death of, 93
recruitment, 50–51

Moses (slave of Thomas Barrow)
battle at Blunt farm, 70–71
conviction of, 122
joins revolt, 59–60
recruitment, 62
trial of, 62, 116–20, 139

Murfreesboro, North Carolina, 78–79,
93, 103

Musgrave (Mrs.), 143

Musgrave, Robert, 150, 205n14

Nat (slave), 47, 54, 59, 72, 231n25,
241–42n37

Nathan (slave of Benjamin Blunt)
conviction of, 122–23
death sentence, 123
identity, 211n44
as reluctant rebel, 58
trial, 242n43

Nathan (slave of Catherine Whitehead),
49, 211n44

Nathan (slave of Nathaniel Francis)
Davy's trial, 115
death sentence, 116
judge as defense council, 112
trial of, 116–17,

*Nat Turner's Slave Rebellion: Together
With the Full Text of the So-Called
"Confessions" of Nat Turner Made in
Prison in 1831*, 3

Ned (slave), 246–47n72

Nelson (slave and original conspirator)
 attitude toward Turner, 21–22
 Cabin Pond meeting, 28–29, 72
 February meeting, 17, 19, 23, 25–26
 as "General," 40
 identity of, 191–92n2
 joins revolt, 62–63
 kills Waller's wife and children, 60
 race war, 200n48
 recruitment of rebels, 54
Nelson (slave of Jacob Williams)
 advance notice of revolt, 218n17
 Stephen's testimony, 111
 trial of, 122–23, 191–92n2
Nelson, "Red" (slave), 42, 53, 206n18,
 213–14n56
 reports on Turner sighting, 139–40
New Bedford, Massachusetts, 163
New Orleans Advertizer, 100
Newsom, Berry (free black)
 conviction of, 132
 death penalty, 130, 132
 execution of, 102, 130
 rebel trials, 214–15n60
 recruitment, 59, 72, 86
 Turner capture, 250n16
Newsome, Sarah, 44
Nicholas, Phillip Norborne, 242–43n45
Nicholls, Michael, 124
Nicholson (owner), 11
Norfleet, Aaron (free black), 102
Norfolk, Virginia, 31–32, 40, 81, 100
Norfolk and Portsmouth Herald, 100,
 104, 151
Northampton County, 76, 78, 82
North Carolina Journal, 104
Northern Neck, Virginia, 255n14
Nottoway Parish, 234n33
Nottoway River, 67

Oates, Stephen B., 3, 98, 103
Ogé, Vincent, 31
On War, 74

oral history, 18, 40, 142, 151, 166, 192n3,
 193–94n8
Ortner, Sherry B., 186n14

pardons, 124–25. *See also* commutation
Parker, James W. (owner)
 battle at farm, 1, 47, 64–69, 79, 115, 131,
 177–78, 223n5
 recruitment, 64, 132
 slave trials, 236n4
 Turner capture, 144
 Turner interview, 148
 Turner trial, 149, 241–42n37
Parker, Joseph (owner), 134
Parker, Solomon (owner), 132–34
Parker, Temperance (owner), 134
Parker, William C.
 as defense attorney, 109, 172
 Gray's daughter as ward, 153
 Hark's trial, 120
 Jerusalem defenses, 225–26n31
 Matt's trial, 121
 Moses's trial, 118–20
 Southampton Grays militia, 237n8
 Turner description, 17–18, 85
 Turner trial, 150, 153
Parramore, Thomas C., 18, 98, 147,
 216n10
Parsons, Nancy, 128–29
paternalism, 4, 185n9
Pate's Hill, 83
Peebles, Hartwell, 44–45, 99
Peete, Alexander P. (owner)
 Alfred, attack on, 89, 94
 Blunt plantation, 73
 as leader of militia, 12, 64–67, 106, 113,
 177, 239n9
 response to revolt, 92, 168
 sees limited support for revolt in black
 community, 91–92
 as trial judge, 107
Person's Mill Pond, 23
Peter (slave), 242–43n45

Petersburg, Virginia, 8, 84, 225n31
Petersburg Intelligencer, 151
Pettigrew, William, 103
Phillips, Ulrich Bonnell, 3–4
Phipps, Benjamin, 13, 139, 142–44,
 249n12, 258–59n4
Pleasants, John Hampden
 battle at Blunt farm, 71
 black casualties, 103–5
 identifies revolt leader, 83
 Jerusalem as refuge, 81–82
 on the plan, 31–32
 rage of whites after revolt, 92–96
 reports on Turner sighting, 140
 torture of slaves, 80
 travels to Southampton, 9
 Waller plantation deaths, 61, 216–17n10
Porter, Jesse J. (owner), 211–12n49
Porter, Richard (owner)
 escape of, 11, 50–51
 rebel trials, 111, 113
 recruitment, 48, 59, 72, 214n58
 slave trials, 211–12n49
Portsmouth, Virginia, 147
Portsmouth Association, 157, 159–61, 255n14
postmodernism, 187–88n21
Powell, James, 114, 120, 244n54
Pretlow, Joseph, 236n5
Pretlow, Moses (free black), 236n5
Pretlow, Thomas (judge), 109, 155, 236n5
Pretlow, Thomas (father of judge), 155
prosecuting attorneys, 109–10, 113–14,
 128. *See also* rebel trials
proslavery, 2, 21, 156

Quakers. *See* Society of Friends

Raccoon Swamp Baptist Church, 132,
 136, 138, 158–60, 254–55n11
race relations, 160, 168
race war, 23–24, 200n48
racism, 3, 4, 7, 168, 189–90n30
radicalization, 2, 6

Raleigh, North Carolina, 21
Randolph, Thomas Jefferson, 2
*The Rebellious Slave: Nat Turner in
 American Memory*, 187–88n21,
 226–27n34
rebel trials, 261n28
 advance notice of revolt, 218n17
 Beck's testimony, 133–38, 159,
 246–47n72
 beginning of, August 31st., 107
 Broadnax as prosecuting
 attorney, 109–10
 cases discharged, 13, 121
 certify Gray's *Confessions*, 153
 closing arguments, 113, 240n24
 compensation for defense
 lawyers, 112
 conviction of rebels, 124
 credibility of witnesses, 115, 117,
 240n28, 241n31
 death penalty, 120–25
 defense attorneys, 15, 109, 112–13, 115,
 150, 153
 evidence in, 14–15, 115–18, 170–71,
 190n32, 258–59n4
 executions after, 122–24
 formal charges, 110–11
 free blacks, 110, 129–30
 mercy for defendants, 127, 132, 158
 non-jury trials, 10, 107–8
 number of, 236n4
 pardons for, 124–25
 response to revolt, 58
 revolving door for judges, 112
 scope of revolt, 135
 shortcuts during, 112
 slaveholdings of judges, 107, 236–37n7
 transportation as sentence, 124, 139
 treason charge, 122
 verdicts in Gray's *Confessions*, 175
 See also court of oyer and terminer;
 defense attorneys; *individual rebels*;
 judges; witnesses

reconstruction, 82, 101, 184–85n8
recruitment
 after battle at Parker's farm, 68–69
 alcohol and, 219n23
 among free blacks, 12, 42–43, 50, 86
 Catherine Whitehead plantation, 47,
 49–51
 double-consciousness, 7–8
 effectiveness of, 5–6, 47–50, 58–59
 Elizabeth Turner farm, 43–44, 45
 Hark, 24–25
 influence of family and friends as tool
 for, 29–30
 Jack (slave of Joseph William
 Reese), 28–29
 killing of whites as tool for, 32–33
 as mitigating factor in rebel trials, 123–24
 motives, 28, 64
 Nathaniel Francis house, 42–43,
 53–54, 214n58
 Newit Harris plantation, 55, 57, 71,
 206–7n20
 Peter Edwards's plantation, 54
 Porter plantation, 50–51
 Rebecca Vaughn plantation, 63
 reluctant rebels, 41–42, 51, 53–54, 61–62
 Will (slave), 28. *See also* revolt
Redric (slave), 18
Reese, Giles (owner), 18, 28, 205–6n17
Reese, Joseph William (owner), 28, 43,
 58, 127
Reese, Piety (owner), 28–29, 43–44,
 207n21
Reese, Sampson, 66, 113, 126–27
Reese, William. *See* Reese, Joseph
 William
religion, 11, 30, 189–90n30
 See also Christianity
resistance model, 4–7, 186n14, 214n57
revenge,
 black, 8–9, 71, 92, 130–32
 white, 8, 93–96, 106, 111

revisionism, 3–4, 184–85n8
revolt
 alcohol and, 1, 11, 29, 35, 57, 64, 72, 89,
 219n23
 antiblack response to, 8–9
 August 20 meeting, 28
 banner of, 40
 battle at Blunt farm, 70–71
 battle at Parker's farm, 64–69, 220n33
 black community response to, 12, 29,
 71, 75, 85–87, 90–92
 black community support for, 10, 12,
 58–60, 110, 128, 166, 190n32, 219n21
 blacks as accessory to murder, 161
 Cabin Pond meeting, 28–29
 casualties of blacks after revolt, 97–101,
 231n23, 231n25
 casualties of blacks during
 revolt, 100–101, 104, 232–33n29
 Catherine Whitehead plantation, 46–48
 children's death at Waller
 plantation, 60–61
 collapse of, 12, 73, 131
 commitment of slaves, 5, 12, 21
 compensation for owners after
 revolt, 239n19
 death penalty for, 120–25
 defection from the ranks, 67–68
 Demerara, 201n50
 double-consciousness and, 58
 early success of, 57
 Elizabeth Turner farm, 43–44
 emancipation question after, 1–2
 end of bloodbath, 95–96
 failure of, 7–8
 February meeting, 17, 19, 23
 final stages, 71–72
 "fog" of war, 74–75
 free blacks in, 86, 102, 132
 Gabriel's 1800, 17, 26, 124–25, 152
 hegemonic forces, 8, 10–11, 167–68,
 187–88n21, 189–90n30

horses, 41, 44–45, 76

impact on interracial churches, 157–58

Independence Day, 26–27, 39

Jerusalem as target, 32, 55, 63–64, 71, 89, 128

justification for, 2, 32–33

killing of whites, 32, 39, 177

launching of, 1, 34–35, 37–40, 203n1

martial law, 96–97, 107

military exercises, 39–40

narrative of slaveholders, 10–11

origins of, 26

payment grades for recruits, 40

planning stages, 1, 31–32

Raccoon Swamp Baptist Church, 132, 136, 138

race relations after, 160, 168

rebel strategy, 33

refuge at Ridley plantation, 70

rumors of in North Carolina, 148–49

scope of, 11–12, 132–35, 138–39, 160

secrecy of, 28, 30, 34, 200n48, 201n50

slave ambiguity about, 6–7

slaveholders petition for compensation, 207n21

slave sale after, 100

sources for, 2–3, 13–14, 183n1, 186n15

St. Domingo. *See* Haitian Revolution

sunspot as sign for, 27–28

suppression of, 1–2, 12–13

torture of slaves, 79–81

uniforms for, 40

Vesey plot, Charleston, South Carolina, 1822, 14, 26, 31

white society response to, 8, 12, 31, 87, 92–95, 164

See also court of oyer and terminer; *individual conspirators*; recruitment; Turner, Nat (slave)

reward for Nat Turner, 140, 144, 258–59n4

Richmond, Virginia, 8–9, 17, 26–27, 85, 124

Richmond Compiler, 106

Richmond Enquirer, 74, 144–45, 226–27n34

Ricouer, Paul, 16

Ridley, Thomas (owner), 68–69, 72, 83, 117–18, 121, 223n5

Ritchie, Thomas, 152, 175

Roanoke Blues militia, 76, 103

Rochelle, Clement (owner), 109, 149, 151

Rochelle, James (owner)

certifies Gray's *Confessions*, 153, 173–75

commutation, 243–44n50

as court clerk, 14–15, 109, 112–13

Jack's trial, 127, 240n24

Lucy and Joe's trial, 125

rebel trials, 190n32

Turner trial, 150–51, 171–73

Roll, Jordan, Roll: The World the Slaves Made, 4–5, 185n9

rumors, 10, 14, 52, 74, 78, 83–84, 148, 198n33, 226–27n34, 244n56

Saint-Domingue, 2, 4, 26, 30–31, 50, 201n51

Salem, Massachusetts, 108

Sam (slave of Nathaniel Francis)

attitude toward Turner, 21–22

Cabin Pond meeting, 28–29

conspirators, 17

Elizabeth Turner attack, 44

February meeting, 19, 23, 25

joined by Porter plantation recruits, 51

Salathiel Francis attack, 42

trial, 58, 236n4

Sam (slave of Peter Edwards)

conviction of, 54

defection from the ranks, 67

trial, 122

reluctant rebel, 54, 214–15n60

Waller plantation, 61, 240n28

Schwarz, Philip J., 108

Scott, 89–92, 94–95
segregation, 163
Shadrach (slave), 110–12, 122
sheriff, 109, 149, 236–37n7
Simmons, Jesse H., 96, 103
slaveholders
 antislavery preaching, 158
 aware of revolt, 51
 compensation for after revolt, 99, 124, 130, 192n3, 207n21, 239n7, 242–43n45
 compensation for defense lawyers in rebel trials, 112
 concern over possible massacre of slaves, 8–9, 12, 166
 confidence in the safety of the county after revolt, 10, 106, 138
 in Haiti, 31
 hegemony of, 8, 11, 167–68
 interracial churches, 11, 189–90n30
 Jefferson as, 27
 as leaders after revolt, 92
 as magistrates in rebel trials, 10, 107–9, 236n4, 236–37n7
 militia commander, 65
 paternalistic attitudes, 4
 protection of blacks after revolt, 9–10, 13, 168
 relationship to slave families, 18
 response to revolt, 90, 158, 164
 sympathy for after revolt, 91–92
 valuation of slaves, 101
 views of, 3–4
 See also revolt; slaves
slavery
 accommodation model, 4, 6, 75
 American Colonization Society, 48, 100
 anti-lynching campaign, 101
 antislavery movement, 155–57, 166
 Christian approval of, 6, 20–21, 156
 double-consciousness, 7, 58, 166–67, 187–88n21, 224n14

economics of, 101
family life, 18, 193–94n8
free blacks and, 28
Haitian Revolution, 2, 4, 26, 30–31
historians of, 3–5
interracial churches, 155–59, 254n10, 257–58n3
moral complexity of, 16
myth of the loyal slave, 206–7n20, 211n44
proslavery, 2, 21, 156
Quakers, rejection of, 155
and religion, 21, 189–90n30
resistance model and, 4–5
as sin, 156–57
slave women and clothes, 214n57
sources for, 186n15
taxation on slaves, 98, 191n1
See also revolt; slaveholders; slaves
slaves
 alliance with British, 128, 244–45n56
 arming of during revolt, 73–74
 census of, 5–6, 31, 47, 109, 181, 201n51, 234n33, 236n5
 compensation for owners after revolt, 91–92, 108, 130, 239n19
 and the court of oyer and terminer, 108
 defend Blunt family, 70
 Haitian population of, 30–31, 201n51
 jailbreak in Sussex County, 135–36
 loyalty of, 11, 90–91, 139, 161–62, 213–14n56, 224n14
 manumission of, 100, 155
 marriage among, 18
 massacre of, 8–9
 oral history, 179
 protection of after revolt, 96
 radicalization of, 6
 resistance model, 6
 Roll, Jordan, Roll: The World the Slaves Made, 4–5
 sale of after revolt, 100

slaughter of after revolt, 8–9, 92–93, 101

slave traders, 125

The Souls of Black Folk, 7

sympathy for rebels, 158

taxation on, 98, 191n1

torture of, 79–81, 94, 101

Union Army enlistment, 7

valuation of, 101

women who supported the rebellion, 47

See also *individual persons*; revolt; slavery

Smith, James Lindsay, 255n14

Smith, O. M., 81–82, 104, 234n38

Society of Friends, 155

solar eclipse, 19, 25

Solomon (slave), 136–37, 246–47n72

The Souls of Black Folk, 7

South America, 31

Southampton County

antislavery movement, 166

Civil War, 155

"fog" of war, 74

intelligence on rebels, 79

interracial churches, 155–56

potential revolt in 1802, 26

rebel trials, 13, 108, 110, 129–32

taxation on slaves, 98, 191n1

as Turner birthplace, 1

See also revolt; slaves

Southampton Grays militia, 91–92, 109, 225–26n31, 237n8

The Southampton Insurrection, 3, 40

The Southampton Slave Revolt of 1831: A Compilation of Source Material, 183n1

Spencer plantation, 68

Squire (slave), 246–47n72

Stampp, Kenneth M., 4

Stephen (slave), 62, 71–73, 111, 116, 218n17

St. Domingo revolt. *See* Haitian Revolution

St. Luke's Parish, 5–6, 55, 101–2, 234n33

Stokes, Montfort, 78

Story, James (owner), 87

Story, Lemuel (owner), 87

Styron, William, 2–3, 15, 203n5, 209–10n34

Suffolk, Virginia, 84

suicide, 7, 102

sunspot, 27–28

Sussex County, 13, 81, 104, 132–38, 158–60, 239n19, 246–47n72

Tarboro Free Press and Southerner, 103

taxpayers, 108, 130

tax records, 99–100, 102, 191n1

Thomas, George, 68

Tom (slave of Catherine Whitehead), 48–49, 121–22

Tom (slave of Nathaniel Francis), 58, 112, 116,

Tom (slave-rebel), 99

torture, 79–81, 94, 101, 144, 242n43

"To the Public," 153

Tragle, Henry Irving, 183n1

transportation as sentence, 124

Travis, Joseph (owner), 1, 17, 24, 34, 37–40, 67, 115

Travis, Sally Francis Moore (owner), 38, 43

treason charge, 110–12, 122

Trezvant, James (owner)

casualties of blacks after revolt, 103–4

demobilizing militia, 95

does not certify *Confessions*, 174

Jerusalem defenses, 225–26n31

as magistrate, 108–9, 173

militia leader, 83

rebel trials, 226–27n34, 236–37n7

responds to Andrew Jackson petition, 106

Turner capture, 144

Turner interview, 148

Turner trial, 107, 149–50, 152, 171–73, 251n30

Trezvant, Theodore, 92–93

Tucker, St. George, 2

Turner, Edwin (owner), 116

Turner, Elizabeth (owner), 43–45, 47,
 58–59, 208–9n30, 211–12n49

Turner, Isham (free black), 102

Turner, James (owner), 47

Turner, John C. (owner), 47, 72, 73, 115

Turner, Nat (slave)
 almost surrenders, 141
 attack on Elizabeth Turner's farm,
 43–44, 208n24
 attacks Sarah Newsome, 44
 baptism, 22–23
 at Barrow farm, 179
 battle at Parker's farm, 66–67
 biography of, 17–18
 Cabin Pond meeting, 29
 capture of, 1, 13, 139, 142–44, 249n12,
 258–59n4
 as Christ-like figure, 145
 compensation for owners, 172
 confession of, 144–45
 cross examination of by Gray, 149, 176
 death penalty for, 99, 150–51, 171–72
 disposition of corpse, 151
 endorses Gray's *Confessions*, 175
 execution of, 1, 151
 family life, 18, 193n7
 father, 18–20, 193–94n8
 February meeting, 1, 19
 Francis farm, 140–41
 as "General," 40, 57, 61
 Gray interview, 1, 13
 and Hark, 24–25
 hearing for, 144
 hiding places, 140, 176
 horse riding, 205n14
 interrogates Will, 29–30
 killing of Peggy Whitehead, 46, 122,
 173, 178, 203n5, 209–10n34
 at large, 84–85

as leader of revolt, 51–52, 83–84,
 226–27n34
list of conspirators, 34
marriage, 18, 194–95n9, 205–6n17
as messianic figure, 23, 25
motive for revolt, 145–46, 258–59n4
moved to Travis farm, 24
not guilty plea, 150, 171
physical description of, 17, 177,
 258–59n4
as prophet, 19
as recruiter, 64, 219n21
reliability of, 148
as religious fanatic, 12, 139, 146, 161,
 177, 258–59n4
revolt planning stages, 1
as revolutionary, 4–5
reward for, 140, 144, 258–59n4
as runaway slave, 19–20
sells body for ginger cakes, 151–52, 251n35
sword as weapon, 41, 141–42, 205n13
torture of after capture, 144
Trezvant interviews, 148, 236–37n7
trial of, 149–50, 171, 175–76,
 241–42n37, 251n30
as Uncle Tom, 21
view of Jack, 126
whipping, 24
white flight after rebellion, 81
See also revolt; *The Confessions of Nat
 Turner, the Leader of the Late
 Insurrection in Southampton,
 Virginia*

Turner's wife
 husband's papers, 145, 170
 identity, 194–95n9
 marriage, 18
 questioning of, 84
 rebel trials, 111, 242n43
 torture of, 80

Turner, Zephenira, 85

two-ness, 7

uncertainty, 16
 within black community, 77, 86–87, 140
 within white community, 12, 73–85,
 90, 223n8
Uncle Tom, 21
Union Army, 7
"Untrue Confessions: Is Most of What
 We Know About the Rebel Slave
 Nat Turner Wrong?" 15
Urquhart, Richard A., 149

Vaughn, Eliza Ann (owner), 63
Vaughn, George (owner), 55, 212–13n52,
 215n61
Vaughn, Rebecca (owner), 62–63, 111,
 119–20
Venus (slave), 48, 111
Vesey plot, Charleston, South Carolina,
 1822, 14, 26, 31, 43
Vick, William (owner), 87, 131
Vicksville, 82–83, 94
Virginia
 free blacks, 129–30
 manumission law, 155
 population of slaves, 31, 201n51
 segregation of in interracial church,
 255n14
 Virginia General Assembly, 1–2,
 207n21
 Virginia House of Burgesses, 108, 146
 Virginia House of Delegates, 105

Wade, Richard, 14
Wallace (slave), 49, 114, 244n54
Waller, Levi (owner)
 actions during raid, 60–61
 breakdown, 217n11
 Daniel's trial, 113
 Davy's trial, 123–24
 death of slave Alfred, 89–92
 death of wife and children, 86, 115, 122,
 216–17n10

Dred's trial, 116
 escape of, 60, 179
 Hark's trial, 120
 rebel trials, 15, 67, 226–27n34
 Sam's trial, 118, 240n28
 testimony in Turner trial, 54, 150, 171
Waller, Thomas (owner), 60–61
Warner, Samuel, 103
War of 1812, 244–45n56
weapons
 arms for rebels, 57
 battle at Blunt farm, 70, 73–74
 Hark (slave), 226–27n34
 as a factor in court, 123
 for loyal slaves, 91
 militiamen, 65–66
 strategy for, 33–34
 Travis house, 37, 41
 in Vicksville, 83
 Waller plantation deaths, 60
Wells, Ida B., 101
Westbrook, David, 249n12
Westbrook, Joel, 38–39
Weston, Thomas, 78
Wheeler, John, 103–4
Whispers of Rebellion, 124
Whitehead, Catherine (owner)
 death of, 5–6, 11, 46, 76–78
 rebel trials, 113–14, 244n54
 recruiting, 47–49, 59, 72
 slave loyalty, 49
Whitehead, Harriet (owner), 5, 46,
 49–50, 76–78, 81, 90–91, 179
Whitehead, Margaret "Peggy" (owner),
 46, 122, 150, 173, 178, 203n5,
 209–10n34
Whitehead, Richard (owner), 45
white society
 casualties among, 1, 32, 61–62, 104, 153,
 170, 175, 234n38
 census of slaves, 201n51
 Civil War, 7, 17, 65, 155

white society (*continued*)
 counterattack, 70
 division within after revolt, 166–67
 economics of slavery, 101
 elite privileges within, 236–37n7
 indiscriminate killing of blacks, 9,
 94–95, 103
 intelligence on rebels, 69, 73–74, 83
 interracial churches, 11, 21, 157, 159–61,
 255n14
 lines of communication, 87, 131
 militia mobilization, 64–65, 237n8
 reaction to the revolt, 8–9, 75–76,
 105–6, 139
 rebel deaths, 100
 rebel trials, 107, 118, 122–23, 149
 as refugees after the revolt, 60, 69,
 78, 81
 response to revolt, 8–10, 12, 31, 87,
 92–94, 105–6, 139, 164
 rumors of some participating in revolt,
 78, 83, 226–27n34
 search for Turner, 140
 skepticism about Turner confession, 148
 slave loyalty, 224n14
 torture of slaves, 79–81
 treatment of slaves, 101
 Turner as religious fanatic, 146
 Turner hanging, 151
 Turner trial, 149–50

 uncertainty of, 12, 73–85, 90, 223n8
 warned of Turner revolt, 50–51
 See also slaveholders
Wickham, John, 8
Will (slave)
 Cabin Pond meeting, 29–30
 death of, 71, 99, 232n26
 as executioner, 5, 38–39, 52
 kills Catherine Whitehead, 49
 kills Elizabeth Turner, 44
 kills Salathiel Francis, 42
 kills Sarah Newsome, 44
 recruitment, 28, 214n58
 Reese family, 43
 support for revolt, 64
 Travis family, 38
 Turner's view of, 29
Williams, Jacob (owner), 62, 191–92n2
Williams, John R. (Choctaw)
 (owner), 52, 78
Williams, Louisa (owner), 52, 212–13n52
Williams, William (owner), 62, 111, 118
Wilmington, North Carolina, 148–49
Winton, North Carolina, 78, 104–5
witch trials, 108
witnesses, 112, 115, 118, 240n28,
 241n31
Womack, John, 54
Worrell, Caswell (overseer), 62–63,
 200n48, 218n17